The Culture & Civilization of China

中國文化与文明

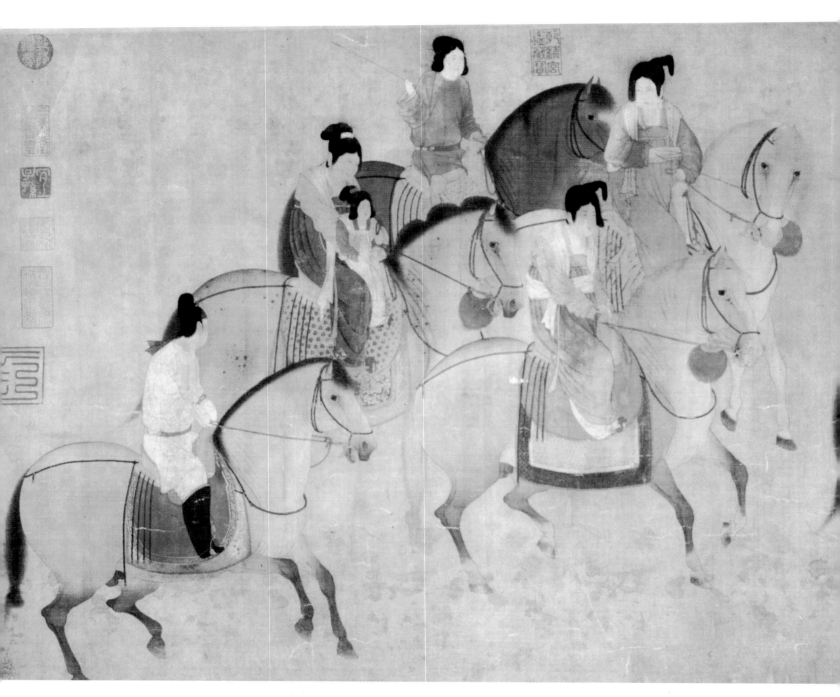

Yale University Press
New Haven & London
Foreign Languages Press
Beijing

Yang Xin
Nie Chongzheng
Lang Shaojun

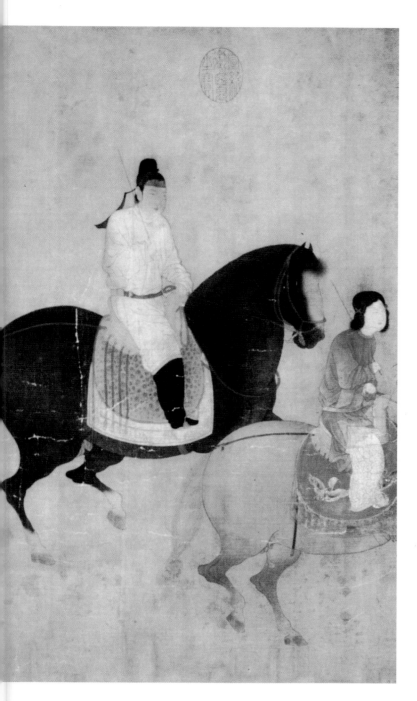

Three Thousand Years of Chinese Painting

Richard M. Barnhart
James Cahill
Wu Hung

Calligraphy for series title by

Qi Kong, president of the Chinese National

Calligraphers' Association.

Frontispiece: *Lady Guoguo's Spring Outing*, Emperor Huizong's copy of an 8th-century painting by Zhang Xuan, Liaoning Provincial Museum, Shenyang (fig. 72).

Designed by Richard Hendel.

Set in Monotype Garamond

by G & S Typesetters, Inc.

Printed in Hong Kong by C & C Offset Printing.

Library of Congress Cataloging-in-Publication Data

Three thousand years of Chinese painting / Richard M. Barnhart . . . [et al.].

 p. cm. — (The culture & civilization of China)

Published simultaneously in Chinese.

Includes bibliographical references and index.

ISBN 0-300-07013-6 (cloth : alk. paper)

ISBN 0-300-09447-7 (pbk. : alk. paper)

 1. Painting, Chinese. I. Barnhart, Richard M., 1934– .

II. Series.

ND1040.T48 1997

759.951—dc21 97–11152

A catalogue record for this book is available from the British Library.

The paper in this book meets the guidelines for permanence and durability of the Committee on Production Guidelines for Book Longevity of the Council on Library Resources.

10 9 8 7 6 5 4 3 2 1

Yale University Press

gratefully acknowledges the financial

support given to The Culture &

Civilization of China by

THE HENRY LUCE FOUNDATION, INC.

PATRICIA MELLON

JOHN AND CINDY REED

THE STARR FOUNDATION

THE CULTURE & CIVILIZATION OF CHINA

Each book in this series is the fruit of cooperation between Chinese and Western scholars and publishers. Our goals are to illustrate the cultural riches of China, to explain China to both interested general readers and specialists, to present the best recent scholarship, and to make original and previously inaccessible resources available for the first time. The books will all be published in both English and Chinese.

The partners in this unprecedented joint undertaking are the China International Publishing Group (CIPG) and Yale University Press, which together conceived the project under the auspices of the U.S.-China Book Publication Project. The series is sponsored in the United States by the American Council of Learned Societies. James Peck is director of the U.S.-China Book Publication Project and executive director of The Culture & Civilization of China series.

Honorary Chairs, The Culture & Civilization of China
>George H. W. Bush, Former President of the United States
>Rong Yirong, Former Vice President of the People's Republic
> of China

Yale Editorial Advisory Board
>James Cahill, University of California, Berkeley
>Mayching Kao, Chinese University of Hong Kong
>Jonathan Spence, Yale University
>James C. Y. Watt, Metropolitan Museum of Art, New York
>Anthony C. Yu, University of Chicago

CIPG Editorial Advisory Board
>Li Xueqin, Director, History Institute,
> Chinese Academy of Social Sciences, Beijing
>Lin Wusun, Chairman, National Committee
> for the Accreditation of Senior Translators, and Chairman,
> Translators' Association of China
>Yang Xin, Deputy Director, Palace Museum, Beijing
>Zhang Dainian, Professor, Beijing University

CONTENTS

CHRONOLOGY

1,000,000–10,000 B.C.	PALEOLITHIC PERIOD
10,000–ca. 2100 B.C.	NEOLITHIC PERIOD
	Xia Dynasty ca. 2100–ca. 1600 B.C.
ca. 1600–ca. 1100 B.C.	SHANG DYNASTY
ca. 1100–256 B.C.	ZHOU DYNASTY
	Western Zhou ca. 1100–771 B.C.
	Eastern Zhou ca. 770–256 B.C.
	Spring and Autumn Period 770–476 B.C.
	Warring States Period 476–221 B.C.
221–206 B.C.	QIN DYNASTY
206 B.C.–A.D. 220	HAN DYNASTY
	Western (Former) Han Dynasty 206 B.C.–A.D. 9
	Xin Dynasty (Wang Mang Interregnum) 9–23
	Eastern (Later) Han Dynasty 25–220
220–265	THREE KINGDOMS
	Wei 220–265
	Shu 221–263
	Wu 222–280
265–420	JIN DYNASTY*
	Western Jin 265–317
	Eastern Jin 317–420
317–589	SOUTHERN DYNASTIES*
	Liu Song 421–479
	Southern Qi 479–502
	Liang 502–557
	Chen 557–589
386–581	NORTHERN DYNASTIES
	Northern Wei 386–535
	Eastern Wei 534–550
	Western Wei 535–556
	Northern Qi 550–577
	Northern Zhou 557–581
581–618	SUI DYNASTY
618–907	TANG DYNASTY
	Great Zhou Dynasty (Wu Zetian Interregnum) 684–705
907–960	FIVE DYNASTIES (in the north)
	Later Liang 907–923
	Later Tang 923–936
	Later Jin 936–946
	Later Han 947–950
	Later Zhou 951–960
907–979	TEN KINGDOMS (in the south)
	Shu 907–925
	Later Shu 934–965
	Nanping or Jingnan 907–963
	Chu 927–956
	Wu 902–937
	Southern Tang 937–975
	Wu-Yue 907–978
	Min 907–946
	Southern Han 907–971
	Northern Han 951–979
907–1125	LIAO DYNASTY
960–1279	SONG DYNASTY
	Northern Song 960–1127
	Southern Song 1127–1279
1115–1234	JIN DYNASTY
1271–1368	YUAN DYNASTY
1368–1644	MING DYNASTY
1644–1911	QING DYNASTY
1912–1949	REPUBLIC
1949–	PEOPLE'S REPUBLIC

*The Western and Eastern Jin dynasties together with the Southern Dynasties are frequently referred to as the Six Dynasties.

EMPERORS OF THE SONG, YUAN, MING, AND QING DYNASTIES

Emperor's Posthumous Temple Name	Reign Dates		Emperor's Posthumous Temple Name	Reign Title	Reign Dates
SONG DYNASTY			**MING DYNASTY**		
			Taizu (Zhu Yuanzhang)	Hongwu	1368–1398
Northern Song			Huidi*	Jianwen	1399–1402
Taizu (Zhao Kuangyin)	960–976		Chengzu	Yongle	1403–1424
			Renzong	Hongxi	1425
Taizong	976–997		Xuanzong (Zhu Zhanji)	Xuande	1426–1435
Zhenzong	998–1022				
Renzong	1023–1063		Yingzong	Zhengtong	1436–1449
Yingzong	1064–1067		Daizong	Jingtai	1450–1456
Shenzong	1068–1085		Yingzong	Tianshun	1457–1464
Zhezong	1086–1100		Xianzong	Chenghua	1465–1487
Huizong	1101–1125		Xiaozong	Hongzhi	1488–1505
Qinzong	1126–1127		Wuzong	Zhengde	1506–1521
			Shizong	Jiajing	1522–1566
Southern Song			Muzong	Longqing	1567–1572
Gaozong	1127–1162		Shenzong	Wanli	1573–1620
Xiaozong	1163–1189		Guangzong	Taichang	1620
Guangzong	1190–1194		Xizong	Tianqi	1621–1627
Ningzong	1195–1224		Sizong*	Chongzhen	1628–1644
Lizong	1225–1264				
Duzong	1265–1274		**QING DYNASTY**		
Gongdi	1275–1276		Shizu	Shunzhi	1644–1661
Duanzong	1276–1278		Shengzu	Kangxi	1662–1722
Di Bing*	1278–1279		Shizong	Yongzheng	1723–1735
			Gaozong	Qianlong	1736–1795
YUAN DYNASTY			Renzong	Jiaqing	1796–1820
Shizu	1260–1294		Xuanzong	Daoguang	1821–1850
Chengzong	1295–1307		Wenzong	Xianfeng	1851–1861
Wuzong	1308–1311		Muzong	Tongzhi	1862–1874
Renzong	1312–1320		Dezong	Guangxu	1875–1908
Yingzong	1321–1323		Puyi*	Xuantong	1909–1911
Taiding huangdi*	1324–1328				
Tian Shundi	1328				
Wenzong	1328–1329				
Mingzong	1329				
Wenzong	1330–1332				
Ningzong	1332				
Shundi*	1333–1368				

*No temple name; personal name or posthumous memorial title is listed instead.

MAP OF CHINA

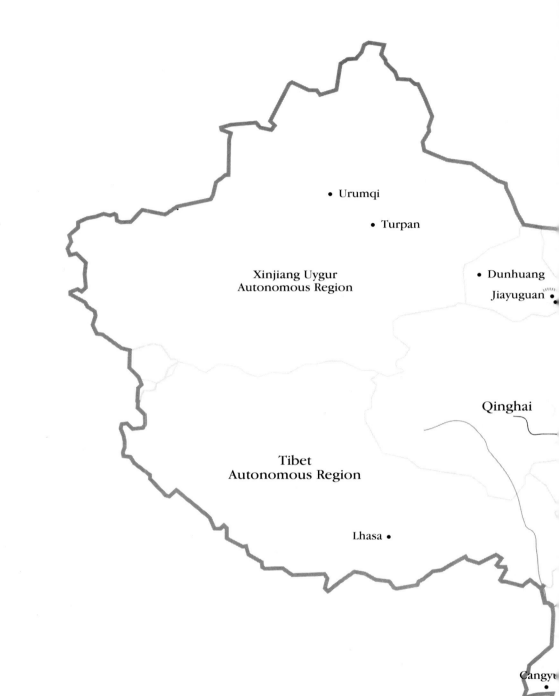

• Urumqi

• Turpan

Xinjiang Uygur
Autonomous Region

• Dunhuang
Jiayuguan •

Qinghai

Tibet
Autonomous Region

Lhasa •

Cangy
•

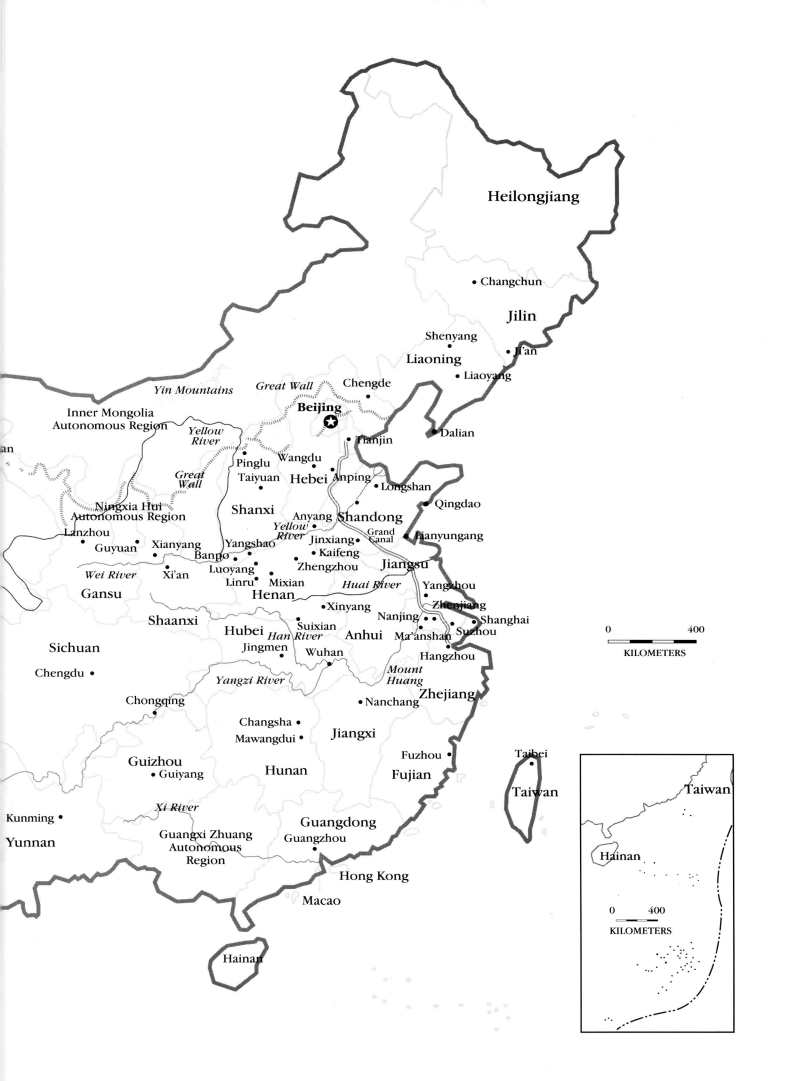

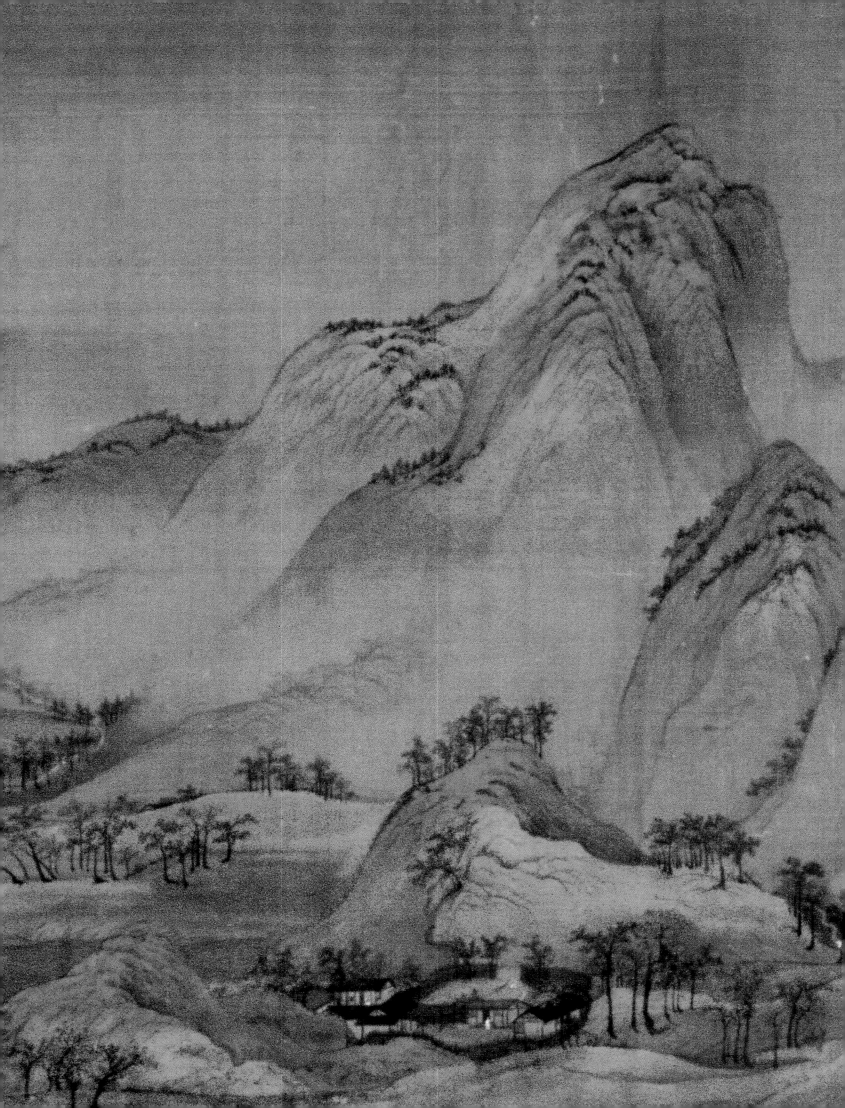

Approaches to Chinese Painting

PART I *Yang Xin*

Chinese painting can be traced back to decorations on pottery and on the floors of thatched huts in the Neolithic period. In the Eastern Zhou dynasty, 2,500 years ago, the use of brush and ink had already developed to such a point that the basic brush-made shapes have changed little since then. Chinese artists, philosophers, and critics have constantly discussed the role and qualities of painting throughout its long and complex history. To this day, the work of most Chinese art historians reflects the distinctive interaction between the painting tradition, on the one hand, and philosophy, poetry, calligraphy, and other cultural forms, on the other. What makes Chinese painting such an exquisite flower in the garden of Chinese civilization is the way the arts of the brush — painting, calligraphy, and poetry — together with the related art of seal engraving, interact, sometimes directly, sometimes indirectly, in producing so many of the masterpieces.

A complex yet important distinction for Chinese scholars as they have examined their painting tradition is between the detailed and technically proficient representation of a scene or object and the representation of its objective *and* subjective likeness. The former approach is associated largely with court painters, whose facility with the brush and whose naturalistic style culminated in many fine works, particularly during the Tang (618–907) and Song (960–1279) dynasties; the latter approach is associated largely with the literati-artists whose works started to appear in significant numbers by the early Song. The contrast is not a total one. Still, the depiction of partly imagined likenesses, not strictly realistic ones, is at the heart of what most Chinese scholars see as distinctive about the Chinese painting tradition. "One should learn from nature and paint the image in one's mind," as the painter Zhang Zao wrote in the eighth century.[1]

In the early periods in the development of Chinese painting, a prominent artistic goal was the realistic representation of the subject matter. Han Fei (280?–233 B.C.), a thinker of the Warring States period, argued that the easiest subjects to paint were ghosts and devils; the most difficult, dogs, horses, and other real things. Why? Because people are familiar with dogs and horses, but nobody has ever seen a ghost or a devil, so they will not know whether an exact likeness has been achieved. From the painted pottery of Neolithic times to the silk paintings of the Warring States (476–221 B.C.) and Western Han (206 B.C.–A.D. 9) periods, there was a developing maturity in style, with successive painters trying to create realistic likenesses in diverse ways. Murals in early tombs and in the Dunhuang caves, painted during the Tang dynasty, attest to their great accomplishments.

In line with this approach, Xie He, an art critic and painter of the Southern Qi (479–502), argued that there are "six principles of painting," one of which is "fidelity

Detail, figure 115 (opposite)

to the object in portraying forms."[2] Zhang Yanyuan, an art historian of the Tang dynasty, agreed. "The subject matter," he said, "must be painted to its exact likeness."[3] But other critics, even early on, believed that paintings need not — should not — be judged solely by a standard of objective realism. Good paintings, they said, achieve the unity of the objective and the subjective, showing both the image as it exists in reality and the image in the painter's mind.

Here we see the emergence of *xieyi,* or "sketching the idea." This, more than realistic depiction, is what many critics have considered to be truly important in painting. *Deyi,* "getting the idea" of the image in the artist's mind, becomes the chief point to grasp when looking at a painting. The viewer has to see beyond the image to the implied meaning. Only by "comprehending the idea," or *huiyi,* can one appreciate the best paintings in the Chinese art tradition.

Artists taking this approach may highlight certain areas and leave large areas blank, except for certain details related to the theme. The spaces of various sizes and shapes form a pattern in themselves, drawing attention to the main subject matter while providing the viewer with room to imagine and wander in. Reality is implied, not necessarily rendered with scrupulous accuracy. A moonlit scene outdoors and a lamplit scene indoors may be painted like the same scene in daylight, with only a moon in the sky or a bright lamp to signal nighttime. In *The Night Revels of Han Xizai,* a scroll painting by Gu Hongzhong of the Five Dynasties period (907–960), burning candles show that the scene is set at night (see fig. 103).

Another example of this widespread approach to reality relates to the depiction of buildings. Chinese painters tend to present buildings as seen straight on or from slightly above, seldom as seen from below. Li Cheng, another artist of the Five Dynasties period, once tried to paint pavilions, pagodas, and other structures atop hills exactly as they appeared to him from below; that is, he did not paint the tiles on the roofs, just the woodwork and frame below the eaves. His experiment was criticized by Shen Kuo, a famous Song-dynasty scholar, who said that Li did not understand how to "perceive smallness from largeness."[4] In succeeding dynasties no artist ever again took Li's approach.

Neither Shen nor other Chinese critics have argued that such works distort reality, however. The opposite is the case. Realistic copying can never show the innate meaning or true nature of a subject, they would say. Only with imaginative representation can the depths of reality

be depicted. By the end of the Tang dynasty in the tenth century, this approach to painting began to find its great forms of expression.

Works executed by court painters into the tenth century before the establishment of the Song dynasty prominently featured human figures, the use of lines to define forms, rich and varied coloring, and realistic representation of the subject matter. This approach fit well with the social and cultural functions that the paintings were designed to fulfill. During the Qin (221–206 B.C.) and Han (206 B.C.–A.D. 220) dynasties, for example, the government used portraits to publicize and eulogize loyal ministers and martyrs and to denounce traitors. Later Xie He even remarked, "All paintings stand for poetic justice; lessons about the rise and fall of ministers over the course of one thousand years can be drawn from paintings."[5]

Scholars and officials of the Tang dynasty went a step further and attempted to bring painting into line with Confucian ideology. In *Lidai minghua ji* (Record of famous paintings of successive dynasties), Zhang Yanyuan argued that the "art of painting exists to enlighten ethics, improve human relationships, divine the changes of nature, and explore hidden truths. It functions like the Six [Confucian] Classics and works regardless of the changing seasons." The cataloguer of the court collection of paintings entitled *Xuanhe huapu,* compiled at the end of the Northern Song (960–1127), attempted to define the social function of figure painting, even arguing that landscape painting, bird-and-flower painting, and animal painting should fulfill a similar ethical function.

In the *Xuanhe huapu,* paintings were divided into ten categories according to subject: religious themes, figures, palace buildings, foreign people, dragons and fish, landscapes, animals, birds and flowers, bamboo, and vegetables and fruit. These categories carefully reflected the official Confucian value system of the time. Landscape paintings, for example, were prized for their portrayal of the Five Sacred Mountains and the Four Great Rivers — places of imperial significance. The merit of birds and flowers initially lay in their "metaphorical and allegorical meaning," while that of vegetables and fruit lay in their use "as sacrifices to deities." In short, paintings were judged largely in terms of how well their subject matter served the gods, the Buddha, sages, and emperors.

The compiler of the *Xuanhe huapu* certainly knew that birds and bamboo were not directly connected to human affairs, but they had to be made metaphorically relevant if they were to symbolize moral and ethical values. Thus, pine trees, bamboo, plum blossoms, chrysanthemums, gulls, egrets, geese, and ducks became symbols of hermits

or men of noble character; peonies and peacocks became symbols of wealth and rank; willow trees, symbols of amorous sentiments; and tall pine trees and ancient cypresses, symbols of constancy and uprightness. In this way, bird-and-flower paintings could serve an instructional purpose.

By the end of the Tang and during the Five Dynasties, before the *Xuanhe huapu* was written, landscape painting and bird-and-flower painting on silk achieved maturity, in the process changing the traditional, simplistic use of sketched lines to define forms. As landscapes came to convey tranquillity or poetic melancholy and refinement, the tendency to use less color or even just water and ink became prevalent. Painters also increasingly used scrolls as a medium.

In art circles in China it is believed that Wu Daozi (active ca. 710–760) marked the peak of court painting. Unfortunately, none of his works have survived, but some copies are said to be based on his original drawings (see fig. 68).

A couple of centuries later, in the Northern Song period, came the rise of the literatus-artist, whose influence on the development of Chinese painting was formidable. The literati-artists were well trained in poetry and calligraphy. Partly to distinguish themselves from professional painters, they often looked at painting in terms of those arts, adopting many of the aesthetic conceptions set forth in *Ershisi shipin* (The twenty-four aspects of poetry) by Sikong Tu of the Tang dynasty, a milestone in the history of poetry criticism. To elucidate such notions as vigor, thinness, primitive simplicity, elegance, naturalness, and implicitness, Sikong Tu described natural settings appropriate to each. Elegance, for instance, could be expressed by depicting scenes with "gentlemen listening to the falling rain in a thatched cottage while drinking from a jade pot; seated gentlemen flanked by tall bamboo groves; or floating white clouds and a few birds chasing each other in a sky clearing after rain."[6]

Another theory of poetry that proved highly influential among literati-painters and art critics was set forth by Mei Yaochen, a Song poet who sought to achieve "depth and primitive simplicity" in his works. Once he remarked that poems "must be able to portray hard-to-catch scenes as if they leap up before the eyes, and imply meaning between the lines. A masterpiece is superior even to this."[7] By "meaning between the lines" he referred to something the author had in mind and the reader could perceive only by intuition, that is, a meaning that could be apprehended but not expressed. The literati-artists saw the applicability of this idea to painting.

Another aspect of the shift from court painting to literati painting was the growing emphasis on painting as an enjoyable activity, intended to please oneself and one's friends. Su Shi, a poet, calligrapher, and painter of the Song dynasty, was one advocate of enjoyment. He once wrote a poem to a friend that read: "I asked why you painted a portrait of me; you said you are a portraitist to amuse yourself." Ni Zan, one of the Four Great Masters of Yuan-dynasty painting, suggested that the pursuit of enjoyment gained in importance as the search for the "exact likeness" grew more desultory. This view was carried forward by Dong Qichang, the great painter and art historian of the late Ming dynasty, who explicitly advocated "painting for fun" and "the painting of fun." Throughout the Yuan (1271–1368), Ming (1368–1644), and Qing (1644–1911) dynasties, particularly toward the close of each, when government power waned and corruption grew rife, the idea of using paintings to "enlighten ethics and improve human relationships" was seldom mentioned by literati-artists.

The practice of annotating a painting with a poem evidently originated among the literati of the Song period. The Tang poet Du Fu composed many poems about paintings, some of which were comments on specific works. Whether any of his poems were written directly on wall paintings or scrolls is unknown. A number of Song poets composed poems about paintings, however, and some of these are found written on the mountings of handscrolls. The earliest known pieces extant today are attributed to Emperor Huizong (r. 1101–1125), a celebrated painter in his own right (see, for instance, fig. 113); among these is the earliest existing example of a painting inscribed with a poem composed by the artist himself. Later painters followed suit; the practice became popular during the Yuan dynasty and common during the Ming and Qing dynasties, when paintings were likely to bear poetry or other inscriptions.

That Chinese characters developed from pictographs led to a belief that painting and calligraphy had a common origin. Recent archaeological findings have established that in fact painting appeared before the invention of script. It remains true, however, that there is a close connection between calligraphy and painting: both involve brushwork, and inscribing a painting requires knowing how to write beautiful script.

Over time, literati, who were well versed in calligraphy, employed in their paintings brushwork techniques affected by their calligraphic style, and came to see the form and content of the inscription as an integral part of the painting. Drawn to the art of calligraphy, they began

to pay close attention in painting to the aesthetic appeal of lines and to the distinctive ways of doing brushwork, instead of just employing lines to compose forms. Xie He, in his Six Principles of painting, introduced terms to evaluate brushwork.[8] In the Yuan dynasty, Zhao Mengfu (1254–1322) inscribed a poem on a painting of rocks and bamboo that concluded with the statement that calligraphy and painting are identical (see fig. 173). Later artists did not take this view but instead cultivated a distinctive personal calligraphic style that was naturally reflected in their paintings. Shen Zhou (1427–1509), for example, who modeled his calligraphy on Huang Tingjian's, executed paintings with the bold and vigorous brushstrokes characteristic of Huang's script (see fig. 203). Others whose painting style shows similarities with their calligraphic style are Wen Zhengming (1470–1559), Zhao Zhiqian (1829–1884), and Wu Changshuo (1844–1927) (see figs. 204, 282, 284).

The inscription on a painting accentuates and complements the image. In the Song and Yuan periods, paintings were usually inscribed after completion to fill up any remaining space, but in the Ming and Qing periods, placement of the inscription was considered when an artist planned the initial composition. In some works the inscribed poem is essential to creating the perfect visual effect. In *Bamboo and Rock* by Zheng Xie (1693–1766), for example, the gray lines and gradations of the calligraphy look like the contour lines of the rock (see fig. 262). In *Fish Swimming* by Li Fangying (1695–1755), the poem hangs vertically like a riverbank.

Seals, which typically imprint characters engraved in an ancient calligraphic style, likewise enhance a painting. The practice of affixing seals possibly originated with collectors who stamped their seals on collections to designate ownership. According to the *Xuanhe huapu,* paintings executed before the Tang dynasty were not stamped. The Tang emperor Taizong inaugurated the practice by having his seals applied to paintings in the imperial household. During the Northern Song, painters began to stamp their own works, often to guard against forgery.

Using seals, however practical, added aesthetic appeal to the paintings, as literati-painters realized. The scarlet stamp could enliven a picture otherwise dull in color, and the choice of seal indicated certain interests and values of the painter, often with subtle cultural, personal, or political implications. Qian Xuan (ca. 1235–before 1307), for example, had a seal that read "brush and ink game," implying that his paintings were for self-amusement. Most painters had their seals carved or cast by artisans, but some made their own.

The incorporation of seals into pictures made Chinese painting into a comprehensive art that combines several others. A painting is often the joint product of a painter, a poet, a calligrapher, and a seal maker. In exceptional cases, as with Wu Changshuo and Qi Baishi (1864–1957), the painters are well versed in all these arts themselves (see, for example, fig. 291). This bringing together of so many art forms ultimately became the most characteristic feature of Chinese painting and the reason why so many works resonate with the culture and civilization of China.

Just as Chinese paintings are enriched by the manifold skills and vision of several artists, this book, too, is the product of several minds, but in this case the contributors come from varying cultural backgrounds. Readers are thus introduced here to a greater diversity of viewpoints and methods than they would receive from any single author. Although scholars inside and outside China working in many fields have learned a great deal from each other's approaches, their differences can be of great value in stimulating discussion, raising new questions, and offering various ways to explore the same topic. In preparing the manuscript for this book, all of us authors contributed points of view. At the same time, through meetings and reviews of each other's work, we shaped our chapters to provide continuity and consistency in the book as a whole. The intensive collaboration was an estimable development in China-U.S. cultural and scholarly exchanges, but our goal was to provide an understanding of the historical evolution of Chinese painting, along with a bouquet of exquisite paintings to enjoy.

Approaches to Chinese Painting

PART II *James Cahill*

The awesome antiquity and continuity of Chinese civilization, and the unmatched fullness of its written record, are generally recognized, and its painting tradition is of a corresponding magnitude. It is the only tradition in world art that can rival the European painting tradition in the sheer quantity and diversity of its output, the number of recorded artists of note, and the complexity of aesthetic issues attached to it, as well as the sophistication of the written literature that accompanies it through the centuries. All this richness and diversity, however, may not be immediately apparent to a newcomer who walks unprepared through the Chinese painting galleries of even a major museum with an excellent collection. I can recall the experience of emerging from a great loan exhibition of European oil paintings at the Metropolitan Museum of Art to enter its Chinese painting galleries and being shocked at how small and flat and hard to penetrate the Chinese pictures suddenly appeared, even to someone like myself who knew them well.

The truth is that Chinese painting, though not a connoisseur's art, does not, on the whole, present its imagery with the same forcefulness and immediacy as European paintings typically do. In part, this is a matter of immersion: an unfamiliar art is always likely to be difficult of access at first. I have sometimes recalled, in thinking about this problem, the experience of taking a noted Chinese artist and connoisseur who had recently arrived in the United States through the European painting galleries of

the National Gallery in Washington, D.C., from Italian primitives to Picasso, and hearing him complain that the paintings all looked more or less alike, besides not exhibiting much variety in their brushwork. A book like the present one aims, among other things, at carrying its careful readers beyond that stage with Chinese paintings, sensitizing them to qualities that may not be apparent to casual viewers but that differentiate the paintings strongly, so that they no longer "all look alike." But viewers may also find it necessary to adjust their expectations and their vision, as one would in going from a concert hall in which a Beethoven symphony is being performed to a smaller room where a string quartet is playing Mozart.

Even after we have made allowances for different conventions of representation, we must grant that Chinese painting techniques involve much less of the illusionistic, of giving the viewer a sense of looking through a window (the picture frame) into a space coextensive with the viewer's. The artists do not attempt to locate the viewer firmly through any such device as single-point perspective or, as is typical of many European painters, to render three-dimensional forms volumetrically on the flat surface through shading and indications of a consistent light source. Chinese paintings are much more likely to read primarily as configurations of brushstrokes on the picture plane, without much opening back into depth. But the same can be said of most of the best twentieth-

century Western paintings—or perhaps it would be truer to say that in both, calculated tensions between surface and depth and between image and abstraction are what engage the viewer's vision most powerfully. If Chinese paintings seemed technically inept to Western viewers of the eighteenth and nineteenth centuries because of their failings in illusionism, they can look all the more modern to us now.

But that approach has its pitfalls, too. To those more seriously engaged with Chinese culture, seeing Chinese paintings as modern can seem a matter of trivializing them, ignoring their original meanings. To appreciate the paintings completely, they would argue, demands a lot of special knowledge and acquired visual skills. This is true, so far as it goes; and to list all the kinds of knowledge and skills demanded would surely discourage any neophyte enthusiast from addressing the subject at all. Chinese artists, to be sure, love to hark back to earlier painting in their styles, appealing to the knowing viewer with learned allusions, like the stylistic echoes of the past in poetry by Pound and Eliot or in some paintings by Picasso. They can call on an assumed mastery in their cultivated audience of an extensive store of esoteric references to their history and literature, as well as to the doctrines of Confucianism, Daoism, and Buddhism. Those of us who write about Chinese painting, including the six authors of this book, try to fill in these allusions and references as best we can for the paintings we discuss; but it is sometimes like explaining a pun or a joke—the discussion turns academic and bogs down. What saves this situation is the capacity of Chinese paintings to appeal on various levels, including the more or less intuitive and purely aesthetic. Responses on this level are by no means trivial, nor are they simply an opening wedge to what lies beyond; they can be as intense and as true to the artist's deepest purpose as anything that art affords. We specialists have become accustomed to hearing from people with no special background in Chinese culture who find, nonetheless, that a serious engagement with Chinese paintings has changed their lives.

On the matter of the traditionalism of Chinese painting, it is important not to take too literally the claims of Chinese artists that they are imitating the past—a claim that had the function of legitimizing their practice in the eyes of their original audiences. Nor should we slip, as even the best Western critics and theorists have sometimes done (Ernest Gombrich; more recently, Arthur Danto), into the belief that in later periods Chinese painting is basically a performance art, a playing out of variations on set themes, one work differing from another

much the way one interpretation of a piano piece differs from another. The truth is that an "imitation" can be very free, to the point where its relation to the claimed model is hard to discern; the creativity of the artist is in no sense compromised. The great late-Ming landscapist Dong Qichang, for instance, if one only reads his pronouncements, could be misunderstood to be a conservative and derivative master; in fact, he was a revolutionary, as innovative as Cézanne or Picasso, and as complex and freely manipulative in his uses of the past. It is true enough, on the other hand, that studying and copying old masters was essential to a Chinese artist's early development—some reached middle age before they emerged from this imitative stage to establish their own schools.

That Chinese paintings were not intended to be read illusionistically as windows into another space is emphasized by the artists themselves in their practice of writing inscriptions prominently on them, as well as by contemporary and later litterateurs who also inscribed poems and words of appreciation on the works themselves and by later collectors who impressed their seals on them in red. The seals and inscriptions can be a distraction for a viewer unaccustomed to the presence of such extraneous markings on a painting, for they tend to hold the attention on the surface instead of allowing it to be drawn into the picture. The Chinese seem able to tune out the markings, much as theatergoers can become oblivious to the proscenium arch and the surrounding audience when watching a play. One adjusts quickly to the conventions of any art. For Chinese connoisseurs, in fact, seals and inscriptions provide added dimensions and depths to the experience of viewing a painting.

The artist's own inscription can be a poem, or a prose account of the circumstances under which the work was done, or some combination of these; it often includes a dedication to some designated recipient and a date, sometimes with a note on what old master is being "imitated." Informative and literary inscriptions of this kind are more often written by literati or scholar-amateur masters on their works; there are ordinarily shorter artists' inscriptions, sometimes only signatures and seals, on paintings by professionals. Longer inscriptions, if written in an elegant script, can demonstrate the cultivated artist's accomplishments in the so-called Three Perfections: poetry, calligraphy, and painting. These, again, are usually the prerogative of the literati. When the painting is accompanied by, or inscribed with, a series of poems by the painter's contemporaries, we can usually assume that it was team-produced as a composite work according to a preset program for presentation to a particular recipient,

perhaps on a birthday or some other auspicious occasion. When the later inscriptions are prose appreciations of the painting, on the other hand, they are often mounted apart from it—above or below it in a hanging scroll or following it in a handscroll—and are known as colophons.

Seals are blocks or sculpted pieces of (usually) soft stone with the text—the user's name or studio name or a motto—carved in archaic characters (seal script) into one flattened end, either in relief or in intaglio. The seal stone is patted on a fibrous pad inked with vermilion pigment in an oil base, and then impressed onto the surface of the painting. Seal impressions on paintings, if not the artist's, ordinarily record ownership, and by identifying them, the knowledgeable viewer can ascertain which collections the painting has passed through. If these are well known and distinguished (and judged to be genuine—seals are widely counterfeited), the value of the work is correspondingly enhanced. On old and famous paintings seal impressions often seem to crowd the imagery of the picture. Collectors of good taste kept their seals small and confined their use to the corners; arrogant collectors and emperors impressed large, showy seals in all the available spaces. All these together, poems and colophons and artists' inscriptions and seals, can make the full appreciation of a Chinese painting, for the cognoscenti, a very rich and complex procedure, much more than simply enjoying it as a picture or admiring the artist's skill.

Since the traditional Chinese critics who wrote the notes of appreciation and the theoretical texts were themselves literati, more or less by definition, and since virtually all of them practiced calligraphy, we should recognize their understandable bias in favor of literati painting, their emphasis on brushwork and other features that painting shares with calligraphy (they love to tell us, quite misleadingly, that painting and calligraphy are a single art), their disdain for "form-likeness" and technical skills that can be learned instead of being innate or being produced by Confucian self-cultivation. We Western specialists have frequently echoed these literati-biased views, consciously or unconsciously, failing to see how incompatible they are with our own quite justified admiration for the achievements of the great professional and academy masters of the Song period and later—achievements that depend on exactly the painterly techniques and breathtaking representational skills dismissed so lightly by the Chinese literati. Both Chinese and foreign specialists today are trying to reach more balanced judgments of the different kinds and modes of Chinese painting—professional or amateur, technically proficient or rough and spontaneous.

The distinction between the professional artists, for whom painting was a vocation and livelihood, and the cultivated amateurs who in theory painted as a leisure-time activity with no thought of profit, giving their works away freely to friends, is basic to Chinese discussions of painting and reflects, however overneatly, a social and economic reality. All our attempts to blur it or ignore it do not make it go away. Much study has been done in recent years on this aspect of Chinese painting, and interested readers can find some of it conveniently assembled in the collection of essays *Artists and Patrons* (1991), edited by Chu-tsing Li and others, or my own book *The Painter's Practice* (1994—see Further Readings for both). The class of learned Chinese known as literati (*wenren*) received a Confucian education in the Classics and were expected to at least attempt the state examinations that led to bureaucratic careers as officials, careers that would enrich and empower themselves and their families. But circumstances often prevented the realization of this ideal: failure in the examinations, disinclination to serve under an alien regime (as in the Mongol Yuan dynasty), and, especially for the later periods when education became more widespread, a huge oversupply of educated and qualified would-be officeholders, far more than the civil service could absorb. Failed would-be officials, if they could not rely on family wealth and landholdings, had to make their living in other ways, as teachers, as professional writers, as doctors, diviners, scribes, or artists. Those among them who became painters thus found themselves outside the traditional amateur-professional pattern and had to create new social roles for themselves.

For the straightforward professional artists, in contrast—those who made this choice or had it thrust upon them while young, without ever receiving a classical education or seriously aspiring to official rank—opportunities were more limited. They were trained through an apprenticeship, typically in the atelier of some local master, and until they distinguished themselves and transcended that status through their individual achievements, were regarded as "artisan-painters," not unlike lacquer workers or makers of furniture. If they attained extraordinary recognition and acclaim in their native places, they might be recommended to the court by some official or minister from the same district and enter the Imperial Painting Academy (the term is used loosely to designate groups of artists active at court), which was staffed in this way by painters from various locales. Short of achieving court status, professionals sought patronage from the affluent elite in the cities, producing paintings on commission or ready-mades for sale from the studio,

usually with seasonal and auspicious themes, to fill the needs of special occasions or simply to hang as decorative works.

Another of the literati's prejudices was against functionalism. Just as they themselves were generalists in their official careers, receiving little specialist training in administrative practice, they placed the highest value on works of art that, in their view, rose above the merely functional. The paintings they themselves produced were far narrower in theme than the repertoires expected of capable professionals and included ink monochrome paintings of bamboo, orchids, blossoming plum branches, old trees, and other plant subjects, for which the technical demands of representation were relatively modest and easily within grasp for people who had already mastered the use of brush and ink through practicing calligraphy. These subjects all carried symbolic meanings, signifying especially the virtues attributed to the scholar-gentleman: bamboo stood for uprightness, simplicity, and "hollow-heartedness," that is, freedom from desires that muddled one's consciousness; the Chinese orchid (lanhua), which grows in secluded places and spreads a subtle fragrance, stood for modesty and sometimes for the scholar-official neglected or undervalued by his ruler; the pine and other evergreen trees stood for steadfastness in adversity, and so forth. Accordingly, paintings of these subjects were ideal as small gifts for fellow literati, often carrying messages that pertained to the recipient's situation. They were given by artists as gifts in an intricate and very Chinese system of receiving and repaying favors or currying favor from superiors — a system that somewhat belies the literati insistence on the high-minded, disinterested creation of paintings.

Besides plants, the literati artists favored landscapes that similarly did not impose the requirement of long studio training on the painter. As done by the literati, landscape paintings tended to be "pure," without narrative themes or prominent and distinctive figural subjects. Such figures and houses as were represented were of a highly conventional character. In these paintings the viewer was expected to admire the brushwork, the "touch" of the individual artist, which was taken to express his personality and cultivation; sophisticated allusions to the styles of old masters, meant to signify the upper-class status of both artist and viewer, for commoners had no access to antique paintings; and a degree of compositional inventiveness, which rescued from dullness or true repetitiveness the oeuvres of artists like Ni Zan in the Yuan period and Dong Qichang in the late Ming, which might otherwise be said to consist largely of

the same scene (a river landscape with trees and distant hills) painted over and over again.

Landscape painting of this kind, however, was a later and special phenomenon; in the great tradition of the early periods landscape painting in China was a very different art, produced under very different premises and conditions. Landscape as a subject in itself, not just a setting or context for human activities or a background to religious images and the like, begins its rise as a separate genre around the ninth century and reaches what most would consider the height of its development in the Five Dynasties and Song periods, in the tenth to thirteenth centuries. While other subject categories, such as Buddhist and Daoist paintings, secular figure painting, and bird-and-flower and animal paintings continued to be produced on a high level by specialist artists and by the versatile professionals, landscape dominated the critical discussions, ignited the passions of collectors, and absorbed the creative energies of most of the best artists from that time on. The creation of the monumental landscape mode in the Five Dynasties and Northern Song periods in the hands of a succession of great masters and its transformation into a quieter, more lyrical imagery in the Southern Song, especially within the court academy, are dealt with in the chapter on those periods in this book.

Some writers on the early history of Chinese landscape painting like to locate its origins within particular religious and philosophical systems, especially Buddhist and Daoist, and suggest that the mountains appearing in early paintings are, on the deepest level, sacred mountains. While many of them doubtless are, writers taking a soberer view, truer to the surviving materials, see early landscape imagery in China as polysemous and diverse in its roots. Trees and rocks in early pictorial art indicate an outdoor location; more tightly organized landscape settings are developed later for historical and legendary narratives. In all these paintings, scenes that might be termed Confucian, moralistic and secular, are found at least as commonly as those with Buddhist or Daoist themes. The truth is that landscape imagery in China, from beginning to end, is an open signifier into which a diversity of meanings can be fitted, with appropriate alterations and additions, often including inscriptions that clarify the particular purpose to which the nature imagery is being put on this particular occasion. Sweeping claims about the nature and origin of Chinese landscape representations, then, can be of only limited application with regard to actual works of art.

The basic media of Chinese painting are brush, ink, pigments, and a ground, usually silk or paper. (The excel-

lent book by Jerome Silbergeld titled *Chinese Painting Style* [1982] gives a full account of these aspects of the art and is strongly recommended to any reader who wants to know more.) Chinese ink takes the form of solid cakes, made by mixing soot with glue and pressing the mixture into a mold. The soot comes from burning either wood, especially pine wood, or oil and must be refined to remove impurities, leaving only a fine carbon dust. The ink cake is rubbed with a little water on a specially chosen and shaped inkstone, which can be either stone or ceramic, to produce the ink for writing and painting. The pigments are similarly made from powdered mineral or plant substances in a glue base. The Chinese brush is composed of carefully selected animal hairs formed into a conical clump and fixed into the end of a bamboo tube; the outer hairs are softer, since they hold the ink or pigment, and the center ones stiffer, to give resilience to the tip. The papers used for painting and calligraphy are made from a variety of fibers (not, as myth has it, from rice) and, on the whole, combine the virtues of toughness and lustrousness with a capacity to age without much discoloration, especially if the scroll is kept rolled up most of the time and not exposed to air and dust. Silk, when the artist paints on it, is the buff or ivory tone of raw silk today; with the passage of time and exposure it darkens, often to the point of making the image difficult to discern. Both silk and paper are usually sized with an alum mixture to make their surfaces less absorbent, so that the ink will not soak into them and diffuse to blur the brushstroke.

The special qualities of the Chinese artists' tools and materials have a lot to do with painting style. The reservoir in the brush can hold enough ink to allow the drawing of long, continuous lines, which since the tip is so fine and the brush is held perpendicular to the surface, can move in any direction without altering in breadth. The artist can also choose, however, to use a line that fluctuates in breadth, thickening when the brush is pressed down, thinning when it is raised. A boundless repertory of special brushstrokes can be achieved by varying the angle of brush to paper and the ways the brush is inked and moved, applied and raised; a single stroke can be made to render a bamboo leaf or a section of bamboo stalk, and at the hands of a master, a few seemingly casual strokes can produce a strikingly vivid image of an old tree or a bird. Especially in the later periods, when the attention of both artists and viewers is often directed more toward the hand of the artist, the *facture* of the work, than toward its imagery, the distinction between "dry" and "wet" brushwork becomes important.

Dry brushwork is done by loading the brush lightly with ink that has partly dried on the inkstone and applying it with a light touch, usually to paper (because of its textured surface), for an effect that can be like charcoal or pencil drawing. For wet brushwork, the brush is loaded more heavily with liquid ink and applied so that the individual strokes, traces of the movement of the brush, can be obliterated. Silk is more suited to finer styles and to heavily colored painting, since the mineral pigments adhere better to its surface, and repeatedly rolling up the scroll is less likely to make the paint flake off. Accordingly, the masterworks of academy and professional painters are more likely to be on silk, and the creations of the literati masters on paper.

The original style of Chinese painting, seen in the earliest examples that survive, combines fine-line delineation of forms—with an emphasis on contours but also some interior drawing—with washes of color. This outline-and-color mode persists through the Tang dynasty, after which it slips into a conservative and sometimes archaistic status, while the most innovative tendencies in painting are developing in other directions. Around the tenth century, artists began to develop systems of repeated brushstrokes that render texture and tactile surfaces. In landscape painting, the *cun,* or texture strokes (literally, "wrinkles"), define geologically the various rocky and earthy masses in landscape imagery; in bird-and-animal painting, fine strokes are patiently applied to differentiate the special plumages of birds and fur of animals. Uneven applications of such strokes also serve as a kind of shading to give an effect of convexity to the forms.

Accompanying this shift—in fact, inseparable from it—is a shift from the colorful styles either to the ink monochrome mode or to ink painting with only light washes of warm and cool colors. Here, again, the Chinese critics and theorists formulate a rhetoric about the superiority of ink monochrome to colorful painting, just as they do for the purported superiority of rough, spontaneous, amateurish styles to the technically finished. These arguments tend to take on a moralistic tone: colorful painting is intended to please the eye and increase the attractiveness of the work and is thus meretricious; ink monochrome reveals the inner structure of the thing depicted instead of only the outer appearance, and so forth. The formulations owe more to ready-made rhetorical positions than to observation and evaluation of the paintings. Meanwhile, the artists made their choices (as always) according to what suited their representational and expressive purposes, with little regard, we can assume, for

those grand theoretical pronouncements in which light and dark in painting are equated with the cosmological forces of yin and yang, or the rough-brush styles are seen as direct manifestations of a Chan (Zen) mode of experiencing the world—even though, like artists today, they may well have repeated these when asked about what they were up to.

We know from texts and from some surviving examples, mostly fragmentary, that large compositions in the form of wall and screen paintings were favored in the early stages of the art. The forms with which we are most familiar in recent times, the hanging scroll and handscroll, appear only in later centuries, along with album leaves and small paintings of a distinctive shape made to be mounted on flat fans. Early screens, which are depicted in many old pictures, are mostly of the standing, horizontally rectangular kind, with the painting done on a single surface; but the screen made up of a series of tall, vertical panels usually forming a continuous composition, like the Japanese folding screen that derived from it, is also of early origin in China. The folding fan, by contrast, originated in Japan and appears in Chinese painting only from the fifteenth century.

The hanging scroll is meant to be hung on the wall and viewed all at once and can remain on display for extended periods, simply as decoration or as a seasonal and auspicious exhibit. The handscroll, by contrast, is opened—unrolled—only when someone means to view it and is rolled up again afterward, much as a book is opened, read, and closed. It takes the form of a long, horizontal roll, usually consisting of a succession of pieces of silk and paper bearing passages of calligraphy and painting, all joined together by paste and a continuous paper backing. One views it at arm's length on a table, holding the still-unseen rolled-up part in the left hand, pulling it out and rerolling with the right hand, so that the writing and painting move rightward beneath one's gaze, and one sees only what will fit between one's extended hands, wherever one chooses to stop. A handscroll is obviously an ideal vehicle for a long text, since Chinese writing is done in vertical columns read from right to left, and it probably originated as that. In painting, it is especially suited to illustrated texts, in which writing and picture alternate; to narratives, in which successive scenes of the story appear as one unrolls; and to landscape panoramas, in which the viewer takes an imaginary journey through a continuous terrain.

The scroll form imposes certain spatial and other conventions on the artist, such as the moving vantage point—a single, located viewpoint cannot be sustained over the whole length. Because the pictorial materials in a handscroll are seen over a stretch of time and in an order dictated by the artist, temporal sequence can be joined to spatial extension in ways that cannot be matched in Western easel painting. Because the experience of viewing a Chinese handscroll takes place over a demarcated stretch of time, it has frequently been likened to listening to a piece of music or seeing a film; but since neither of these—at least until the advent of technology that distorts their character—accords the listener or viewer the options of pausing, speeding, or slowing, or going backward and forward at will, a better analogy is probably with reading a long poem. Long handscrolls present problems for exhibition in museums, because the original and proper way of seeing them cannot easily be reproduced there, and they are usually shown full-length or with as much exposed as will fit into a case. The same problem arises in publications like this one, where reproducing the entire work as a narrow horizontal strip across the page means that each section is postage-stamp size. Reproducing only a portion of the composition, large enough for details and brushwork to be read, is ordinarily the best compromise, for the episodic nature of most handscroll compositions allows a part to stand effectively for the whole.

As I noted at the beginning of this chapter, the huge surviving corpus of Chinese paintings is accompanied by a correspondingly abundant and sophisticated critical, theoretical, and art-historical literature, which, if it were better known, would be envied by specialists in Western art. (For the periods through the fourteenth century, it is conveniently and excellently excerpted and discussed in *Early Chinese Texts on Painting,* compiled and edited by Susan Bush and Hsio-yen Shih [1985].) These Chinese texts, properly interpreted, can take us a long way toward understanding and appreciating Chinese paintings in something like the way their original audiences did. At the same time, they do not answer all our questions, if only because the questions they implicitly pose and address are not the same as ours. Chinese writers on painting, then and now, concentrate on the individual master, his (seldom her) biography, his place in large stylistic lineages and other groupings, and the particular characteristics and strengths of his works. Books that can be considered general histories of painting were composed from the ninth century through the twelfth but after that gave way to collections that provided information and opinions on individual painters and were organized around such lists.

Larger issues continue to be discussed, often vehe-

mently; but to chart these in detail it is necessary to draw together the contending voices from many written sources — collected literary works, miscellanies, and colophons still attached to paintings or recorded elsewhere. No single Ming or Qing writer or book even attempts to comprehend them all or to present the different viewpoints fairly. Together, however, they provide us with clues to the controversies that increasingly characterized discussions of paintings in the later centuries, reflecting the regional, socioeconomic, stylistic, and other allegiances of the artists and writers. (The opening of my book *The Distant Mountains* [1982], pp. 3–30, outlines these controversies for the late Ming period.) Any particular writer states his argument as self-evident and unshakable, so it is only when they are brought together that the dynamic pattern of tensions between opposing views and factions emerges. Chinese scholars today, pursuing the "harmonizing mode" that is traditionally valued in their culture, are inclined to play down the tensions; Western scholars, seeing these as productive of a lively interplay of ideas, tend to bring them to the fore.

Chinese writers on painting construct stylistic lineages into which artists and paintings are recognized to fit; a good connoisseur, along with judging authenticity, will typically identify a painting as "in the style of" a certain old master or declare the artist to have been so-and-so's follower. Such a stylistic lineage begins when some major artist, after spending his early years copying and learning, gives the inherited lineage "one turn" (*yibian*), sending it off in a different direction and "establishing his own house" (*zicheng yijia*), what English speakers would call founding a school. Followers of the master would then carry on this tradition with more or less fidelity or individual contribution. The further the remove from the original master, the more the style tends to slip into a mannerist hardness and to lose in naturalism, because the successive generations of followers are imitating learned forms instead of depicting visual forms of nature. This pattern is typical of the traditional masters and schools of the early period but applies in some degree to later artists and schools as well. On the whole, however, post-Song painters and those who write about them put more stress on individuality of style and brushwork, largely in response to the growing dominance of the doctrines of literati painting, a dominance that operates even when the artists in question do not properly belong to the literati class.

Another kind of classification used by Chinese writers on painting, this one horizontal rather than vertical, synchronic rather than diachronic, is the identification of local or regional schools. Some of the schools are specific to cities — the Wu (Suzhou) School in the Ming, the Nanjing School in the early Qing. Others are regional, such as the Anhui School in the early Qing, which was not located in any particular city and can even be seen as extending beyond the boundaries of Anhui Province proper. The Zhe School in the Ming is even less definable geographically — it is named after the homeplace of the artist credited as its founder, Dai Jin, but the painters associated with it come from a diversity of centers. It is easy enough to dismiss such groupings as ill defined or even meaningless; but these formulations, like most other formulations by the Chinese, have a real basis in observed stylistic and art-historical phenomena and, properly understood, can be useful in organizing the bewilderingly huge and diverse corpus of Chinese painting. The same is true of the numerical listings of artists which Chinese writers are also fond of: the Eight Masters of Jinling (Nanjing), the Four Masters of Xin'an (Anhui), the Eight Eccentrics of Yangzhou, and the like. Again, these are easy to criticize — those who do so point out that the artists included did not all know each other or did not all come from Yangzhou and that different writers do not include the same artists in their lists. The lists are primarily mnemonic devices; once memorized, they allow one to recall who were the most prominent painters active in mid-seventeenth-century Nanjing or eighteenth-century Yangzhou. As such, they are useful, provided one does not misunderstand the "school" (*pai*) to be, like some schools in modern European painting, an association formed by the artists themselves with an agreed-on aesthetic and stylistic basis.

Many of the matters touched on in this introduction will be reintroduced in the chapters that follow, in reference to particular periods, schools, artists, and paintings. But we can see from the discussion so far that there are some differences between traditional Chinese approaches to painting and the concerns and methods that characterize foreign scholarship on the subject. The differences have diminished somewhat in recent years as Chinese and foreign scholars have had more opportunities for interaction and learning from each other, and will no doubt diminish still more in the future. But even though a proponent of any particular method or approach on either side may be prone to see it as the "best" or "right" approach (much as Dong Qichang could identify a "right" or "orthodox" way to depict landscape), a diversity of viewpoints on such an inexhaustible set of problems is surely healthy, and we should not aim at any grand synthesis or overriding homogeneity of scholarly

methods. The present book has the advantage of including sections that reflect the special ways Chinese and non-Chinese scholars write about art and construct their histories of it, besides reflecting the approaches and styles of the six authors individually. Because of the special high-level U.S.-China cooperation that brought it into being, we authors are also privileged to introduce a great many works in Chinese collections to foreign readers for whom they will be mostly unfamiliar and in some cases exciting. I hope that this auspicious beginning will be followed by many more cooperative projects of this kind.

Detail, figure 288 (*opposite*)

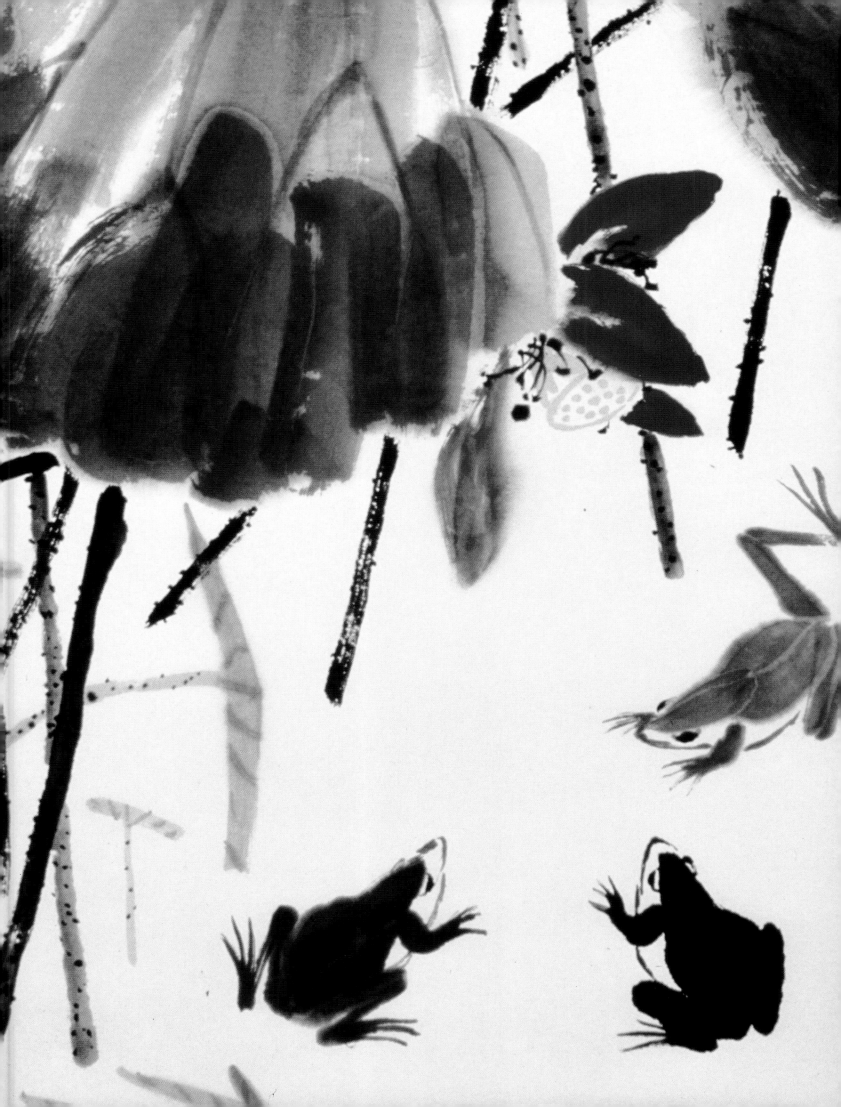

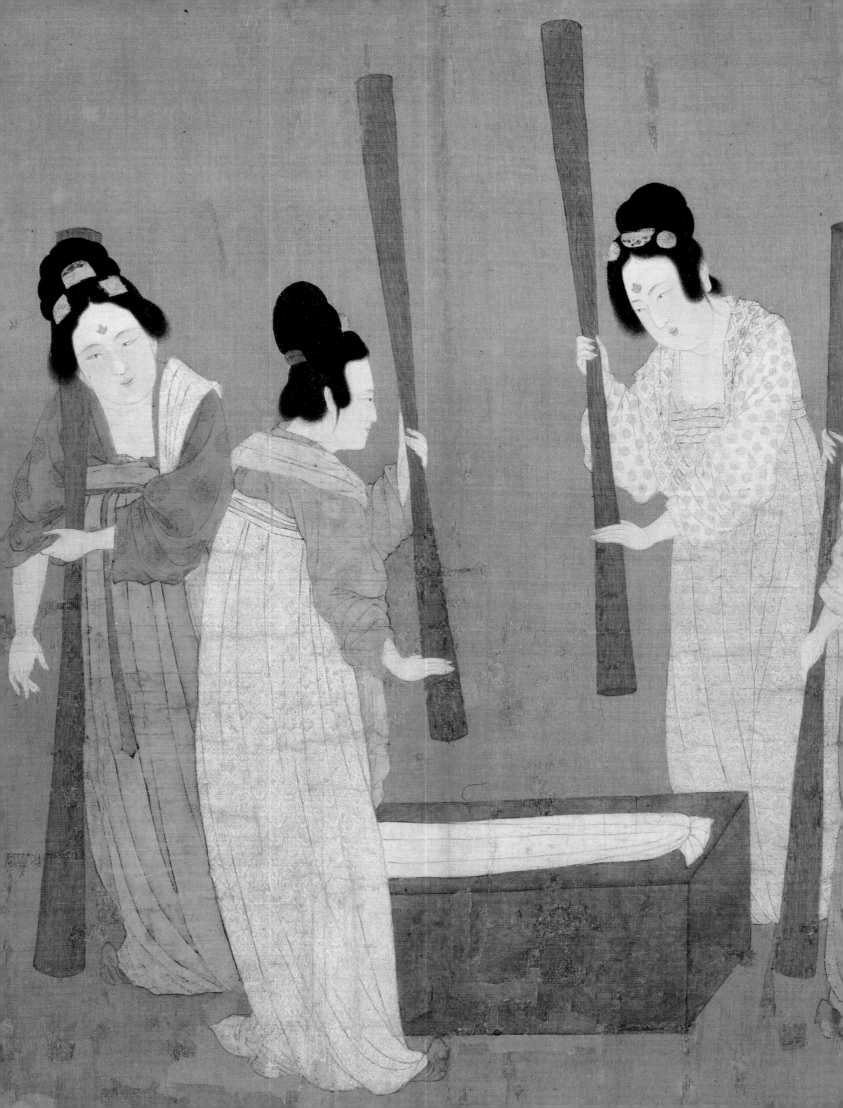

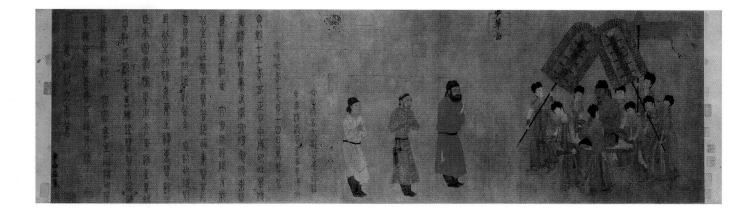

The Origins of Chinese Painting
(Paleolithic Period to Tang Dynasty)

Art historians have had a persistent desire to trace the beginning of Chinese painting. Writing in the ninth century, Zhang Yanyuan opened the first comprehensive history of Chinese painting with an account of a legendary era when writing and painting were unified in pictographs. He contended that the separation of image from word in early historical times initiated painting as an independent art. But "not until the Qin [221–206 B.C.] and Han [206 B.C.–A.D. 220] dynasties could one talk about the subtlety of painting"; and only after great masters emerged during the Wei (220–265) and Jin (265–420) dynasties did the art reach its maturity.[1]

This developmental sequence of early Chinese painting proposed more than a millennium ago still basically holds true. A major difference, however, is that modern archaeological excavations have accumulated considerable evidence for prehistoric and early historical pictorial images and are continually expanding our knowledge. A few years ago the oldest examples of pictorial images in China were Neolithic flower and animal designs painted on pottery vessels. Recently, "rock paintings" (*yan hua*) have been discovered in many of China's provinces, allowing historians to trace the origin of Chinese pictorial art back to Paleolithic times. Chinese archaeologists use the term *yan hua* for both engraved and painted petroglyphs, and the finds include many figurative compositions, sometimes of astonishing dimensions. At

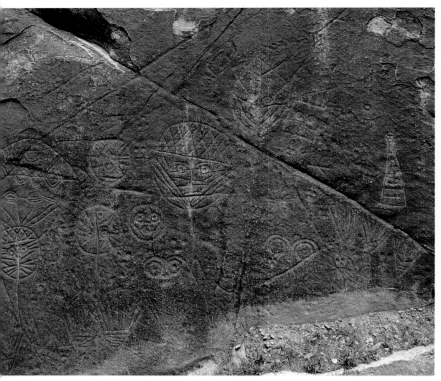

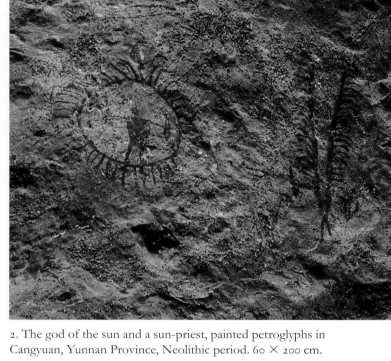

1. Plants with human faces, engraved petroglyphs in Lianyungang, Jiangsu Province, Paleolithic period. 280 × 400 cm.

2. The god of the sun and a sun-priest, painted petroglyphs in Cangyuan, Yunnan Province, Neolithic period. 60 × 200 cm.

one of the earliest sites, the Yin Mountains in Inner Mongolia, a composition covers an entire mountain cliff 70 meters high and 120 meters wide. Thousands of such compositions, created over a period of ten thousand years, connect and overlap to transform the mountain range into a painting gallery three hundred kilometers long from east to west.[2] The enormous spatial and temporal scale of the works implies the existence of religious or shamanistic beliefs, which could have sustained the painstaking effort of many generations of people to carve millions of images onto stone mountains. Among the earliest line engravings in the Yin Mountains is a round face surrounded by rays of light that represents the sun. Similar round forms exist at Lianyungang, a coastal site where a primitive farming culture once flourished, but here they appear as fruits of plants (fig. 1). These and other images seem to reflect a belief, shared over the centuries by many prehistoric peoples around the world, that human beings are part of an animate universe whose components — animals, plants, rivers, mountains, and celestial bodies — all possess a living consciousness. They believe that by transforming the visible world into pictures, they can influence the natural processes of life.

Rock paintings found at Cangyuan, Yunnan Province, depict human activities, including hunting, dancing, the performance of ritual sacrifices, and war. The frequent representation of bows and arrows suggests the relatively

late dates of these pictures; not until Neolithic times were such weapons employed in economic and social life. It is no coincidence that these works show increasingly complex compositions. Now we see, not isolated, static icons, but juxtaposed figures in action. One interesting petroglyph seems to continue the tradition of depicting the worship of the sun (fig. 2).[3] Instead of being a circle with rays, however, the heavenly body has an occupant: a standing figure with a bow in one hand and a stick in the other. Nearby is a figure wearing a tall, featherlike headdress. This second figure, perhaps a shaman, holds an identical bow and stick but in different hands. He thus appears to mirror the figure in the sun and to embody the sun's power.

As the compositions increased in complexity, scenes of daily life increased in number. Sometimes a picture illustrates a single moment in the hunt: an archer with drawn bow aims at a buffalo, goat, deer, or tiger. At other times, the artist offers a panoramic view of social life: numerous figures in solid silhouette seem to represent members of an entire village engaged in group activities. One of the best preserved Cangyuan pictures has a tripartite structure (fig. 3). The lower section shows a violent battle; the middle section, people's peaceful coexistence with domestic animals; and the upper section, a ritual dance led by a principal figure, whose special status is indicated by his or her central position, large size, and

unique headdress. The artist must have consciously organized these scenes into a hierarchical structure: a short horizontal line drawn in the middle of the picture indicates a "ground level" on which domestic fowl stand. Curiously, in terms of both content and composition, this picture resembles a much later pictorial representation on a sixth-century B.C. bronze vessel (see fig. 10).

The study of rock paintings has just begun, and many questions remain. The most serious difficulty lies in establishing a reliable chronology. So far only the pigment of painted scenes can be scientifically examined for dating, and various evolutionary sequences largely reflect each researcher's aesthetic judgment. The relation between these works and later Chinese painting is also uncertain. All known petroglyphs are scattered in remote areas, not in the lower Yellow River and Yangzi River regions, where the center of Chinese civilization lay. The discovery of these works does close a huge gap in the study of Chinese painting, however. These early depictions, especially those from Paleolithic and early Neolithic times, testify to a crucial period in artistic evolution during which great efforts were made to create pictorial forms but when people had not yet developed the concept of a well-defined picture surface and had very little sense of the regularity of design. Pictures were executed on an unprepared and unlimited ground, and the artist worked on a field with no set boundaries.

The concept of a framed and prepared picture surface emerged together with the invention of manufactured forms — pottery vessels and timber-framed architecture. Once such objects appeared, "the [artist's] inventive imagination recognized their value as grounds, and in time gave to pictures and writing on smoothed and symmetrical supports a corresponding regularity of direction, spacing and grouping, in harmony with the form of the object like the associated ornament of the neighboring parts." This theory, put forth by the art historian Meyer Schapiro, explains the appearance of the architectural murals and painted pottery vessels of the Yangshao culture, a major Neolithic tradition that developed in the Yellow River valley from the fifth to third millennia B.C.[4] Scholars have examined the two types of Yangshao pottery called Banpo and Miaodigou. Although stratigraphical evidence suggests that Miaodigou immediately followed Banpo, their radically different decorative styles and design concepts testify to two divergent art traditions. On a Miaodigou pottery basin, for example, a series of spirals and arcs are painted in a broad horizontal band (fig. 4). The fluid and dynamic patterns lead the viewer's gaze to travel smoothly around the vessel. The

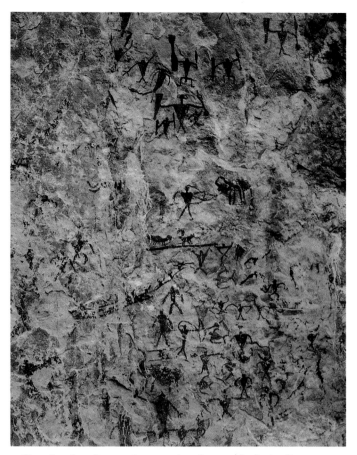

3. Dancing, herding, and war, painted petroglyphs in Cangyuan, Yunnan Province, Neolithic period. 360 × 200 cm. (Reprinted from *Zhongguo meishu quanji* [*ZMQ;* A comprehensive collection of Chinese art] [Shanghai and Beijing, 1984–], Painting, vol. 1, no. 24.)

artist who decorated a Banpo basin (fig. 5), in contrast, divided the interior surface into quarters for two pairs of images and likewise divided the rim into eight equal parts, using alternate symbols to mark the divisions. The Banpo design is thus based, not on the principles of linking and shifting, but on the principles of dividing and echoing. With both styles, however, surface patterns correspond to the shape of the vessel and reinforce its three-dimensionality.

A different and even reversed relation between decoration and shape is demonstrated by other Yangshao examples. In 1978 an imposing pottery vat almost half a meter tall was discovered in Linru, Henan Province. Two principal images dominate the decoration: a huge ax standing on its handle and a stork with a fish hanging from its beak (fig. 6). Unlike most Yangshao decorations, these images are not just patterns; they are life drawings. The painting technique is also unusually sophisticated. The artist used the color white to draw the flat silhouette of each image, then outlined the ax and fish with black ink and elaborated the ax, adding details and even creat-

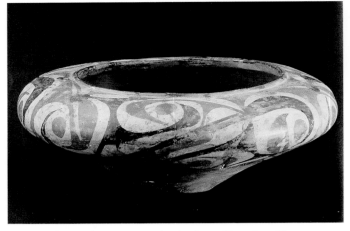

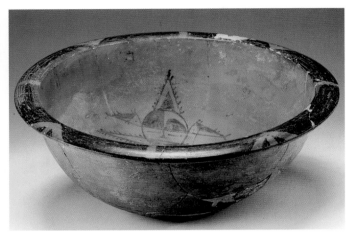

4. Painted Miaodigou pottery basin, from Shanxian, Henan Province, 5th millennium B.C. 20 cm high, 33.3 cm in diameter at the mouth. (Reprinted from *ZMQ*, Ceramics, vol. 1, no. 16.)

5. Painted Banpo pottery basin with human face and fish patterns, from Xi'an, Shaanxi Province, 5th millennium B.C. 19.3 cm high, 44 cm in diameter at the mouth. (Reprinted from *ZMQ*, Ceramics, vol. 1, no. 4.)

ing some incised patterns on the handle. The stork, in contrast, remains a pure white silhouette against the reddish background. The stylistic contrast between the ax and the succinct bird seems to attest to the artist's formal concerns. Most significant, the artist placed all the images on one side of the vessel and thus determined a single angle for viewing. In this sense, the round vat was treated as a flat picture surface. The images, strictly speaking, are no longer decoration subordinate to the three-dimensional object but the subject of a painting.

During the third and second millennia B.C., the focus of Yangshao culture gradually shifted to the northwest, where, in present-day Gansu and Qinghai Provinces, three brilliant regional cultures arose: Majiayao, Machang, and Banshan. The trademark of these cultures is a bulky jar decorated with complex designs that integrate various motifs — circles, waves, spirals, and even anthropomorphic forms — into a highly organic whole. The old Yangshao base in the central plain was now occupied by branches of the Longshan culture, an eastern tradition that favored monochromic vessels with impressed or relief patterns. It is not surprising, therefore, to find that when bronze art developed in this area dominated by the Longshan tradition, the main decorative elements were impressed and relief zoomorphs, not painted designs. Thousands of Shang (ca. 1600 – ca. 1100 B.C.) and Western Zhou (ca. 1100 – 771 B.C.) bronzes have survived, creating an impression that the art of painting was at a low ebb during the second and first millennia B.C. But a more plausible assumption may be that during this period painting was no longer associated with vessels made of solid clay or metal but with the perishable media of wood and fabric.

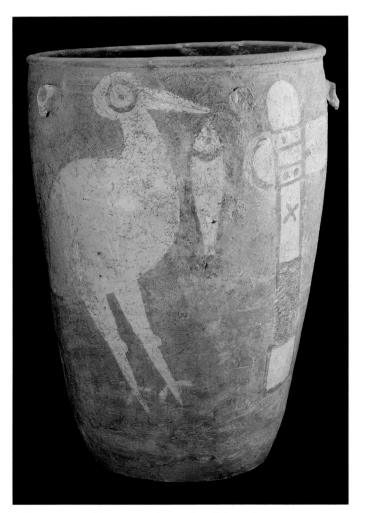

6. Pottery vat with images of a stork, a fish, and a stone ax, from Linru, Shanxian, Henan Province, 4th millennium B.C. 47 cm high, 32.7 cm in diameter at the mouth. Henan Provincial Museum.

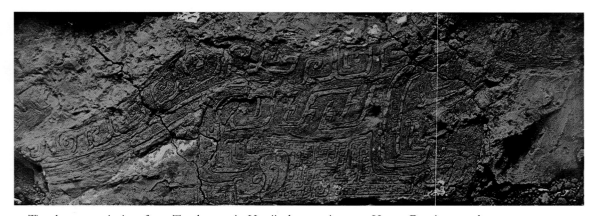

7. *Tiger,* lacquer painting, from Tomb 1001 in Houjiazhuang, Anyang, Henan Province, 13th century B.C. (Courtesy of the Institute of History and Philology, Academia Sinica, Taibei.)

Traces of painted cloth and silk have been found at more than one Shang burial site. In Tomb 2 near Luoyang, Henan Province, a large piece of cotton cloth three meters wide and four meters long originally covered the entire grave pit. The decoration consisted of multicolored geometric patterns painted with a soft brush. A piece of painted silk from nearby Tomb 159 was used as a wall hanging.[5] But fewer painted textiles have been discovered so far than wooden objects decorated with lacquer patterns. The excavations of Shang royal mausoleums in Anyang in the 1920s and 1930s first enabled scholars to identify and reconstruct some lacquered wood objects created on a grand scale, including a two-meter-long carrying stand from Tomb 1001 and a large drum from Tomb 1027. Fragments of lacquer patterns on walls and floors of burial chambers further suggest that the graves of Shang kings originally had colorful wall panels and that their huge coffins were covered with ornate zoomorphic and geometric motifs (fig. 7). Since the Anyang excavations, remains of lacquer paintings have been found in various regions — in Panlongcheng in the south and Gaocheng in the north.[6] Evidently, lacquer enjoyed great popularity as a painting medium at the time; its two basic colors — black and red — create an intense color contrast. Painted lacquerware and musical instruments were originally displayed together with shining bronzes and white pottery vessels. Though decorated with similar motifs, these objects formed an assemblage of diverse materials, textures, and colors.

Paneling painted with lacquer designs may also have embellished royal palaces, but it was certainly not the only form of architectural decoration; murals of mineral and botanic colors on plastered walls had appeared during Neolithic times and continued to be painted throughout the Shang and Zhou dynasties. The two earliest examples of this tradition, both found in the northwest, are a figurative sketch from Dadiwan, Gansu Province, and geometric patterns on the walls of a Neolithic house in Guyuan, Ningxia Hui Autonomous Region.[7] Both are related to the painted pottery of the Yangshao culture, which was absorbed into Shang-Zhou metropolitan art. Archaeologists have found remains of wall paintings both above ground and underground in the capital areas of these two dynasties in the middle Yellow River region.[8] Like contemporary lacquer paintings, one Shang mural has images delineated in contrasting black and red. Its unique value lies in the careful preparation of the surface: the wall was covered with a layer of clay mixed with pieces of straw, then coated with sandy mortar, and finally plastered with white lime. This technique would be employed by Chinese mural painters for the next two thousand years.

The Eastern Zhou, Qin, and Han Dynasties

All these early pictorial forms, styles, and media contributed to the rapid development of painting during the Eastern Zhou (770–256 B.C.), often described as a period of cultural renaissance. Among the hundreds of exquisite objects from the famous tomb of Marquis Yi of Zeng (fifth century B.C.) in Suixian, Hubei Province, one, a duck-shaped lacquer box, displays two miniature paintings on either side, a dance scene and a music recital (fig. 8). The work demonstrates the artist's awareness of the divergent functions and visual effects of representation and decoration. The two scenes appear against an empty background within rectangular frames; dense patterns cover the rest of the vessel. Each picture thus appears as a window through which one glimpses an aspect of court entertainment. In a more general sense, this

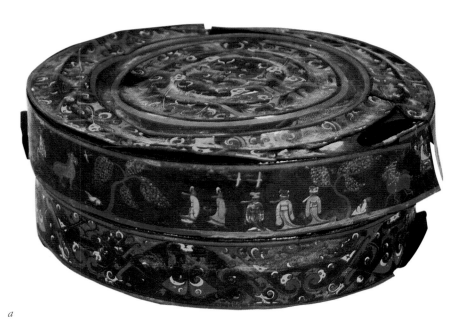

8. Duck-shaped lacquer box with dance and music scenes, from Leigutun Tomb 1 in Suixian, Hubei Province, 533 B.C. or earlier. Hubei Provincial Museum.

a

b

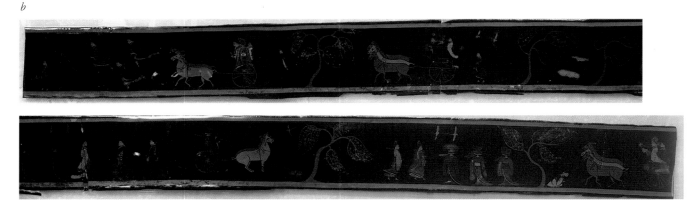

9. Lacquer box, from Baoshan Tomb 2 in Jingmen, Hubei Province, 316 B.C. or earlier: *a,* full view; *b,* procession and greeting scenes. 10.8 cm high, 27.9 cm in diameter. Hubei Provincial Museum.

work signifies two principal features of Eastern Zhou lacquer paintings in the southern Chu area (which was centered on the middle Yangzi River region): the interplay between various artistic styles and a fantastic iconography. Here the two musicians are not human figures but a bird and a beast. Such strange images and scenes, found on many Chu artifacts—including Marquis Zeng's coffin and a zither (*se*) from Changtaiguan Tomb 1 in Xinyang—have led scholars to relate them to the strong shamanistic tradition in Chu culture. This tradition is reflected in Qu Yuan's vivid contemporary descriptions of gods and goddesses, ancient legends, and bizarre creatures in *Songs of the South (Chu ci)*.

This fantastic art differs from other art, much of it also produced in the south, that depicts scenes of daily life— entertainments, processions, and meetings. The most outstanding example of this second tradition is a painted lacquer box from Baoshan Tomb 2 in Jingmen, Hubei Province (fig. 9).[9] As with the duck-shaped lacquer box

from Suixian, its decoration integrates both geometric and pictorial elements. On the vertical side of the lid a series of lively human figures make up a complex spatial design unlike any attempted before. The figures are shown either in profile or from the rear; the latter are generally situated closer to the viewer, either on a chariot to shield a male master or in the foreground to watch the master walking in front of them. In both cases there is a strong sense of depth, indicated by overlapping images, varying sizes, and separated ground levels. The composition, which is 87.4 centimeters long but only 5.2 centimeters tall, is further divided by five graceful trees; the five sections likely illustrate stages of a continuous narrative. The only group of two trees seems to indicate the beginning (and end) of the picture-story. Reading from right to left (as is usual in Chinese art), we find that an official in a white robe is taking a tour in a horse-drawn chariot. The horses increase speed and attendants run ahead; then the chariot slows down, and the official is greeted by a kneel-

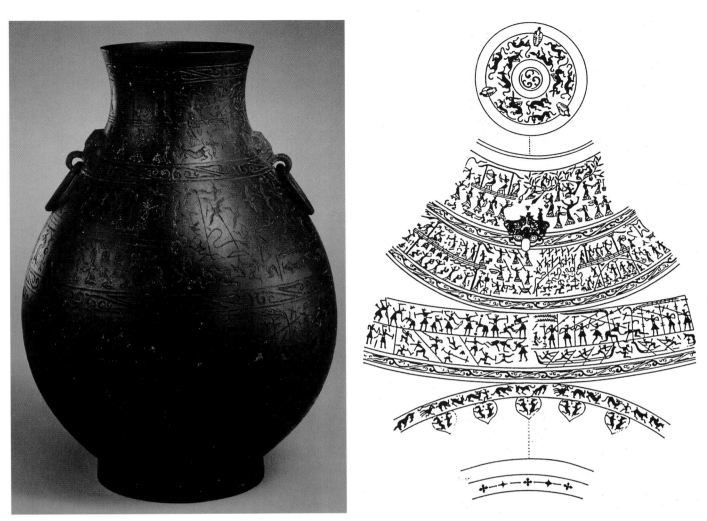

10. Bronze *hu* vessel, 6th–5th century B.C.: *left,* full view; *right,* drawing of the pictorial decoration. Palace Museum, Beijing.

ing figure. Meanwhile, a gentleman wearing a dark robe is on his way to meet the official. In the final scene, the official has descended from the chariot and is meeting the host, but somehow he is now dressed in a dark robe, the host in a white one.

This work shows remarkable advances in both spatial conception and temporal representation. Much like a later handscroll painting, it must be viewed section by section in sequential order. In fact, its various interpretations, including the one proposed above, are largely inspired by its horizontal, sectioned format, which invites the viewer to read figures and scenes as components of a continuous narrative. This compositional style also characterizes the designs of many pictorial bronzes, which became fashionable among Eastern Zhou aristocrats around the fifth century B.C. Figures are incised, cast, or inlaid on such vessels. Those shown in figure 10 are engaged in various activities displayed along parallel registers — shooting arrows in a contest, picking mulberry leaves to feed silkworms, offering sacrifices, hunting animals and birds, and battling on land and water —

which likely represent certain rituals. The impression of the figures' rhythmic movement is enhanced when we shift our gaze over the round surface along the horizontal baseline.

Most paintings of the Eastern Zhou were the product of a collective effort. A fourth or third century B.C. text, the "Examination of Craftsmanship" ("Kaogong ji"), records that the painting process consisted of at least five stages from drawing the sketch to applying color done by artisans with different specialties.[10] Although specialization may have been standard procedure in workshops, some individual painters appeared and were appreciated for their independent spirit. This phenomenon, which may attest to the appearance of the individual artist, is suggested by a story from the writings of the Daoist philosopher Zhuangzi. It is said that once the lord of Song wanted to have a painting done, and many painters came for the job. They all paid respect to the patron and obediently demonstrated their skills. The painter who arrived last, however, ignored the official greeting and took off his clothes as if no one else were present. The lord of

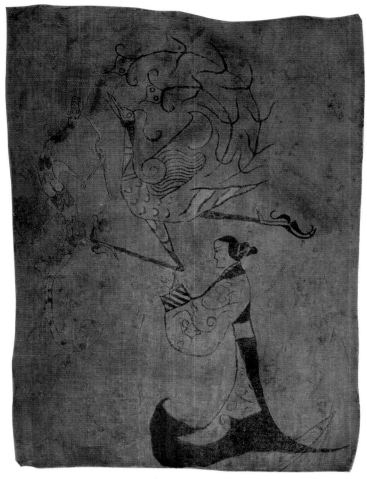

11. *A Woman, a Phoenix, and a Dragon,* ink on silk, from Zhangjiadashan, Changsha, Hunan Province, 3d century B.C. 31.2 × 23.2 cm. Hunan Provincial Museum.

gentleman's portrait had far better control of the brush. Not only could that artist deal with more difficult tasks in representing the subject — the depiction of the figure's round shoulder, delicate cap, and gentle facial expression are convincing and subtle — but the ink lines have an independent aesthetic value and can be appreciated for their smoothness, fluidity, dynamism, and harmonious configuration. In fact, this painting provides a superb example of the drawing style called "floating silk threads from antiquity" (*gaogu yousi miao*), which would be imitated and praised by artists and art critics of later ages.

All these examples of Eastern Zhou painting were used to furnish tombs and decorate utensils and musical instruments. Their function and location signified a profound transformation in art. During the earlier Western Zhou, the ancestral temples of noble lineages had been the primary art centers, housing all kinds of ritual paraphernalia, but during the Eastern Zhou, local hegemonies competed for political dominance and overpowered the Zhou king, and the political and religious centers, which were also the centers of artistic creation and exhibition, gradually shifted to palaces and mausoleums — the monuments of powerful individuals who were members of the new social elite.[11] This transformation explains two general artistic changes that strongly influenced the development of painting: palace and mortuary art replaced ritual vessels, and figural representations replaced imaginary zoomorphs. This transformation was greatly reinforced by the unification of the country brought about by the Qin and Han dynasties, beginning in the third century B.C. The recent excavation of the Qin palaces in Xianyang, a city north of present-day Xi'an, allows us, for the first time, to recognize the brilliance of Qin palace painting. A surviving section of the large murals found along a corridor in Palace 3 shows a procession of seven chariots, each drawn by four galloping horses (fig. 13); another fragment illustrates a well-proportioned court lady dressed in a long skirt with a broad lower hem. These colorful images, painted without the help of outlines, are considered the earliest examples of the "boneless" (*meigu*) technique in Chinese painting.

If these Qin works attest to the achievement of palace murals at the beginning of Chinese dynastic history, paintings from the famous Mawangdui tombs in Changsha exemplify the development of funerary art in the early Han, the dynasty that ruled the country after the Qin. Created half a century after the fall of the Qin in 206 B.C., the tombs contain layers of wooden caskets, as was traditional for burials of members of aristocratic families. But unlike in Eastern Zhou tombs, complex

Song recognized him as a true painter and gave him the assignment. No works from this period can be attributed to individual painters like him. But two silk banners, both dating from the third century B.C. and found near Changsha, south of the Yangzi River, allow us to see remarkable differences in artistic achievement in Eastern Zhou painting (figs. 11, 12).

Both paintings portray the deceased in whose grave they were buried: one bears the image of a woman; the other, a gentleman. The banners were probably used in funerary rites to preserve the likeness of the dead. The two paintings also share drawing techniques and a compositional formula: images are outlined in ink, and the principal figures are shown in profile, accompanied by mystical animals and birds (in figure 11 a phoenix is fighting against a snakelike creature, conventionally designated a dragon; in figure 12 the gentleman is riding on a dragon). The main difference between these works lies in the degree of artistry. The female figure appears as a silhouette; the outlines are rather coarse and uneven, apparently executed by an unassured hand. The painter of the

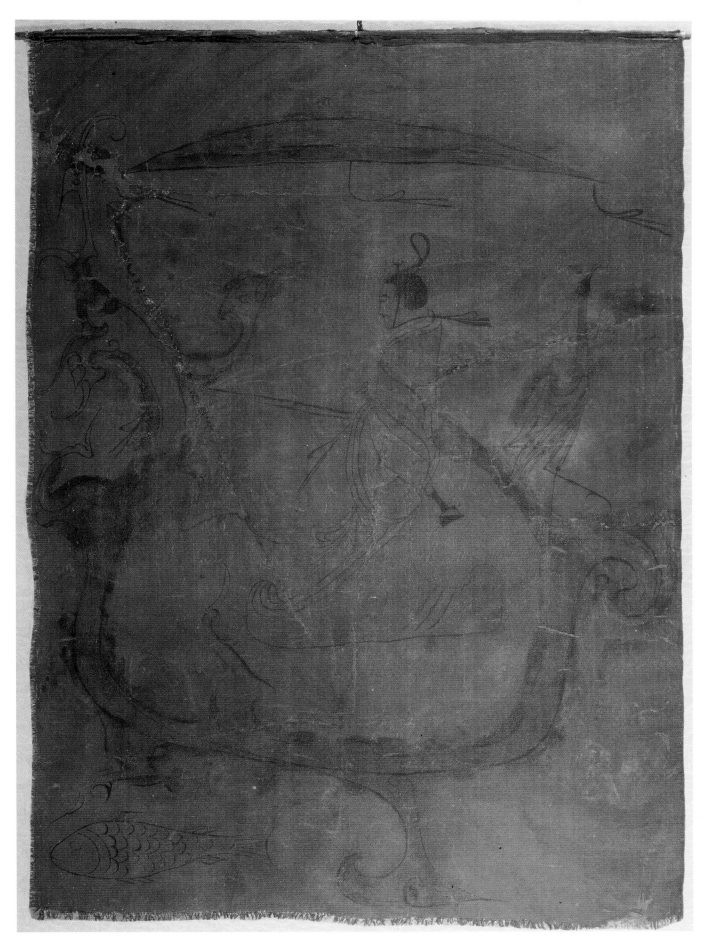

12. *A Gentleman Riding on a Dragon,* ink on silk, from Zidanku, Changsha, Hunan Province, 3d century B.C. 37.5 × 28 cm. Hunan Provincial Museum.

13. *A Horse-Drawn Chariot,* detail of a mural in Palace 3 in Xianyang, Shaanxi Province, late 3d century B.C. Shaanxi Provincial Qin-Capital Cultural Relics Administrative Committee.

pictorial images were widely used in the Mawangdui tombs—not only on funerary banners but also on coffins and wall hangings. These images on different objects constitute a coherent pictorial program pertaining to the function and symbolism of the burial structure. In Tomb 1 for Lady Dai four coffins of decreasing sizes enclosed one another (figs. 14, 15). The first and outermost coffin is painted black, the color of death and the underworld. All painted images sealed inside this coffin were thus designed not for an outside viewer but for the deceased and concern the themes of death and rebirth, protection in the afterlife, and immortality. The second coffin has a black background but is painted with a pattern of stylized clouds and with protective deities and auspicious animals roaming an empty universe. A tiny figure, the deceased woman, is emerging at the bottom center of the head end. Only her upper body is shown, for Lady Dai is about to enter this mysterious world. The third coffin exhibits a different color scheme and iconography. It is shining red, the color of immortality, and the decorative motifs include divine animals and a winged immortal flanking three-peaked Mount Kunlun, which is a prime symbol of eternal happiness.

Inside this tomb on top of the fourth and innermost coffin the excavators found a painted silk banner about two meters long (fig. 16). Many theories have been proposed to explain this painting. In my opinion, the three horizontal bars serve as ground levels to divide the vertical composition into four parts. The top and bottom sections portray Heaven and the underworld, respectively, and the middle scenes represent two stages of Lady Dai's

existence in the afterlife. Ancient ritual canons identify these two stages as those of the *shi* (corpse) and the *jiu* (literally, "the body in its eternal home"). In the painting, family members are offering sacrifices to the shi; the jiu is represented by the woman's portrait.[12] Compared with the earlier funerary banners from the same region, this banner shows many new artistic elements. Iconographically, it portrays the transformation from death to rebirth in a cosmological environment; stylistically, the two middle scenes represent an attempt to depict three-dimensional space—figures overlap, and the more distant ones are smaller.

Painted works from the tomb of Lady Dai's son (Mawangdui Tomb 3) are less researched but are no less important than those from Tomb 1. Most significant are two groups of paintings on silk. Those in the first group, made especially for the burial, include a funerary banner and silk paintings that decorate the coffins (*guan*) and the large wooden casket (*guo*) enclosing the coffins. The silk paintings in the second group consist of illustrated manuscripts, including manuals for physical exercise and divination, which were buried with the deceased together with a huge collection of ancient texts. The funerary banner in the first group resembles the one for Lady Dai, except that the central figure is a young gentleman. Two other paintings in this group, however, are unlike any in Tomb 1. They are works of considerable size; the less damaged one, *A Ritual Gathering* (fig. 17), is nearly one meter wide and more than two meters long. The two paintings were originally hung on the long walls of the casket that enclosed the set of coffins. In a burial of this type, the guo replicates the household of the dead person.[13] This architectural symbolism explains the subjects of the paintings—a large ritual procession and leisure activities, such as touring on land and water—which represent various aspects of the formal life of the deceased. The paintings do not contain mystical or cosmological elements, which abound in the funerary banner, and they seem to employ a different pictorial language. The style of the funerary banner can be traced back to the Eastern Zhou mortuary paintings on silk (see figs. 11, 12), whereas the wall hangings fall within the tradition of depicting worldly events, exemplified previously by the Chu painted lacquer box and the Qin murals (see figs. 9, 13). The artist of *A Ritual Gathering* employed and developed the conventions in this second genre to arrange figures in three contrasting rows: those in the far ground face the viewer; those in the middle ground show their profiles; and those in the foreground are portrayed from the rear. Although neither foreshortening nor a coherent

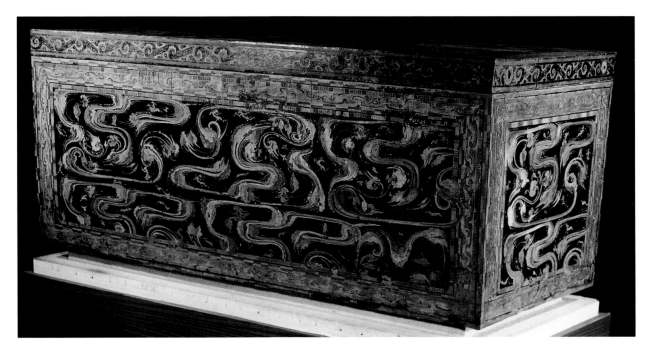

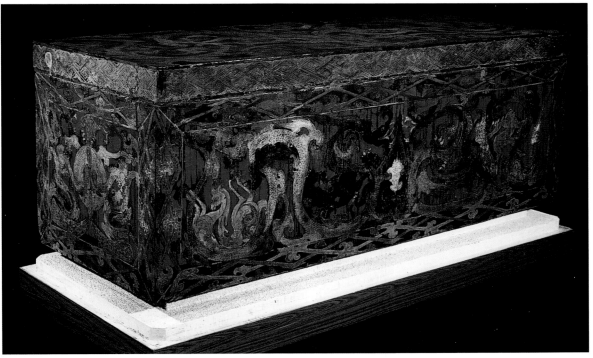

14. Painted black lacquer coffin with cloud patterns, from Mawangdui Tomb 1 in Changsha, Hunan Province, early 2d century B.C. 114 × 256 cm.

15. Painted red lacquer coffin with auspicious animals and an immortal, also from Mawangdui Tomb 1. 92 × 230 cm. (Both coffin illustrations are reprinted from Fu Juyou and Chen Shongchang, *Mawangdui Han mu wenwu* [The cultural relics unearthed from the Han tombs in Mawangdui] [Changsha: Hunan Publishing House, 1992], 6, 13.)

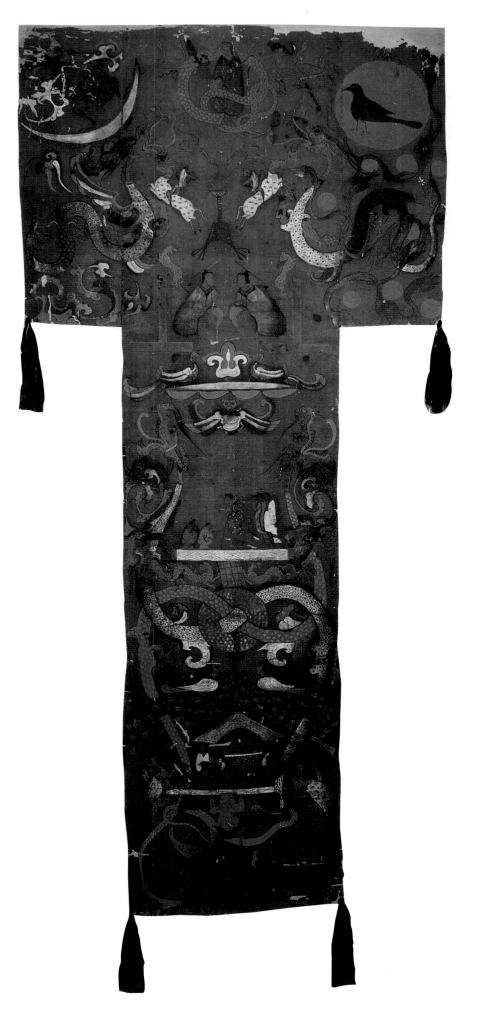

16. Funerary banner with the portrait of Lady Dai, ink and color on silk, from Mawangdui Tomb 1 in Changsha, Hunan Province, early 2d century B.C. 205 × 92 cm (at top). (Reprinted from Fu and Chen, *Mawangdui Han mu wenwu*, 19.)

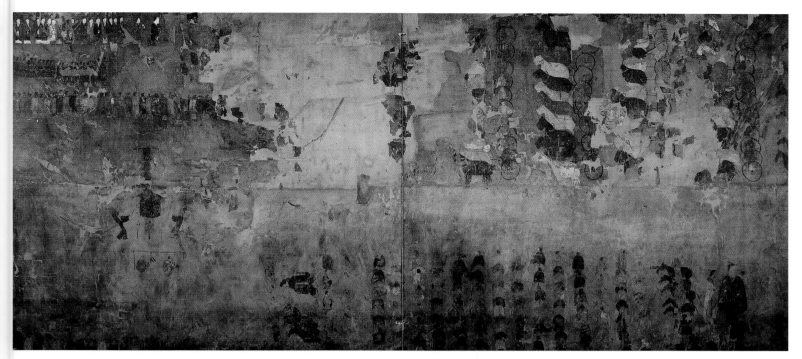

17. *A Ritual Gathering,* ink and color on silk, from Mawangdui Tomb 3 in Changsha, Hunan Province, early 2d century B.C. (Reprinted from Fu and Chen, *Mawangdui Han mu wenwu,* 26–27.)

system of perspective is used, the juxtaposition of figures defines a space within the picture plane.

Following Qin precedents, all the rulers of the Han dynasty had their palaces decorated with elaborate murals, which fell into two thematic categories.[14] One category served a direct political and educational role: portraits of meritorious ministers and generals were painted in the royal palace to inspire officials to follow their example. Emperor Ming (r. A.D. 58–75) in particular established a Hall of Paintings (Hua gong) and covered its walls with illustrations of the Confucian Classics and historical stories accompanied by explanatory texts composed by court scholars. The imperial promotion of Confucian ideology inspired two related kinds of painting: illustrations of Confucian moral tales and iconic images of Confucius and his disciples, which were both displayed in the palace and copied throughout the country. In contrast, works belonging to the second category had strong religious themes. It is recorded that in a persistent search for immortality, Emperor Wu (r. 140–87 B.C.) took a necromancer's advice to decorate his palaces and paraphernalia with divine likenesses in order to attract deities. His religious center, the Palace of Sweet Springs (Ganquan gong), housed "images of the Heavenly Sovereign [Tian Di], the Supreme One [Tai Yi], and a multitude of gods."[15]

All these paintings on aboveground walls vanished when the timber-framed palaces collapsed, so until recently any student of Han painting had to rely on stone carvings owing to the shortage of painted works. This situation has been altered by archaeological excavations over the last forty years. In addition to an increasing number of painted objects — lacquerware, pottery vessels, and bronze mirrors — the most important evidence of Han painting consists of newly discovered murals in tombs. Tomb murals were the result of a crucial change in mortuary structure. Most early Han tombs were "vertical burials," sometimes with wooden caskets draped with silk and coffins covered with lacquer decorations. The "horizontal burials" that appeared in the second and first centuries B.C. more faithfully imitated actual dwellings. Often built of large and small bricks, tombs of this type have a main chamber, with a gate separating it from the outside, and a number of side chambers for storing funerary goods. Murals usually do not cover all the walls but are applied to four distinct positions in the main chamber: the wall above the entrance, the partition lintel and gable, the central beam on the ceiling, and the upper part of the rear wall.

The earliest known tomb murals, in the tomb of Bo Qianqiu and his wife near Luoyang, have been dated to the middle of the first century B.C.[16] The demon queller

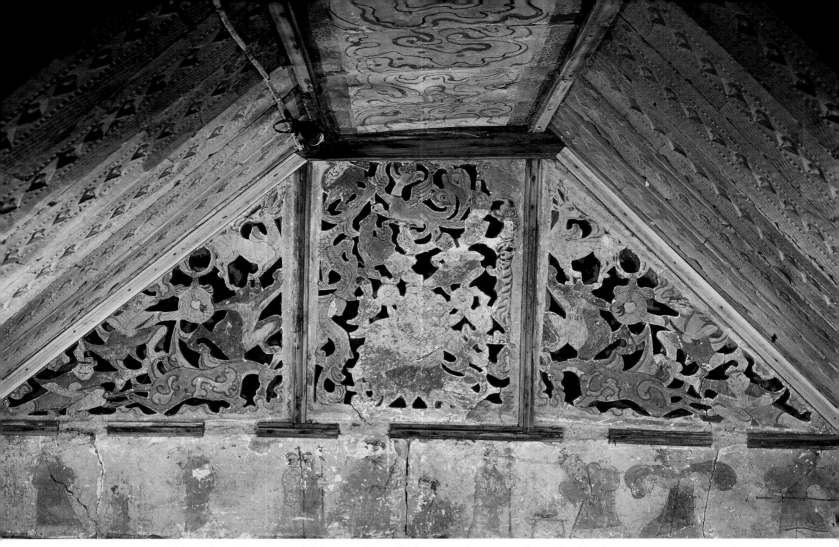

18. Partition gable with an illustration of "Two Peaches Kill Three Knights-Errant," mural in Tomb 61 in Luoyang, Henan Province, 1st century B.C. 25 × 206 cm. Museum of Ancient Tombs at Luoyang.

Fangxiang and his companion animals, the White Tiger and the Blue Dragon, are portrayed on the back wall. The opposite wall bears the image of a huge bird with a human head — possibly an auspicious symbol or an immortal — above a magic mountain. The painting on the central beam of the ceiling is the most complex (it is now in the Museum of Ancient Tombs at Luoyang). Two groups of images frame the horizontal composition. At one end are the male deity Fuxi and the sun; at the other, the female deity Nüwa and the moon. Together these two images symbolize the two opposing universal forces of yang and yin. Heavenly beasts, birds, and immortals fill this cosmic structure. Most interesting, a scene close to the yang group at the far right illustrates the journey of the deceased couple to the land of immortality. Riding on a three-headed phoenix and a snakelike creature, respectively, they are traveling to the abode of the Queen Mother of the West, a goddess in Han popular religion who is shown here seated on wavelike clouds. The themes and images of these murals are not unfamiliar; paintings in the Mawangdui tombs expressed the same desire for pro-

tection after death, immortality, and divine blessing. But instead of being associated with individual coffins as in the earlier tombs, these themes and images are now reorganized into an architectural space. The ceiling provides a logical location for images of celestial bodies and the heavenly journey, and the murals on the front and back walls complement each other with their respective subjects of divine blessing and demon quelling. The significance of these wall paintings thus lies not only in the pictures themselves but also in their transformation of the tomb into a symbolic structure for the dead.

Among the tombs in the Luoyang area dating back to the first century B.C., the Bo Qianqiu tomb is the one that shows continuity and development in early Han funerary art. A nearby tomb in Shaogou (Tomb 61) was built around the same time, but its wall paintings signify another trend: the transplanting of contemporary building murals underground.[17] The historical tales illustrated in the tomb do not have an apparent correlation with the search for immortality or the soul's transformation but are recorded as popular subjects of Han palace paintings.

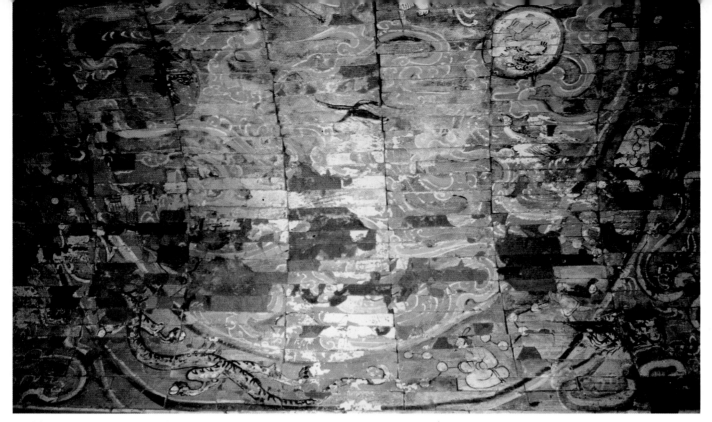

19. *The Celestial Sphere,* detail of the ceiling mural in a tomb on the campus of the elementary school attached to the University of Transportation, Xi'an, Shaanxi Province, 1st century B.C. Preserved in situ. (Reprinted from *ZMQ,* Painting, vol. 12, no. 9.)

It is not difficult to understand why such tales were painted on the tomb walls: this horizontal tomb replicated both the layout and decoration of a freestanding building, which ordinarily had painted walls.

Three striking long, horizontal compositions are in the tomb. The central beam of the ceiling bears images of the sun, the moon, and constellations. The painting on the back wall has been the subject of an intense debate; some scholars consider it an illustration of an episode in Han history (the banquet at Hongmen), but others argue that the bearlike figure in the middle cannot be the story's central character, Xiang Yu.[18] We shall focus on the third composition, on the inner side of the partition lintel, whose content is more definite. Two historical stories are illustrated here. The one depicted on the right is called "Two Peaches Kill Three Knights-Errant" (fig. 18). It is related that Gongsun Jie, Tian Kaijiang, and Gu Yezi were good friends and brave warriors of the kingdom of Qi. As their fame grew, they became arrogant and conceited; their ambition and violent behavior threatened the Qi lord. The clever minister Yan Ying planned a simple scheme to get rid of them: he presented the three men with two peaches as a reward for being the bravest warriors in the state. Gongsun Jie and Tian Kaijiang immediately engaged in a fight for a peach, but then felt ashamed of their greediness and committed suicide; Gu Yezi killed himself to follow his friends. Although the story extols the Confucian ethic of loyalty and good friendship, the

story line is what made it a popular subject of Han folk-songs and funerary paintings.[19]

Instead of illustrating the entire story, the artist focuses on a single dramatic moment: the fight between the warriors before their suicides. Other characters — the Qi lord and Minister Yan Ying — stand aside to witness the event. The selection of episode seems to disclose the painter's disinterest in the moral of the story, which requires the tragic ending. There is also a strong emphasis on the characterization of the warriors; painted as cartoonlike figures whose exaggerated gestures and facial expressions vividly reflect their arrogant and supercilious personalities. Both this picture and the second scene on the lintel, which illustrates the visit of Confucius and Laozi to the boy genius Xiang Tuo, entered the stock of Eastern Han pictorial motifs, becoming standard compositions among painters and stone carvers during the next two centuries.

It is still difficult to ascertain the role of patrons in creating such murals. The wide variety of subjects and the distinct decorative theme of each tomb suggest that the family of the deceased could have selected favorite scenes from a large repertoire of motifs. The Bo Qianqiu and Shaoguo tombs represent two variations, and a tomb in Xi'an represents a third.[20] Neither immortal realms nor historical tales are presented in this tomb. Instead, on the arched ceiling there is an amazingly detailed astronomical diagram (fig. 19). The twenty-eight constellations and

20. *Heavenly Beasts (Blue Dragon and Red Bird),* mural in a tomb in Jinguyuan, Luoyang, Henan Province, Xin dynasty. 21 × 90 cm. Museum of Ancient Tombs at Luoyang.

symbols of the four directions are drawn in a broad circular band surrounding an inner circle in which the sun balances the moon, and cranes and wild geese fly among drifting clouds. Huge wave patterns running horizontally across three adjacent walls suggest a mountain range, and lively animal images adorn the walls here and there. Similar designs usually embellish Western Han incense burners and other portable objects, but they are employed here on a grand scale for architectural decoration. Unlike the Luoyang tombs, in which murals appear only in limited areas, this tomb has an interior covered with images in brilliant red, blue, green, purple, and brown.

Collectively, these tomb murals signify the shifting center of pictorial art. In retrospect, we realize that most pictorial images created before the first century B.C. were from the south and were related to Chu culture, but most painted tombs from the middle of the first century B.C. to the early first century A.D. were located in the Han metropolitan areas of Xi'an and Luoyang in the north.[21] This change seems to support the textual records about the royal patronage of painting and also explains the immediate impact of changing official ideology on the style and content of tomb murals. A painted tomb constructed during the Xin dynasty (9–23 A.D.) serves as an excellent example.[22] The Xin, which replaced the Western Han, was one of the shortest dynasties in Chinese history. Its founder, Wang Mang, relied heavily on omens and a mystical historiography modeled on the pattern of the five elements (wood, fire, earth, metal, and water) to legitimate his mandate. The pattern of elements provided a blueprint for his political monument Bright Hall (Ming tang) and also appears in the decoration of contempo-

rary bronze mirrors. A Xin tomb near Luoyang, which manifests the same pattern, represents an abrupt break in tomb design. Unlike earlier tombs in the area, it has a highly schematic structure underlying its decoration. Symbolic animals and birds associated with the four directions, as well as other mythical figures and creatures, are painted in isolation on the walls of the rear chamber (fig. 20), and celestial and directional symbols appear in compartments on the ceiling. In the front chamber the ceiling bears five round protrusions ringed with paint which form the pattern of the five elements.

Another notable innovation during the first century A.D. was in landscape style. We can date this change to the early Eastern Han dynasty (25–220), which succeeded the Xin. A mural found in a tomb in Pinglu, Shanxi Province, for example, shows a panoramic landscape depicted from a bird's-eye view (fig. 21). Layers of rolling hills with gentle contours and lush vegetation overlap toward the horizon. The hills and the adjacent fields provide an environment for such human activities as farming and raising livestock. In both drawing style and iconography the painted hills differ radically from Han images of the mountains of the immortals, whose triadic or mushroom-shaped peaks deliberately violated observable mountain forms. But generally speaking, few painted tombs of the early Eastern Han are known; and even the Pinglu tomb is tiny, just 4.65 meters long and 2.25 meters wide.[23]

Although we cannot rule out the possibility that large-scale tomb murals of this period may yet be found, it may be the case that the development of funerary painting was slowed down by the sudden popularity of stone carvings, which became the major form of mortuary decoration after the establishment of the Eastern Han dynasty. Not only did emperors begin to construct stone funerary shrines for themselves, but pictorial carvings appeared in large quantities in important political and cultural centers, most notably in present-day Henan and Shandong Provinces.

When pictorial carvings were first made, they imitated either images stamped on tiles or murals painted on plaster walls.[24] The latter are wonderfully exemplified by the feast scenes engraved on the famous Zhu Wei shrine in Jinxiang, Shandong Province.[25] Both the carving technique and the composition of the scenes reveal their strong connection to painted murals. The stone carver used the chisel like a brush to delineate figures and objects in fluid lines and framed the scenes with forms that imitate the beams and poles of a wooden structure. Most significant, these scenes may be considered the first suc-

cessful representations of a unified space in Chinese pictorial art. In the carving, low couches and attached screens enclose the area where banquets take place, and separate the figures in front of and behind the screens. The screens and couches even seem to recede diagonally into the distance, suggesting a system of perspective. But without foreshortening, the oblique outlines of these objects never converge toward a vanishing point but meet at an invisible central axis. Rather than creating an illusory three-dimensional space, the symmetrical composition defines a central viewpoint.

Funerary murals were revived around the middle of the second century. This hypothesis is based not only on the increasing number and wide distribution of excavated painted tombs but also on their unusual scale and innovations in the style and subject of their pictorial decoration. Often huge underground structures, these multichambered tombs belonged to high officials and wealthy families. The occupant of Tomb 2 at Mixian, Henan Province, for example, was probably related to the district magistrate Zhang Boya. Among the tomb murals is a banquet scene displayed in the central chamber. More than seven meters wide, it depicts people at a party watching a colorful acrobatic performance. Unlike contemporary stone carvings, which often illustrate conventional images in a fixed layout, murals in large tombs never repeat one another. It is possible that most carvings were made in workshops according to certain copybooks. Tomb murals, in contrast, could have been done by painters on special commission. As a result, although carvings exist in far greater numbers, they often demonstrate homogeneous regional styles; tomb murals, on the other hand, more clearly disclose patrons' specific concerns and artists' individual styles. A quick look at three painted tombs, chosen from among more than twenty excavated examples, will demonstrate these features of late Eastern Han funerary painting.[26]

Our first example is a tomb discovered in Anping, Hebei Province, in 1971. An inscription on a wall dates the tomb to 176 A.D. and the surname Zhao written near the entrance provides a clue for speculating on the identity of the deceased, who was probably a relative of Zhao Zhong, the most powerful eunuch in Emperor Ling's reign (168–189) and a native of Anping.[27] The enormous scale of the tomb seems to confirm this identification: ten connecting chambers form an underground structure more than twenty-two meters long. Murals appear only in the three chambers near the entrance, which are made in imitation of the reception hall and adjacent rooms in a household. Not coincidentally, they illustrate the pub-

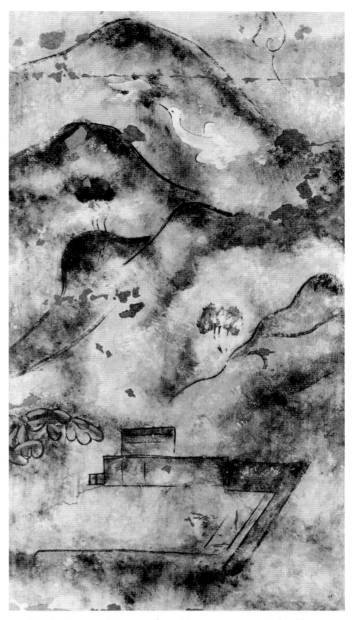

21. *Landscape,* mural in a tomb in Zhaoyuancun, Pinglu, Shanxi Province, 1st century A.D. 88 cm high. (Reprinted from Michael D. Sullivan, *Symbols of Eternity: The Art of Landscape Painting in China* [Stanford: Stanford University Press, 1979], fig. 14. Used with the permission of the publishers, Stanford University Press. © 1979 by Michael D. Sullivan. Photo: Courtesy of Michael D. Sullivan.)

22. *Portrait of the Deceased,* mural in a tomb in Anping, Hebei Province, A.D. 176. 180 × 260 cm.

lic life of the deceased man. In the central chamber, which is reminiscent of a reception hall, a large procession is depicted in four parallel registers. It consists of no fewer than one hundred horsemen and foot soldiers and seventy-two chariots. Because the number of chariots used by a Han official was strictly regulated according to his rank, this composition identifies the high social status of the dead. A door opening on the south wall of this chamber leads to a smaller chamber, where we find a portrait of the deceased (fig. 22). He is presented as a man of strong physique and dignified manner. Seated on a dais under a canopy, he stares steadily at the void before him, ignoring the homage-paying officials illustrated to his

left. An architectural complex painted on the opposite wall must represent his former home, but it is more like a military camp than an ordinary dwelling, for it is surrounded by tall walls and overlooked by a watchtower (fig. 23). Entering the third chamber of the tomb through another door, we find portraits of civil officials painted on all four walls. Perhaps subordinates of the deceased, they are seated on mats and conversing with one another.

The whole pictorial program in the Anping tomb is apparently intended to capture the public grandeur of the deceased official. This representational purpose must have prompted the realistic painting style. The portrait of the deceased, for example, exemplifies the best achieve-

23. *A Walled Compound with a Watchtower,* mural in a tomb in Anping, Hebei Province, A.D. 176. 230 × 135 cm.

ment of Eastern Han portraiture. Instead of depicting the deceased according to type, as we find in many stone carvings, the artist tried to reveal his physical likeness and personality. Unlike earlier profile portraits in silk paintings (see figs. 11, 12, 16), this portrait shows the occupant of the tomb in a frontal view; he confronts the viewer and demands full attention. The architectural complex, presented from an aerial point of view, is a mature work in the ancient painting genre *jiehua* (architectural drawing). Surprisingly, the artist employed the technique of foreshortening; the converging lines of roofed corridors produce a strong three-dimensional effect unusual in early Chinese art.

The emphasis on the dead person's public image and social status also characterizes the murals in Wangdu Tomb 1, in Hebei Province. Painted officials of various ranks flank the entrance and front chamber of the tomb as if paying homage to an invisible master.[28] But these figures are accompanied by a series of strange but auspicious animals and birds — sent down by Heaven in response to good human behavior — which are illustrated along the lower part of the walls in the front chamber. The murals thus fulfill two complementary functions: the lines of subordinate officials consolidate the authority of

the dead, and the birds and animals of good omen establish his outstanding achievements and excellent moral conduct. Figures and images in the Anping tomb are organized in large units, but those in the Wangdu tomb follow a "cataloguing style": individual images are painted side by side and identified by cartouches beside them.[29] Presented without much interaction or physical setting, the figures appear as a series of portraits; the painter's achievement lies mainly in depicting self-contained three-dimensional entities. The Keeper of Records (Zhuji shi) portrayed in the tunnel connecting the front and central chambers of the tomb is a good example (fig. 24). In the portrait the official is seated on a low couch that recedes into the distance and may have been drawn with the aid of a ruler. Unlike earlier muralists, who employed a linear drawing style, the artist who created this portrait combined lines with bold inkwash. This new style, most evident in the treatment of the garment, creates a strong sense of volume seldom seen in other Han murals.

In sharp contrast to the Wangdu tomb with its carefully selected images of officials and its auspicious birds and animals, a huge tomb excavated in Helingol, Inner Mongolia, in 1972 has all sorts of figures and motifs integrated into an overall composition (fig. 25).[30] The artist's goal was not to execute convincing figures in a realistic style; rather, the rapidly drawn images make up an encyclopedic pictorial program. The tomb, which dates to the end of the second century, consists of six rooms: three main chambers along the central axis and three side rooms opening off the front and middle chambers. Its structure does not differ much from that of the Anping tomb, but its interior — three tunnels in addition to the six chambers — is covered with as many as fifty-seven pictorial compositions. An "office gate" (*mofu men*) guarded by armed soldiers is depicted in the entrance tunnel, which leads to the front chamber. The central theme of the chamber is conveyed by paintings covering the four walls — depictions of chariot processions that indicate major events in the career of the deceased. Guided by inscriptions, we follow his gradual rise in the official hierarchy from a "filial and uncorrupt [gentleman]" (*xiao lian*) to secretary (*lang*), to magistrate of Xihe, to commander of Shangjun, to district magistrate of Fanyang, and, finally, to colonel-protector of the Wuhuang tribe. It is a pictorial biography, but one concerned only with the subject's life as an official.

In the middle chamber the composition directly above the doorway leading to the rear chamber depicts a procession crossing a bridge that has two boats sailing under it. The bridge is identified by an inscription as the Wei

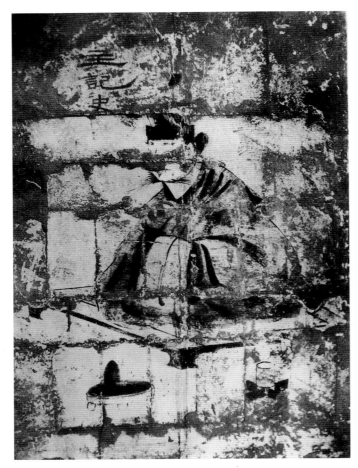

24. *The Keeper of Records,* mural in Wangdu Tomb 1 in Hebei Province, 2d century A.D. (Reprinted from Museum of History, *Wangdu Han mu bihua* [Murals in a Han tomb in Wangdu] [Beijing: Zhongguo gudian yishu, 1955], pl. 16.)

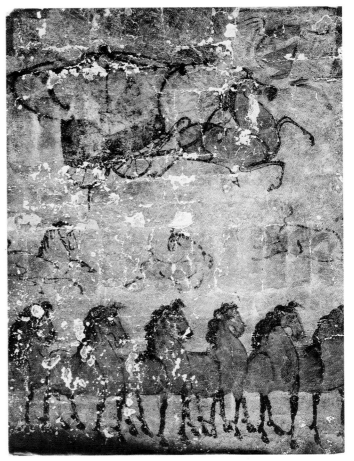

25. *A Horse and Chariot Procession,* mural in a tomb in Helingol, Inner Mongolia, late 2d century A.D. (Reprinted from *Helingol Han mu bihua* [Wall paintings in the Helingol tomb of the Han dynasty] [Beijing: Wenwu, 1978], 83.)

River Bridge. A very similar scene appears in a stone carving in a newly excavated Eastern Han tomb, and it is also identified by an accompanying inscription as a funerary procession crossing the Wei River, a symbol of death.[31] This scene helps explain the different symbolism of the various chambers in the Helingol tomb. The pictures in the front and middle chambers glorify the worldly achievements of the deceased, whereas those in the rear chamber illustrate his existence in the afterlife. The middle chamber is decorated with paintings of different cities and towns where the deceased held posts during his official career. He and his wife are accompanied by ancient sages, filial sons, virtuous women, and loyal ministers — exemplars of the Confucian moral tradition in Chinese history. There are also many auspicious omens, which denote the distinguished conduct of the dead man and the practice of good government. The couple are portrayed once more in the rear chamber, but here they are being waited upon by servant girls in their private domain. Flanking them are great farming fields, supposedly their otherworldly properties. Another large

composition in this chamber represents the Moon Palace, where their souls are meant to reside. The four directional symbols on the ceiling further transform this chamber into a miniature realm of the dead. The afterlife represented in this chamber thus appears as an extension of life and, more important, as an idealized model of the secular world; death will permit the deceased to enjoy a prosperous life forever, and in death an ideal society will be realized.

The Three Kingdoms, Two Jin, and Northern and Southern Dynasties

If the Helingol murals reflected people's dream of an ideal life and society at the end of the Eastern Han, this dream receded after the fall of the dynasty in 220, for the event terminated four hundred years of national unification. The next 360 years were one of the most troubled periods in Chinese history, as the common

designation of the period indicates: Three Kingdoms, two Jin, and Northern and Southern Dynasties (Sanguo, liang Jin, Nanbeichao). Central authority virtually disappeared (except during the Western Jin, from 265 to 317). Many parts of the country were controlled by local powers, some native Chinese, some "barbarian" in origin, which followed one another in bewildering succession. The characteristics of the period, and hence the driving forces behind its cultural and artistic development, were no longer unity, order, and hierarchy but disintegration, variety, and individualism.

Scholars often attribute two contemporary artistic phenomena to this social context. First, chaos, confusion, and profound psychological insecurity drove people to religion. It was during these turbulent years that the Chinese embraced the doctrines of Buddhism and established their greatest Buddhist grottoes, including the Caves of a Thousand Buddhas in Dunhuang, which are famous for their brilliant murals and painted sculptures. The introduction of Buddhist art marked a new beginning for religious art in China. Unlike the earlier ritual art, which had mainly been associated with the private practice of ancestor worship and the cult of immortality, the new religious art dwelled on the Buddha's universal teachings and linked people of different ethnic groups and social status into a single ideological network. Although traces of Buddhist influence exist in Han murals and carvings, religious art did not come into widespread use until the Northern and Southern Dynasties, when it was patronized by imperial and local powers, supported by organized churches, and nourished by millions of people's desire for salvation.[32] The art demanded faith: by donating, making, and worshiping images of Buddhist deities, a devotee could accumulate virtue and eventually find peace and happiness in the Buddhist paradise. The introduction and spread of Buddhist art was associated with a mass movement, the result of a fervor rarely seen in early Chinese art history.

Second, as orthodox Confucianism rapidly lost its appeal, many intellectuals sought spiritual refuge with Buddhist and Daoist sects that encouraged individual expression through philosophical discourse, poetry, calligraphy, and painting. The change in art brought about by this new interest cannot be overemphasized; in a sense, it divides Chinese art history into two broad stages. For thousands of years what we now call works of art — bronze vessels and painted tombs alike — had served a direct function in people's daily life. The creation of these works was inspired by the general desire to make religious and political concepts tangible. Anony-

mous artisans made them by working collectively, and major changes in subject matter and style were determined at first by broad social and ideological movements. This situation changed during the third and fourth centuries. Educated artists appeared and began to render public art in their private idiom; art connoisseurs and critics emerged; and among the social elite collecting paintings became high fashion. Most important to us, portable scrolls became an important medium of painting. In other words, painting was no longer attached exclusively to functional architecture and objects; it had become an independent art genre.

It would be misleading, however, to describe art of this period as an entirely new departure. Not only did Buddhist murals and scroll paintings often derive pictorial elements from traditional art forms, but old traditions, especially funerary art, continued to develop while constantly absorbing motifs and styles from Buddhist murals and scroll paintings. The complexity of the development of painting during this period was thus determined by the country's disunity, on the one hand, and by the formation, continuation, and interaction of various art traditions, on the other. This development cannot be usefully summarized in a unilinear narrative, because history itself followed a diverging course. This course became explicit after the collapse of the Western Jin in 317, when the country was separated into two broad geographical, ethnic, and cultural zones, roughly divided by the Hui River. The north was governed by a host of sinicized foreign regimes (the Northern Dynasties, 386–581), the south by a line of Chinese dynasties (the Southern Dynasties, 317–589). The development of painting in these two areas followed separate paths, yet the constant diffusion, borrowing, and exchange of motifs and styles created a dialogue between various regions and prepared the ground for the first peak of Chinese painting: during the Sui and Tang dynasties.

The North

The tradition of tomb murals continued in the north after the Han dynasty. The social turmoil that started even before the fall of the Han, however, had turned the central plain into a vast ruin. The old capitals were destroyed, the countryside devastated, and the population robbed and massacred. Hardly any significant construction could have possibly taken place in this old heartland of Chinese culture and art. Except for one example, all painted tombs built from the third to the early fourth centuries have been found in the northeast and northwest — two relatively peaceful corners of the country

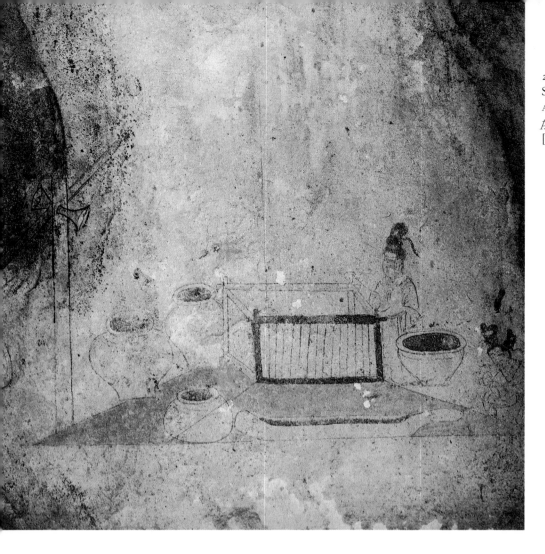

26. *Drawing Water from a Well,* mural in Dong Shou's tomb (Tomb 3) in Anak, North Korea, A.D. 357. (Reprinted from *Koguryŭ kobun pyŏkhwa* [Murals of the Koguryo tumulus] [Tokyo: Chōsen gahōsha, 1985], pl. 19.)

that became refuges for immigrants from the troubled central area.[33] Following a regional tradition, the tombs near Liaoyang, seat of the Liaodong District during the Han dynasty, were made of stone and painted with familiar Eastern Han motifs, including the frontal portrait of the deceased, chariot processions, musical performances, farming and hunting scenes, and astronomical and supernatural images on the ceiling.[34] Although these murals are generally ill preserved, a notable exception is a painted tomb at Anak (Tomb 3) in present-day Korea, which should be carefully distinguished from the many tombs of the Koguryo kingdom found in the same area as well as in Ji'an, Jilin Province, in China.[35] An inscription identifies its occupant to be Marshal Dong Shou, the governor of Lelang (the former Han commandery in Anak), who died in the third year of the Yongping era of the Eastern Jin (357 A.D.). It is possible that after the Chinese government lost control of Lelang to the Koguryo king, Dong Shou remained in the former Chinese colony either as an independent warlord or as an appointed official of the Koguryo king.[36] All aspects of Dong Shou's tomb — structure, decoration, and inscription — serve to identify his Chinese origin. In the inscription he is given a string of Chinese official titles, including General

Pacifying the East and Commander-Protector of the Barbarians, and his death is dated according to the Chinese official calendar then used in a Southern Dynasty. His burial resembles a large stone tomb in Yi'nan, Shandong Province; his portrait follows the Eastern Han prototype found in Anping (see fig. 22); and the grand procession painted on his tomb has similarities with those in the Helingol tomb. Created more than 150 years after these great Han tombs, however, the murals in Dong Shou's underground chambers exhibit significant changes in subject matter. Most important, Confucian themes, both didactic tales and auspicious omens, have disappeared. Instead, there is a keen interest in genre scenes and female imagery. The men portrayed in the tomb are all engaged in official duties and have rigid poses and severe expressions, but the female figures are far more relaxed. Dong Shou's wife, shown in a three-quarter view, is conversing with a servant girl, and other women are cooking in a kitchen, drawing water from a well (fig. 26), or husking rice in a mortar.

The decline of Confucian influence is also evident in the northwestern tomb murals. Moral exemplars and auspicious omen are likewise absent here, and most pictures illustrate daily life on this Chinese frontier. But the build-

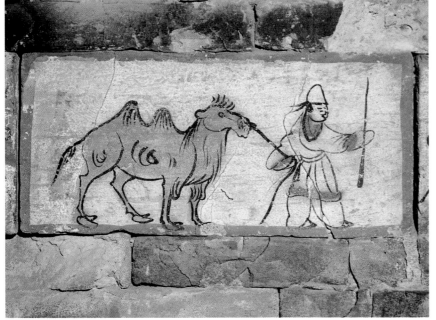

27. Interior of Tomb 6 at Jiayu Pass, Gansu Province, showing painted bricks on the wall, 3d century, each 17 × 36 cm: *a,* full view; *b,* detail, *Herding a Camel.*

a

b

ing techniques and decorative methods are quite unlike those used for tombs in the northeast and attest to an indigenous tradition. A group of third-century brick tombs, discovered near Jiayu Pass at the western limit of the Great Wall, have domed ceilings and are decorated in a unique fashion.[37] In each tomb numerous scenes embellish individual bricks; viewing the pictures in succession is almost like looking at a series of cartoon frames. The bricks are covered with a thin wash of white plaster on which various images — domestic animals, farming and hunting scenes, and episodes in soldiers' lives — are painted with bright colors and sweeping brush lines (fig. 27). These works have been greatly admired in China since their discovery, in part because their

free and spontaneous style suggests the healthy influence of folk art.

This kind of painted tomb continued in the northwest during the fourth century and was adopted in the Turpan area in present-day Xinjiang Uygur Autonomous Region. But the largest fourth- or fifth-century tomb discovered in the Jiayu region (Dingjiazha Tomb 5) belongs to a different type.[38] Located near Jiuquan, Gansu Province, it has two chambers covered with murals in large, continuous compositions. Objects painted in the rear chamber represent various grave furnishings. Images in the front chamber, however, differ according to whether they appear on the ceiling or a wall. Principal motifs on the four slopes of the ceiling — the Queen

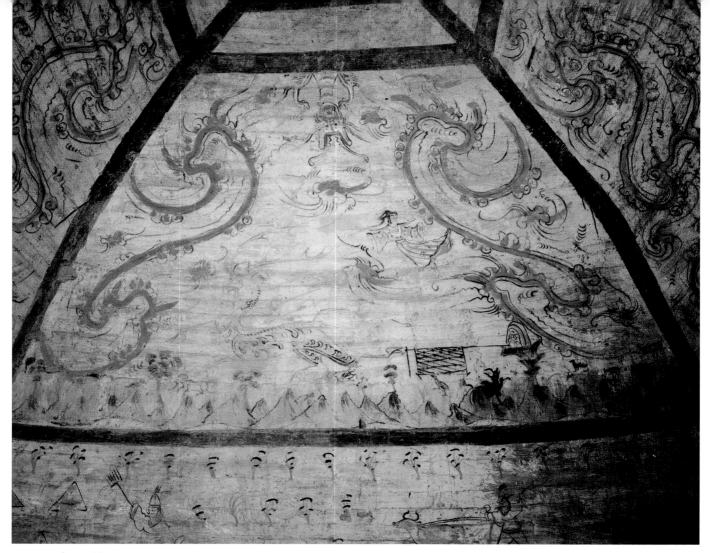

28. *Ascending to Heaven,* ceiling mural in Dingjiazha Tomb 5 in Jiuquan, Gansu Province, 4th–5th century. 145 × 270 cm. (Reprinted from *ZMQ,* Painting, vol. 12, no. 43.)

Mother of the West, the King Father of the East, a heavenly horse, a flying figure (fig. 28) — apparently represent the supernatural realm. In scenes on the walls the deceased is enjoying a musical performance and other aspects of a prosperous afterlife.

We may well wonder why this tomb appeared in the far northwest. It seems dissociated from local culture and seems to derive its decorative scheme from earlier Han murals in the central plain and contemporary paintings in northeastern tombs. This question is partially answered by the special significance of the Jiuquan area, where the tomb is located. An important settlement along the Silk Road since Han times, Jiuquan was a meeting place of peoples and cultural and artistic traditions from east and west. It assumed a new role in cultural transmission after the third century as the main entry point for Indian Buddhism into China and as a melting pot for Buddhist and traditional Chinese art. Not coincidentally, Dingjiazha Tomb 5, which bears influences from the east, became a source for the sinicized Buddhist caves in Dunhuang, a

thriving religious center three hundred kilometers to the northwest.

The first Dunhuang cave-temple was built in 366, but the earliest surviving structures at the site are from the early fifth century. Not surprisingly, the murals and statues in the early caves show dominant Indian and central Asian influences. A distinct Dunhuang style did not emerge until the Northern Wei dynasty (386–535); and Chinese elements increased during the following Western Wei (535–556).[39] Some of the most stirring pictures created during these Northern Dynasties are narrative representations of *Jataka Tales* and stories of model monks and nuns, both with strong Hinayana Buddhist overtones and an emphasis on self-sacrifice, monastic practice, and aloofness from society. King Sibi saves a pigeon by sacrificing his own flesh, Prince Mahasatta feeds hungry tigers with his own body, and Prince Sudata gives up everything he has for charity, including his wife and children. Parallels are found between these stories and the abundant moral tales of chaste widows and filial sons in

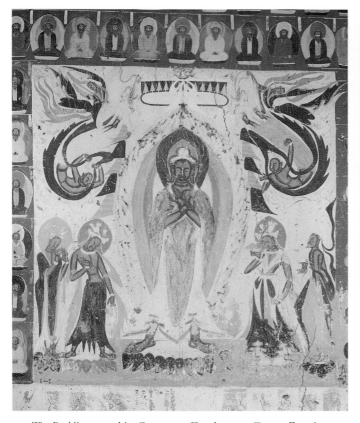

29. *The Buddha,* mural in Cave 249, Dunhuang, Gansu Province, early 6th century.

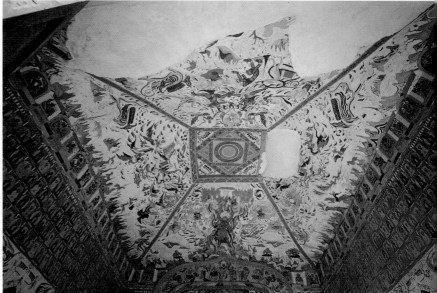

30. *Thousand Buddhas and the Heavenly Realms,* wall and ceiling murals in Cave 249, Dunhuang, Gansu Province, early 6th century.

Han murals and carvings, which likewise promote self-sacrifice and unconditional devotion, but for a different cause.

Generally speaking, Dunhuang art during the Northern Dynasties period underwent a gradual sinification. Often motifs and styles of Indian, central Asian, and Chinese origins are mixed in a single cave. The complexity of this art is exemplified by Cave 249, constructed toward the end of the Northern Wei. On its two side walls, large rectangular compositions present frontal images of the Buddha flanked by bodhisattvas and soaring heavenly *apsaras* (fig. 29). The stylization of the Buddha figure and the drawn-out winglike hem of his garment give the image the appearance of a statue in bronze or stone, an impression reinforced by thick outlines and shading. Numerous small icons called the Thousand Buddhas surround the standing Buddha. Of equal size but varying colors, these small meditating Buddhas offer the charm of hypnotic power. Above them are heavenly musicians playing musical instruments in painted niches (see fig. 30). Close prototypes of these three groups of images — the standing icon, the Thousand Buddhas, and the musicians — are found in Buddhist caves in central Asia and Chinese Turkestan.

Although images of foreign origin dominate the walls, the ceiling is in a Chinese style, like the one in Dingjiazhai Tomb 5. This kind of ceiling, with four sloping quadrants, provided the artist with separate spaces to display art motifs from divergent sources (fig. 30). On the slope opposite the cave entrance, a powerful figure with four eyes and four arms stands holding the sun and the moon. Although this image may owe its origin to Hindu mythology, it is embellished with Chinese pictorial elements. A pair of Chinese dragons flank the figure, and this dragon motif, as well as the juxtaposed sun and moon, can be traced to a Mawangdui banner (see fig. 16). Such Chinese elements are accentuated on other sides of the ceiling. There are hunting scenes, fantastic mountains, and the gods of thunder, lightning, wind, and rain, all following traditional Chinese iconography. The linear and fluid drawing style differs radically from the style of the solid icons on the walls. Perhaps most important, the painter organized individual images according to a basic structural principle adopted from Chinese funerary art. Two flying chariots occupy the centers of the left and right slopes of the ceiling; some scholars have identified their occupants, who are dressed in Chinese royal costume, as the Queen Mother of the West and the King Father of

the East, two principal deities in contemporary popular Daoism. But the major point of the murals is probably not the exact identity of the figures — they are too tiny to be clearly recognized — but the binary structure of yin and yang, which underlies ancient Chinese cosmology. In the two paintings, dragons pull one chariot while phoenixes draw the other; these two mythical creatures are among the oldest symbols of the yin and yang forces. Other motifs surrounding the two chariots further support this interpretation; for example, the Earth Sovereign (Yin) follows the phoenix-drawn chariot, and the Heavenly Sovereign (Yang) follows the dragon-drawn chariot. We find a similar binary structure in the murals of the Dingjiazha tomb, whose ceiling is decorated on opposite sides with the Queen Mother of the West and the King Father of the East. An additional image clinches the relation between the Dingjiazha tomb and Cave 249. A painted mountain range separates the walls and ceiling at both sites. On the walls are figures representing either the deceased or the Buddha while on the ceiling are clouds and heavenly beings painted in a fluid, curvilinear style.

Among the forty-three early Dunhuang caves dated to the Northern Dynasties, seven are from before 439, nine from the Northern Wei, twelve from the Western Wei, and fifteen from the Northern Zhou (557–581).[40] About two-thirds of these caves, therefore, were built between 530 and 580. Interestingly, there was an impressive development of funerary murals in the north during the same fifty-year span. Many large painted tombs belonging to royal members and officials of various regimes have been excavated recently. The most extraordinary and best-preserved ones include the tombs of Yuan Wei (526; Northern Wei dynasty; found at Luoyang, Henan Province), the Ruru Princess (550; Eastern Wei; Cixian, Hebei), Cui Feng (551; Northern Qi; Linxu, Shandong), Li Xian (569; Northern Zhou; Guyuan, Ningxia), Lou Rui (570; Northern Qi; Taiyuan, Shanxi), Dao Gui (571; Northern Qi; Ji'nan, Shandong), and Gao Run (575; Northern Qi; Cixian, Hebei).[41] These tombs together signify an important change in funerary art: painting now played a more important role than architecture in transforming an underground structure into a grandiose residence of the dead. Whereas a multichambered Eastern Han tomb imitated a large household in its architectural form, the Northern Dynasties tombs, even those of nobles and high officials, have a relatively simple design. The majority have just a single chamber. The entryway, however, is elongated, and its walls provide two huge triangular spaces for painting. This new style of architecture and decoration provided the blueprint for the royal mausoleums of the Tang dynasty, built more than a hundred years later.

The excavation of Lou Rui's tomb in 1979 was a sensational archaeological event. Not only is the quantity of wall paintings amazing — there are seventy-one compositions covering more than two hundred square meters — but their quality surpasses that of all known earlier and contemporary funerary paintings. The entryway, which is twenty-one meters long, is like a painting gallery, with images organized on three horizontal registers on each wall. Horsemen and camel caravans are portrayed on the two upper levels on both walls. On the left wall they are galloping toward the opening of the tomb (fig. 31); on the right wall they have returned from outside — soldiers have dismounted and are hesitantly reentering the underground chamber. On the bottom registers, groups of soldiers are blowing long bugles beside unmounted horses (fig. 32). We are not sure about the meaning of these scenes. But whether they commemorate Lou Rui's formal life or describe a tour he will take in the afterlife, their chief value lies not in their ritual symbolism but in their pictorial representation.

To be sure, chariots, horsemen, and ceremonial guards are frequently depicted in tomb murals from the Northern Dynasties, but nowhere do we find such lifelike images as in the Lou Rui tomb. Some animal forms, such as a team of loping camels, are depicted so accurately that they could be models for anatomical drawing. But even in these scenes, realism is not taken as the ultimate goal of painting but as a stylistic mode that could be employed in combination with other styles to produce complex visual effects. Shading is applied to certain images to contrast them with nearby linear forms, and three-dimensional shapes are mixed with concise line drawings to produce a visual rhythm. The painter's goal, if there was an overarching one, was apparently to create a kind of disciplined dynamism by manipulating all available formal means: shape, line, color, and movement. The people and horses never assume the same pose but always complement one another in balanced clusters. Related to such formal concerns is a strong sense of abstraction. As we can see in figure 31, for example, the slightly elongated oval faces become the unifying elements of a complex design. In figure 32 two groups of musicians stand face to face blowing bugles; their straight and tightly stretched bodies are the four trusses of the bridge formed by the long horns.

After the entryway comes a tunnel, then the burial chamber. Murals in these two rear sections exemplify other achievements of Northern Qi (550–577) painting.

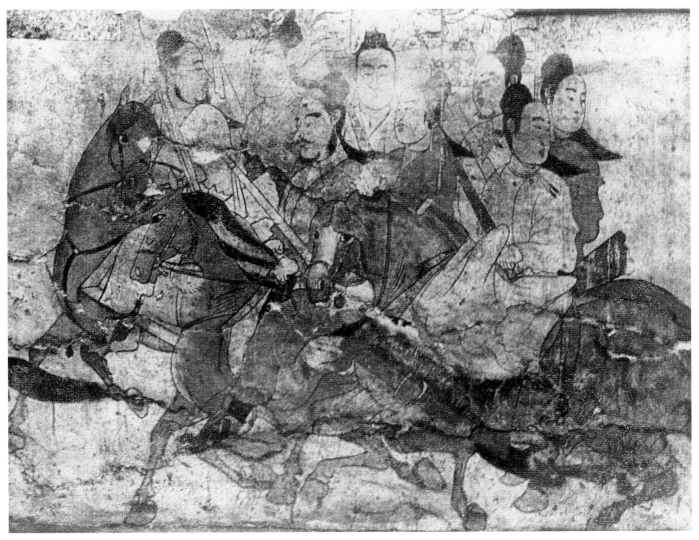

31. *Horsemen,* mural in Lou Rui's tomb in Taiyuan, Shanxi Province, 570. 160 × 202 cm.

32. *Soldiers Blowing Bugles,* wall mural in Lou Rui's tomb in Taiyuan, Shanxi Province, 570. 160 × 202 cm.

The images of individual officials along the tunnel are the best works of portraiture surviving from pre-Tang times (fig. 33). The ceiling of the burial chamber is painted with zoomorphic symbols of the twenty-eight constellations. Like the horses and camels painted in the entryway, these are powerful, realistic drawings of animals, but their *baimiao* (line drawing) style highlights the calligraphic quality of the brushwork (fig. 34). The tomb even suggests a dynamic relation between funerary art and Buddhist art. It is roughly contemporary with Dunhuang Cave 249. We also know that Lou Rui was a famous patron of Buddhist establishments.[42] It is thus not surprising to find Buddhist symbols — *moni* pearls and apsaras — in the tomb and identical images of the god of thunder on the ceilings of both the tomb and the cave.

The unusually high quality of the murals in Lou Rui's tomb has sparked a lively discussion about their possible authorship. Many Chinese scholars link them to Yang Zihua (active mid to late sixth century), a master painter in the Northern Qi court. They argue that Lou Rui was an extremely illustrious figure in that court (his aunt married the founder of the dynasty, and he and the next four emperors were in-laws; his many titles include Prince of Dongan, Grand General, Grand Tutor, and Grand Minister), so Yang may have been asked to decorate Lou Rui's tomb. Records mentioning Yang's realistic depictions of horses and figures offer further evidence for this contention, and, more important, so does a scroll (fig. 35) that is possibly a Song copy of one of Yang's original paintings.[43] The scroll, called *Scholars of the Northern Qi Collating Texts,* illustrates an event in 556: the compilation of standard versions of the Confucian Classics and dynastic chronicles ordered by Emperor Wenxuan. The figures in the scroll have elongated oval faces, which are

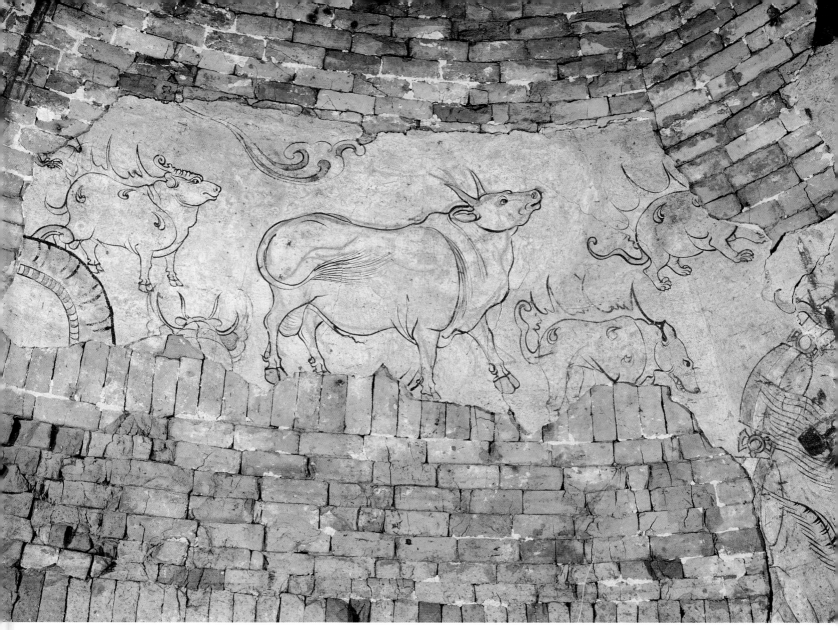

34. *Twenty-Eight Constellations,* detail of ceiling mural in Lou Rui's tomb in Taiyuan, Shanxi Province, 570. 160 × 202 cm.

rarely seen in other early paintings but resemble those in Lou Rui's tomb. Such speculations about the relation between the tomb murals and the scroll painting are significant, for they imply that famous court artists could have contributed to funerary art and that the scroll may be the only surviving copy of a Northern Qi masterpiece.

The South

When we shift our focus to south China, we find very different developments. Virtually no painted tombs were created here from the third to sixth centuries, and Buddhist murals mainly embellished wooden temples, not grottoes.[44] But the most important difference between the two regions was the development of scroll painting in the south, especially in the lower Yangzi River valley,

where various Southern Dynasties founded their capitals. This development, and hence the emergence of painting as an independent art tradition, was closely related to the rapid growth of a literati culture with a strong emphasis on individualism. This movement started from a nihilistic revolt in the third century, whose radical adherents, often designated the Seven Worthies of the Bamboo Grove, were educated men who rejected society and all its rules and conventions but found personal freedom in self-expression, wine, and unspoiled nature.[45] By the fourth century, however, this antisocial tendency had given way to a new intellectual atmosphere; the principal aim was not so much to rebel against conventions as to forge new conventions by finding legitimate places for individual voices within society. Members of the aristocracy happily espoused this aim, becoming patrons of literature and art, or writers and artists themselves. To this educated elite,

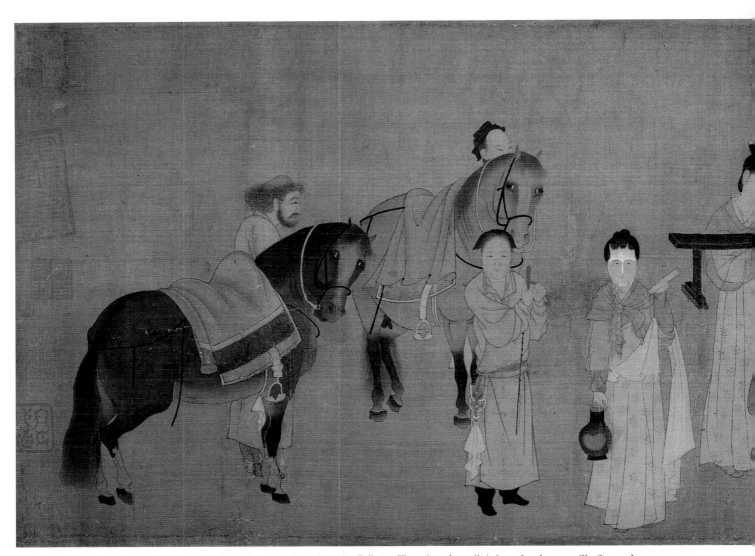

35. Attributed to Yang Zihua, section of *Scholars of the Northern Qi Collating Texts,* handscroll, ink and color on silk, Song-dynasty copy of a 6th-century work (?). Denman Waldo Ross Collection. (Courtesy of the Museum of Fine Arts, Boston.)

nature was no longer opposed to society; rather, it had become emblematic of a refined gentleman. "Pure talks" (*qingtan*) — conversations on philosophy, literature, art, character, and style — reached the point where attention was paid mainly to form, not meaning, indicating the rise of a new aesthetic that verged on the appreciation of art for art's sake.

The development of painting and painting criticism was closely related to the second phase of this intellectual movement. Nihilists of the third century did not consider painting an important vehicle for self-expression, and this disinterest can be explained by the general conservatism of visual art at the time. The recorded titles of paintings from the Three Kingdoms period (220–280) and the Western Jin (265–317) indicate a continuation of the Han tradition of illustrating didactic stories, canonized texts, and omens.[46] For the first time, however, individual artists became well known; men were distinguished for their artistic excellence, not necessarily for

scholarship or other achievements. Another new concept was the idea of an artistic lineage linking artists in teacher-student relationships. Wei Xie (mid-third to mid-fourth centuries), the Sage Painter of the Western Jin, for instance, studied under Cao Buxing (third century), the most famous artist of the previous Wu kingdom, and Wei in turn became "a peerless master of the brush."[47]

A major change in the art scene took place in the early fourth century with the sudden emergence of a large number of well-known artists. Most were men of letters, and some were members of aristocratic families. Among them, the calligrapher Wang Xizhi (307–ca. 365) and the painter Gu Kaizhi (ca. 345–ca. 406) were unsurpassed in their two branches of the visual arts. The earliest writings on painting also date back to the fourth century; these are three essays, attributed to Gu Kaizhi, on the composition of a projected work, evaluation of old and contemporary paintings, and techniques. It was not until the early fifth century that painting criticism began to focus on aes-

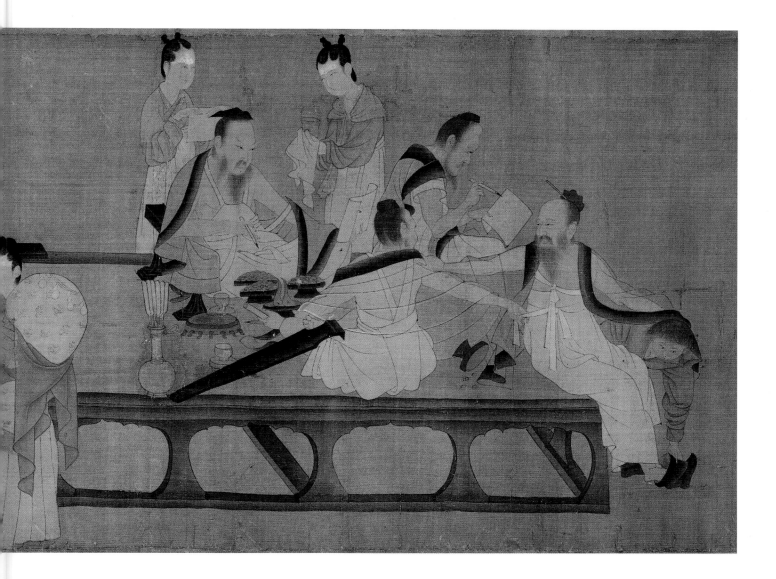

thetic appreciation. Zong Bing (375–443) interpreted a painting as an intermediary between the viewer and a profound philosophical or cosmological principle.[48] For Wang Wei (415–443), a scholar-artist with a keen interest in landscape, a true painting "must come about through divine inspiration." Half a century later, Xie He (active ca. 500?) developed Wang's notion into the first of his famous Six Principles (*liu fa*) of painting, which emphasizes the "spirit consonance" (*qi yun*) of painted forms; the other five principles concern brushwork, shape, color, composition, and copying as a means of training. Based on this theoretical formulation, Xie He was able to evaluate and rank twenty-seven painters of the third to fifth centuries in his *Classified Record of Ancient Painters* (*Gu hua pin lu*). A sequel to Xie's work by Yao Zui (ca. 557) introduces twenty painters who were active during the Southern Qi and the Liang, the second and third Southern Dynasties.[49]

In a different vein, the Tang art historian Zhang Yanyuan (ca. 815–after 875) has left us a detailed report on painting collection and connoisseurship during the Southern Dynasties.[50] He tells about the fanatic collecting of masterpieces by rulers as well as the fatal destruction of their collections when the throne changed hands. Emperor Gao (r. 479–482) of the Southern Qi, for example, gathered 348 scrolls by forty-two famous painters. He classified the works and "would enjoy them day or night, whenever he had leisure." His collection was greatly enriched by the emperors of the following Liang dynasty. The last Liang ruler, however, ordered that the entire collection be burned before he surrendered himself to the invading northern army. The scrolls were fortunately recovered from the embers, more than four thousand in all, and taken north. The rulers of the Chen, the last Southern dynasty, started all over again. More than eight hundred scrolls entered the royal collection during the three decades of their reign. Zhang Yanyuan, while documenting the unprecedented royal patronage of

36. Fragments of a painted lacquer vessel, from Zhu Ran's tomb in Ma'anshan, Anhui Province, 249. Anhui Provincial Museum.

painting and the fashion of collecting, thus partially explains why only a limited number of scrolls were handed down from that turbulent age. Almost all the paintings were lost during the following periods, however, and only some later copies have survived. To study the tradition of southern painting from the third to sixth centuries, we have to rely on excavated materials and later copies of earlier scrolls.

An assemblage of painted lacquerware recently discovered in Zhu Ran's tomb in Ma'anshan, Anhui Province, sheds much light on the state of southern pictorial art during the third century.[51] Zhu Ran was a famous figure in Wu history. Born into one of the most illustrious families in the region, he became a close personal friend of Sun Quan, the founder of the Wu kingdom. His military accomplishments brought him the post of Grand Marshall before his death in 249. Some lacquer objects from his tomb bear inscriptions of a workshop in Sichuan Province, which was then under the rule of the Shu kingdom. But they may have been specially made for customers in Wu, for pictures and decorations on them illustrate Wu stories and reflect the prevailing taste of the Wu elite. An important feature of the pictures is their varied subject matter, which, taken together, signifies an eclectic tendency. There are typical Han motifs of filial sons and loyal ministers, as well as an increasing number of apolitical scenes: children at play, ladies conversing, and gatherings. All these motifs are represented in a new fashion: the picture surface, whether rectangular or round, is divided into parallel registers, with special attention paid to the image in the background—a mountain

range or a screened wall—as a compositional enclosure. The most interesting pictures are found on fragments of a lacquer vase. The top of the vessel is painted with zither players. Some figures on the sides are holding or gazing at wine containers; others are dancing or sobering up (fig. 36). The wine-drinking theme is further indicated by cartouches containing descriptions like "a drunken woman" and "a gentleman wallowing in liquor." Such scenes seem indicative of the general fin-de-siècle mood when the Seven Worthies of the Bamboo Grove found freedom in music and unrestrained drinking.

Images of the Seven Worthies themselves, however, did not appear until more than a century later in an Eastern Jin tomb near Nanjing (fig. 37). Their elegant portraits, delineated in fluid lines stamped on bricks, are on the two side walls of the burial chamber. We must distinguish these relaxed and self-absorbed figures from the historical Seven Worthies, for, as Audrey Spiro has demonstrated, by the fifth century the antisocial Seven Worthies had become popular subjects of the literary imagination.[52] A single feature of the Nanjing tomb reveals that these men were no longer viewed as individuals but as cultural symbols: they are grouped with a much earlier figure named Rong Qiqi, who is said to have achieved the status of an immortal. This new significance of the Seven Worthies explains the continuing popularity of their images during the Southern Dynasties. Cruder versions of their portraits, now grouped with flying apsaras and mythical animals, appear in large graves in Danyang, Jiangsu Province, probably mausoleums of Qi emperors. Having replaced the filial sons and virtuous

wives whose images filled Han tombs, the Seven Worthies became new cultural heroes and exemplified ideal intellectuals in southern society.

Believing that these excellent linear images must have been based on a famous work of art, some scholars have tried to trace the portraits to a scroll painting by Gu Kaizhi or another fourth-century master. Evidence is lacking, however, and it is probably more rewarding to observe specific features of the portraits themselves. One neglected topic of discussion is the marked stylistic difference between the panels on the two walls. The four figures on the left panel form two groups, with the two men in each group seemingly engaged in conversation, but on the right panel isolated figures are absorbed in individual activities — playing a musical instrument, contemplating a wine cup, or meditating. The two compositions also reflect divergent spatial concepts. On the left panel, tree trunks overlap the figures' robes and the mats they are seated on, thus defining the foreground of the painting and indicating a space behind the trees. Vessels scattered between the figures further suggest a tilting ground. In contrast, the composition on the right is far more mechanical. There is very little sense of the third dimension, and the row of trees is used to demarcate spatial cells for the figures, much in the tradition of Han and even pre-Han pictorial art (see fig. 9). Such differences suggest that the panels were designed by two different artists. Although the horizontal format and line-drawing techniques may reflect some influence from contemporary handscroll painting, these panels cannot be equated to scroll paintings. Our chief source of information for scroll paintings in the south derives from a different source: copies of three well-known scrolls attributed to Gu Kaizhi, namely, *Wise and Benevolent Women* (*Lienü renzhi tu*), *Admonitions of the Court Instructress to Palace Ladies* (*Nüshi zhen tu*), and *The Nymph of the Luo River* (*Luoshen fu tu*).[53]

Every introduction to Chinese painting includes a section on Gu Kaizhi, but the answer to the question Who was Gu Kaizhi? still eludes us. Chinese civilization has produced many semidivine figures — dynastic founders, heroes and heroines, painters and musicians — who are half historical and half mythological. Many of the records about them are from later ages, and it is difficult to distinguish fact from fiction. Gu Kaizhi, whose name has become almost synonymous with the origin of Chinese scroll painting, represents one such case. The earliest records of his life, provided in Liu Yiqing's *New Account of Tales of the World* (*Shishuo xinyu*), which was compiled around 430, a quarter of a century after Gu died, were al-

ready colored by the legend that had grown up around his name.[54] These legends were absorbed and elaborated in Gu's first biography, in the *History of Jin* (*Jin shu*), written about four hundred years after the artist's death. His fame grew over the course of time; pre-Tang critics differed markedly in evaluating his paintings, but all Tang writers praised him in the highest terms. His mounting reputation must have contributed to the free association of his name with anonymous early paintings, including the three scrolls mentioned above, which are absent even from the Tang records of Gu's works. Given the lack of reliable contemporary information, then, our initial question — Who was Gu Kaizhi? — must be reformulated. We must ask instead: "What themes and styles are reflected in the works attributed to Gu?" This new question enables us to utilize these three works to explore the complexity of early scroll painting.

Of the three scrolls, *Wise and Benevolent Women* demonstrates the persistence of Han pictorial style in a new intellectual environment. The five-meter-long scroll consists of ten sections (fig. 38). Figures in each section form a tightly interrelated group with no connection to other groups. Short labels identify the figures; longer inscriptions, inserted between the sections, summarize stories and divide the long scroll into a series of frames. Neither the subject matter nor the compositional scheme is new.[55] The innovative elements of the painting include a new interest in individual figures, a more realistic style, and a different selection of motifs. The artist was no longer satisfied with the traditional schematic female images, which were largely symbols rather than representations. The figures in the scroll appear to be acting; their subtle expressions suggest inward contemplation. The costumes are carefully drawn; the folds, emphasized by dark and light inkwash, are convincingly three-dimensional. Although we cannot know the extent to which such stylistic attributes belonged to the original work or were supplemented by the Song-dynasty copier, we can recognize the period character of the painting by the selection of motifs. No single work could illustrate the more than one hundred stories in the Han compilation *Biographies of Exemplary Women* (*Lienü zhuan*), so each painter had to choose among them. Thus the Han-dynasty designer of the Wu Liang Shrine (151) portrayed only chaste and obedient women of the domestic type, and the Han-influenced painter of the Sima Jinlong screen (before 484; see fig. 42) focused on virtuous palace ladies.[56] The subject of the scroll indicates, in contrast, a growing interest in women's intellectual qualities, even in this highly conservative tradition.

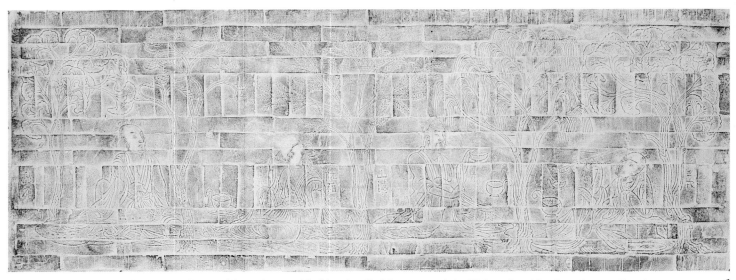

37. *The Seven Worthies of the Bamboo Grove and Rong Qiqi,* molded-brick relief from a tomb in Xishanqiao, Nanjing, Jiangsu Province, Eastern Jin dynasty: *a,* left panel; *b,* right panel. 80 cm high. Jiangsu Provincial Museum, Nanjing.

a

But stylistic and iconographical inventions in the *Wise and Benevolent Women* scroll are still largely subordinated to convention. Our second painting attributed to Gu Kaizhi, *Admonitions of the Court Instructress to Palace Ladies* (figs. 39–41), emerged from the same Confucian moralistic tradition, but the new elements now break through the restrictions of the old ideology and pictorial style. The painting illustrates Zhang Hua's (232–300) text of the same title. Unlike the narrative *Biographies of Exemplary Women,* Zhang's writing addresses abstract principles of female morality, which are difficult to translate into visual form. To resolve this problem, the artist often depicts certain images or events regardless of their rhetorical context. Some pictures even contradict the severe moral tone of the original writing, which is inscribed beside the pictures in the scroll. For example, a passage in the text begins with the sentence "Men and women know only how to adorn their faces; / None know how to adorn their character." Ignoring this criticism, which leads to stern advice ("Correct your character as with an ax, embellish it as with a chisel; strive to create holiness in your nature"), the artist focuses on the initial analogy. Portrayed here are an elegant palace lady who is looking in a mirror and another lady who is having her maid arrange her long hair (see fig. 39). The whole scene is so pleasant and relaxed that no one would ever think there could be harm in such natural behavior, despite the writer's warning.

This painting also exhibits far more stylistic innovation than the *Wise and Benevolent Women* scroll. Some of the nine scenes are based on popular motifs, but the artist was able to transform traditional formulas into something entirely new. In this way he distinguishes him-

self from a mere artisan, whose works, as exemplified by the Sima Jinlong screen, preserve the tradition to a greater extent. One scene on the screen illustrates the story of Ban Zhao, a famous intellectual lady of the court who once refused to sit in the same sedan chair with the emperor in order to preserve the sexual proprieties (fig. 42). The picture clearly follows the conventions of traditional symbolic art: a figure's size is determined by social status or role, and the whole scene appears static and schematic, like a pictorial index of the long inscription to its left. We are astonished by its transformation in the *Admonitions* scroll (see fig. 40). Although the basic composition is preserved, the scene is now full of energy. The sedan carriers, who were stiff and mannequin-like on the screen, are now animated. The concubine, whose giant size on the screen indicates her central role in the story, is reduced to normal proportions. Her elegant profile contrasts with and balances the violent gestures of the sedan carriers. The focus of representation has shifted from a literary, symbolic level to a pictorial, aesthetic level.

Admonitions of the Court Instructress to Palace Ladies, which is probably a Tang copy of an old work, also preserves some of the most beautiful figurative images created by an early scroll painter. One of the palace ladies is portrayed as moving slowly to the left (see fig. 41). With her eyes half closed, she seems to be walking in a dream; her flowing scarf and streamers suggest a soft spring wind. Her black hair makes a contrast with the red blocks on her skirt, but otherwise every form is a configuration of smooth lines that dissolve substance and transform objects into rhythmic structures. We could hardly find a better example of the realization of two of Xie He's artis-

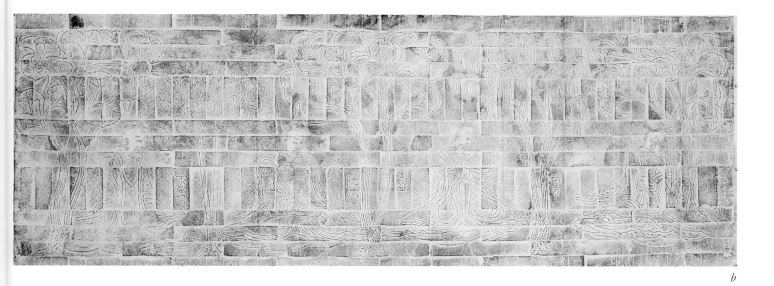

b

tic goals: animation through spirit consonance and structural method in the use of the brush. The significance of the painting lies not only in the depiction of individuals and scenes but also in the attempt to create a coherent composition in the handscroll format. Although individual scenes can largely stand by themselves, the artist ends the scroll with a portrait of the Court Instructress, who seems to be recording the previous events. This mode of representation is derived from a convention in ancient Chinese historical writings, which often conclude with the historian's autobiography.[57] But the image of the instructress in the scroll also plays another role: it transforms the idle act of closing the scroll into a viewing experience. The scroll was read from right to left. Now, to roll it back up, the viewer begins at the end, with the image of the Court Instructress. The scenes glimpsed in reverse appear to illustrate the admonitions she has written on the piece of paper in her hand.

This narrative device achieves a more sophisticated form in our third and last example, *The Nymph of the Luo River,* based on Cao Zhi's (192–232) poetic description of his romantic encounter with the nymph. The opening scene illustrates the poet, a prince of the Western Jin, standing on the bank of the river facing left (fig. 43a). Following his gaze, the viewer unrolls the painting and finds the nymph on the waves. Then come a series of episodes from the romance. Cao Zhi's image also concludes the painting: seated in a departing chariot, he looks back — a gesture that invites us to recall his vanished dream. Here I am referring to the version in the Liaoning Provincial Museum. Many other copies of the painting exist, but only the Liaoning version intermingles images with the poem. Most scholars therefore believe

that it preserves more attributes of the original painting. Other versions either omit the interpolated text or have selected sentences inscribed in frames, thereby achieving a greater continuity of landscape and human action (fig. 43b). But we can probably attribute this more pleasant visual effect to the development of landscape art during the Song and Ming dynasties, when these copies were made.

The Nymph of the Luo River signifies two important advances in Chinese painting. The first is the invention of a continuous pictorial narrative in which the same characters reappear several times. The second is the development of landscape art — hills, trees, and streams are treated not as isolated entities (as in the *Admonitions* scroll) but as components of a coherent physical environment. Indeed, the Liaoning version of the painting suggests that landscape elements often served a double role as representation and visual metaphor. When the poet sees the nymph, for example, he describes her through a series of analogies:

> She moves with the lightness of wild geese in flight,
> With the sinuous grace of soaring dragons at play.
> Her radiance outshines the autumn chrysanthemums;
> Her luxuriance is richer than the spring pines.
> She floats as do wafting clouds to conceal the moon;
> She flutters as do gusting winds to eddy snow.
> From afar she gleams like the sun rising from dawn
> mists;
> At closer range she is luminous like a lotus rising
> from clear waves.[58]

The verbal metaphors — geese, dragons, chrysanthemums, pines, clouds, winds, sun, and lotus — are trans-

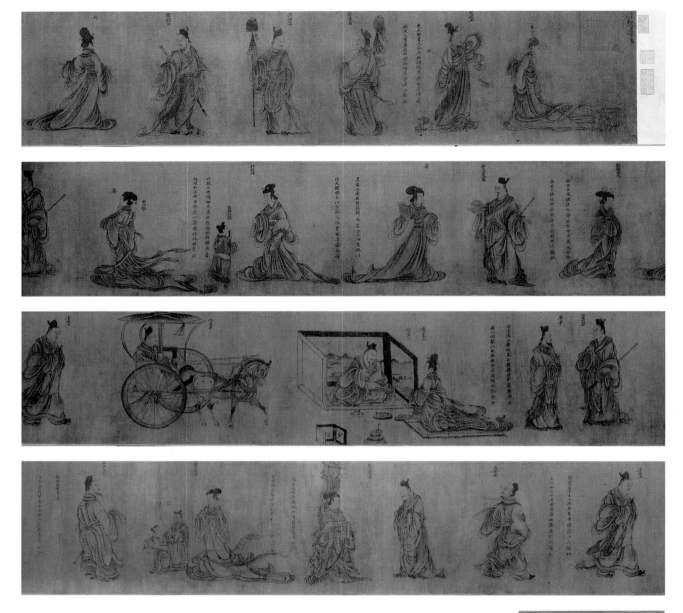

38. Attributed to Gu Kaizhi, *Wise and Benevolent Women,*
handscroll, ink and slight color on silk, Song-dynasty copy
of a 4th-century painting (?). 25.8 × 470.3 cm. Palace
Museum, Beijing.

39. Attributed to Gu Kaizhi, *Adorning Oneself,* detail from
Admonitions of the Court Instructress to Palace Ladies, handscroll, ink
and color on silk, Tang-dynasty copy of a 4th- or 5th-century
painting (?). 24.8 × 348.2 cm. (© British Museum, London.)
opposite, above

40. Attributed to Gu Kaizhi, *The Story of Ban Zhao,* section of
Admonitions of the Court Instructress to Palace Ladies, handscroll, ink
and color on silk, Tang-dynasty copy of a 4th- or 5th-century
painting (?). (© British Museum, London.) *opposite, below*

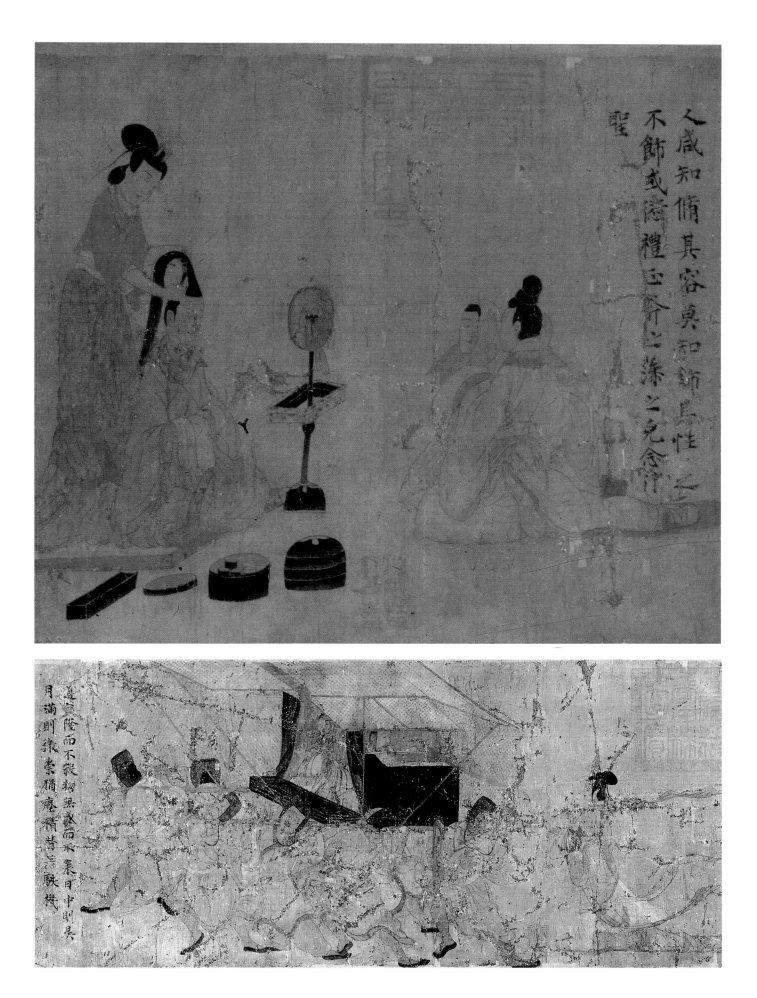

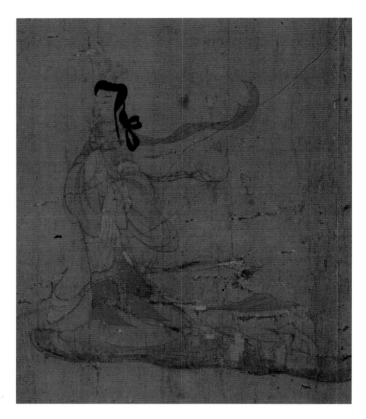

41. Attributed to Gu Kaizhi, *Palace Lady,* detail from *Admonitions of the Court Instructress to Palace Ladies,* handscroll, ink and color on silk, Tang-dynasty copy of a 4th- or 5th-century painting (?). (© British Museum, London.)

lated into pictures and woven into the landscape. Identified by textual excerpts, they are readily understandable as references to the nymph's physical appearance.

Here we find perhaps the most crucial significance of this painting: it creates an artistic tradition rather than revising an old one. Its theme is no longer woman's virtue but her beauty as the subject of poetic inspiration, romantic longing, and pictorial representation. In retrospect, we realize that no matter how innovative the *Wise and Benevolent Women* and *Admonitions* scrolls were, their creators remained faithful to their Han heritage. Only the painter who first composed *The Nymph of the Luo River* invented a female iconography. The path thus opened would be followed by artists in the Tang dynasty.

The *Nymph* scroll also leads us to speculate on the artistic interaction between north and south. The image of Cao Zhi in the initial scene of the painting introduces a new iconography for portraying a royal figure.[59] Two attendants are holding the arms of the royal prince. Others follow him, their gestures repeating one another and their draperies depicted in parallel, rhythmic lines. Similar representations exist in the relief carvings in Northern Wei Buddhist caves in Longmen and Gongxian. A large panel in the central Binyang cave in Longmen shows a Northern Wei emperor coming to worship the Buddha (fig. 44). No trace of Indian or central Asian influence is discernible; the iconography, as well as the sweeping lin-

ear patterns of clothes and the rhythmic movement of the figures, immediately recalls the scene in the *Nymph* scroll. The Binyang cave-temple was constructed between 500 and 523 by Emperor Xuanwu in memory of his father, Emperor Xiaowen. The relief thus likely commemorates Xiaowen's promotion of Buddhist worship in the north. It is perhaps no coincidence that Emperor Xiaowen, who is portrayed here in typical southern fashion, was a key figure in the integration of northern and southern cultures. He was responsible for moving the Northern Wei capital to Luoyang, the ancient metropolis in central China, in 494. He fought tirelessly to promote his regime as a civilized "Chinese" government, not a "barbarian" military power, and mobilized an official campaign to adopt southern costumes, language, surnames, and rituals, as well as bureaucratic, legal, and educational systems.[60] Partly because of this reform and partly because of the old Chinese tradition in the Luoyang area, Northern Wei Buddhist art underwent a dramatic change after 494.

This change is also reflected in funerary art. After the relocation of the dynastic capital, Northern Wei rulers and officials were customarily buried in the vicinity of Luoyang. Their tombs were no longer decorated with colorful murals; instead, a traditional Chinese method was used to engrave pictures on stone mortuary paraphernalia, including sarcophagi, shrines, and "spirit couches"

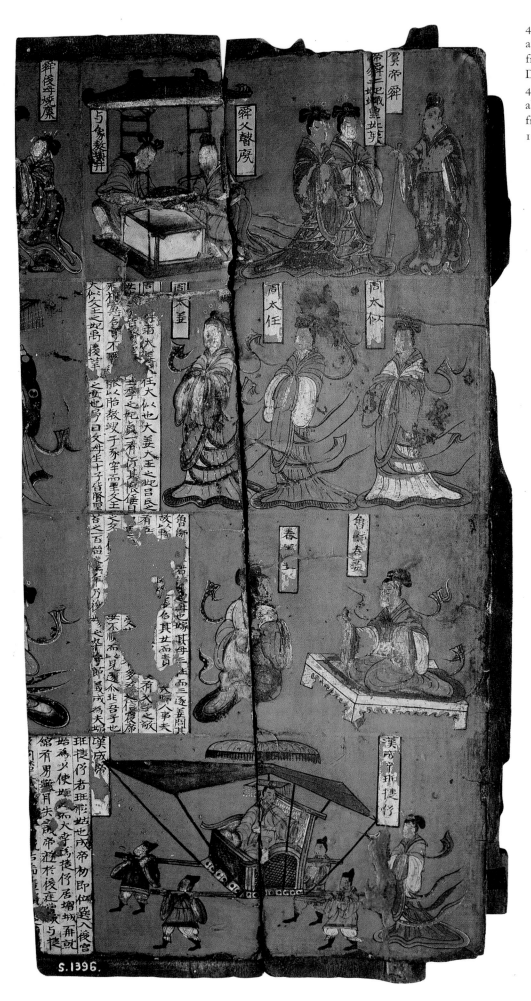

42. *The Story of Ban Zhao,* scene at the bottom of a lacquer screen from Sima Jinlong's tomb in Datong, Shanxi Province, before 484. Each panel of the screen is about 80 × 20 cm. (Reprinted from *ZMQ,* Painting, vol. 1, no. 100.)

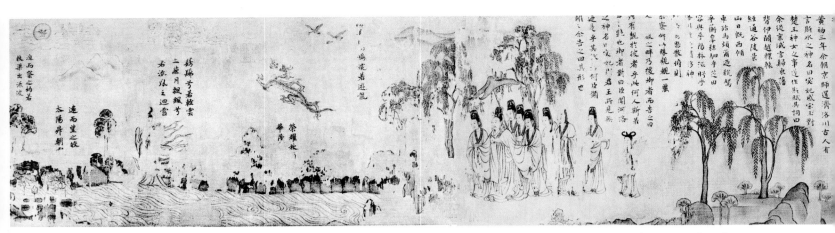

a

43. Attributed to Gu Kaizhi, section of *The Nymph of the Luo River,* handscroll, ink and color on silk, Song-dynasty copies of a 6th-century work (?): *a,* Liaoning Provincial Museum version, 26 × 646 cm; *b,* Palace Museum version, 27.1 × 572.8 cm.

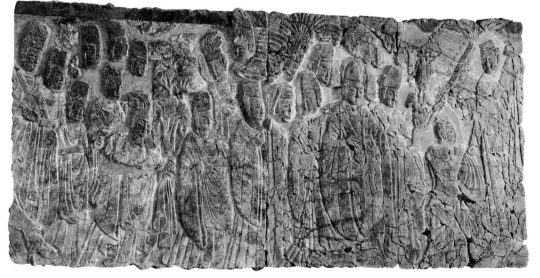

44. *Northern Wei Emperor Worshiping the Buddha,* relief from the central Binyang cave in Longmen, Henan Province, early 6th century. Metropolitan Museum of Art, New York. (Fletcher Fund, 1935. [35.146].)

45. Stone sarcophagus, from Luoyang, Henan Province, early 6th century. Each side panel is 62.5 × 223.5 cm. Nelson-Atkins Museum of Art, Kansas City, Missouri. (Purchase: Nelson Trust.)

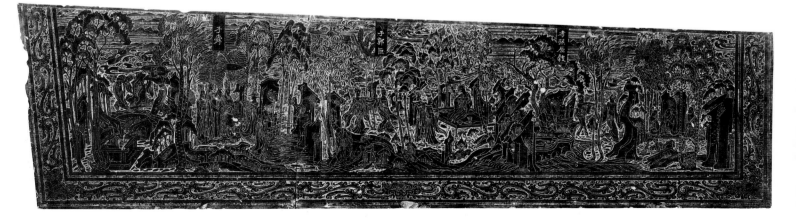

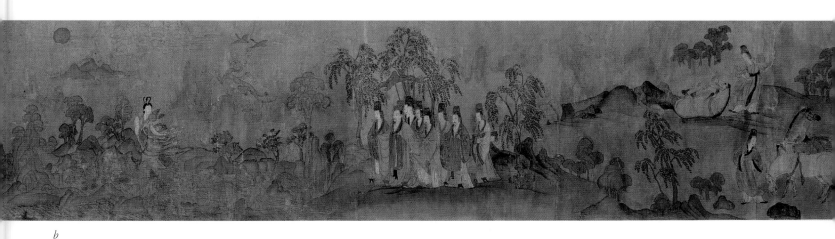

b

(*ling chuang*). The engravings attest to a desire to absorb Chinese elements from different ideological traditions and historical periods. On the one hand, their content is overtly conservative. There is an emphasis on famous filial sons and an exaggerated effort to embrace orthodox Confucian morality, an effort marked by the general neglect of female images (virtuous mothers and wives). On the other hand, their compositional and figurative styles are extremely modern, even according to the standards of southern literati culture. Two objects — a sarcophagus in the Nelson-Atkins Museum in Kansas City and a small shrine in the Museum of Fine Arts in Boston — exemplify this fascinating combination. Stories of filial sons are depicted on the two long sides of the sarcophagus. But these traditional icons have become integral components of a three-dimensional landscape (fig. 45). At the bottom of each composition, a hillock establishes a fore-ground. Tall trees further divide the composition into a number of frames for individual stories, a composition style apparently inspired by southern pictorial works, such as the portraits of *The Seven Worthies of the Bamboo Grove and Rong Qiqi* and *The Nymph of the Luo River.* We are astonished by the naturalism of the scenes. Well-proportioned and animated figures are now supported by a solid ground that recedes into the distance. Various landscape elements — trees, rocks, and streams — construct a convincing environment. A mountain range and floating clouds appear in the background; their greatly reduced size indicates their remoteness. Framed by a patterned band, each pictorial composition seems a translucent window onto an elusive world.

The strong sense of three-dimensionality in these pictures has enticed scholars to interpret them in light of standard criteria in a linear perspective system, such as

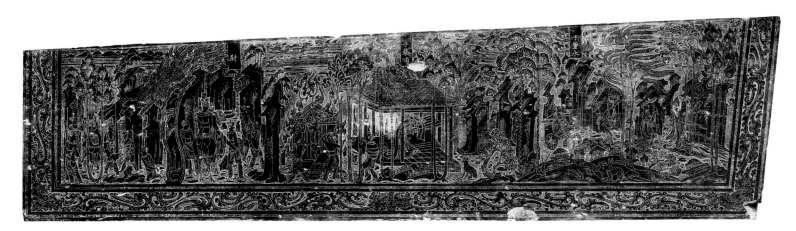

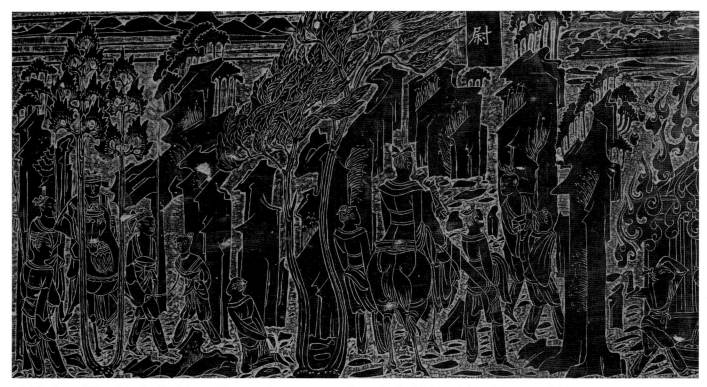

46. *The Story of Wang Lin,* detail of the carvings on the stone sarcophagus in the Nelson-Atkins Museum of Art. (Purchase: Nelson Trust.)

the use of overlapping forms and foreshortening. But the pictures also signify another mode of representing space: through front-and-back and mirror images. A detail on the stone sarcophagus (fig. 46) shows the story of the Confucian paragon Wang Lin, who saved his brother from bandits. A tall tree divides the scene into two halves. In the left scene Wang Lin has thrown himself on his knees and is begging the bandits to take him instead of his brother. In the right scene Wang Lin and his brother have been released. What is most important here is not the subject matter (similar stories were abundantly illustrated during the Han) but the way the story is depicted and viewed. In the left scene the bandits have just emerged from a deep valley and are meeting Wang Lin. In a more general sense, they are meeting us, the spectators. In the right scene Wang Lin and his brother are leading the bandits into another valley, and the whole procession has turned away from us. In viewing the left, frontal scene, we take in the arriving figures, but when turning to the next scene, we cannot help but feel abruptly abandoned. The figures are leaving us and are about to vanish, so to catch them our gaze follows them into the deep valley.

The same representational mode occurs in the *Admonitions* scroll, a work supposedly from the south. The scene depicted in figure 39 is divided into two halves, each with an elegant lady looking at herself in a mirror. One lady

has her back toward us; her face is reflected in the mirror. The other lady faces us; her reflection in the mirror is implicit. The concept of a mirror image is thus presented literally. Each lady is presented as a pair of mirror images, and the two images together form a reflecting double.

Dating from 529, the shrine now in Boston was dedicated to Ning Mao, an official who was partially in charge of building new palaces and temples after Emperor Xiaowen moved the capital to Luoyang. His profession as an imperial architect must explain the unusually high quality of the engravings on his memorial hall. Filial stories, again the principal subjects of the decoration, are illustrated in vertical panels. Each panel is a coherent and complex pictorial space containing smaller spaces defined by curtains, walls, corridors, and landscape elements (fig. 47). On the back wall of the shrine three men attired in similar costumes are each accompanied by a woman (fig. 48). They differ from one another mainly in age. The figure to the right is a younger man with a fleshy face and a strong torso; the one to the left is heavily bearded and has an angular face and a slender body. Both, shown in three-quarter view facing outward, appear vigorous and high-spirited, but the figure in the middle is a fragile, withdrawn older man. Slightly humpbacked, he stands with lowered head, concentrating on a lotus flower in his hand (the lotus is a Buddhist symbol of

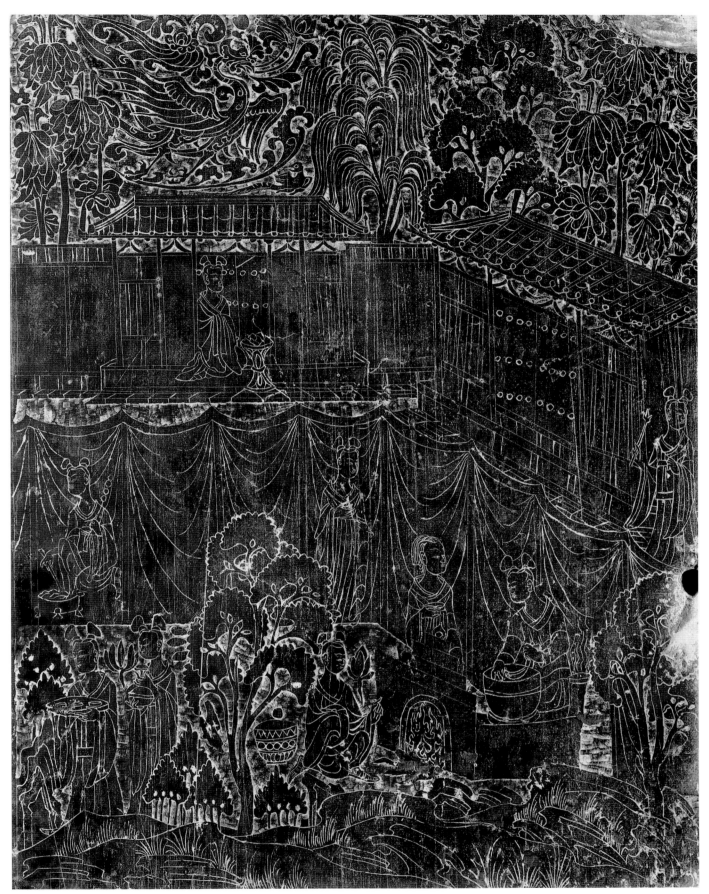

47. *Figures in Landscape,* ink rubbing of an engraving on Ning Mao's shrine, from Luoyang, Henan Province, 529. 70 × 55 cm. (Anna Mitchell Richards and Martha Silsbee Funds. Courtesy of the Museum of Fine Arts, Boston.)

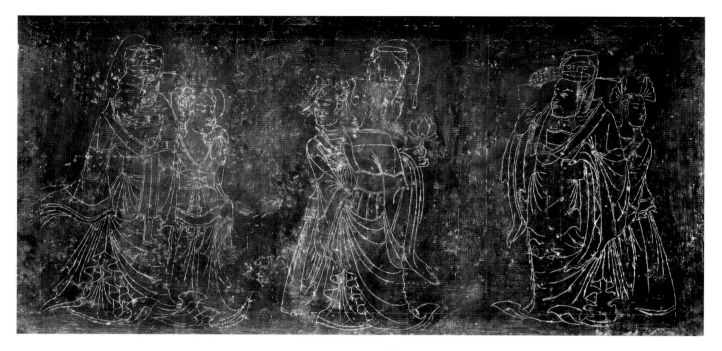

48. *Three Portraits of Ning Mao* (?), ink rubbing of an engraving on Ning Mao's shrine, from Luoyang, Henan Province, 529. 79 × 182 cm. (Anna Mitchell Richards and Martha Silsbee Funds. Courtesy of the Museum of Fine Arts, Boston.)

49. *Gentlemen in Landscape,* mural in Cui Fen's tomb in Linxu, Shandong Province, 551.

purity and wisdom that Chinese intellectuals adopted); he seems to turn inward, as though he is leaving this world and is about to enter the eternal darkness. Perhaps the series of images constitutes a pictorial biography of Ning Mao from vigorous youth to final spiritual enlightenment.[61]

A tomb recently excavated in Linxu, Shandong Province, summarizes the fusion of southern and northern art in the sixth century. It dates back to 550, the first year of Northern Qi rule, but the deceased, Cui Fen, spent most of his official life in the Eastern Wei court, which split off from the Northern Wei in 534. Although a thorough excavation report has not yet come out, photographs of three murals have been published, and in them we can see echoes of both northern and southern pictorial formulas. The composition above the entrance closely resembles the Northern Wei royal procession in the Longmen relief shown in figure 44 and Cao Zhi's portrait at the opening of the *Nymph* scroll. A series of gentlemen in front of strange rocks and under trees (fig. 49) combine elements from the portraits in *The Seven Worthies of the Bamboo Grove and Rong Qiqi* and landscape elements from the scenes on the stone sarcophagus. Finally, the pictorial symbol of the north — a snake twining around a turtle — is almost identical with images found in a number of Koguryo tombs in Anak. In an eclectic manner, these motifs and styles are synthesized into a single setting.

The Sui and Tang Dynasties

There has seldom been a time in Chinese history as creative, vigorous, and productive as the Sui-Tang period. After centuries of strife the country was at last reunified, and unification brought almost instant prosperity. During the rule of Emperor Wendi (r. 581–604), the founder of the Sui dynasty and a man endowed with exceptional administrative ability, the Chinese population doubled. The Sui did not last long, however. Its second and last emperor, Yangdi (r. 604–618), built extravagant monumental works, including the eastern capital, Luoyang, and the Grand Canal, opened to link north and south. Although these projects had lasting historical influence, Yangdi's unrestrained squandering of the empire's resources must have shortened the life of his regime.

The early Tang emperors continued Wendi's consolidation of the country. Under their rule China finally grew into the largest and most powerful country in the medieval world. The person who contributed most to its supremacy was Li Shimin, or Emperor Taizong, whose ascension to the throne in 626 inaugurated more than a century of steady development in all social and cultural spheres. Territorial expansion brought central Asia into the empire and protected caravan routes to the west. The capital, Chang'an (present-day Xi'an), became a cosmopolitan center with a population of more than a million. People of almost every ethnicity, color, and belief found their way to this city, sharing in and contributing to the expanding economy, the enthusiastic acceptance of various religious and cultural traditions, and the highly developed literature and art. The reign of Emperor Minghuang (712–756) is generally considered the most brilliant era in all Chinese history. Rarely have so many great writers and artists lived at a single moment: the poets Wang Wei (699–759), Li Bai (Li Bo, 701–762), and Du Fu (712–770); the painters Wu Daozi (active ca. 710–760), Zhang Xuan (active 714–742), and Han Gan (ca. 720–ca. 780); and the calligraphers Yan Zhenqing (709–785), Zhang Xu (active 714–742), and Huaisu (725–785), among many others.

This golden age was brought to a sudden end when the powerful general An Lushan rebelled in 755. Emperor Minghuang abandoned Chang'an, fled to Sichuan, and abdicated. The rebellion was finally crushed, but it had profoundly eroded the stability of the dynasty. Art during the second half of the Tang, though continuing to develop, never again approached its former greatness. Instead, historians looked back at the achievements of previous generations. Two major historical works on

Chinese painting — Zhang Yanyuan's (847–874) *Record of Famous Paintings of Successive Dynasties* (*Lidai minghua ji*) and Zhu Jingxuan's (ninth century) *Celebrated Painters of the Tang Dynasty* (*Tangchao minghua lu*) — were both written in the mid-ninth century.

Within this historical framework, the development of painting can be roughly divided into three periods — the Sui and early Tang (581–712), the High Tang (712–765), and the middle and late Tang (766–907) — each with distinctive emphasis and characteristics. During the Sui and early Tang the central government promoted a highly politicized art in both religious and secular painting genres. Upon seizing imperial power, the Sui and Tang founders both immediately became powerful art patrons. Two pavilions, called Precious Brush Tracks (Baoji) and Wonderful Calligraphy (Miaokai), were constructed at the Sui palace to house masterpieces.[62] The court attracted famous artists from all over the country and even from foreign lands. Painters in the capital included Zhan Ziqian from Hebei Province, Dong Boren from the south, Weichi Bazhina from Khotan (Hotan in present-day Xinjiang Uygur), and Sakyamuni from India. Other well-known contemporary painters included Zheng Fashi, Zheng Falun, Sun Shangzi, Yang Zihua, Yang Qidan, Yan Bi, and Tian Sengliang, some of whom enjoyed the post of Grand Official (Dafu). Records of their works reflect both artistic competition and assimilation. It is said that Zhan Ziqian and Dong Boren, who came from divergent art traditions, started as rivals but ended as collaborators; their later paintings thus evince mutual north-south influence.[63] Cultural and regional differences, which had often caused dissension during the previous historical period, now contributed to the formation of a centralized metropolitan art tradition in the unified empire.

Although a few extant scrolls attributed to the Sui and early Tang have dominated the attention of modern art historians, artists of this period were primarily mural painters engaged in designing and decorating political and religious monuments. It is possible that the art tradition of the Northern Dynasties, which had revolved around such public works, continued into the Sui and Tang, whose rulers were themselves northerners and even non-Chinese in origin. According to historical records, all famous Sui painters, whether Chinese or foreign, devoted much time and energy to creating large-scale temple murals, mostly in Chang'an and Luoyang.[64] Their scroll paintings, recorded as illustrations of Buddhist figures and tales, political events, historical exemplars, and heavenly omens, had strong religious and political

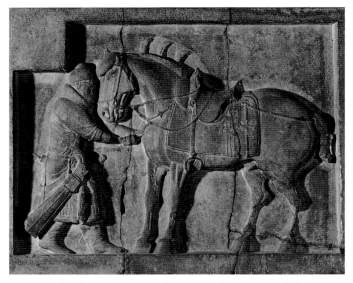

50. *A Battle Charger,* stone carving originally in front of Emperor Taizong's tomb in Liquan, Shaanxi Province, possibly designed by Yan Lide and Yan Liben, 7th century. 176 × 207 cm. University of Pennsylvania Art Museum, Philadelphia. (Neg. #58-62840.)

implications. The more poetic and individual southern art was not suppressed, but it was overshadowed by visual art utilized to legitimate the newly established regime.

The most celebrated painter of this period was Yan Liben (ca. 600–673). Not coincidentally, his background, career, and works exemplify some main features of early Tang court painting in terms of the role and status of artists, their relationship to the emperor, and the function of their art. Yan Liben was born into an aristocratic family. His father, Yan Bi, served Northern Zhou and Sui rulers with his expertise in architecture, engineering, and the visual arts. It is said that Emperor Wu of the Northern Zhou, an admirer of Yan Bi's paintings, married him to a princess and that when the Sui dynasty succeeded the Northern Zhou, Yan Bi made "intricate and elaborate objects" to please the notorious Yangdi. Yan Bi also designed weapons, organized imperial processions, and supervised the construction of a section of the Great Wall; such duties apparently exceeded those of a court painter as narrowly defined in later times.[65] His two sons, Lide (d. 656) and Liben, both served in Taizong's court. As the designers of Tang imperial mausoleums, they were probably responsible for the six famous stone horses in front of Taizong's tomb, which have survived as the best examples of early Tang relief carving (fig. 50). Lide was less a painter than an engineer and architect. Although he made some court portraits, it was other kinds of service — designing ceremonial costumes, constructing palace buildings, and building bridges and ships for military purposes — that won him the title of grand duke.[66] Liben's fame, on the other hand, rested mainly on his art, and he

achieved even greater official glory when he became one of the two prime ministers — the other was a military officer. A popular saying satirized this seemingly strange combination: "The Minister on the Left proclaims authority in the desert; the Minister on the Right attains fame through cinnabar and blue." We wonder why Taizong, an emperor famous for his ability to select personnel, chose these two men as his chief officials. The reason may be found in early Tang politics: representing *wu* (military forces) and *wen* (literature and arts), respectively, they helped the Tang founder create History. In Yan Liben's case, his works recorded important court events, commemorated key political figures, and illustrated the way of rulership through historical exemplars. Although his medium was painting, not writing, he was essentially a court historian.

A short handscroll called *The Imperial Sedan Chair* (*Bunian tu*) in the Palace Museum in Beijing (fig. 51) exemplifies a persistent theme of Yan Liben's representations of important political events, especially diplomatic activities. Possibly a Song copy of Yan's original work, it depicts Taizong in a sedan chair greeting the Tibetan minister Ludongzan. The latter, accompanied by two officials, stands in front of the emperor in an obedient but dignified manner. A colophon records that the event took place in 641, when Ludongzan came to Chang'an to welcome Princess Wencheng, the bride-to-be of the Tibetan king. The language of the painting is very concise. No physical environment is depicted; the focus of representation is the relationship between the two principal figures as representatives of China and Tibet. Taizong and Ludongzan dominate the two halves of the picture, and their different sizes, manner, facial expressions, and physical appearance reinforce the dualism of the composition. These differences, while highlighting the theme of the painting — the historical meeting between two nations — emphasize Taizong's political superiority.

Yan Liben's most famous works, however, are two lost group portraits made at different stages in early Tang history. Right before ascending the throne in 626, the future Emperor Taizong commissioned him to portray eighteen eminent scholars. The work, a mural, was widely publicized, and the inscription accompanying the portraits, written by one of the scholars, noted the crown prince's intention of attracting public support through this art project. Twenty-two years later, Yan Liben received an imperial commission to paint a second series of portraits known as *The Twenty-Four Meritorious Officials in the Lingyan Palace* (*Lingyan Ge ershisi gongchen*). Taizong himself wrote the encomium, asserting the significance of this mural

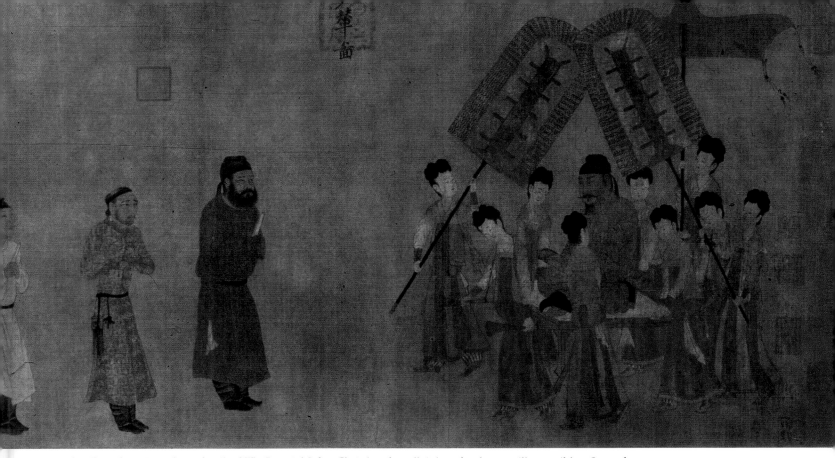

51. Attributed to Yan Liben, detail of *The Imperial Sedan Chair,* handscroll, ink and color on silk, possibly a Song-dynasty copy. 38.5 × 129.6 cm. Palace Museum, Beijing.

in commemorating the founding of the Tang Empire.[67] Like the portraits of the eighteen scholars, these portraits of officials have long since vanished. But a rubbing of an engraving made in 1090 from a version of the painting on a stone stele may preserve some stylistic features of the original work. It shows in smooth outlines four of the officials, each respectfully holding a ceremonial tablet (*hu*) as if attending a court audience (fig. 52).[68] Their nearly uniform poses notwithstanding, they have subtle differences in proportion and facial features. It seems that the artist faced the double task of portraying these men both as individuals and as paragons of loyalty.

These portraits also provide a bridge between two existing handscrolls attributed to Yan Liben. The figural representations are close to those in *The Imperial Sedan Chair* (especially the three standing figures); in composition the work resembles *Emperors of the Successive Dynasties* (*Lidai diwang tu*), a painting of thirteen Chinese rulers from the Han to the Sui dynasties (fig. 53). The physical condition of *Emperors of the Successive Dynasties* must have been considerably altered over the centuries, and scholars have questioned its assigned authorship.[69] But whether or not it was created by Yan Liben himself, this scroll has some characteristics of other early Tang portraits made for political purposes. An important characteristic is the strong conservatism in both subject matter and style. Not

only had emperors been portrayed in similar compositions in Han and post-Han times, but this work continued the old tradition of didactic art, with historical figures serving as moral and political exemplars.[70] The Last Ruler of the Chen (r. 583–589) and Emperor Wu of the Northern Zhou (r. 561–578), for example, face each other in the painting as if engaged in a posthumous conversation. Ruling the south and the north around the same time, these two men represented two kinds of failure that a ruler might meet with. The Chen emperor, refined but weak, wallowed in sensual pleasures and witnessed the fall of his dynasty; the Zhou emperor, cruel and violent, persecuted Buddhists and lost his mandate. Thus the two portraits clearly served to convey political messages. The painting as a whole, a series of such images, is a history of the rise and fall of previous dynasties, providing the Tang emperor with a mirror to reflect upon his own moral and political conduct.

A standard image in this painting—a ruler standing in a three-quarter view and flanked by his entourage—reappears in a contemporary illustration of the *Vimalakirti Sutra* in Dunhuang Cave 220 created in 642 (fig. 54). (Interestingly, two of Yan Liben's illustrations of the same sutra were still extant during the Song.)[71] But instead of representing past rulers, as in *Emperors of the Successive Dynasties,* here the artist depicts the present

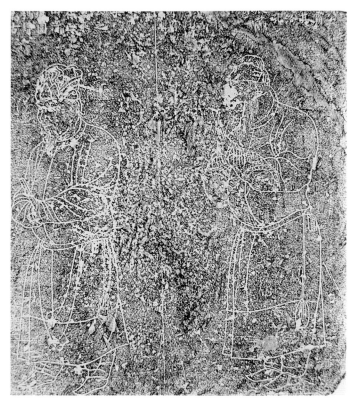

52. Yan Liben, section of *The Twenty-Four Meritorious Officials in the Lingyan Palace,* 648. This is an ink rubbing of a line engraving on a stone stele copied from an existing version of the painting in 1090. Central Academy of Fine Arts, Beijing.

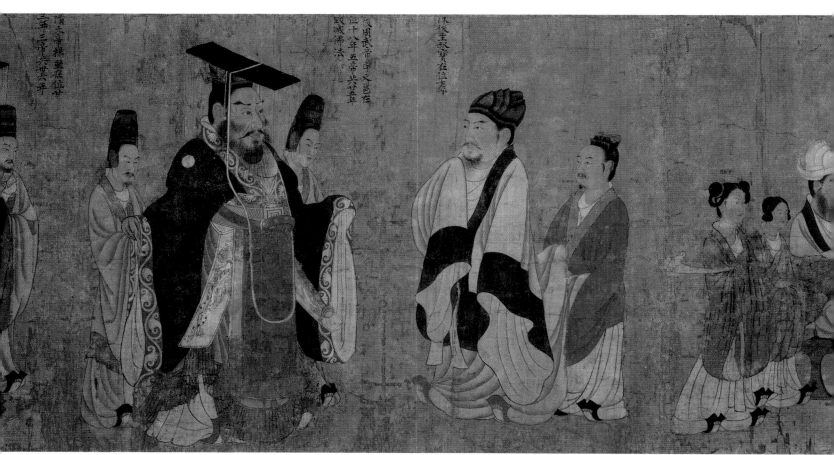

53. Attributed to Yan Liben, section of *Emperors of the Successive Dynasties* showing the last ruler of Chen and Emperor Wu of the Zhou, handscroll, ink and color on silk. 51.3 × 531 cm. Museum of Fine Arts, Boston.

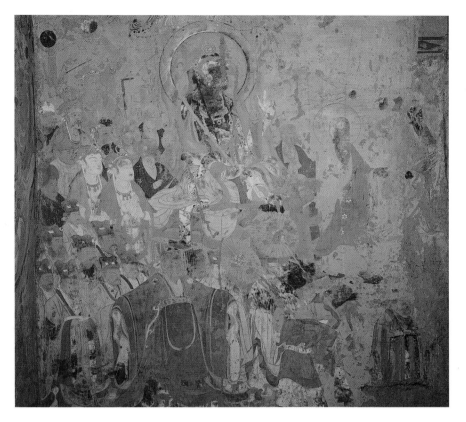

54. *Emperors and Attendants,* detail of an illustration of the *Vimalakirti Sutra,* mural in Cave 220, Dunhuang, Gansu Province, 642.

emperor of unified China facing a group of foreign kings. This example suggests that the rather rigid separation between religious and secular painting in the modern scholarship on Tang art should be questioned. Indeed, the zealous construction of Buddhist temples during the early Tang, as well as the new subjects and styles of their murals, must be understood in the context of contemporary politics. Many scholars have noted the elaborated architectural settings in early Tang "paradise paintings," for instance, but few have related them to the extensive construction of imperial palaces at the time. In fact, there are many structural similarities between the Daming Palace built by Taizong in 634 and the elaborate halls in a paradise scene. It is likely that when the Buddha was situated in a palace environment, religious and political authority became fused in a single composition. Evidence for the political symbolism of Buddhist works is also found in a series of imperial monuments in Luoyang commissioned by Wu Zetian, an empress of the Tang but the first and only emperor of the Great Zhou dynasty between 684 and 705. One of them, the Hall of Heaven (Tian tang), the center of her palace, housed a colossal statue of Buddha reportedly three hundred meters in height.[72]

Among the astonishing number of painted caves in Dunhuang dating from the Sui and early Tang periods —

228 in all — many were created during Wu Zetian's reign and relate directly to her struggle for imperial power. The construction of a huge Great Cloud Temple (Dayun si) in 695, for example, was part of her political campaign; it was one of hundreds of such temples that Wu Zetian ordered built throughout the country to disseminate the *Great Cloud Sutra (Dayun jing),* a scripture whose commentary identifies the empress as the incarnation of the Maitreya bodhisattva. Even more straightforward is a Dunhuang illustration of the *Sutra of Precious Rain (Baoyu jing)* in Cave 321 (fig. 55) in which Wu Zetian is alluded to as the Eastern Empress of Sunlight and Moonlight (Dongfang riyueguang nüwang) and her personal name, Zhao (literally, "the sun and moon in the sky"), is translated into a pictorial image framing the upper border of the huge mural.[73]

Besides having political significance, the Dunhuang mural of the *Sutra of Precious Rain* signifies an impressive advance in landscape representation during the seventh century. In the painting the Buddhist assemblage appears at the center of a panorama depicted from a bird's-eye view. Layers of humped green hills intersect, forming numerous spatial cells in which various lively activities take place. Unlike *The Nymph of the Luo River* and engravings on the Northern Wei sarcophagus, where trees break the picture strips into simple discrete spaces, this mural is a

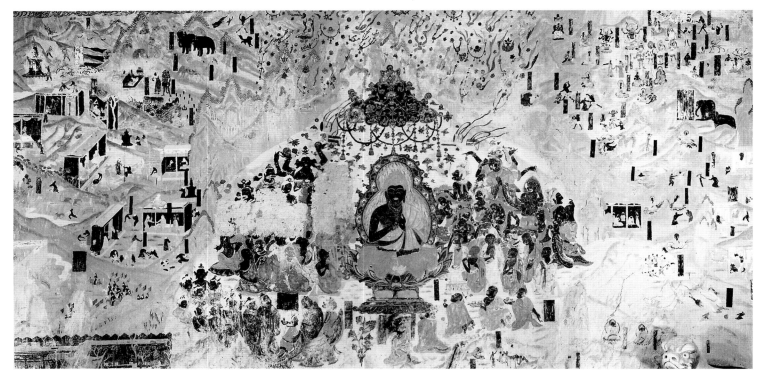

55. Illustration of the *Sutra of Precious Rain,* mural in Cave 321, Dunhuang, Gansu Province, early Tang dynasty.

large rectangular composition in which landscape helps unify and structure the space. The same development is even better reflected in another early Tang mural, in Cave 323, which illustrates the legendary history of Chinese Buddhism on an epic scale (fig. 56). The absence of a focal icon allowed the painter to represent space freely as a continuous and harmonious unity. The section reproduced here depicts the miraculous arrival of two Buddhist statues in China in 313. Round hills and vertical mountain peaks, unified in a green haze, contrast dramatically with dark zigzagging riverbanks and remote mountain ranges. This vast and open landscape stretches far back into the distance; the diminishing size of figures and various landscape elements effectively establishes the sense of depth. This colored mural is a "blue-and-green landscape" (*qinglü shanshui*) depicted with the boneless method. A somewhat different style of blue-and-green landscape, one that combines color application with ink outlines, is exemplified by *Spring Outing* (*Youchun tu*), a scroll attributed to the Sui artist Zhan Ziqian but more likely to be a Song copy of an early Tang work (fig. 57).[74] As in the Dunhuang mural, there are round hills, vertical peaks, and travelers in a wide horizontal space. But the detailed execution and precise outlines attest to an effort to achieve formal regularity and surface ornamentation. The style of this second blue-and-green landscape, traditionally associated with Li Sixun (651–716) and his son Li

Zhaodao (ca. 675–741), became extremely popular after Wu Zetian's reign. Its growing influence was related to an important change in court art toward the end of the early Tang: a gradual shift from heavy-handed political art to apolitical works executed in a more pleasant and relaxed manner. Examining records and works of art from the early eighth century, we see a tendency toward aestheticism and formalism as the royal patrons and court painters increasingly paid more attention to the mode of visual representation than to subject matter.

Unlike Yan Liben and other artists employed by the emperor, the two Lis were themselves members of the imperial clan. Although their noble status enhanced their potential artistic influence, as royal relatives they were exposed to the grave danger of court intrigues, and their role in art was conditioned by the outcomes of political struggles. Li Sixun, for one, spent years in hiding to avoid Wu Zetian's persecution of the Tang royal house and did not return to court until after Wu's abdication in 704. He was immediately appointed Lord of the Court of Imperial Family Affairs (Zongzheng qing); other posts and titles given to him thereafter include chief of Yizhou Prefecture, general of the Imperial Guard, and duke of Pengguo. This sequence of events implies that if Li Sixun really "perfected" landscape painting and influenced Tang art — as Zhang Yanyuan tells us — this must have taken place after 704. It is difficult to imagine that he was

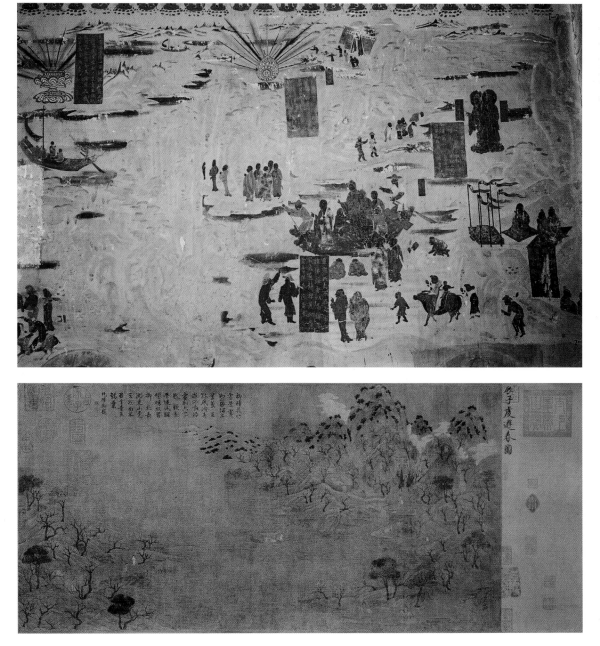

56. *An Episode in the History of Chinese Buddhism,* mural in Cave 323, Dunhuang, Gansu Province, early Tang dynasty.

57. Attributed to Zhan Ziqian, *Spring Outing,* handscroll, ink and color on silk, probably a Song-dynasty copy of an early Tang-dynasty work. 43 × 80.5 cm. Palace Museum, Beijing.

able to play such a prominent role while still in hiding. It is conceivable, however, that his subject matter and style were widely imitated once he regained noble status and became a prominent courtier.[75] The growing political power of his family must have contributed to the dominance of the Li style in court art. Zhang Yanyuan records that besides Li Sixun and Li's son Zhaodao, three members of the family (Li's younger brother Sihui, Sihui's son Linfu, and Linfu's nephew Cou) were also highly regarded painters. Among them, Li Linfu, who continued the family tradition of painting blue-and-green landscapes, became Emperor Minghuang's prime minister and the de facto dictator from 736 to Li's death in 752.[76]

No authentic work by Li Sixun has survived. The only possible attribution—a river landscape entitled *Sailing Boats and a Riverside Mansion* (*Jiangfan louge;* fig. 58)—appears to be closely related to *Spring Outing* and may be another version of the same lost original.[77] Fortunately, landscape murals in Prince Yide's (682–701) tomb outside Chang'an provide reliable materials for studying Li Sixun's art and the early Tang blue-and-green landscapes. A number of factors link these murals with Li Sixun. Like Li, Prince Yide was a member of the Tang royal house and a victim of Wu Zetian: he was put to death in 701 for criticizing his empress grandmother. Not until Wu Zetian abdicated was he given the posthumous title of crown

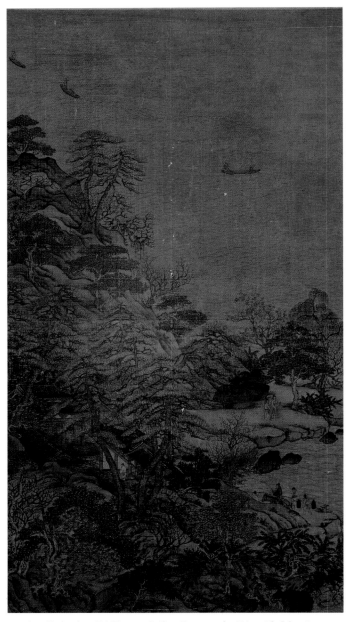

58. Attributed to Li Sixun, *Sailing Boats and a Riverside Mansion,* handscroll, ink and color on silk. 101.9 × 54.7 cm. Collection of the National Palace Museum, Taibei.

prince — his name while he was alive was Li Chong-run — and not until the empress died in 705 were his remains exhumed and transferred to a newly constructed mausoleum near the tombs of his ancestors. For the surviving members of the Tang royal clan, including Li Sixun, Prince Yide's death and posthumous rehabilitation must have typified their collective experience during those turbulent years, and the construction of his tomb must have symbolized the reestablishment of the Li clan's political authority. Two additional facts suggest Li Sixun's direct involvement and influence in the construction and decoration of the tomb. First, as Lord of the Court of Impe-

rial Family Affairs, he would have had the responsibility of arranging funerals for deceased royalty, especially for someone like Prince Yide, whose second burial was of extraordinary political significance at the time. Second, an inscription on the ceiling of the antechamber of the tomb states that a painter named Yang Bian (or Yang Biangui) "wishes to offer his respects forever" to the dead prince.[78] It has been proposed that this painter is listed in Zhang Yanyuan's *Famous Paintings of Successive Dynasties* under the name Chang Bian; Chang was an artist who "excelled in painting landscapes in the style of General Li [Sixun]."[79]

In the tomb, landscape scenes appear in two huge murals more than twenty-six meters long that appear along the sloping passageway. Each mural shows a grand ceremonial procession outside a walled city, an enormous Blue Dragon or White Tiger soaring amid the clouds in the distance. The backdrop to the imperial pageantry is a mountainous landscape with rocky crags, deep ravines, and scattered trees. The upper portion of the landscape is damaged, but the surviving parts exhibit a distinctive style (fig. 59). The painting is remarkable for its color variation. The overall brownish wash is enriched by subtle tonal changes, reddish in some places and yellowish or greenish in others. Shading is used here and there to emphasize volume, and the bright malachite green applied along contours is typical of a blue-and-green landscape. The unusual energy and intensity of the painting are, however, largely due to the crisply drawn lines of ink. Firm and wirelike, these lines or double lines delineate angular rocks with sharp, crystalline facets.[80]

Interestingly, we find similar lines, color combinations, and rock formations in a famous but problematic scroll painting — *Emperor Minghuang's Journey into Shu (Minghuang xing Shu tu;* fig. 60) — whose authenticity and dating have long been the focus of scholarly debate. New evidence from Prince Yide's tomb seems to support the contention that the scroll, though of Song provenance, was based on a Tang original created around 800 by a follower of the Li School.[81] This relatively late date may explain some differences from the Prince Yide murals, including the more overtly decorative quality of the scroll painting and the complete dominance of landscape elements. In the scroll the swirling clouds and broken rocks are now arranged in patterns and painted with glowing opaque colors. Mountains no longer serve as a backdrop to the figures but rise majestically, images in their own right painted in imaginative shapes. Arrays of soaring crags dominate the middle ground and are divided into a tripartite structure by two deep ravines, which guide the viewer's gaze into the distance. We find a similar spatial

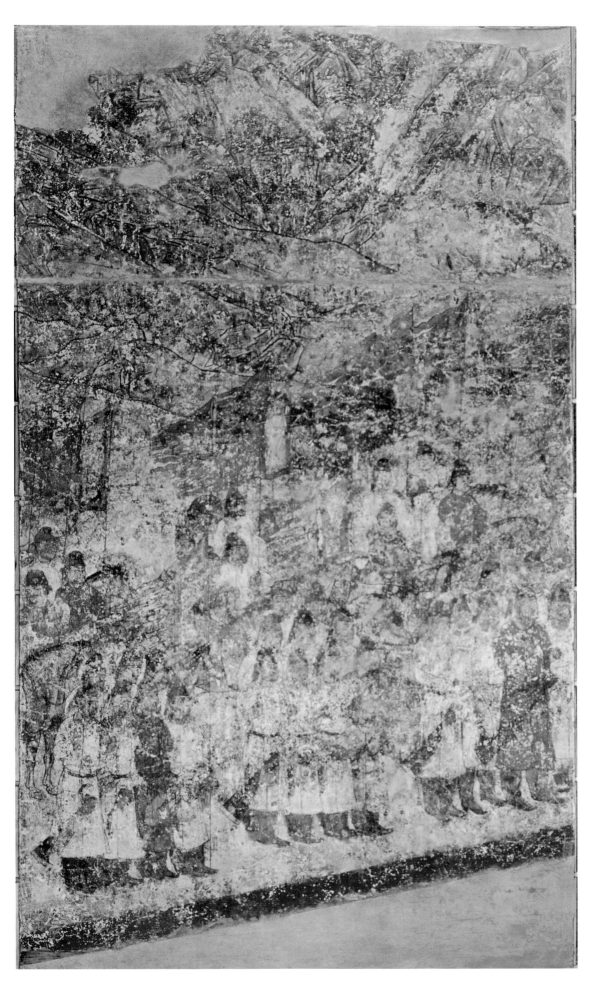

59. *Guards of Honor,*
mural in Prince
Yide's tomb in
Qianxian, Shaanxi
Province, 706.
351 cm high.

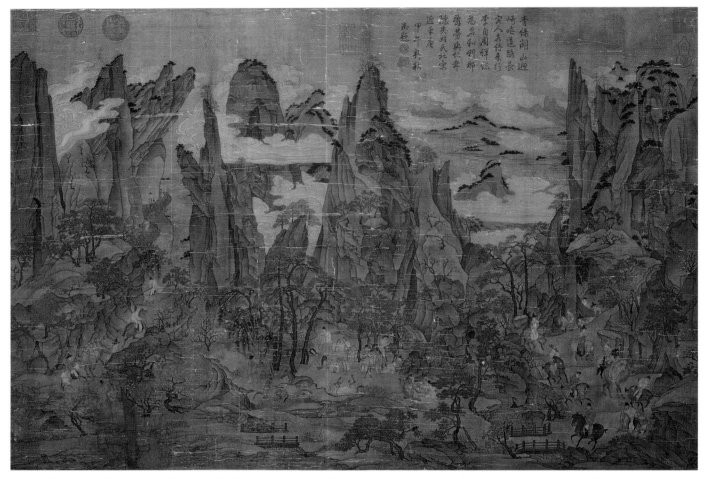

60. Attributed to Li Zhaodao, *Emperor Minghuang's Journey into Shu,* hanging scroll, ink and color on silk, probably a Song-dynasty copy of a Tang-dynasty original created ca. 800 by a follower of the Li School. 55.9 × 81 cm. Collection of the National Palace Museum, Taibei.

arrangement in the scene painted on an early eighth-century biwa (*pipa*), or lute (fig. 61). But *Emperor Minghuang's Journey into Shu* is far more complex and sophisticated. The painter deliberately used landscape to enhance narrative content. The travelers form a winding stream that moves through a series of linked spaces defined by mountains and ravines. Yet the mountains also punctuate this movement and create a strong sense of rhythm. The travelers emerge from behind the cliffs to the right, rest on open ground before the middle peaks, and then continue their journey, vanishing behind the mountain to the left.

Authentic, securely dated funerary murals found in recent years have become one of the most important sources of our knowledge about Tang painting. In many cases, these murals yield reliable evidence for identifying and dating other paintings and styles. Their most crucial significance, however, lies in providing a large group of related paintings that demonstrate the development of Tang painting over a long period as well as the complexity of Tang painting at a given moment. Twenty-seven

painted tombs of high officials and royalty discovered in the Chang'an area have allowed Chinese scholars to speculate on the changing subjects of Tang painting from the early seventh to late ninth centuries. The tombs of Princess Changle and Zhishi Fengjie attest to the coexistence of different painting schools during the seventh century (figs. 62, 63); and murals in three imperial tombs, belonging to Prince Yide, Prince Zhanghuai (Li Xian, 654–684), and Princess Yongtai (Li Xianhui, 684–701), provide the best examples for studying stylistic variations in early eighth-century court painting.[82]

These three imperial tombs were constructed in a single year (706) at nearby locations for the same reason. Like Prince Yide, Prince Zhanghuai and Princess Yongtai were victims of Wu Zetian's persecution of Tang descendants and were given formal burials only after Wu's death. Wall paintings in Prince Yide's and Princess Yongtai's tombs are closer in composition and style, perhaps because these two tombs were ranked as imperial mausoleums (*ling*) at the time of their construction. Prince Zhanghuai's tomb, which was not an imperial mau-

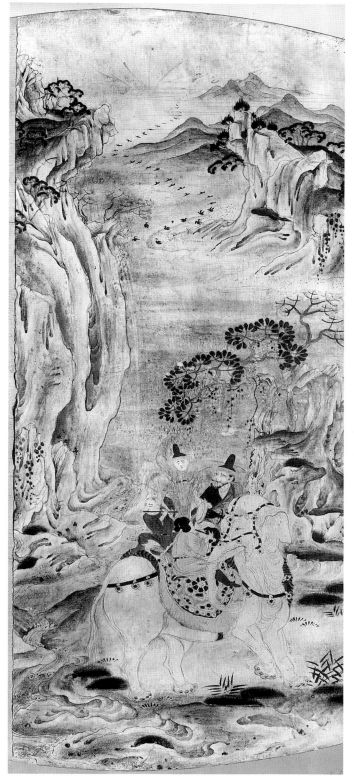

61. *Landscape with Musicians on an Elephant,* painting on a biwa, late 8th century. 53 cm high. (Courtesy of the Shōsō-in Treasure House, Nara, Japan.)

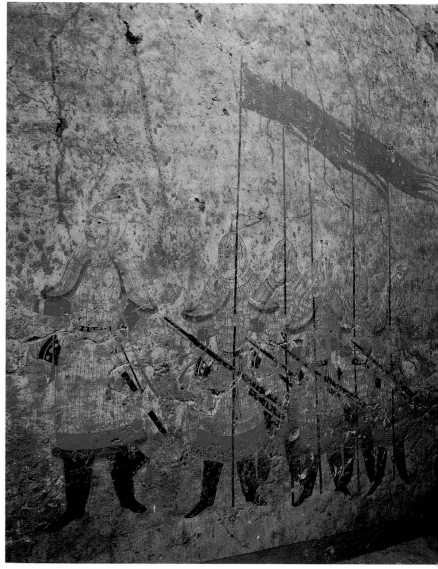

62. *Guards of Honor,* mural in Princess Changle's tomb in Liquan, Shaanxi Province, 643. (Reprinted from *ZMQ,* Painting, vol. 12, no. 93.)

soleum, seems to have been decorated by an entirely different group of painters who favored a less formal and more expressive style.[83] Landscape scenes are also found in this tomb along the entryway (fig. 64). But unlike in the Prince Yide murals with their piled-up crags, here there is an open expanse of space dotted with hills, rocks, and horsemen. The ink lines, too, differ markedly from the angular and wirelike brushwork in Prince Yide's tomb. They possess greater representational value in delineating shape and volume and, having been drawn freely and speedily, share the quality of certain calligraphic styles, such as *xing* (strolling) and *cao* (cursive). Stylistic variations are again reflected in the representation of figures in the different tombs. Prince Yide's tomb has images of stiff officials and soldiers covering the walls, but Prince Zhanghuai's tomb has figures in clusters, linked in dy-

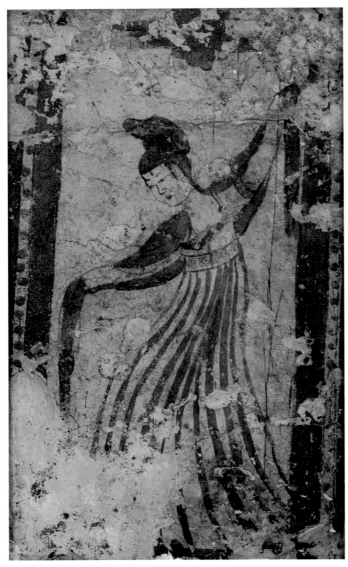

63. *Dancing Girl in Red,* mural in Zhishi Fengjie's tomb in Chang'an, Shaanxi Province, 658. 116 × 70 cm.

namic movement. The painter of the clustered figures was also more conscious of constructing an illusory pictorial space. In one place, a row of bold trees in the foreground separates figures and animals from the picture plane (fig. 65). In retrospect, we realize that this tree motif, which occurs in pre-Han to post-Han pictorial art (see figs. 9b, 37, 45), has a changed function; instead of structuring adjacent spatial cells, it differentiates layers of space.

The existence of such stylistic variation was related to one of the most significant phenomena in Tang art: the appearance of a number of influential painting traditions each of whose adherents identified themselves as belonging to a school following "So-and-so's model" (X *jia yang*). Some of these traditions traced their origin to ancient masters like Cao Buxing and Zhang Sengyou (active 500–550); others followed contemporary masters like

Wu Daozi and Zhou Fang (ca. 730–ca. 800). Art history now encompassed artistic lineages, not just individual artists. As Zheng Yanyuan remarks: "In every case there is a tradition from master to pupil, and all in turn follow one another."[84] Competitions between schools, workshops, and individual artists became increasingly frequent, especially when a large building had to be decorated by a number of painters, sometimes of great renown. In some cases, artists working together tried to keep their techniques secret; in other cases, competitions between individual painters developed into conflicts between regional factions.[85]

Several anecdotes relate that open contests were held between painters asked to illustrate the same subject on different walls in a hall. Two eighth-century murals in Dunhuang Cave 172 prove that these stories are not entirely fictional. Covering the two side walls, they illustrate the *Amitayurdhyana Sutra* in identical compositions, but their divergent painting styles and visual impact betray different hands. The mural on the south wall appears light, airy, and gentle (fig. 66a); the one on the north wall is heavy, solemn, and intense (fig. 66b). This impression arises from the different color schemes and from the painterly or linear qualities of the images. The central Amitayus Buddha in the south mural, for example, is a typically sinicized icon attired in a loose white robe; the drawing is linear, and the painter lingered over the flowing drapery. But the same Buddha depicted on the north wall adheres to an Indian prototype. He wears a tight monastic robe that bares one shoulder and reveals rather than conceals the torso. There is a strong sense of volume: the Buddha and the flanking bodhisattvas are round, solid figures; the outlines are either omitted or merge into shading.[86]

Such stylistic divergences had cultural and political significance. Underlying these two interpretations of a standard composition were two radically different attitudes toward Buddhist art, one a conservative, Indian approach and the other a reformist, sinicizing approach. Given this line of thinking, we might wonder about the implications of a contest between Li Sixun and Wu Daozi, recounted in perhaps the most famous anecdote of this sort found in a Tang text. Zhu Jingxuan records that in the Tianbao era (742–755), Emperor Minghuang ordered these two masters to execute their different versions of the Jialing River scenery in Datong Hall. Wu, in a burst of energy, "finished a landscape of three hundred miles in a single day. . . . But it took Li Sixun several months to complete his work."[87] Since Li Sixun was about fifty years Wu Daozi's senior and died long before the Tianbao era, this record can only be read as a fable.

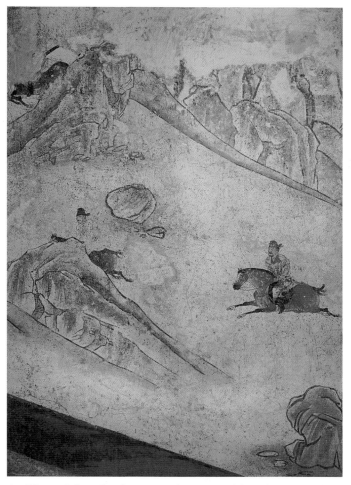

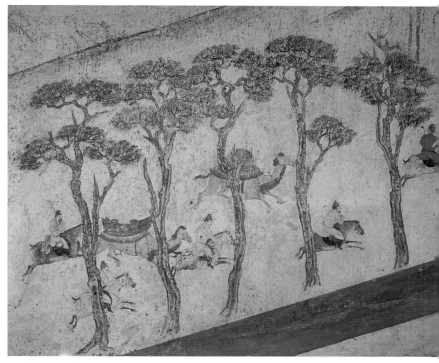

65. *Playing Polo—Trees,* mural in Prince Zhanghuai's tomb in Qianxian, Shaanxi Province, 706. 100–200 × 890 cm.

64. *Playing Polo—Landscape,* mural in Prince Zhanghuai's tomb in Qianxian, Shaanxi Province, 706.

Instead of being real historical personages, the masters stand for art traditions or schools. Their competition symbolizes the tension and conflict between these traditions or schools in terms of style, medium, function, artist, and audience.

On an artistic level, the anecdote reflects the fundamental classification of the Tang painting styles that Zhang Yanyuan considered the basis of art criticism and appreciation: "Only when one realizes that there are these two painting styles, the *shu* [loose] and the *mi* [dense], can one begin to talk about painting." Our discussion of tomb murals has shown the coexistence of these stylistic tendencies during the seventh and early eighth centuries (compare figs. 62 and 63, 59 and 64). By the mid-eighth century the "dense" style of the Li Sixun school seems to have passed its prime: Zhang Yanyuan praised Li Sixun but criticized his son Li Zhaodao for "producing overcrowded and overcomplicated works." Around this time Wu Daozi emerged as the most brilliant artist to fully realize the potential of the "loose" style. As Zhang Yanyuan writes: "With just one or two strokes,

[his] image already reflects [the object]." Zhang's view was shared by Zhu Jingxuan, who "never found Wu's works remarkable for their detailed ornamentation. It is, rather, the incomparable play of his brush [that is remarkable]. In all cases [the brushwork] is profusely varied and full of untrammeled energy. In a number of instances, his wall paintings were carried out in ink alone; no one in recent times has been competent to add color to them."[88]

Scholars have tried to match these descriptions with images. A mid-eighth-century portrayal of Vimalakirti in Dunhuang (fig. 67) seems to reflect Wu's monochrome drawing style, and a stone engraving in the Northern Yue Temple in Quyang (fig. 68) may show his vigorous and profusely varied brushwork. Said to have been copied from a drawing by Wu Daozi, this second work depicts a devillike guardian gesturing wildly, screaming ferociously, and leaping through the air with a halberd on his shoulder, his clothes and hair driven by the wind into long fluttering pennants. The figure's tremendous power seems to arise from the tension in his body and from his movement, as well as from the artist's mixed use of broken

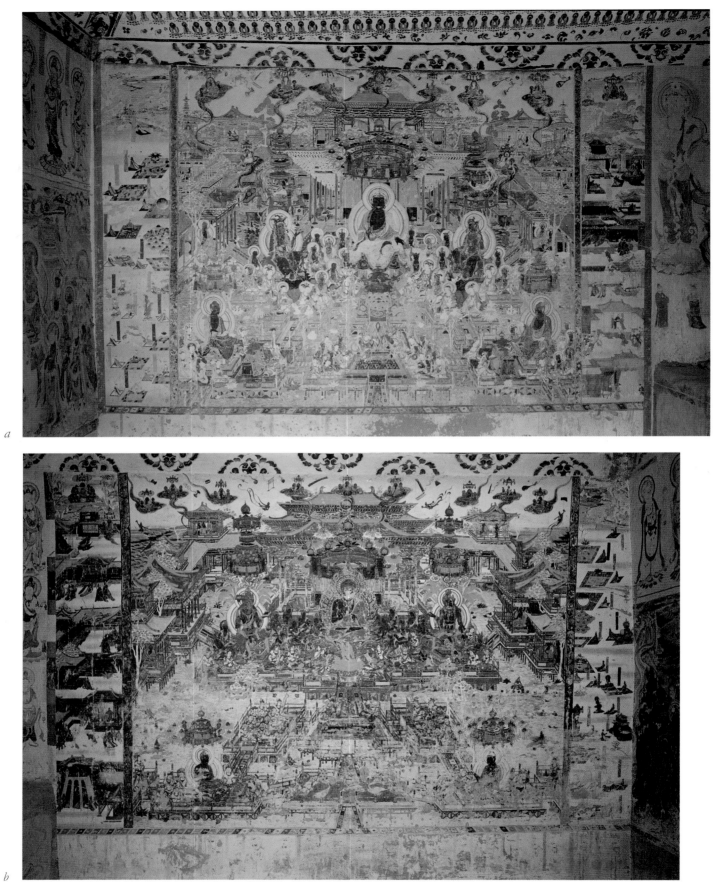

a

b

66. Illustrations of the *Amitayurdhyana Sutra,* mural in Cave 172, Dunhuang, Gansu Province, mid-8th century: *a,* south wall, 300 × 411 cm; *b,* north wall, 300 × 410 cm.

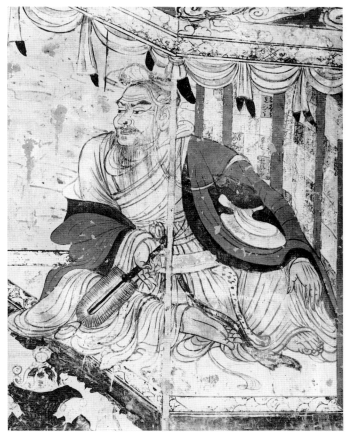

67. *Vimalakirti,* detail of a mural in Cave 103, Dunhuang, Gansu Province, mid-8th century.

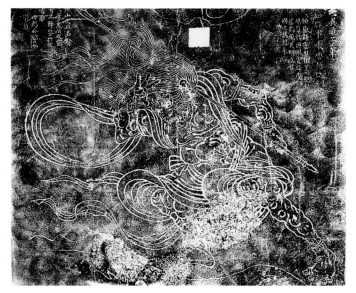

68. Attributed to Wu Daozi, *Flying Demon,* rubbing of a stone engraving in the Northern Yue Temple in Quyang, Hebei Province. 97.5 cm high.

and smooth lines. An isolated figure against an empty background, the guardian does not seem a self-contained image but is, in Max Loehr's words, "enmeshed in a larger unit that is all energy and movement. The demon does not generate the forces here made visible; they act upon him." [89]

In all likelihood, Wu Daozi's powerful representational art was not nurtured by the court, whose increasingly refined taste was best realized in delicate and colorful illustrations of landscapes, palace ladies, flowers, birds, insects, and horses. Rather, the main force behind the development of the style most likely consisted of the builders and decorators of numerous Buddhist and Daoist temples who found their representative in Wu Daozi and finally promoted him to patron god of their profession. [90] In sharp contrast to the wealthy courtier Li Sixun, Wu Daozi was from humble origins and occupied no position in official history. We know little about his life except that he was orphaned at an early age, that he was poor and probably never received formal art training, and that even after he became famous and was recruited by Emperor Minghuang, his duties in the palace rarely extended beyond teaching court ladies or being compan-

ion to a prince. [91] The real world of Wu Daozi remained outside the imperial palace. In the city of Chang'an he had his own workshop and apprentices who often applied colors to Wu's temple decorations. In fact, as we find in Zhang Yanyuan's records, all painters associated with Wu lacked close ties with the court and painted exclusively Buddhist or Daoist subjects. [92] The report that Wu Daozi (more accurately, his workshop) created more than three hundred bays of temple murals need not be an exaggeration. Writing after the great persecution of Buddhists in 845, Zhang Yanyuan was still able to identify murals by Wu Daozi in at least twenty-one monasteries in Chang'an and Luoyang — that is, in about one-third of the total surviving number of monasteries in the two capitals. It is clear that public murals were Wu Daozi's major art medium, not portable scrolls for private enjoyment. [93] His practice centered on Buddhist monasteries and found its primary sources in Tang popular urban culture.

Many anecdotes confirm Wu Daozi's relations to popular culture. Most tellingly, he is often described as a street performer whose nearly supernatural skills, rather than his finished works, dazzled the eye. [94] We are told

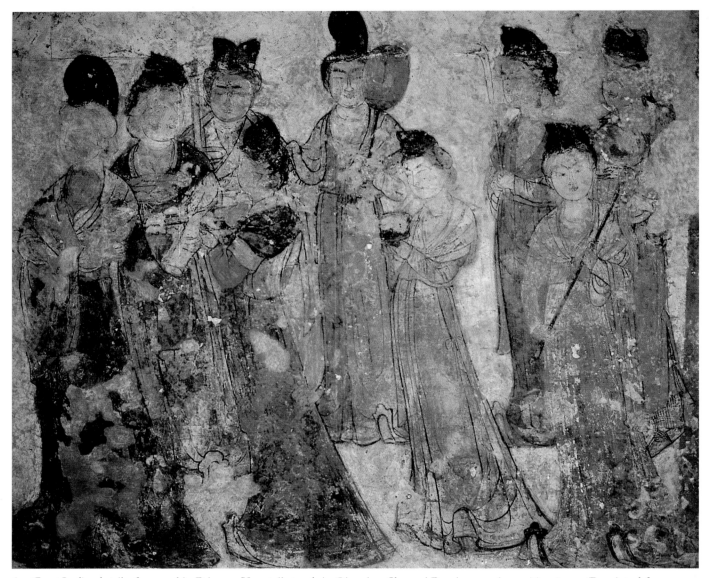

69. *Court Ladies,* detail of a mural in Princess Yongtai's tomb in Qianxian, Shaanxi Province, 706. 177 × 198 cm. (Reprinted from *ZMQ*, Painting, vol. 12, no. 119.)

how he painted a halo in a single stroke without the aid of a pair of compasses: "He raised his brush and swept it around with the force of a whirlwind, so that everyone said a god was aiding him." His audience included passersby of all kinds. An old man told Zhu Jingxuan that when Wu was painting a temple mural, "crowds streamed from the Chang'an marketplaces, old and young, gentry and commoners, struggling with each other to watch him until they were like a wall round about." Such scenes could be found at almost any temple fair in traditional China. Wu's religious paintings had their strongest impact on commoners. An old monk in the Xiangji Monastery related in the ninth century that the butchers and fishmongers who saw Wu Daozi's Hell paintings in that

monastery were so terrified of their sins that they all changed their trade. Wu Daozi and his works were gradually mythicized: he was believed to be a reincarnation of Zhang Sengyou and was thought to be able to remember his former lives by reading the *Vajra Sutra*. Rumors circulated about his wonderful drawings of five dragons, which were reputedly so lifelike that mist swirled around them whenever it was about to rain. Instead of providing reliable biographical information, these stories were part of a dynamic oral tradition.[95] Whereas Li Sixun's life was documented in Tang official history, legends about Wu Daozi spread from mouth to mouth. In the process, Wu became not only the inspiration but also the product of people's imagination.

It has been suggested that eclecticism and polycentrism account for the vitality and richness of Tang culture, that they contributed to a general atmosphere of openness and tolerance in which contention between schools and styles never led to tyranny but to coexistence and mutual influences.[96] This situation became most obvious during the middle and late eighth century, a period that was at once the culmination of established painting traditions and an era of change and renewal. While public religious art flourished to an unprecedented degree, a number of branches of court art — notably, the painting of female images, birds and flowers, and horses — developed into independent genres and produced great masters. In the same period a third trend emerged; here, individualism was taken as the main goal of artistic expression. None of these three traditions was isolated; they stimulated one another, and all contributed to the development of Tang painting.

Artists who had close ties with the court (that is, artists who were royalty, courtiers, or professional court painters) often worked in specific painting genres or subgenres. In addition to producing political paintings, court portraiture, and blue-and-green landscapes, some members of the aristocracy during the early Tang developed a passion for painting birds (especially eagles), animals (especially horses), and insects. Zhang Yanyuan and Zhu Jingxuan list quite a few princes, high officials, and generals as experts in such painting.[97] An important change during the High Tang was the increasing popularity of images of court ladies, attested to by both textual and archaeological evidence. It is recorded that Li Cou, a grandnephew of Li Sixun's who lived in the mid-eighth century, abandoned the family's landscape tradition in favor of female images. "He was most skilled at [rendering] variegated silks and gauzes," writes Zhang Yanyuan, "and his figures were the utmost marvel of his time." Tomb murals found in the metropolitan area further demonstrate the vogue for such images. Created for deceased royalty, high officials, and their relatives, these pictorial works generally reflected the taste of the aristocracy. Once analyzed in chronological sequence, they show the shifting interests of the elite.[98]

Murals in at least fourteen early Tang tombs follow a standard pictorial program. Two mythical animals — the White Tiger and the Blue Dragon — usually flank the entrance to the tomb. Next come large pictures of official gatherings, pageants, and hunting scenes, which cover the triangular walls along the sloping passageway. Symbols of official status, ceremonial paraphernalia, and attendants are depicted in groups along the adjacent corridor, which leads to the antechamber and then to the burial chamber. The walls of the two chambers bear images of royal ladies and servants in domestic settings, as if they were still accompanying their deceased master or mistress (fig. 69).

Grand ceremonial scenes gradually fell out of fashion in the High Tang. In some tombs, images of domestic figures, mainly women, musicians, and servants, appear not only in the rear chambers but also along the entryway. The grandeur of the dead was apparently no longer the patron's main concern; a whole tomb was now conceived and designed as a private underground home. This development reached its apex in the middle and late Tang, when depictions of official gatherings and ritual processions completely disappeared, the walls along the entryway were sometimes left undecorated, and the rear burial chamber became the most decorated section. Here the murals imitate multipaneled screens and transform the chamber into the private quarters of a household.

By documenting such changes, funerary murals provide a general background against which we can better understand the historical position of individual artists and surviving scrolls. Most significant, the murals reveal the radical departure of High Tang court art from early Tang court art, a transformation that involved depoliticization. Images of public activities gave way to those of private life, and solemn officials and generals were replaced by lush palace ladies. To people living in the mid-eighth century, Yan Liben and his meritorious ministers belonged to the remote past. The main appeal of the court was no longer its political insights and judgments but its luxury and glamor. From 745 to 756 the most powerful figure in the country was Yang Guifei, Minghuang's celebrated consort and the most famous femme fatale in Chinese history. It is said that the fashion of portraying portly women owed much to Yang's well-known corpulence. Although this contention is questionable because such figures had appeared in the early eighth century and even before then, Yang Guifei did embody the very essence of this imagery and signify its culmination. As she came to dominate not only Chang'an high society but also contemporary male fantasy, a stereotyped palace lady developed into a cultural icon. Plump and full-faced, this image of an ideal beauty appeared in various media throughout the country and even abroad — silk paintings portraying such ladies are found in Japan (fig. 70) as well as central Asia (fig. 71). This development explains the appearance of Zhang Xuan and Zhou Fang, two masters in this genre. Through their efforts the image of the court lady became a legitimate subject of high art.

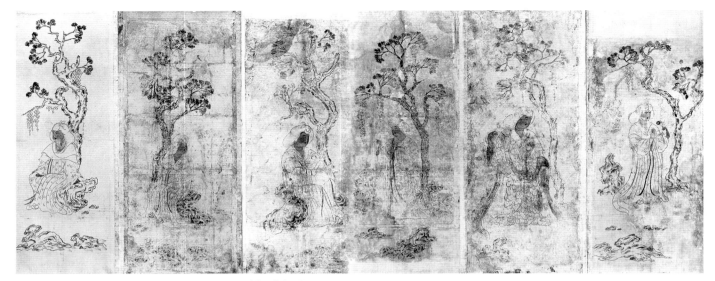

70. *Screen with Ladies Under Trees,* ink, color, and bird feathers on silk, 8th century. 136 × 56 cm. (Courtesy of the Shōsō-in Treasure House, Nara, Japan.)

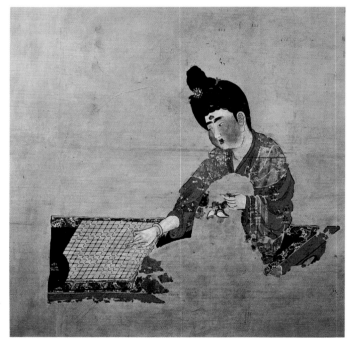

71. *A Woman Playing a Game of Chess,* section of a fragmentary painted screen from Astana Tomb 187 in Turpan, Xinjiang Uygur Autonomous Region, ink and color on silk, 8th century. 63 cm high. (Reprinted from *ZMQ,* Painting, vol. 2, no. 9.)

Zhang Xuan, the elder, was less known during the Tang. Zhang Yanyuan describes him in a single sentence: "Zhang Xuan loved to paint women and babies." Zhu Jingxuan left a longer record but placed him in the second tier of a three-tier ranking system.[99] Zhang Xuan became indispensable in later discussions of Tang painting chiefly because of the existence of two famous copies of his works, both attributed to the celebrated Song artist-emperor Huizong (r. 1101–1126). The double authorship of the scrolls poses questions about the extent to which we can use them as evidence of Zhang Xuan's artistry. In my opinion, they are at best Song reinterpretations of Zhang Xuan's works. Their composition may follow the originals, but the painting style — the opaque coloring, flat images, and especially the meticulous neatness of the ornamental details — reflects the distinctive taste of Huizong's Academy of Painting. One of the paintings depicts Lady Guoguo — a younger sister of Yang Guifei's who was no less famous for her beauty and dissipation — taking a spring outing on horseback (fig. 72).[100] The other painting focuses on a quite different aspect of imperial harem life. Three groups of court ladies are engaged in different stages of preparing newly woven silk (fig. 73), but we should not confuse this with real silk production or the day-to-day work of ordinary weavers. In the ancient Chinese court, silk weaving was primarily a ritual activity; palace ladies were responsible for holding annual ceremonies of picking mulberry leaves and preparing silk. The tradition of illustrating such activities can be traced back to the sixth or fifth century B.C. (see fig. 10). These scenes, the subjects of bronze decorations, stone reliefs, and scroll paintings, helped define the symbolic status and roles of court ladies.

In composition the two works also follow different

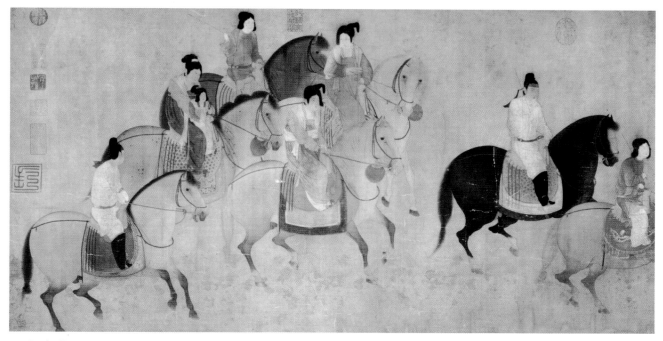

72. *Lady Guoguo's Spring Outing,* Emperor Huizong's copy of an 8th-century painting by Zhang Xuan, section of a handscroll, ink and color on silk, Northern Song dynasty. 52 × 148 cm. Liaoning Provincial Museum, Shenyang.

models. The painting of Lady Guoguo's outing was apparently an offspring of the time-honored tradition of depicting horsemen and chariot processions (see figs. 9, 25, 31). It recalls in particular a large hunting scene in Li Xian's tomb which likewise begins with a few riders ahead of a large royal party. *Ladies Preparing Newly Woven Silk,* on the other hand, continues the tradition of *Admonitions of the Court Instructress to Palace Ladies,* in which figures construct self-contained spatial units within the painting (see fig. 39). Over the centuries viewers have been amazed by the highly sophisticated composition of *Ladies Preparing Newly Woven Silk.* Upon opening the scroll one finds four women, "like a sequence of four lunar phases," surrounding a rectangular trough.[101] Their subtle gestures and movements balance one another; their standing poses and the pestles in their hands emphasize verticality. In contrast, the second scene comprises figures sitting on the ground. With one lady sewing and another spinning, the key image is now delicate silk threads, not heavy pestles. The third and last picture echoes the first scene. It again contains four standing women, also arranged in a sequence of four lunar phases. But these women are stretching out a roll of white silk; the tension of the silk roll along the horizontal dimension becomes the focus of representation. The painting, then, is a typical tripartite composition, like works by Zhang Xuan's follower Zhou Fang.

Zhang Yanyuan writes explicitly about the relationship between Zhang Xuan and Zhou Fang: "At first, Zhou Fang imitated the painting of Zhang Xuan, but then he became somewhat different. He reached the very utmost in stylish appearance, devoting his whole art to portraying people of wealth and prestige, and eschewing [anything reminiscent of] rustic village life. His drawings of costumes are simple but powerful, his coloration soft yet elaborate."[102] This statement, though placing the two painters in a single genre, points to their different historical positions: Zhang Xuan lived at a time when the imagery of court ladies was yet to be further stylized; Zhou Fang, when figures represented the very utmost in stylization. We can therefore understand why Zhang Xuan remained rather shadowy during the Tang, whereas Zhou Fang was ranked above all Tang masters (including Yan Liben, Li Sixun, and others) except Wu Daozi.[103] Later copies of Zhou's works hardly support this lofty evaluation. Fortunately, a painting entitled *Court Ladies Wearing Flowered Headdresses (Zanhua shinü tu;* fig. 74) can be identified with enough confidence as a genuine Tang work — by Zhou Fang himself or by one of his followers — to allow us to glimpse the amazing achievement of Tang female portraiture.[104]

Rare indeed is a Chinese painting so exquisite and sensual. The court ladies portrayed are themselves works of art. Their heavily powdered white faces are painted with tiny lips and fashionable "moth eyebrows," and their tall coiffures are sculptural forms embellished with flowers and jewelry. Ironically, artificiality and anonymity here serve to enhance the women's sexuality. Although their

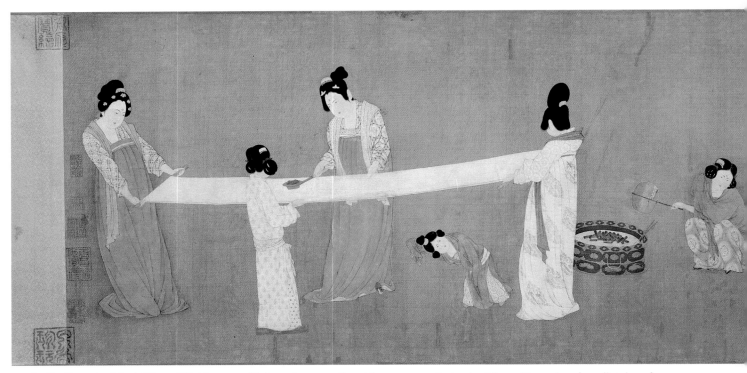

73. *Ladies Preparing Newly Woven Silk*, Emperor Huizong's copy of an 8th-century painting by Zhang Xuan, handscroll, ink and color on silk, early 12th century. 37 × 147 cm. (Japanese and Chinese Special Fund. Courtesy of the Museum of Fine Arts, Boston.)

faces are concealed and turned into uniform masks, their bodies are suggested and revealed by the transparency of their clothes. Executed in rich colors in a subdued tone, their thin gauze robes expose patterned underclothes, inviting the viewer to discover the female body beneath. This observation casts into doubt the contention that the artist's aim was purely aesthetic. Rather, aestheticism is another name for eroticism in this work. No stories or actions are depicted. Instead, the painter conveys a particular sense of femininity and a mood of languor and melancholy associated with court ladies.

This painting also offers a valuable clue for understanding bird-and-flower painting, which, in tandem with the depiction of court ladies, developed into an important tradition in the eighth century.[105] In the scroll, court ladies stand side by side but without casting their eyes on one another. Their attention is absorbed by a second group of images: a tiny red flower, a blooming magnolia, pugs, a crane, and a butterfly on a lady's fingers. The intimacy between these human and nonhuman images indicates the painter's intention to establish analogies between them. The nonhuman images can be understood as representations, similes, or metaphors. As representations, they are components of an imperial garden inside the palace; as similes, they lend their delicacy to the ladies who are also fixtures of the imperial garden; and as metaphors, they are anthropomorphized — they and

the ladies keep each other company and share each other's loneliness. New archaeological evidence suggests prototypes for such images. Line engravings on an early eighth-century imperial sarcophagus show female figures surrounded by clusters of "cut flowers" (*zhezhi huahui*), flying swallows, and wild geese and contemplating birds and flowers they hold in their hands; an example is shown in figure 75.

The last important subject of court painting is animals, especially horses. Surprisingly, the development of horse painting best demonstrates the transformation of court art from the early Tang to the High Tang. Horses, especially the tough, stocky kind from central Asia, had always been a passion of the Tang royal house. But the animal meant different things to different emperors and was depicted variously at different times. The six stone horses of the early Tang are realistic portrayals of Emperor Taizong's battle chargers. Standing in front of the emperor's mausoleum, they symbolize the founding of the empire. (This is most explicit in figure 50, which represents General Qiu Xinggong removing an arrow from the chest of Autumn Dew.) A century later, Emperor Minghuang filled his stables with more than forty thousand foreign steeds. Never having seen a battlefield, these horses were trained to dance in front of the Son of Heaven (fig. 76). No longer warriors, they became comparable to the ladies kept in the imperial harem. Well-

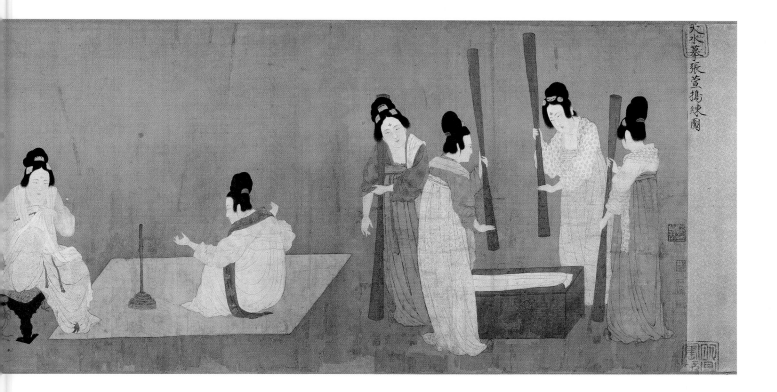

known court painters like Chen Hong (eighth century) and Han Gan received imperial orders to portray the most famous mounts. Their works betray the elements of the early Tang realistic tradition but reflect the High Tang fashion of giving forms a round, fleshy appearance; indeed, we find an unmistakable stylistic resemblance between images of horses and images of palace ladies created in the eighth century. This is perhaps why Du Fu criticized Han Gan for "merely painting the horses' flesh and not their bones." Zang Yanyuan, however, defended Han (whom he considered "the supreme horse painter of all time") for capturing the horse's essential spirit.[106] Zhang's argument is supported by the painting *Shining Light of Night* (*Zhaoyebo;* fig. 77), which is attributed to the artist. Although the title identifies the subject as one of the most beloved horses in Minghuang's stable, the image — a horse with a round torso and short skinny legs — seems far from a naturalistic portrayal of a central Asian steed. Rather, the animal's clumsy physique contradicts and thus reinforces the power of its spirit. Struggling violently for freedom, the horse stamps its hoofs and lifts its head, neighing. But the struggle is hopeless: the horse is tethered to a thick iron pole, whose centrality in the painting increases the impression of stability. Tellingly, the horse turns its agonized eye to the spectator and appeals for sympathy. The animal is anthropomorphized; but unlike the delicate flowers and insects, it seems to allude to the tragic side of court life.

Tang painters did not fall into strict categories. Neither the Imperial Painting Academy nor the tradition of literati painting had yet appeared, so it would be very problematic to classify Tang artists into "professional" and "amateur" types, as later artists were. Records by Zhang Yanyuan and Zhu Jingxuan nevertheless do show certain correlations between painting subject and style and artist's social status and occupation. We have looked at artists related to either court art or popular religious art. Painters in a third group — men of letters — became known in the High Tang and played an increasing role in the middle and late Tang. Although some of them had connections with the court, they are often admired for their unworldliness, either as recluses who found private delight in landscape painting or as "untrammeled" gentlemen whose eccentric style shocked the conventional world.

The famous poet and painter Wang Wei (699–759) and the Daoist hermit Lu Hong (active early eighth century) were two early and rather idealized representatives of this group. Wang is intimately associated with Wangchuan, his country villa in Lantian, south of Chang'an. His poems frequently describe the peaceful local scenery — hills, streams, and bamboo groves, lakeside pavilions and cottages — and he also illustrated the countryside in more than one painting.[107] But these pictures all disappeared even before the Northern Song dynasty (960–1127), leaving little evidence to confirm the belief that he was able to express in visual images the same tranquil feeling that shines through his poetry. This belief was

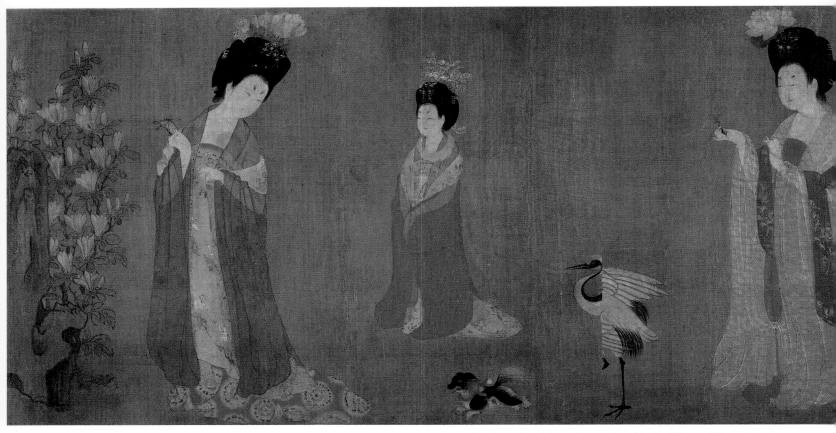

74. Attributed to Zhou Fang, *Court Ladies Wearing Flowered Headdresses,* handscroll, ink and color on silk, Tang dynasty. 46 × 180 cm. Liaoning Provincial Museum, Shenyang.

75. *Palace Lady with Flowers in Her Hand,* ink rubbing of a line engraving on the stone sarcophagus of Princess Yongtai, 706. 132 cm high. (Reprinted from *ZMQ,* Stone Engraving, vol. 2, no. 19.)

76. *Dancing Horse,* jar, silver with repoussé gilt decoration, 8th century. Xi'an Museum.

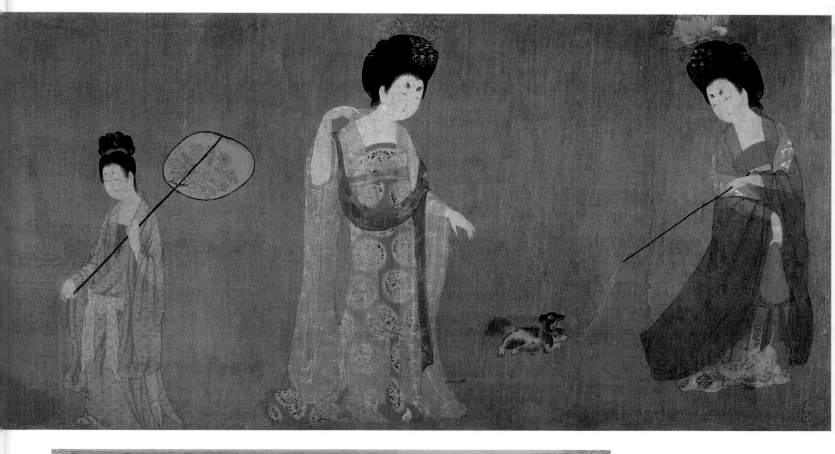

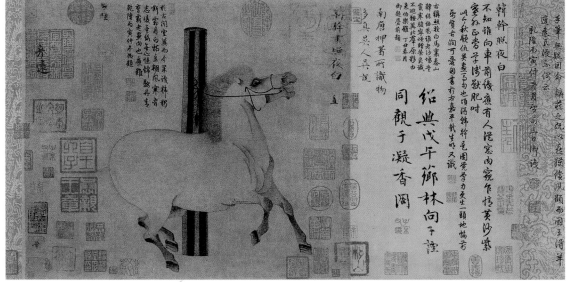

77. Attributed to Han Gan, *Shining Light of Night,* handscroll, ink and color on paper. 30.8 × 33.5 cm. Metropolitan Museum of Art, New York. (Dillon Fund Gift, 1977.)

most likely a creation of Song and post-Song literati, for Tang records of Wang Wei's art, though vague, suggest at least two distinctive styles, one of colored depictions that "bridged the antique and the modern" and the other of strong, brisk monochromic renderings, sometimes drawn with the "broken ink" or "inkwash" (*pomo*) method. The first style reminds us of the blue-and-green landscapes of the Li Sixun School, whereas the second style was probably inspired by Wu Daozi.[108] Wang Wei, a learned man who belonged to neither the tradition of

court art nor the tradition of popular art, could well have adopted different styles.

A Ming-period stone engraving of a panorama of Wangchuan Villa, based on a copy made by Guo Zhongshu (ca. 910–977) in the tenth century, possibly bears traces of Wang's first and more conservative style. The composition is archaic, a series of sites — houses and gardens identified by labels — being connected into a horizontal display (fig. 78). The Daoist hermit Lu Hong used the same composition in a painting of his country

78. *Wangchuan Villa,* ink rubbing of a stone carving made after Wang Wei's drawing, 15th century. 31 cm high. Art Museum, Princeton University. (On loan from the Far Eastern Seminar, Department of Art and Archaeology. Photo: Courtesy of the Far Eastern Seminar.)

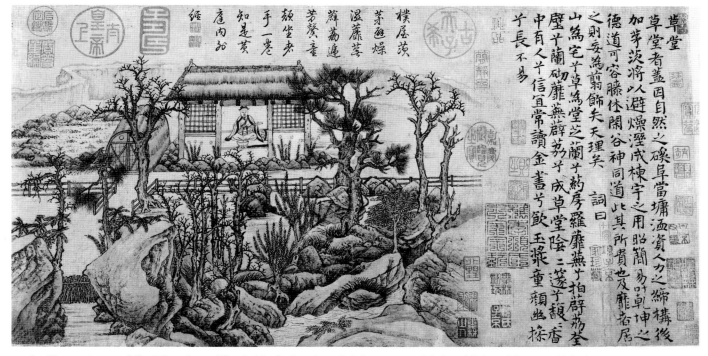

79. Lu Hong, view 1 of *Ten Views from a Thatched Lodge,* handscroll, ink on paper. National Palace Museum, Taibei.

retreat; though later preserved as an album, it was originally a handscroll consisting of ten views. Like Wang Wei, Lu Hong was a "lofty scholar" who specialized in painting mountains and water, trees and rocks. Wang Wei became a devout Buddhist; Lu Hong, a Daoist recluse at Mount Song near Luoyang. Lu refused an appointment as Censor Counsellor, but instead of punishing him, Emperor Minghuang gave him gifts, including the "thatched lodge" on Mount Song where he spent the rest of his life giving private lessons.[109]

Several copies of Lu Hong's *Ten Views from a Thatched Lodge (Caotang shizhi)* exist; the set in the National Palace Museum has the strongest archaic features, including the stagelike setup of each scene and a naive sense of scale (fig. 79).[110] The importance of this version is that if it indeed preserves the basic composition of Lu Hong's original work, then *Ten Views* would be the first work in Chinese art history that we could call a scholarly painting, in a style that would dominate Chinese painting after the Song, for its main features are all related to the self-identity of a scholar-artist. First, the painting depicts neither a generic landscape nor a famous public site but a country estate owned by the painter. Second, the illustrations of this private landscape are also a series of self-portraits of the artist, who appears in most scenes, listening to the sound of a stream, standing on top of a small hill, conversing with a fellow hermit inside a cave, or cultivating longevity techniques inside his thatched hut. Third, unlike earlier works that were illustrations by

an artist of someone else's text (see figs. 39, 43), here images and words were created by the same person. Each section of the painting begins with an inscription that identifies a site and describes it (as well as the author's responses to it) in both prose and verse. The accompanying picture is as a visual counterpart of the words rather than a direct representation of the place. Fourth, the monochrome scenes also develop a visual context in which the inscriptions can be appreciated as calligraphy created by the same brush. It is possible that this kind of composite painting existed in Lu Hong's time. Zhang Yanyuan records that Zheng Qian (ca. 690–764), another famous High Tang scholar-artist, once presented to Minghuang a scroll with his own verses, illustrations, and calligraphy. Delighted, the emperor inscribed it with the words "Zheng Qian's three perfections [*sanjue*]."[111]

Except for some fragments from Turpan (fig. 80), no ink landscape painting has survived from the middle or late Tang; even copies are unknown. This situation is particularly unfortunate because these 140 years constitute a crucial period in the history of this art tradition. On the one hand, texts from the ninth and tenth centuries record an increasing number of scholars devoted to painting pines, rocks, and landscapes; on the other hand, the maturity of monochrome landscapes in the tenth century—to wit, Jing Hao's (ca. 855–915) writing and Li Cheng's (919–967) painting (see figs. 92, 93)—imply a previous stage of intense development.[112] Indeed, we may say that this development was the single most important artistic

80. *Pine and Cypress Trees,* fragment of a Buddhist banner found by the Otani Expedition in central Asia, ink on silk, ca. 8th century. (Reprinted from Sullivan, *Symbols of Eternity,* fig. 30. Used with the permission of the publishers, Stanford University Press. © 1979 by Michael D. Sullivan. Photo: Courtesy of Michael D. Sullivan.)

phenomenon in the second half of the Tang, and it was encouraged not by the prosperity of the state but by its decline.

Tang China never fully recovered from the An Lushan Rebellion of 755–763; gradually what had been a great empire shrank in both body and spirit. An anxious court could hardly foster an inventive art style, and religious persecution struck a heavy blow against temple construction. Only scholars, whose art aimed to express inner feelings, found troubles and even torment inspiring. Many intellectuals returned to the old tradition of the Seven Worthies of the Bamboo Grove for escape, finding personal freedom in wine, music, literature, religion, and

philosophy. A crucial difference between them and the Seven Worthies, however, was that painting had become a major vehicle for expressing individuality, and in the middle and late Tang individuality often verged on eccentricity. Zhu Jingxuan puts some scholar-painters into an "untrammeled class" (*yipin*) because in his opinion they did not conform to any established rules and therefore could not be judged by such rules. One of them, Wang Mo (Ink Wang; d. ca. 805), painted only when drunk. He would spatter ink on a piece of silk, laughing and singing all the while. "He would kick at it, smear it with his hands, sweep his brush about or scrub with it, here with pale ink, there with dark. Then he would follow the configurations

thus achieved, to make mountains or rocks, or clouds or water." The virtues of such a painting style lay in the direct response of hand to thought; relying purely on intuition, the artist created images "with a godlike cunning."[113]

This trend toward nonconformity had already begun in the mid-eighth century. Zhang Yanyuan summarizes Zheng Qian's bohemian life-style in a sentence: "Suffering hardship, he loved the zither [*qin*], wine, and chanting poems." Zheng's student Zhang Zao (mid to late eighth century) was considered the most accomplished scholar-painter of the time; a number of famous Tang writers, including Zhang Yanyuan, Zhu Jingxuan, Bai Juyi (772–846), Fu Zai (d. 813?), and Yuan Zhen (799–831), mention his enormous reputation. He was thought to have surpassed all ancient and contemporary artists in painting pines and rocks, and he was equally gifted in composing large landscape scenes —"giving a luxuriant beauty to both heights and lowlands, and superimposing depth on depth within the space of an inch or two." Fu Zai vividly describes both his work and his manner of painting. He reports that Zhang once walked into a banquet without invitation. Roughly demanding fresh silk from the host, he displayed his extraordinary art in front of twenty-four guests.

> Right in the middle of the room he sat down with his legs spread out and took a deep breath, and his inspiration began to issue forth. Those present were as startled as if lightning were shooting across the heavens or a whirlwind were sweeping up into the sky. Ravaging and pulling, spreading in all directions, the ink seemed to be spitting from his flying brush. He clapped his hands with a cracking sound. Dividing and drawing together, suddenly strange shapes were born. When he had finished, there stood pine trees, scaly and riven, crags steep and precipitous, clear water and turbulent clouds. He threw down his brush, got up, and looked around in every direction. It seemed as if the sky had cleared after a storm, to reveal the true essence of ten thousand things.[114]

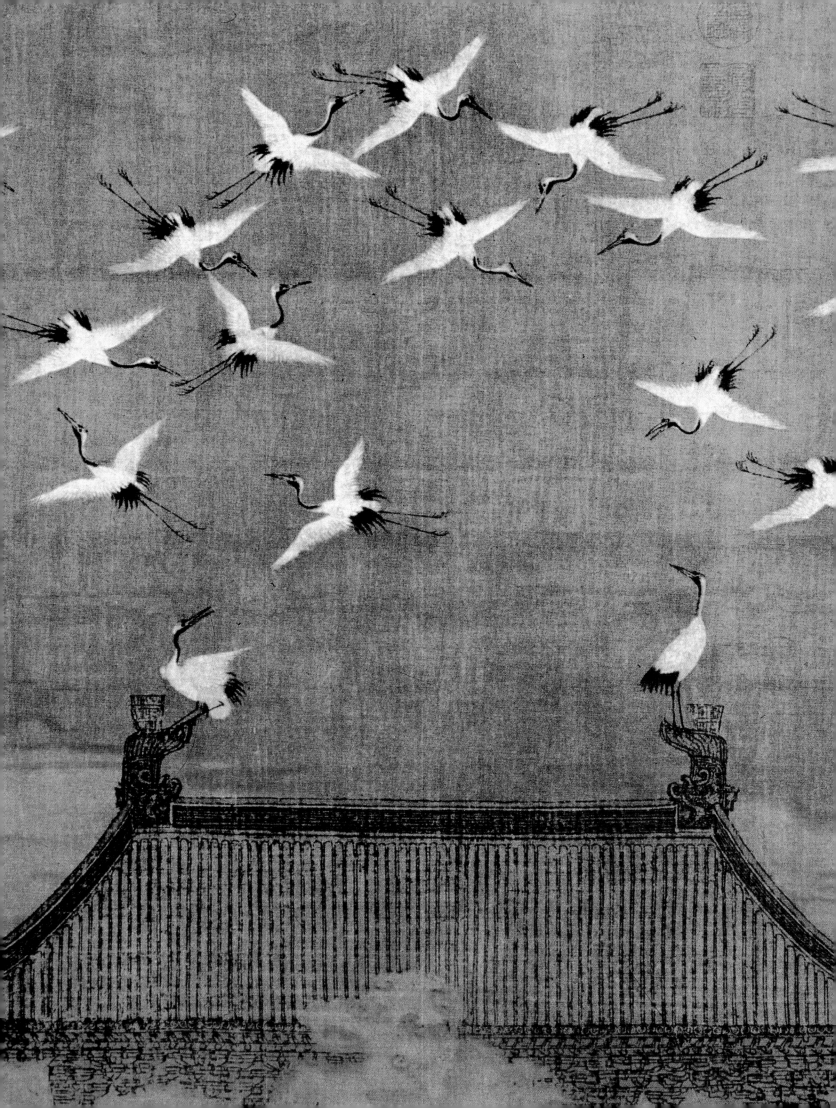

RICHARD M. BARNHART

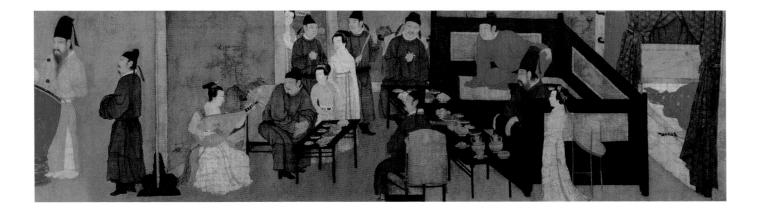

The Five Dynasties (907–960) and the Song Period (960–1279)

The political and military decline of the Tang dynasty extended over many years until, by the beginning of the tenth century, not even the pretense of a central dynasty remained. Rival powers across the old unified empire vied for supremacy for more than half a century without decisive outcome. The five successive states that ruled much of northern China at this time give the period its name, but ten other kingdoms held on to power in other parts of the former Tang realm, and this brief but artistically fertile era is properly called the period of Five Dynasties and Ten Kingdoms.

The three regions that produced the most distinctive artistic cultures were Sichuan, where the Shu kingdom maintained many of the old imperial traditions of the Tang, the Jiangnan state of the Southern Tang, with its capital in Jinling (present-day Nanjing), where a quite different and highly sophisticated royal court created a new and influential form of the Jiangnan culture, and the traditional northern heartland, centered in the former capitals of Chang'an and Luoyang, and in Bianliang (present-day Kaifeng), which would eventually become the capital of the unifying Song dynasty, beginning in 960. These three regions constituted what we might today call the center, and the periphery was also extraordinarily diverse and vital. China was inextricably involved with the surrounding non-Chinese peoples from the late Tang through the Five Dynasties and the succeeding Song period, culminat-

ing in the Mongol conquest of the entire Chinese empire in the thirteenth century. Before that, the Liao, the Xixia, and the Tartar Jin peoples all contributed to the rapidly changing civilization of China.

The Five Dynasties

With the collapse of the central government in 907, artists and craftsmen lost their most powerful patron, the imperial court, which had inspired a true golden age of art and literature in its heyday. The imperial court would not again rise to such heights as patron of the arts until near the end of the eleventh century, but now the regional courts each sought to achieve something that might be regarded as continuing the Tang traditions in art and culture, just as they claimed to maintain those traditions in government — and to make proper claim to the Mandate of Heaven. The Shu kingdom of Sichuan was fortunate in that so many had fled the Tang capital to the traditional western sanctuary ever since Emperor Minghuang himself had "journeyed to Shu" during the disastrous An Lushan Rebellion in 755. By the end of the Tang something like a miniature Tang court existed in Chengdu, complete with poets, scholars, painters, and the other necessary representatives of a flourishing culture.

One of the most celebrated arrivals was the distinguished Buddhist monk painter, poet, and calligrapher Guanxiu (832–912), who arrived in Chengdu in 901, just a few years before the anticlimactic end of the Tang, and remained there until his death. The king of Shu bestowed upon him the honorific name Great Master of the Chan Moon (Chanyue dashi), but he is known by his monk's name, Guanxiu, which means "a string of blessings." Guanxiu is one of the first independent artists famed for his accomplishments in the three arts of painting, poetry, and calligraphy. His art in all three forms is in fact still extant, which is even more extraordinary. The subject for which he gained national fame as a painter was that of arhats, disciples of the historical Buddha, Shakyamuni, who lived harshly simple lives as ascetics in their single-minded devotion to the spirit of the Buddha's teachings. They are the Buddhist equivalent of the original disciples of Jesus and occupy a high place in their spiritual appeal to the masses of worshipers. Artists had been depicting them in painting and sculpture since the Six Dynasties period, often with great power and expressiveness, but it was only with Guanxiu that the image of the arhat took on dimensions that seized the imagination. The set of six-

teen arhats preserved in the Japanese Imperial Household Collection (fig. 81) bears an inscription by the artist dated 894, written in a distinctive seal script as archaic as the images themselves. According to that inscription, Guanxiu began the set in 880 while living in Lanxi, Zhejiang Province, his hometown, and finished it in 894, while residing in Hubei Province.[1] The grotesque, tormented faces of these holy men seem to hold more meanings than even their deep spiritual discipline could suggest. In the view of Max Loehr, Guanxiu's arhats are the visible embodiments of the destruction and suffering of the terrible Buddhist persecutions of the ninth century, when the Buddhist Church was nearly obliterated in China.[2] They indeed seem ravaged by time and memories of death and are depicted by the artist as if they were ancient, wasted survivors of a holocaust. In an age still celebrating the gracious classical figure traditions of the Tang court, these images could only have struck deep chords of amazement and wonder, demanding to be understood in ways that human images in a postpersecution, Neo-Confucian world of order and restraint could not. Guanxiu's arhats, in other words, convey a form of reality that addresses human truth, not aristocratic artifice. Generally speaking, this form of intensified, expressionistic representation — what might be termed psychological archaism — forms a minor, recurring theme in the long history of Chinese painting and is primarily associated with Buddhism. Pain, suffering, and death — the realities of human experience — are scarcely visible anywhere but in Buddhist art, although occasionally they surface surprisingly elsewhere as well, even in the realm of court-sponsored painting.

The primary physical format of painting at the end of the Tang dynasty was still the wall surface, in all probability. Large wood-framed screens were also in common use, and it was during the course of the tenth century that these traditional public formats were seriously challenged by smaller, more portable forms of painting. As scale and function changed and the relation between object and viewer narrowed and became more intimate, new nuances of technique developed and became characteristic of painting in general. By the end of the eleventh century, the techniques of painting had been thoroughly transformed from those used for broad, large-scale wall painting to those used for refined, precise, and elegant miniatures.

Among the most important examples of tenth-century wall painting that still exist is a group of fragments acquired in 1923 by the dealer C. T. Loo and kept at his house in Paris for many years until their publication in

81. Guanxiu, *The Arhat Pindola,* detail of a hanging scroll, ink on silk, 880–894. 90 × 45 cm. Japanese Imperial Household Collection, Tokyo.

1949.[3] They remain today among the finest examples of Chinese wall painting outside the magnificent cave-temples at Dunhuang. In one fragment in the Nelson-Atkins Museum (fig. 82), a strong and refined version of the old Tang (Wu Daozi) style of light color over tensile lines is used to convey the images of two bodhisattvas preparing incense. They probably occupied a large wall together with numerous other saintly beings attending central Buddhas, while before them may well have stood sculpted images, also colorfully painted, in the manner still seen so vividly and dramatically at Dunhuang. Repeated and disastrous persecutions of Buddhism (including one in 955 that destroyed much of the art in north central China, where the present fragments somehow survived) have caused the loss of most such early wall painting in north China; but these bits and pieces testify to a high level of refinement and skill and allow us to connect the great age of Tang wall painting through this period to the late thirteenth and fourteenth centuries, when it reappears in considerable numbers, maintaining a still impressive level of quality. This unbroken tradition is the backbone of the profession of Chinese painting from the seventh century through the fourteenth, and it is to be regretted that so little of it remains.

When the distinguished scholar of the history of painting Guo Ruoxu looked back from the year 1074, when he wrote his *Tuhua jianwen zhi,* or "Record of My Experiences in Painting," across the development of painting from the mid-ninth to the late eleventh century, he observed that no one in his dynasty, the Song, had surpassed the greatest Tang masters of figure painting and narrative subjects. We can affirm this today by comparing the greatest accomplishments at Dunhuang with the most celebrated examples of Song figure painting. Even though not a single original work by any great master of the Tang exists today, it is clear that the Tang achievement in figure and narrative painting went far beyond the Song in ambition, drama, dynamic energy, and narrative power.

Guo also observed, however, that in the painting of landscapes and bird-and-flower subjects the Tang masters did not come up to the standards of the Five Dynasties and the Song. Of this, too, there is no doubt. The differences in these assessments by a thoughtful scholar of painting reflect the fact that subjects rooted in the natural world of flora and fauna, mountains and rivers, gardens and lakes, had gained the interest of artists in the waning years of the Tang and the chaotic half-century of the Five Dynasties. There were few human glories to promote and probably very little satisfaction in the conditions to which human endeavors had brought the once-mighty empire of China. Artists, of course, continued to paint the familiar religious and historical narratives they had been painting for many centuries. Judging from the works of Guanxiu and the unknown wall painters we noted, such work was done at a high level of originality and quality, but it is interesting to observe that Guanxiu achieved his strange power by internalizing the spirit of his sainted subjects and grotesquely deforming their exterior, while the wall painters attained such a high level of quality by the sheer refinement of their techniques. Refinement of technique — drawing, brushwork, color application, shading — and the pursuit of some inward form of spirit or meaning are both characteristic of the highest achievements in Song painting, and we see those elements beginning to appear in their work even though both Guanxiu and the wall painters were essentially Tang artists who lived on after the end of the Tang.

The Development of Bird-and-Flower Painting

Guo Ruoxu, in his comparison of the past and present, argued that if any of the Tang masters of bird-and-flower painting could be reborn in his own time they would fall far short of the great tenth-century masters Huang Quan (903–965), Huang Jucai (933–after 993), and Xu Xi (d. before 975), and their work would seem primitive and dull. These three masters were the most celebrated artists of the popular bird-and-flower subjects

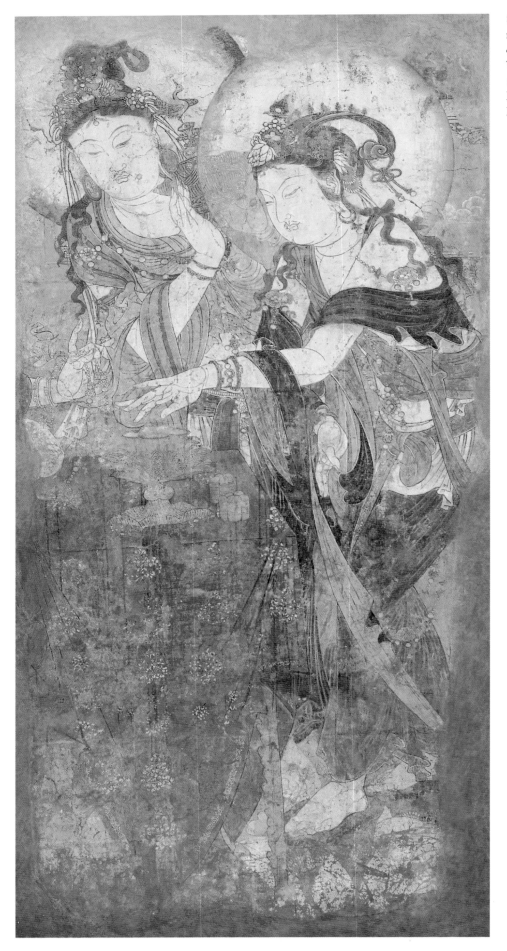

82. *Two Bodhisattvas Preparing Incense,*
mural, fragment of a wall painting
originally from the Cishengsi,
Wenxian, Henan Province, 952.
175.3 × 89 cm. Nelson-Atkins
Museum of Art, Kansas City,
Missouri. (Gift of Mr. C. T. Loo.)

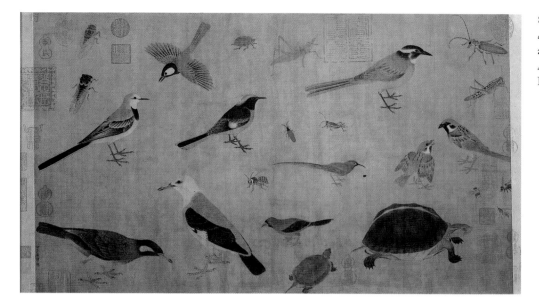

83. Huang Quan, *Sketches of Birds and Insects,* handscroll, ink and color on silk, ca. 960. 41.5 × 70 cm. Palace Museum, Beijing.

who had ever lived, and their influence over the Song and later periods was incalculable. Xu and Huang Quan, in particular, seemed to the critics of their time to have seized the twin peaks of artistic expression, Huang in the realm of the aristocratic and wealthy, Xu in the realm of the retired scholar. Xu Xi's work unfortunately has not survived, but works plausibly associated with Huang Quan and his younger son, Huang Jucai, give form to Guo Ruoxu's words.[4] *Sketches of Birds and Insects* (fig. 83), in the Palace Museum, bears a signature of Huang Quan and a brief inscription presenting this picture to his oldest son, Huang Jubao (d. ca. 960). Jubao, too, was an accomplished painter, and the Palace Museum painting was given to him by his father specifically for him to study. The painting is a series of careful life studies of various birds, insects, and other small creatures, each precisely, realistically rendered and colored, a bit like the nature studies of Dürer. We must assume that one reason for the newly realistic manner of such representations was that painters like Huang Quan were systematically drawing from life. It is obvious, furthermore, that the same thing was being done by landscape painters and by portrait painters. In fact, there was no real differentiation between the artists who were painting all of these subjects. Huang Quan, for example, was a painter of landscapes and figures as well as bird-and-flower subjects, and he probably represents the class of painter generally.

Huang Jubao died before reaching the age of forty, and his works are not known today. His younger brother, Jucai, however, achieved great fame as a follower of their father and carried the family tradition to the new Song court at Bianliang in 965, where it was established as the basis of the Song academic style of painting. The one

painting believably attributed to the younger Huang is *Pheasant and Small Birds by a Jujube Shrub* (fig. 84). This worn and damaged silk scroll still bears most of the documentation — seals, title inscription and attribution, mounting material — given to it in the early twelfth century by Emperor Huizong (1082–1135; r. 1101–1125). In a simple and rather limited composition, we can find some of the motifs of Huang Quan's nature studies transformed into a finished picture. This is probably typical of the practice of painting throughout most of the period from the tenth through the fifteenth centuries among professional masters. Workshops, or studios, employing assistants and disciples (often sons, nephew, or grandsons of the master) worked under the direction of the master to produce his products using his models and guidelines. Painters were craftsmen or artisans by social classification, and their profession was largely hereditary, a family trade. Huang Quan transmitted his trade to his sons and they to theirs, presumably, and even Xu Xi, the "retired scholar," passed his art on to his two grandsons.

The Huang family, serving the Shu kingdom in Sichuan, established the classic bird-and-flower style of painting and saw that style become the standard for the newly established Song court. Another Sichuan family of painters, named Gao, did the same thing for figure painting and Buddhist and Daoist icons. Gao Daoxing, Gao Congyu (ca. tenth century), and Gao Wenjin first served the Shu kings for three generations, then, in the person of Gao Wenjin, accompanied the last Shu king to Bianliang in 965 and became the founder of the Song figure style. A signed and dated (984) woodblock print found inside the Seiryoji Buddha a few years ago is the only document of

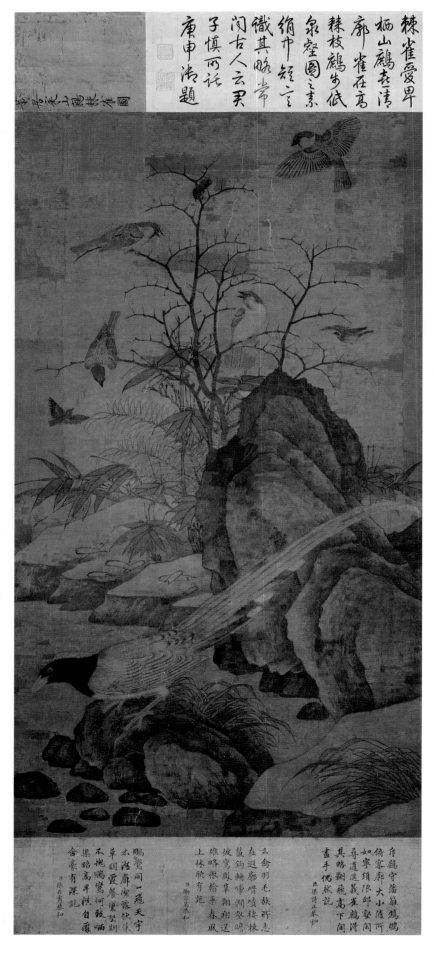

the Gao family tradition, but in a larger sense the entire tradition of such painting in the Song can be said to derive from this Sichuan origin.[5] Of course, the Gao manner was in turn based upon the classic Tang manners of Buddhist representation, namely, those of Wu Daozi (active ca. 710–760) and Cao Buxing, which, by the end of the Tang dynasty, any self-respecting painter was expected to have full command of.

By the early twelfth century the Song imperial government owned more bird-and-flower paintings than any other subject. Because this was one of the most demanding and difficult of subjects, requiring long and painstaking study of natural forms and many years of apprenticeship in order to acquire the depth and variety of techniques and craftsmanship required for even perfunctory representations of, say, kingfishers in autumn bamboo, the sheer numbers of such works in the government's hands must suggest that there was not only a great and continuing demand for such paintings, but also a great supply of painters specializing in them. The Huang Quan and Huang Jucai paintings confirm the remarkably high quality of such works and offer some evidence of the nature of the central imperial style. A later work in the tradition, Cui Bai's (active ca. 1050–1080) *Magpies and Hare* (see fig. 108), seems to indicate that the dominance of the Huang style extended all the way down to the mid-eleventh century. At that point, we also know from texts, a new generation of painter appeared, challenging the old traditions and establishing the foundations for the later academic manner.

The Early Development of Landscape Painting in North China

Between about 900, in the waning years of the Tang dynasty, and the establishment of the new Song state in 960, an equally profound development took place in landscape painting. At the beginning of that brief period, there was no clear image of what landscape might be; at its end, something like a national style of landscape existed, and the later history of the subject had its foundations.

Trying to understand what happened a thousand years ago in an art form that even then was dependent upon fragile pieces of silk is naturally controversial. Any painting surviving from that period has been badly damaged and often repaired and repainted. Its provenance will in-

84. Huang Jucai, *Pheasant and Small Birds by a Jujube Shrub,* hanging scroll, ink and color on silk, ca. 975. 97 × 53.6 cm. National Palace Museum, Taibei.

evitably be substantially unknown, and it will be an almost isolated example of its type. Replicas of old and damaged paintings were regularly made, moreover, and it may have become impossible to distinguish them from their models. On the other hand, the successive government collections were systematically catalogued and documented, and many years of study of those collections and of the documentation of early Chinese painting in general allow us to think that at least we are protected from making the worst kinds of mistakes in writing about the art of this period. Throughout the tenth and eleventh centuries, however, it would be well to acknowledge that we are looking at the *style* of the master or school we are considering, not necessarily at authentic works from the master's hand.

According to all textual sources, Jing Hao (ca. 855–915), from Qinshui, Henan Province, was among the first distinctive masters of landscape. Born under the Tang and probably, like Guanxiu, active under the successive brief dynasties for only a short time before his death, Jing is recalled as a scholar and theorist as well as painter. His treatise on the art of landscape painting was kept in the imperial treasury of the Song government.[6] According to Guo Ruoxu, by the later tenth century Jing Hao's art already appeared primitive and had been far surpassed by even his students, such as Guan Tong (early tenth century). Guo therefore lists Guan Tong among the great landscape masters of the period but refers to Jing Hao only as a predecessor of the great masters.

For that reason, the two paintings attributed to Jing Hao today both appear questionable. Both nonetheless offer pictorial evidence of the evolution or development of early landscape painting, and both bear the name of Jing Hao. Together with the version of his essay on landscape that exists today, they define the art of Jing Hao as well as it can now be defined. One landscape, owned now by the Nelson-Atkins Museum, was reportedly recovered from a tomb and appears almost too primitive and odd to be the work of Jing Hao.[7] It has suffered serious damage to much of its surface and has been crudely retouched. Nonetheless, its signature in seal script is oddly remindful of the seal script signature on Guanxiu's almost exactly contemporary arhats, and there is a rather primitive character to the landscape itself that is also vaguely harmonious with Guanxiu. The Nelson-Atkins picture, in other words, appears to be of the late Tang period and roughly coterminous with Guanxiu.

Mount Kuanglu (fig. 85), on the other hand, is far too advanced and impressive an image of monumental landscape to have ever been counted inferior or preliminary

to the mature landscape art of the Song. It is a grand, confident image of a great range of sheer peaks rising sharply row upon row from a steep river valley. Waterfalls plunge dramatically from the high peaks, and old pines grow ruggedly from the hills. One residence is built by the river, another higher up, and a ferryboat plies the water. Painted in ink with only very slight touches of color on a large silk panel the size of a screen, this is an image of grandness — but also of comfort and invitation to the would-be traveler. The name of Jing Hao appears in the inscription written in the upper right corner by an emperor of the Yuan dynasty who also ordered two scholars attending him to inscribe the scroll (later inscriptions were written by the Qianlong emperor in the eighteenth century). Perhaps we should regard both the painting and its inscriptions as a kind of homage to Jing Hao.

Jing's student Guan Tong typifies those all over China in the early tenth century who were driven by the beckoning image of landscape to find ways to depict it believably and compellingly. He achieved finally a distinctive Guan style of landscape that attained great popularity in north China, testifying to the enormous appeal of the new landscape painting. Several handsome pictures are attributed to Guan Tong and preserve his style, but there are no signed works.[8] *Autumn Mountains at Dusk* (fig. 86) appears to be the pictorial equivalent of one of the celebrated poems describing hard journeys, like Li Bai's "The Road to Shu is Hard" (*Shudao nan*). A barely visible steep path climbs the dark cliffs, and the top of a pagoda appears distantly over the tops of the highest peaks; there is, then, a path here, but its way is difficult and its goal mysterious. The style emphasizes hard rock surfaces and densely compact forms, as in the *Mount Kuanglu* attributed to Jing Hao, and it is likely that these two strong, rocky landscapes represent the early northern tradition in its most plausible form today. Interestingly, when a northern tomb dating from the later tenth century was excavated a few years ago, the silk landscape scroll found in it resembled this manner.[9] It is a style particularly suited to the representation of hard, high, sheer mountain peaks, narrow pathways, and difficult ascents, and it clearly remained popular in the northern areas of China through the tenth century at least.

The Jiangnan Landscape Style

In the flourishing sphere around Jinling, the capital of the Southern Tang kingdom in these same years, a very different manner of landscape was emerging. Termed later the Jiangnan style — referring to the geographical

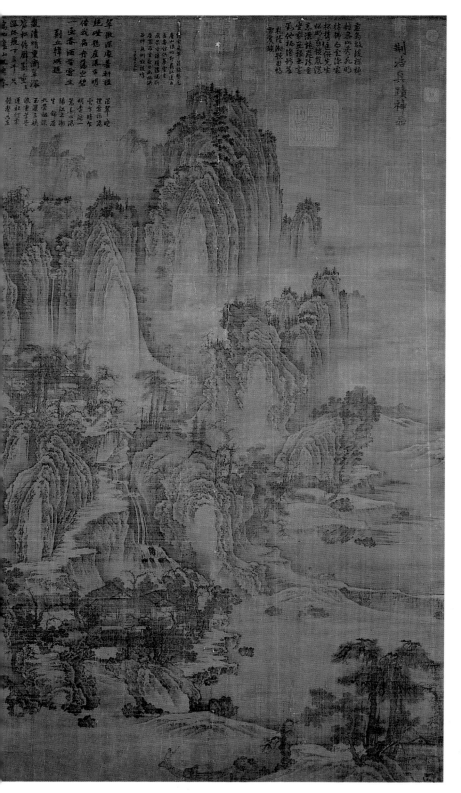

85. Jing Hao, *Mount Kuanglu,* hanging scroll, ink and light color on silk, ca. 900. 185.8 × 106.8 cm. National Palace Museum, Taibei.

86. Guan Tong, *Autumn Mountains at Dusk,* hanging scroll, ink on silk, ca. 925. 140.5 × 57.3 cm. Collection of the National Palace Museum, Taibei.

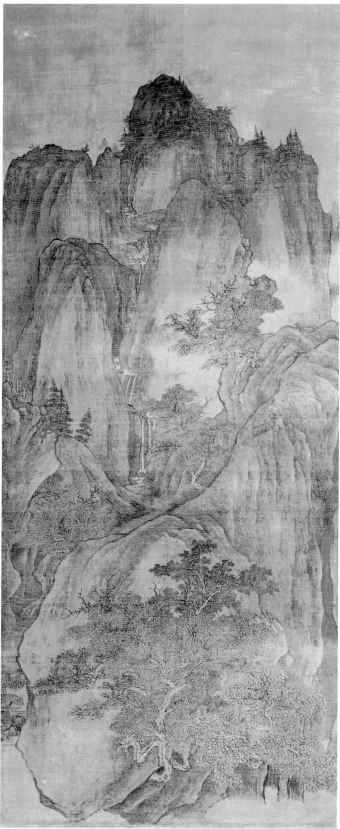

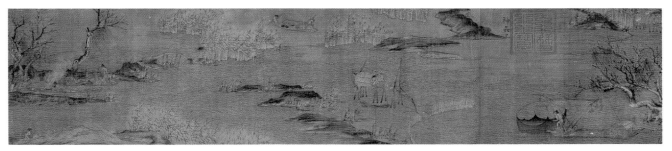

87. Zhao Gan, *Along the River at First Snow,* section of a handscroll, ink and color on silk, ca. 950. 25.9 × 376.5 cm. National Palace Museum, Taibei.

area south of the Huai River, centering in the area of Jinling, or present Nanjing, in Jiangsu Province — this distinctive southern landscape style would have tremendous influence over later artists, but for the present evolved mainly as a localized regional manner. The Southern Tang state achieved a remarkably high level of artistic culture, inspired and patronized by the Li family that ruled the kingdom, and would later be regarded as the standard the Song conquerors of Southern Tang would need to emulate and surpass. Among the minor artists serving the Southern Tang court was Zhao Gan (mid tenth century), whose biographical notice in Guo Ruoxu's *Tuhua jianwen zhi* tells us only that he was skilled at the painting of river subjects and was employed at the Southern Tang court as a student in the Imperial Painting Academy (Huayuan xuesheng). Zhao's long handscroll *Along the River at First Snow* (fig. 87) simply by its survival has become one of the remarkable documents of Southern Tang art. Like a student of river life, Zhao depicts the activities of peasant fishing families in the Nanjing area as the first snow falls along the river. There is a quality of authenticity to this portrayal of daily life in ancient China that owes much to the painter's attention to details of material culture — nets, shelters, costume, fishing apparatus, boats — as well as to his skill in describing gestures, movements, and nuances of human behavior. To approximate the appearance of large, soft snowflakes he blew white pigment through a screen of some kind, splattering it lightly over his silk surface. At the right edge — the beginning of the scroll — an apparently royal hand inscribed the painter's name and rank and the title of the composition in a single vertical column. It is believed that the writer was the last Li prince, Li Yu, who was a great poet, calligrapher, and painter himself.

The landscape elements in Zhao Gan's handscroll, loosely and broadly painted with few sharp contour lines — and hence quite different from the crisply drawn northern landscape we considered above — are doubtless a reflection of the two great masters of Jiangnan landscape, Dong Yuan (d. 962) and Juran (active ca. 960–

985). They had created a loose, wet technique of painting that must have been particularly appropriate to the mist-filled river and lake country in which they lived. The style is seen, for example, in *Summer Mountains* (fig. 88), a handscroll attributed to Dong Yuan (and in two other very similar handscrolls),[10] in *Wintry Groves and Layered Banks* (fig. 89), and in the two landscapes attributed to Juran that we illustrate here, *Distant Mountain Forests* (fig. 90) and *Buddhist Retreat by Stream and Mountain* (fig. 91).

Dong Yuan's compositions are of broad, level riverways and lakes, like the landscape around the lower Yangzi near Nanjing, formed by the many waterways feeding the Yangzi and nearby Lake Dongting. This is fishing country and delta land, where deep, rich soil produces dense growth, where water buffalo and sheep wander at pasture, and over which wet mists settle in the evening. Formed from loose, wet inkdots and broad, flowing inkwashes mixed with tangled, ropy brushstrokes, Dong Yuan's *Summer Mountains* is a placid riverscape that invites leisurely contemplation, a reflective paradise that would attract the busy official to its endless, placid reaches and its warm summer growth, to its fishing streams and its shady paths. The contrast to any northern landscape of the time is striking.

Wintry Groves and Layered Banks extends the intimacy of a handscroll into monumental scale, becoming a window onto endless marshy waterlands literally filling the scope of our vision. The technique here is vigorous and bold, as befits a large scroll, but almost impressionistic too in the broken, sketchy quality of representation. Clearly, the Jiangnan landscape masters conceived landscape itself in a way very different from their northern counterparts.

The contrast may be most striking in the art of Juran, who was a Buddhist priest. How the doctrines of religion and philosophy in China formed themselves in art is difficult to say, but we may conclude with some confidence that the paintings associated with Juran (of which there are only three that possess strong historical character) refer somehow to the Buddhist view of existence.[11]

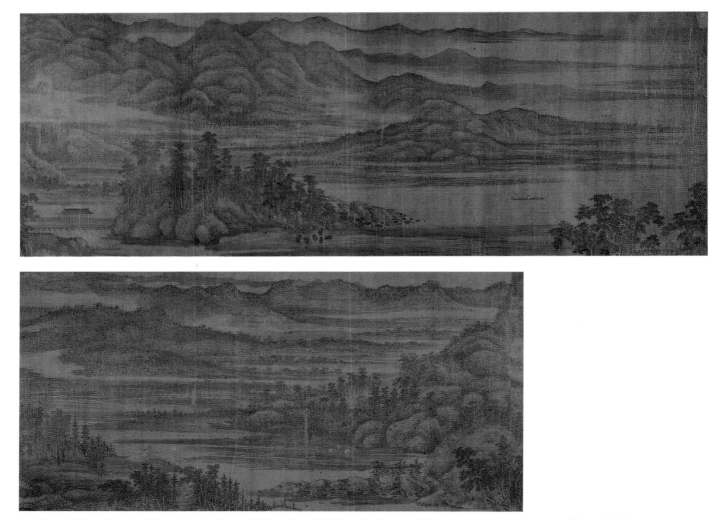

88. Dong Yuan, *Summer Mountains,* sections of a handscroll, ink and color on silk, ca. 950. 49.2 × 311.7 cm. Shanghai Museum.

In this mental cosmos, phenomenal matter has no fixed form or reality, no permanence, and all existence is in a constant state of flux. Dong Yuan's style of painting is obviously perfectly suited to such a vision, even though he himself had no known connection to Buddhism, and Juran evidently saw that capacity to convey his own mind's eye. Certainly, his *Distant Mountain Forests* and *Buddhist Retreat by Stream and Mountain* are perfect images of contemplation, images in which there are no fixed forms, no boundaries, no tactile substance, and no certainty at all as to the nature of existence or means by which we might pursue it. Pale ink and liquid brushstrokes create images of almost ethereal sublimity in which only deserted pathways and empty huts offer any sense of human presence.

The Northern Song

The Song state that emerged from the military campaigns and intrigues of the Five Dynasties in north China to begin reunifying the old empire in 960 would ultimately differ substantially from every dynasty in Chinese history. It began, however, as did all dynasties, as a story of heroes and villains, alliances and sworn oaths, great battles, victories and defeats, and the leader who won the day and became the first emperor of the new Song dynasty was Zhao Kuangyin (927–976). The government he established became one of the most accomplished and decent in history, and its achievement in the realm of art would become the foundation for all later dynasties. From 960 until the Tartar Jin invasion and conquest of north China in 1127, the Song ruled most of the traditional empire of China. This period is called the Northern Song. In the interim between the Tartar onslaught in 1127 and the

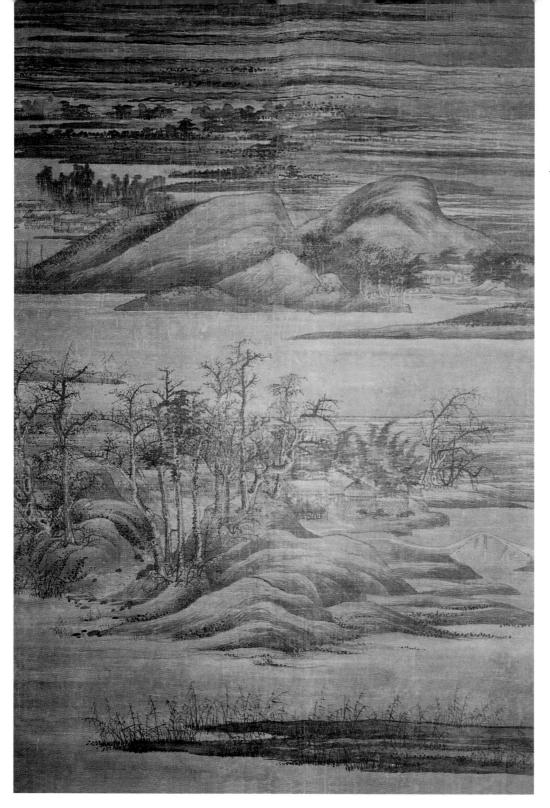

89. Dong Yuan, *Wintry Groves and Layered Banks,* hanging scroll, ink and color on silk, ca. 950. 181.5 × 116.5 cm. Kurokawa Institute of Ancient Cultures, Hyogo, Japan.

Mongol occupation of all of China in 1279, the Song government succeeded in reestablishing itself in south central China, in what is now the city of Hangzhou, and maintained rule over most of southern China. This last era of the Song is called the Southern Song.

During this three-century reign of the Zhao Song dynasty, the art of painting flourished as it never had before. The profession of painting had expanded so explosively that four separate histories of painting were written between about 1060 and 1167, and numerous other biographical, theoretical, and investigative writings were compiled as well.[12] Catalogues of the entire government collection of art and antiquities were compiled in the early twelfth century, the first such undertaking ever published.[13] Of paintings alone, 6,387 are recorded. The Song emperors, beginning with the founder, took a genuine interest in the arts, and the eighth emperor, Huizong, a poet, calligrapher, and painter, became the very model

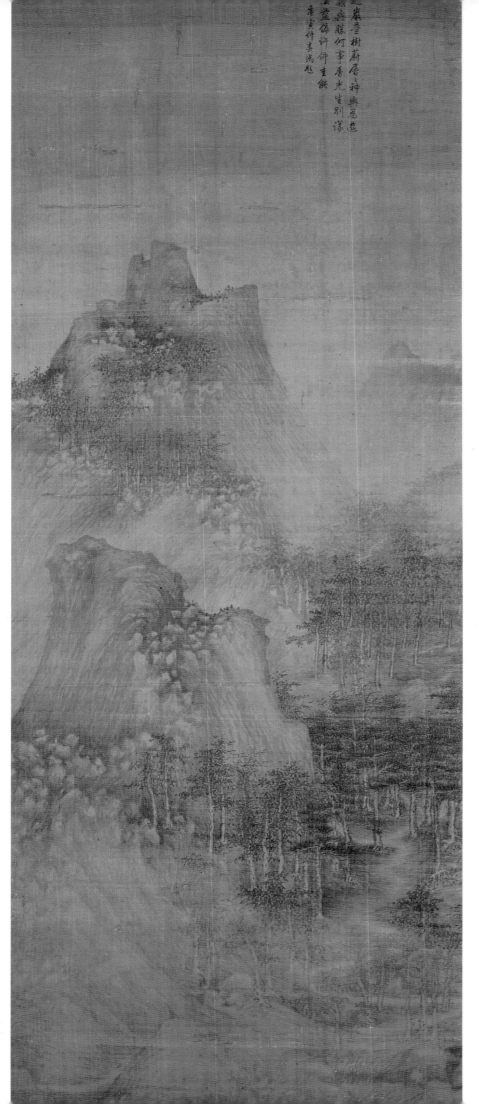

90. Juran, *Distant Mountain Forests,* hanging scroll, ink on silk, ca. 980. 144.1 × 55.4 cm. National Palace Museum, Taibei.

91. Juran,
*Buddhist Retreat by
Stream and Mountain,*
hanging scroll,
ink on silk, ca. 980.
185.4 × 57.5 cm.
(© Cleveland
Museum of Art,
1995. Gift of
Katherine Holden
Thayer, 59.348.)
opposite

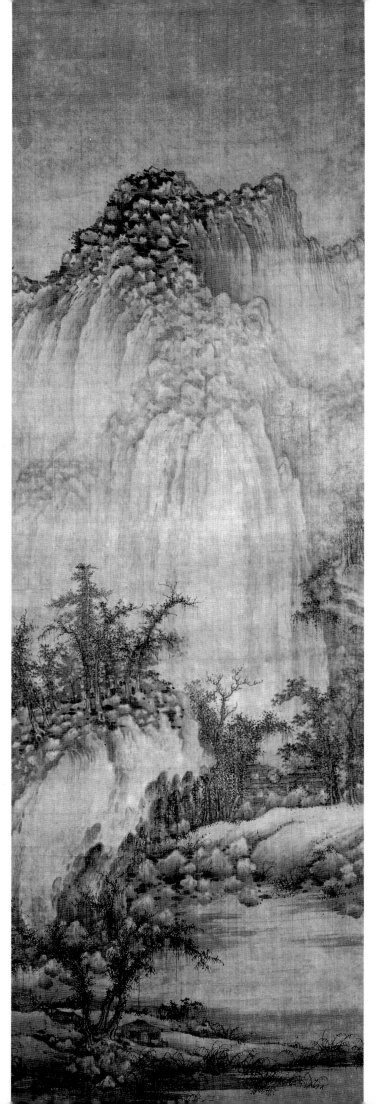

of artist-emperor. Their court became the national center for artistic activity of every kind, from porcelain to ritual music.

Even writing about the art of painting became a challenge because there were so many painters, so many paintings, and so many subjects of nearly every imaginable variety. Scholars of art now had to think about how such a vast body of material could be organized. The form they preferred, on the whole, was classification by subject of specialization. This had not been necessary before the Song, but it too quickly expanded, almost like a miniature model of the profession of painting itself, from the five categories of Guo Ruoxu and six of Liu Daochun to the ten of the Song government catalogue. Even this was inadequate to the varieties of subjects practiced regularly by Song artists. I shall, in any case, follow this pattern in exploring the range and variety of Northern Song painting.

Landscape Painting in the Early Song

Li Cheng (919–967) was born into an aristocratic family that had fled the disruptions of late Tang to Yingqiu in Shandong Province. His father and grandfather had both distinguished themselves for their scholarship and their official conduct, and Li Cheng was raised as a scholar and artist. Later his own son, Jue, became a scholar on appointment to the Hanlin Academy and was invited to lecture to the founding Song emperor on the Classics. Li Cheng's elevation to a position somehow comparable to that of master to the Song nation — and creator of what became the Song national landscape style — is a fascinating story yet to be told. Surely, however, it was significant that he represented both the Tang aristocracy — the old elite — and the newly forming class of scholar-official — the new elite.[14] Li's handsome and inviting landscape art also represents a merging of the northern and southern traditions, as if it were in microcosm the symbolic story of the Song reunification of China. Using the dramatic high mountain compositions of Jing Hao and Guan Tong together with the "pale ink and light mists" of the Jiangnan masters — whose art he obviously knew somehow, as Wai-kam Ho has suggested — Li fashioned a harmonious, spacious, and enormously popular style of landscape representation that attracted multitudes of admirers and hundreds of followers, spawning a tradition of landscape painting that dominated the art until the very end of the Northern Song period in 1127.

Li Cheng's classic landscape style is seen today most clearly in two compositions, *A Solitary Temple amid Clear-*

ing Peaks (fig. 92) and Thick Forests and Distant Peaks (fig. 93). Both paintings are generally assumed to have been painted by followers of Li sometime in the early Song period, but there is no reason not to associate them both directly with Li himself. They have much in common with the works of near-contemporaries like Juran, Fan Kuan (active ca. 1023–1031), and Yan Wengui (active 980–1010) (see fig. 95) and cannot be much later than tenth century in date. Within that context, however, they are distinctive in their richness of tonality, density of form, and harmony of shapes and relations. To describe them as elegant seems appropriate. Li's Solitary Temple amid Clearing Peaks and Juran's Buddhist Retreat by Stream and Mountain have much in common and probably together represent the most distinctive achievement of early Song landscape painting. Juran, at the belated surrender of his state and lord to the Song in 975—fifteen years after the Song declared itself the national government of China—accompanied Li Yu to the capital and there entered the Kaibao Temple. Later he was invited to paint landscapes for the newly built halls of the Hanlin Academy and is said to have imitated Li Cheng. The Cleveland painting is thought to reflect precisely this period of Juran's life and of the formation of a national Li Cheng style. Li Cheng's own work is sharper, more linear, more densely layered, and more crystalline than Juran's, but the similarities between them are striking.

Li Cheng's works contain rich human and architectural details — temples, villages, bridges, pagodas, wine shops, pavilions, and pathways — and constitute deep miniature realms of imaginative construction, dream worlds that one is invited to enter like a tray landscape, or pencai (bonsai in Japanese). Their compositional structure, however, is the very structure of the new empire of Song, with the Son of Heaven represented in the dominant central peak, his ministers and associates in the supportive ranges and hills around the central peak, and the entire vast structure as ordered, clear, and infinite as the great empire of China itself. There is no dust or dirt, no violence or disorder, nature is placid and benevolent, controlled by the power and wisdom of the enlightened ruler who has brought humanity to this lofty condition through wise interaction with Heaven.

Li Cheng's image of the Song world was formed on the efforts of Jing Hao and Guan Tong in the north and of Dong Yuan and Juran in the south, but the entire process of initial experiment to final culmination in the evolution of this art did not take more than fifty years. This dramatic span of time extended from the sad and chaotic end of a great dynasty through fifty years of conflict, tension, and competition among contending states, to the process of reunification that established the Song, a process that in itself took fifteen years or more after 960. The beautiful and elegant world opened up for us by Li Cheng is the painter's version of the new Song state, a state that would become the most dynamic, cultivated, and richly accomplished in Chinese history.

Li's followers represent the canon of landscape painting. Fan Kuan, Yan Wengui, Xu Daoning (ca. 970–1051/1052), Guo Xi (ca. 1001–ca. 1090), Li Gongnian (late eleventh, early twelfth century), and many others whose works are lost extend the Li Cheng tradition into the twelfth century. Each artist formed a personal manner reflecting his own life and ideals but formed closely upon the structure established by Li Cheng.

Fan Kuan was a Daoist mountain man — not one of the fashionably attired urban aesthetes who took the name shanren ("hermit" or "mountain recluse") in order to add a dollop of unconventionality to their quite civilized persona, but an actual mountain man who lived far from the cities of Luoyang and Bianliang, dressed in heavy, old-fashioned clothing, loved wine and the Way, and was an open, generous man of rough and rustic manner. He could not have been more different from Li Cheng, the accomplished and elegant aristocrat. Once, when the great painter Wang Shen (ca. 1048–ca. 1103) tried to characterize the two great masters, he chose the dichotomy of wen and wu, or, broadly, the civil and the military. In China, from the Song period on, the military aesthetic held increasingly little attraction to the ruling powers, and Fan Kuan may be among the last artists whose art was admired for its evocation of heroism, courage, forthrightness, and directness. Surely not by chance, Wang Shen himself was born into a distinguished military family. He further noted this distinction: Li Cheng's landscapes open like windows onto distant and attractive vistas; Fan Kuan's press close to us, blocking our view like walls.

Fan Kuan's sole extant work is one of the masterpieces of landscape painting in the world. Travelers by Streams and Mountains (fig. 94) is about 1.8 meters high, two panels of silk joined at the center and mounted now as a hanging scroll. Originally, perhaps, it was mounted on a large screen or wall; it commands our view with the power of a wall, setting before us a citadel of rock cliffs. Like

92. Li Cheng, A Solitary Temple amid Clearing Peaks, hanging scroll, ink on silk, ca. 960. 111.4 × 56 cm. Nelson-Atkins Museum of Art, Kansas City, Missouri. (Purchase: Nelson Trust.)

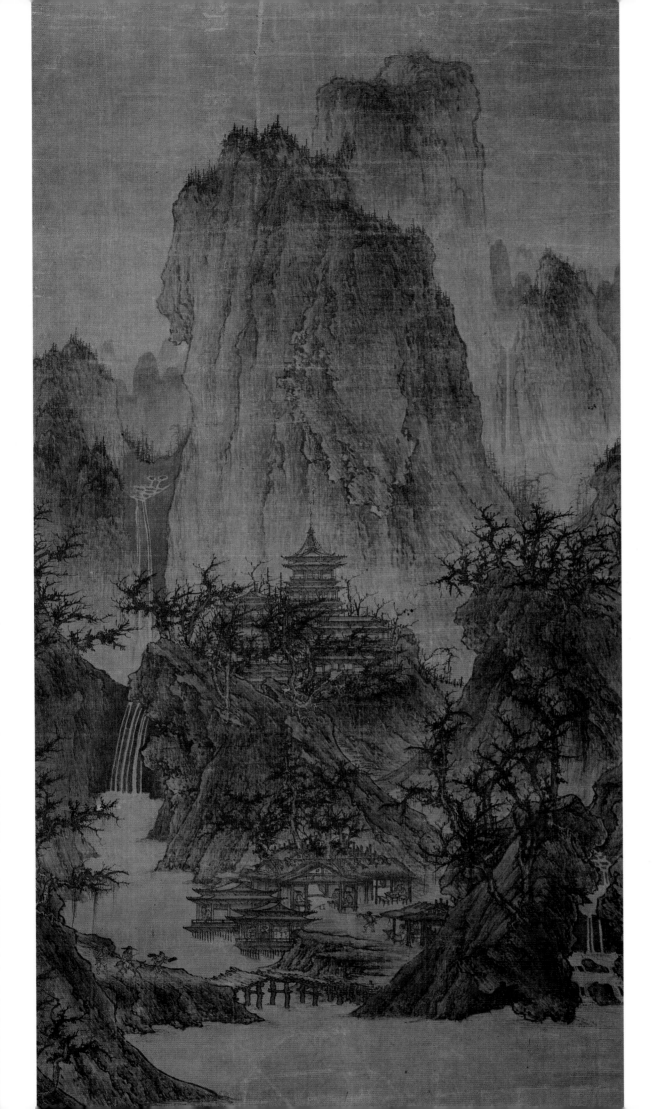

93. Li Cheng, *Thick Forests and Distant Peaks,* detail of a handscroll, ink on silk, ca. 960. 45.4 × 141.8 cm. Liaoning Provincial Museum, Shenyang.

the Great Wall of China or the ancient walls of Beijing, these powerful, massive forms permit no entry, extend no invitation. The gates are permanently closed to casual travelers, although hardy mountaineers like the mule train drivers in the foreground might pass through, and a few adventurous Daoist travelers like the one barely visible near the center of the picture occasionally pass through seeking sanctuary. These are the mountains in which Fan Kuan lived, we suppose, the mountains he saw every day of his life, wandered through in all weather, slept in sometimes, hunted and fished in, and chose to paint as he knew and loved. The indomitable will and ambition of the early Song period is surely embodied in this image, its strength and its courage, its military might and confidence. Slowly the Song rulers withdrew from this position toward a suspicion of military strength that brought its own fruits and its own failures, but for a time the image of the great Song was certainly and powerfully conveyed by Fan Kuan's *Travelers by Streams and Mountains* — and we are still able to sense in his image those qualities and to remember a nation and a people at a unique historical moment in time through it.

Fan Kuan and Li Cheng were recognized almost instantly, it seems now, as the preeminent landscape artists of the Song dynasty, and if their art is the combination of *wen* and *wu,* then it was surely also seen as entirely appropriate to the new age, a perfect merger of the two necessary sides of statecraft. Many others explored the terrain within these parameters, finding new and attractive ways to convey the beauty of the natural world to a nation that had quite suddenly recognized that world as its own im-

age and reality. Yan Wengui was a contemporary of Fan Kuan, active in the late tenth century. He too was associated with the military and originally posted to army duty. As a landscape master in the growing tradition of Li Cheng he favored a distinctive manner, emphasizing exquisite detail and refinements of execution, and a kind of miniature polish that was not only exceedingly popular in its time, but that took root in the Imperial Painting Academy loosely established in the early Song to become the mainstay of academic landscape painting at Bianliang for many years. Yan's *Pavilions and Mansions by the River* (fig. 95), a rare early handscroll on paper, exemplifies the strengths and weaknesses of his art.

Architectural Subjects

This popular genre of Song painting was identified as a separate subject category only in the eleventh century. Most professional painters no doubt painted architecture, carts, boats, and bridges as necessary to depict landscape and urban scenes, genre subjects, and so on, but there were also specialists in the subject, men who devoted themselves to an ambitious exploration of intricacy of detail and concreteness of illusion, as it was recognized were required of true masters of this category. Guo Ruoxu noted, "When one paints architectural constructions, calculations should be faultless and brush drawing of even strength. Deep distances penetrate into space and a hundred diagonals recede to a single point."[15] Three paintings will illustrate some aspects of this genre. Guo Zhongshu's (ca. 910–977) *Traveling on the River in Clearing Snow* (fig. 96) was originally a very large horizontal composition, at least seventy-five centimeters high and three times that length, an accurate copy of which is owned by the Nelson-Atkins Museum.[16] The present fragment bears an inscription by the Jin emperor Zhangzong (r. 1190–1208) with the painter's name and title. Two heavily loaded riverboats are being pulled along a frozen winter river, as the numerous figures on them are glimpsed across the intricately rendered boat architecture. Some huddle against the cold, others point and chat about the towing process. The goal here is in the attainment of intricacy of detail and coherence of illusion in the rendering of man-made things, achievements that require knowledge and experience beyond the normal expectation of painters. Guo Zhongshu's painting, according to the *Xuanhe huapu,* was "lofty and antique and has never been easy for people to understand."[17] By the time that was written, of course, Guo had been dead for more than a century, and his art must have truly appeared antique. In his own time, however, like so much else in the

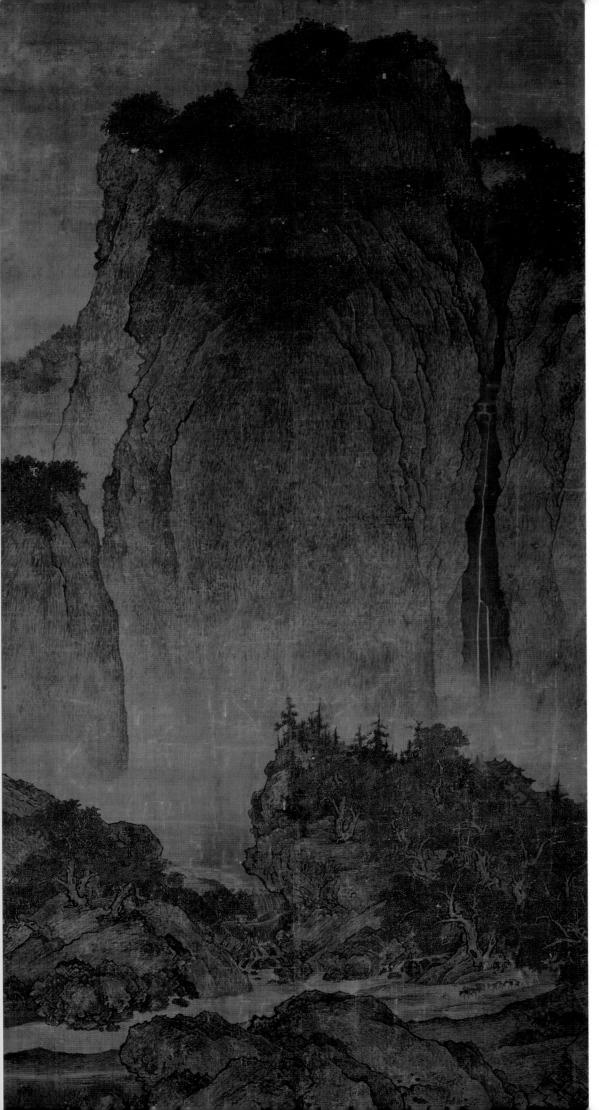

94. Fan Kuan, *Travelers by Streams and Mountains,* hanging scroll, ink on silk, ca. 1000. 206.3 × 103.3 cm. National Palace Museum, Taibei.

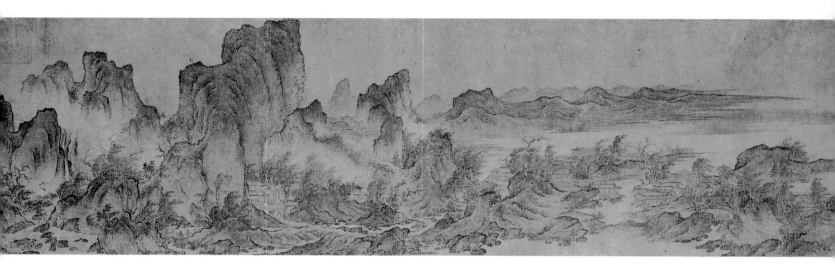

95. Yan Wengui, *Pavilions and Mansions by the River,* handscroll, ink and color on paper, ca. 1000. 26 × 135 cm. Osaka Municipal Museum of Art, Osaka, Japan.

realm of art, his painting was a vivid and immediate evocation of present reality, as much so in its entirely different way as Guanxiu's fiery and indomitable arhats were in theirs.

Another important example of the genre of architectural painting is a short handscroll in the Shanghai Museum (fig. 97) depicting in minute detail the structure and mechanical operation of a waterwheel-driven flour mill. The entire operation, from the arrival of raw grains to the mill to the grinding of wheat into flour and the bagging and carting away of the product, as well as the conducting of business, is represented. It is as if the painting were done as an illustrated treatise on the business of milling. In the lower right corner is a newly built wine shop, advertising the new wine of autumn, in which we can see several customers. This little touch seems to extend the commercial transactions into another dimension, as if the money economy were the engine driving society. The Song was indeed a commercially adventurous and rapidly developing economic society. Since the Guo Zhongshu composition is also about commercial river transport (the boats are heavily laden with cargo), we begin to see a connection between economic enterprise and the genre of architectural renderings.

Perhaps then the masterpiece of such painting, *Peace Reigns over the River* (fig. 98), can also best be understood as a depiction of commercial activity in the flourishing Song economy, as if it were a bid by the central government to attract investors to the great urban centers. It is difficult to imagine any other patron or purpose for this astonishing representation of a great Song commercial city, probably meant generically to represent the Song capital,

96. Guo Zhongshu, *Traveling on the River in Clearing Snow,* hanging scroll, ink on silk, ca. 975. 74.1 × 69.2 cm. Collection of the National Palace Museum, Taibei.

Bianliang (modern Kaifeng), which was built along the commercially active Bian River and joined to the Grand Canal linking north and south China specifically for the purpose of commercial transportation. Almost as striking as the intricate, realistic detail and vast, extended scope of this long handscroll is the fact that its author, a painter named Zhang Zeduan, is apparently unrecorded outside of the colophons attached to this painting itself.

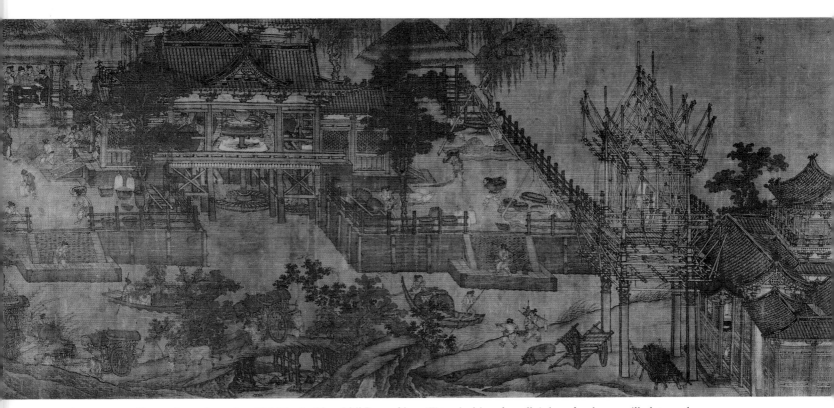

97. Anonymous (formerly attributed to Wei Xian), *Flour Mill Powered by a Waterwheel,* handscroll, ink and color on silk, late 10th or early 11th century. 53.3 × 119.2 cm. Shanghai Museum.

The first colophon writer, a man named Zhang Zhu, who lived in Beijing under the Tartar Jin dynasty and wrote his note in 1186, sixty years after the destruction of the city of Bianliang supposedly represented in the scroll, tells us everything that is known about Zhang Zeduan: "The Hanlin scholar Zhang Zeduan, styled Zhengdao, is/was a native of Dongwu (Shandong). When young he traveled to the capital for further study. Later he practiced painting things. He showed talent for fine-line architectural drawing [*jiehua*], and especially liked boats and carts, markets and bridges, moats and paths. He is an expert in other types of painting as well."[18] Generally, later scholars assume that Zhang was active during the early twelfth century, during the reign of Huizong, but there is no evidence to support this. The reference to Zhang as a Hanlin scholar associates him not with members of the Academy of Painting under Huizong, but with the earlier eleventh century, during the long reign of Renzong (r. 1023–1063), when such court masters as Gao Keming (active ca. 1008–1053) and Yan Wengui were loosely appointed to the Hanlin Academy. The landscape elements of *Peace Reigns over the River* also appear related to paintings of this period rather than to those of the early twelfth century, when one can find very little produced at the court with which the present scroll can be compared.[19]

The technical accomplishment of this work, furthermore, has little to do with the achievements in painting esteemed by Huizong, but rather with the kinds of realism associated with the early Song period and such masters as Fan Kuan, Qi Xu, Yan Wengui, Huang Quan, Guo Zhongshu, and Zhao Chang (ca. 960–d. after 1016). It may well be, therefore, that *Peace Reigns over the River* will prove to be a product of the intensive developmental age of early Song, when new cities, including the capital, were being built and expanded, a powerful economic engine was being put in place, and the flourishing commercial enterprise was humming.[20] Whatever its precise date of execution and expected purpose, the scroll remains a vivid image of daily life in eleventh-century China and a panorama across which one's eyes pan like a moving camera. If we could listen to it, the scroll would explode into the shouting voices of hawkers selling their wares, boatmen yelling at each other, camel trains clattering through the streets, and pedestrians and vehicles humming at the noise level of midtown Manhattan. It is above all an image of commerce, and the virtual epitome of realism in Chinese painting.

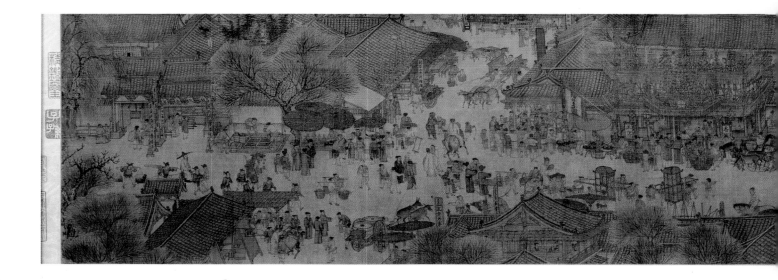

Buddhist and Daoist Images

Both the imperial court and the vast network of Buddhist and Daoist churches required the constant production of ritual and dedicatory images of the religious pantheons. Temple and monastery walls were covered with paintings, and in the pattern of Guanxiu's arhat scrolls large sets of wall scrolls were made to be hung across a wide wall surface on special occasions like the birthday of the Buddha. The early twelfth-century government collection owned 1,179 such paintings by a total of forty-nine different painters, twenty-five of whom lived in the tenth and eleventh centuries. Aside from the set of scrolls by Guanxiu, a single woodblock print made by the influential tenth-century Sichuan master Gao Wenjin, and a rubbing taken from a stone engraving after another Sichuan master, Sun Zhiwei (d. ca. 1020), no signed works of this popular category exist. China has not been kind to its great heritage of portable religious painting, but fortunately a small number of such works have been protected elsewhere, especially in Japanese temples, where the majority of such works are preserved today. *The Peacock King* (fig. 99) makes exquisitely clear how much beauty has been lost. This too is a startling example of Northern Song realism, now in the service of Esoteric Buddhism. The fierce and beautiful Bright King sits meditatively on a flowering lotus throne on the back of a brilliant peacock, who in turn stands atop a lotus pod in a sea of golden clouds. With mystical weapons in four of his six hands, the Peacock King gazes serenely and confidently out at those who come to worship the Buddha he protects. He appears to us exactly as the scholar of art Liu Daochun wrote that such images should: "In Buddhist images, one esteems grave sternness and com-

passionate perceptiveness."[21] This elegant, stylish image is quite possibly still in the Sichuan style of Buddhist representation that was established at the Song court by Gao Wenjin and other court masters of Western Shu after 965. The distinctive Sichuan manner will continue down to the end of the Song dynasty, and we will observe it again in the art of Muqi (thirteenth century).

A Daoist image of similar type is the Boston Museum's *Daoist Deity of Earth Reviewing His Realm* (fig. 100), one of a set of the three deities representing the powers of heaven, earth, and water. Here, as is appropriate to the controlling powers of the cosmos, the deities occupy symbolic representations of their respective realms. The lord of the earth emerges from beneath a cliff overhang thickly grown with trees and shrubs. Autumn is the season of the image. In the immediate foreground, along a smaller pathway walks a parade of demons and grotesques, so that the entire image vaguely evokes thoughts of the demon queller Zhong Kui. Like *The Peacock King,* the Boston composition is above all a painterly image. Techniques such as the drawing, the brushwork, color application, compositional design, and so on are merely the necessary mechanical processes by which the image was formed: they have no separate or independent interest. Almost certainly, in fact, the painting was produced in a workshop or studio by a number of painters including the master, but also his assistants and apprentices. The silk surface would have been turned over and the back painted in places to provide a deeper color base; perhaps the figures were done by one hand and the landscape by another, perhaps this and the other compositions in the set were all done by worker-apprentices tracing a design done by the master. In any case, all such paintings are as

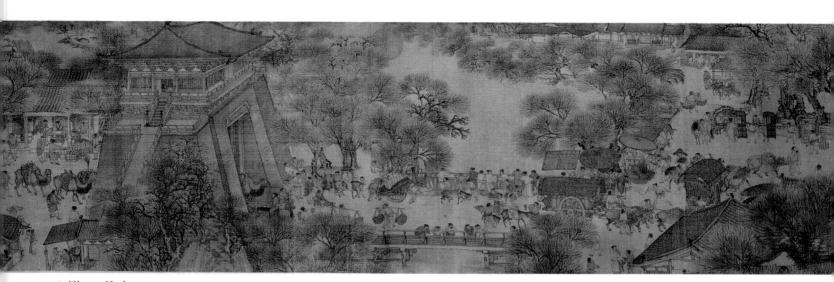

98. Zhang Zeduan,
Peace Reigns over the River,
section of a handscroll, ink
and color on silk,
11th–12th century.
24.8 × 528.7 cm.
Palace Museum, Beijing.

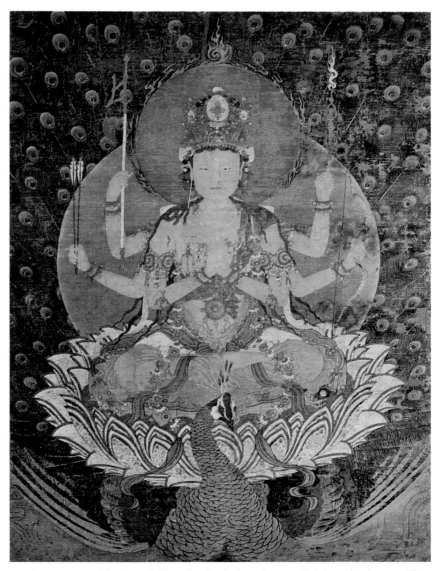

99. Anonymous, *The Peacock King,* detail of a hanging scroll, ink and color on silk,
ca. 1125. 168.8 × 103 cm. Ninnaji, Kyoto. (Courtesy of the Yale University Slide
and Photograph Collection.)

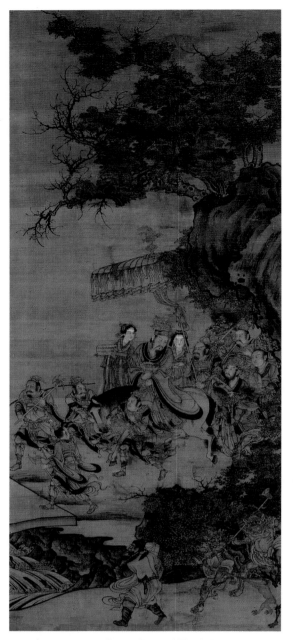

100. Anonymous, *Daoist Deity of Earth Reviewing His Realm,*
hanging scroll, ink and color on silk, ca. 1150. 125.5 × 55.9 cm.
(Chinese and Japanese Special Fund. Courtesy of the Museum
of Fine Arts, Boston.)

101. Zhao Yan, *Eight Gentlemen on a Spring Outing,* hanging scroll,
ink and color on silk, 10th century. 161.9 × 102 cm. National
Palace Museum, Taibei. *opposite*

much craft as art, and the traditions of the craft were
passed on from master to pupil, father to son, over many
generations.

Secular Figure Painting

There was probably little distinction between those
who painted religious images and those who painted sec-
ular, or historical, images and portraits in the Song dy-
nasty. The same masters and workshops could produce
one type of image for one patron, another for other
needs. Figure painting of every kind flourished through-
out the Five Dynasties and Song periods, at a level of
professional craft as high as at any time or place in the
world. One of the most surprising facts about the con-
cept of craft in the entire period is the frequency with
which members of the old traditional aristocracy devoted
themselves to the art of painting just as if — or *almost* as
if — they were professional painters. The great landscape
master Li Cheng, for example, was born into the old
Tang imperial clan, and Wang Shen, descended from one
of the dynastic founders, raised in the imperial palace,
and subsequently married to an imperial princess, was a
superb master craftsman. Of course, most notably, the
emperor Huizong ruled not only as emperor of all China
but as master painter to the empire. Yet another remark-
able example of this type of artist is the early tenth-
century imperial son-in-law Zhao Yan (d. 922), who lived
in north China under the same Liang dynasty in which
both Jing Hao and Guan Tong had worked as landscape
masters. Zhao, who lived the high life of royal prince,
was a passionate scholar of art and a distinguished
painter.[22] The only extant work still associated with him
is a classic Song composition of mounted horsemen on a
galloping spring outing (fig. 101), known as *Eight Gentle-
men on a Spring Outing.* We have in fact no means by which
to date such paintings any more closely than to as broad a
period as the tenth to eleventh century. Zhao was ad-
mired for his paintings of princely horsemen like himself,
however, and this is exactly such an image. The horses
are spirited and vigorous, their riders gay young blades of
a character perhaps typical of the blooded aristocracy
throughout much of the world in the medieval period.
Most impressive is the sheer skill and beauty of the craft
of painting in such works. The composition is sturdy and
architectonic, established by a strong structure of archi-
tecture, trees, and garden rock: this is presumably a royal
park of imperial scale. Across the foreground the bril-
liantly dressed riders pass in varied motion, like their
horses, an impressive formation of figures and animals in

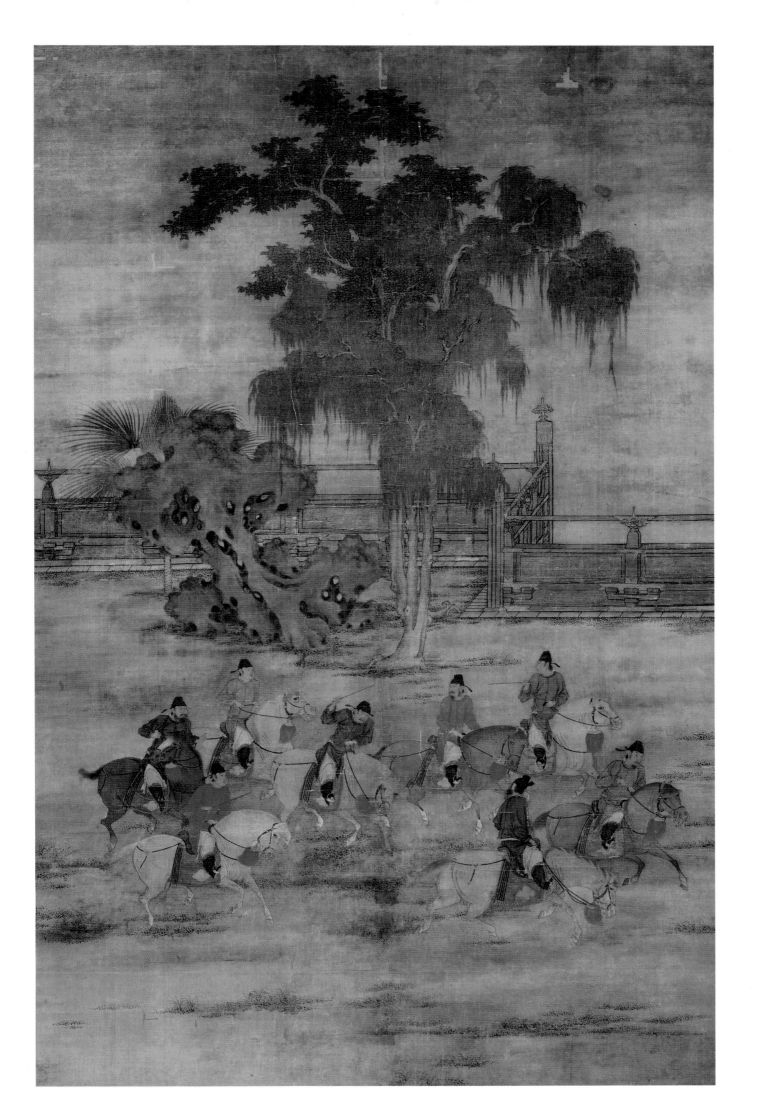

space. The colors of the costumes alone are breathtaking. One imagines the viewers of the time exclaiming in awe at the depth of the sky blue, the intensity of the reds, and the glow of greens and purples. This coloristic panorama extends throughout the composition, to the top of the furthest tree where jade green leaves appear and to the mossy, earth-brown tones of the grass. Painters such as this "Zhao Yan" were attempting to create realistic, illusionistic windows onto the world exactly as the great landscape masters of the time were.

Another classic figure narrative of this era is the dramatic story of *Breaking the Balustrade,* an actual event that took place in the Han dynasty (fig. 102). Made for the imperial court, no doubt, the painting proclaims the morality, justice, and rightness of the government to all who might be needed to serve it. The events that are illustrated demonstrate the wisdom of the emperor, who recognizes courage and rightness and both rewards and punishes in accordance with strict justice. The villain stands cowering behind the stern seated figure of the emperor Chengdi (r. 46–45 B.C.), the main hero opposite and across from him, clinging stubbornly to the balustrade and demanding to be put to death on the spot. Another man of morality occupies the center, where he bows and intercedes on behalf of our hero. A garden and architectural setting very similar to that of Zhao Yan's *Eight Gentlemen on a Spring Outing* sets the stage, and on it a carefully planned choreography is played out.

It is certainly typical of such paintings to be set outside, as both of these aristocratic images are. Interior scenes, like the Dutch later made so popular, were only rarely painted in imperial China, and when they were it was to specific effect, quite different from the European interior. The most extraordinary example of such an interior setting is *The Night Revels of Han Xizai,* a handscroll traditionally attributed to a late tenth-century portrait artist who served the last Li prince of the Southern Tang state (fig. 103). Set in the palatial rooms of the statesman Han Xizai, whose portrait figure is seen several times through the length of the scroll, the narrative purportedly tells a tale of debauchery, immorality, and an unhealthy mixing of the properly separate strata of society. The interior setting seems to function as a framework to the impression we are given of looking on surreptitiously at scandalous events we are not normally able to see at all. According to the later Song mythology upon which our interpretation of this famous work is based, the ruling Li prince was considering appointing the scholar-official Han Xizai to a ministerial post but was concerned about

rumors of his depraved and debauched behavior. He therefore dispatched two painters to secretly observe Han Xizai's notorious parties and submit a report in the form of just such a painting as this. According to more objective accounts, Han Xizai was one of the most accomplished and upright of men, a true statesman, and the last Li prince was an artist and enlightened ruler, the model for the role of ruler-artist that Huizong later usurped for himself at the expense of Li Yu. Evidently, therefore, the present painting was done in order to impugn the integrity of not only Li Yu and Han Xizai but the entire Southern Tang state — which had the courage to withstand the Song until fifteen years after they announced their new dynasty. Only in 975 did Li Yu submit his kingdom and himself to the Zhao Song dynasty. Several modern scholars date *The Night Revels of Han Xizai* to the late twelfth century on the basis of what they regard as Southern Song elements in the many landscape paintings painted within the scroll, on screens and on furniture. More likely the scroll is a product of the Northern Song period, probably not far in time or place of origin from the court of Emperor Huizong, who had good reason to propagate images such as this of his most significant rival. The scroll is first mentioned, in any case, in the catalogue of Huizong's collection. The landscapes within the picture are a good selection of the landscape styles prevalent in the late Northern Song period, and the figure style is yet another rare example of Song realism. Many of the figures in the scroll are identifiable with historical personages and are, in effect, portraits. It is known that portraits of Han Xizai were very popular in the early Northern Song period, another indication of the high esteem in which both he and the Southern Tang kingdom were held at that time, and presumably this famous handscroll was based upon them.

Portraiture

The Night Revels of Han Xizai is among the most important examples of Song portraiture, a genre of painting that has not been very well studied.[23] Throughout the long Song era, in fact, portraiture remained a highly esteemed art form and was a highly visible one as well. Art historians like Guo Ruoxu compiled biographies of the leading portrait artists, and the names of many of them are noted even though their art has become very rare.[24] The imperial court depended upon their continual service for royal portraiture and diplomatic functions, the Buddhist and Daoist churches required portrait masters,

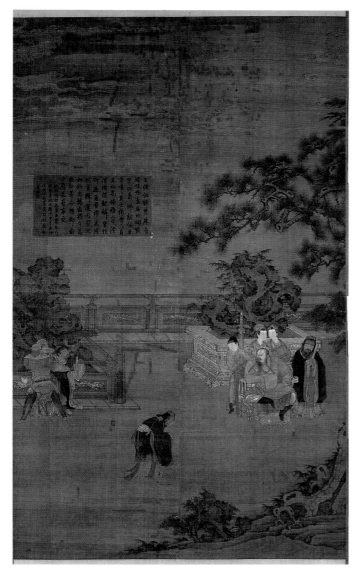

102. Anonymous, *Breaking the Balustrade,* hanging scroll, ink and color on silk, ca. 1100. 173.9 × 101.8 cm. National Palace Museum, Taibei.

and both families and extended clans required their services at every level of society. Striking in Guo Ruoxu's biographies is the number of portrait masters who were Buddhist monks and the number who were specifically employed at the imperial courts. *The Night Revels of Han Xizai* was presumably done in part by a typical court master specializing in portraiture (as well as a landscape painter, and perhaps others). Official portraits of the Song emperors and their empresses still exist and have recently been brought to our attention as monuments of Chinese portraiture by Wen Fong.[25] A number of very fine priest portraits also exist still, and we reproduce one of them here as an example of the genre. *Portrait of a Buddhist Monk* (fig. 104) is an undated and unidentified portrait of an unknown priest. Oddly, a spurious inscription

in gold has been added to the painting identifying the figure as Priest Bukong, a famous Tang monk, and ascribing the work to a well-known Southern Song specialist in Buddhist subjects. In fact, it is a classic formal portrait of a monk-teacher, seated in the traditional position for such portraits. The unknown monk, bearded and shaven-headed, sits reflectively, hands in lap against a spectacular piece of cloth, his empty slippers on the stool in front of him. The face is rendered with close attention to individual personality; we can have little doubt that this plain, calm-looking monk has attained a level of knowledge that would engross us if we were fortunate enough to be able to converse with him. Especially beautiful in the rendering is the acute and loving attention given to the drapery and its details of folds and patterns, and these are details that speak for a date in the late Northern Song period, around 1100.

Another incomparable series of portraits of both men and horses was painted by a leading scholar-artist of the same period, Li Gonglin (ca. 1041–1106). Li represents another social class altogether, that of the scholar-gentry, although Li claimed descent from the Southern Tang royal family. His associations were closely with the scholar-bureaucrats like the poet Su Shi (1036–1101) and the calligrapher Huang Tingjian (1045–1105), all of them men who were beginning to seek ways to adapt the art of painting to the uses of scholars who were not professional craftsmen. Li Gonglin, however, more closely resembles the aristocratic painters like Zhao Yan and Wang Shen in his devotion to the art and craft of painting. His *Five Tribute Horses* (fig. 105), in any case, is a marvel of portraiture, reduced to plain ink line, without color, without setting, intense and microscopic in scrutiny, that preserves the appearances and personalities of five gift horses presented to the Song court between 1086 and 1089, and their five foreign grooms. Like Guanxiu, whose arhats were based upon foreign physiognomies, Li Gonglin was apparently fascinated with foreigners. The extent to which the Song interacted constantly with foreign peoples and cultures has perhaps not been sufficiently noted.

Nomadic Tribes

One of the new categories of subject matter defined in the government catalogue of its collection, the *Xuanhe huapu* of 1120, is that of Nomadic Tribes, for example. The category is introduced with these words: "When they sent their sons and younger brothers to study and happily offered tribute and fulfilled obligations, then,

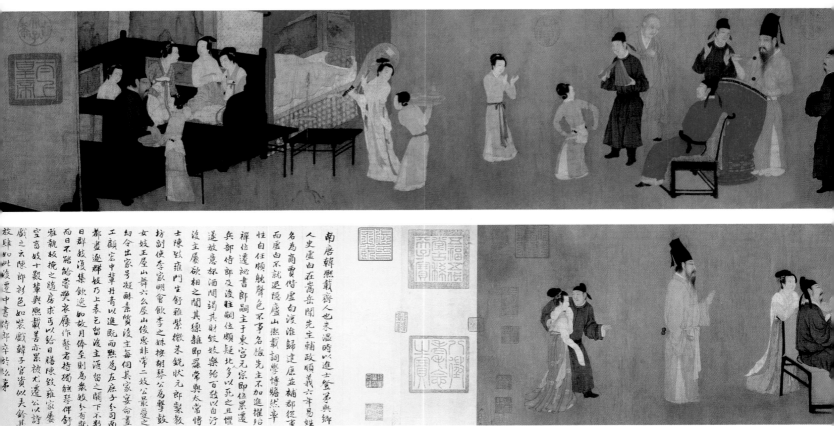

103. Gu Hongzhong, *The Night Revels of Han Xizai,* handscroll, ink and color on silk, ca. 970. 28.7 × 335.5 cm. Palace Museum, Beijing.

although their strange regions were far away and their customs, language, climate and ways different, the philosopher kings of old still never rejected them. That is why the barbarian tribes are seen in the tradition of painting."[26] Only five painters are included in this section, all of them active in the tenth and eleventh centuries. Li Gonglin is not mentioned, of course, since he was distinguished for his traditional figure painting, but it is interesting that he chose to depict these foreign grooms so carefully, with exactly the same care he gave to the horses he loved so dearly. It has been suggested that in doing so he deliberately drew attention to the essential humanity of even central Asian tribal chieftains, forgetting the popular practice of demeaning foreigners by emphasizing their oddness. Similarly, instead of depicting a colorful pageant of submission to the Son of Heaven, Li draws our attention to the odd bonds of sympathy he sees between each horse and its groom, as if each were somehow a part of the other. Li Gonglin devoted much of his spiritual energy to Buddhism and was probably a very devout believer. His *Five Tribute Horses* suggests that he perceived deep spiritual connections among the various forms of life, almost as if in visualization of the Buddhist concept of karma.

Horses and Buffalo

Horses and buffalo were ever-popular subjects of painting and held basic associations with the imperial heavens (horses) and mundane earth (water buffalo). Symbolically, horses — swift, intelligent, heroic — were commonly related to great scholars, distinguished officials, and aristocratic lords in the service of the state, while water buffalo nearly always evoke thoughts of the bucolic life of retirement and leisure. The great early masters of both types of subject lived in the Tang dynasty. Han Gan, Cao Ba, and Wei Yan were notable masters of horse painting, while Dai Song and Han Huang excelled at water buffalo. Among the most notable examples of horse painting in the Song period is Li Gonglin's *Five Tribute Horses,* which comes closest to the kind of horse portraiture associated with George Stubbs later in England. Li was in fact widely regarded as the most accomplished Song master of horse painting, and another of his few extant works is his copy of a painting attributed to Wei Yan called *Pasturing Horses* (fig. 106). This is a work that reveals the most painstakingly craftsmanly side of the distinguished scholar-painter. At imperial command, according to his own inscription on the scroll, he care-

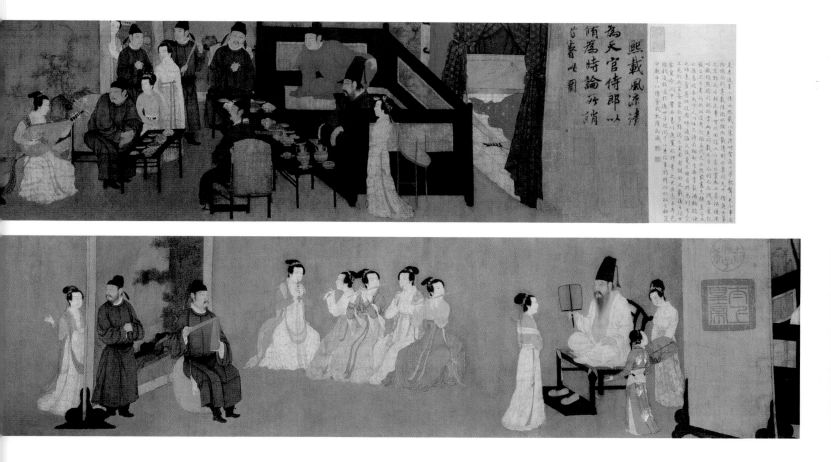

fully copied this entire lengthy, intricately detailed composition consisting of more than a thousand horses and hundreds of men. If most later practitioners of the scholarly mode of artistic life would have been demeaned by the need for such a humbling, difficult, and painstaking task, it is evident that Li Gonglin did such careful copies of ancient paintings all of his life that he made such works his virtual masters, and that he not only learned from but remade and transformed these hallowed models into new and challenging works of art that addressed the issues and circumstances of his own time.[27] In the present instance he has transformed his antique model into a very modern picture that is as much about the limits of control and the nature of human freedom and happiness as it is about horses and grooms. The sheeplike herd of horses, heads down, that is driven in from the right by a tightly packed array of mounted horsemen is allowed gradually to spread out, slow down, stop, wander away, feed, water, rest, and amble freely as their attendants disappear. By the end of the scroll, there is no control left in place, and the horses are scattered across the wide steppes like free men living in retirement. Li himself lived in retirement from government service as long as he could and later retired as early as possible. The Song bu-

reaucracy was the only powerful system of employment open to men like Li Gonglin, and its pressures and harsh limitations must have sometimes seemed as inhibiting as the herded horses appear to be at the beginning of Li's handscroll.

The same vision of freedom that Li suggests at the end of *Pasturing Horses* is suggested in another handscroll in Beijing, *Pasturing Water Buffalo* (fig. 107). The painter to whom this bucolic image is attributed, Qi Xu, was a native of the Jiangnan region, active in the early Northern Song period, that is, probably the late tenth or the early eleventh century. His reputation was made largely on the strength of his water buffalo compositions, although he also painted birds and flowers more generally. The rare Beijing handscroll, only recently rediscovered, was in the collection of Emperor Huizong in the early twelfth century. Its carefully realistic details, strongly plastic drawing of earth and rock forms, and dense, thick, leafy tree growth are very similar to other early Song works, such as those of Yan Wengui, Fan Kuan, and the anonymous Shanghai *Flour Mill Powered by a Waterwheel,* while the broad level river landscape remains the essential Jiangnan image of landscape. With Li Gonglin's *Pasturing Horses* and Qi Xu's *Pasturing Water Buffalo,* then, we have two

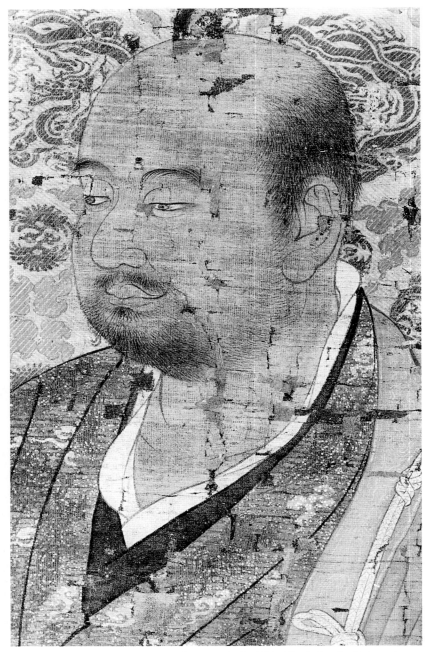

104. Anonymous, *Portrait of a Buddhist Monk*, detail of a hanging scroll, ink and color on silk, ca. 1100. 21.3 × 16 cm. Kozanji, Kyoto.

classic Northern Song images of the early Song desire for freedom, release, and bucolic tranquillity.

Bird-and-Flower Painting

The sturdy traditions established at the early Song court by the Huang family of Sichuan and the heirs of Xu Xi from Jinling formed the basis for the entire Song tradition of bird-and-flower painting, just as Li Cheng created the enduring classic Song landscape style. In both great traditions, however, significant developments oc-

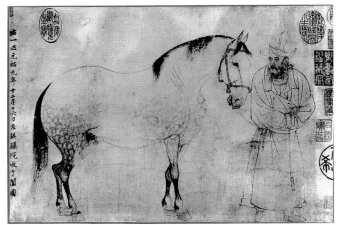

105. Li Gonglin, *Five Tribute Horses,* section of a handscroll, ink on paper, ca. 1090. Collection unknown. (Courtesy of the Yale University Slide and Photograph Collection.)

curred during the course of the eleventh century that modified and advanced both modes of art. It is striking, in fact, that so many of the most innovative and powerfully individualistic painters of the eleventh century shared the experience of being particularly favored by the vigorous, stern, and highly moralistic emperor Shenzong (r. 1068–1085). The great landscape master Guo Xi was Shenzong's personal painter, and such diverse masters as Cui Bai and Liu Cai (d. after 1123) received the benefit of his patronage. These men are among the most adventurous artists of their time, as was Emperor Shenzong's brother-in-law, the landscape painter Wang Shen. Clearly, Shenzong's keen intelligence extended into the realm of art and set a high standard for his son, Zhao Ji, who later became Emperor Huizong. The consistent patronage of the arts by the Song emperors beginning with the founder, Zhao Kuangyin, is a rare and highly significant factor in the overall achievement of Song art.

Cui Bai, a native of Haoliang in Anhui Province, is typical of the painters who came from all over China to the flourishing capital, seeking appointment to the court. He was an eccentric and erratic genius of art, inept at practical matters, but so skilled and admired that Emperor Shenzong allowed him to hold a position in the Academy of Painting with no duties or responsibilities except to paint at the emperor's personal order. He was thus akin to the great landscape master Guo Xi in the exclusiveness of his appointment. His *Magpies and Hare* (fig. 108) bears the Chinese title *Shuangxi tu,* or "Picture of Double Happiness." This is a verbal play on the fact that the sound *xi,* pronounced almost like the English word "she," may mean both "magpie" and "happiness." "Two magpies" is

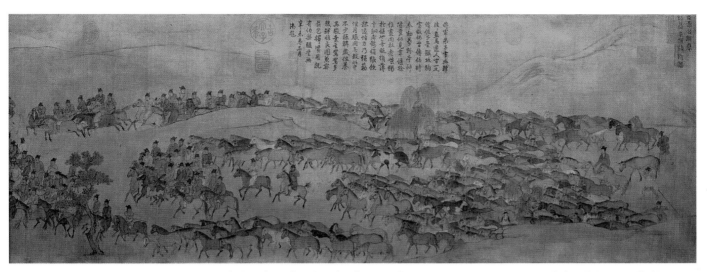

106. Li Gonglin, *Pasturing Horses,* section of a handscroll, ink and color on silk, ca. 1085. 46.2 × 429.8 cm. Palace Museum, Beijing.

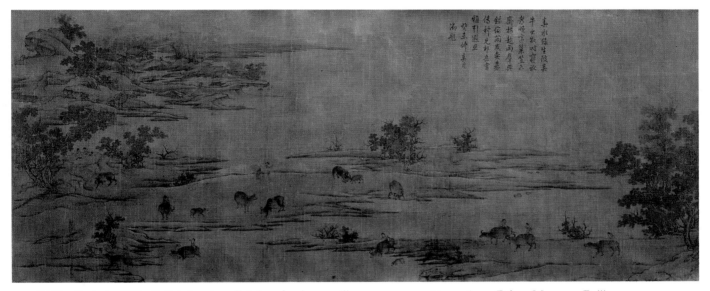

107. Qi Xu, *Pasturing Water Buffalo,* handscroll, ink and color on silk, ca. 1000. 47.3 × 115.6 cm. Palace Museum, Beijing.

also, therefore, double happiness. The painting, then, becomes an appropriate pictorial metaphor expressing congratulations, good wishes, hopes for the future, or other expressions of good will. Paintings of birds and flowers done for the imperial court — and presumably for other patrons as well — were often read, understood, and titled in this way, as verbal and visual puns on homophonic sounds and interidentification.[28]

Cui Bai's picture of two magpies jabbering in their mocking way at a phlegmatic hare who glances idly up at them has the relation to earlier compositions of this kind (like Huang Jucai's *Pheasant and Small Birds by a Jujube Shrub,* fig. 84) of motion pictures to still photography. It is as if the formerly motionless images had come to life. The golden autumn wind blows through this little corner of the world and fills it with movement and sound. The

magpies above chatter down at the hare, one of them quickly circling in the air, while around him the grasses are swept by the breeze, and the branches and leaves dance in the wind. These movements are held in balance by the line of vision linking the unexcitable hare to the colorful birds who jabber at him. Like the earlier masters, Cui Bai paints each motif realistically, but he sweeps in the upturning earthen forms broadly and loosely, like a landscape master, and he organizes his composition like a choreographer.

Within Cui Bai's composition the stillness of the hare is like the eye of the picture — literally, like the eye of a storm. Around him swirl the forces of autumn, but he himself is still and silent. This quality of stillness is one that Song painters often pursued. Motion, however, of such visible character is rarely seen in Chinese painting

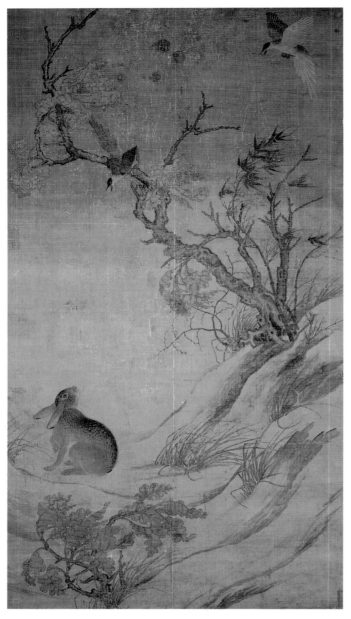

108. Cui Bai, *Magpies and Hare,* hanging scroll, ink and color on silk, 1061. 193.7 × 103.4 cm. National Palace Museum, Taibei.

before this time. The date inscribed on the painting by Cui Bai along with his signature corresponds to 1061 and is the earliest such inscribed date on any Chinese painting, which must suggest the approximate time the attainment of an illusion of motion became common. Guo Xi's *Early Spring* of 1072 (fig. 109), discussed below, is another dated monument of this stage, as is Liu Cai's beautiful handscroll *Fish Swimming amid Falling Flowers* (fig. 110). So similar to Cui Bai's *Magpies and Hare* in its interior movement as to be unmistakably from the same period is the large *Monkeys in a Loquat Tree* (fig. 111), a painting that must be associated with the Hunan master Yi Yuanji, who was the first to achieve fame for his depictions of monkeys and gibbons. Yi was a versatile master of birds and flowers, fruits and insects but wished to find new subjects that would allow him to depart from the models of his predecessors. This is a continuing pattern in Song painting and is indicative of the rapid change and movement within the world of art from the beginning of the dynasty to its end. Monkeys, apes, and gibbons are all called *yuan* in Chinese, and that broad category of animal was rich in symbolic meanings (like virtually every other subject traditionally favored by Chinese painters and poets). Every twelfth year is the year of the monkey, for example, and therefore approximately one in twelve Chinese is identified with the monkey. This alone would account for the large number of paintings of monkeys extant, but the animal also evoked romantic images of remoteness and of the high, inaccessible cliffs among which they lived. Their cries echo still from some of the thickly overgrown gorges along the Yangzi River. The monkey king associated with the quest for the Buddhist canon is a popular figure in China, and as was once true in the West one could easily see small monkeys kept as pets or trained animals on the streets. Oddly, according to such scholars as Guo Ruoxu, no one had specialized in the painting of monkeys and gibbons before Yi Yuanji. The anonymous *Monkeys in a Loquat Tree* depicts one ape hanging from a branch and looking back at its companion, who sits quietly on the powerfully twisting trunk and looks up, as if exchanging casual remarks. All details, from the fine fur of the animals and rough bark of the tree to the overripe fruits and decaying leaves, are painted with exquisite nuance, and a rich three-dimensional effect, like a bas-relief, is created by leaving the silk surface blank except where all of the foreground motifs are

109. Guo Xi, *Early Spring,* hanging scroll, ink on silk, 1072. 158.3 × 108.1 cm. National Palace Museum, Taibei.

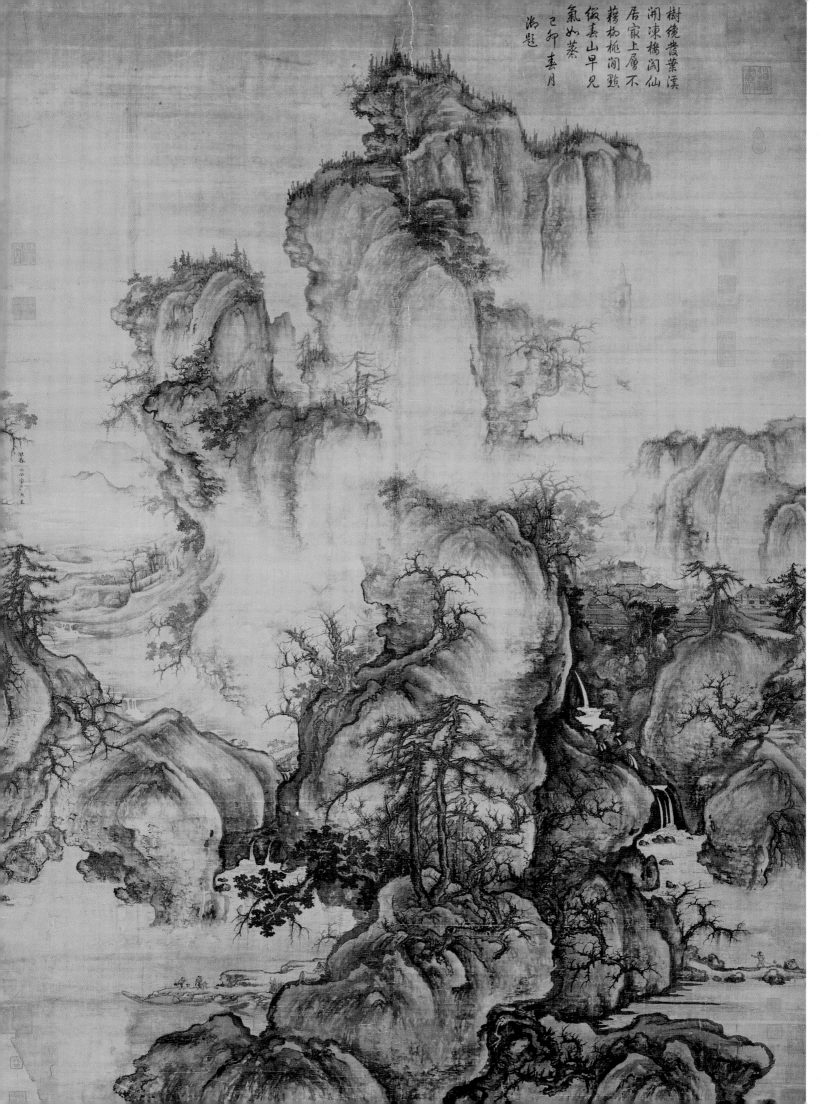

樹繞疑葉溪
潤凍橋闊仙
居家上屬不
藉杨桃間題
緩素山早見
氣如蒸
己卯春月
御題

110. Liu Cai, *Fish Swimming amid Falling Flowers,* handscroll, ink and color on silk, ca. 1075. 26.4 × 252.2 cm. St. Louis Art Museum. (Purchase: W. K. Bixby Oriental Art Fund.)

placed. As with Cui Bai, we feel that the painter was actually looking at and studying his motifs in the context of the making of the painting. He knew how apes moved and interacted, how leaves look when autumn comes, and how the deep, rough bark of a loquat tree feels to the hand, as it were, and he tried to convey his knowledge through his painted forms.

Fish and Dragons

In his detailed discussion of painting, Guo Ruoxu, around 1074, says little about the painting of fish. Dragons and water in general he analyzes with care, but the greatest fish master of the period had only begun to paint around the time Guo wrote, and his work was apparently not yet known to Guo. By the time the imperial catalogue *Xuanhe huapu* was compiled in 1120, Liu Cai was acknowledged as the artist who had changed depictions of dead fish on the kitchen table into living, moving forms deep beneath the surface of the water, and he headed the category of Dragons and Fish. A tenth-century master from Piling named Dong Yu was widely acknowledged as the greatest master of dragon painting, but no pictures of dragons survive from before the thirteenth century.[29] Like his older contemporary Cui Bai, Liu was an ambitious and erratic painter, obviously one who sought new themes, new ideas, and new ways of representing, and who sometimes succeeded and sometimes failed. Liu's position in bringing a new sense of life to old forms of painting is very much like Cui's (and like Guo Xi's position in landscape painting).

Fish Swimming amid Falling Flowers (see fig. 110) is a quiet symphony of rhythm and movement, the effect of which is attained precisely through the many ways the painter creates the impression of swimming, darting, drifting fish and schools of fish. It opens with a branch of blossoming peach flowers that touches the water like the entrance to the fabled "Peach Blossom Spring" and informs us that,

in some important way, we are about to enter a realm where time stands still. A small school of slender fishes fights for the bits of pink blossoms that fall into the water, and one fish swims quickly away with its prize while the others circle and fleetly follow. Below, we see the water grasses that grow from the mud, and here and there a shrimp or other crustacean. The dense, sheltering thicket of water plants that follows is a breeding ground for the large fish that surround it. Swarms of newborn fish are visible, and above, on the surface of the water, flat, brilliant green lily pads appear. In the third section a garden of water plants becomes the center of focus, a bouquet formed of exquisitely subtle tonalities of inkwash and pale green and brown colors. Suddenly, a brilliant orange goldfish appears, then jade green leaves and more goldfish, as the composition comes to a close with the appearance of the patriarchal figures in this watery world, several huge carp who appear to the lesser fishes we have seen as kings to their kingdom.

The Daoist philosopher Zhuangzi gave us the central image of fish in Chinese thought when he spoke of "the pleasure of the fishes" attained by losing all memory of things deep in the waters of the rivers and lakes.[30] This became the always desired but rarely attained dream of the busy official. Before Liu Cai there was no visual correspondence to this ideal, and it quickly became a popular theme in painting. Thirty scrolls by Liu were in the government collection by 1120, and fish subsequently acquired many other symbolic forms and functions.

Later Northern Song Landscape Painting

The towering figures in mid and late eleventh-century classical landscape painting are Xu Daoning and Guo Xi. Xu was a natural virtuoso whose genius expanded the rules of art, and Guo Xi was a thoughtful professional master who became personal painter to Emperor Shenzong. An important essay on landscape painting, *Linquan*

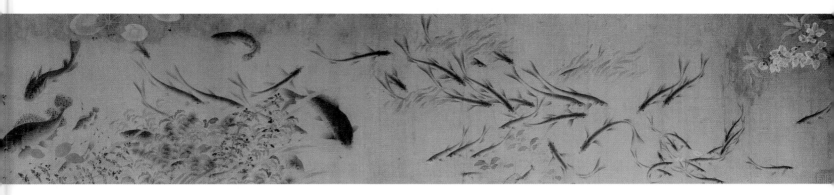

gaozhi, or "The Lofty Power of Forests and Streams," was compiled by Guo Xi's son and submitted to the throne. It argues eloquently that the purpose of landscape painting is, first, to faithfully recreate the actual appearances and moods of the natural world, and, second, to glorify the imperial order, which is no less than the earthly form of cosmic order. Painting is necessary, he says, because men can only too seldom actually look upon and experience the realities of nature—which is vital to the nourishing of the human spirit. The man Guo Xi served, the emperor Shenzong, only rarely in his life had occasion to directly enjoy the natural world outside of his imperial palaces and scarcely ever in the normal human way, without attendants, musicians, servants, guards, and the complete imperial entourage around him. His admiration for Guo Xi was no doubt based upon the artist's skill at recreating the great world glimpsed by Shenzong so rarely.[31]

Like Cui Bai, who also painted only for Shenzong, Guo Xi attempted to bring the music of nature to the emperor's eyes and ears, as it were. More quietly, Liu Cai did the same. Somehow, these painters found new ways to please the all-powerful ruler who esteemed them for their genius. Certainly, the meeting of these extraordinary individuals at the side of a gifted and intelligent emperor has much to do with the sheer brilliant creativity of their art. Emperor Huizong received most of the later attention, but Shenzong was an enlightened patron of the arts, and one furthermore whose personal tastes were somewhat wider and more eclectic than his eleventh son's.

Guo Xi's most powerful extant work, *Early Spring* (see fig. 109), dated 1072, is a vision of flux, growth, life, and order precisely suited to the imperial gaze. Looking at this deep and high vision of the world must have been a little like looking at a dream of empire. Guo uses every possible technique, with many brushes and many different inks and washes in a rich painterly building up of

form, to create this monument of the national landscape. He honors Li Cheng with his composition and his space. Not surprisingly, given the identity of his patron, Guo's name is joined to that of Li Cheng to define the very tradition the two men created. The Li-Guo school is the classical, imperially approved version of landscape painting and constitutes the official canon.

The complex, dense, and vigorous techniques of Guo Xi were anticipated by the eccentric Xu Daoning, whose *Fisherman on a Mountain Stream* (fig. 112) must have been painted just before midcentury. Xu, however, was a freer spirit than Guo Xi and seems to have enjoyed painting while drinking wine, depending totally upon his talent and momentary inspiration. This, at least, was the pattern of his mature years; earlier he is said to have been a careful imitator of Li Cheng. Xu's marvelous handscroll is a visionary's image of high mountain valleys in autumn. If paintings of landscape reflect the actual appearances of the time, then Xu's virtually denuded earthen slopes confirm the textual evidence indicating that most of north China was already deforested by this time. Despite their barrenness, a Mozartian elegance of line defines the ranges of thin peaks, and only a magician could have worked such a miracle of illusion by which ink is transformed into pure space. At the center of Xu's world is the grass-cloaked fisherman of the title, who tries madly to find a little peace and tranquillity in this remote paradise—which, alas, is beset by hawkers, travelers, food sellers, and braying asses. The irony seems in fact to be the very point of the human presence in this former wilderness.

The Emperor and the Scholars

Zhao Ji (1082–1135) was the eleventh son of Emperor Shenzong. This meant to the young man that there was virtually no chance that he might ever become emperor, and he was free to devote himself to the true passions of

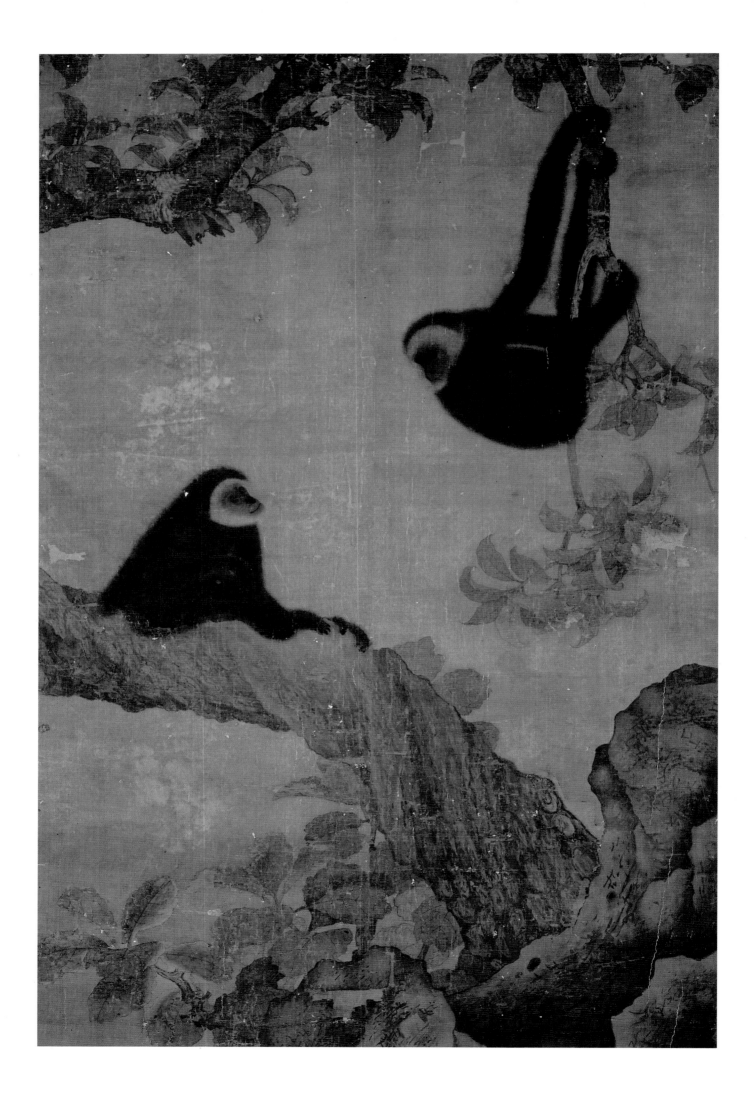

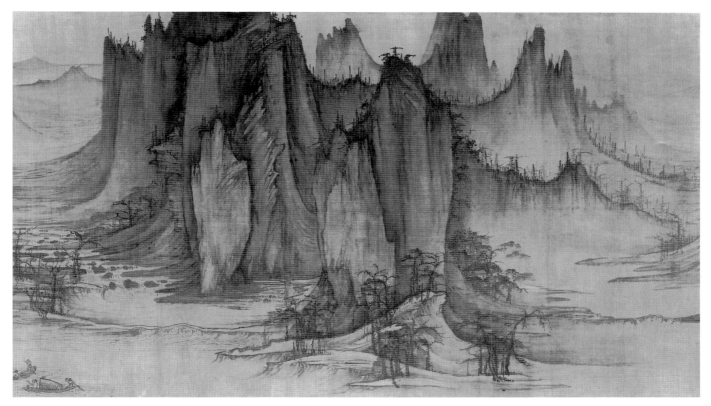

112. Xu Daoning, *Fisherman on a Mountain Stream,* section of a handscroll, ink and color on silk, ca. 1050. 48.9 × 209.6 cm. Nelson-Atkins Museum of Art, Kansas City, Missouri. (Purchase: Nelson Trust.)

his life, literature, the arts, and Daoism. His family was highly cultivated, as we have remarked, and in the imperial palaces of Bianliang came and went all of the most talented men of the country at one time or another. Unfortunately for both Zhao Ji and his country, despite all odds he did succeed to the throne, and at the age of eighteen was crowned emperor of China. His complete lack of preparation, ability, and interest in that unwanted task led to near bankruptcy of the country, corruption and abuses of every kind, and ultimately loss of half of China to the Tartar Jin tribes. The emperor, captured by the Tartars at the age of forty-four, died as their prisoner, in the northern steppe country, eight years later.

Huizong, as he later became known, grew up heedless of that future, in the company of the glittering talents that gathered in the capital. His father, the emperor Shenzong, as we have repeatedly noted, was himself an exemplar of the generous and appreciative imperial patron. He had chosen as his sons-in-law two distinguished painters, Li Wei (active ca. 1050–ca. 1090) and Wang Shen, who became in effect the young Huizong's uncles and tutors in art. When, unexpectedly, the young Zhao Ji

111. Anonymous, *Monkeys in a Loquat Tree,* hanging scroll, ink and color on silk, 11th century. 165 × 107.9 cm. National Palace Museum, Taibei.

became the emperor Huizong, it was not to matters of state, about which he knew little, to which he turned, but to art, about which he knew a great deal.

Up until Huizong's time, painters on appointment to the court constituted a loosely defined academy of painting. This had been the practice in the important tenth-century states of Shu in Sichuan and Southern Tang at Nanjing, and the first Song emperor deliberately set out to reconstruct such a system at the new Song capital. The leading court painters from all of the conquered or surrendering states were invited to Bianliang, where they established the foundations of the new Song academic traditions. Their organization was very flexible and never strongly institutionalized. Even as late as the time of Shenzong, as we have noted, the emperor could more or less personally offer terms of appointment to such masters as Guo Xi, Cui Bai, and Liu Cai, in the simple expectation that their responsibilities were simply to paint as the court saw fit. Such painters were sometimes appointed to the Hanlin Academy and sometimes to other offices that were held nominally.

Huizong chose to reform this loose system, to put it in order, on firm grounds, and furthermore to advance the profession of painting to a higher state than other crafts, making it comparable to such arts as calligraphy and poetry. The model for such artists was not hard to

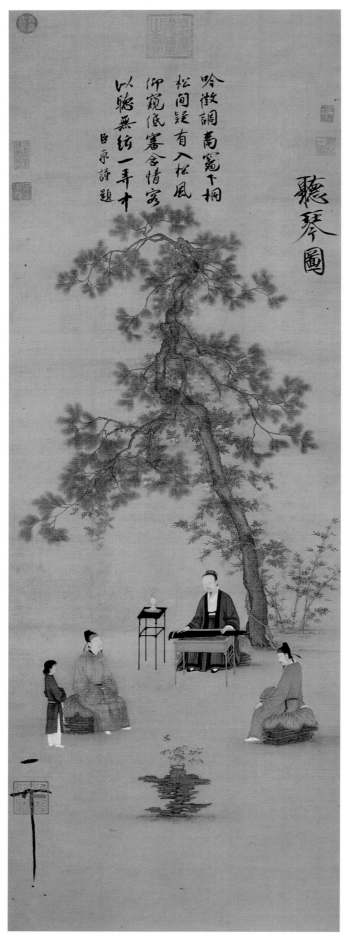

吟徵調宮宮下桐
松間疑有入松風
仰窺低審含情客
以聽無絃一弄中
臣京謹題

聽琴圖

find. Huizong himself personified it, as an accomplished painter, calligrapher, and poet, and so did other members of the imperial family, like his distinguished "uncles" Wang Shen and Li Wei and like his cousins Zhao Lingrang (Danian) (active ca. 1070–1100) and Zhao Shilei. The Zhao family was in fact the most prominent family of artists in China. The Painting Academy of this family would necessarily reflect its ideals, and they had been formed on the basis of close association between members of the royal family and leading scholar-artists like Wang Shen, Li Gonglin, and Mi Fu (1051–1107). Traditional craft was the basis of the profession, and the Zhao family admired and rewarded craft, but painting was expected to assume higher qualities as well. To accomplish this, Huizong himself took charge of the process, becoming in effect master painter to the empire. He introduced new curricular requirements, including the study of calligraphy and poetry, and codified some of the new interests of the poet-painters like Su Shi by creating associations between poetry and painting. What this accomplished is difficult to say because the type of thoughtful, knowledgeable, and creative artist that Huizong sought to train in this way already existed. Certainly, however, he attracted more widespread interest in painting itself than had any emperor before him and probably brought more painters to the capital than ever before. It is not likely, however, that Huizong's court painters had a higher overall achievement than those of his father or of the first Song emperors, Taizu (r. 960–976) and Taizong (r. 976–997). Indeed, it could be reasonably argued that by his attentions to the art of painting Huizong limited more than expanded its horizons in the long run. Or, perhaps, we simply know more about the limitations imposed by Huizong than about those imposed in their own ways by his predecessors. The power of the emperor of China was of an absolute immensity that we can scarcely comprehend today.

Huizong emphasized three aspects of painting. First was realism, rooted, he insisted, in the careful, direct study of nature. His own carefully studied, realistic renderings of small birds, flowers, and rocks always demonstrate this requirement and became a legacy to the later Song academy to which we shall refer.[32] Huizong also insisted, second, upon a systematic study of the classical

113. Emperor Huizong, *Listening to the Qin,* hanging scroll, ink and color on silk, ca. 1102. 147.2 × 51.3 cm. Palace Museum, Beijing.

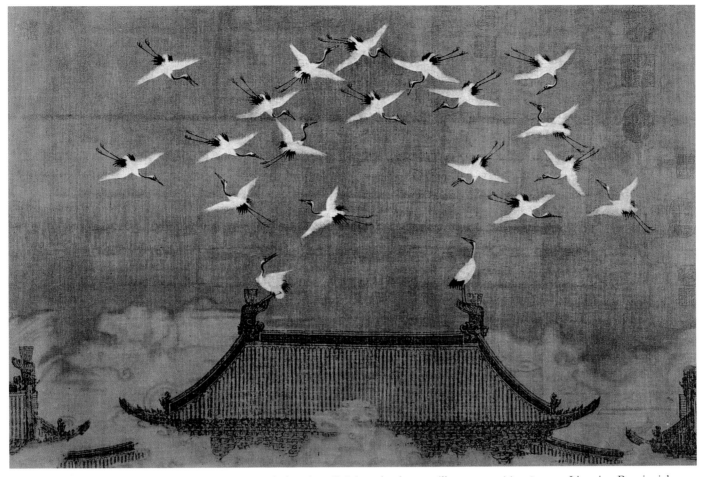

114. Emperor Huizong, *Auspicious Cranes,* section of a handscroll, ink and color on silk, 1112. 51 × 138.2 cm. Liaoning Provincial Museum, Shenyang.

painting traditions of the past. His own government collection of painting and calligraphy was the largest ever formed, and its catalogue, the *Xuanhe huapu,* is a major document in the process of canonization. It proclaimed Li Cheng the first master of landscape painting, Li Gonglin the foremost master of figure painting, and Xu Xi and Huang Quan the fathers of bird-and-flower painting. Other masters in each tradition were ranked and ordered more or less accordingly, so that for the first time since Zhang Yanyuan's *Lidai minghua ji* of the ninth century the entire historical panoply of painting and painters was laid out clearly. Again, Huizong himself best demonstrated the utility of his insistence on mastering the past. His copies of earlier figure paintings from his collection are the very measure of this practice (see figs. 72, 73).

Listening to the Qin (fig. 113) has been shown to depict the emperor himself playing the classic scholar's zither, or *qin,* to an attentive and reflective audience of two high officials, one of whom is the prime minister, Cai Jing, who later wrote a poetic inscription at the top of the scroll. A jadelike pine towers above them, and an elegant garden rock forms a kind of repoussoir framing the com-

position to the front. The simple clarity and limitation of elements is derived from Tang court art of the kind associated with Yan Liben, Zhang Xuan, and Zhou Fang, and, in general, a strong impression of a classic, high art is achieved. No doubt the picture performs several symbolic functions, although it is hard not to remember the extent to which the artistic emperor was coddled and indulged by his more rapacious officials as they encouraged him to devote himself to his private artistic passions while they in turn plundered the treasury and led the country to near ruin and disgrace.

Huizong's third requirement was the attainment of a "poetic idea," or *shiyi,* in painting. His painters were tested for their imaginative capacities in visualizing Tang poems, for example, and it was the emperor himself who first popularized the actual physical combination of painting, poetry, and calligraphy in a single work. This combination, known as the Three Perfections, or *sanjue,* would become the favored mode of later scholar-artists. It would be wrong to cite Huizong's *Auspicious Cranes* (fig. 114) as a perfect demonstration of the poetic idea, given that the painting functions above all as a kind of

propagandistic auspicious image certifying by the observation and representation of certain natural phenomena the virtues of Huizong's beneficent reign. Nonetheless, there is poetry in the elegance and calligraphic beauty of the picture, and it does indeed represent a new concept of painting that is not seen before. All of Huizong's paintings, in fact, attain a classic beauty rooted in the past, in realistic observation, and in poetic ideals, which together constitute the artistic image of his reign. No ruler before him had ever devoted so much talent and energy to the shaping, defining, and propagation of the visual embodiment of his own era. After Huizong, many emperors understood the effects of such an image and endeavored to create one themselves, beginning with the first emperor of the later Southern Song period, Gaozong (r. 1127–1162), who was one of Huizong's sons and understood perfectly the need for a powerful visual propaganda.[33]

Huizong's contributions to the development of landscape painting are also distinctive. He himself was a master of the subject, and his handscroll *Rowing Home on a Snowy River* in Liaoning is an accomplished work in the official Li Cheng style.[34] Not less impressive is the sole extant work of one of the emperor's young, talented protégés, the otherwise unknown Wang Ximeng (1096–1119). *A Thousand Li of River and Mountains* (fig. 115) is a breathtakingly beautiful blue-and-green landscape panorama painted for the emperor by a brilliant young artist who arrived at court in his teens and unfortunately died only a few years later. The young man received the gift of direct instruction in the art of painting from Huizong, and the present picture must have been something like a graduate examination. It bears a colophon by the prime minister, Cai Jing, which provides the only information known about Wang Ximeng. This brilliant coloristic manner had an old history, going back to the Tang court and to the Li family of court officials, who are said to have invented it. It was adopted by the Song imperial family as an appropriate emblem of their reign and was used widely throughout the Song period. Members of the imperial family continued to prefer the blue-and-green landscape style and technique, and it was later utilized by Zhao Mengfu (1254–1322), whose life as perhaps the last significant member of the Song imperial

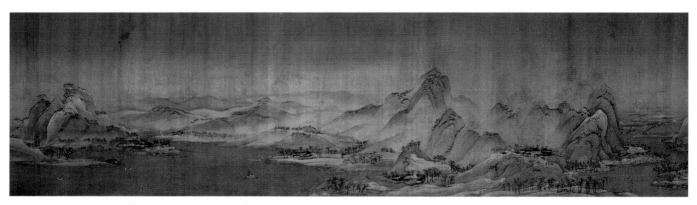

115. Wang Ximeng, *A Thousand Li of Rivers and Mountains,* section of a handscroll, ink and color on silk, 1113. 51.5 × 1191.5 cm. Palace Museum, Beijing.

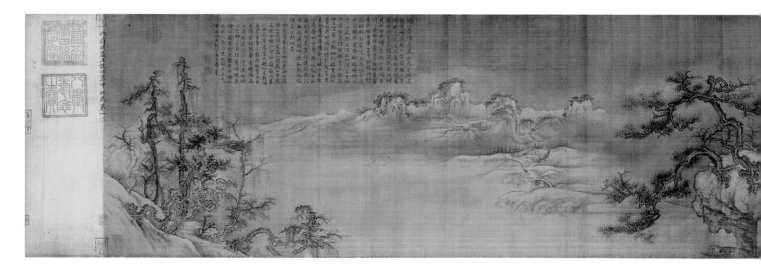

family lends a particular poignancy to its use in the period of Mongol rule. As if painted under Huizong's instructions, Wang Ximeng's landscape combines classical roots in the blue-and-green tradition, elegant and realistic drawing, and a glowing, golden atmosphere that is a kind of visual poetry.

Another great practitioner of the manner was Huizong's "uncle," Wang Shen — actually, they were only related by marriage, although Wang Shen, like Huizong, was raised in the imperial palaces and was for all practical purposes a member of the imperial family by virtue of his descent from one of the military heroes of the founding of the dynasty. A poet, scholar, connoisseur, calligrapher, and hereditary military official — born into "the race of generals," according to his friend Su Shi — Wang fell into the net of political intrigue surrounding the reformer Wang Anshi and Emperor Shenzong and was exiled for a number of years before being allowed to return to his palace in Kaifeng. It is odd that we do not even know the dates of Wang Shen's birth or death because he was one of the great landscape masters of his time and a distinguished member of the imperial family. He was still alive when Huizong ascended the throne, but for how long we do not know. He had fundamentally influenced the young emperor. Wang must have acquired his basic knowledge of painting from Guo Xi, whose style his closely reflects. *Light Snow over a Fishing Village* (fig. 116), however, takes the balanced and ordered elements of the Guo Xi manner and subjects them to a powerful reorientation, drawing them out of balance, opening them up, stretching and pulling them into a new configuration that is entirely personal and almost radically individualistic. For the first time, in his art we encounter the figure of the wandering scholar, dark-hooded, walking through the snow in the deep mountains, like one of Caspar David Friedrich's heavily cloaked German scholars gazing at the moon. This is something akin to the romantic landscape art of nineteenth-century Europe, a vision of landscape clearly and frankly seen through the eyes of an individual who shapes it into his own image. Wang Shen created a landscape of exile, in which the alienated artist finds his place amid a landscape that had been until now an imperial realm, shaped by the imperial gaze and power. In this same remote world of exile, the poet Su Shi wrote his most introspective poetry, and the calligrapher Huang Tingjian created his most powerfully individualistic works.

Perhaps the perfect embodiment of this new landscape of exile is Wang Shen's famed composition *Serried Hills over a Misty River* (*Yanjiang diezhang tu*), the best version of which is in the Shanghai Museum (fig. 117). Opening the scroll at the right, we can see almost nothing for nearly half the length of the scroll. Only empty mist and two pale, almost invisible small boats are glimpsed. The effect of this emptiness is to dislocate the viewer, who must ask where the landscape is and wonder where he is being taken. Then, across the water, islands of blue and green appear, shimmering, like a mirage: the glowing world of exile far from the imperial power, where, unexpectedly, so many artists of the time found new inspiration for their art. This is the beginning of the powerful tradition of the scholar-painters of China, men who stood just beside the imperial structure — sometimes in fact just within it — and found the authority to comment upon it, to look at it from their separate place, and to attempt to shape it into a form closer to their interests and values. Such men were in fact never very far from the center of imperial power, were indeed essential parts of

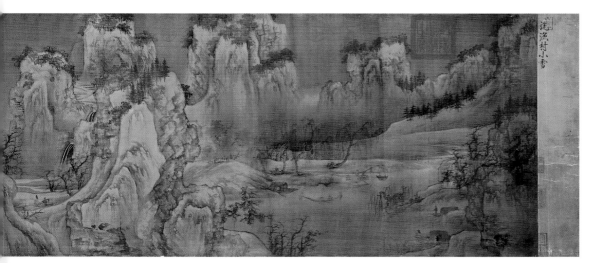

116. Wang Shen, *Light Snow over a Fishing Village,* handscroll, ink and color on silk, ca. 1085. 44.4 × 219.7 cm. Palace Museum, Beijing.

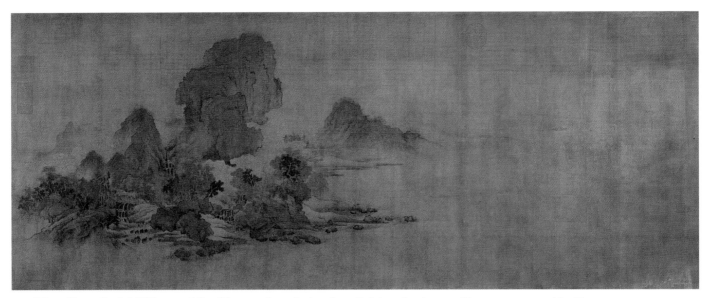

117. Wang Shen, *Serried Hills over a Misty River,* section of a handscroll, ink and color on silk, ca. 1100. 45.2 × 166 cm. Shanghai Museum.

The Southern Song

that power, but were also closer to the common reality of their times, closer sometimes to the interests of the great landholders, whom they embodied and represented, and even in some important ways closer to the interests of the common people, upon whom they depended for their wealth.

Li Gonglin was one of them, and we have already considered his art. A very rare work by one of his immediate followers, Qiao Zhongchang (active early twelfth century), illustrates better than anything else extant the radical redirections they brought in so many ways to the art of painting (fig. 118). Qiao's *Red Cliff* is an extended illustration of Su Shi's second prose poem on the theme of the Red Cliff and an inventive, calligraphic exploration of a new pictorial mode of representing. Li Gonglin's landscape painting is the stylistic prototype, and Li surely painted numerous narratives of this type himself.[35] What is perhaps most surprising about such works is the fact that their heroes are living men of the time, men whose lives were locked into the political and social realities of a complicated and unpredictable world. Su Shi's calligraphy was banned from the court of Huizong, and his name posted in an official list of enemies of the court. Yet, here he is before us, the hero of his own narrative of the meanings of life, a serene, Daoist view of cosmic existence the center of which is far from the colorful rituals of the imperial court.

The inevitable end of Huizong's inept and massively corrupt political reign came with the victory of Tartar Jin armies over the Song military in north China in 1127. Huizong first abdicated in favor of his eldest son, then submitted himself and his family as prisoners to the Jin conquerors of the Song capital. During the following decade, as Huizong, his emperor-son, and their families were taken ignominiously from one nomadic encampment to another, Chinese and Tartar armies continued to battle over the fate of China. Huizong's sixth son took the vacated imperial throne and reigned over these chaotic conditions as Emperor Gaozong, eventually establishing a new capital in the southern coastal city of Hangzhou and an uneasy peace with the Jin rulers of north China. This new, severed China is known as Southern Song. The great events that occurred during this period of transition — "crossing to the south," as it is sometimes referred to — constitute a dramatic, fascinating story, and one of course in which art and artists are inextricably bound up. The vast imperial collections of art amassed by Huizong now suffered destruction, loss, and damage — only one of the many times the artistic heritage of the Chinese people has been nearly destroyed. All systematic structures and organizations sustaining artistic production were temporarily disrupted, and a new order had to be established following the declaration of a new capital in Hangzhou. Once a fragile stability was es-

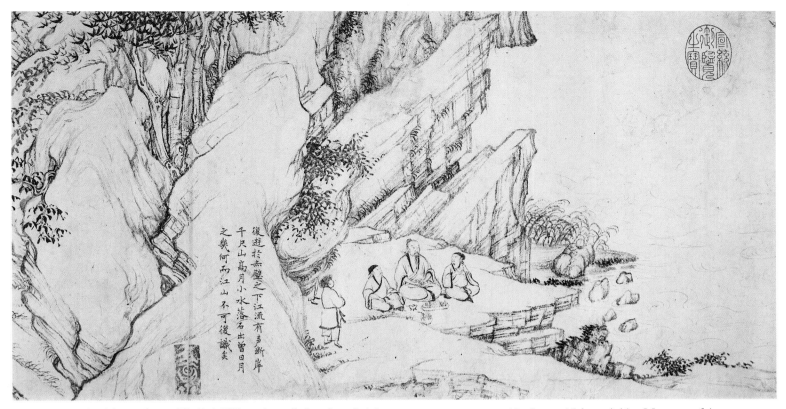

復遊於赤壁之下江流有聲斷岸
千尺山高月小水落石出曾日月
之幾何而江山不可復識矣

118. Qiao Zhongchang, *The Red Cliff,* section of a handscroll, ink on paper, ca. 1123. 29.5 × 560 cm. Nelson-Atkins Museum of Art, Kansas City, Missouri. (Purchase.)

tablished, Gaozong quickly set about restoring the old order. The Painting Academy was newly reconstituted along with the other orders of imperial government, and, in fact, Gaozong, the astute son of an artistically accomplished father, quickly realized the important roles that art could play for his regime. Dynastic revival became a central theme of his new government, and artists became important components in the propagation of the national image.[36]

No new changes of style are visible as a result of the dramatic events of the time, however, only new subject matter appropriate to the new policies and propaganda efforts of the court. Li Tang (ca. 1050–after 1130) is the most significant painter of the period, and judging from datable works by him from the late Northern Song and early Southern Song periods, respectively, he went on painting as before in spite of the high adventures he is reported to have experienced during the dangerously unsettled years of the transition (when he is said to have been captured by bandits, one of whom was a young painter named Xiao Zhao [active ca. 1130–1160], who became a major follower). *Wind through the Pine Valleys* (fig. 119) bears Li Tang's signature and a date corresponding to 1124. It is one of the major dated monuments of Song landscape painting and a work of great originality and apparent redirection within the Imperial Painting

Academy. It is difficult to account for such a dramatic change in the imperial image of landscape, in fact, unless we assume that court painters like Li Tang had considerable freedom to experiment with styles and techniques; after all, the semiofficial imperial style of painting promoted by Huizong was based upon Li Cheng on the one hand and the imperial blue-and-green landscape style on the other. It may well be that *Wind Through the Pine Valleys* was originally a blue-and-green landscape from which the mineral pigments have now mostly disappeared (traces are visible, as Suzuki Kei has pointed out).[37] The sharp, rocky spires of that old image associated with the Tang imperial masters Li Sixun and Li Zhaodao are joined by Li Tang to the rugged monumentality of Fan Kuan to create what now looks like a new landscape style, and almost a reaction against the serene Li Cheng manner. This would become the basis for the later Southern Song academic style of landscape painting, and its techniques of ax-cut brushstrokes, sharp-edged rocks and cliffs, and twisting, angled trees would constitute the essential artistic vocabulary of the leading Southern Song masters.

A few (or many — we do not have a clear chronology) years later, at the tentative and uncertain court of Gaozong, Li Tang continued to paint such landscapes, as his *River Temple in the Long Summer* (fig. 120) indicates. Nearly black with chemical deterioration and damage, this once

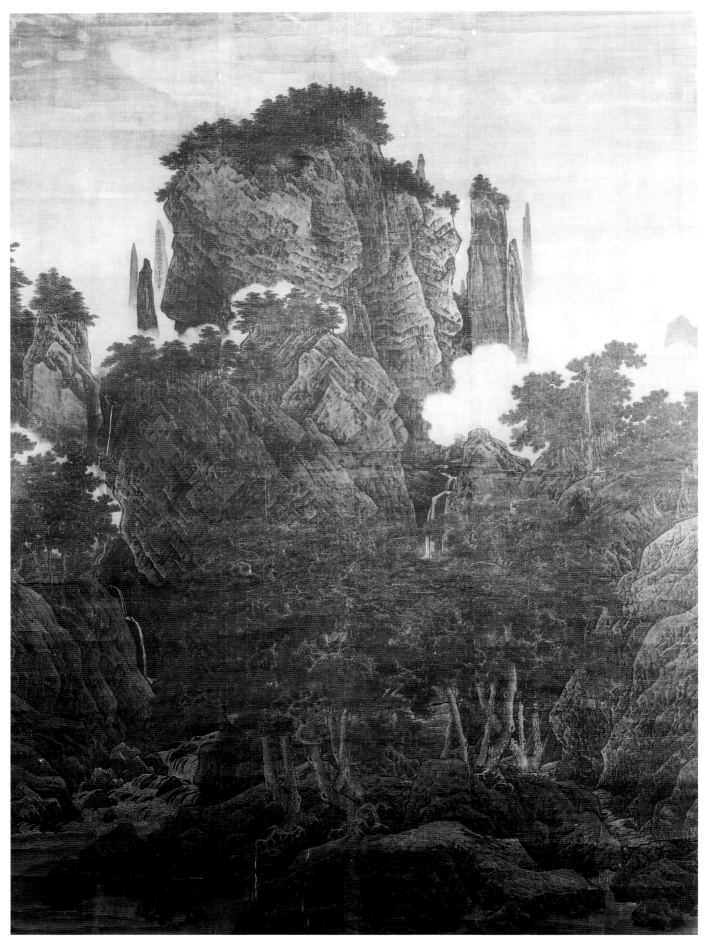

119. Li Tang, *Wind Through the Pine Valleys,* hanging scroll, ink and color on silk, 1124. 188.7 × 139.8 cm. Collection of the National Palace Museum, Taibei.

blue-and-green river landscape bears a bold inscription by the emperor declaring Li Tang to be the Li Sixun of the present-day, a nice verbal play on Li Tang and Tang Li (Sixun). Apparently, therefore, under the imperial gaze, such paintings as *Wind Through the Pine Valleys* and *River Temple in the Long Summer* were essentially new versions of the old imperial manner.

A different aspect of the evolving imperial landscape was painted by a leading member of the old Song imperial family, fittingly enough, a gifted painter named Zhao Boju (d. ca. 1162), who was one of the many members of his family who attained distinction in art. Zhao's *Autumn Colors over Streams and Mountains* (fig. 121) echoes such earlier imperial images as those of Wang Shen and Wang Ximeng, as well as Huizong's own landscape painting, but achieves a striking substance and tactile presence that has led some scholars to think that the painting must have been painted by a Northern Song artist closer to Li Cheng and Fan Kuan than to Li Tang. Indicative of both the uncertainty of such matters and the nearly pure accident by which such works survive at all is the fact that the present painting has no known history before it was presented to the first emperor of the Ming dynasty, Zhu Yuanzhang, by an official who acquired it from an antique dealer. The emperor, apparently, decided that it was by Zhao Boju and declared it to be an autumn landscape. In fact, the season of the scroll is not autumn, but spring, and the actual original identity of the painting is completely unknown. It could well be a version of the celebrated story of paradise gained and lost, "Peach Blossom Spring." It belongs, in any case, with Wang Ximeng's long blue-and-green landscape style handscroll among the finest extant examples of the Song imperial manner of landscape painting.

The Southern Song Painting Academy

All of the old subjects were revived under the new government, and many new ones appropriate to the new image of dynastic revival. Old historical narratives telling of imperial hardship, survival, and rebirth especially flourished, including the popular "Eighteen Songs of a Nomad Flute," [38] the story of Duke Wen's return to power in the state of Jin, [39] and new stories of auspicious omens and miraculous events surrounding the divine reign of Gaozong. [40] Apparently, Li Tang was returned to a position of leadership within the newly reestablished Imperial Academy of Painting, along with other survivors of the transition, and new talents were drawn to the beautiful, flourishing capital in Hangzhou. Set between West Lake and the Qiantang River, which flows into the sea, Hangzhou is one of the most attractive cities in the world and became perhaps the most flourishing economic center of the world during the twelfth and thirteenth centuries.

The painting that evolved and flourished there was patronized by members of the imperial family first, especially by the succession of powerful empresses and their families, including several emperors who were especially attentive to the powers of art. High officials followed the imperial pattern and played a similar role in patronizing the glittering array of artistic talents who gathered in Hangzhou. The art they preferred was miniature and portable, easily accessible for the casual writing of poems and couplets and used quite casually as a form of communication. The most popular format may have been the fan or single album leaf, beside or on the back of which one could inscribe a few lines. [41] This miniature format is especially suitable for the quality of concentration and intensity that is so characteristic of Southern Song art as a whole. A sense of layered depths and invisible dimensions is suggested by much Southern Song art, paintings and ceramics alike, both of which were of course patronized preeminently by the imperial court.

Li Di's (ca. 1100–after 1197) *Shrike on a Winter Tree* (fig. 122) personifies these qualities, as if it were a crystallization of frozen intensity and concentration itself. There is an almost European quality to the drawing of the branches and trunk of the tree — a three-dimensionality often found in Song court art — and a realistic, nearly scientific accuracy to the drawing of the bird, both of which are perhaps the legacy of Huizong and his reforms. Between 1174 and 1197, Li Di served three successive emperors as court master and is representative of the profession of painting in his time. Painting was essentially a craft or artisan tradition and was maintained successfully over long periods by families of artisans like Li Di, whose son, Li Demao (active ca. 1241–1252), also served as a court painter. Their contemporary Li Song (active 1190–1230) was originally a carpenter but was adopted by a court master named Li Congxun (active twelfth century) and trained by him as a painter to succeed him. Later, Li Song trained his nephew Li Yongnian (active ca. 1265–1274) and others, who then "continued his tradition," as the biographies always say. That is, they continued to produce the product for which the family was employed. The most famous such family in the Song period was the Ma family of Hezhong, Shanxi Province. Beginning with Ma Ben (Fen) (early twelfth century) in the late Northern Song period, the Ma family served the emperors of China for five generations. Judging from

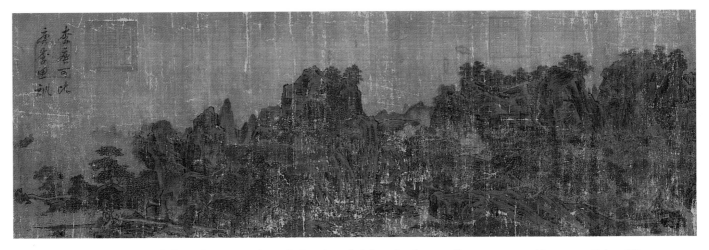

120. Li Tang, *River Temple in the Long Summer,* section of a handscroll, ink and color on silk, ca. 1150. 44 × 249 cm. Palace Museum, Beijing.

the many extant works by three members of the family, Ma Yuan (active before 1189–after 1225), Ma Gongxian (twelfth century), and Ma Lin (active early to mid thirteenth century), their enterprise was the very model of a typical artisanal occupation. It continued for a century and a half with at least one painter in each generation receiving official appointment to the academy and thus perpetuating the family's financial well-being. Probably the family's very life and welfare depended upon that continuing appointment, and their enterprise was a communal one whose survival they all worked to insure. We must imagine a major studio or workshop run by the family and employing assistants, apprentices, managers or agents, pigment and ink makers possibly (although these and other materials may have been regularly supplied by the court), mounters, and so on. A master painter probably held title to the position and salary that represented the family's fortune, and all other family members contributed in some manner to their common enterprise, that is, the production of paintings bearing the mark, craft, and quality of the famous Ma family. Always perfect specimens of artful craft, these paintings are literally imperial objects, made so as to be worthy of receiving the imperial gaze, touch, and brush. Typically, an emperor or empress inscribed a poem or poetic couplet and personal imperial dedication directly on the surface of such a painting or on a facing page or on the reverse of a fan, for example. The example we illustrate, *Banquet by Lantern Light* (fig. 123), bears no signature of the artist but a long poem in the center top written by an imperial hand. The poem refers

121. Zhao Boju, *Autumn Colors over Streams and Mountains,* handscroll, ink and color on silk, ca. 1160. 56.6 × 323.2 cm. Palace Museum, Beijing.

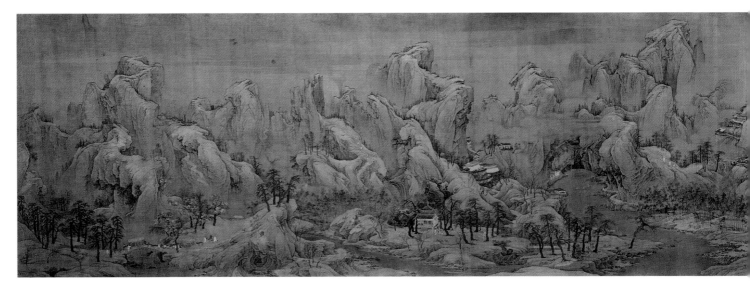

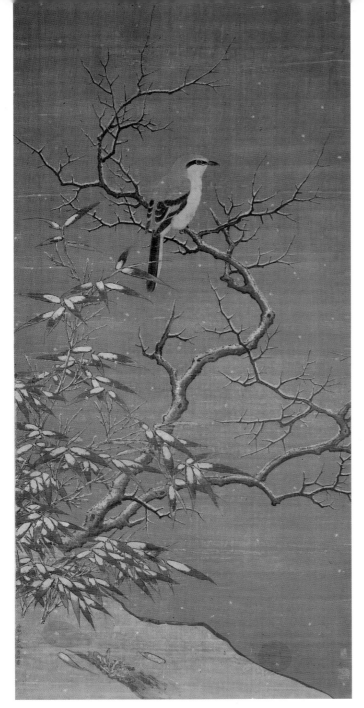

to a banquet that had taken place one evening (the painting was probably done in the days just following) at which Emperor Ningzong (r. 1195–1224), his empress, and three members of the empress's family had been present. Just inside the drawn blind we can see the three guests approaching their unseen hosts, who are hidden behind the screen. Outside, musicians and dancers perform for the company. It is apparently an early spring evening because the heavily pruned and dramatically shaped plum trees in the foreground are blossoming and a rainy mist fills the air, according to the poem.

Evidently the major purpose of the banquet and the painting recording it was to make widely known the elevation of Empress Yang's brother and his sons to such eminence that the emperor invited them to elegant banquets — and then furthermore had the most celebrated family of court artists depict the event in their expected elegant fashion. The poem was probably written by Empress Yang herself, although some believe that Emperor Ningzong was the composer if not the calligrapher. All of the expected features of the Ma style are present. In a carefully constructed composition, the imperial presence is sheltered in a lower corner, tightly buttressed by the architectural and landscape elements around it, and the entire composition could be marked off by a straight diagonal line drawn from the lower left corner to the upper right. Necessary motifs of the Ma style are the sharp, angular plum trees, the tall, dramatic pines rising into the night sky, the pale silhouette of distant mountaintops, and the dense mist that lies in heavy banks over the scene. The strongly defined interior space is an invitation

122. Li Di, *Shrike on a Winter Tree,* hanging scroll, ink and color on silk, 1187. 115.2 × 52.8 cm. Shanghai Museum. *above*

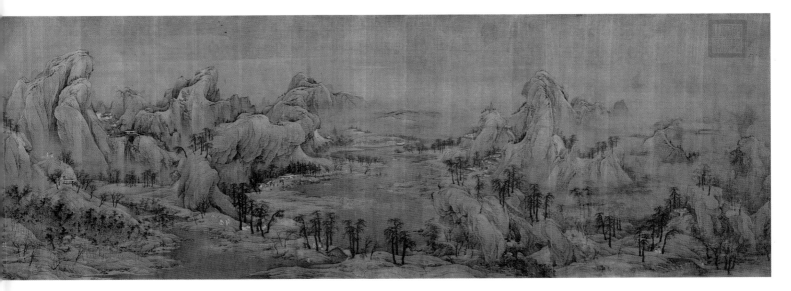

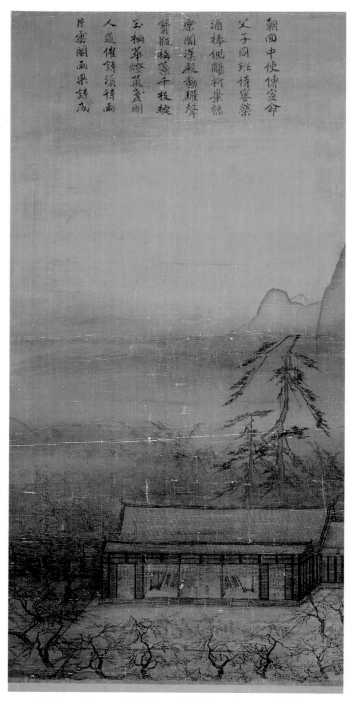

朝
國
中
使
傳
宣
命

父
子
同
班
侍
宴
榮

酒
捧
倪
醨
祈
景
福

樂
聞
漢
殿
動
雛
聲

籤
瓶
梅
蘂
千
枝
綻

玉
柵
萃
燈
萬
盞
明

人
益
催
詩
須
待
雨

片
雲
閣
雨
果
詩
成

123. Ma Yuan, *Banquet by Lantern Light,* hanging scroll, ink
and color on silk, ca. 1200. 111.9 × 53.5 cm. National Palace
Museum, Taibei.

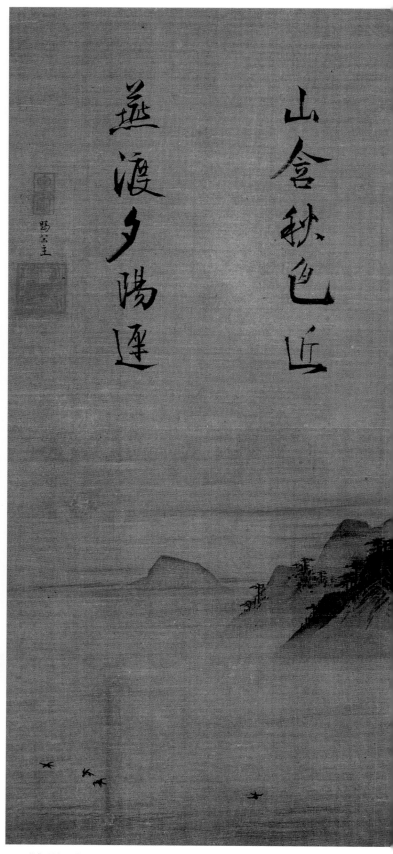

山
舍
秋
色
匠

燕
渡
夕
陽
連

124. Ma Lin, *Sunset Landscape,* hanging scroll, ink and color on
silk, 1254. 51.5 × 27 cm. Nezu Institute of Fine Arts, Tokyo.

to the imperial gaze that literally owns this palatial vista and whose presence is always somehow near at hand in all of the paintings of the Ma family.

The last of the family to paint for the Song emperors was Ma Lin, whose life may have extended until the final Mongol destruction of the Song. His touching *Sunset Landscape* (fig. 124) seems almost to be an elegy for his dynasty, so preoccupied is it with the end of light and vision. Illustrating a couplet by the Tang poet Wang Wei that can be translated "Mountains hold the autumn colors near, / Swallows cross the evening sun slowly," Ma Lin very simply depicts a lake or river at twilight as a few swallows flit across the water toward the setting sun. The familiar mountain silhouettes also carry the eye into the glowing sky beyond.

Oddly, many scholars have noted a quality of melancholy in the art of Ma Lin. He often seems to focus his art upon a moment of intense beauty in the very process of disappearing as we see it with him. But, of course, it was probably not Ma Lin who chose those poignant moments but his patrons, Emperor Lizong (r. 1225–1264), whose sharp, elegant calligraphic hand inscribed the couplet above, and the emperor's ladies. In Ma Lin, they found the perfect voice to sing their sad songs for them as they presided over the end of a great empire.

The academy master with the boldest vision was a contemporary of Ma Yuan named Xia Gui (active early thirteenth century). Their names together — Ma-Xia — have come to represent the typical achievement of the Southern Song academy. Xia may have been somewhat older than Ma Yuan, but they were certainly active at court together and must have known each other as rivals for the imperial favor. There were, in fact, so many active and often competing members of the imperial family that there was surely room for a dozen leading masters at the Southern Song palace. Xia Gui, like the Mas, has left us many small pictures done for the imperial brush, but also two classic landscape handscrolls that still grow in fresh and interesting ways from the achievements of Li Cheng and Juran at the beginning of the dynasty. *Pure and Remote Views of Streams and Mountains* (fig. 125) could almost be a demonstration of the formal characteristics of Song landscape painting, with its clear structure of near, middle, and far distance, its few and carefully alternating motifs, and its beautifully swift, nuanced depiction of rocks and foliage. Almost effortlessly, it seems, Xia Gui creates a landscape without end, as if no scroll could be long enough to hold his vision. Here is the final form of Li Tang's ax-cut brushstrokes, now icy, wet chips of the brush sculpting mountains from the empty air that the paper surface has become.

Xia Gui's second great handscroll is the enigmatic *Twelve Landscape Views* (fig. 126), of which there are many copies. Taken at evening, each brief view passes before our eyes in the settling darkness as if we watched a film in slow motion recording the end of the day. Here are "wild geese over distant mountains," "a ferryboat returning to a misty village," "the clear and lonely sound of a fisherman's flute," and "misty bank at evening mooring." Pale, distant landscape forms give way to the darkening shapes of night as the light slowly disappears and the scroll comes to an end. The twelve views in the original handscroll moved casually through the hours of the day, from morning to night. Time is of course central to the Chinese concept of space, but nowhere except perhaps in film and music have time and space been so seamlessly and artfully interwoven as in such works of art as this.

Chan Painting and the End of the Song

The final brief chapter of Song painting was written in the Buddhist monasteries around West Lake in the decades just prior to the Mongol invasion of China in the 1270s — and, in fact, probably continued for a time in those same monasteries after the Mongol victory over the Song and the establishment of a "barbarian" dynasty. Buddhism played a significant role in the history of Song painting, from the beginnings of the landscape tradition to the origins of literati art and theory in the late Northern Song. Still, it has proven difficult to isolate any distinctly Buddhist elements in painting aside from subject matter, and it has been questioned even whether there was anything that should be termed a purely Buddhist manner of painting at all. The late Song flowering of Chan painting, however, is a striking instance of a clearly Chan Buddhist — or, at any rate, Buddhist (the distinctions between Chan and, say, Tiantai Buddhism need not concern us) — artistic phenomenon.

Certain subjects and techniques of painting were associated with Buddhist subjects and forms of expression even within the Imperial Painting Academy. Liang Kai, a leading thirteenth-century academic master, painted in a wide variety of styles, unlike the Ma family heirs or Xia Gui and his son, for example, and must represent a different type of artistic personality, perhaps even a different sociological model. If the traditional painting families had every reason to conservatively continue producing a predictable product, why did Liang Kai not produce such a product? Why is nearly every painting by him different? Possibly his art was always somehow rooted in Buddhist

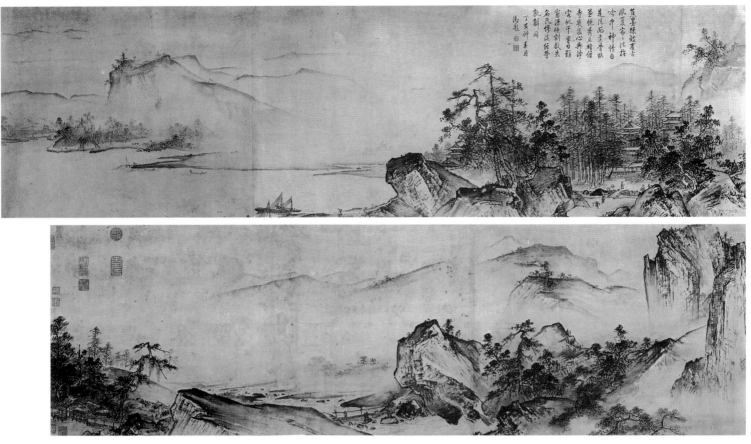

125. Xia Gui, *Pure and Remote Views of Streams and Mountains,* sections of a handscroll, ink on paper, ca. 1200. 46.5 × 889 cm. Collection of the National Palace Museum, Taibei.

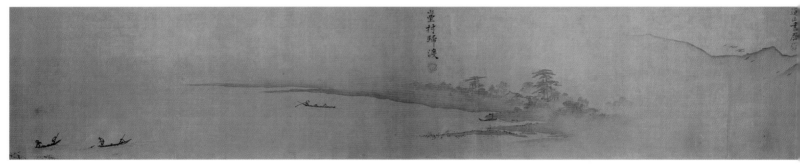

126. Xia Gui, *Twelve Landscape Views,* section of a handscroll, ink on paper, ca. 1225. 28 × 230.8 cm. Nelson-Atkins Museum of Art, Kansas City, Missouri. (Purchase: Nelson Trust.)

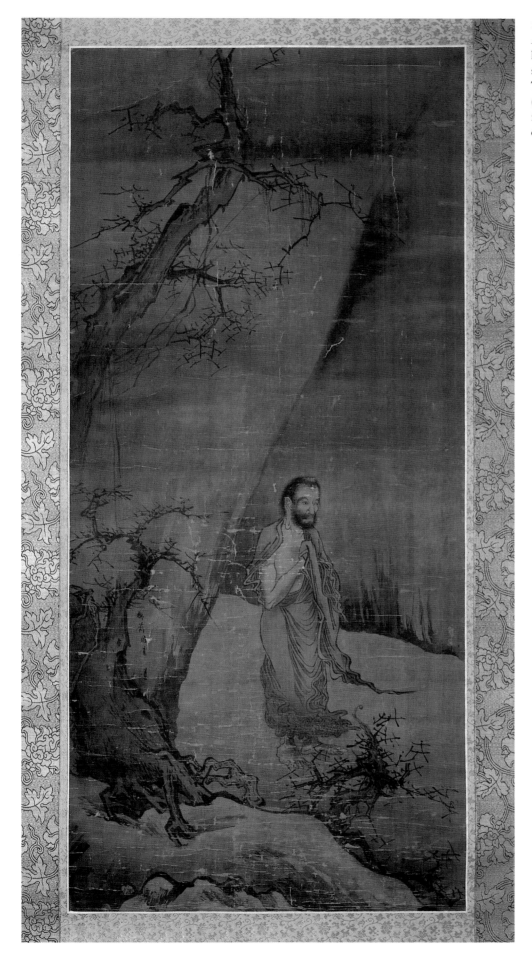

127. Liang Kai, *Shakyamuni
Emerging from the Mountains,*
hanging scroll, ink and color on
silk, 13th century. 117.6 × 51.9 cm.
Tokyo National Museum.
(Preserved by the Agency
for Cultural Affairs [Bunkacho]
of Japan.)

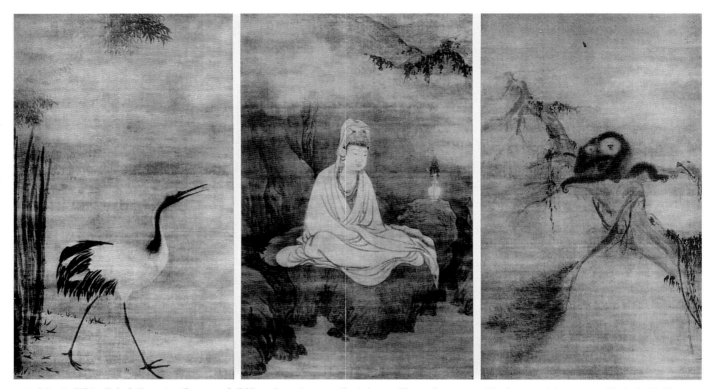

128. Muqi, *White-Robed Guanyin, Crane, and Gibbons*, hanging scrolls, ink on silk, 13th century. Each 173.9 × 98.8 cm. Daitokuji, Kyoto.

traditions. The great temples probably maintained continuous traditions of hereditary painters who were highly trained like academic and independent professional masters, but who also lived within a rougher, freer community that often prided itself on its unconventionality and eccentricity. Muqi, whom I shall turn to, perfectly embodies such a tradition because he appears to have been both a Buddhist monk of some stature and a professional painter, but one who also painted in a simple, terse, swift style of ink drawing that appears to be typical of Chan artists generally.

Some of Liang Kai's extant paintings were done for the imperial court in a manner designed to suggest a distinctly untrammeled Buddhist flavor, others in a refined and accomplished detailed *baimiao,* or plain line, style derived from Li Gonglin — who can also be regarded as a Buddhist painter in some fundamental sense — and still others in the sketchy, abbreviated, rough style that the Buddhist painters must have thought of as their own. Liang's *Shakyamuni Emerging from the Mountains* (fig. 127) was painted for the court, according to the signature, but can scarcely be described as academic in any way. The figure style is an old one, to be sure, related ultimately to the "flowing water and scudding clouds" drapery manner of the Tang giant Wu Daozi but is done in such a free and

easy way that it bears no academic air whatever. The swiftly and boldly drawn branches and rocks are even less academic, so that we want to conclude that Liang Kai was painting for the imperial court a kind of identifiably Buddhist image in a manner known to be a Buddhist one. Liang Kai here obviously wanted to impart a sense of the ineffable, unconquerable inner spirit of the Buddha, who emerges from long ascetic meditation wasted and gaunt but holding within himself now the seed of knowledge of the meaning of existence that would soon emerge at Vulture Peak as the dharma law. Like Shakyamuni, Liang Kai is said to have renounced his secular positions, resigning his position in the academy, and is thought to have spent the latter part of his life in the environs of the monastic communities around West Lake. The more extremely abbreviated and cursive images bearing his name presumably date from this period.[42]

Muqi's *White-Robed Guanyin, Crane, and Gibbons* (fig. 128) is a contemporary Buddhist icon of a type similar to Liang Kai's *Shakyamuni Emerging from the Mountains,* painted by a Chan artist who signs himself "Monk from Shu," *Shuseng.* Muqi, together with Liang Kai and another monk named Yujian Ruofen, represent late Song Buddhist ink painting in China in its clearest form. Like Liang Kai, Muqi appears to have been a professional painter. His *White-Robed*

Guanyin is the centerpiece of a triptych that has been kept at the Daitokuji temple in Kyoto for many centuries. The two flanking scrolls, a gibbon and baby resting on the branch of an old pine tree on the right and a crane crying out from a misty bamboo grove on the left, were presumably intended to provide expanded visual dimensions and mysterious spiritual reverberations to the central Guanyin, whose image represents supreme compassion. Gibbons and cranes were traditional symbols of human life and folly on the one hand and longevity or even immortality on the other, so they would seem to be appropriate counterbalances to a spiritual icon addressing the faithful as savior and hope for redemption. In any case, what signifies beyond the routine in this case is the way Muqi painted the familiar images. His mother gibbon looks out directly at us in a way we could rarely see under normal circumstances, and she is tightly holding her baby, who also stares at us. This creates a surprising confrontation, and leaves us with an unsettled feeling: what are we to think when we look into the eyes of two gibbons sitting in a high tree beside the sainted Guanyin? As if in direct opposition to the still and silent gibbons, Muqi's crane gallops loudly through the bamboo, head raised and beak open as if crying out in that startlingly human voice of the crane. On either side of the white-robed, meditating Guanyin, seated in a grotto in her legendary island home, these images appear to convey this message: the infinite compassion of Guanyin is as real yet intangible, as mysterious yet accessible to all men as the cry of a crane from the misty bamboo or the shriek of a gibbon from the high trees.

Scholars will argue about the nature of Chan painting, but it is likely that the central fact of Buddhist art is its consistent effort to illuminate spiritual values through pictorial images. This is different from the illustration of Confucian ideas through stories of human action, or the suggestion of Daoist immortality through the depiction of odd Daoist eccentrics in odd ways. It is more subtle and more difficult because it puts art to a different kind of use, a use closer to the expression of meaning in landscape painting than to other subjects. If style itself, and techniques as well as subject matter are always considered to have the capacity to convey spiritual meanings, then we would have to look more closely at the use of these elements in Buddhist art than in any other mode of art — except that of the literati masters. It is in any case hardly surprising that the late Song period is filled with images of the sacred and the spiritual, both inside the imperial court and outside. As Song China neared its eventual destruction by the Mongols, many must have realized — or feared — that the physical and human world they knew could not long endure. At such times throughout the world, the sacred realm beckons with renewed power.

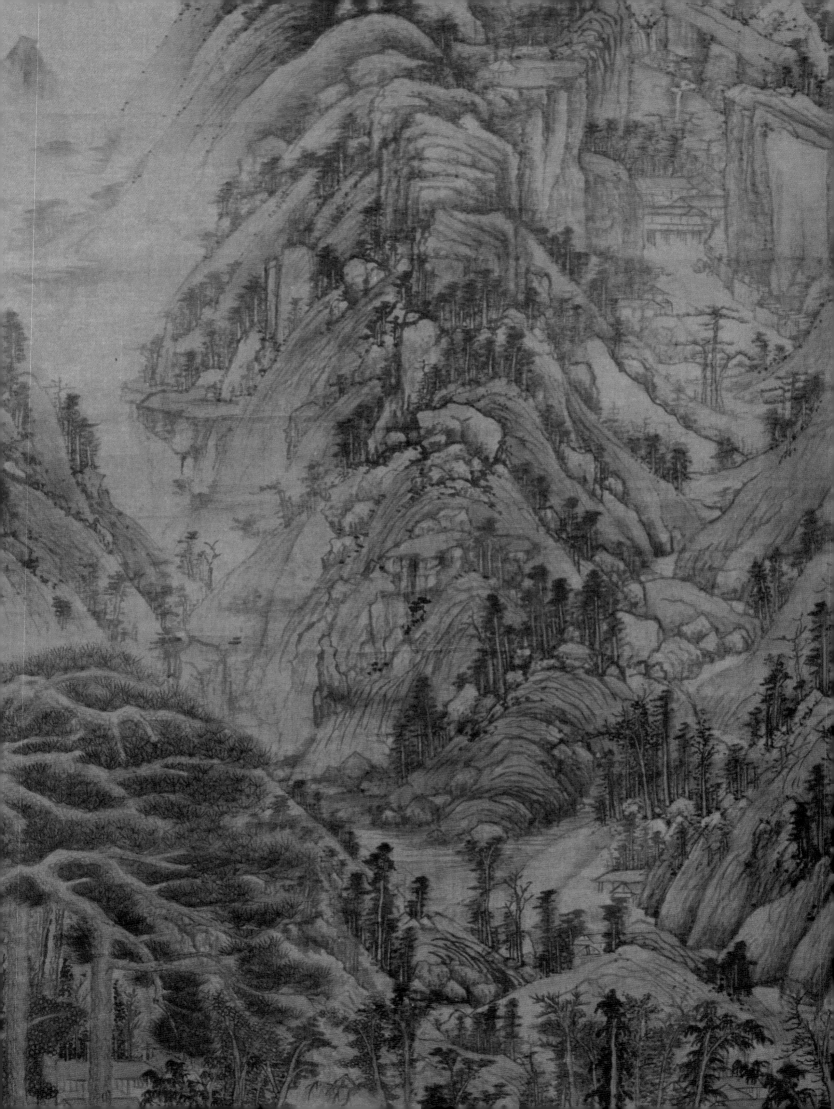

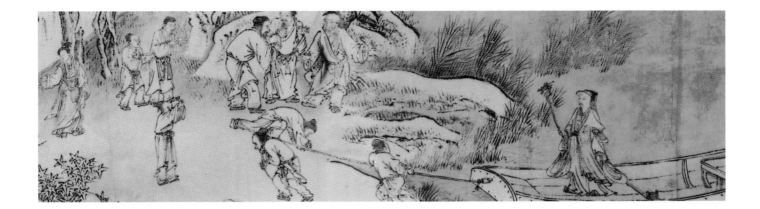

The Yuan Dynasty (1271–1368)

The Southern Song period, for all its cultural glories, is seen by historians as an age of weakness in the Chinese state, characterized by retrenchment in area and influence, humiliating military impotence, and a mood of nostalgia bordering on escapism. The conquest of China by the Mongols in the third quarter of the thirteenth century ended even this fragile peace, putting China for the first time completely under foreign rule. Educated Chinese who normally would have attempted careers in public service found themselves mostly disenfranchised, since the Mongols had no tradition of recruiting scholars as administrators and preferred to employ members of other conquered races, central Asians and Jurchens, in ruling China. Those Chinese who were invited to serve faced a painful dilemma: If they joined the new Yuan administration, they could be branded turncoats and their positions could be made insecure and unrewarding. If they withdrew out of loyalism to the vanquished Song and finished their lives in reclusion as *yimin* (literally, "leftover subjects"), they would forsake the traditional rewards of scholarship and be forced to support themselves and their families as best they could with their talents. Moral grounds could be found for either course; those who chose service argued that China still needed good native administrators to temper the harshness of rule by people unfamiliar with Chinese ways. The new directions that painting took in the early Yuan were pursued mostly by artists who were in one way or another involved in these

Details, figure 155 (*opposite*) and figure 137 (*above*)

issues and responded to them in the subjects and styles of their works. Much early Yuan painting thus can be said to have a political dimension, along with other kinds of meaning and expression.

The central phenomenon in painting of the period, at least in art-historical retrospect, is the emergence of the literati-amateur movement as the dominant force. Several factors underlie this development. The Imperial Painting Academy, which throughout the Southern Song had followed the aesthetic directions established by Emperor Huizong, joining high technique with poetic or other literary content, did not survive the dynastic change; artists who continued in this vein in the Yuan were, on the whole, minor figures. The political unification of south and north made it possible for the southern literati, notably those of the Jiangnan, or Yangzi delta, region, to rejoin the scholar-amateur tradition of painting as active participants. Inaugurated in the late Northern Song period by artists such as Su Shi, Mi Fu, and Li Gonglin, that tradition had been kept alive in the north under the Jin dynasty by masters such as Wang Tingyun. The withdrawal of loyalist scholars from public life obliged them to seek other pursuits, among which painting was prominent, for both self-fulfillment and survival. Under the harsh political and economic conditions of the Yuan occupation, educated people formed networks of mutual support, coteries within which traditional Chinese cultural practices were perpetuated. The more affluent members helped those who were impoverished, in a kind of gentlemanly patronage system. Much Yuan painting, calligraphy, and poetry was produced under these conditions and was intended for presentation to others of the artist's or poet's group, with some expectation of recompense, usually nonmonetary (judging from the evidence we have for later periods). Such networks were by no means made up exclusively of yimin, or loyalists, nor was the practice of scholar-amateur painting in the early Yuan confined to them. It flourished as strongly among those who sought or accepted official service; in fact, as we shall see, one of its preeminent practitioners, Zhao Mengfu, belonged to this group.

Loyalist Painters of the Early Yuan

Plant subjects such as bamboo and blossoming plum, usually rendered in ink monochrome, had been favorites of amateur painters from the time of Su Shi and his friend Wen Tong. Artists who had gained their facility with brush and ink by practicing calligraphy could display it most effectively in paintings of this kind, which were technically untaxing and did not require the specialist skills of the studio-trained professional masters. The symbolic meanings attached to plant subjects made them ideal for carrying congratulatory and other messages between literati, and for strengthening their sense of community at a time when these common values seemed threatened. The yimin artist Zheng Sixiao (1241–1318) painted *lanhua,* the Chinese orchid, in pictures that conveyed the idea of modest reclusion both formally, in their simple clusters of unassuming brushstrokes, and as images — the orchid had long served in poetry as a metaphor for the sensitive man who had withdrawn from the world.[1] In the generation before him, Zhao Mengjian (1199–before 1267), a member of the Song imperial family, sometimes depicted a theme even more apposite to the situation in which the cultivated Chinese scholar-gentlemen found themselves: the "Three Friends of the Cold Season." The Three Friends — pine, bamboo, and blossoming plum—symbolized, as survivors of the harshness of winter, the Confucian virtue of maintaining one's integrity in trying times.[2] A fan painting of this theme bearing Zhao's seal (fig. 129) derives some poignancy from presumably having been painted during the years when the Song was suffering defeat. It presents overlapping branches of the three plants in a precise, controlled way not out of harmony with the Song academic mode; none of the rough-brush effects or marks of spontaneity that would characterize so much Yuan painting are to be seen here, and the work seems to affirm the persistence of order under stress.

An yimin artist especially fervent in his loyalism was Gong Kai (1222–1307), who had held a minor office under the Song. After the Yuan conquest he lived in extreme poverty, supporting himself and his family by occasionally selling his paintings and calligraphy, or exchanging them for food and other necessities. Lacking even a table, we are told, he would have his son kneel and use his back as a support for the paper as he worked. Two of Gong's paintings are extant: *Emaciated Horse,*[3] in which he uses the long-established image of the mistreated but still noble animal to protest the plight of China in extreme adversity, and a handscroll entitled *Zhong Kui Traveling* (fig. 130). Zhong Kui was a legendary demon queller who had manifested himself in a dream to the eighth-century emperor Minghuang. The emperor described his dream to his court artist, Wu Daozi, who thereupon painted the first of thousands of portrayals of the hero. Zhong Kui pictures could serve apotropaic functions, protecting houses from baleful influences, but

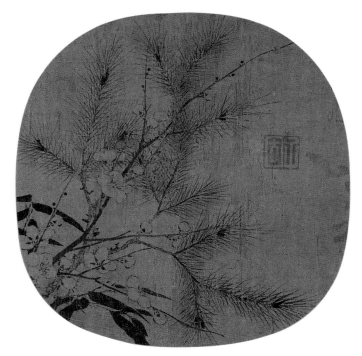

129. Zhao Mengjian, *Three Friends of the Cold Season,* fan-shaped album leaf, ink on silk, Yuan dynasty. 24.3 × 23.3 cm. Shanghai Museum.

they could also carry sophisticated political messages. Gong Kai's, although it depicts the seemingly innocuous subject of Zhong Kui setting off with his sister on a hunt, is probably an example of the latter: it may represent a desire for some force that could rid the country of "demons," that is, foreigners. The inscriptions that accompany the scroll hint at this message without stating it directly; potentially seditious sentiments could only be stated obliquely, even cryptically, whether in images or in words.

The blunt inelegance of Gong Kai's brush drawing was deliberately cultivated as signifying both amateurism and sincerity. The most famous loyalist painter of the early Yuan, Qian Xuan (ca. 1235–before 1307), was no less sincere and in principle an amateur. In contrast to Gong Kai, however, he preferred a fastidious fine-line mode with flat washes of color. Implicated in this style is the practice of archaism: reference to the distant past, especially the Tang dynasty, which from the Yuan vantage point could be viewed as China's golden age, a time of expansiveness and power. It also implied the rejection of the styles — and by extension the political weakness — of the Southern Song. Qian Xuan's paintings are often accompanied by poems that subtly express sadness over the fall of the native dynasty and the "coming of darkness."

Qian Xuan lived in Wuxing, a town north of Hangzhou and south of the Taihu, or Great Lake. With

the dispersal of the Imperial Painting Academy at Hangzhou, other centers, Wuxing prominent among them, became gathering places for scholarship and art. Qian Xuan was one of a group of poets and cultivated scholars active there in the late Song and early Yuan known as the Eight Talents of Wuxing. In 1286 the first Yuan emperor, Kublai Khan, sent an emissary to invite more than twenty Wuxing scholars into service in the new northern capital of Dadu (present-day Beijing). It is unclear whether Qian Xuan, then in his early forties, was among those invited; in any case, he stayed behind. The leading figure among those who accepted the invitation and went north was Qian's younger colleague, and probably in some sense his student, Zhao Mengfu (1254–1322). Qian was accordingly praised for preserving his principles, and Zhao criticized for compromising his, especially in view of his position as a descendant of the Song imperial family (Zhao Mengjian was his uncle). But the issue, polarized in later arguments, was not so clear-cut in their time; the two remained good friends, and Zhao went on to become one of the most accomplished and highly respected figures of the Yuan. In any case, Qian Xuan gave up his status as a scholar and became, in effect, a professional painter, earning his living by producing paintings of flowers, figures, and landscapes.

Qian Xuan's flower paintings survive in some number and have been well studied. They were reportedly so popular that by his late years forgeries were appearing in quantity, and he is said to have changed his style and inscribed all his later works to identify them as his own. A remarkable archaeological discovery made in 1971 — a Qian Xuan painting of lotuses found in the tomb of an early Ming prince named Zhu Tan, who died in 1389 (fig. 131) — seems to confirm this practice: Qian states in his inscription that he has changed his *hao* (sobriquet) and "put forth some new ideas" in recent years to confound the forgers. The painting, like Qian's others of plant subjects, is executed in fine, even line and washes of light color, a reserved, even fastidious mode that might seem at odds with the colorfulness and decorative beauty of the subject. Other, lesser artists were continuing the Song tradition of decorative, richly colored flower paintings; Qian Xuan is at pains to dissociate his art from theirs. His avoidance of all strong appeal to the senses can be read as an expression of his temperament and subtler taste, but also as a rejection of any hint of commercialism. Lotus plants conventionally evoked the idea of purity, since they rise from the mud but remain pristine; Qian's poem, written after the painting, adds another dimension of meaning by mentioning a recluse,

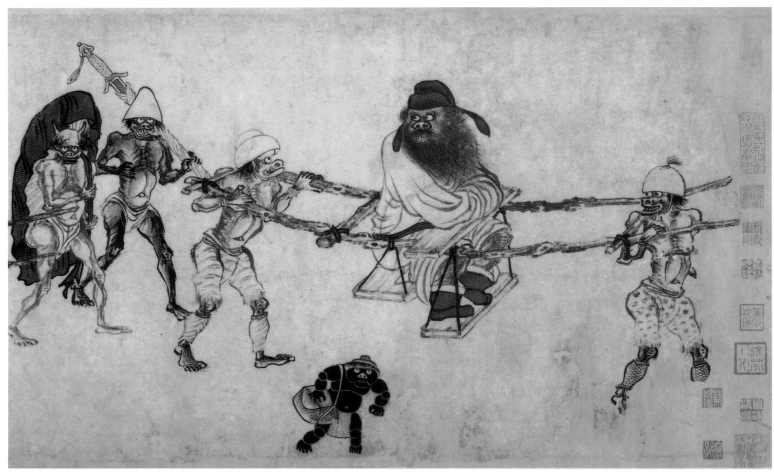

130. Gong Kai, *Zhong Kui Traveling,* section of a handscroll, ink on paper, Yuan dynasty. 32.8 × 169.5 cm. (Courtesy of the Freer Gallery of Art, Smithsonian Institution, Washington, D.C.)

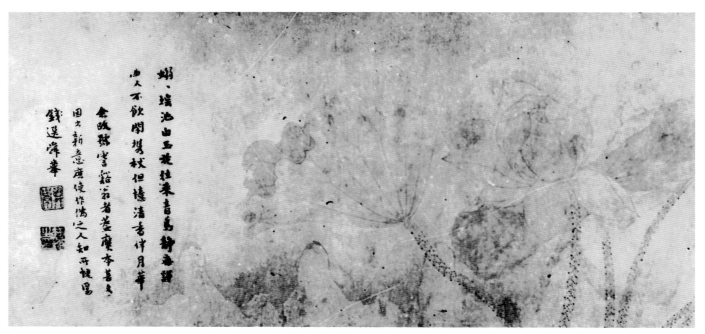

131. Qian Xuan, *Lotuses,* handscroll, ink and light color on paper, Yuan dynasty. 42 × 90.3 cm. Shandong Provincial Museum.

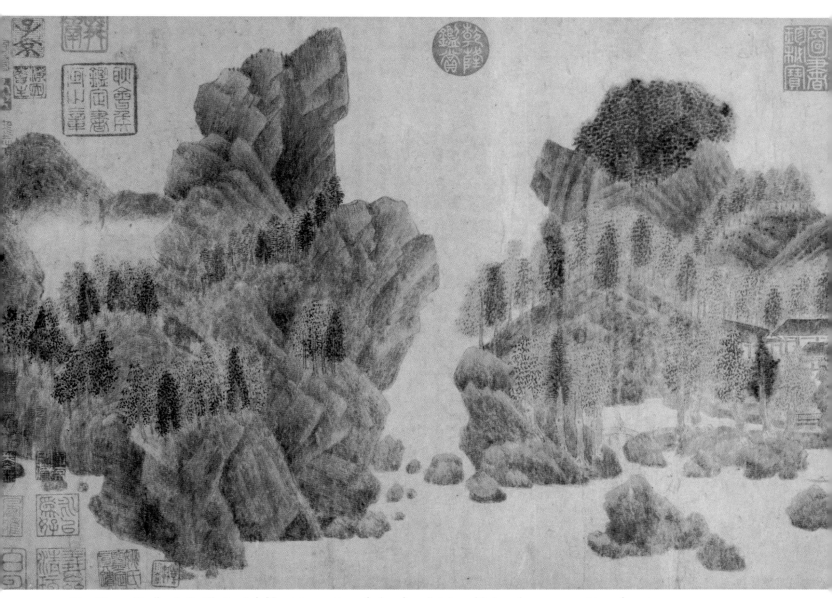

132. Qian Xuan, *Dwelling in the Floating Jade Mountains,* section of a handscroll, ink and light color on paper, Yuan dynasty. 29.6 × 98.7 cm. Shanghai Museum.

thus turning the flowers into objects of that person's contemplation.

Most of Qian Xuan's landscape paintings are executed in another line-and-color-wash manner, the archaistic "blue-and-green" landscape style using heavy mineral pigments. An exception is the handscroll titled by the artist himself *Dwelling in the Floating Jade Mountains* (fig. 132) and representing, he tells us, his own mountain retreat, located to the west of Wuxing. It is a famous work, with laudatory colophons written by some of the leading Yuan and later artists and literati. But to any reader familiar with the naturalistic portrayal of enchanting scenery in the Song dynasty, with its atmospheric treatment of distance, textural differentiation of rock and earth surfaces, and so on, Qian Xuan's picture will surely seem stiff and graceless, a "great leap backward" from,

for instance, the paintings of Xia Gui. No doubt it was intended to be just that: a reversion to a more primitive stage of landscape that Qian knew from old paintings, combined with imitations of more recent vintage— *Dwelling in the Floating Jade Mountains* resembles in some respects late Song and Yuan works by *retardataire* masters following Northern Song or earlier traditions. But some acquaintance with genuine old works also underlies Qian's style: when Zhao Mengfu returned to Wuxing in 1295, he brought a collection of old paintings that he had acquired in the north; and if *Dwelling in the Floating Jade Mountains* belongs to Qian Xuan's late years, as it is believed to, it must reflect the impact of this renewed contact with pre–Southern Song traditions.

Archaistic is the locating of the land masses more or less evenly across the middle ground; the viewer is given

no easy access to them, a compositional feature that also enhances the theme of reclusion. The fine-line texture strokes are uniform and undescriptive, as is the pale green coloring; the rock formations are flattened, geometricized, and in some places oddly striped; the scale is unnatural — the trees diminish markedly, for instance, as the composition develops leftward, making the furthest-left parts read as more distant, even while their location with respect to the baseline of the painting prevents them from receding properly. The effect is visually unsettling, an aspect of the picture's primitivism. Tree foliage and the tipped-up upper surface of the large bluff left of center, an allusion to the landscape style of Fan Kuan (see fig. 94), are dense areas of abstract dotting. The picture as a whole is more evocative of diverse artistic manners and traditions than descriptive of a particular place; like other Yuan landscapes we will consider, notably Zhao Mengfu's *Autumn Colors on the Qiao and Hua Mountains* (see fig. 134), this is a work of pseudotopography. And yet in one feature the composition responds to its subject: the cluster of houses in the left section, representing Qian Xuan's country villa, is set among trees and enclosed by curving ridges to convey a sense of security and isolation from the outside world. Portrayals of people's retreats and "secluded dwellings" make up a major part of Yuan landscape painting and often use this compositional device.

Three of the writers of colophons on the scroll, Huang Gongwang, Zhang Yu, and the early Ming artist Yao Shou, remark on Zhao Mengfu's indebtedness to Qian Xuan as a painter; Zhang reports that Zhao "in his early years received his painting methods" from Qian. Zhao Mengfu, however, was in the end by far the greater master, the one who more than anyone else set the course that later Yuan landscape painting would follow.

Artists in Officialdom and at Court

Zhao Mengfu's family, descendants of one of the Song emperors, had settled in Wuxing in the twelfth century and had enjoyed the privileges of members of the imperial clan. Zhao's acceptance of Kublai Khan's offer of an official post, then, was regarded by some as dishonorable collaboration. An anecdote was even told in which he visited his uncle Zhao Mengjian, who afterwards directed his servant to wash the seat in which Mengfu had sat; but since Zhao Mengjian had been dead nearly twenty years by the time Zhao accepted the post, the story is obviously apocryphal. At the Mongol court Zhao

served as division chief in the Ministry of War, using his position, as those who made this choice always claimed to do, to benefit his own people: first by opposing a powerful Uighur minister whose economic policies were harmful to the Chinese, and later by working to reinstitute the civil service examination system, which would give them a fairer chance at employment in the administration. The anti-Chinese minister was condemned to death in 1291, and the examination system was reinstated in 1315. Zhao went on to serve under four more emperors, govern two provinces, and hold a number of other high posts, including the directorship of the Hanlin Academy, the court academy for historical compilation and other imperially sponsored scholarship. He reconciled his career with his conscience by adopting the stance of *chaoyin,* "recluse at court," and expressing it in poems and paintings. The concept of chaoyin was based on the belief that someone could be engaged in a political career in the outside world while preserving internally the mentality of the recluse, spiritually remote from the contamination of public life. Similarly, the *shiyin,* or "recluse in the marketplace," remained aloof in his mind from the commerce in which he necessarily engaged.

The earliest of Zhao Mengfu's landscape paintings that survives, *The Mind Landscape of Xie Youyu* (fig. 133), is a pictorial statement of the chaoyin ideal. It bears only a seal of the artist, but a colophon by his son Zhao Yong certifies it as an early work by his father, and other colophons by Yuan writers indicate that it was painted while Zhao Mengfu was in service; the evidence thus suggests a date shortly after 1286.[4] Xie Youyu or Xie Kun (A.D. 280–322) was a scholar-official of the Eastern Jin period who, asked to compare himself with another official, replied that although the other was his superior in court observances, he himself excelled in "a single hill, a single stream," that is, in his imagined persona as a recluse living in the wilds. Some decades later, the great painter Gu Kaizhi had portrayed Xie among peaks and rocks; asked to explain this innovative use of a natural setting, Gu quoted Xie's own remark, adding, "This gentleman should be placed among hills and streams." In painting the picture, Zhao was of course likening his own situation and attitude to those of Xie Youyu. But he may also have painted it for presentation to some other new official in the same situation, as an expression of sympathy and support.

Zhao Mengfu's picture might be based on some version of Gu Kaizhi's that had survived to his time (but is unknown today), or it might be simply an imaginative recreation. In either case, it agrees with landscape settings

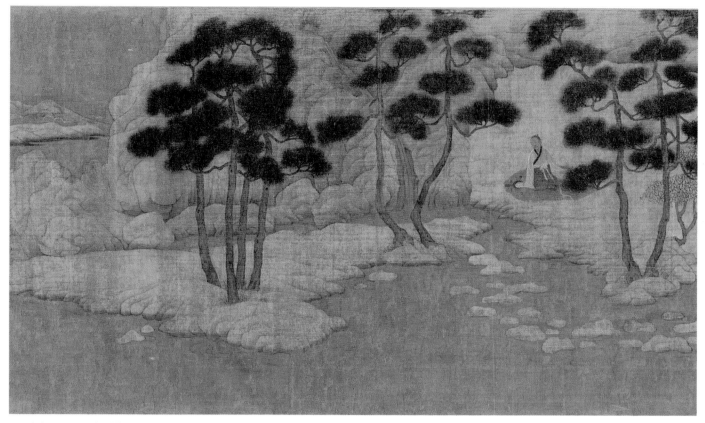

133. Zhao Mengfu, *The Mind Landscape of Xie Youyu,* section of a handscroll, ink and color on silk, Yuan dynasty. 27.4 × 116.3 cm. Art Museum, Princeton University. (Edward L. Elliott Family Collection. Museum purchase: Fowler McCormick, Class of 1921, fund. Photo credit: Clem Fiori.)

in works ascribed to Gu (such as *The Nymph of the Luo River;* see fig. 43) in the fine outlines and heavy color washes, principally mineral green, with which the hills are depicted, and in the regular spacing of the landscape elements, which are arrayed laterally across the middle ground, with only a brief opening into distance at the end. Xie Youyu is seen between trees, seated on the sharply tilted bank, located by the painter in what art historians writing about early modes of composition call a "space cell." Like Qian Xuan's *Dwelling in the Floating Jade Mountains* handscroll, this is an allusive work, displaying the artist's understanding of antique style and evoking corresponding memories and associations in the mind of the cultivated viewer. With these virtues, the painting can afford a certain naiveté, a degree of impoverishment in conventional values of technique and spatial organization. The scholar-amateur artist could count on his style-conscious viewers — the only audience he professed to address — to be unwilling (and frequently unable) to distinguish real technical deficiencies from deliberate archaistic awkwardness.

Zhao Mengfu's famous *Autumn Colors on the Qiao and Hua Mountains* (fig. 134), painted in 1296, is a more am-

bitious work, and more forward-looking: it has been one of the most controversial and influential of Chinese paintings.[5] It was painted for Zhao's friend Zhou Mi (1232–1298), whose ancestral homeland in Shandong Province it schematically represents. Zhao Mengfu was able to visit the place on his northern travels and portrayed it from memory shortly after his return to the south. The painting is far from being a visual report, however, having more the character of a picture-map rendered in an archaistic manner. Among the old paintings Zhao had acquired in the north were works by the tenth-century landscapist Dong Yuan (see figs. 88, 89), and it is Dong's style, whether studied in originals or transmitted through copies and imitations, that underlies the basic organization of the picture on the *pingyuan,* or "level-distance," plan. A strict symmetry prevails: the two "mountains," depicted as conical and breadloaf-shaped protrusions from the flat plain, stand in far middle distance at right and left; further and nearer tree groups in front of them mark stages of recession; and a larger tree group occupies the center, upsetting the scale and spatial continuity of the rest. Houses, reeds, trees, and other elements are not made to diminish in size

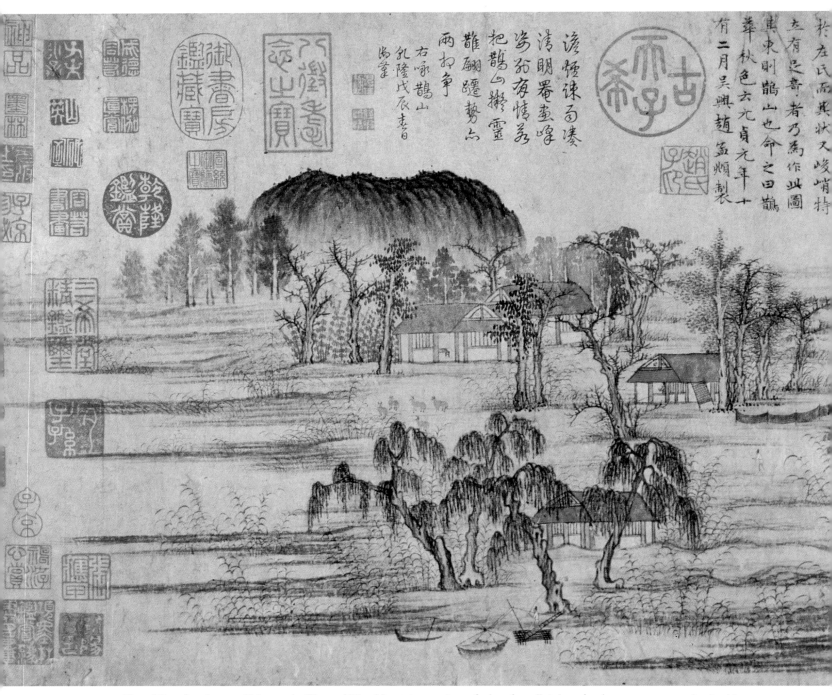

於左氏而其狀又峻峭特

立右有足奇者乃為作此圖

其東則鵲山也命之田鵲

華秋色云九貞元年十

有二月吳興趙孟頫製

古

後恍惚珠可凄
清朗翠畫峰
峻岩有情兮
把鵲以撫靈
離翻躍勢汕
兩和爭

右咏鵲山
乾隆戊辰春日
尚掌

134. Zhao Mengfu, *Autumn Colors on the Qiao and Hua Mountains,* section of a handscroll, ink and color on paper, 1296. 28.4 × 93.2 cm. Collection of the National Palace Museum, Taibei.

with distance, and the wavering groundlines fail to mesh convincingly into a continuous plane. These anomalies, which would be faults in a conventional painting, here signify a calculated rejection of the skillful devices of "recent painting" (a term always used disparagingly in Chinese writings) and an evocation of an earlier stage when landscapists were still engaged with large problems of rendering distance and achieving spatial cohesiveness, short of full mastery. In an often-quoted inscription for another painting, Zhao wrote: "The most precious quality in painting is the antique spirit. . . . My own paintings may seem to be quite simply and carelessly done, but the true connoisseur will recognize that they adhere to old models and are thus deserving of approval. I say this for connoisseurs and not for ignoramuses."

Allusions to old styles, however, account for only part of the painting's effects and achievements; in other respects, *Autumn Colors on the Qiao and Hua Mountains* is a strikingly innovative work. The ropy brushstrokes with which much of it is drawn, and the interweaving of these to constitute the forms as tactile entities (replacing the older outline-and-color or outline-and-texture-stroke

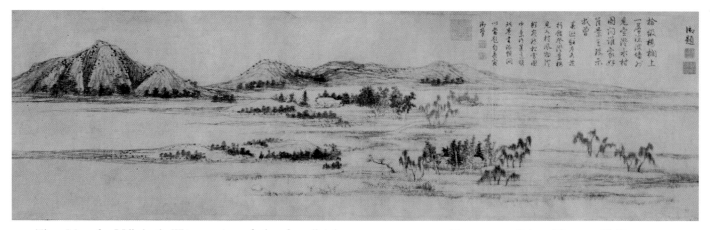

135. Zhao Mengfu, *Villa by the Water,* section of a handscroll, ink on paper, 1302. 24.9 × 120.5 cm. Palace Museum, Beijing.

methods), offered a model for rendering forms that many later Yuan landscapists would adopt. And the decisive move away from both naturalism and Southern Song idealization was to prove equally persuasive to many of the artists who followed.

A late landscape by Zhao Mengfu, painted in 1302, is titled *Villa by the Water* (fig. 135). The word *cun* in the Chinese title is sometimes rendered as "village" but can mean simply a cluster of houses; here it refers to the country villa of the person for whom Zhao painted the landscape, one Qian Dejun. The villa is certainly not conspicuous in the picture — it is not even clear which of the several groups of low buildings is to be identified as Qian Dejun's retreat. Here, even more than in Qian Xuan's *Dwelling in the Floating Jade Mountains* (see fig. 132), a state of untroubled reclusion is conveyed in the plain, unimpressive scenery — nothing even so dramatic as the mountains and trees of *Autumn Colors on the Qiao and Hua Mountains* is to be seen — and the extreme reserve of the brushwork, which rejects all that is gestural and overtly expressive in its sensitive, dry strokes and sparse dotting. Archaistic references have been absorbed into a fully formed personal style. The composition, again of the pingyuan type, develops quietly from its opening with a grove of leafy and bare trees (a favorite motif of Zhao's) through an extended middle section in which the houses, bridges, a boat, and a few tiny figures are set among scrubby willows and other trees on the spits of marshy ground. Two rows of low hills close off the recession. The modesty of the work did not diminish Qian Dejun's regard for it; in a second inscription, Zhao Mengfu relates that Qian brought it back to show him a month later, already mounted in scroll form. Zhao adds, with the characteristic self-disparagement of the literatus artist, "I am very much embarrassed that something that was only a free play of my brush should now be so much cherished and valued by my friend." But this work, too, was to be extremely admired and influential: it bears colophons of praise by no fewer than forty-eight writers, and its mode of dry-brush drawing without washes or strong tonal contrasts must underlie the similar effects in works by such later Yuan masters as Huang Gongwang and Ni Zan. Most of all it demonstrated, perhaps more than any previous work, how a personal style, developed within the new means of literati painting, could effectively convey a state of mind, in this case one of tranquillity and escape from worldly attachments.

Besides landscapes, Zhao Mengfu painted many other subjects: religious and secular figures, birds and flowers, a goat and sheep.[6] His paintings of bamboo, old trees, and rocks will be considered below. He was especially renowned in his time and later as a painter of horses; curiously, this is the side of his painting that has proved most difficult for recent scholars to deal with, partly because so many forgeries exist (along with genuine old horse paintings by lesser masters to which Zhao's name was added to enhance their value), and partly because the practice of archaistic awkwardness in paintings of horses, even more than in landscape paintings, is hard to distinguish from real failings of painterly technique. The horses in Zhao's paintings often appear balloonlike; we are meant to read them as playing on the old practice of foreshortening, but that is a cultivated response; it contends with the simpler one of seeing them as the product of sheer awkwardness.

Zhao had painted horses from childhood but turned to them with special enthusiasm during his period in the court of Kublai Khan, where he became well known among other officials for this genre.[7] Although in some part painted for his own pleasure, his horse pictures must also have been done for presentation to other officials; portrayals of horses had served for centuries as pictorial metaphors for the character and special concerns of

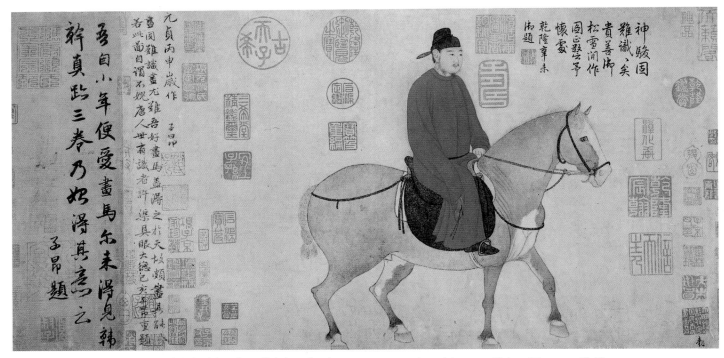

136. Zhao Mengfu, *Mounted Official,* handscroll, ink and color on paper, 1296. 30 × 52 cm. Palace Museum, Beijing.

the scholar-official, and, like other subjects noted earlier, could carry a variety of auspicious wishes and other messages. The early twelfth-century catalogue of Emperor Huizong's collection, *Xuanhe huapu,* has this to say about horse paintings: "It has been said that literati gentlemen were often fond of painting horses, because they served them as an analogy for all sorts of careers the gentlemen might have in the world, through being innately a worn-out nag or a thoroughbred, slow or quick, retiring or distinguished, fortunate or unlucky in their encounters."[8]

Zhao Mengfu's *Mounted Official* (fig. 136), painted in 1296, depicts a red-coated man wearing an official's hat. Zhao has written the title and date on the painting, and on the mounting a short inscription: "From my childhood days I loved painting horses. Recently I have been able to see three authentic scrolls by Han Gan. Now I am beginning to understand some of his ideas." The painting, then, is among other things a demonstration of Zhao's new, deeper grasp of the style of this great Tang period master (see fig. 77), and a part of Zhao's project of recovering the past of painting and using it as a basis for exploring new styles. Zhao expresses his own conviction of success in this enterprise in another inscription written on the picture in 1299: "It is not only difficult to paint, it is even more difficult to understand painting. I like painting horses, because I have talent and can depict them with the greatest skill. In this painting I do feel that I can match the Tang masters. There must be people in the

world with the great vision [to recognize this]."[9] Whatever skill the painting reveals, however, is of a special kind, more a matter of taste or sensibility than of technique; divorced from its antique references and seen as a picture, it seems stiff and insufficiently animated. Figure paintings by literati artists often occupy this aesthetically tenuous ground, needing verbal argument to compensate for deficiencies in self-evident values.

Although Kublai Khan called on Zhao Mengfu to paint on at least one occasion (in 1309, when he was ordered to do a picture of auspicious grain), he was never properly a court painter; his rank as an official placed him far above that status. Proper court painters were employed in the Mongol court, although there was no organized court academy such as had existed under Emperor Huizong and later emperors in the Song.[10] Other artists, such as Zhao Mengfu's follower Ren Renfa, might be in ambiguous situations, holding official rank but nevertheless sometimes being required to do paintings for the court. Among the true court painters active early in the dynasty was He Cheng (1224–after 1315), an artist from the Beijing region who specialized in historical scenes, architectural subjects, and horses. His major surviving work (fig. 137) is a long handscroll in the Jilin Provincial Museum illustrating the "Homecoming" ("Guiqulai") ode of Tao Yuanming, or Tao Qian (365–427). Because this poem celebrates the practice (for which Tao Yuanming was the classical exemplar) of leaving a government

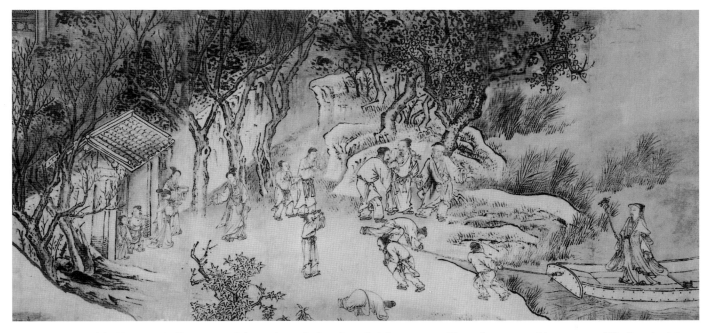

137. He Cheng, *Tao Yuanming's Homecoming Ode*, section of a handscroll, ink on paper, Yuan dynasty. 41 × 723.8 cm. Jilin Provincial Museum, Changchun.

post to live in the country, a copy of the text by some distinguished calligrapher, accompanied by a painting illustrating it and laudatory colophons by others, was a suitable gift for some high official on his retirement. The project would be organized, typically, by a fellow official, who would engage the calligrapher and painter and invite others to contribute inscriptions.[11] In the case of the Jilin scroll, the "Homecoming" ode and three accompanying inscriptions were written in 1309; He Cheng's painting was added several years later. Zhao Mengfu added a colophon in 1315 recording this coming together of the work.

The painting, over seven meters long and executed in ink on paper, is in an eclectic manner, employing the *baimiao* line drawing associated with Li Gonglin for the figures and elements of the Guo Xi and Li Tang styles for the landscape. The rendering of this setting in bold, broad, sometimes rough brushstrokes made one seventeenth-century critic wonder why the painting had been so highly praised, despite what he viewed as its sloppy execution. We might see the same roughness as a strength, a relief from the overneatness, even prissiness, of most works by Li Gonglin followers in the late Song and Yuan. He Cheng, unconstrained by literati reserve or refinements of archaistic taste, responds to Tao Yuanming's vivid poem with richly narrative, if somewhat prolix and prosy, pictures. Near the beginning of the scroll, the poet is seen standing in a boat approaching the shore, where his family and a crowd of servants wait to

welcome him home. Their varied postures contrast with the dignified stance of the poet, the largest and most upright figure, who thus dominates the scene. This weighting of roles, and the individualization of figures within the group, is the heritage of Song academic historical and genre paintings, linking He Cheng with the recent past and separating him from the new tendencies seen in works by Zhao Mengfu, his associates, and their followers.

Painting in the Mongol court flourished especially under Emperor Renzong (r. 1312–1320), whose sister, Princess Sengge, was an avid collector, and Emperor Wenzong (r. 1328–1332), who established a prestigious literary academy called the Kuizhangge, or Pavilion of the Star of Literature, where paintings were appreciated and inscribed. Active in the period spanning these reigns was the official and court artist Wang Zhenpeng (fl. ca. 1280–1329), who came from Zhejiang Province and specialized in the fine-line, highly detailed architectural drawing called *jiehua*. Best known among his works of this kind are handscrolls representing the Dragon Boat Regatta on Jinming Lake, an annual spectacle that Emperor Huizong had sponsored on a lake near his palace. Wang presented a painting of this subject to Renzong in 1310 and did another in 1323 for Princess Sengge at her request. The appeal of these scrolls to the emperor and his sister must have lain partly in their subject, which offered lively entertainment in addition to evoking the imperial splendor of a past dynasty, and partly in the tour-

138. Wang Zhenpeng (?), *Dragon Boat Festival,* section of a handscroll, ink on silk, Yuan dynasty. 25 × 114.6 cm. Palace Museum, Beijing.

de-force technique, which could be admired as sheer craftsmanship. The sinicization of the Mongol rulers, although by this time advanced, probably still fell short of permitting them to share fully the high literati taste and inverted aesthetic that valued awkwardness over skill, plainness over decorative beauty. That aesthetic was associated, in any case, with the scholar-official class, not with the aristocracy.

"Dragon Boat Regatta" scrolls ascribed to Wang Zhenpeng or bearing his signature exist in several collections; the best may be in the Metropolitan Museum of Art, New York.[12] An unsigned Yuan-period handscroll painting of the same subject (fig. 138), a work devoid of old seals or colophons, closely resembles the style of Wang Zhenpeng and may well be his work, but it is looser and more lively in its drawing than any of the others. One theory is that it is a *huagao,* or preparatory sketch, by Wang, which later would have been redone in a tighter and more polished version. Although this may be true, we should also note some points in which it is representationally more convincing than the others, in ways that frequently distinguish originals from copies: the architecture reads more volumetrically, not (as in the others) simply as flat pattern; verandahs and palace rooms are visually penetrable, with figures and furniture seen inside; the figures are characterized slightly by posture; and the recession and diminution of forms along the water plane are handled with greater skill. These are, of course, relative matters, and the work cannot compare in these respects with, for instance, the great *Peace Reigns over the River,* also known as *Spring Festival on the River* (see fig. 98). But for all its tour-de-force character, the painting preserves enough directness and vitality in its depiction of the festival to permit the viewer to enjoy such details as the acrobatics being performed on some of the boats, with figures swinging high in the air or flying off into the water.

Figure Painting in the Yuan

Ren Renfa (1255–1328), like Zhao Mengfu, followed a career of official service under the Mongols and as a painter specialized in portrayals of horses. His daughter married a central Asian official, a member of the Kangli family that had accompanied the Mongols to China to help staff the administration; Ren himself, a specialist in hydraulic engineering, rose to the post of assistant controller for irrigation. One of his most famous paintings, a handscroll entitled *Fat and Lean Horses,* offers a piece of pictorial rhetoric in defense of his choice: the fat horse, as he relates in his inscription, represents the prosperous official who uses his position to enrich himself, while the lean horse, with which Ren clearly identifies, is the self-sacrificing official who expends his own substance for the welfare of the people and grows thin in service.[13] These and others of Ren's horse paintings differ markedly from Zhao Mengfu's in using a conservative style firmly based in Song painting, devoid of archaistic references or cultivated gaucheries. The same highly finished style, drawing in fine outlines with shaded washes of color, is seen at its best in Ren's only preserved figure painting (apart from grooms in the scrolls of horses), *Zhang Guo Having an Audience with Emperor Minghuang* (fig. 139). Zhang Guo was a Daoist magician who could ride vast distances on a magical mule; when he stopped to rest, he would fold it up like paper and put it in his hatbox. He could bring it back to life when needed by spraying it with water from his mouth. In Ren Renfa's painting, he is seen demonstrating his magic powers before the Tang emperor Minghuang. As the old magician looks on with a crafty smile, a boy releases the miniature mule, which flies toward the emperor; Minghuang leans forward, credulous but reserved, while a courtier standing nearby clasps his hand and opens his mouth in wonderment. The richly colored figures are animated and full-bodied, representing a taste and tradition very different

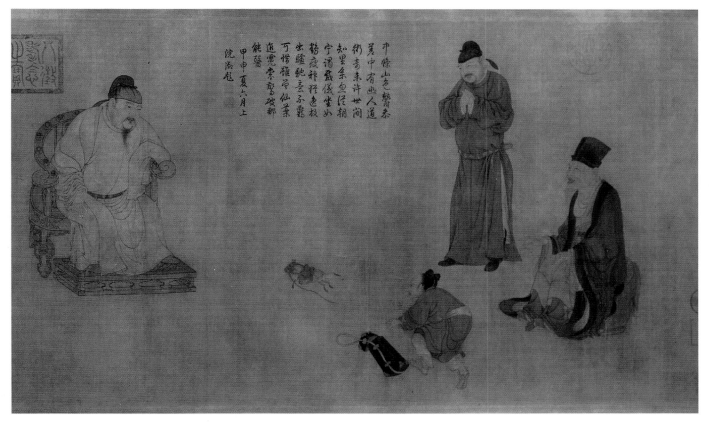

139. Ren Renfa, *Zhang Guo Having an Audience with Emperor Minghuang,* section of a handscroll, ink and color on silk, Yuan dynasty. 41.5 × 107.3 cm. Palace Museum, Beijing.

from Qian Xuan's fastidious paleness or Zhao Mengfu's antiquarian stiffness.

Still another mode of figure painting is represented by the works of Zhang Wu (fl. ca. 1340–1365), a follower of Li Gonglin best known for his several sets of illustrations to the "Nine Songs," shamanistic odes from the Chu state in the fourth century B.C. that are sometimes ascribed to the poet Qu Yuan. The classical model for these was the set painted by Li Gonglin himself in the baimiao manner, and Zhang Wu's pictures, of which three scrolls survive, are based loosely on Li Gonglin's.[14] The earliest of Zhang's extant scrolls, painted in 1346, is in the Jilin Museum; *Lady of the Xiang River* (fig. 140) is one of the figures. Like the Nymph of the Luo River in the painting ascribed to Gu Kaizhi (see fig. 43), the Lady of the Xiang is presented by the poet as an object of desire who "turns on me her eyes that are dark with longing," and with whom he has made a tryst for an erotic encounter that evening.[15] But, again like the Nymph of the Luo, she appears in paintings as a sylphlike figure with no taint of corporeality, flitting over the waves with long scarves swirling around her. Zhang Wu's painting further removes the figure from any realm of sensuality, as Li Gonglin's original must have done, with a cool, pure linear drawing that might be termed neoclassical.

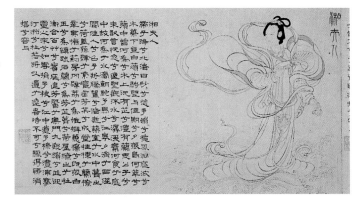

140. Zhang Wu, *Lady of the Xiang River,* section of a handscroll, ink on paper, 1346. 29 × 523.5 cm. Jilin Provincial Museum, Changchun.

Zhang Wu came from Hangzhou and had a brief career in the bureaucracy but quit out of disappointment, perhaps the victim of discrimination against Chinese from the south. He was a friend of the literatus and calligrapher Yang Weizhen (1296–1370), and also of the rich patron Gu Dehui (1310–1369); in 1348 he painted for the latter a *Picture of the Elegant Gathering at Jade Mountain.*[16] We can assume that, like other Yuan literati we will encounter, he made his living largely through turning his painting somehow to profit and enjoying the hospitality and favor of patrons such as Gu Dehui.

The popularity of paintings of Daoist immortals, shamanistic deities, and similar subjects in the Yuan, both among the literati and in the court, is part of a larger phenomenon, an upsurge in religious belief and practice that spread through all levels of society, taking more intellectual forms among the elite and simpler ones among the masses. Popular sects of Daoism flourished, especially in the north; the Mongols and other foreigners practiced esoteric Buddhism or the lamaist religion of Tibet; Chan Buddhism continued strong; and syncretic sects appeared, combining elements of these with Confucian moralism. Some of the artists we will consider below were deeply involved with the Daoist and syncretic sects. Involvement with religion could also be motivated by practical considerations, as families donated their property to temples in an effort to escape heavy taxation and survive in perilous times.

The unassertive modes of painting favored by the literati, such as Zhang Wu's thin baimiao drawing, with its distant allusions to antiquity, were for obvious reasons unsuitable for religious images to be hung in temples and viewed by crowds of commoners; these had to be bolder in visual effect and stronger in emotional impact. A master of this kind of painting was Yan Hui, who came from Zhejiang Province and must have received a professional studio training in that stronghold of Song traditions. A record of his having done wall paintings for a palace building in the period 1297–1307 suggests some involvement with the court. A book written in 1298, *Huaji buyi,* speaks of him as having been already active as a painter in the late Song, and as an artist respected by scholar-officials. Chinese critics of later times, by contrast, held him in low regard, and some of his best surviving works have been preserved in Japan, notably a pair of large hanging scrolls portraying Daoist immortals kept in a Kyoto temple.[17] Among the few known Yan Hui works still in China is a darkly imposing picture of Li Tieguai (fig. 141). This Daoist transcendent—who, like Zhang Guo, later came to be included among the Eight Immortals of popular Daoism—is always depicted as a lame beggar with a crutch. He was able to send forth his animus, or soul, to roam the heavens, leaving his physical self behind; during one such excursion his disciples burned the body, thinking him dead, and on his return he was forced to occupy the corpse of a recently deceased beggar.

In Yan Hui's picture Li Tieguai sits on a rock beneath an overhanging cliff by a waterfall—the iconography is shared with, and probably borrowed from, the many representations of the White-Robed Guanyin in this setting—looking balefully outward, his leg hooked around

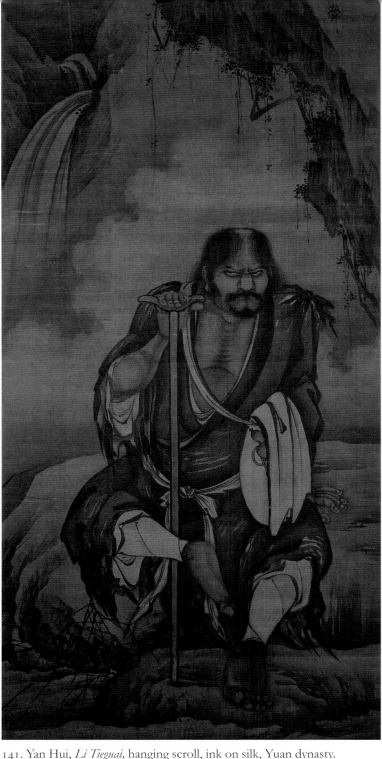

141. Yan Hui, *Li Tieguai,* hanging scroll, ink on silk, Yuan dynasty. 146.5 × 72.5 cm. Palace Museum, Beijing.

his iron crutch, his demeanor more that of a burly tough than of a beggar. Heavy shading on both the clothing and the fleshy parts heightens the effect of massiveness and power. The strengths of Yan Hui's art, as eminently exemplified here, were exactly the qualities that made the literati writers belittle him; their critical dogma prevented them from admiring strong emotional expression and bold effects of all kinds. But Yan Hui's figure style was to be taken up by Ming dynasty (1368–1644) Zhe School masters such as Wu Wei.

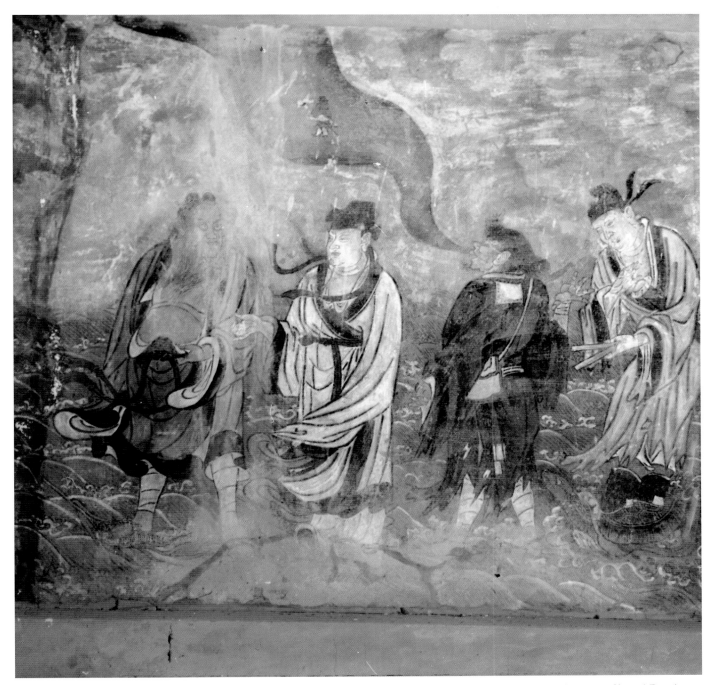

142. Anonymous, *The Eight Immortals Crossing the Sea,* detail from a wall painting in the Chunyang Hall, Yongle Gong, Shanxi Province, mid-14th century.

None of the paintings done on the walls of temples by masters as famous as Yan Hui survive, but Yuan-period wall paintings by lesser artists, some identified by name in inscriptions, exist in some number, either in situ or removed to museums. They continue the great tradition of religious mural painting from the Northern Song period, as it had continued under the Jin dynasty in the north. The best-preserved and finest group is in the Yongle Gong, a Daoist temple located near Yonglezhen in Shanxi Province. This was where the legendary Daoist

immortal Lu Dongbin was supposed to have lived, and a temple dedicated to him had been there for centuries. It burned in 1262 and was rebuilt; the wall paintings date from the first half of the fourteenth century. The Chunyang Hall, on the walls of which the legends about Lü Dongbin are represented, bears a date corresponding to 1358 and the names of eight disciples of a mural painter of the early Yuan, Zhu Haogu. Zhu's name is mentioned in local records and appears in signatures on wall paintings, but it is never included in books on artists; no

specialists in religious wall painting are given individual treatment in writings on artists after the Northern Song.[18] Among the paintings in the Chunyang Hall is *The Eight Immortals Crossing the Sea;* we reproduce the left half of the composition, including the three best-known of the eight (fig. 142). The white-robed figure, second from left, with scholar's hat is Lü Dongbin; to his left is his teacher, Zhongli Quan; to their right is Li Tieguai, seen here blowing out his animus in a cloud of breath, his tattered robe heavily shaded, as in Yan Hui's picture. The fourth immortal is Cao Guojiu, shown as a court official and identified by wooden clappers. The figures are bulky, strongly differentiated in posture and aspect, animated by swinging sleeves and gesturing hands. Like Yan Hui's painting, *Eight Immortals* represents a public art that was obliged to communicate its message forcefully and could not indulge in the stylistic nuances of Zhao Mengfu or Zhang Wu.

A major area of Yuan figure painting still little studied is portraiture. Until a relatively late period, the seventeenth century and after, it was considered a functional art by Chinese connoisseurs and placed outside the categories of painting "worthy of refined appreciation," as they put it. Accordingly, portraiture has suffered critical neglect and stood poor chances of survival. A few Yuan-period priest portraits have been transmitted in Japan, notably portraits of the great priest-calligrapher Zhongfeng Mingben (1263–1325), who was a respected friend of Zhao Mengfu and other scholar-officials.[19] From the time of Kublai Khan on, portraits of the Yuan emperors and their relatives were made by court artists; two early sets of these in album form exist, in the Palace Museum, Beijing, and the National Palace Museum, Taibei.[20] For portraiture outside the court and the clergy we have less evidence, but a single work by the leading portraitist of the late Yuan, Wang Yi, provides a clue to its nature, together with an anonymous portrait of the landscapist Ni Zan, to whose paintings we will turn later.[21] Wang Yi's portrait was in fact done in collaboration with Ni Zan, whose inscription on it is dated 1363 (fig. 143). It represents the scholar-poet Yang Qian, or Yang Zhuxi (his studio name, "Bamboo-west"), strolling alone with a staff, wearing a cap and robe. Wang Yi painted the portrait figure, and Ni Zan the rocks and pine. Chinese descriptions of the painting praise the portraitist's capturing of Yang Zhuxi's "uprightness and respectfulness." Although this is true, we should note also that the characterization is not accomplished (as Chinese theorists insist) by some penetrating portrayal of the face that reveals the subject's inner nature — the face is bland and

expressionless — but, as usual in Chinese portraits, by stance, attributes, and setting, all of which function as signs to be read by the knowing viewer. The two painters, that is, attribute certain qualities to Yang by the guise in which they portray him and the objects with which they surround him — rocks and pine trees, which stand for integrity. The sparseness of the setting and the thinness of Ni Zan's rendering similarly invest the subject with corresponding qualities, pure-mindedness and reserve.

Wang Yi, another painter who came from Zhejiang and presumably inherited some tradition of portraiture from the Song, is the author of an essay on this genre of painting — the earliest such essay known in China — that has been preserved and translated.[22] Like later discussions, it concentrates on the art of transmitting character through facial depiction, besides giving information and advice on pigments and other matters of materials and technique, while saying nothing about what were in fact the portraitist's principal means of investing his sitter with particular attributes. Such a gap between the writer's concerns and those of the painter is common in Chinese painting and its literature, even when the painter and writer were the same person.

Landscapists of the Early and Middle Yuan

After we have given due weight to Yuan figure and horse painting, portraiture, religious images, and the large category (to be considered below) of birds and flowers, bamboo, and blossoming plum, it remains beyond question that the major achievement of Yuan painters was in landscape. It was landscape painting that occupied the greatest masters, occasioned the most fruitful critical and theoretical writing, and passed on most of value to artists of later centuries. The shaping of landscape painting into a medium for the expression of an artist's individual nature and feelings, a development that begins in Zhao Mengfu's works and culminates in those of Huang Gongwang, Ni Zan, and Wang Meng, was a major triumph for the whole literati school, serving to place it at the forefront of painting for later collectors and critics.

The momentum imparted by Zhao Mengfu, both in reviving old styles and in opening new forms and types in landscape pictures, continued through the dynasty. The archaistic blue-and-green landscape style practiced by him and by Qian Xuan had little following, at least until the middle Ming; but his revitalization of the Dong Yuan

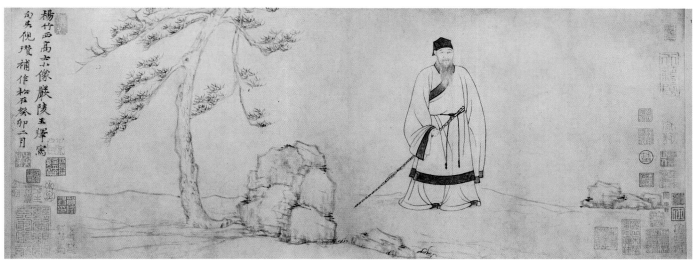

143. Wang Yi and Ni Zan, *Portrait of Yang Zhuxi* [*Yang Qian*], handscroll, ink on paper, 1363. 27.7 × 86.8 cm. Palace Museum, Beijing.

tradition, and also the northern landscape tradition of Li Cheng and Guo Xi (see figs. 125, 126), which Zhao took up in his late years, set the main directions that later Yuan landscapists followed.[23] They all worked within stylistic ranges that were narrower than Zhao's, and none attempted to draw on such a diversity of traditions and sources.

A lesser current that had some popularity in the Yuan was the so-called Mi family manner of landscape practiced by followers of Mi Fu (1051–1107) and his son Mi Youren (1075–1151). It was from its inception associated with government circles (where the Mis themselves had been active), since its subject matter — hills in fog or hills before rain — carried an auspicious message — a prosperous terrain, well nourished and by extension well administered — that could make such pictures suitable for presentation to scholar-officials. In the early Yuan, the leading exponent of the Mi-style landscape was Gao Kegong (1248–1310), an older contemporary of Zhao Mengfu who, like Zhao, held high rank in the Mongol administration, serving as governor of two provinces. His family had come from east Turkestan, present-day Xinjiang Uygur Autonomous Region, but Gao Kegong himself received a classical Chinese education. In some of his works, such as the often-published *Clouds Encircling Luxuriant Peaks* of 1309,[24] he combines several old traditions, those of Dong Yuan and Zhao Lingrang along with that of Mi Fu. Another, recently rediscovered major work by Gao Kegong, *Evening Clouds on Autumn Mountains* (fig. 144), preserves the Mi style, particularly that of Mi Youren, in purer form. A famous recorded work, it survives now only in fragments; it was one of the paintings taken by the last emperor, Puyi, to his palace in Shenyang, and was torn into several pieces when the palace was sacked. The surviving parts bear no signature or seal of the artist, but only an inscription by a high official, Deng Wenyuan (1258–1328). Abrasion has obscured some brushwork and removed some color, although enough of the warm washes and mineral green remains to suggest its original appearance. The conical peaks, the rustic houses half-hidden among trees, and the rendering of fog with curling contours relate the painting closely to Mi Youren's 1130 handscroll in the Cleveland Museum of Art[25] and to other Song-period works associated with the two Mis. The derivation is so close that one would be hard put to define what is distinctively Yuan in the style of Gao Kegong's painting; perhaps it is the drier, softer brushwork and the more insistent repetitiveness in the shapes of the hills.

As Zhao Mengfu's new mode of landscape spread among his followers and gained popularity, it was adopted also by some artists who were not aspirants to scholar-official status but acknowledged professional painters. One of these who had the honor of studying directly with Zhao, a minor master named Chen Lin, was in turn the teacher of a much better painter, Sheng Mao. Sheng's birth and death dates are unknown, but he was active around 1320–1360. He had learned painting first from his father, a Hangzhou artist who presumably followed the local, Song-derived tradition; Chen Lin must have helped him break free from this unfashionable and perhaps stultifying background. Sheng Mao was a prolific, versatile master whose works range in style from simple, spontaneous-looking pictures not unlike the "ink-plays" of the literati to large, elaborate compositions that demonstrate his formidable technical proficiency. We can assume that this diversity of styles corresponds to a diversity of tastes and situations among his patrons; he

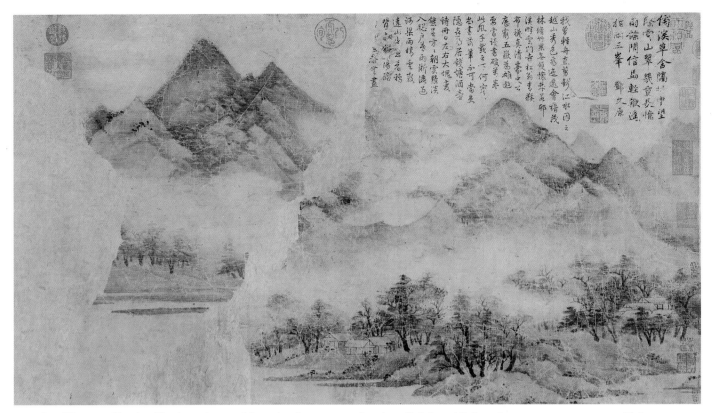

144. Gao Kegong, *Evening Clouds on Autumn Mountains,* fragmentary handscroll, ink and light color on paper, 1300. 49.5 × 84 cm. Palace Museum, Beijing.

was the kind of artist who could accommodate a great range of demands. Such versatility was not seen positively by literati writers, for whom professionalism was a stigma rather than a strength, and Sheng Mao receives little praise from them. They write poetic inscriptions on his works, but more to honor the recipient than to praise the artist.

An example is his *Waiting for the Ferry on an Autumn River,* painted in 1351 (fig. 145). Five writers, contemporaries of the artist, have inscribed quatrains at the top in different calligraphic manners; Sheng Mao's inscription at far left is in a square, undistinguished script and supplies the date, title, and a dedication to one Xibo, in addition to his signature. Whether Sheng Mao was himself capable of poetry and calligraphy we have no way of knowing; that he does not demonstrate proficiency in either art in any surviving work may be only because the practice of these by professional painters was not encouraged by their patrons. We can assume from similar cases that the picture was commissioned from Sheng by someone for presentation to Xibo, and the five others were invited to inscribe it. The scene is conventional: in the lower left a traveler, identified as a cultured man by the *qin,* or scholar's zither, carried by his servant, has reached the place where his road ends at the riverside and sits beneath trees waiting for the ferry, which is seen in the up-

per right. What the implications of this familiar scene might have been, and why it was done for Xibo, are questions still to be answered as we belatedly explore the thematics and contexts of creation for Chinese painting. Sheng Mao's rendition, while preserving elements of the Zhao Mengfu model, is more spacious, more naturalistic, more Song-like than similar works by literati artists. His characteristic brushwork, with sharp-ended, fluctuating strokes interwoven for a restless effect, is seen on the foreground earth surfaces.

A large, impressive work painted in colors on silk, with a spurious signature and seals of Zhao Mengfu but attributable by style to Sheng Mao or a close follower, is *Villa in the Mountains* (fig. 146). Sheng's style was popular in court circles during the Yuan-Ming transition; a nephew of his named Sheng Zhu served under the Hongwu emperor. One can imagine a painting of this kind being done for presentation to some great minister, flattering him by portraying in idealized form his mountain villa, the elegant hospitality it could offer to his guests, and the social position and power that all this indicated. The composition incorporates an implicit narrative, laid out, as it might be in a handscroll, in a series of linked spaces for the viewer to read as a temporal sequence. The event is a visit to the villa by the trio of high

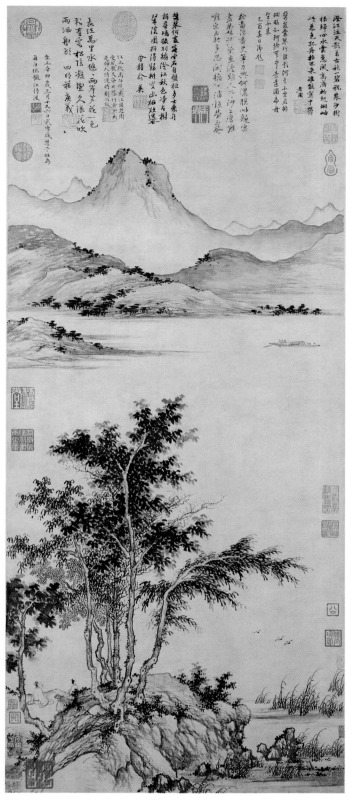

145. Sheng Mao, *Waiting for the Ferry on an Autumn River,* hanging scroll, ink on paper, 1351. 112.5 × 46.3 cm. Palace Museum, Beijing.

officials seen at the bottom — the one in front may be the emperor himself (fig. 147). The narrative begins in the lower left corner with a bridge that the three guests have just crossed, and on which their horses and grooms still wait. Then it moves to the open space outside the gate at the lower right, where they stand with their attendants. Passing through into the courtyard, they will be greeted by beautiful female musicians and dancers who will entertain them at a banquet inside the house. Later they will make their way up the path to a pavilion located on a ledge commanding an expansive view over the owner's estate and the surrounding terrain. Servants are seen ascending the path carrying a qin and other appurtenances of a scholarly gathering; inside the pavilion antique bronzes and ceramics are arranged on a table for their appreciation. This narrative line, which curves from lower left to upper right, is balanced by a beautifully realized recession up the left side along the river valley into the fog-filled ravine, above which are a waterfall and distant peaks. Comparison with signed works of Sheng Mao, such as the well-known *Pleasant Summer in a Mountain Retreat,*[26] suggests that the painting may well be his; but determining its authorship is of smaller concern than recognizing its quality. Such a work stands apart from the style-oriented paintings of the literati artists and those who imitated them, including sometimes Sheng Mao himself; it recalls the scope and grandeur of Northern Song landscapes, in which idealized narratives were similarly embedded in spatially complex but clearly readable landscape structures.

The negative appraisal of Sheng Mao by later critics underlies a well-known anecdote, which is probably apocryphal since it appears in writing only in the late Ming. It is designed to praise Sheng's contemporary and fellow townsman Wu Zhen for the purity and depth of his paintings by contrasting them with the alleged meretriciousness of Sheng's. In the story, the two artists live close to each other (as in fact they did) near Jiaxing, a town east of Wuxing. Wu's wife and children, observing crowds of people going past their gate toward Sheng's house carrying gifts of money and silk to commission paintings, deride Wu for not attracting the same kind of clientele; Wu replies that in twenty years it will be otherwise. And so it proved, the anecdote concludes; Sheng's paintings, although skillful, came to be recognized as inferior to the "richness and depth" of Wu's. Wu Zhen was eventually numbered among the Four Great Masters of Yuan painting (replacing, rather unfairly, Zhao Mengfu, who had been included in an earlier grouping).

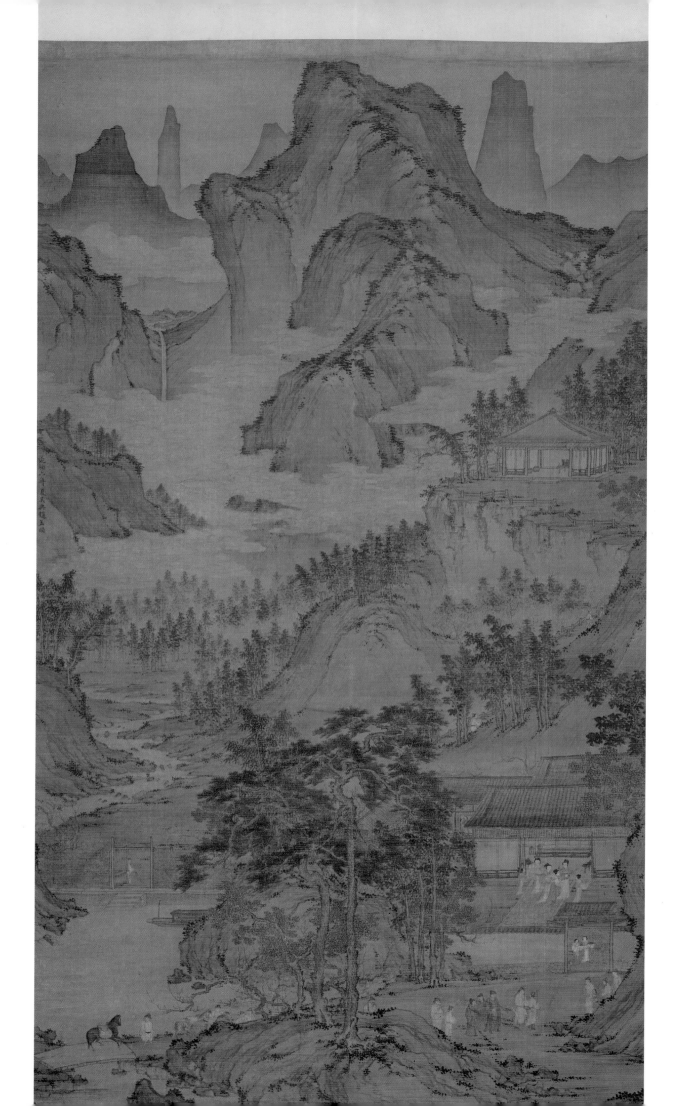

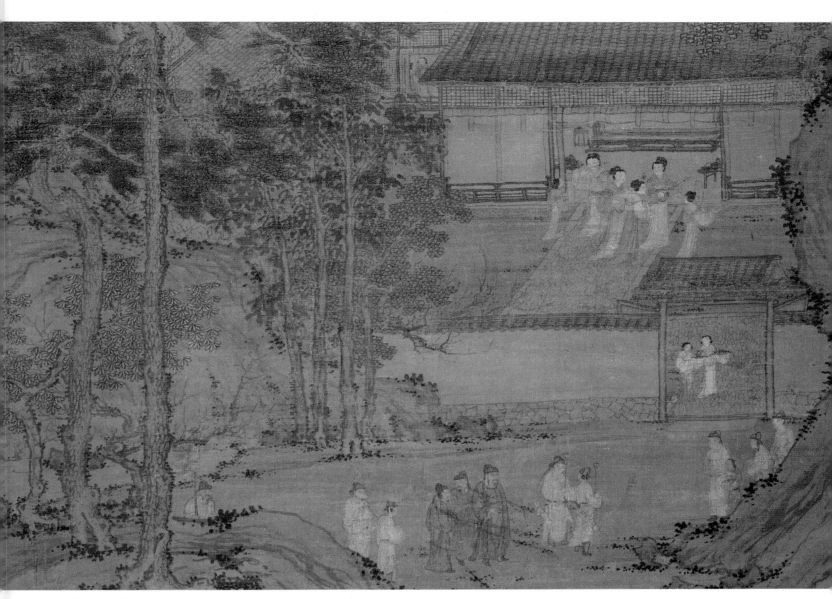

147. Detail of figure 146.

Wu Zhen (1280–1354), unlike other Yuan "recluses" who were really quite gregarious, was a true hermit, well educated but never attempting official service, never traveling far outside his hometown except for trips to Hangzhou, making a meager living by practicing divination in the marketplace and selling his paintings. He is said to have been unsociable, a trait confirmed by the fact that his works are virtually never inscribed by others. He was little noticed by other artists in his time and only begins to loom large among Yuan painters when Shen Zhou and others in the Ming dynasty learn from him and appreciate him.

146. Sheng Mao or follower (spurious signature of Zhao Mengfu), *Villa in the Mountains,* hanging scroll, ink and color on silk. 209 × 116 cm. Palace Museum, Beijing.

Wu Zhen painted both landscapes and bamboo; his landscapes are typically river scenes with fishermen, a genre well suited to the temper of the time, expressing as it did a longing for security and escape from the unpleasant realities of human society. Their distinctive character can be stated most easily in terms of what is excluded from them: dramatic effects, expressive figures, striking scenery, agitation of the kind created by Sheng Mao's more dynamic forms and brushwork. Like Zhao Mengfu's *Villa by the Water,* Wu Zhen's landscapes convey a mood of tranquillity, a quality for which Chinese writers use the term *pingdan,* literally, "blandness," close to what we call reserve. An ideal example is his *Fisherman,* painted in 1342 (fig. 148). The poem inscribed by the artist at the top is about fishing, but the painting is not; the man seen in a boat near the foreground bank gazes abstractedly at the moonlit expanse of water and low hills, while the

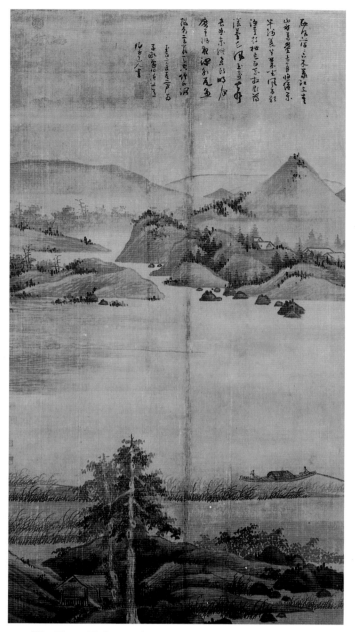

148. Wu Zhen, *Fisherman,* hanging scroll, ink on silk, 1342. 176.1 × 95.6 cm. National Palace Museum, Taibei.

call this "round" brushwork, distinguishing it from the "pointed" kind used by Sheng Mao, for example, in which varying pressure is applied to a brush held mostly in a slanting position, for an effect more nervous and energizing.

Wu Zhen's famous handscroll *Fishermen,* based on a painting ascribed to the tenth-century landscapist Jing Hao which Wu himself owned, exists in two versions. One, now in the Freer Gallery of Art, was painted around 1340;[27] the other version, in the Shanghai Museum (fig. 149), is undated by the artist but accompanied by a colophon written in 1345 by Wu Zhen's fellow townsman Wu Guan, for whom the painting was probably done, since his seals are impressed on it. Wu Guan was a rich collector and amateur painter who admired Wu Zhen's work, as his colophon makes clear; we can imagine him seeing Wu's earlier version and requesting one for himself, as Princess Sengge had requested another *Dragon Boat Festival* scroll from Wang Zhenpeng. The two *Fishermen* scrolls are not identical in composition, and the earlier one shows traces of improvisation and correction that are smoothed over in the second version. Both present a succession of fishermen in boats, each accompanied by a four-line poem in "fishermen's song" meter. Fishing, in Yuan paintings and poetry, became a metaphor for the reclusive life and escape from worldly entanglements. The figures are in fact scholar-anglers and reveal in their postures and demeanor that they are not on the river primarily to catch fish: they sleep, gaze at the scenery, hail each other, row their boats. Only one, seen in a section near the end (fig. 149 top), is actually making a catch; the viewer is prepared for this climactic event by encountering three twisting trees, uncharacteristically animated, on the bank just before this boat appears, the branches of the leftmost one arched and reaching out like the fisherman's arm holding the pole. A bit further on, at the end, the buildings of a riverside villa are drawn in Wu's engaging parallel-line manner, which reduces them to flat pattern, enhanced by whimsical tiltings of roofs and warped perspective.

The dominant tradition of landscape painting in north China had for centuries been the so-called Li-Guo School, inaugurated by Li Cheng in the tenth century and developed by Guo Xi and others in the eleventh. Zhao Mengfu and other Yuan landscapists who practiced this mode were not so much revivers of it as revitalizers, since it had been carried on by conservative lesser masters under the Jin. Artists of this school portrayed the expansive, sparsely vegetated river valleys of the north, with hills eroded into strange shapes and clumps of bare or

boatman rests his oar. The composition of the painting is based on stabilizing horizontals, countered only by the vertical trees; the ground forms swell moderately into low mounds, with only the triangular hill in the upper right, one of Wu's favorite forms, rising to greater eminence and echoing the treetops in its shape. Houses in the upper right similarly echo a rest shelter in the lower left. These relationships of forms, stretched diagonally across the picture surface, project a sense of separation and loneliness; this is another aspect of the appeal of this river-landscape type to Yuan people. Wu Zhen's brushwork is limited to a few types of strokes, all characteristically broad and blunt, done with the brushtip centered within the stroke and pressure applied evenly; Chinese

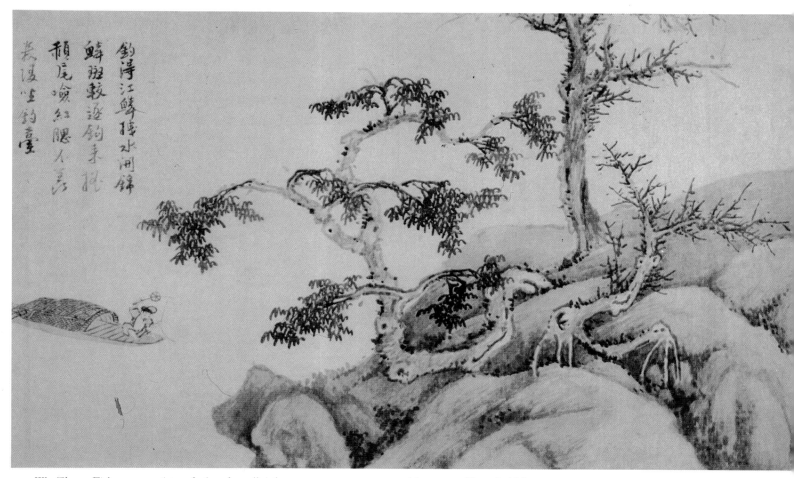

coniferous trees. Paintings from the early phases of the school conveyed a bleak grandeur and a sense of rigor in the struggle of living things for survival under harsh conditions.

Luo Zhichuan, an artist active in the early Yuan who is virtually forgotten in China but represented by several works in Japanese and American collections, practiced the Li-Guo manner in relatively pure form, keeping its moodiness and depths of dark expression. His finest surviving work, *Jackdaws in Old Trees* (fig. 150), in fact bears an old attribution to Li Cheng, along with two of Luo's seals identifying him as the true artist. It is a wintry river scene, with near and far points in the smooth passage into depth marked by groups of twisted trees, and low, snow-covered hills in the distance. The jackdaws are returning to roost at evening, a motif that ordinarily evokes nostalgia for homecoming but here may have deeper meaning. Richard Barnhart, writing about this painting, quotes an inscription by Zhao Mengfu on a similar work that includes the lines: "The flock of circling birds has the appearance of hunger and cold, and they seem to be weeping sadly." Barnhart comments: "Under the circumstances, it requires no great effort of the imagination to believe that this subject held symbolic meaning for the entire class of scholars living out the winter of Mongol occupation."[28] Luo Zhichuan, about whom very little is known, was evidently himself a scholar living in retirement. That he was born in Jiangsu Province, not in the north, suggests that he may have belonged to some circle in which the Li-Guo–manner paintings newly brought from the north by Zhao Mengfu and others in the late thirteenth century could be viewed and appreciated. But there is no indication that he knew Zhao, nor do his paintings reveal any contact with the transformations of the Li-Guo tradition that Zhao and his followers were carrying out.

That transformation is well exemplified by the works of Tang Di (1296–1364), who was from Wuxing and spent some time in Zhao Mengfu's household, where he learned poetry and painting from the master. He entered the Yuan administration and held official posts both in the capital and as prefect of Xiuning in Anhui Province, besides serving as a court painter and receiving the favor of Emperor Renzong for his participation in the decoration of the Yuan palaces. His extant paintings are mostly hanging scrolls painted on silk and typically set a group of tall foreground trees against a broad expanse of river and shore, marked by tree clusters of diminishing size and

the rustic thatched houses seen behind them and across the river. Pictures of such subjects, painted for men in or out of official service, embodied the idea of escaping from the trammels of government to commune with fishermen and farmers, who are sometimes also seen in Tang Di's pictures. Both the artist and his audience, that is, observe nature from an outsider's position, overlaying it with human values instead of, like Luo Zhichuan and his Song predecessors, according it a fully inherent, uncontingent value.

Another of Zhao Mengfu's protégés who painted landscapes in the Li-Guo manner was Zhu Derun (1294–1365). Like the others, he came from the south and served in the north. For a time, on Zhao's recommendation, he held a post as historian in the Hanlin Academy, and later he served as a professor of Confucian studies in Manchuria. After retiring to Suzhou for nearly thirty years, he reemerged in 1352, during the turmoil of the late Yuan, as a military adviser to a provincial governor. His paintings, like Tang Di's, present a relatively narrow

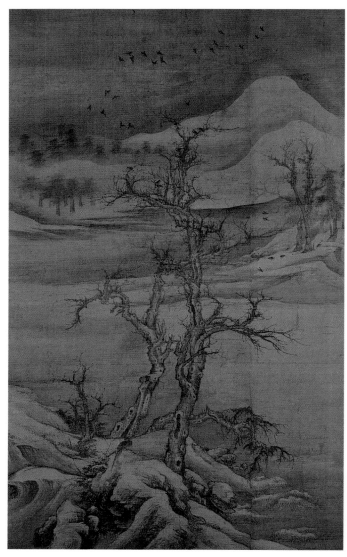

150. Luo Zhichuan, *Jackdaws in Old Trees,* hanging scroll, ink and color on silk, Yuan dynasty. 131.5 × 80 cm. Metropolitan Museum of Art, New York. (Purchase, Gift of J. Pierpont Morgan, by exchange, 1973 [1973.121.6].)

ending in low hills. This much he has in common with Luo Zhichuan, but in other respects the two artists diverge: where in Luo's paintings the emotional tone of the imagery is the basis of expressiveness, in Tang's it is vigorous brushwork and expressive distortions that create the effects. Luo's naturalism is not to Tang's taste. The trees in his paintings, with their crab-claw branches and spidery patterns of twigs, along with the scalloped contours of earth masses, give a rococolike decorative quality to his style. The greater sense of animation in Tang Di's pictures is typically accentuated by figures engaged in some seminarrative activity. In *Drinking Party in the Shade of Pines,* painted in 1334 (fig. 151), four gentlemen sit on the ground, with their servants standing nearby; that they are probably scholars living in retirement is indicated by

151. Tang Di, *Drinking Party in the Shade of Pines,* hanging scroll, ink and color on silk, 1334. 141.1 × 97.1 cm. Shanghai Museum.

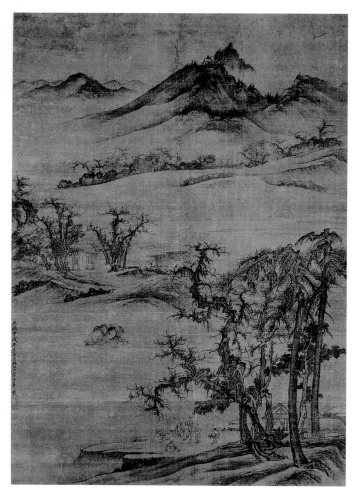

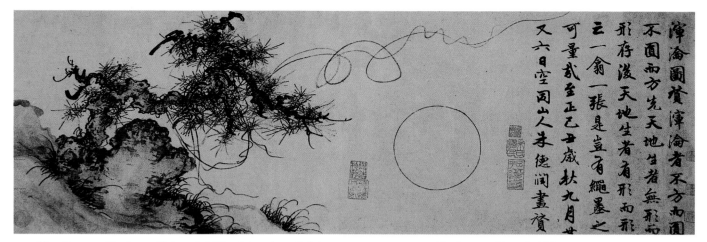

152. Zhu Derun, *Hunlun tu [Primordial Chaos],* handscroll, ink on paper, 1349. 29.7 × 86.2 cm. Shanghai Museum.

range of motifs, which are repeated from one to another. A painting that both confirms and belies this observation is the short handscroll that Zhu Derun painted in 1349 entitled *Hunlun tu,* or *Primordial Chaos* (fig. 152). *Hunlun* refers to the great undifferentiated matter out of which the cosmos was formed, and the philosophical intent of the work is stated in Zhu's inscription, which takes the form of a brief essay on this Daoist cosmological concept. Hunlun, he writes, is not square but round, not round but square. Before the appearance of heaven and earth there were no forms, and yet forms existed; after the appearance of heaven and earth forms existed, but their constant expansion and contraction, or unfurling and furling, makes them beyond measuring.

The work, in keeping with this theme, is part picture, part cosmic diagram. The objects in it represent, among other things, states of transformation, or rates of growth and decay: very slow in the earth and rock, somewhat faster in the pine, faster still in the wind-blown, "unfurling" vines. One might be tempted to read the circle at the right as another symbol of change, the inconstant moon, or its reflection in the water, but it is too large and too abstract to encourage that reading and must in some way represent the circular hunlun itself. (Moreover, the painting was done on the twenty-sixth day of the lunar month, when the moon was waning, not full.) Close examination indicates that the circle was drawn with some kind of compass, perhaps with the brush anchored to the center by a string; it was certainly not done freehand. The drawing of the swirling vines seems also to have loosened itself from representation and entered the realm of the abstract and diagrammatic. One could also see Zhu Derun's rendering of the bank, rock, pine, and grasses as similarly driven more by brush momentum than by attention to defining forms; and yet these recur almost exactly, only mirror-reversed, in another short handscroll by Zhu

in the Palace Museum, Beijing, where the simple addition of a boat with figures and loose strokes representing distant hills makes them into elements of a spacious river scene.[29] To generalize from this work and a few others that Yuan painting as a whole assumed the character of calligraphy would be a mistake, as the other illustrations in this chapter make obvious; but it is true that a "calligraphic" rendering of forms, "written" rather than "painted," had become an option for artists, who could use it for works that are often, like Zhu Derun's, more intellectual and philosophical than pictorial.

By the late Yuan, the Li-Guo manner was being practiced less as a distinct style than as a component of more or less eclectic blends of elements from various old landscape traditions. The great landscapist Huang Gongwang states at the beginning of his essay on landscape painting that "the brushwork, the trees and rocks, of these two [schools — those of Dong Yuan and Li Cheng] are not alike, and students should give exhaustive attention to the distinction," implying that they should not be mixed lightly. But in fact artists were by then combining them into new syntheses that, in the cases of such major masters as Huang and Wang Meng, drew so freely and unselfconsciously on the past, avoiding overt archaistic references, as to be essentially new styles. In the hands of lesser masters, such eclectic blends could produce pictures that were pleasant and accomplished without being especially innovative. Such a work is *Farewell at Lake Dianshan* by Li Sheng (fig. 153). It is sometimes described as a Li-Guo–manner painting, and there are indeed traits of that tradition, but they do not dominate the composition. According to the artist's inscription, dated 1346, it was done for a friend named Cai Xiawai, who was leaving to become abbot of a Daoist temple in Nanchang in Jiangxi Province, and was probably presented to him at a farewell gathering at which Li Sheng and others wrote

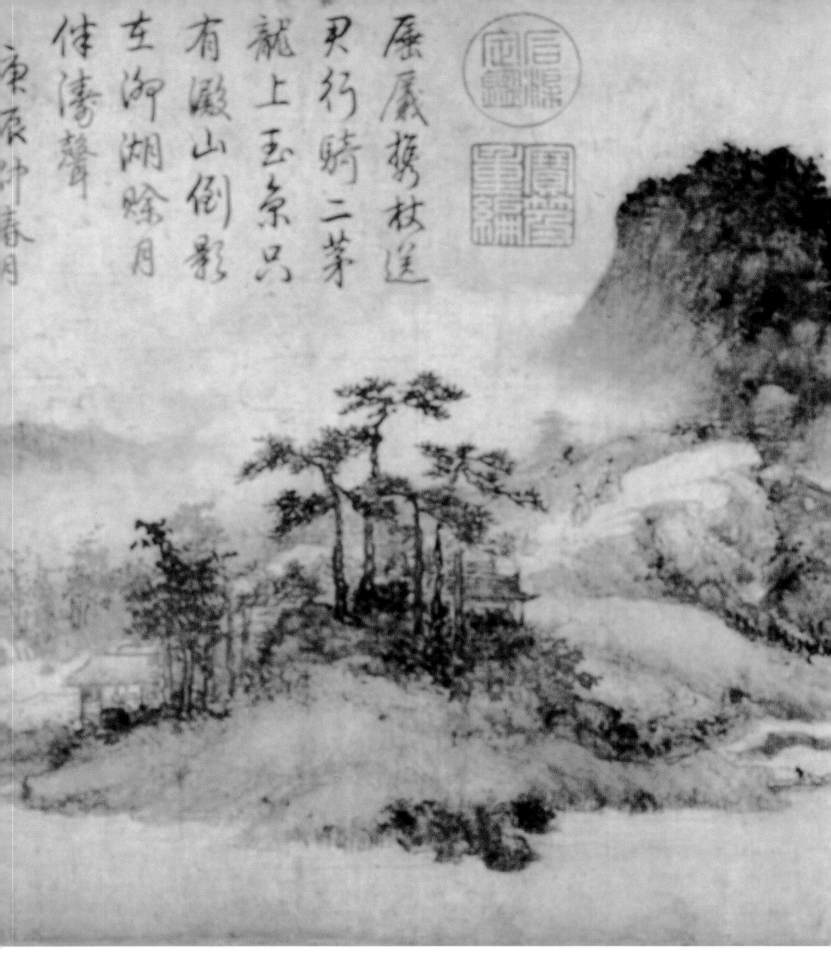

層層�─杖進
尺行騎二茅
龍上玉京只
有殿山倒影
在御湖除月
佳濤聲

庚辰仲春月

153. Li Sheng, *Farewell at Lake Dianshan,* section of a handscroll, ink and light color on paper, 1346. 23 × 68.4 cm. Shanghai Museum.

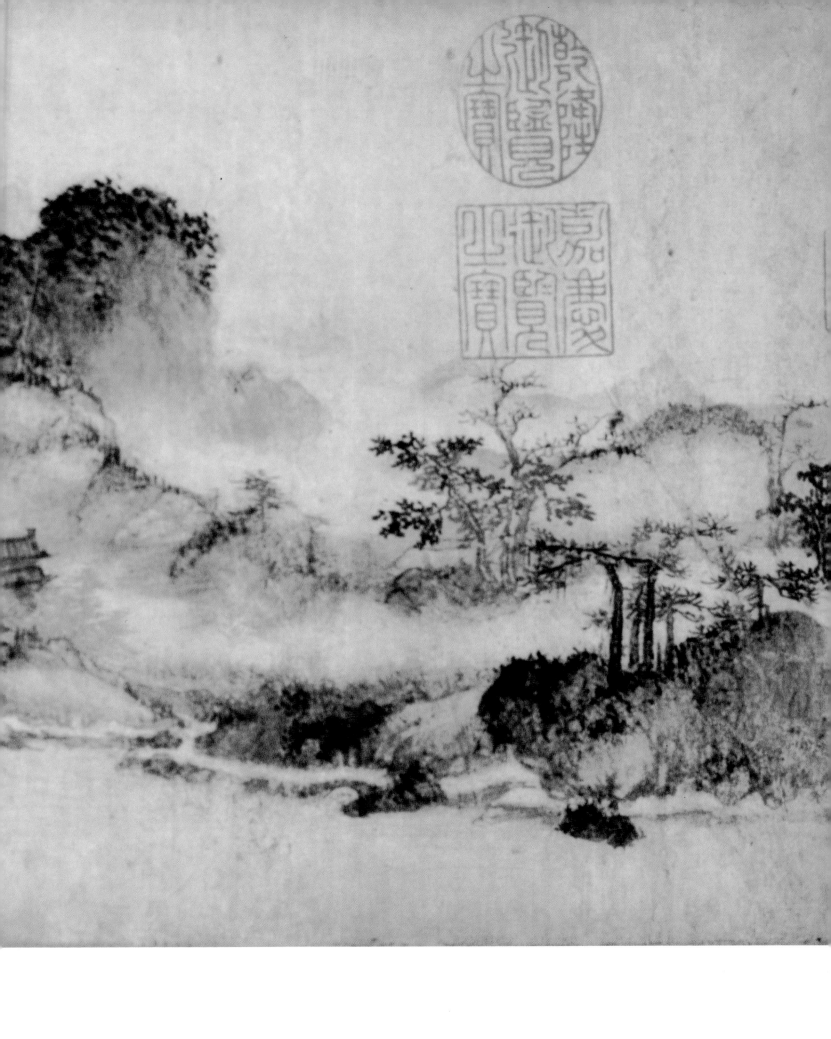

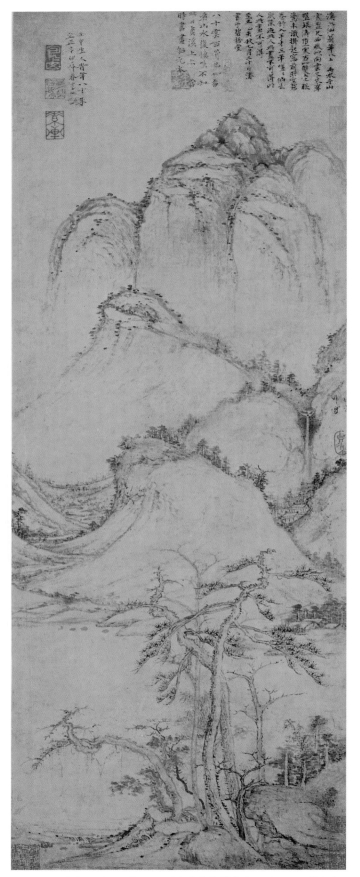

154. Cao Zhibai, *Sparse Pines and Secluded Cliffs,* hanging scroll, ink on paper, 1351. 74.5 × 27.8 cm. National Palace Museum, Taibei.

parting poems, originally attached to the scroll but now lost. The scenery depicted on the scroll, and where the gathering took place, may well be Dianshan Lake in Jiangsu Province. Li Sheng lived there in his late years; his birthplace was in northern Anhui Province. If we see some affinities with the great *Dream-Journey on the Xiao and Xiang Rivers,* painted two centuries earlier by "Mr. Li" from another part of Anhui — the earthy hills rising out of fog, the use of gradations of ink tone in rendering groves of leafy trees blurred by atmosphere — we may dimly be discerning an unrecognized regional tradition. This atmospheric rendering, Li Sheng's extraordinarily delicate brushwork, and the overall painterly effect distinguish the picture from most landscapes of its time. Two figures seen on a bluff near the center of the scroll may emblematize the idea of parting: the lower one stands with head tilted upward while the other moves away, toward a valley in which the roofs of a temple are seen, perhaps representing the one where Cai Xiawai will become abbot.

The transformation of the Li-Guo manner in the late Yuan, and its disassociation from the circle of Zhao Mengfu and officialdom, is best represented by the late works of Cao Zhibai (1271–1355). Cao was a successful man with a talent for engineering who devised projects for creating arable land by diking and filling marshy or inundated ground; part of his wealth came from these projects, and his own landholdings at Songjiang, a town southwest of present-day Shanghai, were probably augmented in this way, making him one of the richest men of his time. He visited Beijing and was offered government positions but refused them, preferring to live on his estate, where he built pavilions, studios, libraries, and towers. He entertained some of the notables of the age, including the artists Huang Gongwang and Ni Zan. His earlier works, as represented by three paintings from the 1320s,[30] are sensitive portrayals of pines and other trees in groupings that suggest social hierarchies, an analogical significance that is confirmed by writings about this theme from Guo Xi's essay onward. From Cao Zhibai's late period, two landscapes survive, dated 1350[31] and 1351; to his signature on the latter (fig. 154), he proudly adds his age, "eighty years," and two congratulatory poems by contemporaries written on the painting also refer to his octogenarian status. The foreground tree group, dominated by two long-trunked pines, resembles those in the earlier works and must have the same anthropomorphic implications, making one read the expressive "postures" of the trees in terms of human feelings, apart from their poignancy as pure images. Beyond, the rounded

hills rise to fill the upper part of the scroll, giving the composition an austere monumentality uncommon in Li-Guo School works of the Yuan period. The construction of the highest peak, partly flattened, partly lumpy (a feature of the Dong-Ju landscape tradition), along with the dry brushwork and sparsity of washes, relate the painting stylistically to the works of Cao Zhibai's close friend Huang Gongwang, whose masterwork, *Dwelling in the Fuchun Mountains,* had been completed just the year before.

Three of the Four Great Masters, and Others: Late Yuan Landscape

Most of what we have been looking at in landscape painting of the middle Yuan can be regarded as a working out of stylistic implications in landscapes by Zhao Mengfu, and the absorption of his new ideas into the mainstream of landscape. The next truly innovative landscapist after Zhao was Huang Gongwang (1269–1354). He and two younger masters, Ni Zan and Wang Meng, along with Wu Zhen, were designated by Dong Qichang in the late Ming as the Four Great Masters of Yuan painting; earlier groupings had included Zhao Mengfu and Gao Kegong, but it was Dong's that prevailed and is still followed today. Of the four, it was Huang Gongwang who most decisively altered the course of landscape painting, creating models that would have a profound effect on landscapists of later centuries.

Huang Gongwang was born in Changshu, near Suzhou, to a family named Lu, but was adopted as a child by a Mr. Huang of Wenzhou in Zhejiang Province, who raised and educated him. A child prodigy, he passed the examinations for a civil service career and held a minor post as a legal clerk for several years, but resigned after being implicated in a charge of tax irregularities and imprisoned briefly. He lived for a time as a professional diviner and as a teacher of Daoist doctrine; later he retired to a place near the West Lake in Hangzhou, where he taught philosophy to disciples. He is the author of an essay, really a series of short notes, titled "Secrets of Landscape Painting," published shortly after his death and probably written down originally for the tutelage of his students, since it provides practical advice on matters of technique as well as theoretical pronouncements.[32] His

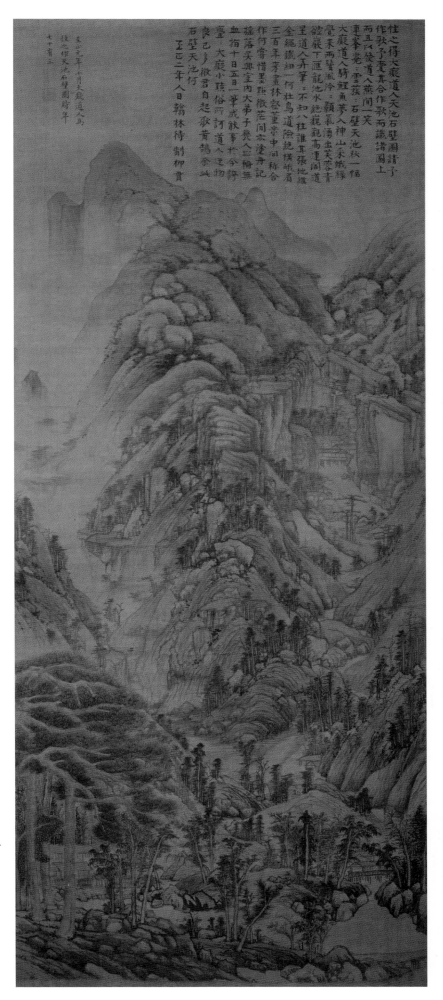

155. Huang Gongwang, *Stone Cliff at the Pond of Heaven,* hanging scroll, ink and color on silk, 1341. 139.4 × 57.3 cm. Palace Museum, Beijing.

last years were spent in retirement in the Fuchun Mountains west of Hangzhou, where he painted, between 1347 and 1350, his famous handscroll representing the scenery of that region (see fig. 156).

Huang Gongwang's *Stone Cliff at the Pond of Heaven,* painted in 1341 (fig. 155), has not been published so often or praised so much as *Dwelling in the Fuchun Mountains* (it is a more austere work, and the silk on which it was painted has darkened, making it harder to appreciate), but it has been scarcely less influential. It is the earliest extant painting in which the landscape masses are composites of dynamically interacting parts; their shapes tend to geometricism or to simple ovoids and arcs, repeating one another enough that Huang's method can be termed modular construction. The abstract character of the picture arises from this method, and from the subordination of variety in the individual forms, which are made rigorously to perform their compositional functions at some sacrifice of pictorial or descriptive values. Artists of later times, including Dong Qichang and the Four Wangs of the early Qing dynasty, revered this work and devoted themselves to working out the implications of its dynamic formalism. The painting depicts a real place, located on Mt. Hua west of Suzhou, but is very different from pictures of the kind that aim at "making the viewer feel as though he were in the actual place." The pond and cliff of the title are at the head of the valley ascending to the right; this and a deeper recession on the left enclose a long ridge, which the gaze of the viewer follows upward on a cadenced progress, with dark clumps of trees and small rocks marking stages in it. A few houses are seen under tall pines at the bottom, but, as usual with buildings in Huang's paintings, they are drawn so schematically as to be almost devoid of narrative import.

Huang Gongwang's *Dwelling in the Fuchun Mountains* (fig. 156) was painted between 1347 and 1350; according to the artist's inscription at the end, he sketched out the entire composition in one sitting, then carried the scroll with him when he traveled, adding to and going over it when his mood was right, without quite finishing it. The intended recipient, a certain Wu-yung, or "Worthless" (a facetiously self-deprecating sobriquet), was worried that someone else would get it; he made Huang "inscribe it in advance" — and, presumably, finish it off hurriedly, as the quick brushwork and improvised forms of the beginning and ending sections betray. The remainder is done with more care but similarly records the process of its making by displaying the traces of the painter's hand instead of concealing them. The same had been true of most progressive Yuan painting at least since Zhao

Mengfu's *Autumn Colors on the Qiao and Hua Mountains* of 1296 (see fig. 134), but no one before had so successfully reconciled the creation of substantial, well-constructed landscape forms with an effect of semi-improvisation. Huang Gongwang understood and utilized Zhao's method of interweaving thick, dry brushstrokes to create visually tangible forms. Some of the thinner passages, along with the determined plainness of the scenery, may recall Zhao's *Villa by the Water* of 1302 (see fig. 135), but Huang Gongwang's compound brushwork, overlaying darker over lighter, drier over wetter — reflecting the scroll's long gestation — provides much richer textures and a stronger sense of tactile surface. It allows Huang to build dynamically complex masses like those in his *Stone Cliff at the Pond of Heaven* without resorting to the firm outlines and graded washes of that picture. (The modes of viewing hanging scrolls and handscrolls more or less dictated bolder definition of form and more stable structures in the hanging scroll, which was viewed from a distance and for longer periods; the handscroll, which was seen at arm's length and more briefly as it passed before the viewer's eyes, lent itself to softer renderings and often more daring compositional devices.)

There is little of atmospheric dimming in Huang's scroll (or in *Stone Cliff at the Pond of Heaven*); romantic mists would have eroded the structural clarity of his work. A few patches of fog appear, but they play no major role in his treatment of space, which, as in Northern Song landscape, is rendered as intervals between clearly defined masses. In the passage reproduced here, for instance, a ridge curving into depth — a simplified form of the one in *Stone Cliff,* defined in a softer, earthier manner — creates on its concave side an enclosure into which a smaller hillock located some distance from it to the right seems almost to fit; the two masses thus define between them a curving space within which houses, trees, and a stream are located. Huang Gongwang's engagingly loose brush drawing, giving the scenery a slightly unkempt look, diverts our attention from the calculated construction of the scroll; later imitators were mostly to lose this effect of spontaneity in their neater, more schematic, and less natural-looking versions of Huang's compositional formulae.

An unusual work by Huang Gongwang that has gone virtually unpublished is *Clearing After Sudden Snow,* a short handscroll painted as an appendage to a work of calligraphy by Zhao Mengfu (fig. 157).[33] Zhao had written for Huang four large characters, "Clearing After Sudden Snow," copied loosely from the same four characters in a letter, preserved in copies, by the great fourth-century

calligrapher Wang Xizhi. Some time later, probably in the 1340s (one colophon is dated 1345), Huang presented the scroll to a certain Mo Jingxing, adding a painting to illustrate this brief text. The painting is unsigned and bears no seal but can safely be taken as Huang's work because of its style and its position in the scroll. With the exception of a red, wintry sun, it is done in ink and depicts a large house overlooking a mountain valley surrounded by cliffs. Inside the house is a Buddhist sculpture, of which only the lower part and the lotus seat are visible, with an incense burner set before it. Groves of bare trees enhance the wintry moon, and, standing before and behind the house in dark and pale ink, mark stages of depth. The brushwork is feathery-soft throughout the picture; what is remarkable is that Huang Gongwang, while confining his drawing to this extreme softness of touch, can build such monumental rock constructions, making them both substantial and intelligible. By exposing their flattened tops and indicating their receding sides with successions of angular strokes, the artist allows the viewer to read their volume. Others of Huang's paintings, those using systems of insistently repeated brushstrokes and forms, lay the foundation for the styles of the Orthodox School masters of the early Qing (see chapter 5); this one seems similarly to supply the essentials of the style that, partly by way of Huang's young friend Ni Zan, would deeply affect the Anhui School artists of that same period, such as Hongren and Zha Shibiao.

Ni Zan (1301–1374; some recent scholarship indicates instead a birthdate of 1306) was born into a rich land-owning family of Wuxi in Jiangsu Province and lived in comfort until middle age, engaged in scholarship and artistic pursuits. He built a Qingbige, or "Pure and Secluded Pavilion," where he kept a great library and his ever-growing collection of antiquities, calligraphy, and paintings. Famous scholars and poets from all over the country were entertained there; Ni was by nature aloof and arrogant but enjoyed the company of people whom he judged to be of sufficiently refined tastes. He was obsessive about cleanliness, insisting that everything with which he came in contact be immaculate and washing his hands frequently. Already by the 1330s, however, this ideal existence was going wrong: a series of natural disasters, floods and droughts, brought about widespread famine and homelessness in the Jiangnan region, agriculturally the richest in China, and the Mongol government imposed oppressive taxes on the wealthy families to raise revenue. Many were forced to sell their holdings or escaped taxation by giving their land to Buddhist and Daoist churches. Ni Zan, whose older brother was a de-

vout Daoist, probably used the latter expedient, although standard, idealized accounts tell of his having foreseen the disorder of the coming dynastic change and distributed his property among relatives and friends.

Peasant revolts were widespread during the 1340s, and the biggest of them, the Red Turbans revolt, began in 1351, further devastating the region. Shortly after that, Ni Zan set off with his family on what would be twenty years of wandering, mostly around the lakes and watercourses between Suzhou and Songjiang, living in a houseboat much of the time and staying with friends and acquaintances, whose hospitality he often repaid with his paintings. Zhang Shicheng, the pretender to the throne who occupied Suzhou from 1356 to 1367, repeatedly invited Ni Zan to join his "court," but Ni always refused, avoiding all involvement in political and military conflicts. After the final collapse of the Yuan government and the establishment of the Ming dynasty in 1368, he emerged from hiding; since his wife had died and his children had left him, he wandered alone as a recluse, ultimately returning to Wuxi, where he fell ill and died at the home of a relative.

Paintings by scholar-amateur artists had always been taken to be expressive of their personal situations and feelings, but this basic tenet of literati painting theory had proved problematic in practice. For example, attempts to base negative judgments of Zhao Mengfu's paintings on disapproval of his "collaborationist" politics are unconvincing. With Ni Zan we have perhaps the first case in which the association of the man and his paintings seems clear and obvious, so that he becomes the paradigmatic self-expressive artist. His landscapes, in their unpeopled thinness and plainness, can be seen as emblems of high-minded disengagement from society and longing for a cleaner, simpler, peaceable world. Recent studies have called even that seemingly self-evident correspondence into question; like Dong Qichang in the late Ming, Ni Zan is increasingly undergoing revisionist readings of his character and relationship to the conditions of his age, in which his reputed "pure loftiness" of spirit is regarded more as a rhetorical projection than as an inner truth.[34] This is not the place to engage in that argument, however; my treatment of Ni Zan's paintings will follow conventional assumptions.

The landscape type associated with Ni Zan — ink-monochrome paintings of widely separated riverbanks rendered in sketchy brushwork, and foreground trees silhouetted against the expanse of water — appears to have developed only midway in his career. In his earliest extant work, painted in 1339, the horizon is low, the forms

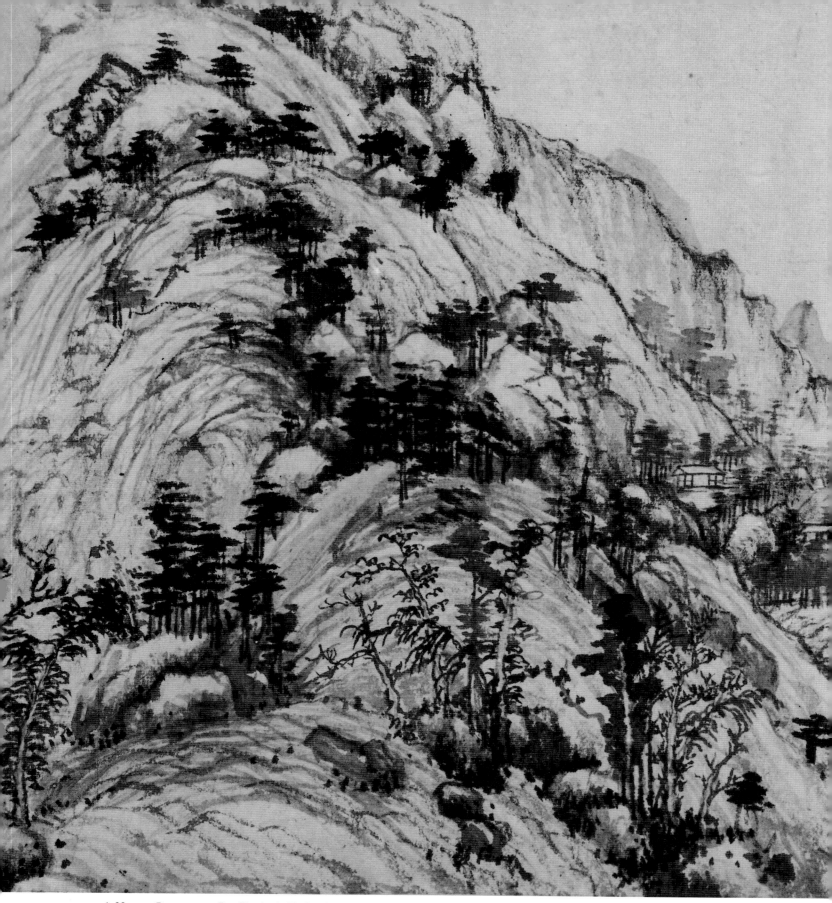

156. Huang Gongwang, *Dwelling in the Fuchun Mountains,* section of a handscroll, ink on paper, 1347–1350. 33 × 636.9 cm.
National Palace Museum, Taibei.

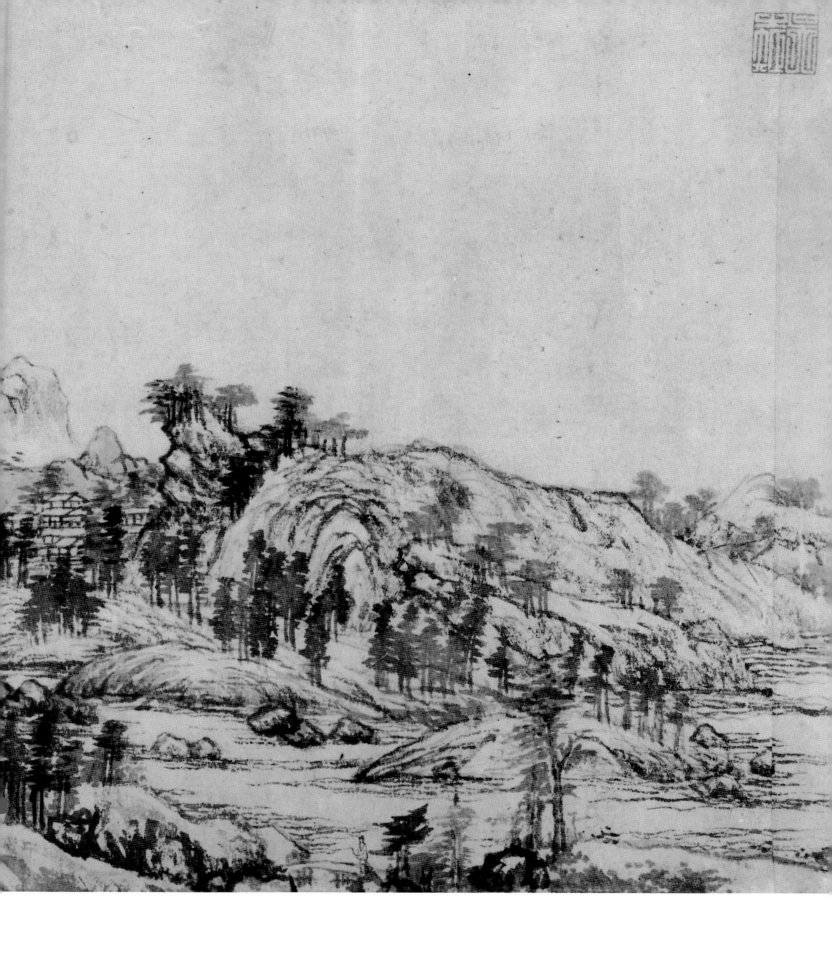

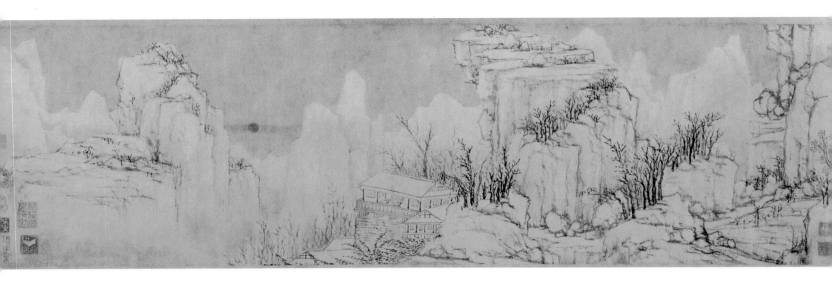

157. Huang Gongwang, *Clearing After Sudden Snow,* handscroll, ink and light color on paper, ca. 1340s. 104.6 cm long. Palace Museum, Beijing.

158. Ni Zan, *Water and Bamboo Dwelling,* hanging scroll, ink and color on paper, 1343. 53.5 × 28.2 cm. Museum of Chinese History, Beijing. (Former Deng Tuo Collection.)

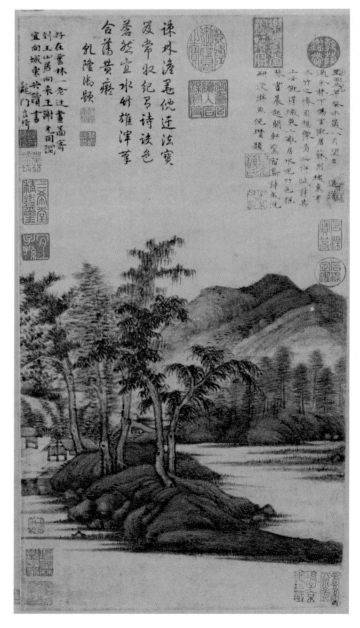

strongly shaded, the trees set against sky; even a figure is included, as in none of his other surviving paintings.[35] Ni's *Water and Bamboo Dwelling* of 1343 (fig. 158) has no figure, but it also differs from the familiar "minimalist" landscapes of his later period in depicting thatched houses, a fence, and a bridge, in including a profusion of leafy trees, and in adding washes of color to the strongly defined and textured forms. His style as seen here is in fact not so markedly different from that of Sheng Mao in the same period. The horizontal banks and modest hills, however, already betray the taste for plainness and tranquillity that will characterize the later works. The painting was done, he relates in his inscription, for a certain Jindao, who came to visit and told him that he was renting a place to live east of Suzhou, in an area noted for water (streams) and bamboo. Ni Zan makes his picture by imagining how this dwelling will look.

Six Gentlemen (fig. 159), done only two years later, already displays the landscape formula that Ni Zan was to follow in most of his later works, with the high horizon ending a broad expanse of river and the tops of the foreground trees stopping somewhat short of this, without encroaching on the further landmass. Not even the familiar *tingzi,* or rest shelter, appears; the painting is an extreme example of the Yuan practice of portraying the plainest of unremarkable scenery and making it seem

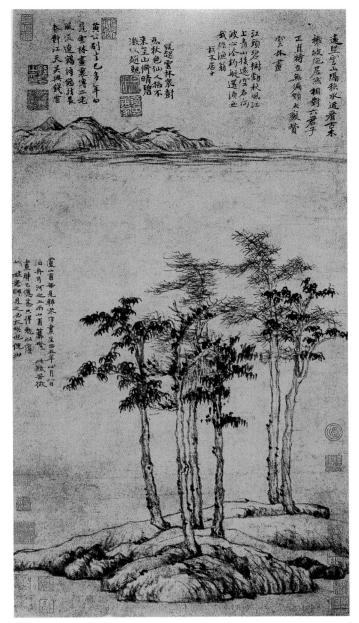

159. Ni Zan, *Six Gentlemen,* hanging scroll, ink on paper, 1345. 61.9 × 33.3 cm. Shanghai Museum.

Ni Zan's *Remote Stream and Cold Pines* (fig. 160)—the title was provided by the artist in his inscription—was done as a present for a friend who was leaving to take an official post; Ni writes that he means it to suggest the idea of "calling to reclusion," to convey the attractions of untroubled retirement after the man's period of service was over. The end of the Yuan or the beginning of the Ming dynasty, when the painting must have been done (it is undated), was indeed a perilous time to be involved in public life, whatever one's political commitments, and one might choose reclusion out of a desire for security as much as for lofty Confucian ideals. Ni Zan's compositions represent this aspect of withdrawal from society in their stabilizing horizontals and verticals as well as in the absence of buildings, figures, or distractions of any kind. The nearly square shape of *Remote Stream and Cold Pines* and the adoption of a more level line of view oblige the artist to arrange the scene in an untypical way, compressing what would usually be nearer and further shores into a single, continuous passage of terrain, through which the stream flows leisurely into the foreground. But the device of having elements of the picture echo each other diagonally across the intervening space, used in most of his landscapes, is seen here too, and his rendering of cubic volume in the earth forms by bent brushstrokes and subtle defining of upper and side planes, typical of his late works, is exemplified at its best. This is a cool vision of the world as Ni Zan wanted it to be: orderly, uncluttered, undemanding of anything but the simplest sensory engagement.

The Rongxi Studio of 1372 (fig. 161) is generally regarded as Ni Zan's masterwork among his surviving paintings. He inscribed it twice, once with a simple date and signature, and again two years later in 1374 when, he writes, the original recipient brought it back to him with the request that he rededicate it for presentation to another, "the medical doctor Renzhong." This doctor was the master of the Rongxi Studio from which the painting took its name—it means "Room for the Knees" and must refer facetiously to its cramped dimensions. It was located in Wuxi, Ni Zan's hometown, and Ni ends his inscription with a wistful hope that he can return and see his painting once more. He did indeed return to Wuxi shortly afterwards, and perhaps realized his wish before his death in the eighth month of that year. What is remarkable, however, is that a single conventional river landscape with tingzi could be made to "represent," in

somehow significant. The sparse drawing, mostly in dry brushwork, has the effect of dematerializing the materials of the painting, purging them of ponderousness; this was, of course, a mode learned from Zhao Mengfu, and even more from Huang Gongwang. Huang was in fact present at the gathering when the painting was done and inscribed a quatrain that supplied its title, presumably a metaphor for six upright friends. Ni Zan's own inscription relates how he had just docked his boat when his host met him with a lamp and a piece of paper, insisting that he paint a picture; tired as he was, he complied. His inscription partly accounts for, and partly serves to excuse, the minimalist character of the picture, which must have seemed radical even in an age of innovative landscape.

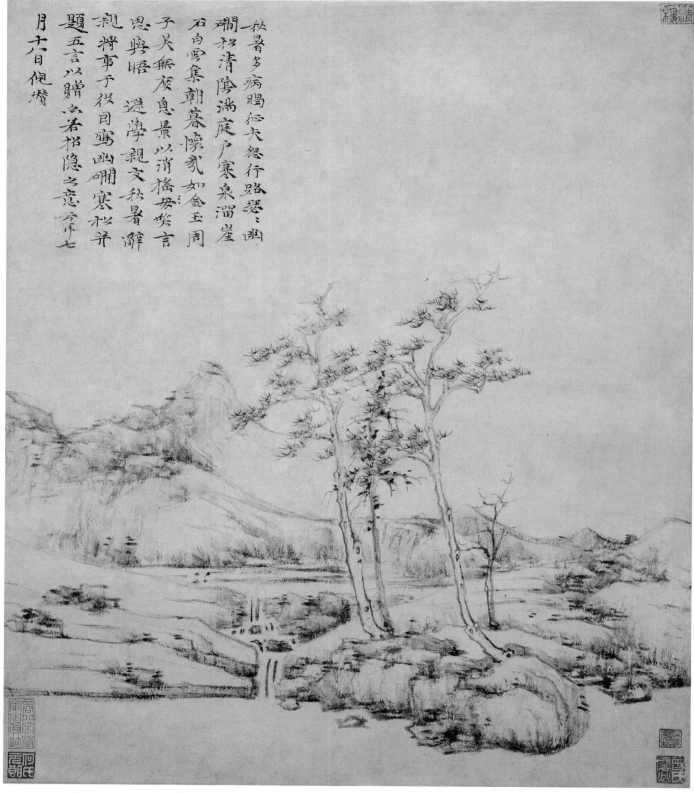

月十六日倪瓉

題五言以贈六若招隱之意乙巳七

親將事于役目寓幽�

思與晤　遙學親交秋暑瀨

子美無庱息景以消搖無斁言

石自雲集朝暮懷家如金玉同

珊松清陰湍庭戶寒泉溜崖

一秋暑多病暘征夫怨行路瑟之幽

160. Ni Zan, *Remote Stream and Cold Pines,* hanging scroll, ink on paper, late Yuan /early Ming dynasty. 59.7 × 50.4 cm.
Palace Museum, Beijing.

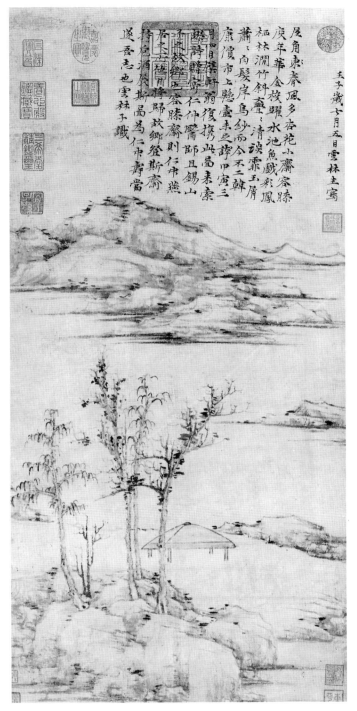

161. Ni Zan, *The Rongxi Studio,* hanging scroll, ink on paper, 1372. 74.7 × 35.5 cm. National Palace Museum, Taibei.

contrast, was to invest it with the values of literati culture in its highest, even most rarefied, manifestation. Already shortly after Ni Zan's death, we read, the cultural level of Jiangnan families — their "elegance" (*ya*) or "vulgarity" (*su*) — was judged according to whether or not they owned one of his works.

The well-deserved eminence of *The Rongxi Studio* among Ni's works is based on its ideal realization of the aim implicit in his whole artistic enterprise: to achieve the formal substance and spatial readability of conventional landscape painting within the limitations imposed by his expressive purpose. The brushwork is as hesitant and unassertive as ever, the ink tone as pale (except for the few sparsely distributed dark accents), the scenery as plain. The drawing is done with a slanting brush that turns abruptly downward in midstroke to delineate the earthy forms, which are self-contained and placid. Nothing intrudes forcibly on the consciousness of the viewer; the painting, like Ni Zan's others, embodies the artist's longing for disengagement from a contaminated world.

Frequently paired with Ni Zan in art-historical writings, in a relationship more of contrast than of similarity, is his younger contemporary Wang Meng (ca. 1308–1385). He was the son of Zhao Mengfu's daughter and may have received some early instruction in painting from his grandfather. He followed the family tradition of involvement in official service, holding a minor post during the 1340s. But the Red Turbans revolt and the collapse of Mongol control in the Jiangnan region brought his career to a halt, and he withdrew to a "hermitage" in the Yellow Crane Mountain north of Hangzhou, from which he took the studio-name Firewood Gatherer of the Yellow Crane Mountain (Huanghao Shanqiao). He spent some years in Suzhou while it was under the control of Zhang Shicheng and was a prominent figure in the group of poets and artists gathered there. After the founding of the Ming dynasty in 1368, when it appeared that the restoration of native Chinese rule would bring a return of the old Confucian system of appointment and advancement through merit, he accepted a post as prefect in Shandong Province. But, like many others, he fell victim to the harrowing of educated men by the first Ming emperor, Zhu Yuanzhang, who, as a former Red Turban bandit of low-class origins, mistrusted them and had many put to death on charges of sedition. Wang Meng was one of a group of people who met in 1379 at the home of the prime minister, Hu Weiyong, to look at paintings; when in the following year Hu was accused of treason and executed, Wang was implicated, probably wrongly, and died in prison.

some sense, both the retreat of the person for whom the painting was originally done and then, by the simple act of reinscribing it, Renzhong's studio. Paintings of this kind were certainly not intended to be descriptive — if that were the purpose, a technically proficient professional master would have been engaged, and the picture would, at least in theory, have been more functional than aesthetically engaging. To have one's house or studio "portrayed" by such a prestigious master as Ni Zan, by

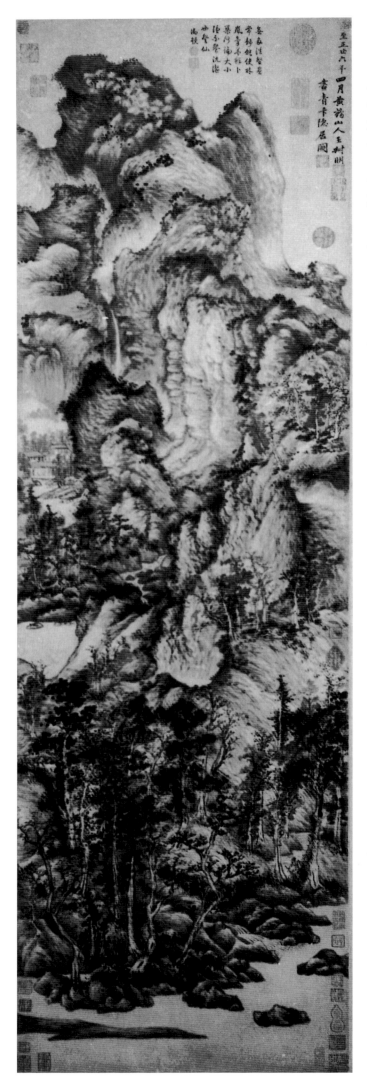

A recent study of Wang Meng's masterwork, *Dwelling in the Qingbian Mountains* of 1366 (fig. 162), reads it in the context of the artist's life and circumstances.[36] It was probably painted for Zhao Lin, paternal grandson of Zhao Mengfu and thus Wang Meng's cousin, and represents the Zhao family villa in the Qingbian Mountains, located north of their home in Wuxing. In type, then, the painting belongs with such works as Qian Xuan's *Dwelling in the Floating Jade Mountains* (see fig. 132) as a landscape of eremitism; Wang had painted several of these earlier and here follows the compositional convention of compartmentalizing the picture, with the retreat (seen as a cluster of houses in far middle left) situated in the enclosed part and access to the outer world represented in the lower part by water and by a path on which a man is walking with a staff. But the usual implications of comfortable security that such pictures carried were inapplicable to the time and place: when the painting was done, the armies of Zhang Shicheng and Zhu Yuanzhang were fighting in this vicinity, destroying whatever exemption from turmoil the gentry families had enjoyed. It must be this sense of loss of an ideal way of life that Wang Meng's painting conveys in its turbulence. Works of the kind that distantly underlay it — paintings by Dong Yuan in the tenth century and Guo Xi in the eleventh, or the Northern Song monumental landscape type more generally — allowed the viewer to participate visually in an ordered universe, organized coherently so as to be readable and traversable. By retaining so many features of that type, Wang Meng raises corresponding expectations, which he thereupon violates radically with his unnatural shifts of light and shadow, his spatial ambiguities or distortions, and his powerful destabilizing of the whole terrain. His brushwork has exactly the opposite effect from Ni Zan's: a diversity of brushstroke types are close-packed or overlaid for tactile richness; curling strokes impart a restless flow to the surfaces, besides transmitting the nervous energy of the artist's hand.

Wang Meng's *Ge Zhichuan Moving His Dwelling* (fig. 163) is undated but would appear from its style to belong to the same middle period, the 1360s. From Wang's inscription, added to the picture some years later, we learn that it was done for a certain Rizhang, probably the same person for whom the well-known *Forest Grottoes at Juqu* was painted.[37] He is believed to have been a Buddhist monk named Zucheng Rizhang; why Wang would paint a Dao-

162. Wang Meng, *Dwelling in the Qingbian Mountains,* hanging scroll, ink on paper, 1366. 141 × 42.2 cm. Shanghai Museum.

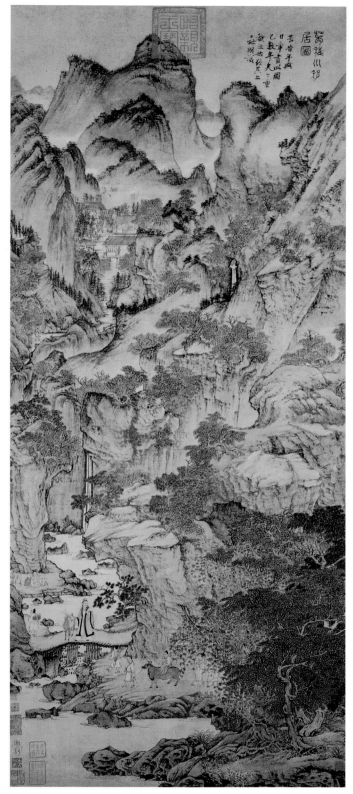

163. Wang Meng, *Ge Zhichuan Moving His Dwelling,* hanging scroll, ink and color on paper, ca. 1360s. 139 × 58 cm. Palace Museum, Beijing.

ist subject for him is unclear. Ge Zhichuan, or Ge Hong (283–343), was a historical personage, the author of the earliest Daoist alchemical text, the *Baopuzi neibian,* who later was numbered among the transcendents or immortals of Daoism. The "moving his dwelling" depicted here must be the episode in his life when he traveled to Guangzhou, intending to continue south in search of cinnabar for refining the elixir of immortality; prevented from going on by the local governor, he ascended nearby Mt. Luofu and prepared the elixir there. The valley with thatch-roofed houses in the upper left, where servant figures are seen awaiting their arrival, must represent his destination. On another level, the composition echoes pictures in which the Daoist transcendent ascends to heaven with his entire family—the late third-century adept Xu Sun, or Xu Jingyang, is one who did this, and thematically similar pictures are sometimes identified as representations of him. In that reading, the hidden valley, difficult of access and hemmed in by mountains, would stand for the attainment of paradise.

The procession of family members, mostly on foot but with his wife and child riding an ox, moves across the foreground; Ge Zhichuan himself stands on the bridge looking back at them, holding a feather fan in one hand and resting the other on the back of a deer that carries a bundle of scrolls, presumably Daoist holy texts (fig. 164). Above him, beyond two resting porters, the path disappears, to reemerge far above and lead into the valley. Like Sheng Mao in his *Villa in the Mountains* (see fig. 146), Wang Meng employs with great skill a Five Dynasties and Northern Song mode of landscape to lead the viewer's eye through a succession of spaces in which a temporal narrative is embedded. In keeping with this purpose, he draws his pictorial materials —figures, trees, rocky masses —with extraordinary finesse, using dry, precise brushstrokes and avoiding all that is gestural, calligraphic, or indicative of spontaneity. Such a technical feat, which in some respects is beyond anything attempted in Wang's other works, enlarges our esteem for the artist.

Because no Wang Meng painting dated later than 1368 is known, identification of works of his late period can only be circumstantial and speculative. A group of undated paintings that share certain characteristics can provisionally be placed there: they are loose in brushwork, rich in color, and confined largely to the picture surface, avoiding pulls into depth, careful definitions of space, and illusionistic light-and-shadow effects. The *Temple at Mt. Taibai* handscroll (fig. 165) is so striking in these features that foreign scholars, at least, would have had

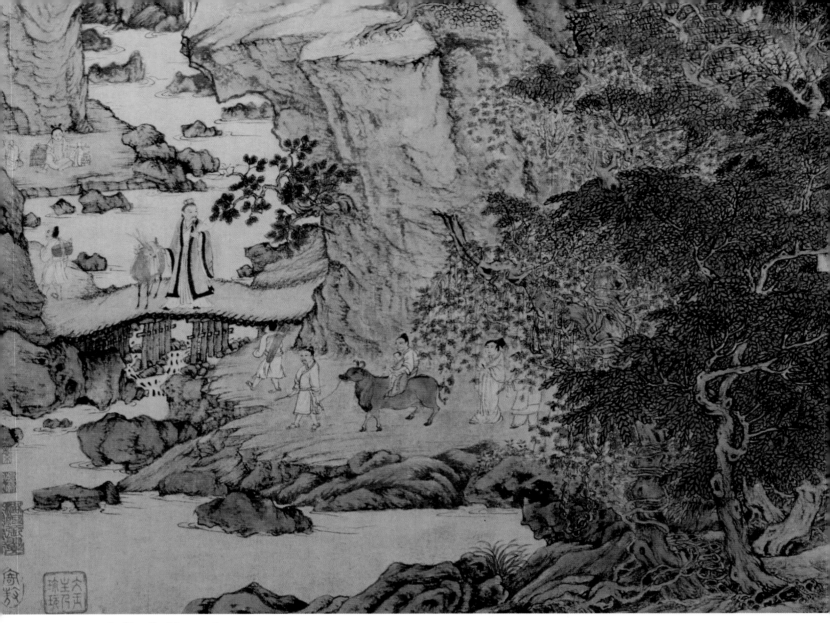

164. Detail of figure 163.

difficulty until recently accepting it as a work of the same hand, or even the same period, that produced *Dwelling in the Qingbian Mountains* of 1366 or *Ge Zhichuan Moving His Dwelling*. Ming masters, such as Shen Zhou (who in fact owned this painting), imitated these aspects of the late Wang Meng manner so closely that a painting like this one could easily be mistaken for a work of theirs. But it now occupies a secure place, and a high one, in Wang Meng's oeuvre. The temple portrayed in it is the Tiantong Si at Mt. Taibai near Ningpo in eastern Zhejiang. The twenty-li (roughly ten-kilometer) approach to the temple occupies most of the 2.65-meter length of the scroll, with Buddhist pilgrims and others seen making their way through a forest of pines and over bridges; the temple itself is reached only at the end, so that the experience of unrolling the scroll is structurally similar to a religious pilgrimage — another example of Wang Meng's

highly inventive use of landscape composition to represent a narrative theme. It may well be that paintings of this type were done frequently for temples and kept among their treasures; that more have not survived may be due to the destruction of temple holdings in late-period China, in contrast to Japan, where they have been passed down over centuries. Colophons to the scroll include several by Yuan and early Ming monks, the earliest dated 1388. Wang Meng has written a title at the beginning and presumably wrote a signature at the end, but at present only his seals appear there on a separate piece of paper. Speculation is that evidence of his authorship may have been removed by the temple at the time of his political trouble, when association with him was perilous, and partially restored later.

At the right of the section reproduced here, a mounted party including two red-coated government officials

nears the temple. Other visitors and monks stand around the ponds in front of the main hall; the lower part of a Buddhist sculpture is seen through the curtained opening, and members of the monastic community are visible through other doors and windows. This way of permitting the viewer to see into the building, and the setting of galleries and courtyards beyond the main hall at an angle so that one seems to look down into them, is unusual for this period and follows a system used in tenth-century and earlier architectural paintings, notably the great *Flour Mill,* formerly attributed to Wei Xian, in the Shanghai Museum (see fig. 97). It seems likely that Wang Meng, here as elsewhere in his works, is adopting features of style from old paintings he was able to view, incorporating them into a fundamentally new mode of landscape.

Wang Meng's deep engagement with the rendering of spaces and substantial forms, and his uses of these in building complex, never-repeated compositions, have been demonstrated in all the works considered thus far and could be exemplified by quite a few others. It is all the more remarkable that he also, probably in his late period, explored a flattening mode that had the effect of reducing the picture to a configuration of brushstrokes on the paper surface. A radical excursion in that direction is the small ink-on-paper *Landscape* (fig. 166). Neither Wang's brief inscription (only his sobriquet and signature) nor the poems written on it by two contemporaries reveal anything about the circumstances of its making. In the case of Ni Zan, the relative looseness and flatness of some of his late works, especially his bamboo pictures, are attributed to his having "responded to obligations" (*yingchou*) too frequently in his last years; one writer of the time, Xia Wenyan, comments that these and his earlier works look as though they came from two different hands. The same situation may account in part for this same tendency in the late period of Wang Meng, although in an artist of such stature it must also have been a matter of aesthetic decision.

Whatever lies behind it, the work is painted entirely in short, dry, mostly curling strokes of ink, without the washes and rich texturing that Wang Meng usually employs. One could liken the effect to the thinness and transparency of Ni Zan's pictorial fabric, but Wang's composition differs from one of Ni's in filling most of the space, allowing no restful intervals; one's first impression of it is of a flat, evenly textured shape occupying all but a small part of the frame. Examined more closely, this shape separates along diagonal divisions into large, heavily eroded landforms topped by rows of trees, and some

spatial order emerges, along with a minimal narrative structure: in the lower left a man sits in a tingzi gazing at a waterfall; another walks on the path at the right, making his way upward to where the path ends at a thatched hut, inside which a monk sits in meditation. The picture thus recalls the "visiting the holy man" or even "searching for enlightenment" themes of earlier paintings. Even the brushwork textures, seen in the original work, prove to contain nuances of touch and ink tone that make the painting both richer and more readable than it may seem at first, especially in reproduction.

The examples of Ni Zan and Wang Meng demonstrate, among other things, the wide range of expressive and descriptive effects that could be accomplished in landscape painting by the late Yuan period, which allowed it to be turned to a corresponding diversity of uses: self-expressive, political, philosophical, religious. It could reproduce, like Wang Meng's *Temple at Mt. Taibai,* the experience of a Buddhist pilgrimage; it could also convey, as do some of the works of Fang Congyi, a Daoist version of the world. Fang (ca. 1301–after 1380) was a Daoist cleric who entered the order while young and from the 1350s served as a priest in a Daoist temple in Jiangxi. He used the name Fanghu, or "Square Pot," the name of one of the legendary Isles of Immortals. His most impressive surviving work was painted in 1365 and is titled *Divine Mountains and Luminous Woods* (fig. 167). In composition the painting follows established models such as Gao Kegong and the Song traditions on which Gao's style was based — Fang is classified in Chinese writings as a follower of Gao Kegong and Mi Fu. In other respects, however, it agrees better with the new expressionist mode exemplified supremely by Wang Meng. There is no record of the two artists having been acquainted, but because Fang moved in literary circles while Wang frequented Buddhist and Daoist temples, and because they had friends in common, the likelihood is strong that they knew each other's works. Fang Congyi destabilizes his landscape forms here with restless, fluctuating brushwork, as Wang Meng does in *Dwelling in the Qingbian Mountains* of the following year; if Wang is expressing in this a private turbulence and Fang a Daoist vision, it only underscores the truth that forms and styles in art do not carry fixed meanings. Fang's mountain peaks heave upward and lean sideward; the trees below engage in an energetic dance; the insistent application of the slanting *dian,* or dotting, makes it seem to vibrate apart from the masses instead of adhering to them. In the Daoist cosmology, matter exists only in a state of flux or process, as the basic amorphous stuff of the universe (*qi*) coalesces

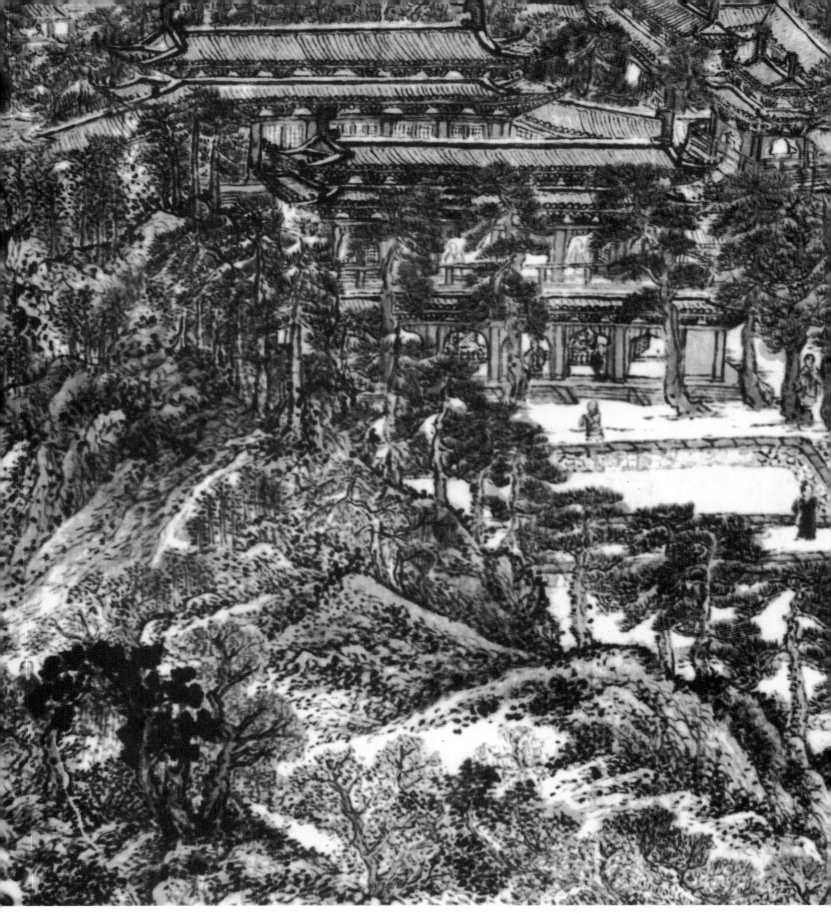

165. Wang Meng, *Temple at Mt. Taibai,* sections of a handscroll, ink and color on paper, Yuan dynasty. 27.6 × 238 cm. Liaoning Provincial Museum, Shenyang.

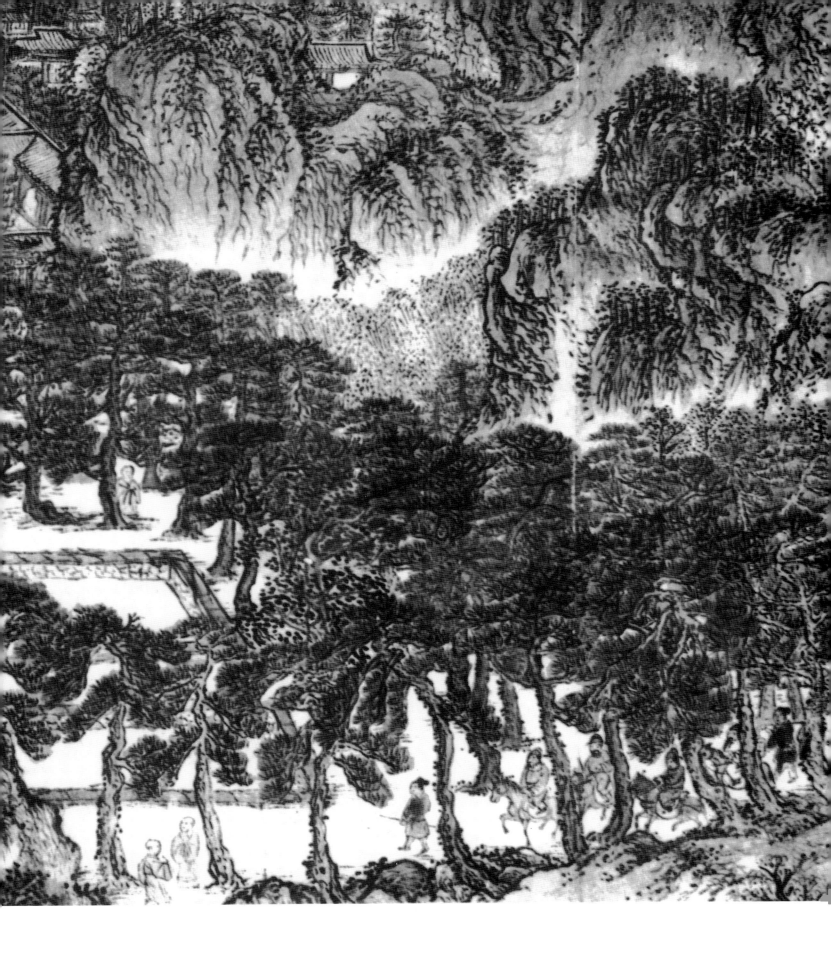

caoshu manner, in cursive, running brushwork, and that is a good characterization of Fang's extraordinary mode of depiction. The brush does not pause anywhere to dwell on differentiation of texture or detail, but concentrates on transforming mass into movement, creating riverbanks and trees as tangles of raveled strokes. The enormous cliff rises sheer to splay out at the top in an

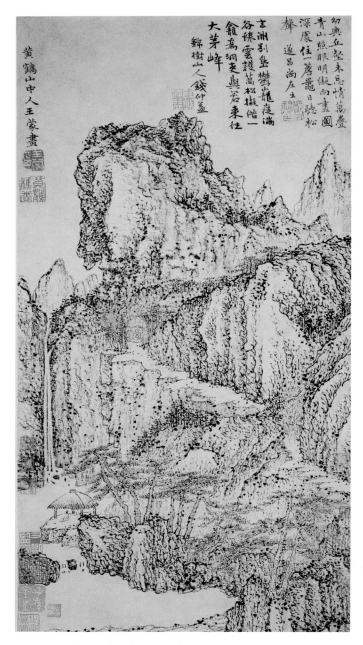

166. Wang Meng, *Landscape,* small hanging scroll, ink on paper, Yuan dynasty. 54.4 × 28.3 cm. Shanghai Museum.

167. Fang Congyi, *Divine Mountains and Luminous Woods,* hanging scroll, ink and color on paper, 1365. 120.3 × 55.7 cm. National Palace Museum, Taibei.

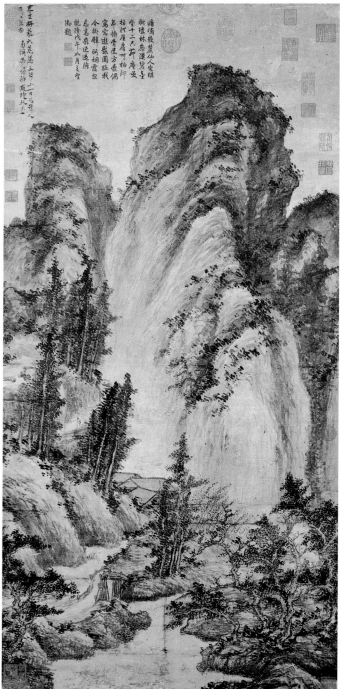

and dissolves, and such a conception would seem to underlie Fang Congyi's painting.

Rowing by Mt. Wuyi (fig. 168) of 1359 is Fang Congyi's earliest surviving dated work, but also one of his most radical in style. It was painted for a Mr. Zhou, who had recently made the spectacular trip by boat down the Nine Bends River past Mt. Wuyi in eastern Fujian Province. A year had passed since they parted; Fang was concerned about him and painted this picture "in the manner of Ju-ran" as a reminder of the trip, writing the title in archaic script in the upper right and a dedicatory inscription at the left in his elegant *caoshu,* or draft script. Chinese appraisals of the painting state that it, too, was done in the

explosion of energy like windblown grasses, its shape recalling the mushroom of Daoist lore but also the *que* (pillars) of Han and Six Dynasties religious cosmology that marked the presence of divinity in a landscape. The scattered dotting creates an even more powerful agitation than that in *Divine Mountains and Luminous Woods*. Yet the impression of complete spontaneity belies the care with which the artist has constructed his scene, setting the darker, more fully defined foreground bank against the paler distant one, handling matters of scale and atmosphere almost like a Northern Song master.

In addition to these late Yuan landscapists who display strongly individual styles, there were others whose achievements were more modest but still respectable, and who consolidated the stylistic innovations of the period into a coherent, manageable landscape mode that literati artists in the early Ming would continue. One of these was Zhao Yuan, a native of Shandong Province who was active mainly in Suzhou, where he served as a military adviser to Zhang Shicheng during his occupation of the city. He was a friend of Ni Zan and Wang Meng, and in 1373 collaborated with Ni on a handscroll (the whereabouts of which are now unknown) depicting the Lion Grove Garden (Shizi Lin) in Suzhou with its famous rockeries. His end was tragic: at the beginning of the Ming he was summoned to court to serve as a court painter and given the task of painting portraits of ancient worthies — a time-honored way for the new dynasty to establish its Confucian credentials by setting up models for emulation. Zhao, who had no professional training and must have been an amateurish figure painter at best, failed to please the Hongwu emperor, Zhu Yuanzhang, and was executed.

A work from his happier days is *A Thatched Hall at Hexi* (fig. 169), painted in 1363 for Gu Dehui, or Gu Aying (1310–1369), a rich literatus and patron of letters who had hosted many notable gatherings of poets and artists at his Jade Mountain villa at Kunshan. In 1356 Gu moved to a more remote and secluded retreat at Hexi, near Wuxing, to avoid being drawn into the Suzhou regime of Zhang Shicheng, who had offered him a prefectural post. It is this Hexi retreat that Zhao Yuan portrays in his deliberately placid picture, writing the title and his signature in the upper right in archaic seal script characters. The longer inscription is by Gu Dehui himself, who writes that he loves this place because of its inaccessibility — it is reachable only by boat and hard to find, a refuge from tax collectors. Zhao Yuan stresses the remoteness of the place by creating a long recession across the water and making Gu's "thatched hall" the

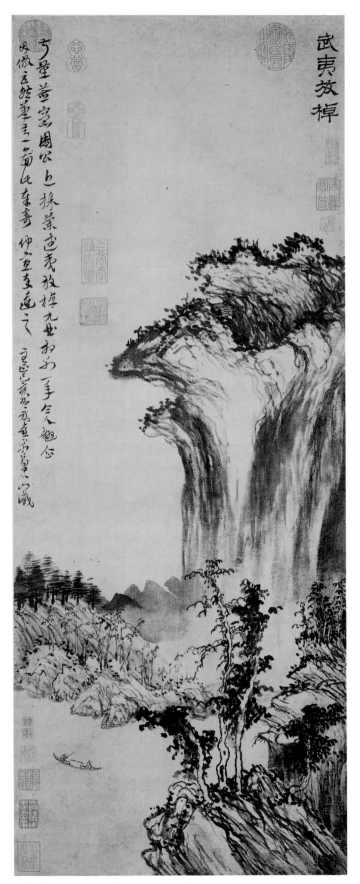

168. Fang Congyi, *Rowing by Mt. Wuyi*, hanging scroll, ink on paper, 1359. 74.4 × 27.8 cm. Palace Museum, Beijing.

only human habitation visible, apart from a roof dimly seen behind trees on the further bank. The master of the retreat is seen inside it, approached by a new arrival with a staff; two others stroll outside beneath the trees, indicating that Gu is no true recluse but is continuing his practice of entertaining literary friends. Three fishermen in boats at middle left look as if they had drifted in from a Zhao Mengfu painting. The scenery, which appears so generalized to us, is praised in Gu Dehui's inscription for its resemblance to the real place; and no doubt it was indeed successful in evoking, in a cultivated mind attuned to the scholar-artist conventions of the time, the ambiance of Gu's lakeside villa, a temporary haven from the political and military turmoil of the outside world.

Chen Ruyan (ca. 1331–before 1371), a native of Suzhou, was another member of this circle. A friend of Ni Zan and Wang Meng, he too held office in Zhang Shicheng's short-lived government. He accepted a provincial post under the new Ming government and met the same fate as the others, execution for some unspecified transgression. His *Realms of Immortals* handscroll (fig. 170) was probably painted while he was serving under Zhang Shicheng; according to an inscription by Ni Zan written in 1371, in which he mentions that the artist was already dead by then, it was done as a birthday gift to a Mr. Pan, who was Zhang Shicheng's brother-in-law. It was, then, among other things a counter in an elegant and intricate pattern of social intercourse, set against the more practical ground of winning favor with highly placed personages, incurring and discharging obligations, repaying gifts and hospitality, which underlay a significant part of the production of paintings in scholar-amateur circles. It was a pattern in no way incompatible with the freest of aesthetic impulses: a commonality of taste and assumptions ensured that an artist following his own preferences in style and subject usually would please the recipient as well; and since such paintings were read as expressions of personal feeling, these choices of the artist's were integral to the very content of the work. Still, some aspects of Chen's painting are as if predetermined, the given as opposed to the chosen: the Daoist paradise with pines and cranes stood for longevity and was thus appropriate for birthdays; the fine-line drawing and heavy green color, besides having the same paradisiacal reference, recalled the archaistic works of Zhao Mengfu (see fig. 133); the sheer peaks, mushrooming at the top, also alluded to antique landscape and were common currency in the late Yuan. Chen executes all this with a *faux naïf* charm: in the section reproduced here, a boy dances with two cranes, observed by two of the transcendents, while another

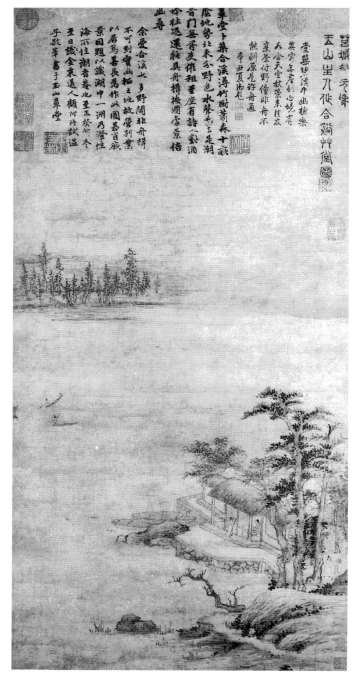

169. Zhao Yuan, *A Thatched Hall at Hexi,* hanging scroll, ink and light color on paper, 1363. 84.3 × 40.8 cm. Shanghai Museum.

transcendent appears in the sky between mountaintops, arriving on the back of another crane.

Birds and Flowers, Bamboo and Blossoming Plum

The previous chapters, devoted to the pre-Song and Song periods, have traced the development of three large subject categories of Chinese painting: figures, landscape,

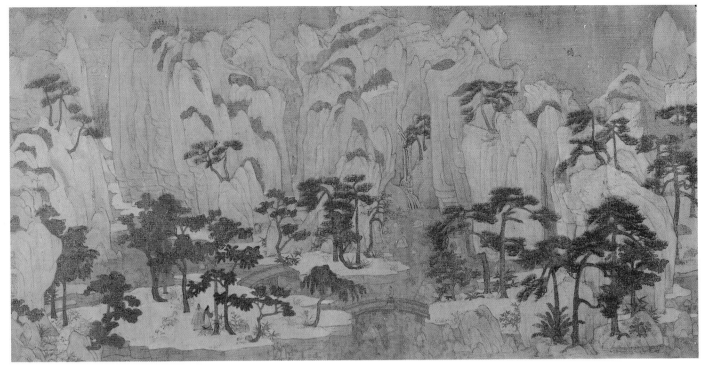

170. Chen Ruyan, *Realms of Immortals,* section of a handscroll, ink and color on silk, Yuan dynasty. 33 × 102.9 cm.
(© 1996. Intended gift to the Cleveland Museum of Art, Mr. and Mrs. Dean A. Perry.)

and a third category consisting of various subjects from nature — animals and birds, insects and plants. Paintings of birds, flowers, and animals by Song masters had attained heights of understanding and technical refinement that were never to be reached again. Yuan bird-and-flower paintings by conservative artists survive in some number, especially in Japanese collections; they are mostly the works of artists still working in Song traditions in the region of Hangzhou, or the products of local schools elsewhere that specialized in decorative and symbolic pictures of particular subjects, such as the Piling School located southeast of Nanjing, which specialized in pictures of plants and insects.[38] Attractive though some of them may be, as a group they add little to what the Song had accomplished.

The practice of bird-and-flower painting by literati artists might seem to have been given a promising start in the early Yuan by Qian Xuan, but he had little following in the fine-outline-and-color manner. Among the followers of Zhao Mengfu were a few who tried to create bird-and-flower works that met his new aesthetic principles by referring back to antique models while introducing new features of style. One of them was Wang Yuan, who came from Hangzhou and learned painting directly from Zhao Mengfu. He is reported to have executed mural paintings in a palace building and a Buddhist temple around 1328; his extant dated works all fall into the 1340s. Most of

them are carefully arranged set pieces based on a composition type adopted from tenth-century painting — Wang Yuan is said to have imitated the Five Dynasties master Huang Quan. They tend to be somewhat stiff, as revivalist art is likely to be, lacking the animation and naturalism of their early models.

A good example, less stiff than most, is his *Pheasants and Small Bird with Peach and Bamboo* of 1349 (fig. 171). The season is spring, as indicated by the blossoming of the peach tree and the rivulet at the left that flows from spring rains or melting snows. The male pheasant perches on a rock by the river, preening his breast feathers, self-absorbed; the female appears inconspicuously below, looking up. For such a colorful subject, Wang Yuan's choice of ink monochrome over the colored style may seem anomalous; it reflects, presumably, an intent to separate himself from the straightforward professional masters and an appeal to the more reserved literati taste. But in other respects, especially its polished execution, the picture exhibits the quasiprofessional standards that Zhao Mengfu seems to have encouraged in the artists who followed him, such as Tang Di in landscape and Ren Renfa in figures and horses.

The practice by scholar-amateur artists of making ink monochrome paintings of a limited group of symbolic subjects — bamboo, rocks, old trees, pines and orchids, narcissus and blossoming plum — was noted early in this

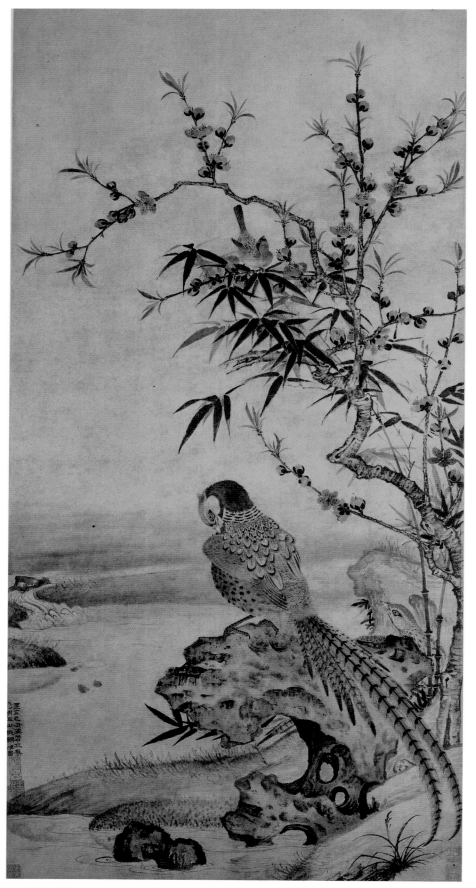

171. Wang Yuan, *Pheasants and Small Bird with Peach and Bamboo,* hanging scroll, ink on paper, 1349. 111.9 × 55.7 cm. Palace Museum, Beijing.

chapter. Among this group, bamboo was easily the fa-
vorite. Inaugurated by Su Shi, Wen Tong, and other pio-
neer literati artists in the late Northern Song and carried
on by some artists working in the north under the Jin
dynasty, the genre of ink bamboo had apparently been
taken up by so many enthusiastic and largely self-taught
amateurs in the early Yuan that the leading bamboo
painter of the age, Li Kan (1245–1320), directs his scorn
at them in his *Zhupu,* or "Treatise on Bamboo." He
writes that they "aim too high and leap over the steps be-
tween, releasing momentary feelings and smearing and
daubing about. Then they think that by obtaining release
from step-by-step craftsmanship they have attained [art]
through naturalness."[39] Li Kan's essay, one of several on
the painting of special subjects composed in the Yuan —
others include Wang Yi's on portraiture, Huang Gong-
wang's on landscape, and one on blossoming plum by
Wu Taisu — lays out just the kind of step-by-step in-
struction that, in Li's view, the dabblers scorned but
needed.

Li Kan, like his friend Zhao Mengfu, held a series of
posts in the Mongol administration, culminating in his
appointment as president of the Board of Civil Service.
His paintings of bamboo were done in two distinct man-
ners. One was the *goule* or *shuanggou* manner, in which the
stalks and leaves were drawn in ink outline and filled in
with color; the other was the ink monochrome manner,
following the tradition of Wen Tong, in which broad,
shaped brushstrokes depicted the sections of stalk, twigs,
and leaves, and were done in varying ink tones to render
the back and front sides of the leaves and the cylindrical-
ity of the stalks, as well as to distinguish nearer and fur-
ther planes of depth. *Bamboo and Rocks* (fig. 172) is an
excellent example of the former. It bears no signature,
only two seals of the artist. As with *Pheasants and Other
Birds with Peach and Bamboo,* its large size and nearly square
shape suggest that it was painted for a screen, and it
would have made a handsome addition to any room,
opening up space in addition to presenting its symbolic
materials. Two dark outcroppings of earth or rock, and a
bank extending back, define the space of the picture, to-
gether with the placement of the plants. Clumps of grass
and shrubs grow beneath the tall stalks of bamboo. Li
Kan's systematic study of the real growth of bamboo, as
well as paintings of it, carried out on his official travels,
underlies his meticulous depiction of the shoots, the clus-
ters of overlapping leafage, and the shaded green of the
leaves. No picture could be further from the abstract and
flattened character of typical ink bamboo as practiced by
most scholar-amateur artists, who were less concerned

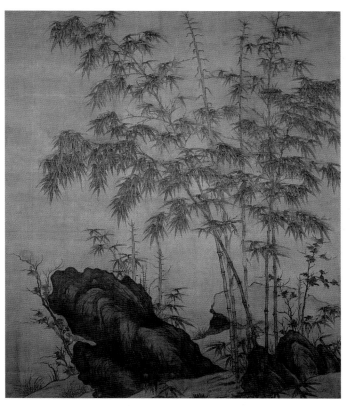

172. Li Kan, *Bamboo and Rocks,* hanging scroll, ink and color on
silk, Yuan dynasty. 185.5 × 153.7 cm. Palace Museum, Beijing.

with conveying the properties of their subject than with
manifesting their cultivation and individuality through
brushwork and other features of style.

The genre of ink bamboo — or, more properly, of
rocks, old trees, and bamboo — is seen at its highest level
of achievement in Zhao Mengfu's *Elegant Rocks and Sparse
Trees* (fig. 173). It bears only his signature and seals but is
accompanied by an equally famous piece of his writing,
a quatrain that argues for the close affinity, or near-
identity, of painting and calligraphy. It reads (as translated
by Wen Fong):

> Rocks as in flying white [script], trees as in seal script,
> When painting bamboo one applies the spreading-
> eight [late clerical] method.
> Those who understand this thoroughly
> Will realize that calligraphy and painting have always
> been the same.[40]

The dubiousness of this last claim — it applies only in
the loosest way to a minor segment of Chinese paint-
ing — has not prevented it from being widely repeated
and inspiring countless calligraphers to attempt to turn
their skills to painting, usually with very limited success.
What we admire in *Elegant Rocks and Sparse Trees* is not

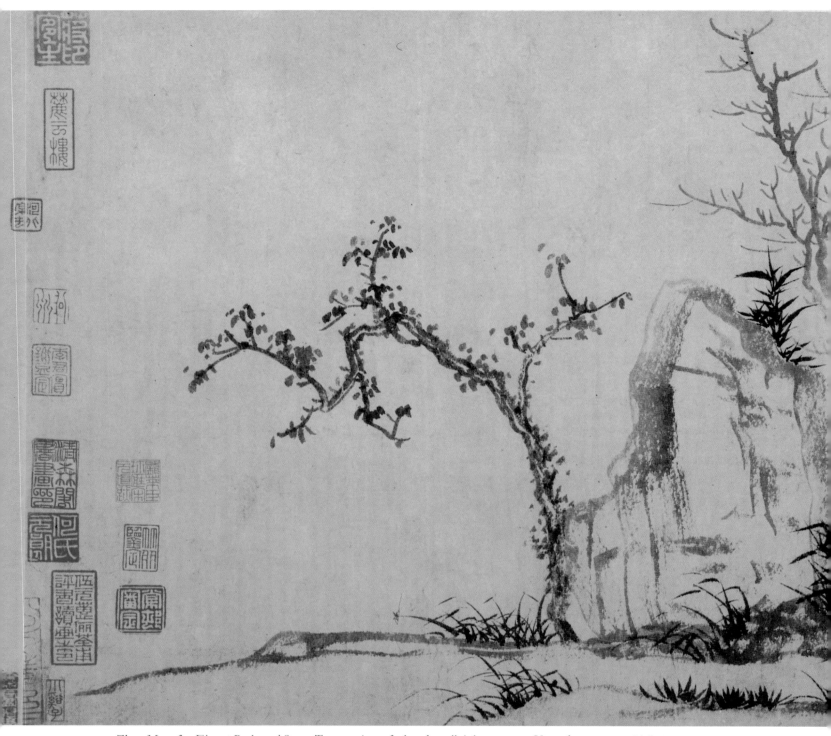

173. Zhao Mengfu, *Elegant Rocks and Sparse Trees,* section of a handscroll, ink on paper, Yuan dynasty. 27.5 × 62.8 cm. Palace Museum, Beijing.

Zhao the master calligrapher but Zhao the highly accomplished painter; not the "calligraphic" brushstrokes in themselves but the way they are made to function representationally. Broad, broken strokes (the "flying white") shape the rocks and give them surface roughness and volume; firm, blunt strokes in black ink (the "seal script") convey the stiffness of the branches and twigs of trees; spiky clumps of tapered strokes (the "late clerical" script)

depict the bamboo leafage. The affinities of the brushstrokes to those of calligraphy are nonetheless real and justify the use of the term "calligraphic" for paintings such as this. Tang Hou, a connoisseur and art theorist who adopted and expanded the ideas of Zhao Mengfu, observes that "painting plum blossoms [in ink] is called writing [*xie*] plum blossoms; painting bamboo is called writing bamboo; painting orchids is called writing or-

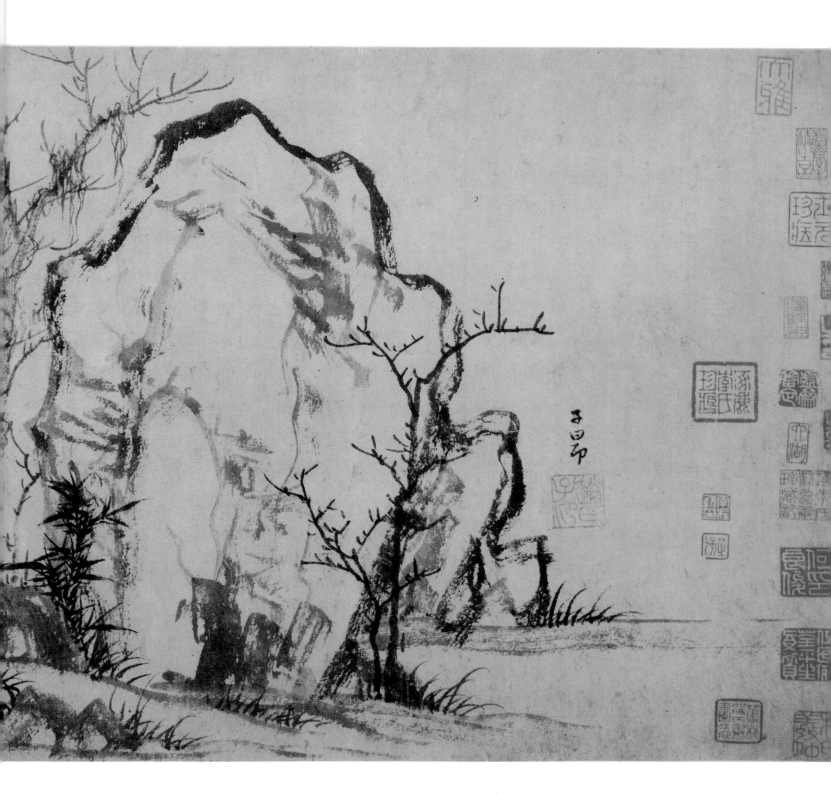

chids." Tang goes on to quote a line from a Song-period poet: "If the idea is adequate, do not seek for outward likeness."[41] But this association of "capturing the idea" with the spontaneous ink monochrome mode of painting and "seeking for outward likeness" with the careful, conservative styles is also of limited validity; it would be difficult to argue that Li Kan's painting (see fig. 172) is less successful in conveying the "idea" or the "principle" of bamboo than Zhao Mengfu's. The visual excitement generated in the viewer by a painting like Zhao's comes from the experience of reading the brushstrokes simultaneously as elements of an image and as expressive traces of the artist's hand.

Another leading bamboo painter of the time was Zhao Mengfu's wife, Guan Daosheng (1262–1319). The daughter of an old Wuxing family and well educated, she

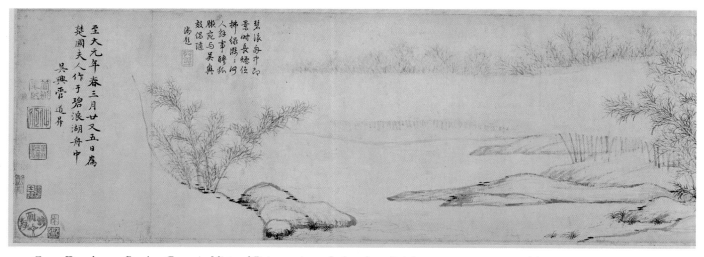

174. Guan Daosheng, *Bamboo Groves in Mist and Rain,* section of a handscroll, ink on paper, 1308. 23.1 × 113.7 cm. National Palace Museum, Taibei.

married Zhao in 1269, after the death of his first wife. She bore him two daughters and two sons, one of whom, Zhao Yong, became a successful official and painter himself. Guan Daosheng was a calligrapher and poet as well as a painter; besides bamboo, she painted blossoming plum, orchids, landscapes, and Buddhist figures, sometimes even doing wall paintings in temples. Later critics who praise her paintings almost invariably add a backhanded compliment to the effect that they were not at all like the frail, delicate brushwork of gentlewoman-painters.

Among the few surviving works reliably from her hand are several ink bamboo pictures close to her husband's in style. More interesting and distinctive is the short handscroll painted in 1308, *Bamboo Groves in Mist and Rain* (fig. 174). She dedicates it to another noblewoman, whom she addresses as "Lady Chuguo," and adds that she painted it "in a boat on the green waves of the lake." The picture can in fact be taken as a view from a boat of groves of bamboo growing on the lakeshore. Guan Daosheng is said to have specialized in depicting thickets of bamboo, in contrast to the individual branches or stalks painted by most other artists. In this preference she may be following a local Zhejiang tradition, as represented in small paintings of misty bamboo groves preserved in Japan under the name of Tan Zhirui, an artist unrecorded in China who was active in the early Yuan. Since these paintings were brought to Japan by Chan Buddhist monks who had studied in northern Zhejiang, some of them with the great priest Zhongfeng Mingben, who was a close friend of Zhao Mengfu and Guan Daosheng, it is reasonable to assume that she knew the artists who produced these pictures; her work may in

turn have inspired some of them. Bamboo painting of this genre is less a calligraphic exercise than the flat, single-branch kind, more a matter of sensitive observation and sympathetic portrayal. In Guan's picture the range of ink tonality is kept narrow, in keeping with the misty atmosphere; separation in depth is accomplished by overlapping earthbanks, and by a layer of fog that intervenes between near and far. The bamboo stalks are drawn with supple, continuous strokes, and the leafage with feather-soft touches.

Among the scholar-officials in the Yuan court who practiced ink bamboo painting was Ke Jiusi (1290–1343). His father was a friend of Li Kan, and he may have learned bamboo painting directly from Li. Through his scholarship and artistic talents, he came to the attention of Emperor Wenzong, who appointed him director of painting and calligraphy in the Kuizhangge, where he served as a court connoisseur and curator of the imperial collection. In his late years he retired to Suzhou. Far less versatile as a painter than Zhao Mengfu or even Li Kan, he limited himself largely to modest compositions of bamboo stalks and branches, occasionally adding other plants and garden stones. *Ink Bamboo for the Qingbige,* dated 1338, represents him at his best (fig. 175). The Qingbige (pavilion) was on the estate of Ni Zan, and Ke Jiusi was staying with that wealthy young aesthete at the time he painted the picture; its orderly, uncluttered look must have pleased Ni's austere taste. Ke's elegant employment of shifting ink values in the leaf clusters and on the stalks answers dictates of taste more than representation, although it does serve, along with the simple shaping of the rock, to give a minimal depth to the work. Ke Jiusi's purpose is at a further extreme from Guan Daosheng's; his

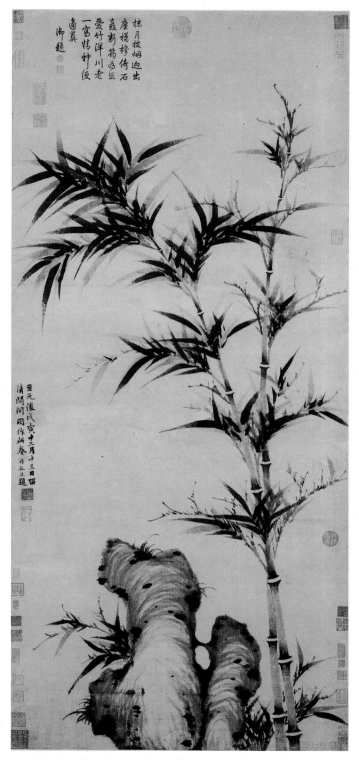

175. Ke Jiusi, *Ink Bamboo for the Qingbige,* hanging scroll, ink on paper, 1338. 58.5 × 32.8 cm. Palace Museum, Beijing.

work is a highly disciplined performance in an established style, an expression of homage to the Wen Tong tradition and the literati values it had come to stand for.

Guo Bi (1280–ca. 1335) was the son of a prominent official and a scholar of some standing. Failing to pass the examinations, however, he held only minor posts. He painted landscapes in the Mi family manner, and pictures of bamboo and old trees. A diary by him has survived, covering the period 1308–1309; it records his travels, mostly in the region of Hangzhou; comments on private collections of paintings and calligraphy, as well as wall paintings in temples that he visited; and notes on paintings and calligraphy that he executed on his travels, usually at the request of hosts, or in return for gifts of food and wine.[42] *Lonely Bamboo and Bare Tree* (fig. 176), dedicated in his inscription to a certain "Priest Wuwen," must represent the kind of spontaneous work he produced on such occasions. In subject and composition it resembles the better-known work of the Jin artist Wang Tingyun (1151–1202), painted about a half-century earlier.[43] The composition, like Wang Tingyun's, centers on a segment of old tree trunk rendered in broken, dragged brushstrokes; a branch projects to one side, and sprigs of growing bamboo occupy the other. The brushwork seems deliberately harsh and inelegant, modulating suddenly from light to dark, dry to wet, to characterize its unidealized, unbeautiful subject. Both brushwork and image convey, within the code of values in literati painting, the idea of uncompromising integrity.

The best bamboo painter of the late Yuan, and perhaps of the whole dynasty, was Wu Zhen, whom we considered earlier as a landscapist. A major portion of his surviving oeuvre is made up of pictures of bamboo, mostly represented as isolated branches, the "shadow bamboo" supposed to have been inaugurated when someone traced in ink on a paper window the shadow of bamboo branches cast by the moon. In his prose inscription on an uncharacteristic but deeply affecting work, *Stalks of Bamboo by a Rock,* painted in 1347 (fig. 177), the artist writes of having studied bamboo painting half his life, and of now being old. He has seen many works purporting to be by Wen Tong and Su Shi, but genuine ones were rare among them. One exception, a work by Wen Tong "quite beyond comparison with the vulgar mannerisms [of the forgeries]," he had seen in the collection of the Xianyu family, possibly relatives of the calligrapher and scholar Xianyu Shu (1257?–1302), who had spent some years in Hangzhou and was a noted collector. But despite his efforts to imitate it, Wu Zhen could not attain "one ten-thousandth" of its quality, because his brush force was not yet mature, "as can be seen from this [painting]." This is the conventional modesty of the literatus and seems especially unwarranted here: what Wu Zhen accomplishes in his picture is not anticipated in any work associated with Wen Tong or any other Song artist. The expressive capacity of bamboo, like that of land-

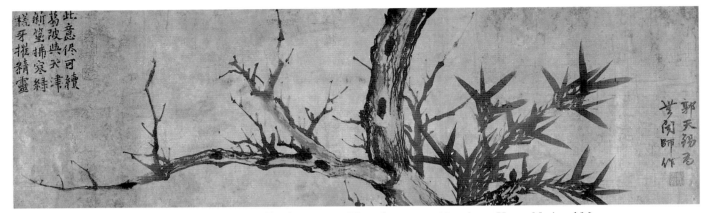

176. Guo Bi, *Lonely Bamboo and Bare Tree,* handscroll, ink on paper, Yuan dynasty. 33 × 106 cm. Kyoto National Museum.

scape, had been expanded in the hands of the Yuan masters, and images of it could evoke a broad range of feelings or ideas, from aggressive ardor to loneliness and melancholy. The mood of Wu Zhen's painting is certainly at the latter end of this spectrum, with the few unassuming stalks drawn in pale ink and revealing the effects of season and weather in their bare twigs and few drooping leaves. A shallow space is opened behind the loaf-shaped rock by groundlines brushed in dilute ink; the composition stands midway between the kind that situates the bamboo in a real-world setting, pervaded by space and blown by wind, and the flat "shadow bamboo" type that gives it only an abstract, ink-on-paper existence. The effect is of isolation and impoverishment, and bespeaks the same sensitive observation, even a kind of compassion, that one feels in Guan Daosheng's very different picture.

Ni Zan also painted bamboo, old tree, and rock pictures; an excellent example is his undated *Autumn Wind in Gemstone Trees* (fig. 178). Although the style indicates that it must be late in his oeuvre, it is by no means one of the loose, sloppily executed pictures that his contemporary Xia Wenyan, as mentioned earlier, writes of as having been done to respond to obligations. This one may well have served that function for Ni, but it is a disciplined, lucidly organized picture with no wasted brushstrokes, no excess flourishes meant to signify spontaneity. The dry, careful delineation of the rock, with a few dark dian (dots) as accents, permits an unambiguous reading of its shape, as the springy stalks and sharp-pointed leaves of the bamboo and the more varied brushstrokes of the tree describe the different materials of these plants and transmit their growing life. The brushwork in the tree, in particular, is as constantly modulating, as charged with

vitality, as that in Ni's *Rongxi Studio* (see fig. 161). Ni Zan's own inscription, a quatrain, is answered by two others by contemporaries in the upper left; a certain Lu Zhixue, using a script style close to Ni Zan's, adds a fourth, along with a prose note in which he writes of having been with the artist for more than ten years on the Songling River, "burning incense, playing with the brush, toasting each other with wine, composing poems." He dates his inscription 1384, ten years after Ni Zan's death.

The blossoming plum tree, another favorite theme for literati painters, had a somewhat different place in Chinese culture from that of bamboo. Enthusiasm for the blossoming plum had developed into a cult in the Southern Song period, with poets expressing almost erotic attachment to its sensuous beauty, and painters both in the Imperial Painting Academy and among the scholar-amateurs creating ravishing images of it. Masterworks by Ma Yuan and Ma Lin in the academy, and of Yang Wujiu and other scholar-artists, would seem to have left little space for development by painters of later times, and the genre of ink plum became increasingly conventionalized, especially after the Yuan. But this does not appear to have lessened its popularity. Around the middle of the fourteenth century, a little-known artist named Wu Taisu composed a treatise that codified the painting of ink plum as Li Kan had done for bamboo; *Songzhai meipu* survives only in four incomplete copies in Japan, where Wu Taisu's only extant paintings are also preserved.[44]

The best-known painter of flowering plum in the Yuan dynasty was Wang Mian (1287–1359). Like Wu Taisu, he came from Kuaiji in Zhejiang Province. Failing in his aspirations toward a career either as an official in the civil service or as a military adviser to the powerful, he re-

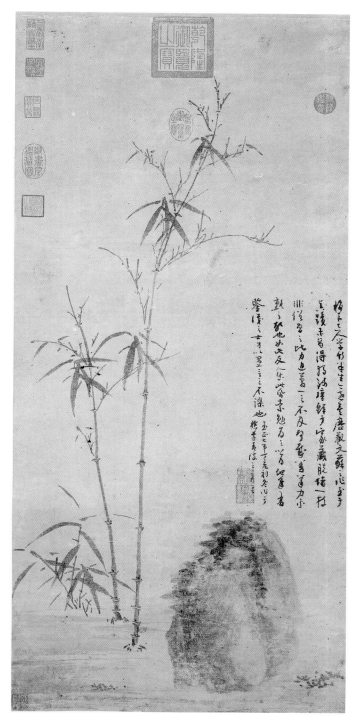

177. Wu Zhen, *Stalks of Bamboo by a Rock,* hanging scroll, ink on paper, 1347. 90.6 × 42.5 cm. National Palace Museum, Taibei.

signed himself to making his living by painting; in this, at least, he was successful. His contemporary Song Lian writes: "Those who sought [his paintings] came in crowds, [and stood] back to shoulder to watch. He used [paintings on] long and short lengths of silk in order to earn what he needed for rice. When people mocked him, Mian said, 'I depend on this for my livelihood. Why [otherwise] would I want to be a painting master working for others?'" Wang Mian exemplifies, in fact, along with Wu Zhen and others, a phenomenon that was increasingly common in the Yuan: artists who possessed the credentials for scholar-amateur status but who chose, or were forced by circumstance, to make their living by painting. We might see this as the beginnings of the practice in later Chinese painting of turning literatus-artist status into a marketable commodity. The diversity of sizes, materials, and styles in Wang Mian's oeuvre — large, decorative hanging scrolls on silk, short handscrolls or album leaves featuring single branches and painted on paper — are best understood as the artist's response to a corresponding diversity of clients and patronage situations, as well as to his inner artistic impulses.

An excellent example of Wang Mian's late style, painted in 1355, is his *Branches of Blossoming Plum,* a relatively small work on paper (fig. 179). The artist himself has inscribed six quatrains on it, and others have been added by four contemporaries; moreover, the paper *shitang* above the painting and even the space on the mounting silk surrounding it are filled with inscriptions by such illustrious Ming writers as the calligraphers Zhu Yunming and Wang Chong and the painter Tang Yin. The painting might seem a frail support for all these effusions of praise, but it holds its own with a delicate richness, the profusion of blossoms filling the available space. The conventional S-shaped curve around which plum branch paintings are usually organized is preserved in one branch that extends from near the upper right corner to the lowest point at left, but other branches and twigs partly obscure this, giving the composition some measure of freshness. The painting conveys something of the springtime experience of being enveloped in a cloud of fragrant blossoms, one of the many ways to enjoy flowering plum.

The famous *Breath of Spring* by Zou Fulei (fig. 180) is the only extant work of a less-known but extremely accomplished master of ink plum painting. Nothing is known about him beyond what is contained in the inscriptions on the painting, according to which he was a Daoist physician and painter of blossoming-plum pictures. He lived in seclusion with his elder brother, also an artist, who specialized in bamboo. The painting is dated

The Yuan Dynasty 193

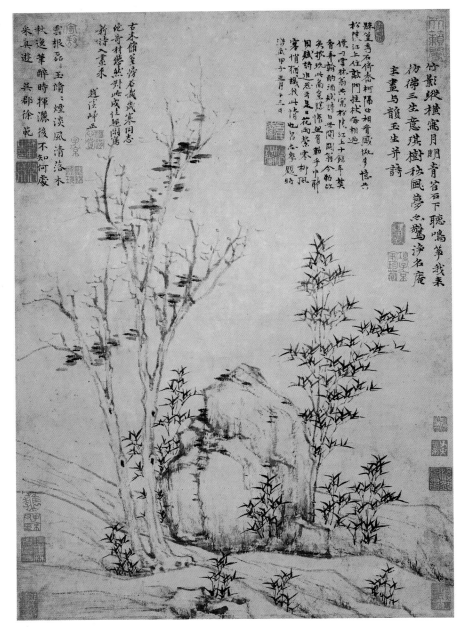

178. Ni Zan, *Autumn Wind in Gemstone Trees,* hanging scroll, ink on paper, Yuan dynasty. 62 × 43.4 cm. Shanghai Museum. *left*

179. Wang Mian, *Branches of Blossoming Plum,* hanging scroll, ink on paper, 1355. 68 × 26 cm. Shanghai Museum. *opposite*

180. Zou Fulei, *A Breath of Spring,* handscroll, ink on paper, 1360. 34.1 × 223.4 cm. (Courtesy of the Freer Gallery of Art, Smithsonian Institution, Washington, D.C.) *below*

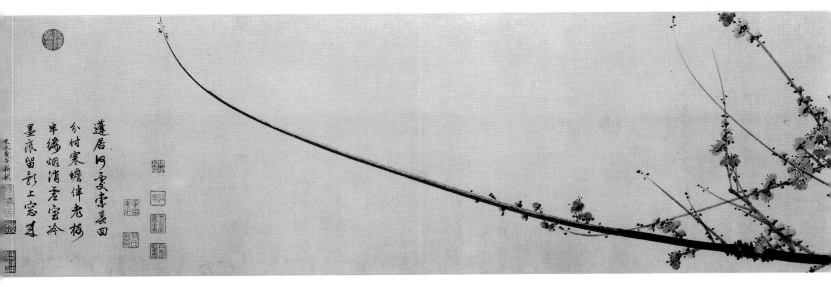

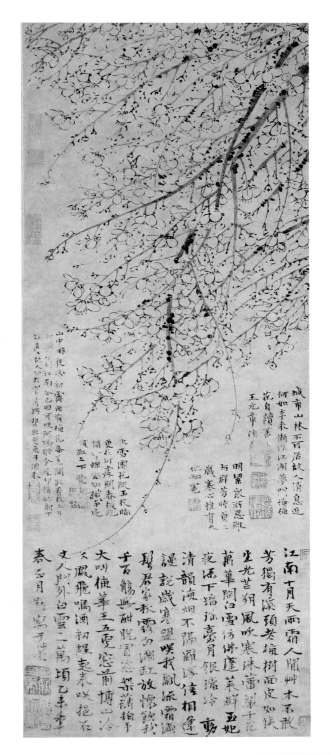

1360. Zou Fulei must have been one of the many educated men who became "hermits" during the disorders of the late Yuan, living by their learning and artistic talents. In his poem on the painting, he writes of sitting on an autumn night wishing for the return of spring, with the moon shining on the bare plum tree; his painting, he says, will preserve for him the shadows that the blossoming branches had cast on his paper window in spring. We can take this as a veiled expression of longing for the return of peace and stable rule. Zou's plum branch is one of the most perfectly controlled performances in brush and ink in all Chinese painting. Like Zhao Mengfu's *Elegant Rocks and Sparse Trees* (see fig. 173), it exemplifies how seemingly spontaneous, "calligraphic" brushstrokes can be made to function representationally within the structure of an image, rendering light and shadow, the roughness of bark, the springiness of twigs, and a sense of vigorous growth in the whole. An insistent black dotting, varied in size, stands for moss on the trunk, the calyxes of blossoms, and unopened buds at the tips of twigs, besides imparting an all-over vibrancy to the picture. Most striking, as one studies this extraordinary work, are the perfect upward curve of the long stroke that ends the branch, the pattern made by the interaction of straight and curving twigs, and the method of painting the blossoms: each petal, perfectly round and even in tone, appears to have been made by allowing a droplet of dilute ink to dry untouched on the paper surface.

The final collapse of the Mongol regime and the conquest of all of China by Zhu Yuanzhang, who would become the first Ming emperor, brought a hiatus to the great development of literati painting begun under the Yuan. The recovery would be slow. The works of the Four Great Masters of Yuan landscape painting would continue to stand as models for scholar-artists of later periods, embodying qualities and values that could be pursued but never ultimately recaptured.

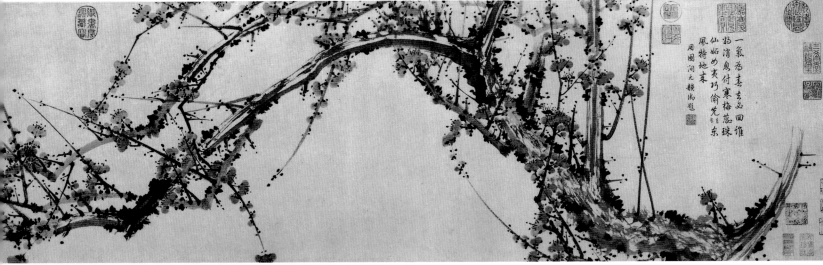

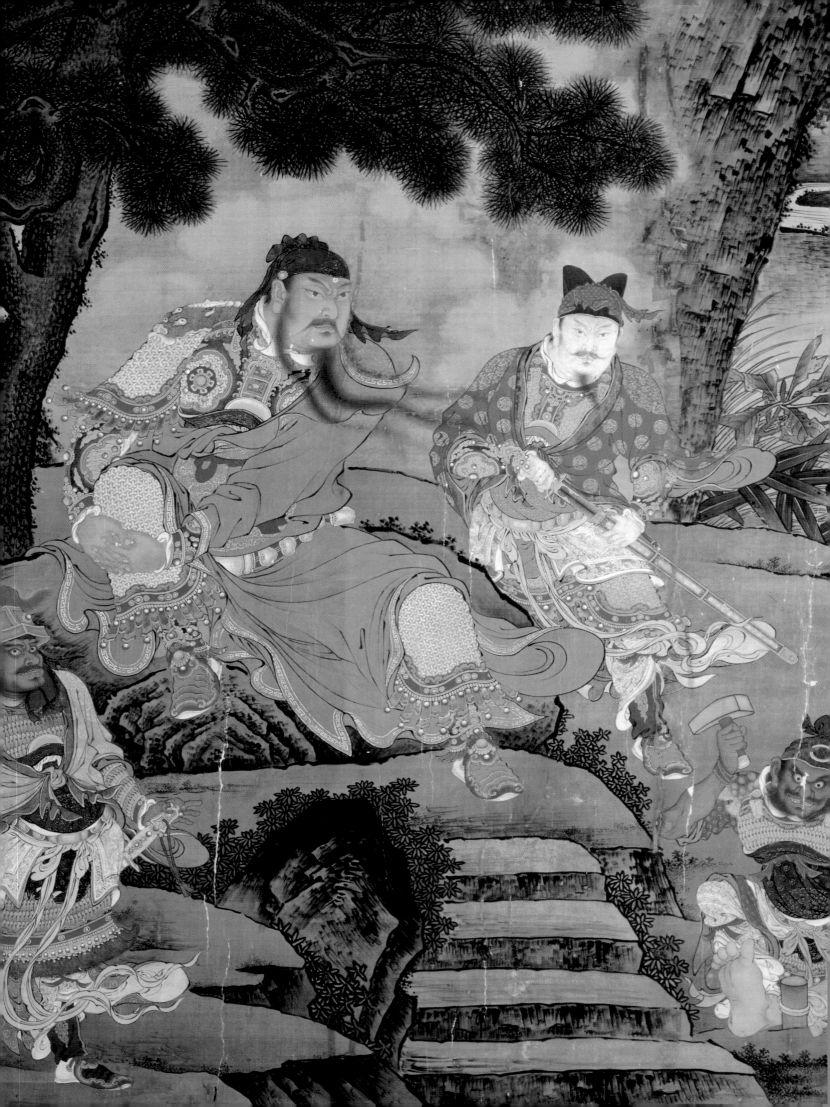

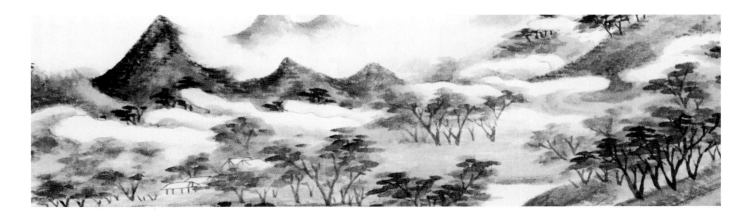

The Ming Dynasty (1368–1644)

After more than a decade of brutal war, in 1368 Zhu Yuanzhang emerged as the victorious general of the warring factions of south China, eliminated the separatist forces, chased Emperor Shundi of the Yuan dynasty out of Beijing, and established the Ming dynasty, which ruled until 1644. Not since about 1127 had a native, Han Chinese dynasty ruled over the entire empire. There did not appear during the early Ming, as during the Yuan dynasty and the later Qing dynasty, large numbers of *yimin* — "leftover subjects," loyalists to the fallen dynasty — including loyalist artists. Initially Confucianism again had great influence among Chinese scholars and painters.

What Ming artists faced from the very beginning, however, was the question of how to draw on and develop two existing artistic traditions: that of the professional artists (a category that includes artisans, craftsmen, and court painters) and that of the literati artists. The Ming court was a major supporter and sponsor of professional artists. The early Ming emperors desired to revive and restore the cultural and artistic supremacy of the past, especially the Song dynasty. During the Xuande reign in particular, with the ruler himself an active and talented poet, there was a golden age in landscape painting, bird-and-flower composition, poetry, and calligraphy patronized by the court. Literati painting, further developed by the Wu School masters centered in Suzhou, flourished. Drawing on both literati and professional painting traditions, other Ming painters cloaked their references to the past

Details, figure 183 (*opposite*) and figure 204 (*above*)

in very personalized, individualistic modes of painting. The imperial family often requested the services of the most accomplished artists. Thus the individual styles of the professional painters and the artistic demands of the imperial family became the leading factors determining the artistic trends of an era. However, since the Northern Song dynasty, and especially during the Yuan, scholar painting had developed, forming a distinct theory and particular technical methods, challenging the status and artistic style of the professional artist.

The consolidation, rise, and decline of the dynasty not only coincided with the rise and fall of court painting; it also affected the status of professional artists beyond the palace walls. In contrast, literati painting, which had gained prominence during the Yuan, declined during the early Ming for political and other reasons. By the middle of the Ming, however, with the emergence of such scholar-painters as Shen Zhou (1427–1509) and Wen Zhengming (1470–1559), scholar painting began to flourish as imperial power began to weaken. The decline of professional painting and the rise of scholar painting gave Ming painting its dazzling colors.

Continual internal strife weakened Ming rule and enfeebled its ideological control. Beginning in the middle of the Ming period, many scholars lost interest in classical Confucian teachings, which were seen as ossified and dogmatic. There was dissatisfaction with the "eight-legged essays," the required style of writing for the civil service examinations. People ridiculed the "fake moralists" demanding a transformation of society. Such sentiments were reflected in painting through the pursuit of the new and unorthodox and of sensuality in the form of aesthetic pleasures. This tendency received additional impetus from the growth of the urban economy, the resulting taste for luxuries, and the unprecedented collecting of art objects by merchants. By the late Ming, many schools of painting had appeared in various cities and regions, including the Wu, Zhe, Jiangxia, Huating, and Bochen Schools. The unique colors of Xu Wei, Wu Bin, Chen Hongshou, and others, the sudden increase in the number of female artists, and the semipublic dissemination of erotic paintings were ways in which Ming painting broke with the past.

Court Painting and Painters

The Ming court did not restore in toto the practices of Han Chinese officialdom nor did it re-create the Hanlin Academy that had been established in the Song dynasty. Instead, it continued the Yuan system, which enlisted artists to serve the court. During the Hongwu reign period (1368–1398), artists were commissioned by the court and given various official titles. The main task of such professional painters as Sun Wenzong (active ca. 1360–1370) and Chen Hui (early fifteenth century) was to paint the emperor's portrait. Shen Xiyuan (fourteenth century) and Chen Yuan were granted the titles of Clerk at the Secretariat of the Cabinet, and Official at Large at the Wenyuange (Pavilion of the Source of Literature), respectively, because Emperor Zhu Yuanzhang liked their portraits of him. Zhou Wei (active ca. 1368–1390), Sheng Zhu (active second half of fourteenth century), Zhuo Di (active early fifteenth century), and Shangguan Boda (active ca. early fifteenth century) were among those responsible for creating murals for the palace and imperial temples. Most of these artists came from Jiangsu and Zhejiang Provinces and had their own distinctive painting styles.

Yet the reign of Zhu Yuanzhang cast a shadow on Ming court painting. The emperor was by nature suspicious and jealous. Exhausted by the tasks of unifying the country and cleansing his court of opponents, he became increasingly paranoid. To strengthen his rule, he frequently sentenced artists and others to death. Among them were Zhao Yuan (active late fourteenth century), who, "by order of the emperor, was asked to paint portraits of the famous in history and did not live up to the expectation of the emperor. He was thus punished."[1] No document records how Zhao Yuan so dissatisfied him. Sheng Zhu, who "served as the household attendant of the emperor during the Hongwu reign period, was rewarded. Later, when he painted the mural of the Tianjie Temple, he offended the emperor by painting a jellyfish on the back of a dragon. He was therefore executed."[2] Even Zhou Wei, by nature a very cautious man, was framed and later put to death. Wang Meng, who was involved in a notorious frame-up of a high official, "languished in prison and finally died." That so many artists were put to death in such a short period of time is rare in Chinese history.

During the Xuande (1426–1435) and Hongzhi (1488–1505) reigns, however, Ming imperial power was consolidated, and the crown appreciated and supported the arts. Court painting flourished, particularly under Emperors Xuanzong (r. 1426–1435), Xianzong (r. 1465–1487), and Xiaozong (r. 1488–1505), all painters in their own right. During these years, painters were housed in the Forbidden City in the Hall of Benevolence and Wis-

dom (Renzhi dian), Hall of Military Valor (Wuying dian), where emperors received military leaders, and the Emperor's Canopy (Huagai) so that they could be summoned at any time. In accordance with a regulation set by Emperor Chengzu (r. 1403–1424), the emperor gave artists various military titles in the Embroidered Uniform Guards and promotions at will.[3] The Imperial Guards — soon notorious for monitoring the behavior of court officials — looked askance at court painters, even though the artists' titles were often honorary, granted only to facilitate the payment of stipends and keep them close to the emperor. After the death of Emperor Xiaozong, the head of the cabinet, Liu Jian, proposed to "streamline the surplus officials," charging that "hundreds of painters were given official titles indiscriminately. Shouldn't they be dismissed from office?"[4] With the decline of imperial power after the Jiajing reign period (1522–1566) and the lack of interest on the part of the emperors, court painting of the Ming dynasty lost its luster.

Ming court painting inherited the Song academic style, but with variations. Court painters of the Ming dynasty were all experienced career painters recruited from the common people. Most of them came from Jiangsu and Zhejiang Provinces, the political and cultural center of the Southern Song dynasty.

Literati painting, though it flourished in the Yuan, was not yet widely accepted in the Ming. Literati painting has inherent shortcomings. Painting was a hobby for the scholars, not a formal profession. They received no rigorous training in painting techniques. They stressed conveying the idea behind the image rather than accurately depicting reality. By emphasizing spontaneity, artistic intuition, and the direct expression of feelings in the technical application of the brush and ink, they precluded the development of a wide range of subjects. In portrait painting, for example, because of the standards for portraying figures, strict training is required to obtain the necessary skills of representation. Thus scholar-painters rarely ventured into portraiture. Instead, Ming literati works are overwhelmingly landscapes and bird-and-flower paintings. An example of the genre's comparative popularity can be found in the example of the professional painter Sheng Mao (active ca. 1320–1360) and the scholar-painter Wu Zhen (1280–1354), who both supported themselves by selling their works from their houses. Although they lived next door to each other, people constantly streamed to Sheng for his paintings, whereas not many went to Wu. There was as yet little market for literati paintings.

Court Portraiture

For convenience, the court artists are examined here according to the three main categories of figure, landscape, and bird-and-flower painting. Court figure painting during the Ming bears the heavy stamp of politics, for the main task of the painters was to draw portraits of the emperor and his concubines. An almost complete set of portraits of Ming emperors exists. Portraits of Zhu Yuanzhang by the court painters show a benevolent-looking old man with gray hair and white beard, whereas those done by local professional specialists often depict an ugly emperor. There are also two portraits of Emperor Chengzu: one was once kept in the palace (it is now in the National Palace Museum, Taibei), and the other was a copy of the first and a gift to a lamasery in Tibet (Potala Palace, Lhasa). The copy shows a larger-than-life figure with a long black beard and a dark-reddish face with a unique character and a dignified expression. For portraits of later emperors, only the face is drawn from life. The crown, costume, throne, carpet, and posture are all portrayed conventionally. The sequence of the emperors' facial expressions reveals the decline of the empire. The portrait of Emperor Xizong (r. 1621–1627), for example (Palace Museum, Beijing), shows only a blank expression, his face lacking the early vividness of his ancestors. Portrait painters also depicted entertainment at the imperial court, as in *Xuanzong Playing in the Court* and *Xuanzong Going Hunting* (both in the Palace Museum, Beijing). The painters Shang Xi (active ca. 1430–1440) and Zhou Quan painted works of this kind, too.

Portraits also could serve educational purposes, portraying wise and virtuous rulers and ministers of the past. *Emperor Taizu Calling on Zhao Pu on a Snowy Night* (fig. 181) by Liu Jun (active ca. 1500) depicts Zhao Kuangyin, founding emperor of the Northern Song dynasty, calling on Zhao Pu one snowy night to discuss affairs of state. Zhao Pu was subsequently promoted to prime minister and became known for bringing peace and prosperity to the country by applying the teachings of Confucius to statecraft. As usual, the emperor is portrayed as a man of powerful build, seated in a frontal position and with a dignified air. Zhao Pu, wearing the plain clothing of an ordinary person, sits in profile presenting his views to the emperor. The carpet of white snow, the flaming red of the charcoal fire, and the guard outside the gate are all images of security, order, and comfort that enhance the harmonious atmosphere between the two on this long, cold night.

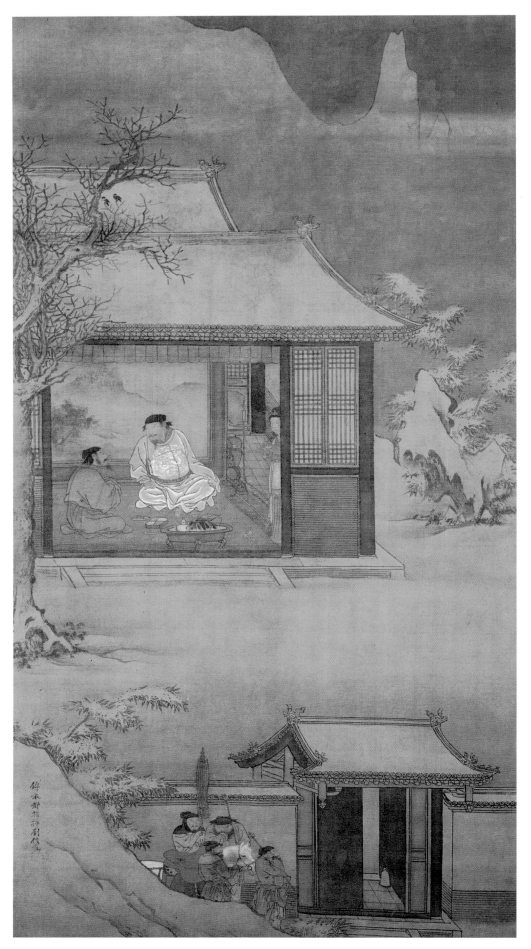

181. Liu Jun, *Emperor Taizu Calling on Zhao Pu on a Snowy Night,* hanging scroll, ink and color on silk, Ming dynasty. 143.2 × 75.1 cm. Palace Museum, Beijing.

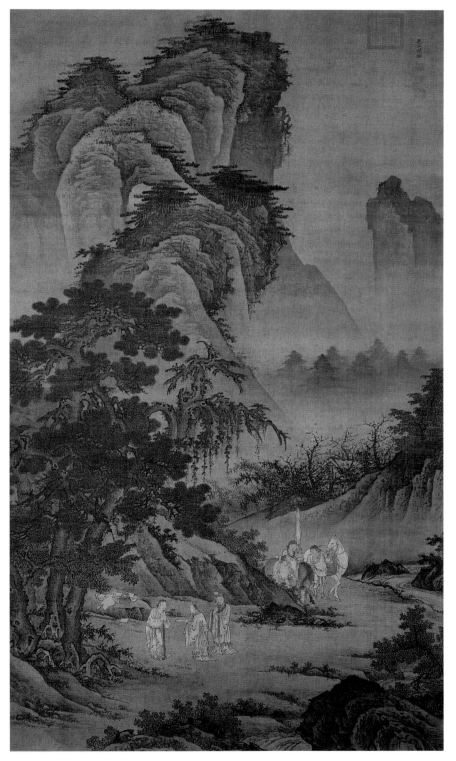

182. Ni Duan, *Inviting Pang Degong,* hanging scroll, ink and color on silk, Ming dynasty. 163.8 × 92.7 cm. Palace Museum, Beijing.

Another portrayal of a worthy official, *Inviting Pang Degong* (fig. 182) by Ni Duan (active early fifteenth century), is based on the story of Liu Biao, governor of Jingzhou Prefecture during the Three Kingdoms period. In this picture, Liu Biao, a distant relative of the imperial family of the Eastern Han, is seeking the help of the recluse Pang Degong. Thanks to his willingness to honor the wise whatever their social status, Liu was able to bring peace and stability to the area under his con-trol, even during the wartime years. *Flight of the Tigers at Hongnong* (Palace Museum, Beijing) by Zhu Duan (active ca. 1506–1521) similarly depicts the story of the gover-nor of Hongnong Prefecture, Liu Kun of the Eastern Han, who managed public affairs so successfully that all the tigers, long a symbol of disaster, fled across the river when they heard his name. Although the political theme of these works is clear, the figures are small, leaving more space for the mountains, rivers, and houses.

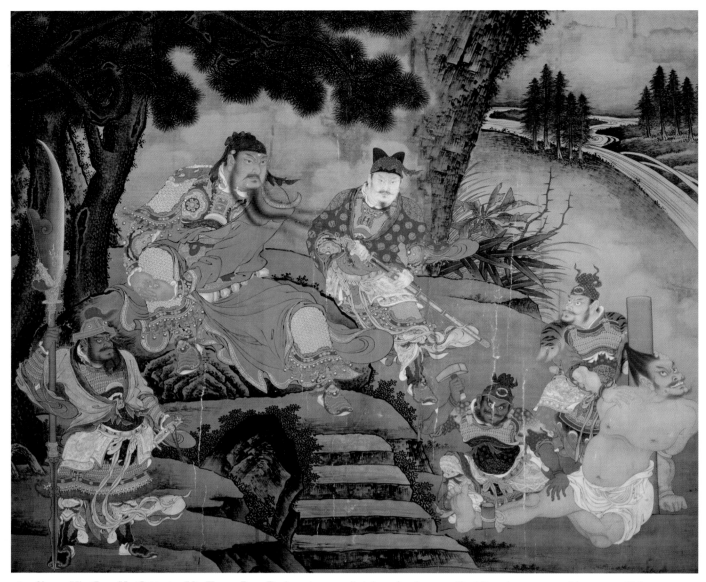

183. Shang Xi, *Guan Yu Capturing His Enemy Pang De,* hanging scroll, ink and color on silk, Ming dynasty. 200 × 237 cm. Palace Museum, Beijing.

Shang Xi's *Guan Yu Capturing His Enemy Pang De* (fig. 183) depicts the capture of Pang De, then a general of the state of Wei, by Guan Yu, a noted general of the state of Shu. The hanging scroll is bigger than usual, with figures looming large in the foreground and pines and rocks extending to the horizon. Shang Xi, a skilled mural painter probably recruited from the common people, was a native of Puyang in present-day Henan Province. The portrayal of the characters and the brushwork reveal a close link between this work and the murals in the Chunyang Hall of the Yongle Palace, Ruicheng County, Shanxi Province, built during the Yuan dynasty (see fig. 142). There were quite a few local specialized mural painters like Shang Xi in the palace; the murals in the Fahai Temple in the western suburbs of Beijing were the works of these anonymous artists.

Another of Shang Xi's works, *Emperor Xuanzong and His Retinue* (Palace Museum, Beijing), is also on a large scale. Dominated by many figures, in breadth and the techniques used to paint the trees and rocks in the background it is reminiscent of the styles of Li Tang and Ma Yuan, both court painters during the Southern Song. Shang Xi was constantly trying to change his style to cater more to the imperial taste. In appreciation of his artistry the emperor awarded him the title Commander of the Imperial Guards.

Although the works of Xie Huan (active 1426–1452), another professional figure painter, are less well known, his *Literary Gathering in the Apricot Garden* (Museum of Zhenjiang City, Jiangsu Province) is notable. The painting depicts three important court officials (Yang Rong, Yang Shiqi, and Yang Pu, known as the Three Yangs) in

an apricot garden, where they are writing poetry and drinking wine. This is a group portrait of a commemorative nature. The artist depicts the garden's beauty in a style influenced by the Southern Song tradition. The painter has even included himself in the picture, as a figure placed at a distance from the center. Court artists rarely included themselves in their pictures.

Court Landscape Painting

The painting styles of prominent academic landscape painters of the Ming dynasty, which include Guo Chun (1370–1444), Shi Rui (active early fifteenth century), Li Zai (active mid-fifteenth century), Wang E (active ca. 1488–1501), and Zhu Duan, differed markedly depending on the degree to which they pursued the styles of the Northern and Southern Song and Yuan dynasties. Guo Chun's *Blue-and-Green Landscape* (Beijing Municipal Cultural Relics Store) evokes the Northern Song landscape painting style which had permeated Yuan-dynasty works, whereas the brushwork used in painting the trees and shrubs is reminiscent of that of Guo Xi, also of the Northern Song.

Shi Rui, recruited during the reign of Xuanzong, was a low-ranking official at the Hall of Benevolence and Wisdom. His landscape painting was influenced by the blue-and-green landscape style of the Sui and Tang dynasties. Of Shi Rui's works, *Admiring Flowers, Greeting the New Year,* and *Fisherman's Delight in a Riverside Village* are worthy of mention. *Admiring Flowers* (Shōtō Museum, Tokyo) was painted for a man named Gu who had ranked third (*tanhua*) in the civil service examinations presided over by the emperor. In the Tang dynasty, a flower-admiring party (known as a *tanhua* party) would usually be held in an apricot garden to celebrate a candidate's success in the examinations.

The clear and neat structure of Shi Rui's works resembles the typical style of the early Northern Song. In *Greeting the New Year* (fig. 184) people roam in magnificent halls and pavilions that look like royal houses and that stand amid overlapping rolling hills that stretch all the way to the riverside, where there are many boats. On the other side of the river, hills dotted with villages and towns seem to disappear in the distance. The artist's meticulous brushwork allows him to depict many small scenes, yet the painting still presents a sweeping view of a landscape. During the later Ming and early Qing period, *Greeting the New Year* was mistaken for the work of Li Zhaodao of the much earlier Tang dynasty, whereas Shi Rui's *Fisherman's Delight in a Riverside Village* (private collection) was deliberately tampered with so that it seemed to be the work of Yan Wengui of the Northern Song. Similarly, some works of Zhu Duan, who followed the style of Guo Xi, were mistaken for Guo Xi's. Literati painting was on the rise during the latter period of the Ming dynasty, pushing court painters out of the limelight.

The works of Li Zai are somewhat similar to those of Sheng Mao of the Yuan. Li Zai's painting *Qing'ao Riding a Carp* (Shanghai Museum) is a depiction of a fairy tale. *Gazing at a Distant View from a Riverside Pavilion* (fig. 185) is a representative work by Wang E, whom Emperor Xiaozong acclaimed as the "present-day Ma Yuan." The long, ax-cut brushstrokes of his mountains and rocks and the angular twists and turns of his pine branches all retain features of Ma Yuan's brushwork and modeling technique. Wang E's composition is more balanced than Ma Yuan's, however, and his brushwork is finer.

Court Bird-and-Flower Paintings

Although landscape was a predominant theme, a period of acclaimed decorative and dramatic bird-and-flower paintings was initiated by Bian Jingzhao, Lin Liang, and Lü Ji. Bian Jingzhao, also known as Wenjin (active ca. 1426–1435), a court artist during the reign of Chengzu who also served in the Hall of Military Valor, was a noted artist in this area. He inherited the themes and techniques of the Huang Quan tradition of the Five Dynasties, and his works are characterized by realism, precise outlines, and bright colors. *Three Friends and One Hundred Birds* (National Palace Museum, Taibei), painted in 1413, shows the pine, bamboo, and blossoming plum, which were known as the Three Friends of the Cold Season. The one hundred birds, singing together, auspiciously symbolize peace in the world. According to the eighteenth chapter of the *Xuanhe huapu* (The Xuanhe painting catalogue), the Song court painter Yi Yuanji had done four paintings named *One Hundred Birds*. "Poets have six skills, and they have a rich knowledge of birds, animals, plants, and woods. Nature records the moment of their blossoming, withering, singing, and silence. What is wonderful about painting is that an artist can express the beauty of nature with his brush. Together with poets, they create beautiful scenes."[5] To this painting Bian attached four of his seals. The four Chinese characters on one seal read, "Spiritual cultivation through nature," and another reads, "A rich knowledge of plants, woods, birds, and animals."

Another of Bian Jingzhao's works, *Bamboo and Cranes* (fig. 186), depicts two red-crowned cranes walking leisurely in a bamboo grove. Cranes and bamboo generally symbolize noble and pure qualities and represent hermits

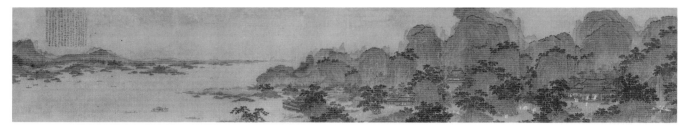

184. Shi Rui, *Greeting the New Year,* handscroll, ink, color, and gold on silk, Ming dynasty. (© Cleveland Museum of Art, 1997, John L. Severance Fund, 1973.72.)

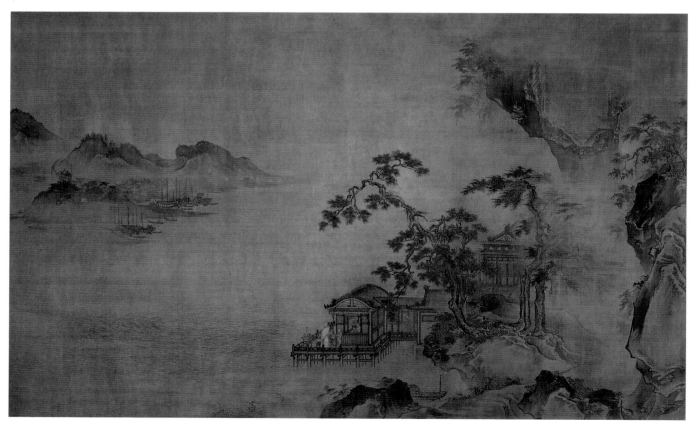

185. Wang E, *Gazing at a Distant View from a Riverside Pavilion,* hanging scroll, ink and color on silk, Ming dynasty. 143.2 × 229 cm. Palace Museum, Beijing.

secluded in mountains. Imperial power was not opposed to such "secluded hermits"; on the contrary, it sometimes even commended them and considered them attributes of a "tranquil world." Using translucent white powder and thick black ink, Bian Jingzhao painted the cranes' feathers to show a sharp contrast between black and white. The bamboo grove, stream, and riverbank were delineated with only a few clear, crisp strokes. Though the artist intended to convey a sense of purity, there are traces of overembellishment that make the cranes look like birds raised in the imperial garden, a hazard that may have been difficult for court painters to avoid.

Also noted for his bird-and-flower paintings was Sun Long (fifteenth century), grandson of Sun Xingzu (the marquis of Zhongmin at the time of the founding of the Ming dynasty) and a low-ranking official in the Hanlin Academy during the Xuande reign period. Because he was born into an aristocratic family, he often accompanied Emperor Xuanzong while the latter worked on his paintings. Sun Long was especially good at painting grass and insects. His works lacked other court painters' expression of their self-indulgence and self-admiration. His works were not considered suitable as wall decorations because people of the court did not appreciate his freehand brushwork, characterized by vivid expression. Rather than contrive to imitate the tradition of professional painters, he drew on works showing scholars' self-admiration from the Southern Song to the Yuan dynasties. Unlike most scholar-painters, who used black ink to convey a sense of loneliness, Sun Long applied various colors to the paper to create cheerful paintings.

In his *Album of Flowers, Birds, Grass, and Insects* (Shanghai Museum), Sun Long used only a few brushstrokes to depict vividly different kinds of grass, insects, birds, plants, and flowers. The seemingly scattered brushwork and the bright colors suggest the lively and bustling atmosphere in the countryside on a sunny autumn day. In his handscroll *Flowers, Birds, Grass, and Insects* (Jilin Provincial Museum), Sun depicts a mouse trying to eat a watermelon while a frog on top of duckweed attempts to catch a dragonfly gliding over its head. Though Sun Long's technique and the painting's composition show a clear debt to Song artists, who paid meticulous attention to their subjects, his style of using colors instead of black ink was dubbed the "bone-immersing" method (though it had nothing to do with the bone-immersing method of Xu Chongsi of the Song dynasty). *Swimming Goose by Flowers and Rocks* (fig. 187) conveys a sense of his excellent painting skills.

Emperor Xuanzong was a painter in his own right and often gave his works to his ministers to show his favor. His paintings show different styles, and some were probably painted by court painters in his name. However, his *Balsam Pear and Mouse* (fig. 188), with his inscription "painted by the emperor," was in his own hand, though the few strokes of the grass and the mouse resemble Sun Long's in technique. What is different, however, is that the emperor used ink more than colors, and his brushwork, in contrast to Sun Long's bold and confident style, appears rather weak and hesitant. *Zhuge Liang Living as a Hermit in Seclusion*, painted in 1428 (Palace Museum, Beijing), was a work "done by the Emperor for Lord Chen Xuan of Pingjiang." The characters "for Lord Chen Xuan of Pingjiang" were added later when this painting, originally created for the emperor himself, was given to Chen Xuan. Emperor Xuanzong gave it to recognize his numerous battle achievements in subduing the minorities in the south and to honor his accomplishments as the leading official in charge of shipping and several water conservancy projects.

Two outstanding Ming palace painters of birds and flowers who are always mentioned together as "incomparable" are Lin Liang and Lü Ji. Lin Liang (active ca. 1488–1505) was from Nanhai, Guangdong Province. Because his family was poor, he earned a living as a messenger when still quite young. Gradually he gained some fame for his paintings. During the Tianshun reign period (1457–1464) he was recruited to the imperial palace, first as an official in the Construction Ministry, and he lived in the Hall of Benevolence and Wisdom. He was promoted and eventually became a commander in the Imperial Guards.

Lin Liang's bird-and-flower paintings are utterly unlike other court paintings. Using only water and ink, in general, he applied his brush as in freehand-style calligraphy, giving an impression of lack of restraint. His favorite subject, a powerful eagle or falcon, appears in *Eagle and Wild Goose* (fig. 189). *Birds in Bushes* (fig. 190) is a rare example of one of his handscrolls. Painted in monochrome ink on paper, with light washes of color added, the scroll depicts a gathering of birds by a pond surrounded by shrubs and grasses. Some are flying, some are hopping around, chasing after each other; the waving branches and leaves seem to be in rapport with the birds, suggesting a nourishing and friendly natural world. Equally successful is the artist's combination of simple brushstrokes and a kind of willfulness that gives a carefree feeling. This style of art, formed after Liang Kai and Muqi, was the ideal pursued by scholar-painters. To the Chinese, one

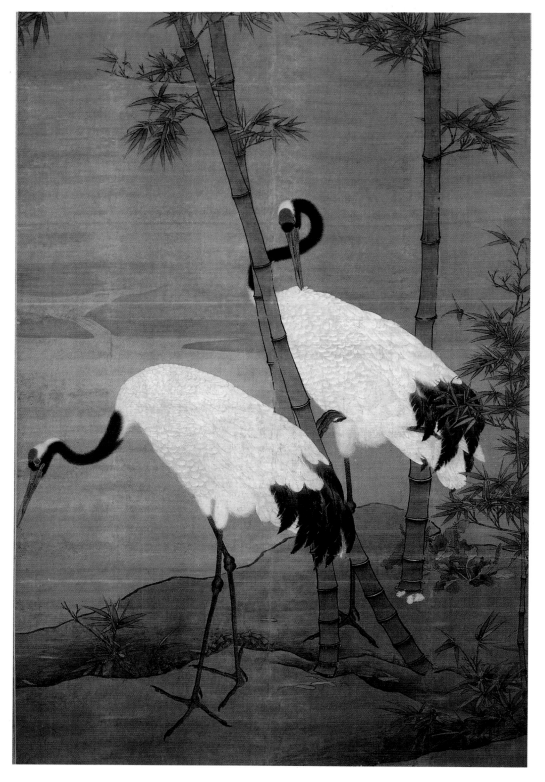

186. Bian Jingzhao, *Bamboo and Cranes,* hanging scroll, ink and color on silk, 15th century. 180.4 × 118 cm. Palace Museum, Beijing.

188. Zhu Zhanji [Emperor Xuanzong], *Balsam Pear and Mouse*, handscroll, ink and light color on paper, 1427. 28.2 × 38.5 cm. Palace Museum, Beijing.

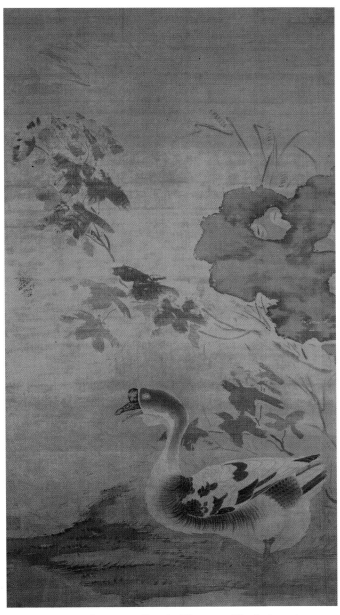

187. Sun Long, *Swimming Goose by Flowers and Rocks,* hanging scroll, ink and color on silk, Ming dynasty. 159.3 × 84.2 cm. Palace Museum, Beijing.

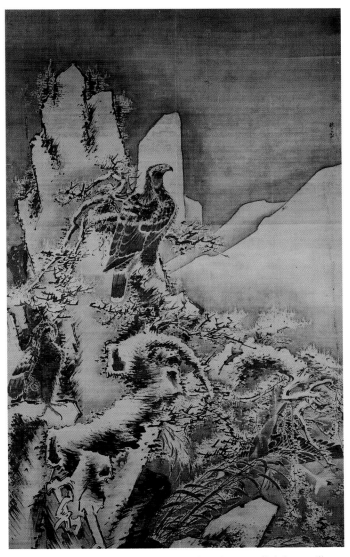

189. Lin Liang, *Eagle and Wild Goose,* hanging scroll, ink on silk, Ming dynasty. 170 × 103.5 cm. Palace Museum, Beijing.

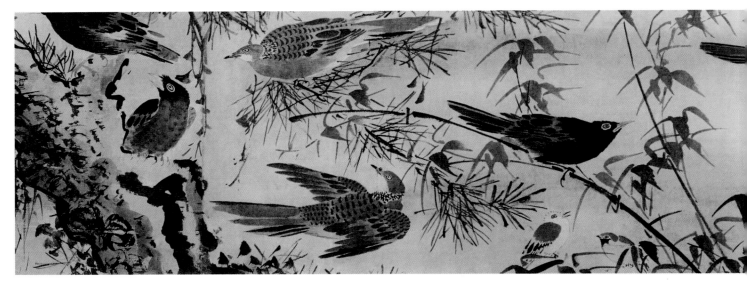

190. Lin Liang, *Birds in Bushes,* section of a handscroll, ink and light color on paper, Ming dynasty. 34 × 1211.2 cm. Palace Museum, Beijing.

way of returning to nature is via the pursuit of artistic effect achieved by chance in the course of unrestrained creation and via the aesthetic fulfillment gained as a result. This casual effect promoted the development of the uniquely Chinese monochrome ink freehand brushwork, to which Lin Liang contributed. Critics often fail to give him full credit, partly because his brushwork was overly expressive and lacked subtlety and partly because of the prejudice against professional court painters.

Lü Ji (active ca. 1500), a native of Ningbo, Zhejiang Province, served in the Hall of Benevolence and Wisdom and was promoted to commander in the Imperial Guards during the Hongzhi reign period. Faithfully abiding by the rules and rituals of the court, he established good relationships with officials. He was so highly thought of by Emperor Xiaozong that when Lü was terminally ill, a continual flow of nobles and ministers called at his deathbed.

Lü Ji's bird-and-flower paintings fall into two categories. One includes works in a meticulous style, using firm outlines and thick coloring, which he learned from Bian Jingzhao. Examples are *Cassia, Chrysanthemums, and Mountain Birds* (fig. 191) and *Camellia and Silver Pheasant* (Palace Museum, Beijing). Lü Ji's works of this type were deeply influenced by Ma Yuan and Xia Gui in overall composition and treatment of the rocks and trees in the background. Gradually, he evolved a style of his own which exerted a widespread influence on bird-and-flower painters inside and outside the palace and which has often been described as typical of Ming-dynasty academic bird-and-flower paintings.

Lü Ji's other painting style was borrowed directly from Lin Liang's freehand sketch–style brushwork. It is said that in his early years he counterfeited Lin Liang's works and sold them. Typical of this style is *Egret, Eagle, and Falling Lotus Flowers* (fig. 192), which depicts an amusing scene of an eagle disturbing the peace of a lotus pond on an autumn day. The flapping of the eagle's wings, the panicked flight of the other birds, together with the swaying of reeds swept by the wind and the toss and turn of the faded lotus blossoms, are vividly portrayed. This method of depicting an animated scene with animals and plants originated during the Northern Song; Cui Bai's *Magpies and Hare* (see fig. 108) is a good example.

The Zhe and Jiangxia Schools of Painting

As Ming court painting flourished, two schools of painting rose to prominence outside of the palace: the Zhe School, led by Dai Jin, and the Jiangxia School, led by Wu Wei. Both Dai Jin and Wu Wei were professional painters, and their styles derived from the same sources as did the styles of the court painters. They are often included loosely in the Zhe School and the Academy. With the fall of the Southern Song, a large number of court painters scattered about in Jiangsu, Zhejiang, and Fujian Provinces. This was one of the reasons for the dissemination of the academic painting style and gradually gave rise to professional painters and local specialists. The multileaf album *Mount Hua* (fig. 193), painted by Wang Lü (fourteenth century) during the early Ming, is a continuation of this tradition, as are Dai Jin's works.

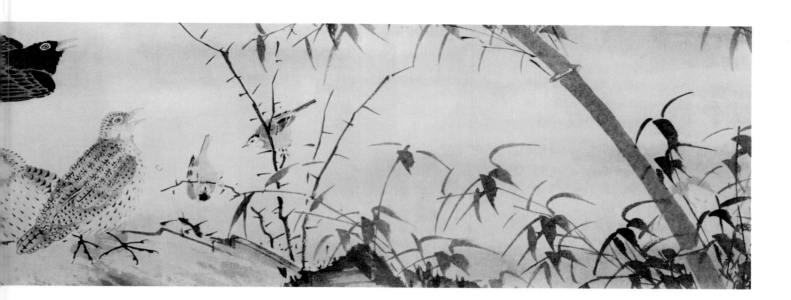

Dai Jin (1388–1462) was a native of Qiantang (present-day Hangzhou), and as a young man, he was a goldsmith and silversmith. During the Xuande reign period, he was recommended to serve in the palace, but reportedly other palace painters, out of jealousy, made false charges against him before the emperor, whereupon he was driven out of the palace. After returning home, he made a living by selling his paintings and became famous near and far. Some described his paintings as the best of that dynasty.[6] He was widely acclaimed by society, and his rejection by the court aroused much sympathy and resentment among people. Stories about his experiences in the capital became more and more complex and absurd, and the affairs involved many court painters, including Xie Huan, Ni Duan, Shi Rui, Li Zai, and Dai Jin's student Xia Zhi (fifteenth century). Though the exact time of Dai Jin's stay in Beijing cannot be determined, he was still there in 1441, when a hometown friend, a procurator by the name of Chen, was dismissed from office and was about to leave for home. Other officials from the same town gathered to give Chen a farewell party, and Dai Jin painted *Returning Home by Boat* (Suzhou Museum) as a parting gift for Chen.

During these years, specialization was becoming more and more widespread, and an increasing number of

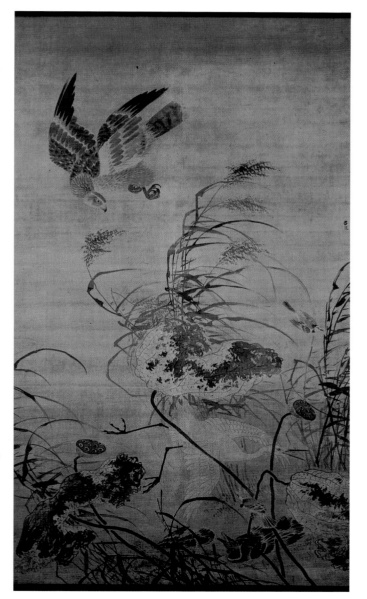

191. Lü Ji, *Cassia, Chrysanthemums, and Mountain Birds,* hanging scroll, ink and color on silk, Ming dynasty. 190 × 106 cm. Palace Museum, Beijing. *overleaf*

192. Lü Ji, *Egret, Eagle, and Falling Lotus Flowers,* hanging scroll, ink and light color on silk, Ming dynasty. 190 × 105.2 cm. Palace Museum, Beijing.

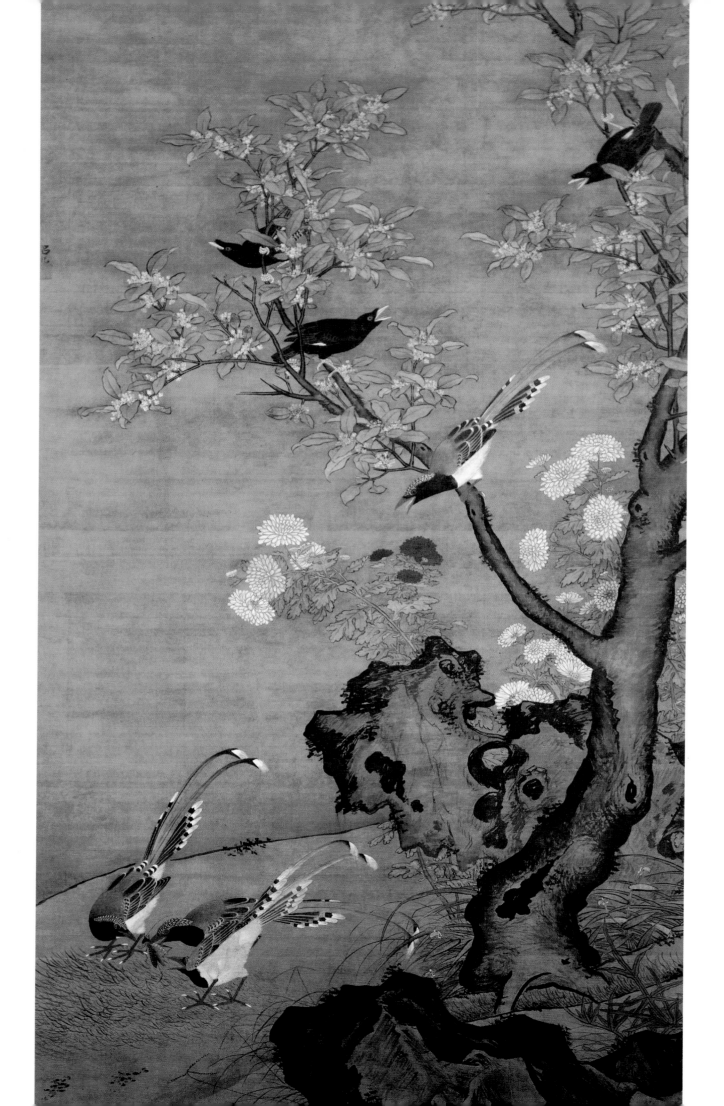

painters modeled their work on the various styles of earlier painters. Dai Jin's talent lay not only in his superb skills and techniques but also in his versatility in handling figures, landscapes, and bird-and-flower themes, as well as his extensive use of the historical legacy of Chinese painting. *Spring Mountains Cloaked in Green* (Shanghai Museum), on the one hand, reflects Ma Yuan's style, in the rendering of the pines in particular. *Travelers Through Mountain Passes* (fig. 194), on the other hand, was influenced by the style of Li Tang and Liu Songnian, only the brushstrokes are more relaxed and seem to have been executed in an offhand manner. The pines in *Seeking the Dao at Dongtian* (Palace Museum, Beijing) are reminiscent of murals by local artisans. In his *Landscape After Yan Wengui* (Shanghai Museum), the hazy atmosphere created by his inkwash and dotting was apparently influenced by the Mi family landscape paintings. Even the most ruthless critic of the Zhe School, Dong Qichang, was astonished by the conception and skill revealed in this work: "In the history of painting in this dynasty, Dai Jin stands out prominently. What is most unique in this imitation of Yan Wengui is that it is imbued with a light, clear touch and devoid of the original colors."

Dai Jin's figure paintings are mostly portrayals of Daoist and Buddhist priests and the secluded lives of earlier sages and men of virtue. *The Night Excursion of Zhong Kui* (fig. 195) deals with a traditional subject, the ghost catcher, who, according to Chinese mythology, comes out at night to capture evil spirits. Gong Kai of the Yuan dynasty painted the same subject (see fig. 130), but Dai Jin's treatment is completely different. Here the image of Zhong Kui fills almost the entire frame width, and particular prominence is given to his eyes. He sits in a sedan chair carried by four small devils. Two other demons are carrying his luggage and umbrella. In the hazy moonlight, they seem to be in a hurry. Perhaps Zhong Kui is out on inspection, searching for more devils hidden among men. One can tell from the modeling of the figures and the brushwork that the artist had assimilated certain traditions of local professional and mural painting, both of which had gradually diminished during the post-Song and Yuan periods.

Six Patriarchs of Chan (Liaoning Provincial Museum) represents another of Dai Jin's figure painting styles. Characterized by close attention to composition and detail, it is regarded as one of his earlier works. In *Elegant Gathering at Nanping* (Palace Museum, Beijing), however, which was painted in 1460, during the last years of his life, his brushwork and composition appear to be much lighter and freer. The painting depicts a meeting between the Yuan-dynasty man of letters Yang Weizhen and his friend Mo Jingxing at Xinghua Zhuang (Apricot blossom village). Dai Jin painted this picture at the request of Mo Ju, one of Mo Jingxing's descendants. Xinghua Zhuang was the private garden of the Mo family, situated on the bank of the famous West Lake in Hangzhou. Green willows line the shore of the lake, and painted boats frolic on the water. In the distance towers Nanping Mountain. Commemorative works of this kind recalling an event of bygone days were a long-standing artistic tradition.

There are few remaining bird-and-flower paintings by Dai Jin. *Three Egrets* (Palace Museum, Beijing) is suggestive of his early style, a continuation of the style of Ma Yuan. *Hollyhock, Rock, and Butterflies* (fig. 196), in contrast, represents Dai Jin's later style. The surface texture of the rocks seems to have been painted with rough, ax-cut texture strokes, while the hollyhock and butterflies are finely and elegantly executed, in a style reminiscent of the Northern Song and with strokes entirely different from his earlier, swift brushwork. The many painters who imitated Dai Jin's original style were called the Zhe School because he was a native of Zhejiang Province.

Whereas Dai Jin was rejected by the palace, Wu Wei (1459–1509) left the palace of his own accord. Also called Small Immortal, he was born of a poor family; his father died when he was very young, and he worked as a house servant to make ends meet. At seventeen he went to Nanjing, and there he became famous, thanks to the patronage and financial support of Zhu Yi, the duke of Chengguo. He was twice called to serve in the palace during the Hongzhi reign period, and in the Hall of Benevolence and Wisdom he became a favorite of Emperor Xianzong. Wu Wei was granted a seal carved with the words "Number One Painter" and was often summoned to the palace to paint. Though he was by nature honest and straightforward, he loved to drink and lost his temper easily. His air of disdain for high officials and nobles enraged them, and twice he was forced to leave the palace. In 1506, after Emperor Wuzong ascended the throne, Wu Wei was once again summoned, but he died from complications resulting from his excessive drinking before he could set out for the capital.

Wu Wei learned from Dai Jin's paintings and from earlier painters. However, Wu Wei's use of brush and ink was even more unrestrained than his predecessors'. His *Fishing Boats at Xishan* (Palace Museum, Beijing) depicts aged trees and scattered rocks in the foreground and tall, precipitous mountains in the distance. Fishermen on the river are either casting or hauling in their nets, and boats are sailing out or coming in, all painted in a free and

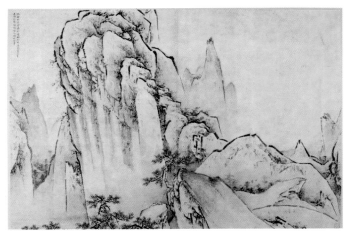

193. Wang Lü, *Mount Hua,* album leaf, ink and light color on paper, Ming dynasty. 34.5 × 50.5 cm. Shanghai Museum and Palace Museum, Beijing.

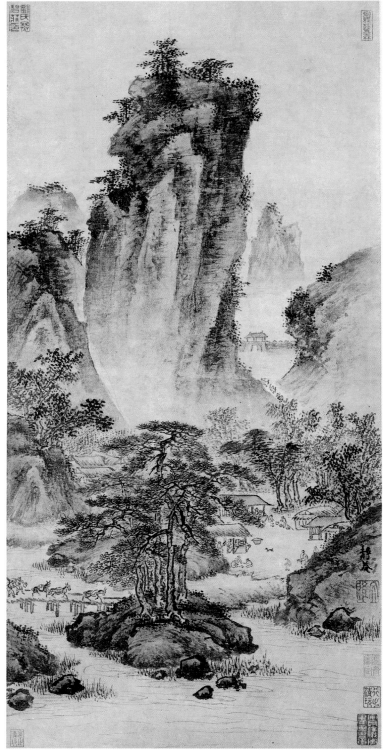

194. Dai Jin, *Travelers Through Mountain Passes,* hanging scroll, ink and color on paper, Ming dynasty. 61.8 × 29.7 cm. Palace Museum, Beijing.

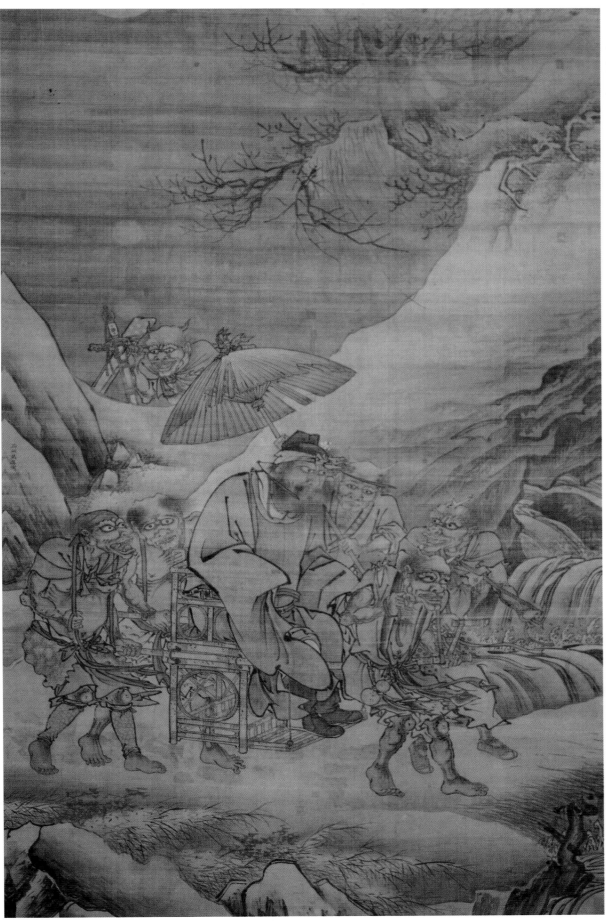

195. Dai Jin, *The Night Excursion of Zhong Kui,* hanging scroll, ink and color on silk, Ming dynasty. 189.7 × 120.2 cm. Palace Museum, Beijing.

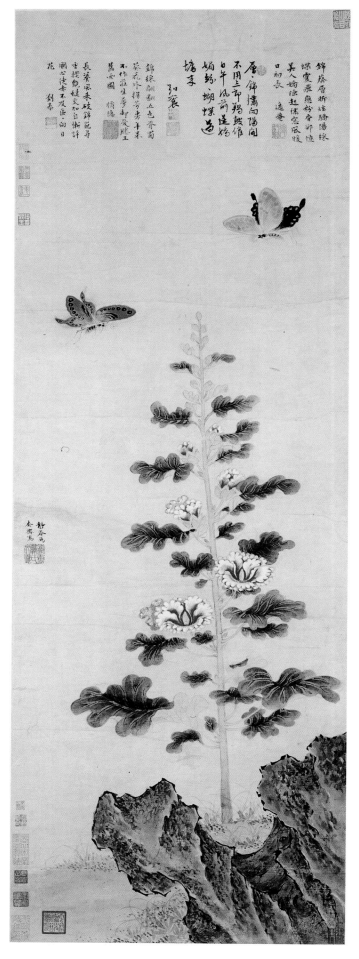

leisurely manner. Compared with the brushwork of scholar-painters, however, Wu Wei's is undisciplined and lacks subtlety; his landscapes look plain and naked and lack depth. Rather than depicting a spiritual world with political implications in sophisticated and elegant images, his works are closer to real life. *Ten Thousand Li of the Yangzi River* (fig. 197), painted in Wuchang in 1505, a few years before Wu Wei died, is a handscroll nearly ten meters in length. With a lively style, the artist presents seemingly endless mountain ranges and peaks, rivers and shoals veiled in mist, bustling towns and cities one after another, and boats sailing with the wind. The painting has enormous force, manifesting both a boundless energy and great technical maturity.

Wu Wei's figure paintings appear in two styles — the meticulous, and the vigorous and unrestrained. Examples of the first type include *Spring at Wu Lin* (Palace Museum, Beijing), *Asking for the Ferry* (fig. 198), and *The Iron Flute* (Shanghai Museum); and *Reading in the Shade of the Willow Tree* (Palace Museum, Beijing) exemplifies the second type. *The Iron Flute* is based on a story about Yang Weizhen, a scholar of the Yuan dynasty, who once had an old iron sword made into a flute with a remarkably beautiful sound. From then on, he called himself the Iron Flute Daoist. Neglected by officialdom, he spent his days playing his flute, accompanied by singing and dancing girls and boys. In this painting, Yang sits leaning against a rock amid intertwining pines. A servant girl stands by his side holding the flute. Across from him sit two servant girls, one putting a flower in her hair and the other hiding her face behind a fan, both carefully delineated. The girl with the fan is particularly touching; one can vaguely discern her beauty through the thin gauze of the fan — a remarkable display of Wu Wei's skill. The work reveals a more controlled side of the artist's style and character as well as that part of his life in which he had to socialize with aristocrats and nobles.

Several other artists whose unrestrained styles were similar to Wu Wei's are Zhang Lu (ca. 1464–ca. 1538), Jiang Song (fl. ca. 1500), and Wang Zhao (fl. ca. 1500). In his *Hurrying Home Before the Rain* (fig. 199), Zhang Lu uses inksplash to depict the dark mountain peaks. With unruly strokes, he portrays the forest swept by the wind, presenting the viewer with a fascinating scene of that moment just before a storm.

196. Dai Jin, *Hollyhock, Rock, and Butterflies,* hanging scroll, ink and color on paper, Ming dynasty. 115 × 39.6 cm. Palace Museum, Beijing.

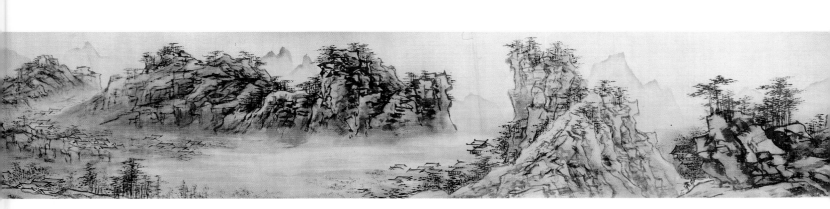

The Zhe School, headed by Dai Jin, and the Jiangxia School, a regional group of artists whose style was based on that of Wu Wei, along with the court artists, dominated the scene during the early and middle periods of the Ming dynasty. However, their favored status was challenged by literati painters with the rise of the Wu School of painting. The professional painters' styles came under constant criticism, the sharpest coming from Dong Qichang, who essentially argued that there were two shortcomings. First, the brushwork was overly expressive and lacked subtlety. The works of later artists, in particular, were considered slipshod and unoriginal. Second, these professional artists came from humble social backgrounds, in contrast to the well-bred literati. Under the onslaught of such criticism, the professional painters gradually lost their market and were left without the means of earning a livelihood. In order to survive, some, like Lan Ying, changed their painting style, moving closer to the style of the scholar-painters. Others turned to the masses, searching for fresh outlets, which led to the rise of the popular New Year's paintings and woodblock prints toward the end of the Ming dynasty.

197. Wu Wei, *Ten Thousand Li of the Yangzi River,* section of a handscroll, ink and color on silk, 1505. 27.8 × 976.2 cm. Palace Museum, Beijing.

198. Wu Wei, *Asking for the Ferry,* handscroll, ink on gold-leaf paper, Ming dynasty. 46.5 × 118.5 cm. Palace Museum, Beijing.

The Four Great Artists of Wu and the Wu School

The Wu School of painting is so called after Wu, the ancient name of Suzhou, a city in the Yangzi delta region where literati artists flourished during the Ming; it is famous for its beautiful landscape and highly developed culture. Toward the end of the Yuan dynasty, Suzhou was frequented by many artists, including Ni Zan and Wang Meng. Zhu Derun, a native of the city, lived in seclusion there for thirty years. Together these three artists sowed the seeds of literati painting. Had art been left to develop freely, there would have been an upsurge of scholar-amateur painting in and around Suzhou after the Yuan. However, during the years when Emperor Taizu was fighting for the throne and, later, when his son Emperor Chengzu was struggling to consolidate power, Suzhou and the surrounding area were under the control of their opponents. Punitive reprisals by the throne after the war resulted in long-term economic depression, and the local literati suffered political persecution. In Suzhou, Gao Qi (1336–1374) was savagely executed in public, and Xu Ben (1335–1380) and Chen Ruyan were both sentenced to death. Elsewhere, Zhao Yuan (active late fourteenth century) was ordered to take his own life, Zhang Yu (1323–1385) was forced to drown himself, and Wang Meng was tortured to death in prison. The effect of this series of political persecutions went far beyond the psychological intimidation of the southern scholars.

It was not until the middle of Ming rule, when the area no longer posed a threat to the emperor, that conditions

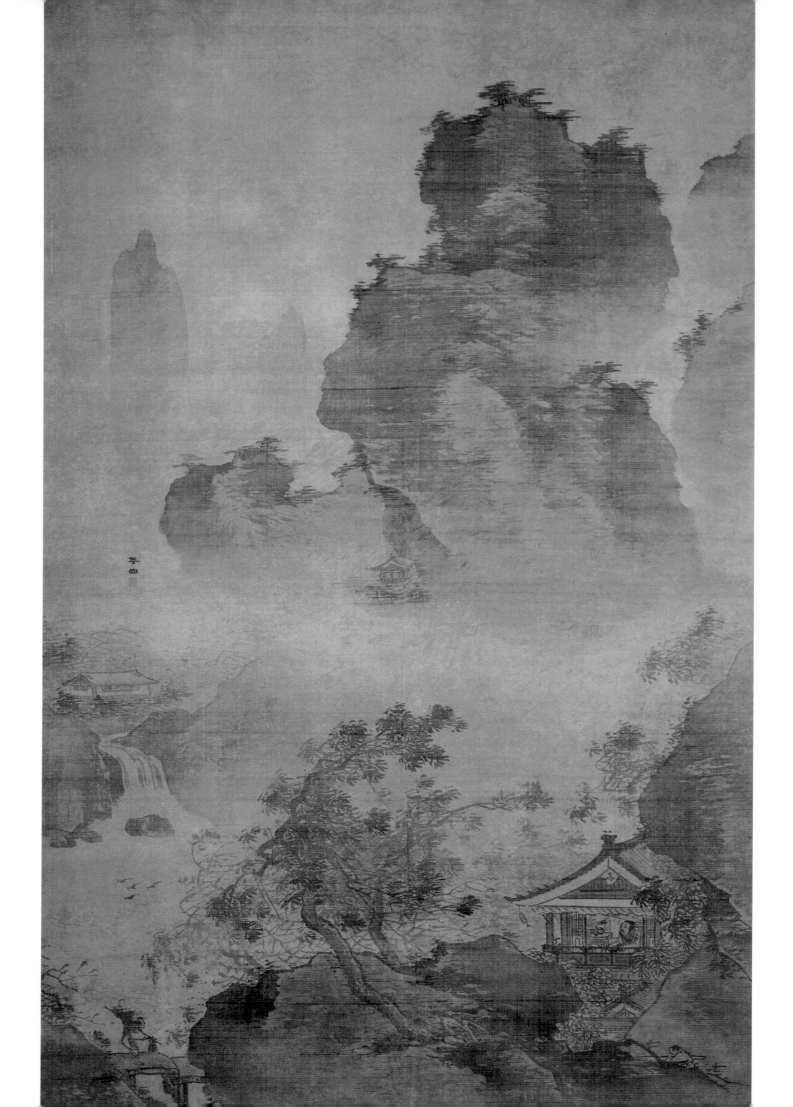

for artists began to improve. After repeated requests by local officials, the court finally reduced the taxes on Suzhou and the surrounding area and allowed more applicants to take the civil service examinations, which helped revive the economy and rejuvenate cultural life. The first scholar-painters to emerge in the more open era were Xie Jin (fl. ca. 1560), Liu Jue (1410–1472), Du Qiong (1396–1474), and Zhao Tonglu (1423–1503). They passed on to Shen Zhou and Wen Zhengming the literati painting style of the Yuan dynasty and thus founded the Wu School of painting. Also worthy of mention are painters from nearby areas, such as Wang Fu (1362–1416), Xia Chang (1388–1470), and Yao Shou (1423–1495), who were officials but were better known for their paintings.

At the same time, professional painters in Suzhou also became active. Zhou Chen (active ca. 1472–1535), in addition to creating many new works himself, taught Tang Yin and Qiu Ying, who were to win great fame and who, together with Shen Zhou and Wen Zhengming, came to be known as the Four Great Artists of Wu.

Shen Zhou (1427–1509) was born into a scholars' family and received a good education. His teachers — Chen Kuan, Liu Jue, and Zhao Tonglu — were all noted Suzhou scholars and were well versed in painting. His father, Shen Heng (1407–1477), and his uncle Shen Zhen (b. 1400) were painters as well as scholars. The family code set down by his grandfather Shen Cheng (1376–1463) may have kept him from following in the footsteps of other intellectuals and seeking a government post. Although recommended by local officials, Shen Zhou gracefully declined the offer of government service. He kept himself aloof from worldly affairs, spending his time traveling, writing poetry, and painting. His plain and unsentimental poems were free from passionate outpourings. His greatest wish was for the court to employ more just officials so as to ensure a peaceful life for the common folk. Shen Zhou enjoyed considerable prestige in the Suzhou area and was respected by local officials. His name was known even in the capital.

Starting with his teachers, his father, and his uncle, Shen Zhou was influenced by scholar-painters, especially the Four Great Masters of Yuan painting (Huang Gongwang, Ni Zan, Wang Meng, and Wu Zhen). In the years before he reached forty, he made a detailed study of all four, imitating their brushwork until he felt at ease with it. His *Lofty Mount Lu* (fig. 200), from 1467, and *Returning Kindness with Fame* (Palace Museum, Beijing), painted in 1469, represent the fruits of his study.

199. Zhang Lu, *Hurrying Home Before the Rain*, hanging scroll, ink and color on silk, Ming dynasty. 183.5 × 110.5 cm. Palace Museum, Beijing.

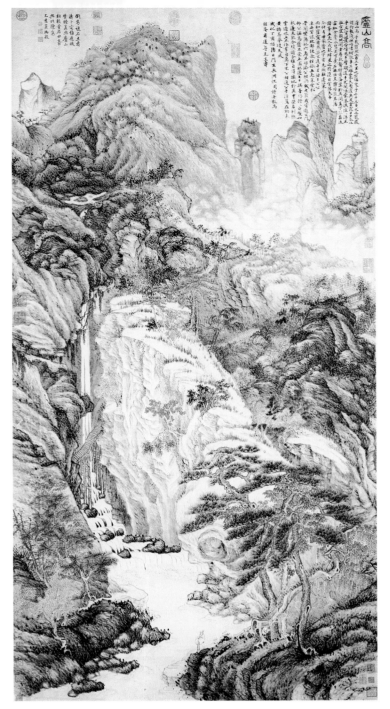

200. Shen Zhou, *Lofty Mount Lu*, hanging scroll, ink and color on paper, 1467. 193.8 × 98.1 cm. National Palace Museum, Taibei.

Lofty Mount Lu follows the manner of Wang Meng in both composition and brushwork. It was painted as a birthday gift for Shen Zhou's teacher Chen Kuan, hence the long poem inscribed on the hanging scroll and the meticulous attention paid to detail. Mount Lu is located in the northern part of Jiangxi Province, and from it one can see the Yangzi River. Shen Zhou had never been there. The hanging scroll represents an attempt to describe the strong character and virtues of his teacher by depicting the height and grandeur of the mountain. He cleverly places the figure admiring the scenery at the very bottom of the picture, bringing it into relief against the rocky cliffs and the blank space that represents water.

The eye then follows the waterfall and the mountain ridge, reminiscent of the back of a fish, until it reaches the peak. Only then does the whole picture convey the feeling described in the *Shi jing* (Book of songs), "I lift my eyes to admire the mountain so high; I halt my steps to drink in the beauty of this land." The close attention to minute details in the brushwork and the rich variation in the composition of the rocks and trees are rarely seen in Shen Zhou's other works.

The handscroll *Returning Kindness with Fame,* a landscape painted at the request of a friend as an expression of gratitude to a doctor, consists of three sections. The section painted by Shen Zhou reveals his pursuit and imitation of Wu Zhen's composition and brushwork.

Shen Zhou initiated the practice of employing the brushwork and modeling methods of the Four Great Masters of Yuan painting, as well as those of Mi Fu and his son, Mi Youren, Dong Yuan, and Juran, to express the artist's sentiments in inscriptions on the paintings. The combination of the brush-and-ink landscapes, the calligraphy, and the artist's sentiment enhanced both these paintings and the role of those earlier artists in the history of Chinese painting. From the age of forty to sixty, Shen Zhou continued to use the brushwork manner of the previous generations' artists, yet he transformed their techniques into his own style. Examples include *Landscape in the Manner of Dong and Ju* (Palace Museum, Beijing), referring to Dong Yuan and Juran, from 1473, *Landscape in the Manner of Ni Zan* (fig. 201) from 1479, and his *Copy of Huang Gongwang's Dwelling in the Fuchun Mountains* (Palace Museum, Beijing), completed in 1487. In the long handscroll *Scenery of Cangzhou* (fig. 202), one of Shen Zhou's later works, he employed the brushwork styles of all Four Great Masters of Yuan painting in a seamless combination that indicates that he must have been well versed in them all. Perhaps he did this to give the scroll more variation and visual interest, but the result is that patterns created by the play of the brush and ink overpower the landscape. In his inscription on the scroll, he criticizes those of his generation who studied Dong Yuan and Juran to the point of abandoning true landscape representation. Shen Zhou's efforts to master the various brushwork manners of earlier landscape painters led to the pursuit of form at the expense of content by artists of the late Ming.

By the time he was about fifty, Shen Zhou's landscape painting had reached maturity and his style was characterized by quick, bold strokes and simple, clear compositions. Skillfully combining poetry, essays, calligraphy, and painting, he depicted the mountains and rivers of his

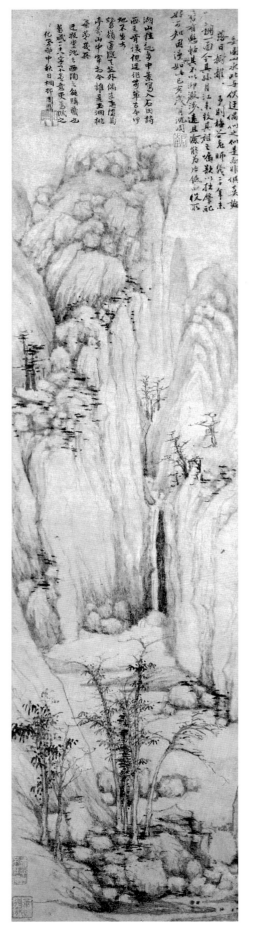

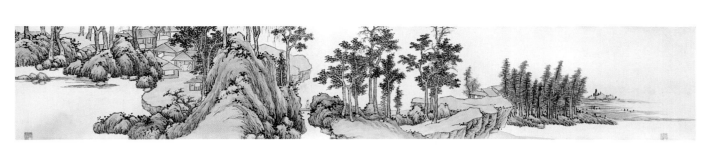

202. Shen Zhou, *Scenery of Cangzhou,* section of a handscroll, ink and color on paper, Ming dynasty. 29.7 × 885 cm. Palace Museum, Beijing.

hometown, the gardens of his friends and relatives, the gatherings and partings with his friends, and his personal feelings about various aspects of life. These works were not naturalistic recordings of events but, rather, expressed the artist's thoughts and feelings, in the tradition of literati painting. Thanks to Shen Zhou's efforts, literati painting gradually came to be enjoyed by a much wider audience than before.

Shen Zhou was also a bird-and-flower painter, and he occupies an important place in the development of literati paintings in this genre. *Dream Journey* (fig. 203), an album of seventeen paintings, consists of seven landscapes and images of cape jasmine, apricot, hibiscus, hollyhock, and rape flowers, loquats, pomegranates, chicks, cicadas singing in the willows in autumn, and animals grazing on rolling hills. The flowers are painted in light colors, some with and some without outlines. Shen's style is characterized by a suavity quite different from both Sun Long's simplicity and ease and Lin Liang's boldness and unrestraint. Shen Zhou places more emphasis on conveying thoughts and feelings, and a poem or inscription accompanies each painting. For instance, on the pomegranate painting he wrote these lines: "Who split open the pomegranate to reveal the ruby fruits inside? I don't want to hide anything. All of my life I've feared deceit." The poem enlarged the painting's theme, introducing various overtones, which is a unique feature of literati paintings. Shen Zhou liked to paint individual flowers or birds rather than a group of them, to keep his paintings clean and simple, with few layers, giving prominence to the brush and ink. Adding poetry to the painting thus enriched the content. These inscriptions distinguish literati painters from artisans.

With respect to the combination of poetry, calligraphy, and painting, Shen Zhou's influence on later generations is profound indeed. Wen Zhengming was Shen Zhou's most distinguished student. Following Shen's

201. Shen Zhou, *Landscape in the Manner of Ni Zan,* hanging scroll, ink on paper, 1479. 120.5 × 29.1 cm. Palace Museum, Beijing.

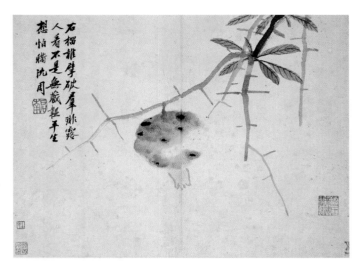

203. Shen Zhou, *Dream Journey,* album leaf, ink and color on paper, Ming dynasty. 27.8 × 37.3 cm. each. Palace Museum, Beijing.

death, Wen Zhengming carried on with his legacy and gathered around him a large number of students, including his son and nephew. All born in Suzhou, the birthplace of the Wu School of painting, they were responsible for a new upsurge in the popularity of literati painting.

The young Wen Zhengming did not appear intelligent at first. However, his father, Wen Lin, a local administrator, was very strict and sought out the best-known teachers among the Suzhou literati for his son. At the age of nine, Wen Zhengming studied the Classics under Chen Kuan; at nineteen, he learned calligraphy from Li Yingzhen and at twenty, painting from Shen Zhou. Wen Zhengming was also able to exchange ideas with a number of fellow students and friends, such as Zhu Yunming (1461–1527), Du Mu (1459–1525), and Tang Yin, and the young scholars learned from each other. Moreover, Wen was quiet and calm by nature and very diligent in his studies, and he soon became known in the Suzhou area for his learning. His father sought to mold his son in his own image, hoping that he, too, would one day pass the civil service examinations and rise in officialdom to win honor for his ancestors. But Wen Zhengming was ill fated and failed the local examination ten times. In 1523, at the age

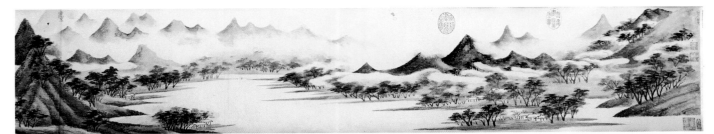

204. Wen Zhengming, *Landscape in the Mi Family Cloudy Mountain Style,* section of a handscroll, ink on paper, ca. 1533–1535. 24.8 × 60.2 cm. Palace Museum, Beijing.

of fifty-four, he was recommended by the governor of Jiangsu to attend the Imperial College in the capital, and later he served in the Hanlin Academy in a low-ranking secretarial job. He was not happy in this high-pressure post and resigned after four years and returned home. From then on, his sole interests were writing poetry and essays, painting, and doing calligraphy. He was writing a tomb inscription for someone just before he died at the age of ninety.

It is difficult to single out characteristic paintings from Wen Zhengming's vast number of works. This is owing partly to his serious temperament and discipline and partly to his strict creative style. His works are noted for their well-balanced composition, meticulous brushwork, and elegant colors, best illustrated in *Landscape in the Mi Family Cloudy Mountain Style* (fig. 204), created between 1533 and 1535. The original Mi family painting was an impromptu production, a simple impression of a scene created with thick ink and bold strokes, almost a mockery of the traditional landscape painting of pre-Song days. However, in the hands of Wen Zhengming, this kind of antitraditionalism became like a tamed wild horse. In this painting, the composition of the mountains is complex, the perspectives are varied, but the brushstrokes are gentle and mild, neither quick nor slow. Wen took nearly three years to complete this work, yet it appears to have been done all at once.

The East Garden (fig. 205) depicts a literary gathering in the private garden of Xu Shen. The ancient pines and other trees, the rocks by the lake, and the pavilion are all tightly knit in a picture of elegant beauty. In this portrayal of the typical pastimes of men of letters not in official positions, scholars, with servant boys at their side, are reciting poetry, admiring paintings, or playing chess. This leisurely life, free of political interference and official responsibilities, began with men like Du Qiong, Liu Jue, and Xie Jin and became a legacy for scholars south of the Yangzi River.

The brushwork in *The East Garden* is meticulous, done in a method that Wen Zhengming learned from Zhao

Mengfu. The green hills and waters of Tang and Song painting, with their heavy coloring and strong color contrasts, give way to a light-colored setting with touches of mineral green and azurite blue plus some cinnabar red which create a gentle, harmonious atmosphere. This method complements the monochrome ink freehand sketch style of earlier literati paintings; other examples are *Sacrificial Ceremony at Lanting* and *Tea Party at Huishan* (both in the Palace Museum, Beijing). Because Wen Zhengming greatly respected Zhao Mengfu's character, as well as his calligraphy and paintings, he often took him as his model. Many of Wen's painted orchids, bamboo, and rocks closely resemble those by Zhao.

Old Trees by a Cold Waterfall (fig. 206) is rather special among Wen Zhengming's works. On this long, narrow hanging scroll, ancient pines and cypresses reach toward the sky while a waterfall plunges down a cliff. The layout seems crowded at first, but a slit of sky visible at the top of the scroll and the reflecting springwater at the bottom lead the viewer's imagination to a wider world. The composition displays a cleverness behind the apparent clumsiness, and one feels a peace and calm in a hazardous situation. The crude, rugged brushstrokes convey a sense of force, quite different from Wen Zhengming's usual subtle elegance. The impression is very much like that of Shen Zhou's *Lofty Mount Lu,* except that the latter presents a distant panoramic view while the former is a partial close-up. Wen Zhengming was eighty years old when he created *Old Trees by a Cold Waterfall,* but as is evident from the painting, he was mentally still very active and his brushwork was full of vitality. Had he been more of a rebel, as was Tang Yin, his art might have been even more brilliant.

Wen Zhengming's figure painting did not follow one consistent style throughout his career. *Goddess and Lady of the Xiang River* (Palace Museum, Beijing), from 1517, for example, shows two beautiful women, one behind the other, surrounded by empty space. The figures, clothing, decorations, and colors all suggest an imitation of the style of the Six Dynasties (that is, the Western and Eastern Jin

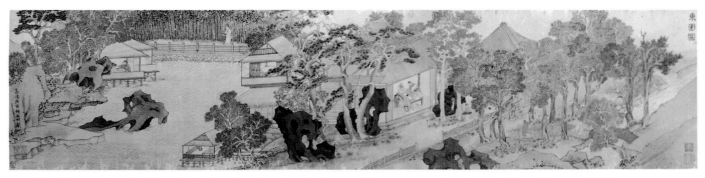

205. Wen Zhengming, *The East Garden,* handscroll, ink and color on silk, 1530. 30.2 × 126.4 cm. Palace Museum, Beijing.

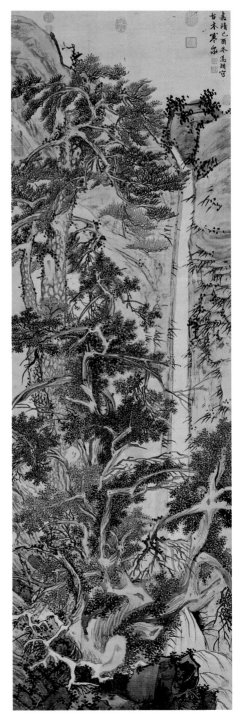

206. Wen Zhengming, *Old Trees by a Cold Waterfall,* hanging scroll, ink and color on silk, 1549. National Palace Museum, Taibei.

and Southern Dynasties, 265–589). But in his inscription on the painting, Wen claimed that he was following in the footsteps of Zhao Mengfu and Qian Xuan to counter the trend of painting women in Tang clothing and to pursue a still older tradition. Wen was attempting to oppose vulgarity by upholding the grace and elegance of the literati legacy and to replace direct sensual enjoyment with intellectual and spiritual fulfillment. Wen Zhengming, forty-seven years old when he painted this picture, did not maintain his interest in this goal. His return to the ancient style of figure painting, in fact, contributed to Chen Hongshou's grotesque style in the late Ming.

The Suzhou professional painter Zhou Chen is significant in the history of Chinese painting for his own artistic achievement as well as his training of Tang Yin and Qiu Ying, two students who later became famous as members of the Wu School. Zhou Chen was accorded little respect by scholars, in part because they considered him a poorly educated man, and he did not achieve the fame and position he may have deserved. As Zhou Lianggong later wrote, "Tang Yin, who learned painting from Zhou Chen, turned out to be a better painter. This is because Tang Yin had read extensively."[7] Nevertheless, it was an open secret that Tang Yin often asked Zhou Chen to paint for him when Tang could not produce enough work to meet the needs of the art dealers. As long as Tang Yin signed the painting, people did not care; they paid more attention to the artist's name than to the work of art.

Born to a poor family, Zhou Chen learned painting as an apprentice in a workshop where styles created by court painters from the Southern Song dynasty onward were popular. Zhou Chen's style was highly influenced by the works of Li Tang and Ma Yuan, especially the shading and texturing method used for mountains and rocks and the stance of the trees. Though he was a professional painter, his themes and subjects often depicted the life of scholars. His *Chunquan (Spring River) in Seclusion* (Palace Museum, Beijing), painted for a scholar named Pei Chun-

quan, shows a river flowing by several thatched houses set off by trees. Across the river, mountains appear indistinctly in the distance. Located far from the city, this beautiful place appears to be an ideal spot for scholars to live and study. Tang Yin's *Serving Tea* (Palace Museum, Beijing) was composed in a similar way, although Tang Yin's main figure entertains his guests by offering them tea to express a sense of leisure, whereas Zhou Chen's is asleep by the table, showing the secluded man's indifference to the outside world.

The Northern Sea (Cleveland Museum of Art) is adopted from "The Happy Excursion" in Zhuangzi. In this imaginary sea lived a large fish named Kun. When the wind blew and the waves rose high, this fish metamorphosed into a huge bird by the name of Peng, which then flew to the Southern Sea. This romantic story implies that one must wait for the opportunity to realize one's ambitions. Zhuangzi's philosophy of relativity and pursuit of absolute intellectual freedom was popular among Confucian scholars who had failed in their efforts to become government officials. A large number of scholars who had lost their jobs in the government owing to political struggles often found comfort in discussing Daoism and Chan Buddhism. On one side of the sea are rocks and a man sitting by the window of a house overlooking the water. Below, visitors are approaching on the high bridge. The turbulent breakers send up fountains of spray, as if dragons and snakes are playing together. Sea and sky merge into one boundless universe; rocks appear solid and robust; the mountains, whose summits cannot be seen, are dotted with cascades and springs, presenting a scene of tranquillity. The hardy and twisted pines standing against the wind contrast sharply with the surging waves. Unlike Tang Yin's *Whispering Pines on a Mountain Path* (see fig. 207), which expresses the painter's emotion by trying to depict sound, Zhou Chen's work presents the beauty of grandeur and robustness.

Zhou Chen's *Beggars and Street Characters* (Cleveland Museum of Art and Honolulu Museum of Art) is an unusual collection of album leaves. The twenty-four figures depicted include men and women, young and old, all in rags. Some are blind or crippled; some are performing in return for money; others are playing with monkeys and snakes. Zhou Chen said that he had seen these people on the street and that he painted them for "educational purposes." Though the figures are somewhat exaggerated, the execution is not undisciplined and shows the painter's mastery. Then-celebrated scholars of the time praised the convincing power of Zhou Chen's works. Huang Jishui commented, "Viewers were overwhelmed by all the vivid figures," and Zhang Fengyi said, "Those who don't feel sad after seeing the painting would not be human." In his epilogue, Wen Jia writes in a colophon, "whenever Tang Liuru [Tang Yin] saw Zhou's work, he would speak of him as Master Zhou. He admired his works so much that he said he could never be as good as Zhou in ingeniousness of brushwork." Most Ming literati painters did not concern themselves with portraying reality accurately, and works showing a keen awareness of social problems were rare.

Although Tang Yin (1470–1523) was a student of Zhou Chen's, he was more of a literati painter. He was the same age as Wen Zhengming and was his fellow student and friend. As a child, Tang Yin was clever but cared little for study or work. Urged by his friends, he took a local civil service examination in 1498 in Nanjing and came out at the top of the list. This surprising success whetted his thirst for wealth and fame. Soon he went to Beijing for the national examination. He was implicated in a case of bribery and was imprisoned, tortured, and banned for life from taking the civil service examinations. This blow almost shattered Tang Yin mentally, and he turned to Chan Buddhism for solace. He began to regard everything as void and adopted an alias, the Liuru Lay Buddhist.[8] In order to make a living he had to sell his paintings. Full of indignation, he once lamented, "When not even the best lakeshore land can attract a buyer, who will buy the mountains in my paintings?" and "I would paint a fresh bamboo to sell, but the bamboo shoots on the market are worth no more than mud." Poverty-stricken and ill, Tang Yin died at the age of fifty-four.

Although Tang Yin's life was a tragic one, his art shows real genius. In addition to learning painting from Zhou Chen, he had been advised by Shen Zhou. Through Zhou Chen he inherited the technical legacies of professional artists from Li Cheng and Guo Xi to Li Tang, while in spiritual and artistic conception, he had the qualities of a literati painter. His *Whispering Pines on a Mountain Path* (fig. 207) is one of the most vigorous of his many landscapes. The rhythmically arranged towering peaks, waterfalls, and swaying pines, together with the motion of the figures crossing the small bridge, produce a lyrical illusion that rivals Li Tang's *Wind Through the Pine Valleys* (see fig. 119). Tang Yin's *Sunset and Lonely Ducks* (Shanghai Museum) takes its theme from "Preface to Tengwangge Pavilion" by the Tang poet Wang Bo. In this imaginary rendition (a reconstructed pavilion built on the original ruins can be found today in Jiujiang, Jiangxi Province), willows sway in the breeze as the setting sun casts its glow on the mountain cliff. The freshness of the scene is

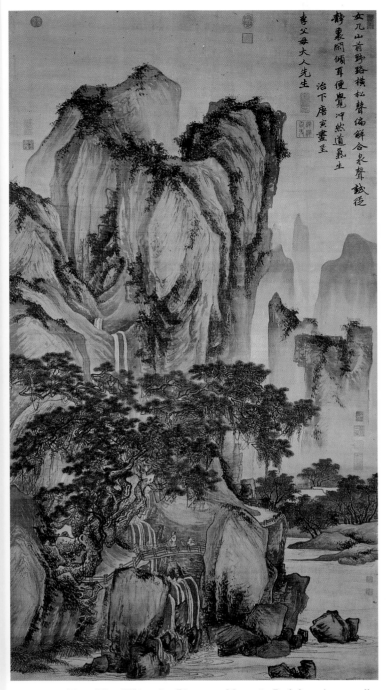

207. Tang Yin, *Whispering Pines on a Mountain Path,* hanging scroll, ink and color on silk, Ming dynasty. 194.5 × 102.8 cm. National Palace Museum, Taibei.

depicted with long, thin brushstrokes, fluent yet firm. Then there is the serenity of *The Yi-an* (Palace Museum, Beijing) and the splendor of the landscape in *Serving Tea* (Palace Museum, Beijing). Tang Yin's landscapes are fairly close to nature in composition, scenery, and modeling. Furthermore, they embody the artist's personal appreciation of rural scenes, as is evident in *Small View of the Yellow Thatched Hut* (Shanghai Museum).

Tang Yin was one of the few successful figure painters of the Ming dynasty. He loved to paint beautiful women and, above all, prostitutes. *Silk Fan in the Autumn Breeze* (fig. 208), *Tao Gu Presents a Poem* (fig. 209), and *Li Duan-*

duan Requesting a Poem (National Palace Museum, Taibei) are some of his best in this genre. Through these paintings, he mocks life and worldly matters, lashes out at the hypocrisy of moralists, and expresses his sympathy for courtesans and prostitutes. *Silk Fan in the Autumn Breeze* depicts a beautiful maiden whose facial expression conveys sadness and loneliness. In his accompanying poem, Tang borrowed an ancient allusion and personified the fan to show his disapproval of human relations based purely on individual interests, and satirized those who curried favor with people in power.

A strikingly different kind of figure painting is *Dreaming in the Shade of a Tong Tree* (fig. 210), which shows a scholar reclining in a rattan chair under a tree, eyes closed in meditation. In the accompanying poem, Tang Yin writes, "Gone for life all thoughts of fame, not even in my dreams under the old locust tree." No doubt this is both a self-portrait and a self-consolation, and it reflects the sentiment of many neglected men of letters. The Qing-dynasty painting *Master Dongxin* [Jin Nong] *Noon-Napping Under a Banana Tree* by Luo Pin (Shanghai Museum), done in 1760, was inspired by this work in both composition and theme.

Reminiscing with Xizhou (National Palace Museum, Taibei), from 1519, was Tang Yin's last masterpiece. He was sick, and when friends came to visit, together they recalled the past with all its vicissitudes. To express his feelings, Tang Yin painted this picture, using a hand weakened by illness. It shows numerous disorderly trees and rocks, a shabby straw hut, and two men sitting across from each other recollecting times past, conveying a sense of bleak loneliness. The scene occupies the lower part of the painting, with a poem above, which adds to the oppressive atmosphere. The poem reads,

> For fifty years
> I have been singing and dancing;
> I have had pleasure among flowers and slept under
> the moon.
> My name is known far and near;
> Who would have believed I lacked the money for a
> drink?
> I feel ashamed to call myself a scholar;
> Yet people think I am an immortal.
> I have been working hard
> So that I can live up to my name.

At around the same time he painted *Reminiscing with Xizhou,* Tang Yin wrote eight poems (Shanghai Museum) that offer a summary of the artist's life, with honors as well as humiliations. In the painting one senses these two

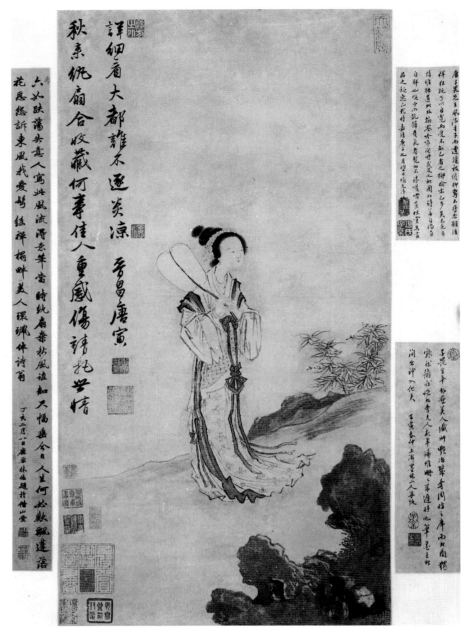

208. Tang Yin, *Silk Fan in the Autumn Breeze,* hanging scroll, ink and color on paper, Ming dynasty. 77.1 × 39.3 cm. Shanghai Museum.

conflicting emotions—an outward calm and ease and an inward pain.

Like Tang Yin, Qiu Ying was a student of Zhou Chen's and an artistic genius who died young. Born to a poor family, he worked as a painter of scenes on walls and doors when he was young. Later, he studied with Zhou Chen and was once tutored by Wen Zhengming and his son. The epilogue by Wang Zhideng on Wen Zhengming's *Goddess and Lady of the Xiang River* recounts that after Wen Zhengming drew the sketch, he twice asked Qiu Ying to apply the colors, but Wen Zhengming was not satisfied. Qiu Ying could copy ancient paintings so that the imitations passed as genuine. At one time, he was invited to the homes of the famous art connoisseurs Xiang

Yuanbian and Chen Guanyan and asked to copy and restore ancient paintings, as well as to create new ones. An intellectually brilliant and hard-working man, Qiu Ying was able to assimilate much of the experience and techniques of previous masters in the course of copying their works, gradually forming his own distinct style, which won much praise from the literati. In Suzhou, where many men of letters worked in a hierarchical society, a worker of Qiu Ying's humble background would never have been ranked with Shen Zhou, Wen Zhengming, and Tang Yin had it not been for his convincing accomplishments in the realm of art. Qiu Ying died around the age of fifty, leaving behind a large number of works.

Qiu Ying's artistic achievement lay in his ability to

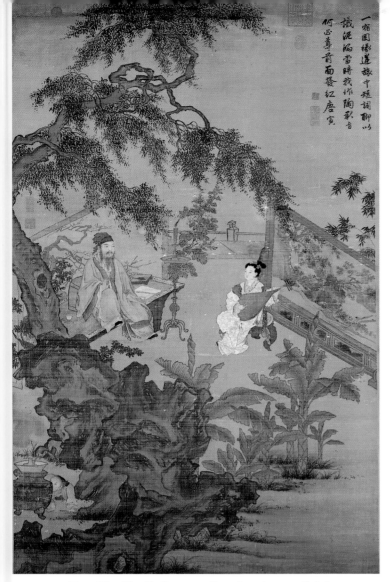

209. Tang Yin, *Tao Gu Presents a Poem,* hanging scroll, ink and color on silk, ca. 1515. 168.8 × 102.1 cm. National Palace Museum, Taibei.

adapt meticulously executed and heavily colored figure paintings and blue-and-green landscape paintings, both of which in the hands of other artists of the time tended toward the commonplace. Literati painters saw themselves as embodying a classic simplicity against the current delicacy, the elegance of monochrome ink against the vulgarity of bright colors, and the profundity of connotation against superficiality. Qiu aptly drew on such literati opinions and yet preserved his original artisan flavor, thus allowing for a touch of elegance without sacrificing his delicateness and splendor. His artistic skills far exceeded those of the literati painters; even Dong Qichang acknowledged his supremacy.

One of Qiu Ying's landscape styles derives from the blue-and-green landscapes of Zhao Boju of the Song dynasty. *Thatched Houses in the Peach Blossom Village* (fig. 211), *Jade Cave Fairyland* (fig. 212), and *Peach Blossom Spring* (Tianjin Art Museum) are examples of this type. The first

image depicts a realistic scene, whereas the other two are imaginings of an earthly paradise. *Thatched Houses in the Peach Blossom Village* was painted for the art connoisseur Xiang Yuanqi, the elder brother of Xiang Yuanbian, also a connoisseur. Collector's seals of Xiang Yuanbian are impressed on the four corners of the painting. As Xu Zonghao indicated in his colophon on the side, some speculated that this was a portrait of Xiang Yuanqi, who is portrayed as a recluse of high moral integrity, the supreme praise for a scholar at that time. Dong Qichang

210. Tang Yin, *Dreaming in the Shade of a Tong Tree,* hanging scroll, ink and color on paper, Ming dynasty. 62 × 30.8 cm. Palace Museum, Beijing.

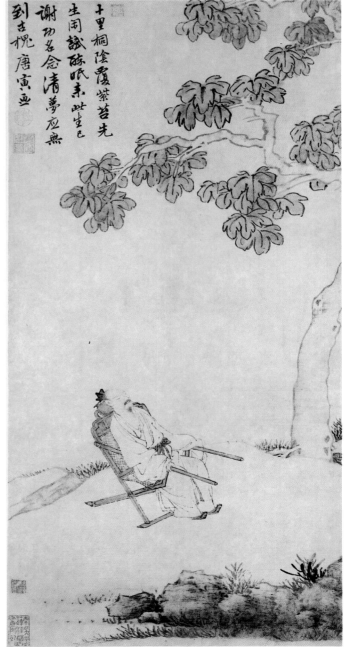

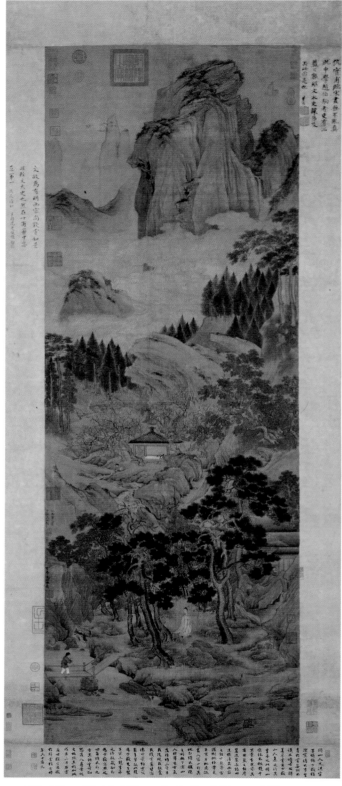

211. Qiu Ying, *Thatched Houses in the Peach Blossom Village*,
hanging scroll, ink and color on silk, Ming dynasty.
150 × 53 cm. Palace Museum, Beijing.

gave the work his highest accolade, saying in his colophon, "All of Qiu Ying's imitations of Song paintings, without exception, can be confused with the originals. Those among them in which he studies Zhao Boju, in particular, show his ability to surpass his models. Not even Wen Zhengming can compete with him, as this painting testifies." Although the halls and pavilions vary from picture to picture, there seems to be no difference in the rocks, mountains, bushes, and trees, or in the way the figures in the paintings are dressed. In composing the paintings, Qiu Ying used a peculiar landscape to highlight the mortals and a realistic landscape to create the imaginary surroundings of the gods. The scholar in *Thatched Houses* is dressed in a long gown with wide sleeves. He is portrayed strolling in a pine forest. In the background are several huts. Steps lead up the mountain slope to a platform where a pavilion stands amid a cluster of peach blossoms. Next to the pavilion, a gurgling stream winds its way into the distance. Further up the slope is a sea of pines and cypresses, with white clouds floating in and out, while all around, towering peaks pierce the sky.

Qiu Ying's *Fisherman Hermit at Lotus Valley* (fig. 213) and *Waiting for the Ferry in Autumn* (National Palace Museum, Taibei) represent another of his landscape styles, which is based on the work of the Song painters Li Tang, Xiao Zhao, and Liu Songnian. However, Qiu is more meticulous and pays more attention to details in composition and brushwork. Both paintings depict scenes south of the Yangzi River. From the rivers and lakes to the distant hills, from the fields and village homes to the fishing boats and nets, as well as the people traveling to and fro, everything is placed in harmonious balance and exquisitely delineated to create an enchanting scene of idyllic beauty.

Some of Qiu Ying's figural illustrations are copies of ancient works, such as *Sericulture and Agriculture* and *Copy of Xiao Zhao's Illustration for Zhongxing Ruiying* (both in the Palace Museum, Beijing). Others are his own creations, such as *Garden for Solitary Pleasure* (Cleveland Museum of Art) and *Evening Banquet in the Peach and Plum Garden* (Chionin, Kyoto), which are meticulously executed garden scenes with figures, done in ink and color on silk. The figures, especially the young men and women, appear very much like those described in the popular novels and dramas of the time. The men have oval faces, are delicately featured, and carry themselves in a courteous manner. The women, who seem gentle and attractive, have dainty brows and lips, slender silhouettes, and small white hands. The figures that Qiu Ying created with his brush follow the aesthetic ideals of the era in which he lived.

In addition to painting in the meticulous style and using bright colors, Qiu Ying also worked with monochrome ink in the freehand sketch style. The strokes of the brush are simple and crude yet convey elegance. *Listening to the Qin Beneath the Willow* (Palace Museum, Beijing) and *Wang Xizhi Writing on a Fan* (Shanghai Museum) are two examples.

Shen Zhou, Wen Zhengming, Tang Yin, and Qiu Ying, despite their disparate experiences in life, together dominated Suzhou art circles for more than one hundred years. Their students and descendants continued their tradition until the Qing dynasty.[9]

Impressionist Bird-and-Flower Paintings by Chen Chun and Xu Wei

Chinese use of monochrome ink in the bird-and-flower paintings developed to an unprecedented height during the Ming in the works of Lin Liang, Shen Zhou, and Tang Yin. These artists were followed by Chen Chun and Xu Wei, who made fresh contributions to this genre. In particular, Xu Wei's inksplash freehand sketch style had a profound influence on subsequent painters.

Chen Chun (1483–1544) was from Suzhou and was fond of painting from childhood. As his father was a close friend of Wen Zhengming's, Chen Chun became Wen's student. Chen was the eldest of Wen's students. Although he was admitted to the Imperial College, he refused to serve at court and voluntarily returned home to lead a secluded life. Although he studied under Wen Zhengming, his paintings were not in the least like his teacher's. In his preface to a collection of Chen Chun's works, Qian Yunzhi compared the works of the two artists. "Wen's paintings are standard, Chen's are singular; Wen's paintings are elegant, Chen's are brilliant. Both have reached the zenith." To encourage the student to outdo his teacher, in writing and academic pursuits, the Chinese use the analogy "Indigo blue is bluer than the indigo plant it is extracted from." In art, there is the similar maxim "The point of learning from the teacher is not to achieve a resemblance but to inherit the spirit," which encourages innovations in style. The differences between standardness and singularity and between elegance and brilliance represent variations in artistic style. The fact that Chen Chun did not strictly follow in the footsteps of his teacher Wen Zhengming explains why his achievement in

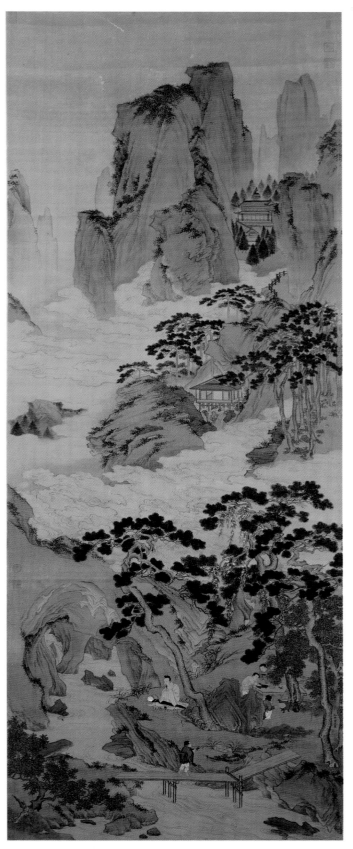

212. Qiu Ying, *Jade Cave Fairyland,* hanging scroll, ink and color on silk, Ming dynasty. 169 × 65.5 cm. Palace Museum, Beijing.

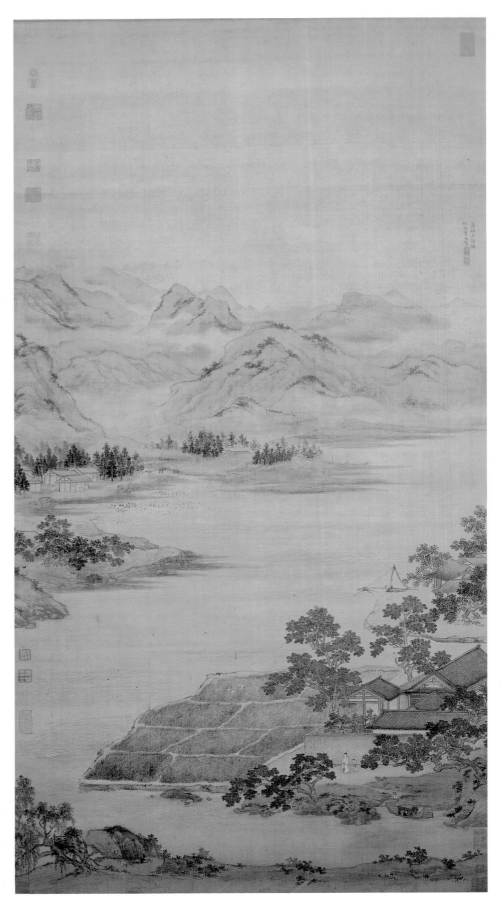

213. Qiu Ying, *Fisherman Hermit at Lotus Valley,* hanging scroll, ink and color on silk, Ming dynasty. 167.5 × 66.2 cm. Palace Museum, Beijing.

214. Chen Chun, *Ink Flowers and Fishing Boat,* section of a handscroll, ink on paper, 1534. 26.2 × 566 cm. Palace Museum, Beijing.

art and his position in art history are greater than those of Wen's other pupils, who were more strictly imitative.

Chen was unwilling to be bound by tradition. Technically, he was mainly influenced by Shen Zhou, but he far surpassed Shen in his lively use of the brush and his outpouring of emotions. This is evident when one compares Chen's crabs in *Flowers and Grasses* (Shanghai Museum) with Shen's in *Sketches from Life* (National Palace Museum, Taibei). Chen's bird-and-flower paintings are mostly sketches of flowers and grasses growing in the courtyard or vegetables and fruits in the fields, which are given character and ideals that transcend the worldly. In his handscroll *Ink Flowers and Fishing Boat* (fig. 214), done in 1534, he painted plum blossoms, bamboo, orchids, chrysanthemums, hollyhocks, narcissus, camellias, a sparrow, and pines, as well as a landscape. Drawing different kinds of flowers on a single scroll had been a means of expression since the beginning of the Southern Song dynasty, but to add a landscape at the end was rare, which shows Chen's defiance of tradition. He used light ink for the simple brushwork in this depiction of a snow scene. A boat floating on the river carries a fisherman with a fishing rod on his shoulder. An inscription reads:

There is little snow on the river,
The water is so cold the fish would not bite.
May I ask the fisherman, Are you out to catch fish
Or are you just in the fishing mood?

Here the artist is making an analogy to the story of Wang Huizhi of the Eastern Jin paying a visit to Dai Kui on a snowy night. Wang went to Dai's house but did not go in; instead, he turned around and went home. Asked why, he said, "I went there because I was just in the mood. Since the mood had gone, what was the point of entering the house?" Chen's painting of the fisherman was an attempt to show that the fisherman's interest lay not in the fish but in the enjoyment of fishing. This is also suggestive of his own aesthetic philosophy: the point is not in the painting itself but rather in the thought it conveys. From this derived the monochrome ink sketching of ideas or the freehand sketch style.

Mi Family Style Landscape (fig. 215) is a major work by Chen Chun completed not long before he died in 1544, while he was traveling in Jingxi (in Yixing County, Jiangsu Province). From the Fazang Temple where he lodged, he looked out on the distant hills and was moved to paint this picture, imitating Mi Youren's brushwork. Chen Chun's ties with Mi family landscapes stem not only from their compatible spiritual quality but also from the two

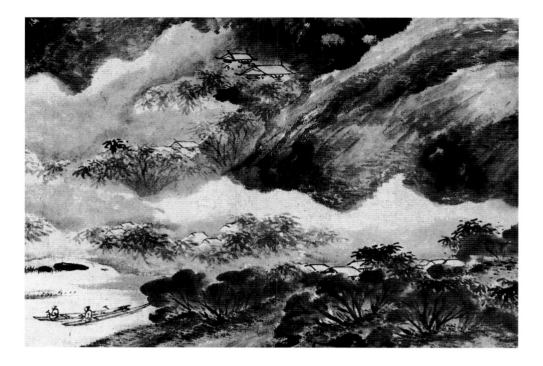

215. Chen Chun, *Mi Family Style Landscape,* handscroll, ink on paper, 1544. 55 × 498.5 cm. Tianjin Art Museum.

paintings by the Mis in his family collection—*Cloudy Mountains* and *Dayao Village.* Although these works had also influenced Shen Zhou and Wen Zhengming, in his imitations of Mi family landscapes Chen Chun did not simply copy their method of shading. Chen used the Mi family method as the basis for his work but applied a variety of techniques, including *cun* (texture strokes), to show the shading and textures of rocks and mountains, *ca* (rubbing with a very dry brush), *dian* (dotting), and *ran* (adding a wash or a tint of color). In particular, he was much more versatile in his methods of depicting the size and layers of his landscape motifs. For instance, one of his daring experiments was to leave a blank space along the contour of the trees to give a sense of the transparency of sunlight after rain.

After Chen's death Xu Wei (1521–1593) carried on his experimental approach. Xu Wei, who called himself the Qingteng Lay Buddhist and the Tianchi Mountain Hermit, was a native of Shaoxing in Zhejiang Province. He was a man of great achievement not only in painting but also in literature, drama, and calligraphy. His father died shortly after his birth, and he was brought up by his stepmother and elder brother. At the age of twenty, he passed the county civil service examination and was accredited as a scholar, but from then on, he failed all eight examinations he took at the provincial level. He subsisted on the meager pay he received from teaching until he was invited to be an aide to a regional viceroy and thus came to participate in affairs involving military secrets. Later, the viceroy was arrested for having been the friend of a notoriously corrupt high official and committed suicide

while in prison. The mental strain that this incident caused Xu Wei resulted in a recurrence of schizophrenia, and he killed his second wife. For this he was thrown into jail to await execution, but after seven years, owing to the efforts of his friends, Xu was released from jail. Plagued by poverty, illness, and loneliness, he died in solitude.

Owing to the reverses and frustrations of his life, Xu Wei's talents were never fully displayed. Thus the predominant theme of his works, whether in poetry, calligraphy, or painting, was his resentment at the injustices of life, at not being recognized for his talents and having nowhere to turn for help. His *Grapes* (fig. 216) includes this poem:

> Half my life wasted, now an oldster am I;
> Alone I stand in the study as the night wind howls.
> Pearls from my pen can find no buyer;
> Then let them scatter amidst the vines.

His *Pomegranate* (National Palace Museum, Taibei) manifests a similar outlook.

However, in *Yellow Armor* (fig. 217), he went beyond lamentation in the accompanying poem:

> The village rice has ripened, the crabs are in season;
> With their pincers like halberds, they swagger
> in the mud.
> If you turn one over on a piece of paper,
> You will see before you Dong Zhuo's navel.

Dong Zhuo was a sinister and powerful minister during the Eastern Han. It is said his belly had so much fat that after he died, people lit lamps with the fat from his navel.

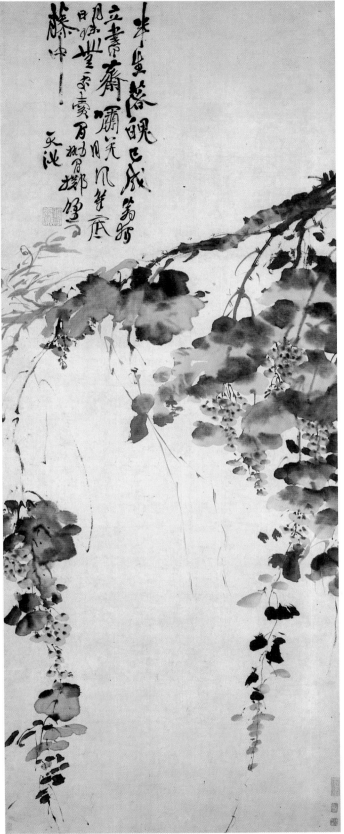

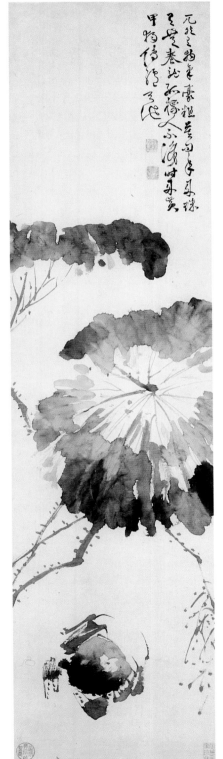

217. Xu Wei, *Yellow Armor,* hanging scroll,
ink on paper, Ming dynasty. 114.6 × 29.7 cm.
Palace Museum, Beijing.

216. Xu Wei, *Grapes,* hanging scroll, ink on paper, Ming dynasty.
166.3 × 64.5 cm. Palace Museum, Beijing.

By comparing Dong Zhuo to a domineering crab, Xu Wei lashed out against the vicious officials who prospered from the suffering of the common people.

In his inscription for *Ink Flowers* (Palace Museum, Beijing) he wrote:

> In my performance the ink is dripping wet,
> The flowers and grasses are confused about the
> season.
> Do not complain that this painting lacks several
> strokes,
> For recently the Way of Heaven is full of misdeeds.

Here the Way of Heaven is not a reference to nature's changing seasons. Rather, it is an insinuation directed against the entire feudal regime. Initially dissatisfied, Xu Wei was now full of indignation. He cursed not only the evil ministers but the emperor himself. He once reminded his colleagues, "Do not take painting too lightly. There is the judgment of history written in the silent poems."

More than once, Xu Wei spoke of his painting career as a kind of game. "At this old age, painting is but child's play." Guided by such an approach, he was able to take bold steps with regard to form. In his paintings of grapes and melons, for example, one often finds it difficult to distinguish the fruit from the leaf, and his palm leaves and peonies appear to be wavering shadows in the moonlight. The ink seems to have been splashed on the paper at will, in an impassioned and forceful manner. Such direct expression of feeling through the brush and ink can be achieved only when the painter is liberated from having to depict the portrayed object's physical image. Play was a key to achieving this freedom. Xu Wei was a true practitioner of Ni Zan's motto, "Use the brush leisurely. Do not go after superficial identity but simply express what is in your heart."

Xu's extraordinary art was not appreciated by his contemporaries, but after his death his work profoundly influenced later painters, from Bada Shanren and the Eight Eccentrics of Yangzhou in the eighteenth century to Qi Baishi in the twentieth. Also influential at this time was bird-and-flower painter Zhou Zhimian (fl. ca. 1580–1610), a contemporary of Xu Wei's. A native of Suzhou, Zhou introduced the method known as "outlining the flowers, dotting the leaves."

Dong Qichang and the Huating School

Dong Qichang (1555–1636) was the most influential literati painter after Wen Zhengming. Because he was born in Huating (present-day Songjiang, a part of Shanghai), he and the group of painters gathered around him came to be known as the Huating or Songjiang School of painting.

During the Ming dynasty, Huating, the site of the Songjiang prefectural government, was a newly emerging industrial and commercial city. With a population of 200,000 during the fifteenth century, it was best known for the cotton cloth it produced and marketed. Beginning in the Yuan dynasty, Huating had become a center of the arts. The city was the birthplace of the well-known painter and art patron Cao Zhibai, and the family of Song-Yuan painter Gao Kegong made it their home during the war-torn years. Gao was the great-great-grandfather of Dong Qichang's great-grandmother. Ren Renfa, Yang Weizhen, Huang Gongwang, Ni Zan, and Wang Meng had been officials, teachers, or residents there, and their presence in Huating boosted the city's cultural development. During the Ming dynasty, Huating became known for several famous calligraphers and painters, including Shen Du (1357–1434), Shen Can (1379–1453), Zhang Bi (1425–1487), Mo Shilong (active ca. 1567–1600), Gu Zhengyi (fl. ca. 1580), and Sun Kehong (1532–1610). So it was not accidental that Huating eventually replaced Suzhou as the most important city for Chinese painting.

Dong Qichang passed the highest imperial court examination and rose in the hierarchy to the top civilian post, in charge of imperial family affairs in the Ministry of Rites. His success in officialdom put him in a position far superior to Wen Zhengming's. However, the Ming dynasty was in decline, and social conflicts and contradictions within the ruling circles were acute. To avoid being drawn into the political vortex, Dong Qichang frequently found pretexts to return to his hometown, where he was able to socialize with his friends, to collect, appraise, and admire works of earlier calligraphers and painters, and to create his own poetry, calligraphy, and painting. He became one of the few talented intellectuals who was at once a book collector, artist, connoisseur, and writer.

Among Dong Qichang's literati friends were Mo Shilong, who was older than he, and Chen Jiru (1558–1639), who was near his age. The three men shared many interests, frequently meeting to discuss antique books and paintings. They inspired each other, and out of their discussions Dong Qichang developed his theory of painting, recorded in *Huazhi* (The principles of painting), a book compiled by later painters in the sixteenth century. In Dong's opinion, "temperament and charm," listed among Xie He's Six Principles of painting, were bestowed

by nature and could not be learned; and yet he also said that one could achieve them only by "reading thousands of books and by traveling thousands of *li*." Reading was for the self-cultivation of the artist, whereas traveling could broaden one's inspiration from nature. In learning to paint, he stressed that one must first learn from the ancients and then from nature, and he was particularly opposed to "asking the way from people around." In other words, nature was more important than the ancients; he was not one of those who believed in the doctrine of "returning to the ancients." In addition, he thought that painting should be an entertaining activity, and beneficial to one's physical and mental health, rather than a source of mental strain, claiming that excessive diligence was detrimental to one's health. To prove his point, he gave as examples Huang Gongwang, Shen Zhou, and Wen Zhengming, men who because they did not exert themselves too much enjoyed long lives, and Zhao Mengfu and Qiu Ying, who lived intensely and died young. From the point of view of "finding enjoyment in painting," he advocated that a painting should satisfy "scholarly taste" and not "the taste of an artisan," which was a further elaboration of the viewpoint put forward by Su Shi and Qian Xuan of the Song. Scholarly taste and artisan taste were considered as opposite as elegance and vulgarity. Thus, the artist had to paint the way he wrote, if he was to prevent his work from falling into the category of "sweet vulgarity." Dong Qichang advocated the literati painting that had become popular during the Song and Yuan dynasties, and he rejected the paintings of professional artists represented mainly by the Zhe School and the court painters of the Ming dynasty.

In an attempt to find a historical basis for his theory, Dong Qichang distinguished between the Northern and Southern Schools. Dong explained that "the Chan sect of Buddhism was divided into Northern and Southern schools in the Tang dynasty. The Northern and Southern schools in painting also appeared at the same time." Introduced by an Indian monk named Bodhidharma, the Chan sect in Chinese Buddhism was divided during the Tang dynasty into the Northern School, headed by Shenxiu, and the Southern School, headed by Huineng. The Northern School stressed "gradual awakening," whereas the Southern School emphasized "sudden awakening." Simple and unrestrained, Huineng's method was well received by Buddhists. After the Song dynasty, the Southern School developed rapidly, whereas the Northern School gradually declined. The Southern School reached its prime by the end of the Ming dynasty, when, in order to escape political conflicts at court, many scholars went to live in seclusion and found spiritual comfort in Chan Buddhism.

Inspired by this phenomenon, Mo Shilong and Dong Qichang used the theory and viewpoint of Chan in their study of the historical development of painting styles. In order to connect Chan and painting, they argued that the two schools of painting — Northern and Southern — also emerged during the Tang.

> Li Sixun and his son of the Northern School did landscape painting, and it was carried on in the Song dynasty by Zhao Gan, Zhao Boju, Zhao Bosu, Ma Yuan, and Xia Gui. Wang Wei of the Southern School painted with light ink, thus changing the way of doing certain strokes. His method was inherited by Zhang Zao, Jing Hao, Guan Tong, Dong Yuan, Juran, Guo Zhongshu, Mi Fu, and his son Mi Youren, as well as by the Four Masters of Yuan painting [Huang Gongwang, Wu Zhen, Ni Zan, and Wang Meng]. During the same period in Buddhism many of the followers of Huineng, the Sixth Master of Chan, including Maju, Yunmen, and Linji, belonged to the Southern School of Chan. While many flourished, the Northern School declined.

Here, Dong Qichang's overview of the development of literati painting tries to identify it with the Southern School. At the same time, however, he contradicted himself and blurred his key concepts when he attempted to link the form of painting (monochrome ink or blue-and-green landscape painting) and the method of creation (strict training or painting as a game learned through self-instruction) with the background of scholars. Nevertheless, Dong's theory influenced Chinese art circles for nearly three centuries.

Dong Qichang's landscape paintings exemplify his theories. For instance, the many similarities to ancient paintings implement his idea that one should first learn from the ancients. Of course, there are works in which his inscriptions do not correspond to the brushwork. For example, in his *Mountain Passes Clearing After Snow*, done in 1635 (Palace Museum, Beijing), an outstanding work from the last years of his life, the seemingly endless mountains and valleys covered with trees are painted with rough and awkward strokes in fresh ink. In the inscription, Dong says that it is in imitation of Guan Tong, but there is no resemblance between the two. Similarly, the inscription for *The Qingbian Mountains* (fig. 218) says that it was in imitation of Dong Yuan, when in fact it had been inspired by Wang Meng's *Dwelling in the Qingbian Mountains* (see fig. 162). This large landscape looks like a

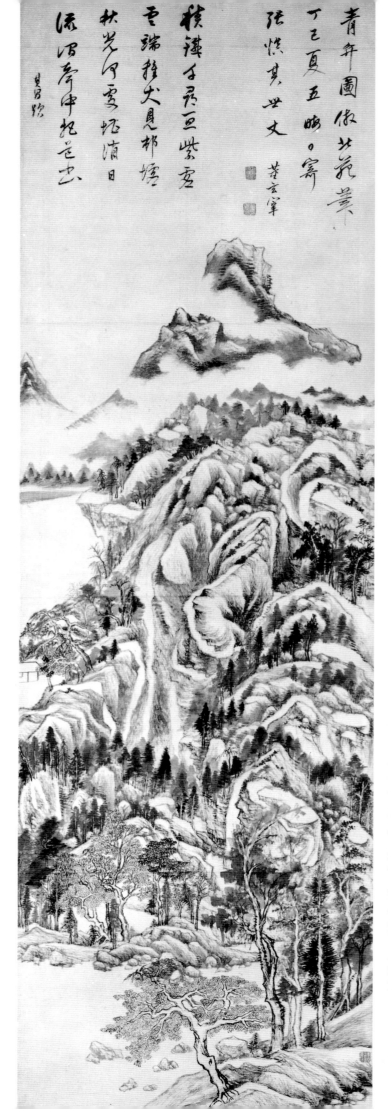

青卞圖像此苑業
丁巳夏五晦。寫
張懊其世文
積漙于龍豆紫雲
雲瑞抽尖見郏壇
秋光何雲坭湑日
流泗亭申起邕去
昌硯

view from the back of Wang Meng's depiction of the same subject. Over the towering mountain peak, one can see the river flowing into the distance with more mountains shrouded by clouds. It is an awe-inspiring picture, yet it lacks the lifelike naturalness of Wang's painting, which conveys so well the bulk and profundity of the mountain mass.

What Dong Qichang's paintings sought to convey through the brush and ink was not nature itself but a mood. The alternate application of a dry brush for shading and rubbing and a wet brush for contrast results in filling every part of the painting with contradictions. The juxtaposition is inherent in the effort to unite subject and technique: "In uniqueness of scenery, a painting can in no way compare with the landscape [of nature]. On the other hand, when you think of the remarkable power of the brush and ink, the [natural] landscape is definitely inferior to a painting."[10] In addition, one can trace the styles of many earlier painters in his constantly changing brushwork. Thus, Dong Qichang's landscapes are not views of the natural countryside that one might visit or where one might live. They are drawn from an intellectual perspective, borrowing from nature and the historical legacy of artists.

The album *Eight Scenes in Autumn* (fig. 219), painted in 1620, is a series of imitations of ancient artists. Those mentioned by Dong himself include Mi Fu, Fang Congyi, Huang Gongwang, Dong Yuan, and Zhao Gan. By imitation, he meant similarity in structural design, modeling, and brushwork. Instead of evaluating the series by how truthfully the scenes reflect nature, one should judge it by the versatility and maturity of the brushwork, for it reflects the unequaled ingenuity of the artist. In his imitation of *The Magnificent Huyun Mountain,* for example, the composition is extremely simple, and the slopes and mountain peaks are not true to life and lack variation. But the sharp, forthright strokes of the brush, the fresh, moist ink, the contrasts of color, and the contrast between the solid and the void give one a sense of innocent beauty. Dong Qichang completed this painting while traveling along the Yangzi River on his way to Suzhou. The scenery on the trip and the time he spent appreciating ancient paintings with friends so delighted him that both his brushwork and his colors reflect that cheerful mood. Reading the accompanying poem first and then examining the painting leads the viewer into a realm beyond the scene itself. The intellectual dimension or

218. Dong Qichang, *The Qingbian Mountains,* hanging scroll, ink on paper, 1617. (© Cleveland Museum of Art, 1997, Leonard C. Hanna, Jr., Bequest, 1980.10.)

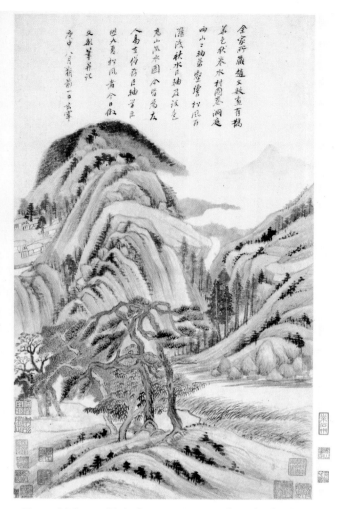

219. Dong Qichang, *Eight Scenes in Autumn,* album leaf, ink and color on paper, 1620. 53.8 × 37.7 cm. each. Shanghai Museum.

perspective is very similar in Ming poems; unlike Tang poems, which prefer the simple, straightforward style, these are particular about the source of every word. They frequently contain allusions and are forceful and sonorous in rhyme, rhythm, and tone. The content is rich and profound, though increasingly removed from real life. This rarifying trend is the outcome of the pursuit of Dong Qichang's intellectual perspective — hence the call by Shitao during the Qing dynasty for a "return to nature."[11]

At almost at the same time as the Huating School of Dong Qichang, the professional artist Lan Ying (1585–1664) and his students were active in Hangzhou, in Zhejiang Province. These artists are referred to as the Wuling School because Hangzhou was called Wuling in ancient times, but they were also known as the Later Zhe School because Lan Ying was from Zhejiang. When Lan Ying was eight years old, "he participated in a sacrifice-offering ceremony and painted a landscape on the ground with the ashes. The painting was small, but it had the breadth of a giant landscape."[12] Notwithstanding this

exaggerated account, Lan Ying was a prodigy. Because his family were poor they sent him to a local art studio where he could learn painting as an apprentice. There, at the beginning of his career, he made paintings of architectural features and beautiful women, using meticulous brushstrokes. As he grew up, he realized that if he wanted to be an artist of high social status, he must associate with scholars and learn the techniques of literati painting. Toward this end he began to travel extensively, visiting distinguished artists of the time. In addition to seeing local scholars, he went to Songjiang and Nanjing to call upon Dong Qichang, Chen Jiru, Sun Kehong, and Yang Wencong (1597–1645). He had two purposes in mind — to ask for instruction and to seek their approval — and he got what he wanted. In the inscription to *Landscape in the Manner of Huang Gongwang* (National Palace Museum, Taibei), Chen Jiru wrote, "There is simplicity and vigor in the mountains, and vitality and richness in the plants. This is Zhang Boyu's [Zhang Yu's] comment on Zijiu's [Huang Gongwang's] paintings. If he should see this painting by Tianshu [Lan Ying], even as the scroll began to unfurl he would know that a great talent had been born, and would store the painting lest it be lost to the winds." A reference to the Jin-dynasty painter Gu Kaizhi shows that Chen Jiru thought highly of Lan Ying.

It was fashionable for literati painters of that time to imitate artists of earlier generations, indicating that their paintings were "after so-and-so" to show off how cultured they were. Lan Ying was no exception, and he often wrote on his paintings, "This painting is done in imitation of so-and-so." He imitated more than twenty artists, some of whom lived as early as the Tang dynasty, including the most prominent artists of both the Southern and Northern Schools. However, unlike many of his contemporaries, he would not label his paintings as done in imitation of some ancient artist. For these works he took pains to study the brushwork of his model artist. Although there is doubt about the authenticity of the works of some of the earlier artists he imitated, Lan Ying was making every effort to learn from the ancients. With that solid foundation and his masterful skill, he was able to produce accomplished paintings with a brandish of the brush. The works he did during middle age were meticulous; his style became more casual in later years. But the skills he learned during his early years as a professional artist were always present, which differentiates him from other painters.

Lan Ying's *Landscape in the Manner of Li Tang* (Shanghai Museum), painted in 1631, was executed deftly because Li Tang's style was so similar to his. The painting depicts

two scholars reveling in the landscape, illustrating the idea of aloofness. In the foreground is an autumn forest, with overlapping age-old trees in a variety of colors. In the forest there are houses and a pavilion in which the scholars sit chatting. In the background mountains rise straight up, with cataracts pouring down the slopes. The skillful technique and composition are far beyond the reach of most literati painters. Although Lan Ying intended to depict the life and ideas of scholars, most of his scenes are superficial rather than thought-provoking.

In *White Clouds and Red Trees* (Palace Museum, Beijing), painted in 1658, the artist's inscription says that he was "imitating Zhang Sengyou's bone-immersing technique." The works of Zhang Sengyou, an artist of the Southern Liang dynasty in the first half of the sixth century, were no longer in existence by the Ming dynasty, but Ming artists believed that alternating red and green in painting landscapes was the style of the Six Dynasties. Dong Qichang also imitated paintings of this type. In Lan Ying's painting, the rows of mountains were painted with azurite and mineral green, and ancient trees on the mountain slopes and at the foot of the mountains were dotted with red, white, light blue, and light green leaves. He used a white powder for the clouds, and, indeed, the entire painting has a bright tone. The artist could have blurred the outlines for a more impressionistic effect, but he restricted himself to the techniques of professional artists, who inevitably left their imprint on his work.

The earlier artist whose works Lan Ying studied most was Huang Gongwang, for Huang was the model artist for the Ming literati painters whom Lan Ying aspired to join. His *Landscape in the Manner of Huang Gongwang* shows why Lan Ying's paintings were noted for their careful composition and balanced spatial structure and were popular at the time. But his brushwork, at once vigorous and unrestrained, invited criticism as well as acclaim. Qin Zuyong aptly commented in his *Tongyin lunhua:* "The skill of this artist is indeed superb. The trees and rocks look rustic and unrestrained. If he had moderated his brushstrokes he might well have rivaled Wen Zhengming and Shen Zhou." [13]

Portrait and Figure Painting in the Late Ming

Following the fall of the Song dynasty, religious fervor gradually died down, and fewer and smaller cave grottoes and temples were made or built. With the decline of religion, Ming figure painting lost its biggest patron and receded in importance until the late Ming. A small renaissance occurred with the emergence of figure and portrait painters such as Ding Yunpeng, Wu Bin, Chen Hongshou, Cui Zizhong, Zeng Jing, and Xie Bin.

Ding Yunpeng (1547–1621), a native of Xiuning in Anhui Province, excelled in painting religious figures. His most representative works are *Five Forms of the Bodhisattva Guanyin* (fig. 220), *Guanyin* (Palace Museum, Beijing), and *Masters of the Three Religions* (fig. 221). In the first painting, the five Guanyins, each looking different from the others, are meticulously executed. The composition gives one a feeling of spaciousness, for the blue in the background sets off the white robes of the Guanyins, accentuating the grace and splendor of each. During the latter years of his life, Ding Yunpeng used bolder brushwork. His *Guanyin* shows the bodhisattva holding a little boy in her arms, resembling a Western Madonna and Child, which is unprecedented in the traditional portraits of Guanyin. The twisting parallel folds of her robe also bear a close resemblance to the folds in a Western Madonna's robe. One factor that may be responsible for this is that when the Italian missionary Matteo Ricci came to China in the mid-sixteenth century, he visited the Nanjing area several times, bringing with him copperplate engravings of Madonnas. Ding Yunpeng may have seen the engravings; if so, this work would represent the earliest Western influence on Chinese painting.

The landscape paintings of Wu Bin (active ca. 1573–1620), a native of Putian in Fujian Province, are somewhat bizarre. His grotesque rocks create a fantastical image which is purely from the artist's imagination. Yet Wu Bin was also a painter of religious figures, as in *Five Hundred Arhats* (fig. 222), which portrays an enormous number of Buddhist disciples in a variety of postures and gestures. The arhats have facial expressions that are almost comical, in contrast to the arhats of the Tang and Song dynasties, which exuded solemnity and wisdom. *Portrait of the Buddha* (fig. 223) features the Buddha Shakyamuni sitting cross-legged on a rush mat on top of a huge rock. The folds of his garment, drawn with stiff, hard, regular lines create an impression of childlike innocence. The wave and whirlpool designs on the rock platform are produced by rubbing, the same method used to create his fantastic mountains and rivers. Ding Yunpeng's and Wu Bin's portraits of religious figures were no longer primarily for reverential purposes; these works were increasingly intended for aesthetic appreciation.

Among the figure and portrait painters of the late Ming, Chen Hongshou and Cui Zizhong stand out. As they were born in different regions, they were known as "Chen in

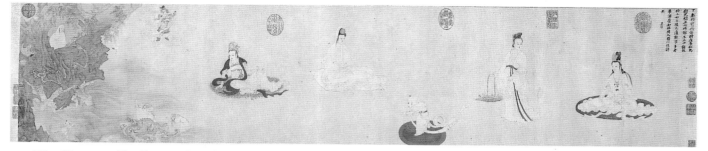

220. Ding Yunpeng, *Five Forms of the Bodhisattva Guanyin,* handscroll, ink, color, and gold on paper, ca. 1580. Nelson-Atkins Museum of Art, Kansas City, Missouri. (Purchase: Nelson Trust.)

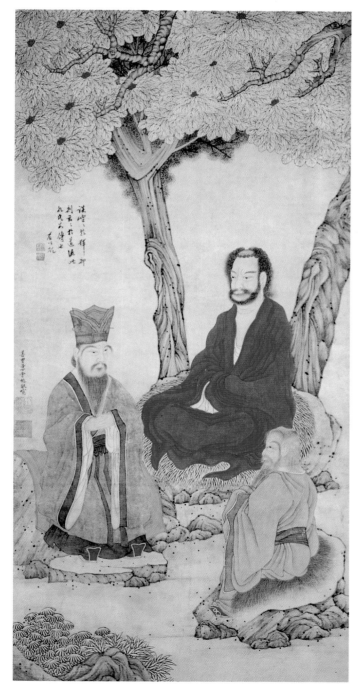

221. Ding Yunpeng, *Masters of the Three Religions,* hanging scroll, ink and color on paper, Ming dynasty. 115.7 × 55.8 cm. Palace Museum, Beijing.

the South and Cui in the North." Linking two names like this is a customary way of expressing acclaim for outstanding individuals that in no way indicates similarity in their artistic styles.

Cui Zizhong (d. 1644) was from Laiyang in Shandong Province and lived in Beijing. He was once a county scholar, but after repeatedly failing the civil service examinations, he gave up the idea of entering officialdom and devoted all his time and energy to painting. When Dong Qichang was at court tending to imperial family affairs, Cui presented him with one of his own works in the hopes of gaining Dong's recognition. Because he was unwilling to sell his paintings for a living, Cui lived in dire poverty. He was also unsociable by nature, seldom mixing with others, and when the Ming dynasty fell in 1644, he shut himself up in a mud hut and starved himself to death.

Judging from the few of Cui's works that have survived, most of his paintings were depictions of historical or supernatural figures. *Capturing Clouds* (Palace Museum, Beijing), painted in 1626 and based on an episode about the Tang poet Li Bai, depicts Li Bai admiring the clouds. Clearly the artist did not intend to tell the story of the poet bottling the clouds but rather to celebrate the extraordinary nature of the poetic act. The mountains, rocks, and trees in the background call to mind Song landscapes. *Entertaining a Guest in the Apricot Garden* (fig. 224), painted by Cui in 1638 for his friend Wang Yuzhong, is one of his best. The image of two friends seemingly discussing a poem or an essay in a garden with blossoming apricot trees may be a portrait of the artist and Wang Yuzhong, or it may simply depict two friends. One is reminded of Tao Yuanming's famous lines, "Together we appreciate the unique work, exchanging and analyzing our different views." The painting is clearly about friendship, and the brightly colored background and figures further accentuate the harmonious atmosphere.

Cui Zizhong followed the traditions of professional painters. The postures of the figures and the apricot trees

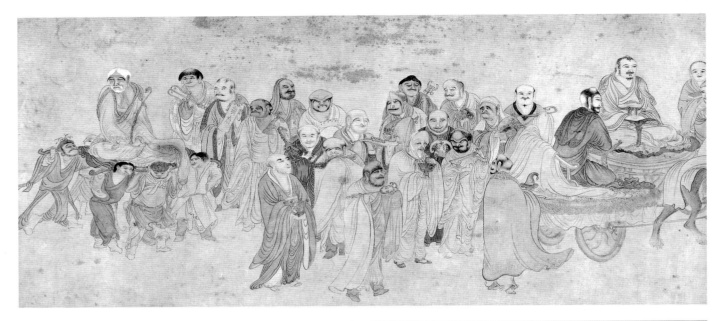

222. Wu Bin, *Five Hundred Arhats,* section of a handscroll, ink and light color on paper, Ming dynasty. (© Cleveland Museum of Art, 1997, John L. Severance Fund, 1971.16.)

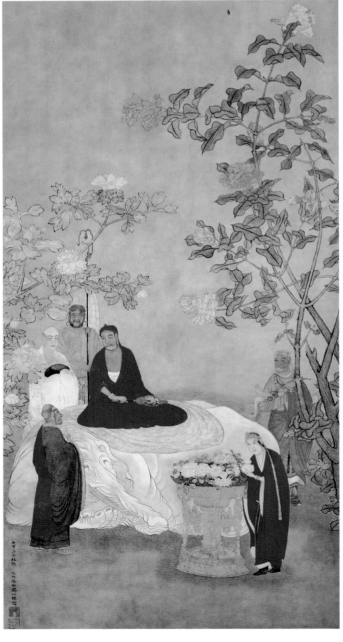

223. Wu Bin, *Portrait of the Buddha,* hanging scroll, ink and color on silk, Ming dynasty. 146.2 × 76.3 cm. Palace Museum, Beijing.

in the latter painting recall Qiu Ying's *Evening Banquet in the Peach and Plum Garden* (Chionin, Kyoto), and the rocks greatly resemble those of Shi Rui, although there may be no direct link between Cui Zizhong and the earlier artists. Nevertheless, Cui pursued a classical form of expression, and Qiu Ying was an expert at imitating past painters, whereas Shi Rui modeled his paintings on the landscapes of Northern Song. Cui did not allow his technique to be swept along by the raging tide of literati painting.

Cui Zizhong's *Xu Zhengyang Moving His Family* (fig. 225) deals with a supernatural theme. The story goes that Xu Xun of the Eastern Jin, becoming imbued with the Daoist spirit, soared into the sky, along with his family, and was henceforth worshiped by Daoists as an immortal. There is another extant painting on the same theme by the same author (National Palace Museum, Taibei). According to Cui's inscription, he had seen many ancient drafts (*fenben*) of paintings on the same theme before he created his. He admits to imitating those works but never let himself be bound by them. As none of these drafts is available, there is no way of comparing them. However, the painting does recall Wang Meng's *Ge Zhichuan Moving His Dwelling* (see fig. 163). Coincidentally, Wang also had two versions of this painting, one in the meticulous style, from the early years of his life, and the other rough, from his later years. Although the characters and episodes the artists portrayed were quite different, their common aim was to use the supernatural theme to convey the idea of escaping from the turmoil of the human world. As Wang Meng lived the majority of his life at the end of the Yuan dynasty and Cui Zizhong saw the decline of the Ming, the two shared a discontent caused by political and social unrest, and it is not coincidental that they both dwelled on the same theme.

Cui Zizhong's pursuit of classical expression continued the traditional techniques passed down from professional painters in the early Ming. This carryover and the ideas and sentiments he shared with men of letters merged to produce his own painting style. Wu Weiye, one of the noted artists of the time, linked Cui with the other significant artist: "Whose works are immortal after these forty years? Cui Qingyin [Cui Zizhong] in the north and Chen Zhanghou [Chen Hongshou] in the south."

A native of Zhuji in Zhejiang Province, Chen Hongshou (1598–1652) was as much a failure as Cui in his attempt to enter officialdom through the civil service examinations. However, the two were totally different in character. Chen liked liquor and women and led an unrestrained, dissolute life. He was socially well connected and was at one time the student of such well-known scholars as Liu Zongzhou and Huang Daozhou. In 1642, he was admitted into the highest educational institution as a student. Later, he was enlisted by the imperial family to copy portraits of emperors of the various dynasties. As it was a time of political instability and he was not interested in being a court painter, Chen left for home after a year. In 1645, when Qing troops pushing south took Zhejiang Province, many of Chen's teachers and friends sacrificed their lives to defend the Ming. Captured by Qing troops himself, Chen narrowly escaped death. He shaved his head and became a monk, adopting the names of Huiseng (Repentant Monk), Huichi (Belated Repentance), and Chiheshang (Late-Coming Monk). The many extant works signed "Repentant Monk" or "Belated Repentance" were all done by Chen after the fall of the Ming.

Chen Hongshou was a talented artist who matured early. It is said that when he was only four years old he painted a portrait more than three meters high of Guan Yu, a noted general during the period of the Three Kingdoms. At fourteen, he was able to bring in some money by selling his art works. At the age of nineteen he made a series of woodblock prints to illustrate *The Nine Songs* by the ancient poet Qu Yuan of the state of Chu. The basic outline of his style in figure painting was already present. Chen became well known as an illustrator of plays and other literary works, as well as a designer of pictures for playing cards. Still extant are his illustrations for the *Romance of the West Chamber* and loose-leaf woodblock prints of *Outlaws of the Marsh* and *Antiquarian Playing Cards*. During his childhood, Chen made many copies of the stone engravings of Confucius and his seventy-two disciples that are said to have been drawn by Li Gonglin. He also received instruction from Lan Ying that laid the groundwork for his figures and landscapes.

In Chen's figure paintings, the faces are often exaggerated, the garments drawn at whim, disregarding the person's bone structure. Although many modern critics classify these works as "distortions," Chen Hongshou himself saw this technique as the revival of an earlier method. A good example is his *Lady Xuan Wenjun Giving Instructions on the Classics* (fig. 226), painted in 1638, when he was forty-one, in the prime of life. The painting, a gift to his aunt on her sixtieth birthday, was meticulously executed. Lady Xuan Wenjun was a scholar who educated her sons so well that Emperor Fu Jian of Qianqin (350–394) set up a class in her home where she taught 120 pupils the book *Zhou guan,* a classic on government administration which almost no one else could comprehend. Chen's aunt, a widow, must have been a very knowledgeable

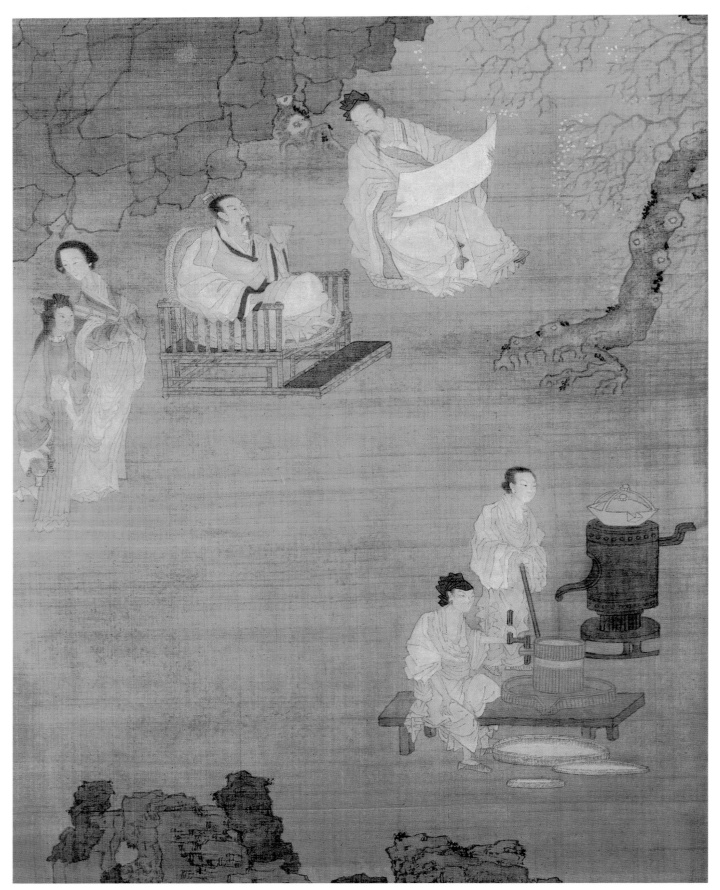

224. Cui Zizhong, *Entertaining a Guest in the Apricot Garden,* hanging scroll, ink and color on silk, 1638. Nicholas Cahill Collection, on extended loan to the University of California, Berkeley, Art Museum.

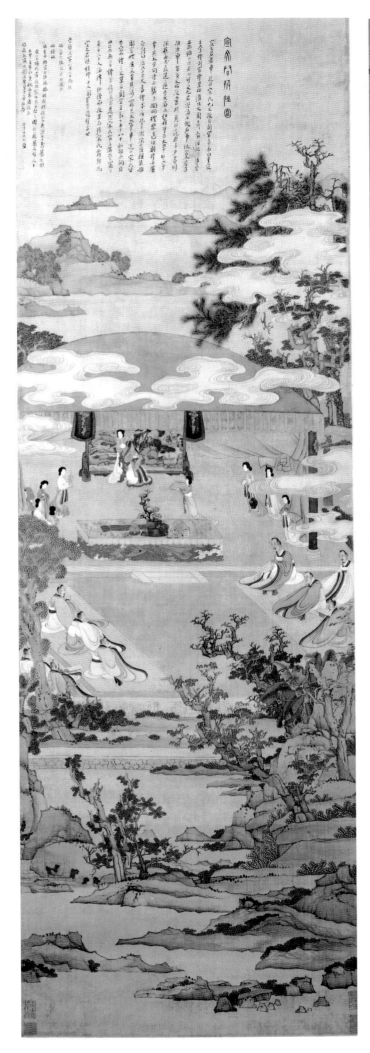

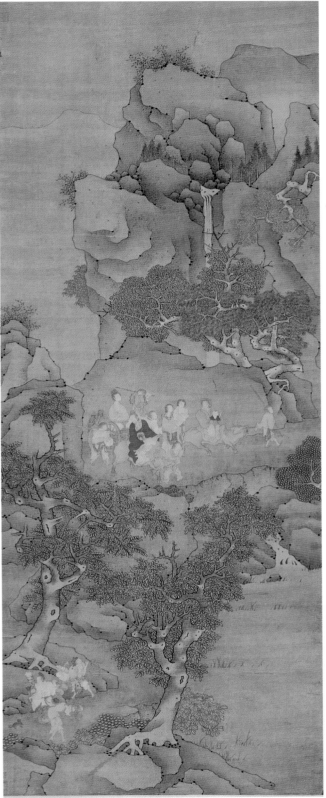

225. Cui Zizhong, *Xu Zhengyang Moving His Family,* hanging scroll, ink and color on silk, Ming dynasty. 165.6 × 64.1 cm. (© Cleveland Museum of Art, Mr. and Mrs. William H. Marlatt Fund, 1961.90.) *above*

226. Chen Hongshou, *Lady Xuan Wenjun Giving Instructions on the Classics,* hanging scroll, ink and color on silk, 1638. (© Cleveland Museum of Art, 1997, Mr. and Mrs. William H. Marlatt Fund, 1961.89.) *left*

woman, and he expressed his admiration for her in the painting of Lady Xuan Wenjun. Whether the comparison is appropriate or not, the work itself is a portrait of a historical figure based on the artist's imagination. To make it as accurate as he could, Chen paid a lot of attention not only to the design of the hall, the furnishings, and the objects on the table but also to the figures, garments, and decorations. The maids have delicate, agile figures, their long, loose gowns reaching the ground. The men, with their exaggerated faces and loose-sleeved robes, bear a definite resemblance to figures of the Six Dynasties period. The figures could very well have been modeled on those in *Admonitions of the Court Instructress to Palace Ladies* (see figs. 39, 40, 41) and *Wise and Benevolent Women* (see fig. 38), reputedly the works of Gu Kaizhi. At that stage of development, figure drawing tended to be simple and childishly clumsy. It was Chen Hongshou's expressed wish to revive that style.

Returning Home (fig. 227) was painted in 1650 for his old friend Zhou Lianggong, a collector and connoisseur of calligraphy and paintings. In his book *Duhualu* (Readings on paintings), Zhou highly praised Chen Hongshou. Their relations became estranged, however, following the fall of the Ming because Zhou accepted an official post under the Qing administration. At first, Chen ignored Zhou's repeated requests for a painting. Finally, he presented Zhou with this work, which is based on the well-known essay of the same title by Tao Yuanming. The theme had been a favorite one among painters since the Song and Yuan, but Chen Hongshou did not try to interpret and depict the contents of the essay. Rather, he reorganized the topics according to his own plan to depict the integrity of Tao Yuanming and his likes and interests. Altogether he painted eleven segments, on the topics of picking chrysanthemums, concentrating strength, planting sorghum, going home, lacking wine, removing the seal (giving up his post) and returning to his country home, borrowing wine, admiring a fan, rejecting gifts, begging, and straining wine. Each segment is a painting by itself, with a title and a short explanation, each expressing an idea. Chen could have been inspired by painting illustrations for plays and cards. The figures and their garments are in a highly formalized style associated with Six Dynasties painting, but the postures are replete with emotion.

For example, in the segment *Picking a Chrysanthemum,* the man holds the chrysanthemum to his lips as though kissing it, an expression of deep love. The accompanying lines read, "With the yellow flower just beginning to blossom and wine to quench my thirst, what else can I ask for?" In *Removing the Seal,* Tao Yuanming removes the official seal and hands it to the servant boy while he stands, head held high in the wind, his determination never to turn back etched on his face. Chen wrote these words on the picture, "To make a living, I came; refusing to bend my back, I leave — the way out of a tumultuous world." The segment entitled *Returning Home* shows Tao Yuanming walking with a stick, his garment and belt swept up by the wind; he appears impatient to return home and live a secluded life. The accompanying couplet reads, "The pines yearn for me; how can I not return?" In this painting, Chen Hongshou portrays Tao Yuanming with an easy, casual demeanor. Chen embodied his admonition to Zhou Lianggong in both the poetic lines and the painting. It is not recorded how Zhou reacted to this painting, but he stayed in his post as a Qing government official and later barely escaped death at the hands of Qing rulers. After being removed from office, he wrote a biography of Chen Hongshou in which he deliberately altered when Chen presented him with the painting to before the fall of the Ming dynasty. He may have regretted ignoring his friend's admonition to return home earlier.

Chen Hongshou's *Shen An Wearing Flowers in His Hair* (fig. 228), *A Literary Gathering* (Shanghai Museum), and *Life of a Recluse at Shiliuguan* (National Palace Museum, Taibei) are among the finest examples of figure painting, each imbued with a profound idea and executed according to a well thought out plan. While painting *Literary Gathering at Xiyuan* (Palace Museum, Beijing), his last work, Chen had to stop halfway owing to serious illness. In 1725, seventy-three years after his death, the noted painter Hua Yan of Yangzhou completed the painting. In landscape and bird-and-flower paintings, too, Chen Hongshou displayed great creativity. His daring in cutting out extraneous elements, his novelty in composition, the rich decorative flavor, and the strong projection of character are unique in Chinese painting and have left their imprint on Chinese painters to this day.

The skills and methods of portrait painting during the Ming, a viable way of earning a living that was supported by society, were usually passed down from father to son and from master to apprentice. Painters and ordinary craftsmen had a similar way of life and work except that the former, being engaged in artistic labor, were granted slightly more respect and were addressed as "sir" or "master painter." Outstanding local specialist figure painters were often recruited for service in the palace. Yet neither court nor professional portrait painters left their names on their works. One of the first Ming portrait painters to

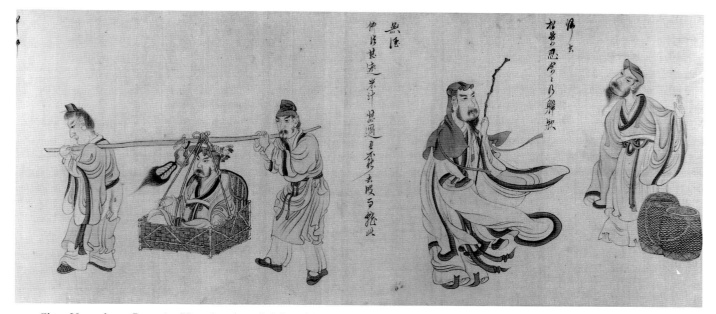

227. Chen Hongshou, *Returning Home,* handscroll, ink and light color on silk, 1650. Honolulu Academy of Arts. (Purchase, 1954.)

be recorded in art history was Zeng Jing.

Zeng Jing (1564–1647), a native of Putian in Fujian Province, resided in Nanjing. A professional painter, his portraits were so highly respected that scholars invited him to their homes to paint for them. He painted portraits of such well-known individuals as Dong Qichang, Chen Jiru, Wang Shimin, Lou Jian (1567–1631), and Huang Daozhou. Because portraiture required that the painter be in the presence of the person portrayed, Zeng Jing constantly moved around, working in Nanjing, Hangzhou, Wuzhen, Ningbo, Songjiang, and other cities. His income from painting was sufficient to provide him with well-furnished living quarters wherever he went. His portraits were described as breathtakingly real, as though they were reflections of the sitter in the mirror. The facial expressions were said to be exactly like those of the real person. Zeng Jing reached maturity in portraiture at about the age of fifty and was at the height of his creativity at seventy.

Portrait of Wang Shimin (fig. 229), which he painted in 1616, is his earliest existing work. Wang was a scholar-painter and the oldest of the Four Wangs of the Orthodox School of landscape under the Qing. At the time this portrait was painted, Wang was only twenty-five. Wearing a light-colored gown and a head cloth, he sits cross-legged on a rush hassock, a horsetail duster in his hand. He has a handsome face and delicate features, but looks quite serious and serene, more mature than his age — as might be expected of someone with his family background in civil service and his strict education. The painting also differs from portraits by local specialists in that, rather than filling the entire space of the painting, the figure occupies only the lower central part of the space.

In fact, highlighting a person's character and aspirations by surrounding the figure with empty space is the most characteristic feature of Zeng Jing's portraits. His *Portrait of Zhang Qingzi* (fig. 230), painted in 1622, is of a famous doctor well versed in poetry and literature who was dubbed "a scholar in doctor's garb." In the painting, Zhang is dressed in a light-colored robe and wears a pair of red shoes. With one hand smoothing his beard, he is walking at ease. The figure occupies about one-third the length of the scroll. No background is provided, but one gets the feeling that Zhang Qingzi is walking out in the open. The kind and benevolent countenance of the man is that of a doctor who saves people's lives. Moreover, the large areas of empty space are associated with the elegant manner of a scholar and recluse. Thus, even though the size of the figure is small, his character looms large.

Zeng Jing was an expert in the traditional method of bringing the person's character into sharp relief by portraying him in action and by emphasizing his surroundings and possessions. *Portrait of Ge Yilong* (fig. 231) shows the scholar wearing a black headcloth and a white frock and seated leaning on a pile of books. Ge Yilong was known as a bookworm who spent enormous sums of money on books and ended up bankrupt. To highlight his craze for books, Zeng Jing shows no other possessions in the picture. Yet Ge's posture and clothes reveal his disdain for worldly concerns.

Many critics consider Zeng Jing's portrait painting significant because of his assimilation of the illusionistic concave and convex method of Western oil painting. Actually, illusionism is an inherent part of the Chinese painting tradition. In his book *The Principles of Painting,* Dong Qichang quoted the ancients as saying that "every

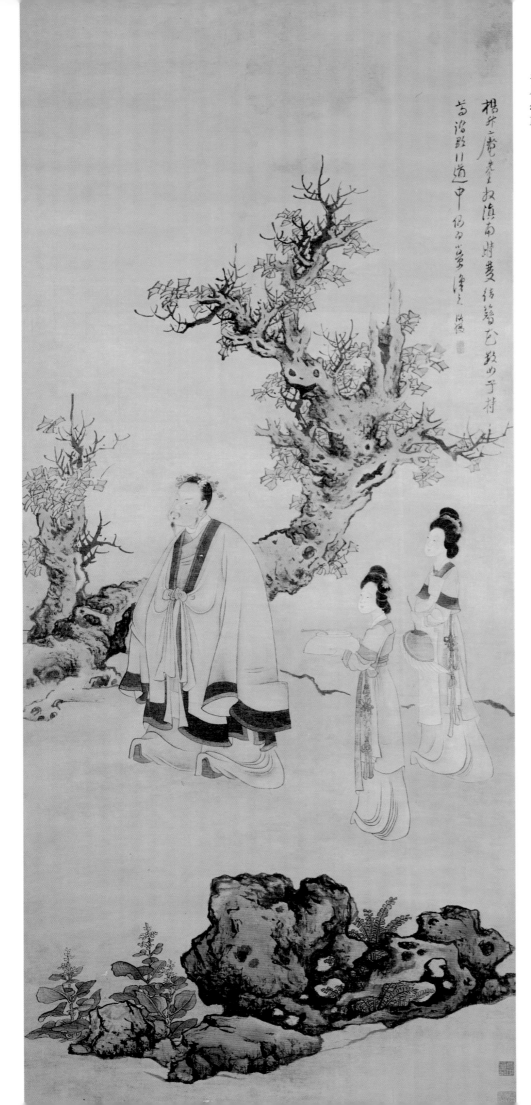

228. Chen Hongshou, *Sheng An Wearing Flowers in His Hair,* hanging scroll, ink and color on silk, Ming dynasty. Palace Museum, Beijing. 143.5 × 61.5 cm.

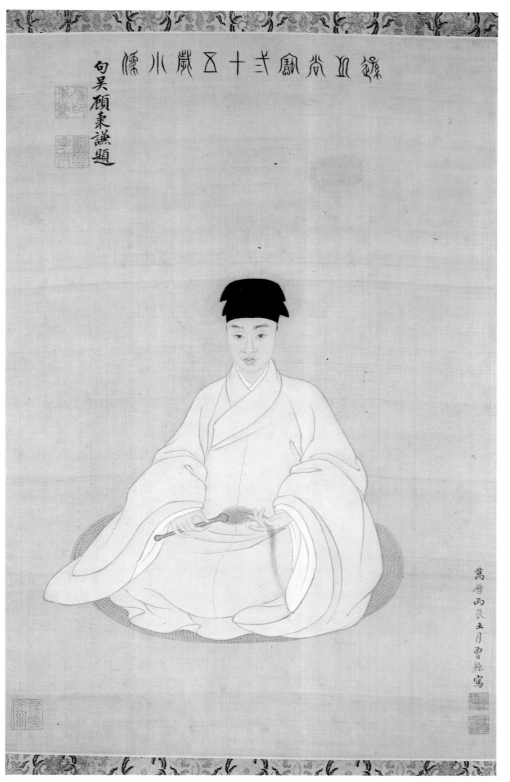

萬曆丙辰五月曾鯨寫

229. Zeng Jing, *Portrait of Wang Shimin,* hanging scroll, ink and color on silk, 1616. 64 × 42.3 cm. Tianjin Art Museum.

brushstroke stands out." The difference between the Western and Chinese traditions lies in the way the spatial illusion is achieved. Zeng painted portraits which captured each sitter's reflection as in a mirror. He made no optical adjustments, kept his viewpoint level, and painted with lines and very few shadows, thereby preserving the natural protrusions and sunken parts of his subject's face. What are known in painting as the "three white spots" (the brow, nose, and lips) stand out. Zeng Jing's achievement in portrait painting is that, having inherited the legacy of Wang Yi of the Yuan dynasty and assimilated the methods and skills of local specialists, he raised the aesthetic value of portraiture — a portrait became something to appreciate, not just a keepsake — and paid increased attention to the depiction of facial expressions. A good observer, he was quick to capture human ges-

tures and expressions, and was expert at using empty space in his compositions to emphasize them.

Among Zeng Jing's disciples and followers, known as the Bochen School, Xie Bin (1601–1681) was the most accomplished. Born in Shangyu, Zhejiang Province, he inherited Zeng Jing's techniques but was more scholarly in his compositions. His *Portrait of Zhu Kuishi* (see fig. 250), done in 1653, was painted in black ink without any color. Zhu Kuishi, wearing an official robe, sits on a stone, his complexion clear and his face thin and smiling. In the background are giant pine trees, green and profuse, painted by Xiang Shengmo (1597–1658). Although the painting is a collaboration between two artists, it is still harmonious. It seems that the two artists frequently worked closely together. The four-character title, "Dense Pine Forest," was written in seal script by Xiang Shengmo. Xie Bin's *Carefree Immortal Among Waves of Pines* (Jilin Provincial Museum) is a portrait of Xiang Shengmo. Similar in theme to the previous image, this painting has a figure more casual in his posture and clothing. The background pine trees were later painted by Xiang himself.

Female Artists

In Chinese society, for several thousand years women's position was subordinate to men's. Feudal rulers promoted Confucian doctrines known as the Three Obediences and the Three Cardinal Guides as the ideological basis for social stability. The Three Obediences were that a woman was required to obey her father before marriage, her husband during married life, and her sons in widowhood. The Three Cardinal Guides were that ruler guides subject, father guides son, and husband guides wife. From birth to death women had no independent social status, their actions and the expression of their ideas was restricted, and their individual personalities and talents were stifled. As a result, there are few female artists in Chinese history. This began to change toward the end of the Ming dynasty, when their number began to increase. According to Tang Shuyu in *Yutai huashi* (The jade platform history of painting), of the 216 known female artists from ancient times to the reign of the Jiaqing emperor (r. 1796–1820) of the Qing dynasty, half lived during the Ming dynasty and four-fifths of these lived during the late Ming.[14] Despite women's circumscribed role in society, female painters were able to work owing to either a family tradition of painting or artistic training

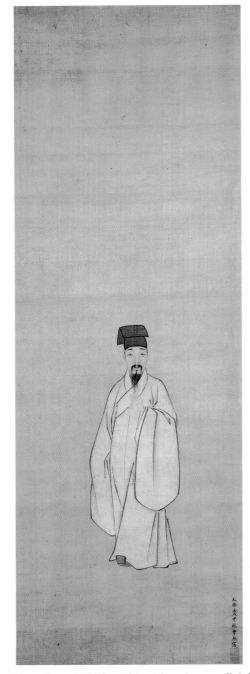

230. Zeng Jing, *Portrait of Zhang Qingzi,* hanging scroll, ink and color on silk, 1622. 111.4 × 36.2 cm. Zhejiang Provincial Museum.

as preparation to be a concubine or prostitute.

Among the most noted female artists of the Ming dynasty was Wen Shu (1595–1634), who was a daughter of Wen Congjian (1574–1648) and great-granddaughter of Wen Zhengming. She married Zhao Jun, son of Zhao Huanguang. Wen Shu's father inherited the family tradition and was good at landscape painting. Her father-in-law, a scholar, excelled in seal script calligraphy; her husband's expertise was seal carving and he loved to collect seals. Sometimes, after she completed a painting, her

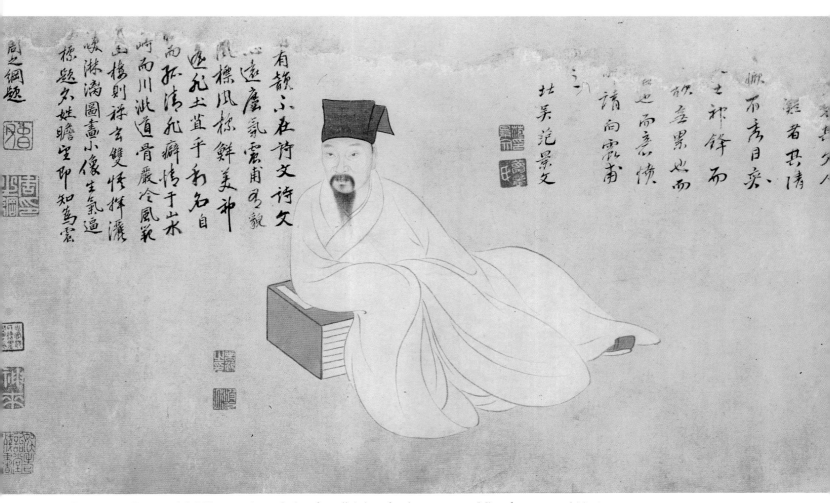

231. Zeng Jing, *Portrait of Ge Yilong,* section of a handscroll, ink and color on paper, Ming dynasty. 30.6 × 78 cm. Palace Museum, Beijing.

husband wrote the inscription. Wen Shu's works featured flowers, grass, and insects. *Sketches of Flowers and Butterflies* (Shanghai Museum), painted in 1628, is typical of Wen Shu's work. Using color on paper, she painted three types of flowers, a stone, and three butterflies. The composition of the painting is spare, giving a sense of quietude and void. The butterflies are meticulously executed and true to life. The flowers, two or three blossoms of each type, rarely overlap one another. Her brushwork is moist and delicate. The colors are bright but not gaudy, and the flowers have an exquisite beauty. Wen Shu's composition of flowers is rather simple, somewhere between a sketch and a painting, which she may have borrowed from artisanal embroidery. At that time, every girl was supposed to be good at needlework, and the four skills required of a woman included spinning, weaving, embroidery, and sewing. It is only natural that Wen Shu sometimes adopted patterns characteristic of embroidery in her paintings.

In a painting of 1630 on yellow paper, *Daylily and Rock*

(fig. 232), a rock is rendered in somewhat heavy but still delicate brushstrokes. A daylily, with elongated green leaves and yellow flowers, grows behind the rock. The color is pleasantly subdued and the composition simple. Traditionally, a daylily expresses filial piety; this image might have been used to celebrate an elderly person's birthday because the rock, representing a mountain, is a symbol of longevity. In addition, vermilion on a gold background are the colors of jubilant occasions for the Chinese.

Women who were not born into artistic families had few outlets for creativity, but there was another entree into the world of painting. It was not uncommon for scholars and officials to take concubines or to frequent prostitutes, who were expected to be accomplished in the arts and often had received instruction in painting. A powerful and wealthy person might also own a large number of boys and girls who performed songs and dances for him. The city of Yangzhou was a famous center for training entertainers who came from poor fami-

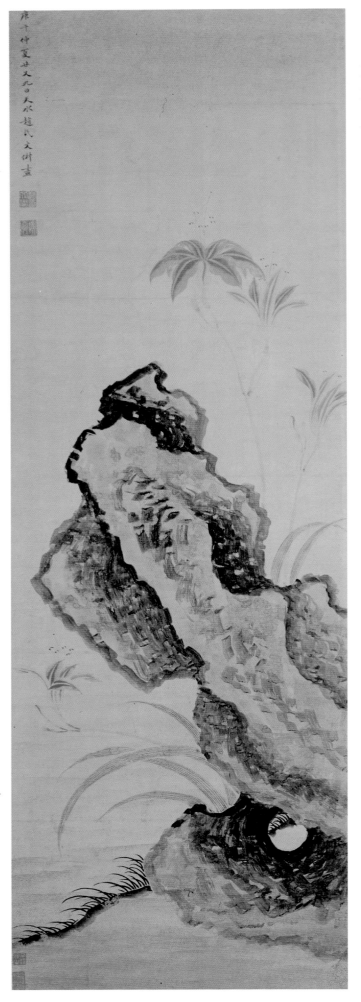

lies. After they were sold, the girls were trained to sing, play musical instruments, play chess, and create paintings and calligraphy. Then they were sold again, this time at a very high price, to a man as his concubine or to a brothel. If the woman was beautiful as well as artistically talented, she was able to ask a high price from her clients. Prostitutes who became artists include Ma Shouzhen, Xue Susu, Kou Mei, Gu Mei (1619–1664), and Li Yin.

Ma Shouzhen (1548–1604) was a famous prostitute in the Qinhuai area in Nanjing.[15] She was particularly intimate with the scholar Wang Zhideng, who often wrote poems on her paintings. Orchids (accompanied by bamboo and rocks) are the subject matter for most of her paintings. In *Orchid and Bamboo* (Jilin Provincial Museum), she painted the orchid using the double outline technique, with rocks in the back interwoven with bamboo. The inscription reads, "An imitation painting presented to the poet Yan Ping for his comments." This is the way a man would have put it at that time. No respectable woman would have dared to give her painting to someone as a gift, but a highly cultured prostitute could.

Bamboo, Orchid, and Rocks (Palace Museum, Beijing), painted in 1604, was Ma Shouzhen's last work. She painted several layers of orchids with the double outline technique and monochrome ink method. The orchid's long leaves interweave with each other and dance in the wind. The beautifully arranged rocks, bamboo, and glossy *lingzhi* fungus set each other off, further enlivening the work. Her brushwork is that of an experienced artist, and her style is similar to Wen Zhengming's. She was strongly influenced by the Wu School in painting the orchid because Wang Zhideng was from Wu Prefecture and was a great admirer of Wen Zhengming. Expressing her appreciation for the lone orchid growing wild in nature, she wrote:

> The low cattail and mugwort are not worth
> cherishing;
> The orchid and bamboo in the field are more lovely.
> I forget their smell when I enter the room,
> Realizing there is a secluded hermit in the ravine.

Xue Susu (ca. 1564–ca. 1637) was a famous prostitute of Jiaxing, Zhejiang Province. It is said that when Dong Qichang was a private school teacher in Jiaxing before he became *jinshi* (a successful candidate in the highest imperial examination), he fell in love with Xue Susu the first

232. Wen Shu, *Daylily and Rock,* hanging scroll, ink and color on paper, 1630. Palace Museum, Beijing.

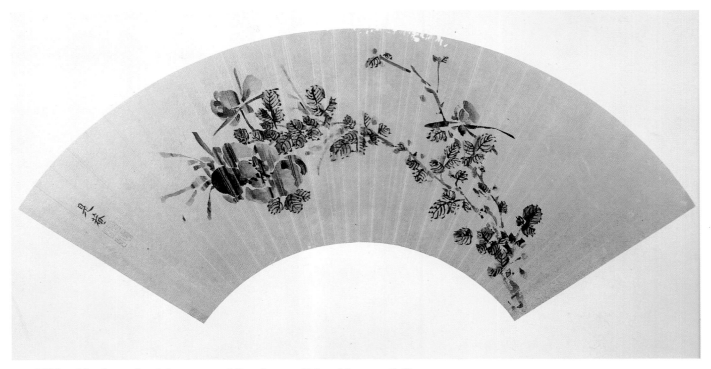

233. Li Yin, *New Season,* fan, ink on paper, Ming dynasty. Palace Museum, Beijing.

time they met. The artist Li Rihua (1565–1635) wrote the following comments on one of Xue Susu's paintings, *Bodhisattva Among Flowers:* "Xue Susu was good at playing the *zheng* [an ancient stringed musical instrument], spinning, embroidering, and adorning herself. She knew all entertainments that made men happy. As she got older, she wanted to have a child of her own but failed. Now she has done this painting to beg for the Goddess of Mercy's blessing on behalf of all couples who want to have a child."[16]

Xue Susu was proficient at writing poems and calligraphy and painting orchids, bamboo, and narcissus. Her *Orchid and Rocks* (Shanghai Museum) was produced in 1596. She was invited to a party of scholars by a person named Shu Qing, where seven people, including Wang Wenfan, Fang Wenxiao, Zhu Yunqing, and Fang Ying, wrote poems on that painting. Two clumps of orchids grow on the side of a cliff along with young bamboo. The image is painted in black ink in easy, smooth brushstrokes, the application of ink alternately thick and light, dry and wet. The poems on the painting hint that it was an impromptu work.

Li Yin (ca. 1616–1685) signed her paintings "Woman of Learning from Haichang." She was the concubine of Ge Zhengqi, who at one time served as the caterer for the imperial family. Li Yin liked to paint flowers on silk in black ink. The composition of her paintings was comparatively simple, but they are not as delicate as Wen Shu's. Most are imitations of themes of literati paintings. *Birds*

and Flowers (Shanghai Museum), painted in 1634 in ink on silk, depicts peony, magnolia, rose, lotus, hibiscus, pomegranate, hydrangea, chrysanthemum, and plum. Swallows, sparrows, and bluebirds frolic in their midst. The painting was an imitation of Chen Chun's work, down to the use of brush and ink. According to the comments on the painting written by Ge Zhengqi, she did the painting at his request when he served as a government official in Beijing. One wet autumn day, the rain-soaked flowers in his courtyard looked to him like a sickly beauty, so he asked Li Yin to paint a picture of them. He admired the scenes of rain and her painting. *Flowers in Four Seasons* (Honolulu Academy of Arts), executed fifteen years later, was also painted in ink on silk and has a similar content, but the composition and brushstrokes are much more mature and skillful. *New Season* (fig. 233) suggests the subject matter and style of Li Yin's paintings.

During the troubled final years of the Ming dynasty, gifted artists responded to and reinterpreted the great traditions of Chinese painting. Some followed in the footsteps of the literati masters, putting into practice Dong Qichang's orthodox prescriptions or perpetuating the academic modes of painting. Others pursued highly individualistic, often eccentric adaptations of past styles. Drawn from China's cultural heritage, Ming styles, attitudes, traditions, and innovations became part of the Chinese tradition that inspired the artists in the ensuing Qing dynasty.

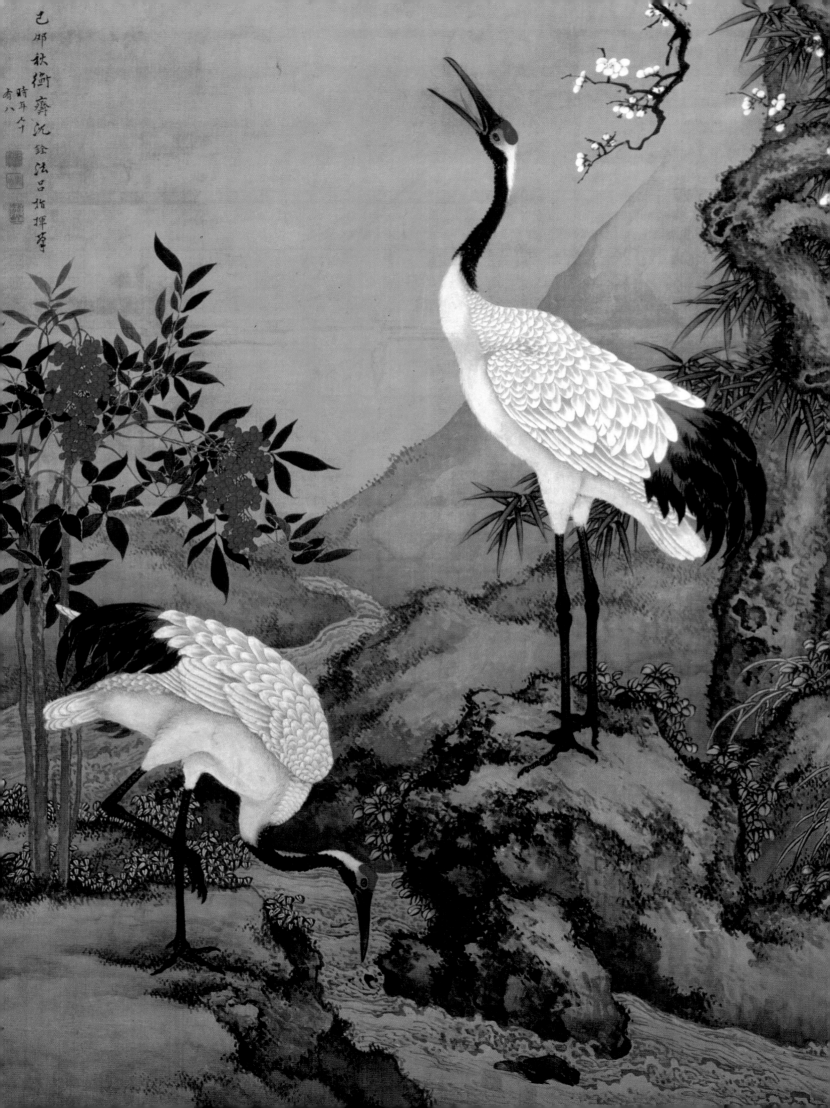

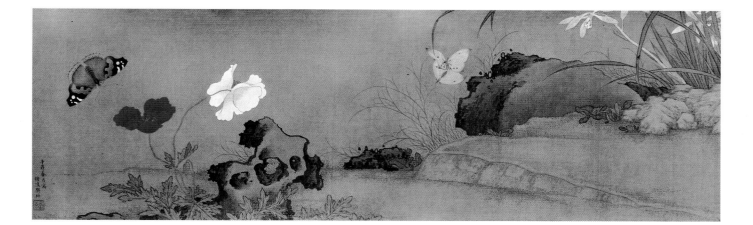

The Qing Dynasty (1644–1911)

The Qing, last of the feudal dynasties, was established by the Manchus, a non-Han people who originally lived in the Songhua River valley in northeast China. They ruled China for 267 years, from the time the Manchu army swept down the Central Plain to the abdication of the last Qing emperor, Puyi. The Manchus' overthrow of the Ming was violent, involving a great deal of bloodshed and destruction. This ruthlessness, and the fact that the Manchu, like the Yuan, emerged from one of the minority peoples, created hostility among the literati. Many took part in the armed resistance to the new dynasty that lasted until the 1680s; the less militant expressed their dissatisfaction in writings and paintings. Even after the firm establishment of the Qing regime, many people, mainly intellectuals, continued to advocate restoration of the Ming. They were called *yimin*—"leftover subjects," loyalists to the fallen dynasty—and their clash with the new regime reflected a strong national consciousness that pervaded the early years of the dynasty.

The Manchus became enthusiastic patrons of Chinese art. The Kangxi emperor (r. 1662–1722), among others, promoted regional schools of art and employed a number of court painters who specialized in decorative, colorful paintings, as well as in landscape compositions in the literati manner. From early on, the Qing emperors were also influenced by Western ideas and technology, especially by Western artistic traditions. Under the Qianlong emperor (r. 1736–1795), China entered a period of political,

Details, figure 274 (*opposite*) and figure 249 (*above*)

economic, and cultural supremacy, in which the empire's borders were expanded. The emperor played an active role in the arts, both painting and composing poetry himself and promoting court painters and sponsoring the publication of catalogues of the imperial collection.

Contact with the West, especially through Jesuit missionaries, increased, as did trade with European countries. Although Western trade was restricted in the mid-eighteenth century, Western engravings and oil and fresco painting techniques were known, and they had some influence on court and popular culture. As well, Western architectural styles influenced Chinese buildings. During the nineteenth century, China came under increasing pressure from Western powers, while rebellions by secret societies sapped the imperial coffers. The devastating opium trade with the British led to the forcible opening of Nanjing in 1842. The Treaty of Nanjing, which ceded Hong Kong to the British and imposed fixed import and export tariffs, was a catalyst for the revolt of the Taiping Heavenly Kingdom and other direct attacks on Qing control from 1851 to 1864. Foreign powers chipped away at the empire, demanding favorable trade, payment of indemnities, and other concessions, which were both costly and humiliating.

Brief attempts to regroup and rebuild during the late nineteenth and early twentieth century proved futile. Natural disasters, including floods and epidemics, and foreign debt caused the last dynasty of China to collapse, victim to the revolution of 1911.

Throughout the Qing, Chinese artists were forced to become conscious of their cultural tradition; they struggled to define it and to find the best way to preserve it. Following past masters, they embraced artistic traditions while reinterpreting them in creative and individualistic ways.

The Early Qing

After defeating the rebel leader Li Zicheng's peasant army, which had forced its way into Beijing, the Manchus marched swiftly southward, battling the remaining forces of the Ming dynasty. The defenders resisted stubbornly, prompting the Manchus to adopt brutal measures, sometimes slaughtering the entire population of a defeated city.

Even after the resistance movement ended, many Han literati and others refused to cooperate with the new regime and still looked upon themselves as subjects of the Ming dynasty. Many sought refuge in religion, becoming Buddhist monks. The longing for the fallen regime had an important bearing not only on Chinese history but on the development of Chinese art. We see this in the landscape paintings, which became a way for artists to express their deep dissatisfaction with their new world. By painting images that subtly evoked the fallen Ming nation, these artists could reveal their dissatisfaction with the Qing. By portraying dark and somber images of mountains and valleys, they could suggest a mood of melancholy or regret. By depicting trees growing upside down and cliffs suspended in the air, they could imply that they lived in a world that had been turned on its head.

The Four Great Monk Painters

The Four Great Monk Painters — Hongren, Kuncan, Bada Shanren, and Shitao — lived at roughly the same time; they all experienced the fall of the Ming. Kuncan, who had become a monk during the Ming, was deeply loyal to the fallen dynasty. Hongren, Bada Shanren, and Shitao were not very religious; they became monks to escape the foreign Manchu rule.

Hongren (1610–1664) was born in Shexian, Anhui Province. He turned away from the world, following the priest Guhang and becoming a Buddhist monk himself in 1646, when he realized that there was no hope of restoring the Ming dynasty. He lived in seclusion in the Qiyun Mountains but often traveled between Mount Huang and the Yandang Mountains, where he occupied himself with his painting. The mountains and streams became his only companions, and his paintings convey his understanding of them, his attempt to depict their true likeness. When he died, his friends and students buried him at the foot of Mount Huang's Piyun Peak. Because he was fond of plum blossoms, they planted several dozen plum trees around his grave. It was said that when these blossomed, they were like bright stars in the sky.

Hongren's landscapes, painted in sparing but highly refined brushstrokes, show the stylistic influence of the Yuan-dynasty painter Ni Zan. But Hongren differed from Ni Zan in his ability to impart life to his rocks and trees. Intriguingly, Ni Zan, who was not a monk, seemed to embody in his pictures the Chan Buddhist idea of detachment. The monk Hongren, on the other hand, reveals through his paintings his passionate engagement with life. It seems fair to infer from this that Hongren's monkhood was not a simple religious choice.

Most of Hongren's paintings share the same highly constructed landscape motifs, which, although they rely on past masters, have been distilled into a pristine, dreamlike

world divorced from reality — in this case, the turbulence of his present. The cleaned-up, almost sanitized world can be seen as the ultimate statement of Hongren's personality and his loyalty to the past: the peaceful rhythms and sensitive recollections of past masters recall a world of solidity and steadfastness that evokes his loyalty to the fallen dynasty.

Pine Cliff and Clear Spring (fig. 234) is a detailed depiction of a sheer mountain peak standing on the edge of a smooth lake. Sturdy pines grow at its base, almost hiding a summerhouse. Pines also grow on the rocky cliff, clinging stubbornly and sending roots into the crevices of the rocks. The lake at the foot of the mountain is as smooth as a mirror. This quietude is broken only by a stream flowing down a gully between two mountains. In front of the bamboo grove stands what appears to be a Buddhist monastery. There are no human figures in the picture, and the scene seems completely isolated from the outside world. Using clean and elegant brushstrokes, and simplifying and generalizing the natural scenery, Hongren presents an unspoiled ideal world through the natural charm of the mountain and lake.

Kuncan (1612–1673) was born in Wuling (today's Changde in Hunan Province), but he often stayed in Nanjing, where he became close friends with famous literati who were still loyal to the Ming dynasty, including Gu Yanwu, Qian Qianyi, Zhou Lianggong, Gong Xian, and Cheng Zhengkui. They used to gather at the Youqi Monastery on Ox Head Mountain, where Kuncan lived. When the Manchu army marched south, he favored the resistance fighters, but they were soon overwhelmed. He hid in the mountains, suffering a great deal, and later traveled from monastery to monastery. Living as a recluse, he wrote poems and painted pictures. Even after he became a monk, he still cherished strong nationalist feelings, as suggested by the following story. Kuncan had a friend named Xiong Kaiyuan, who was also a monk. One day Xiong went on an excursion to Bell Mountain, outside the city of Nanjing. On Xiong's return, Kuncan asked, "Did you pay homage at the Xiaoling Mausoleum [the tomb of Zhu Yuanzhang, the founding emperor of the Ming dynasty]?" "We are monks; we don't have to pay homage," Xiong replied. At this, Kuncan flew into a rage and bitterly scolded him. When his friend asked forgiveness, Kuncan retorted, "You don't have to apologize to me. You should kowtow at the Xiaoling Mausoleum and repent!"

In contrast to Hongren's elegant paintings, Kuncan's landscapes are forceful and free. Although he drew extensively on traditional masters, he did not limit himself to an established style or school but combined what was best in each. In addition to learning from the Four Great Masters of the Yuan dynasty, Kuncan was influenced by Shen Zhou, Wen Zhengming, and Dong Qichang, who were among the greatest of the Ming artists. The way Kuncan applied the ink shows the influence of the great Song artist Mi Fu, with his mountains shrouded in clouds. This is especially evident in *Origin of Immortals* (fig. 235). The painting, on a hanging paper scroll, shows water cascading from the hills to a stream flowing by a few thatched houses at the bottom. On the slope far away is a small village. Even farther away, hidden in a deep valley, is a group of buildings with high roofs and upturned eaves that resemble temples. A solitary angler sits in a boat in the middle of the stream.

Kuncan liked to use calligraphy on his paintings. The inscription in the upper right-hand corner describes the artist's joy in living in seclusion with only the natural landscape for company:

I still find joy in this secluded life,
Treading on the path, I find beautiful scenes as I
 please.
I play my musical instrument as I walk along the river,
Until I enter a fascinating place through the clouds.
The water is deep and the land is open and flat,
The mountains shine under the sunlight.
The deafening sound of a spring covers other noises,
The flat rocks look so clean as if they have been
 swept.
I feel so happy I forget my fatigue,
The stream winds all the way up to the high
 mountain.
When I look ahead, the mountains look as if they
 are cut,
And the irregular mountain caves are exquisite.
I feel as if I am high in the sky,
My steps feel so light as I walk in the pine woods.
Resting in the mountains, I forget about the material
 world,
The place is so quiet that even monks don't come
 here.
I plan to live here for the rest of my life,
Until I die in this mountain.
By Can Daoren (Old Daoist) of Shixi (Stone Stream),
 at Zutang, in the spring of the year of *jiachen*[1]

Bada Shanren (1626–1705) is the best known of the Four Great Monk Painters and one of the most distinguished artists in the history of Chinese painting. His birth name, Zhu Da, tells us that he belonged to the Ming

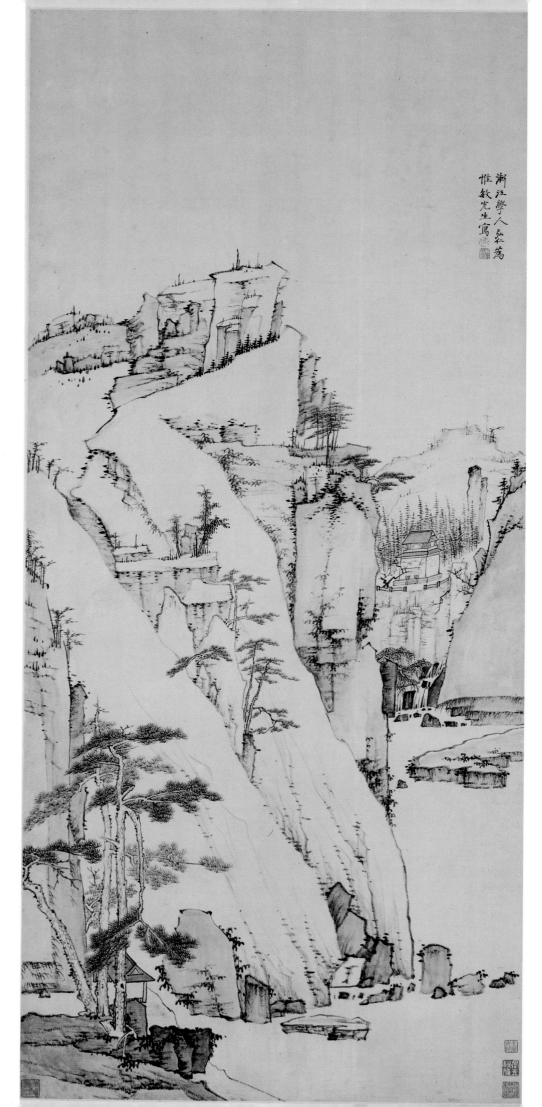

漸江學人弘仁為
惟敏先生寫

234. Hongren, *Pine Cliff and Clear Spring,* hanging scroll, ink on paper, Qing dynasty. Guangdong Provincial Museum.

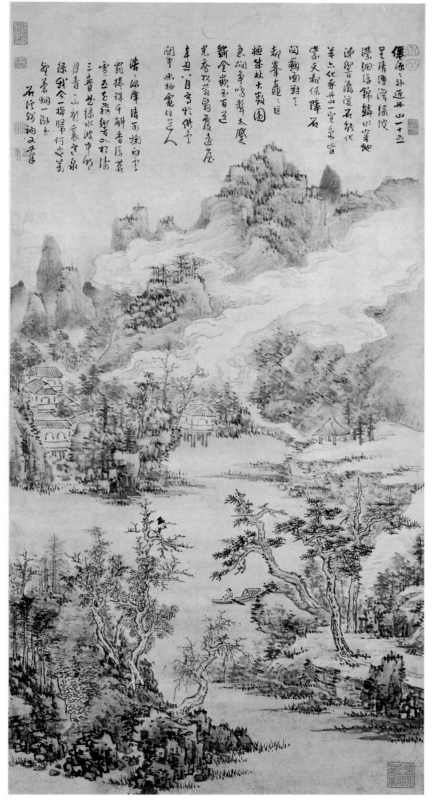

235. Kuncan, *Origin of Immortals*, hanging scroll, ink and color on paper, 1661. 84 × 42.8 cm. Palace Museum, Beijing.

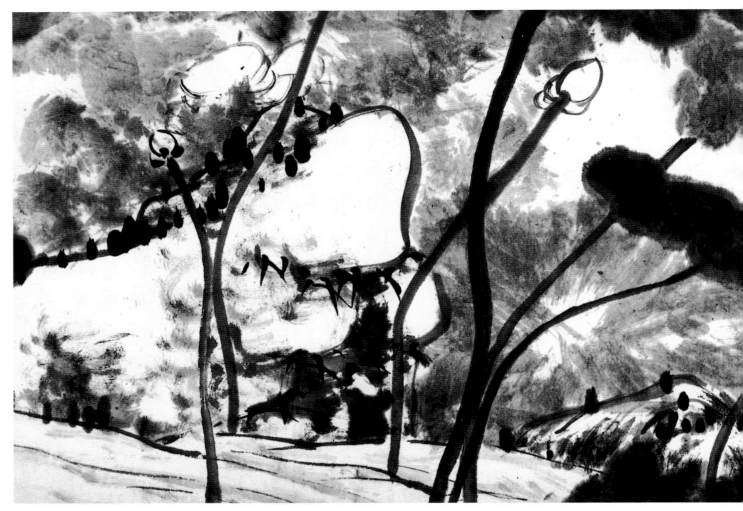

236. Bada Shanren, *Flowers by a River,* handscroll, ink on paper, 1697. 46.6 × 128.2 cm. Tianjin Art Museum.

imperial family; his status and background were therefore quite different from those of Hongren and Kuncan.[2] A descendant of the prince of Yiyang, from the northeastern part of today's Jiangxi Province, he was born in Nanchang. As a child and young man, he enjoyed wealth, adulation, and a leisurely life in a prince's mansion. A lively, cheerful young man, Bada Shanren loved to comment on the world around him, often surprising people with his wit.

He was eighteen when the Ming dynasty was overthrown, and the change brought the sudden destruction of his aristocratic world. This catastrophe gradually soured his cheerful disposition; one day he marked his door with the character for *dumb* and thereafter refused to speak. When he was spoken to, he would simply nod or shake his head to indicate agreement or disagreement, and he greeted his guests with hand gestures, smiling wryly to show that he understood what his friends were saying. He continued this way for more than ten years,

until he finally abandoned his home and joined a monastery in the Fengxin Mountains near Nanchang. For the next twenty years, he cultivated Buddhist truths and taught them to more than a hundred followers. After long years of depression and repressing his feelings, he began to behave as if he were insane. He would sometimes lie prostrate and weep bitterly, sometimes raise his face to the sky and laugh uproariously, swinging his arms and legs in a dance; sometimes he would sing at the top of his lungs. But his behavior may have been feigned: as he wrote in a poem of 1682, "There is a guest at Yuzhang [Nanchang] gate, / I pretend to be mad and talk to the flying swallows."[3]

As he grew older, Bada grew more peaceful, finding diversion in calligraphy and painting. Although he gave himself many names after he became a monk, he signed most of his paintings and calligraphic works Bada Shanren (Dweller of the Eight Great Mountains). When he wrote the four characters for Bada Shanren, he often

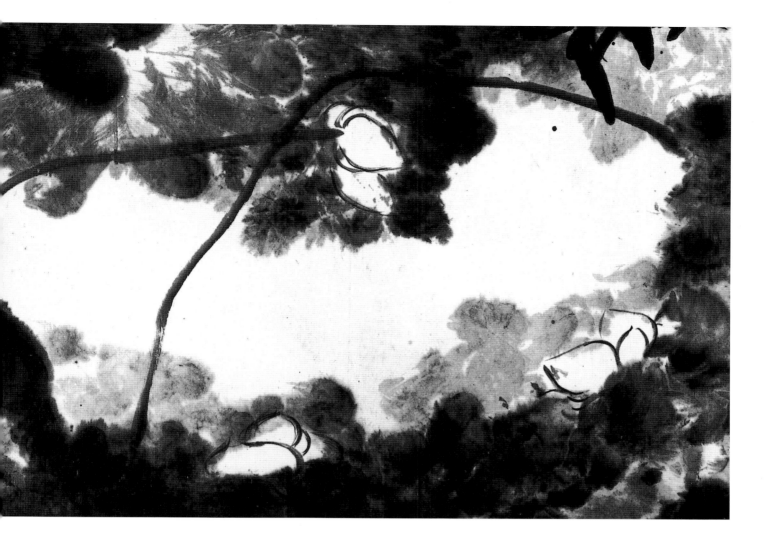

linked them together, so that they resembled the two characters for *kuzhi* (cry) and *xiaozhi* (laugh), thus expressing the contradictions of his nature; he could neither cry nor laugh. Bada Shanren lived the rest of his life with this inner conflict.

Bada developed remarkably innovative and idiosyncratic techniques with which to paint flowers, birds, and landscapes. He painted his creatures with clean and sparing brushstrokes: fishes or birds, often strange and mocking, sometimes appear with squarish upturned eyes that express dissatisfaction, anger, or longing. His flowers, lotus, and grass create a lonely, desolate atmosphere, while his trees, stunted and broken, are expressive of a bleak but intensely emotional world. His bamboo symbolizes the virtues of loyalty as well as contemporary troubles.

Bada combined painting, poetry, and calligraphy in a passionate and intricate manner, often employing allegory in his poetic inscriptions to satirize the Qing or to express his nostalgia for his former life. Often the poems are full of references to obscure sources and elusive metaphors; yet they reveal as well his flashes of humor and love of verbal games. Although they are often difficult to comprehend, they suggest his fond memories of the past. In a poem of the 1690s, he expresses his lost hopes of a Ming restoration.

> Long rain falls, my boat has nowhere to go,
> Clouds move on, at my studio in the lotus.
> At this time, I exhaust my view of the south,
> It is already this picture of Bright Mountain.[4]

Another poem, this on his Landscape Album (ca. 1693), reads:

> Master Guo [Xi]'s modeling strokes are like small clouds,
> Old Dong [Yuan]'s hemp-fiber shading is mostly on his trees.
> Try to imagine how people nowadays should understand the meaning of painting—
> Like Yifeng [Huang Gongwang], who still painted the mountains and rivers of Song.[5]

Flowers by a River (fig. 236) is a long handscroll. Although the lotus leaves, flowers, and rocks are painted in dark ink, they nonetheless suggest a riot of colors. Nowhere is his mastery of lotus painting more evident than in this remarkable work, whose emotional power is reinforced by Bada's poem evoking the life of Jiang Wanli, the Song-dynasty loyalist. According to the inscription, the painting took four months to complete, yet its criss-cross strokes and continuous brushwork make it look as though it was created in one breath.

Shitao (1642–1718), another of the Four Great Monk Painters, came from a background similar to Bada's. A descendant of the Ming imperial family, Shitao was quite young when the Ming dynasty fell, so he did not feel the sorrow of subjugation as deeply as Bada. Shitao was the son of Zhu Shouqian, prince of Jingjiang, who was killed in an internal power struggle in 1646. A household attendant took him away from the prince's mansion and saved his life, and he succeeded in living anonymously for many years thereafter.

In 1662 he became a Chan monk under the name of Yuanji. Among the names he gave himself were Leftover Man of Jingjiang, Blind Buddhist, and Monk Bitter Gourd, evocative of the grief he felt at the fall of the Ming. As a monk, he wandered from place to place, making a living by selling his paintings: he traveled to Mount Lu and Mount Huang, stayed in Xuancheng (in what is now Anhui Province) and Jiangning (just south of today's Nanjing). In 1692 he settled in Yangzhou, in the present-day Jiangsu Province.

In his later years, after the Qing dynasty had consolidated its power, Shitao's nationalistic feelings became less pronounced. In fact, when the Kangxi emperor came to Yangzhou during his tour of the south in 1684, Shitao joined the local notables who proudly came out to welcome the emperor. He even wrote a poem to commemorate the occasion.

Shitao was distinguished for his paintings of landscape, bamboo, and rocks. He was free in both style and brushwork and emphasized that the painting must reveal the unfolding of the painter's personality. He explained: "I am always myself, and must naturally be present in whatever I do. The beards and eyebrows of the ancients will not grow on my face, and the lungs and bowels of the ancients cannot be put into my body."[6] He opposed the blind copying of the old styles or imitation of paintings of the past. Artists should go out and see things with their own eyes and comprehend in their own hearts so that "the mountains and rivers would meet and merge with you in spirit." Only in this way could the artist create works that would "show the soul instead of just the appearance of the object" and thus prove himself able to "look between likeness and unlikeness."[7]

Most Spectacular Peaks (Palace Museum, Beijing), painted when the artist was fifty, is a handscroll depicting various kinds and shapes of mountain peaks. In the inscription, Shitao wrote: "I have sought out all the exotic mountains and made them parts of my draft." And he adds that too many artists are fond of imitating "So-and-so in brush work" or "such-and-such painting style." This is like putting an ugly woman in front of a blind man and asking him to comment on her beauty. His principle is "neither to set up nor to illuminate any method." His words "Search for all spectacular peaks before painting them" embodied a motto that artists of later generations emulated: "Learn from nature and paint realistically."

Shitao painted *Clear Autumn in Huaiyang* (fig. 237) after he settled down in Yangzhou. This may be a picture of the Huaiyang Plain in northern Jiangsu or an area in the northern outskirts of Yangzhou. Although the picture, which depicts a wide, distant horizon, at first appears flat and unfinished, as if it were just a sketch, it is full of vitality. A winding section of city wall separates the densely collected houses and sparse trees inside the city from the reed-choked river and thick woods outside. In the distance we see only a small boat on the empty river with a fisherman sitting leisurely and carefree in it, surrounded by the peacefulness of the natural beauty. The lengthy inscription at the top of the painting expresses Shitao's nostalgia for the old Yangzhou; it is a vivid description of the changes that have taken place.

Shitao also offered unusual and incisive observations on painting techniques. He wrote of ink-application techniques, as well as of the wonderful variations in ink shades. "There is a vast universe in the dark, dark clusters of ink," he inscribed on one painting.[8] In addition to his book *Sayings on Painting from Monk Bitter Gourd,* Shitao's views and theories can be found in the inscriptions and poems on his paintings. His achievements gained him fame in Yangzhou art circles; his views had great influence on the conservative, dry painting style that was typical of the early Qing. All of the Eight Eccentrics of Yangzhou in the mid-Qing were influenced by Shitao.

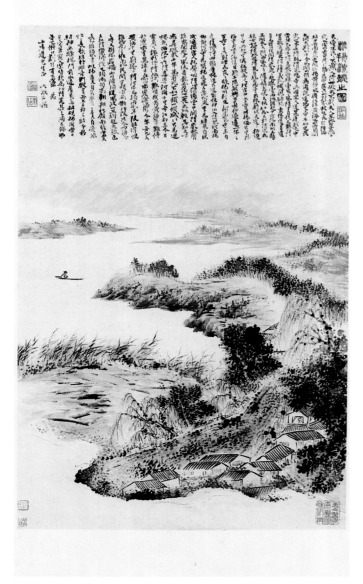

237. Shitao, *Clear Autumn in Huaiyang,* hanging scroll, ink and color on paper, Qing dynasty. Nanjing Museum.

The Six Masters of the Early Qing

The Six Masters of the Early Qing were Wang Shimin, Wang Jian, Wang Hui, Wang Yuanqi, Wu Li, and Yun Shouping (also known as the Four Wangs, Wu, and Yun). Five of the six were noted landscape painters, while Yun Shouping was skilled in painting flowers. They are grouped together for several reasons: they were contemporaries, whose lives covered a hundred-year span from the end of the Ming to the beginning of the Qing dynasty; they were closely related to one another, either by blood or in a teacher-student relationship; they worked in close proximity; and, most important, they followed the same artistic traditions and shared artistic interests.

In their views on art and their artistic style, the Six

Masters belonged to the category of scholar-painters. Instead of faithfully depicting mountains and rivers, they used nature to express their feelings, beliefs, and emotions. In their works they wanted to show "the hills and valleys in their minds." And although the Six Masters emphasized the importance of following traditions of literati painters, they were actually trying to find a spiritual haven in a tumultuous world.

The six are the principal figures in the Orthodox School of landscape painting. This school grew out of the late Ming, when Dong Qichang's writings consolidated the amateur literati styles of the Southern School into an orthodox tradition. What were once private, expressive painting styles were formalized, conventionalized, and repetitively executed. Practitioners used Song and Yuan styles and produced variations in their own manner, putting Dong's theories into practice.

The Four Wangs stressed technique, concentrating on the techniques of brushwork and application of ink. With their admiration for the drawing technique, style, and compositional methods of past artists, they seldom went outside to look at the countryside for themselves. Instead, they created their landscapes in the studio, imitating the works of their predecessors and pursuing the beauty of artistic form in the likeness of their works to those of the past. In praising Wang Hui's paintings, Wang Yuanqi once noted, "The charm and the composition are so vivid that they look similar to those of the ancients. It was really lucky for an old man like me to see paintings by Wang Hui. But it is such a pity that Dong Qichang cannot see them today."[9]

The later paintings of the Four Wangs, however, were more formalized. In explaining how his theory of painting developed, Wang Shujin, the descendant, five generations later, of Wang Yuanqi, noted, "The method of painting under heaven from the ancient times to this day was nothing but horizontal and vertical strokes. If rocks are painted horizontally, then trees should be vertical; if trees lie horizontal, rocks should stand vertical; with horizontal branches, leaves should be vertical; horizontal clouds go with vertical peaks; horizontal slopes suit vertical mountains; and horizontal cliffs should have vertical cascades. Thatched houses should be painted under dense woods; beside lying rocks, moss should be dotted. This can be summed up as the major principle of painting."[10] The ever-changing things of the earth become figures composed of horizontal and vertical strokes. This rigid painting method was opposed by many artists.

Wang Shimin (1592–1680), the eldest of the Four Wangs, was the son and grandson of Ming government

officials and art collectors. Immersed in traditional culture and art at home, Wang Shimin began painting as a child. Later he served as a Ming official, but he soon resigned his post. After the Ming was replaced by the Qing dynasty, he found solace in painting. He died in his hometown at age eighty-eight.

Wang Shimin learned much from the Four Great Masters of the Yuan dynasty: Wu Zhen, Wang Meng, Ni Zan, and, in particular, Huang Gongwang. His landscape paintings draw on these artists without appearing to be slavish imitations. He uses delicate brushstrokes to create a style that is both elegant and vigorous. In *Pavilions on the Mountains of Immortals* (fig. 238), painted when he was over seventy, the rocks look hard and solid; they are executed with a highly skilled dry-brush method, similar to that used by Huang Gongwang in his rock paintings. The dense trees resemble those of Wang Meng.

Wang Jian (1598–1677), a native of Taicang in Jiangsu Province, belonged to the same clan as Wang Shimin. Although Wang Shimin's senior by a generation, he was six years younger. The two were close friends and often discussed art together. Wang Jian was born into a scholar's family. His grandfather, Wang Shizhen, was a famous man of letters during the Ming dynasty and a great art collector. Wang Jian passed the imperial civil examinations at the provincial level toward the end of the Ming dynasty and served as an official in Lianzhou (now Hepu, in Guangxi Zhuang Autonomous Region) for a few years. But after he had resigned from his post and returned to his hometown, he never again served as an official. He died at the age of seventy-nine.

Like Wang Shimin, Wang Jian grew up in a literary and artistic atmosphere; he learned to paint by making copies of masterpieces, absorbing what was best in the early painters. Wang Jian borrowed much of his technique from Wang Meng, skillfully using the brush in an upright position. His pictures were painted in dark ink, which gave the hills and valleys a deep, serene, and cohesive appearance. The trees are luxuriant but orderly. All the elements of the pictures are closely knit. *Dreamland* (fig. 239), painted in 1656 when he was fifty-eight, displays superb brushwork. The upper portion of the picture carries a long inscription that explains how in the sixth lunar month of that year, the painter went to Bantang for the summer. One day, having nothing to do, he dozed off after lunch and dreamed of a scenic place where there was a thatched cottage, surrounded by a yard that was sparsely planted with flowers and bamboo. In front of the cottage was a clear lake on which a carefree old man fished from a boat. On the wall inside the cot-

tage hung a misty landscape by the Ming painter Dong Qichang. When Wang Jian awoke, these things were still fresh in his memory; he immediately picked up his brush and painted them. The landscape in *Dreamland* was executed in closely arranged and elegant brushstrokes against a background painted in faint ink. The texture of the rocky mountains was brought out with a dry brush. The tiny waves on the surface of the lake give a decora-

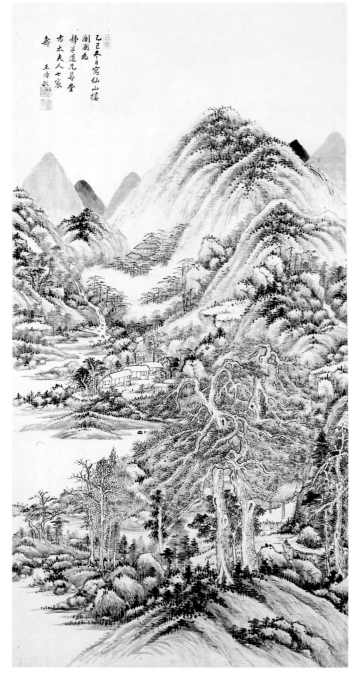

238. Wang Shimin, *Pavilions on the Mountains of Immortals,* section of a hanging scroll, ink and color on paper, ca. 1665. 133.2 × 63.3 cm. Palace Museum, Beijing.

tive effect. The cottage Wang Jian saw in his dream was actually the Wangchuan Villa of Wang Wei, the founder of the Southern School of painting during the Tang dynasty, a style that was extolled by Dong Qichang as well. Wang Jian's allusion suggests his admiration for this school.

Wang Hui (1632–1717), who learned to paint from Wang Shimin and Wang Jian, was born in Changshu, Jiangsu Province. Wang Hui came from a family of artists: five previous generations contained professional painters. In his youth he was deeply influenced by Huang Gongwang because his first teacher, Zhang Ke, was a follower of the Huang School. In fact, for a time, he earned his living by making copies of Huang's paintings. When he met Wang Jian, in 1651, the latter introduced him to his friend Wang Shimin. Under Wang Shimin's guidance, Wang Hui's skills improved steadily. He later traveled about the country, further perfecting his technique. After the deaths of Wang Shimin and Wang Jian, Wang Hui became the most prominent painter in the south, achieving national fame. He was commissioned by the Kangxi emperor to arrange the painting of the emperor's tour of the south. *The Kangxi Emperor on His Southern Inspection Tour* (fig. 240) takes up twelve enormous scrolls. After the emperor had inscribed the praise "clear and bright mountains and rivers" on one of the scrolls, Wang Hui began to style himself Clear and Bright Old Man.

In his landscape paintings, Wang Hui drew various elements from former painters, fusing them into his own style. He sought to adopt the way the Yuan painters wielded the brush, the Song painters depicted hills and valleys, and the Tang painters created atmosphere. Although Wang Hui learned the most from the Four Great Masters of the Yuan dynasty he was also interested in the works of the painters of the Song dynasty's Imperial Painting Academy. Yet he could take the best of various artists and was the most creative artist of the four.

Autumn Trees and Crows (fig. 241) is a painting from Wang Hui's late years (he was eighty). The picture shows a dense growth of bamboo, a summerhouse sitting by the water, and trees. The branches of the trees in the background appear between the limbs of the foreground trees, thus giving the picture perspective, which was unusual at this time. The empty stretches of water and the mist give the picture a refreshing tone and breathing space. The undulating hills in the background lead the viewer's eye to the distance. The poem inscribed on the painting is by Tang Yin, an artist of the Ming dynasty, and it conveys a feeling of melancholy similar to the spirit evoked by the picture:

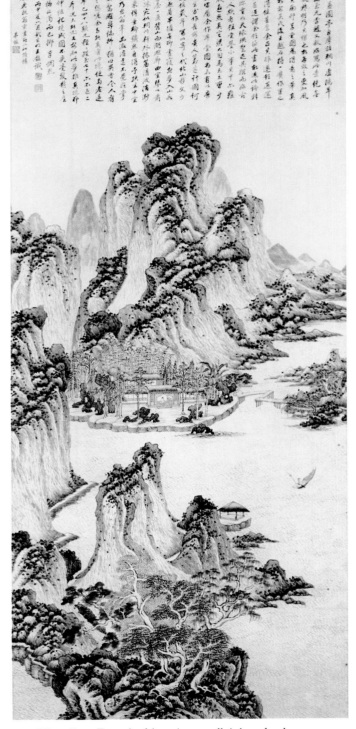

239. Wang Jian, *Dreamland*, hanging scroll, ink and color on paper, 1656. 162.8 × 68 cm. Palace Museum, Beijing.

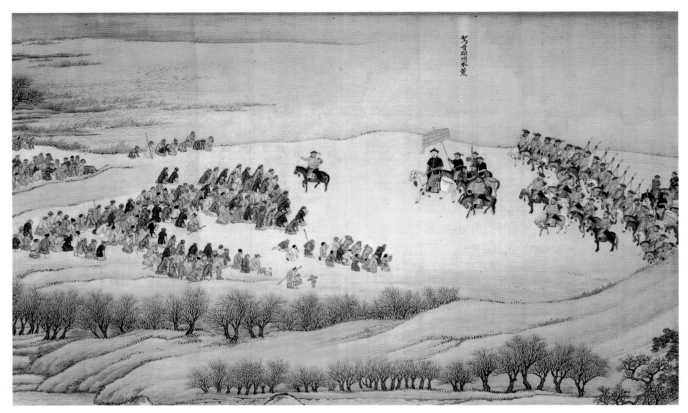

240. Wang Hui and others, *The Kangxi Emperor on His Southern Inspection Tour,* section of a handscroll, ink and color on silk, Qing dynasty. 67.8 × 2313.5 cm. Musée des Arts Asiatiques – Guimet, Paris. (© Photo RMN-Thierry Ollivier.)

The little house by the stream looks more beautiful
 at dusk,
The autumn tree around the eve gathers shadowy
 crows.
I wonder when we can meet again,
So together we can drink tea by the cold light.

As is often said of Chinese paintings, "the poem contains the picture and the picture contains the poem," which is perhaps the highest goal of Chinese artists in their poetry and painting.

Wang Yuanqi (1642–1715) was the last of the Four Wangs. The grandson of Wang Shimin, he was two when the Ming was superseded by the Qing dynasty. Although he studied the Classics and learned to paint as a child, he went into government service as an adult. He passed the examinations at the provincial level in 1669 and at the national level a year later. After serving as a local and then as a central government official for a number of years, he was appointed a court official in 1700, later becoming a member of the Imperial Secretariat and a trusted civil official of the Kangxi emperor. Wang Yuanqi remained a successful government official throughout his life. Yet he continued to paint, executing a large number of pictures

in his spare time. His style greatly influenced landscape painting at court. For many years, he lived in Haidian on the northwestern outskirts of Beijing. He died in Beijing at the age of seventy-three.

His landscapes show the strong influence of his grandfather Wang Shimin, as well as Wang Shimin's model Huang Gongwang. Wang Yuanqi saw himself as both learning from "Dachi" and passing on his legacy. (Dachi, meaning "great fool," was one of Huang Gongwang's self-chosen names.) Wang Yuanqi was highly skilled in his brushwork, often applying ink and color several times in a single painting to enhance the gradation of shades and bring out the texture of the image. He emphasized the key points in a picture with dark ink, while imperceptibly merging color with the ink in his faintly colored landscapes, to create a unique style that has been described thus: "There is color in the ink and ink in the color."

Layers of Verdant Hills (fig. 242) was painted in Beijing for the emperor and kept in the palace. Executed in ink and color on paper, this picture of lofty mountains and

241. Wang Hui, *Autumn Trees and Crows,* hanging scroll, ink and color on paper, 1712. 118 × 74.7 cm. Palace Museum, Beijing.

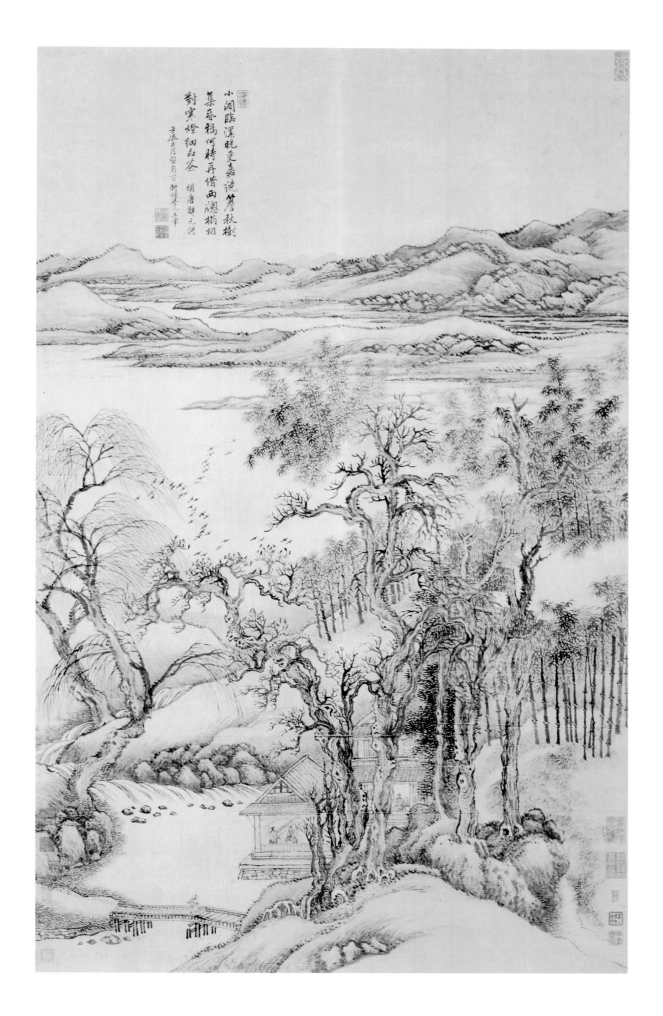

deep valleys reveals the special attention the painter paid to the depiction of rocks: the hard rocks of the mountains have been rendered with sparing brushstrokes that are not clearly defined in outline. The clouds and mist in the valleys and depressions, along with the widely scattered houses and pines at the foot of the mountains, give life and vigor to the picture. Wang Yuanqi was particularly good at using dry but elegant brushstrokes for mountains and rocks. The dry brushstrokes were applied repeatedly so that the images appear solid and real. At first glance, his ink and brushwork seem monotonous and colorless, but a closer examination reveals his masterly brushstrokes in the luxuriant growth of grass and trees and the richness of the earth.

Wu Li (1632–1718), another of the Six Masters of the Early Qing, learned to paint from Wang Shimin and Wang Jian and discussed art with Wang Hui. Wu's father died when Wu was a boy, and his family was reduced to poverty. From an early age, Wu supported himself and his mother by selling his pictures. When he was thirty-one, both his mother and his wife died. Deeply depressed, he sought solace in religion. He first studied Buddhism (one of his sobriquets was the Lay Buddhist of Peach Stream) and later came into contact with Catholicism. He was formally baptized and became a Catholic priest at the age of fifty-one. He planned a trip to Europe but he reached only Macao, which was then occupied by the Portuguese. After returning to the Yangzi delta, he devoted himself to missionary work for the last thirty years of his life, painting few pictures.

Like the work of the other Six Masters, Wu Li's landscapes evolved from the Four Great Masters of the Yuan dynasty. But the way Wu used his brush and ink is more varied and more expressive of his personality; his technique won praise from Wang Yuanqi and Wang Hui, who both enjoyed a high reputation in art circles at that time. In the colophon on one of Wu's paintings, Wang Hui wrote: "The Mojing Daoist [Wu Li] and I were born in the same year, came from the same place, and went to the same school. We haven't seen each other for a long time, since he went into seclusion and I became busy with my own life. Yet whenever I see his works, which bear such striking similarities to those of the Song and Yuan dynasties, they always inspire admiration in me."[11]

Spring on the Lake (fig. 243), presents a peaceful scene in the Yangzi delta: a zig-zagging lake shore lined with willow trees and reeds. A narrow path winds its way along the embankment; the mountains in the background are shrouded in mist. Ducks swim and feed on the lake as small birds perch in the trees. Green predominates: the grass on the slopes of the shore and the tender buds of the trees fill the picture with a sense of new life. The scene appears natural, something that can be seen anywhere in the Yangzi delta. Although the pictures Wu painted in later years display more skillful and mature brushwork, they are no longer as lively as this picture, which appears to have been painted directly from nature.

Wu's views on creativity and aesthetics were quite different from those of the Four Wangs. "My paintings do not seek formal resemblance, and they do not fall into ready-made styles. You could call them spirited and free." He did not simply imitate his predecessors. He "wouldn't take the draft for a painting as the rule." Yet, on the other hand, he did not belittle the ancients either. He insisted that artists "get the gist of the painters of the past" and asks that they "see the mountains and rivers for themselves and let the real thing inspire them."[12] Only when an artist has deep feelings about his subject can he paint it.

Scenes of the sea and banyan trees from Wu's travels to Macao and Fuzhou often appear in his paintings. He employed shadow, perspective, and contrast — at that time, Western techniques. From choice of subject to style and technique, Wu's paintings differ from those of the other Six Masters, yet they still retain many traditional elements of Chinese paintings.

Yun Shouping (1633–1690) was primarily a painter of flowers, although he also painted landscapes. He was born in Wujin (now Changzhou), in Jiangsu Province, where many of his family had served as Ming government officials. When the Manchu army came down from the north, his father, Yun Richu, took the young Shouping and joined the resistance movement. Father and son were separated in the confusion of war. Yun Shouping was later found by Chen Jin, the Qing military governor of Jiangsu and Zhejiang, and became his adopted son. He was reunited with his father five years later, when he visited the Lingyin Temple in Hangzhou and met his father there by accident. As Yun grew older, he learned to paint from Wang Shimin and Wang Jian. He began with landscapes, later specializing in flowers. Eking out a living by selling his pictures, Yun remained poor all his life. Yun was the shortest-lived of the Six Masters, dying when he was only fifty-seven.

Yun Shouping made every effort to change what he considered the vulgar and ornate style of the court paintings of the Ming dynasty. He continued the "boneless" method initiated by Xu Chongsi in the Northern Song dynasty, a technique whereby flowers were painted without a dark outline. After creating the shapes, he applied

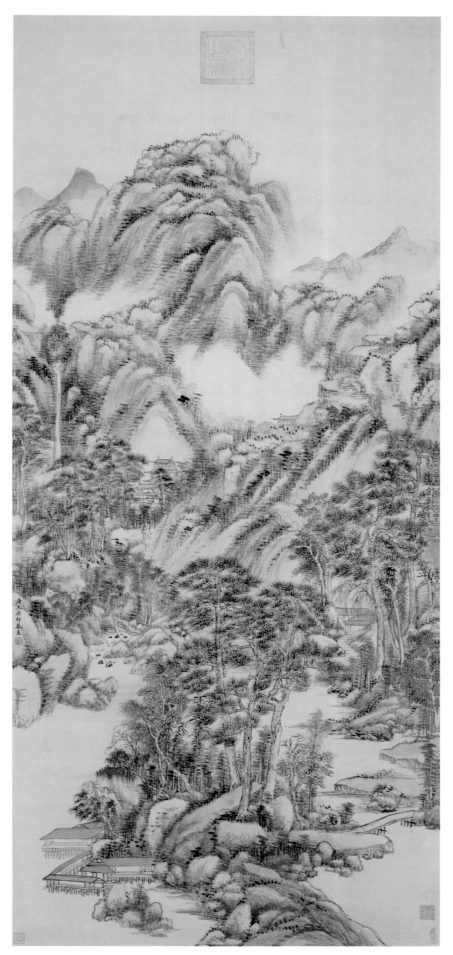

242. Wang Yuanqi, *Layers of Verdant Hills,*
hanging scroll, ink and color on paper, Qing
dynasty. 139.5 × 61 cm. Palace Museum, Beijing.

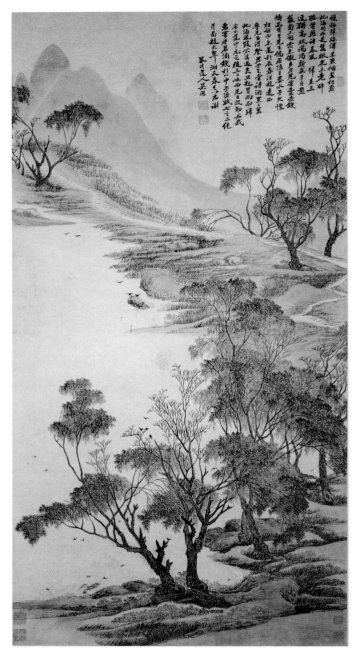

243. Wu Li, *Spring on the Lake,* hanging scroll, ink and color on paper, 1676. 123.8 × 62.5 cm. Shanghai Museum.

(figs. 244 and 245) are lively and elegant, the landscapes dreamy and poetic. All the pictures are gentle and quiet, a style preferred by the literati of the time.

The Eight Masters of Jinling

At the beginning of the Qing dynasty another group of artists flourished, who were known as the Eight Masters of Jinling. The national capital in the early Ming dynasty, and still the political, cultural, and economic center of southeast China, Jinling (now Nanjing) was the city next in importance to Beijing. After the founding of the Qing, many loyalists congregated there. Most of the Eight Masters of Jinling maintained their loyalty to the Ming, expressing their feelings in their works. The eight — Gong Xian, Fan Qi, Zou Zhe, Wu Hong, Hu Zao, Gao Cen, Ye Xin, and Xie Sun — chiefly painted landscapes of the Jinling region.

Gong Xian (1618–1689) was the most influential and accomplished of the Eight Masters of Jinling. A native of Kunshan, Jiangsu Province, he had become dissatisfied with the political darkness of the late Ming, when eunuchs had usurped the authority of the court. He associated himself with the Fu She (Revival Society), a group of intellectuals who wished to revive the glory of the early Ming dynasty. After the dynasty fell, he became even more dissatisfied with the new Manchu rulers. Retaining his loyalty to the Ming, he lived in obscurity on Qingliang (Pure, Cool) Hill in Jinling and earned his living by selling his paintings and teaching.

Having spent most of his life in Jinling, every hill, river, lake, glade, and tree there was dear to him. He frequently painted famous local resorts like Qingliang Hill and Mount Qixia. He generally used only ink; few of his paintings contain any color. To depict the hills and trees of the moist and rainy south, he invented the "accumulating-ink" method: he created a strong atmospheric effect by repeatedly applying a brush lightly inked with various tonalities of ink to the same spot. This new method evolved from the Mi family's paintings from the Song dynasty of mountains wreathed in clouds. Some of Gong's scrolls, however, were painted with only a few brief brushstrokes, a style that was completely different from that of his other works. Pictures in the accumulating-ink method are known as the "dark Gong," though the adjective refers to little more than Gong's dark, shadowy style. The spare, linear style he also used, especially in his youth, is called the "light Gong."

Gong Xian's view of art was similar to that of Shitao. Both were opposed to rigidly adhering to old rules of painting. Fine artists of the past took nature and life for

color on wet paper or diluted it with water to produce a refreshing, elegant, natural, and lively image. The subject of a painting might be a single flower, plant, or rock, through which Yun created a world of beauty. His method of painting soon gained widespread popularity, and many artists acknowledged his influence. Wang Hui, a good friend of Yun Shouping's, aptly said that Yun's flowers "emit fragrance and glow with lifelike color." He wrote this encomium on Yun's painting *The Fragrance of a Nation in Clearing Spring* (1688; Wong Nan-p'ing Collection). The flowers in *Landscape, Flowers, and Plants*

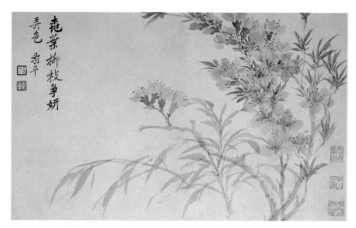
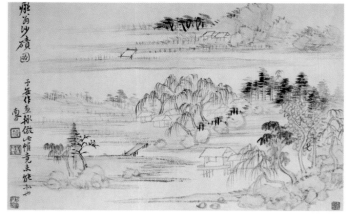

244 & 245. Yun Shouping, *Landscape, Flowers, and Plants,*
album leaves, ink and color on paper, Qing dynasty.
22.8 × 34.6 cm each. Palace Museum, Beijing.

the source of their art rather than imitating their predecessors. Gong complained that whereas the calligraphy and painting of the ancients stemmed from nature, artists of his time made drafts of paintings by the ancients their Bible and worshiped their words as scripture. Gong urged students of painting to go out and see the mountains and rivers for themselves, using the works of the ancients for reference only.

Qingliang Hill Scenery (fig. 246), painted in Gong's dark style, depicts the scenery of that hill in the north part of Jinling. Even though the hill and rocks that make up its subject are unspectacular, the picture offers a profound and serene view of nature. The inkwashes, the variations of light and shade, and the arrangement of solid and empty spaces are special features of Gong's works that allow him to achieve a personal effect.

We know less about the lives of the other Eight Masters of Jinling, although many of their paintings have survived. Gao Cen (active ca. 1679), for example, was born in Jinling and learned to paint when he was a boy. He was also a poet. Many of his landscapes, like *A Glimpse of Stone City* (fig. 247), depict the scenery around Jinling. Gao did not use Gong Xian's accumulating-ink method nor did he follow Gong in his methods of creating shapes and applying color; rather, he made use of traditional linear methods. He was skilled at outline drawing and rarely employed the dry-brush method for shading. He also painted the more casual and playful album leaves. Moreover, unlike Gong's, most of Gao's pictures were painted in color on silk.

The dates of Wu Hong's birth and death are unknown, although he was active from about 1670 to 1680. A native of Jinxi in Jiangxi Province, he lived for a long time in Jinling and was a skilled painter of landscapes, bamboo, and rocks. Like Gao Cen, Wu Hong wrote poems as well as painted. His works, executed with free brushstrokes, are realistic in style. His superb brushwork is particularly evident in those of his ink works that contain no color.

Wu's *Swallow Rock and Mochou Lake* (fig. 248) is divided into two sections, the second of which is pictured here. The first depicts Swallow Rock, which stands on the edge of the Yangzi River on the northern outskirts of Jinling, not far from the Guanyin Gate. When the moon is bright, the river becomes a wide white ribbon, and the rock, silhouetted against the sky, looks like a swallow about to take flight. The painting depicts a night scene; the river is shrouded in mists and all is quiet. Ferries and fishing boats are moored along the banks. The second section shows Mochou Lake, to the west of Jinling. Pavilions and walkways surround the wide lake, as do willows. It is spring: red flowers, green trees, and crowds of tourists abound. The objects on the lake and along its shore are depicted in all their beauty. Perhaps the artist was trying to suggest that even though the government had changed, natural beauty remained.

Fan Qi (1616–after 1694) was a painter of landscapes as well as of flowers, birds, grass, and insects. Born in Jinling, he lived to a mature age. He painted his *Flowers and Butterflies* (fig. 249) when he was very old. The picture is highly decorative, with ornamental rocks, flowers, and butterflies painted on paper flecked with gold. Butterflies and rocks denote good luck, which suggests that the picture might have been painted to celebrate a birthday.

It is possible that Zou Zhe (1636–ca. 1708) painted flowers, but only his landscape paintings are extant. His compositions feature rows of stunted pine trees on slopes or pines springing up from rocky bases. Sometimes he includes low-lying buildings and human figures,

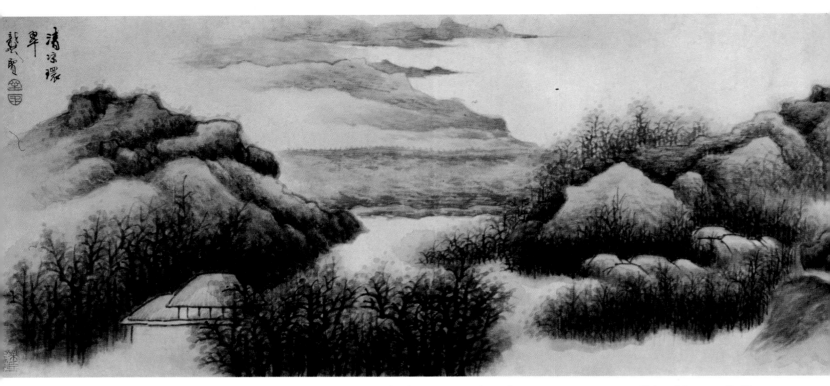

246. Gong Xian, *Qingliang Hill Scenery,* handscroll, ink and color on paper, Qing dynasty. 30.2 × 144.2 cm. Palace Museum, Beijing.

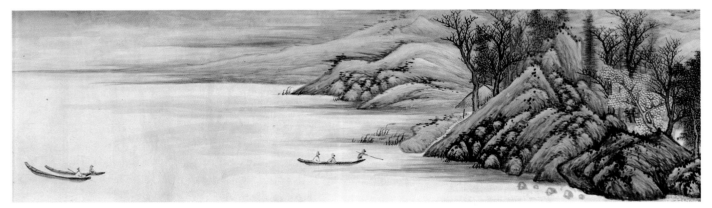

247. Gao Cen, *A Glimpse of Stone City,* section of a handscroll, ink and color on silk, Qing dynasty. 36.4 × 701.8 cm. Palace Museum, Beijing.

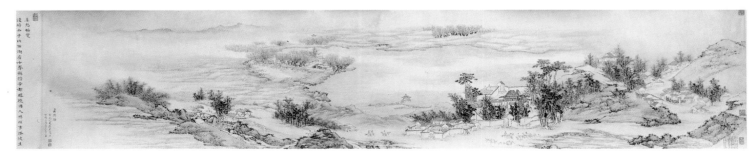

248. Wu Hong, *Swallow Rock and Mochou Lake,* section of a handscroll, ink on paper, Qing dynasty. 31 × 149.5 cm. Palace Museum, Beijing.

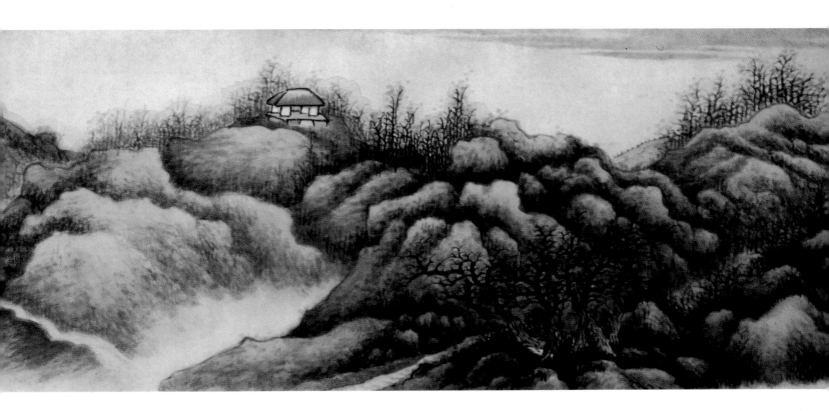

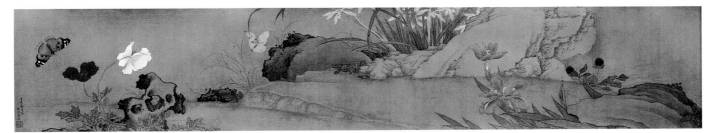

249. Fan Qi, *Flowers and Butterflies,* section of a handscroll, ink and color on gold-leaf paper, Qing dynasty. 19.8 × 197 cm. Palace Museum, Beijing.

which add to the rustic intimacy of his works. Little is known about Hu Zao (active ca. 1670–1720), Ye Xin (fl. 1647–1679), and Xie Sun (late seventeenth century), and their signed paintings are rare.

Portrait Painters

Throughout the Ming and Qing dynasties, there were fewer portrait painters than landscape and bird-and-flower painters. But portraiture, which served a practical purpose, nonetheless made headway in the early Qing, and a number of painters became famous as portraitists.

Qing portrait painting was basically a continuation of the Bochen (Zeng Jing) School, which had achieved prominence toward the end of the Ming dynasty. Primarily undertaken by professional artists because it required special training, portrait painting did not have the status of other art: most portrait painters were unheralded. Only the best of them acquired the status of scholar-painters. But they were becoming prolific; the great demand for portraits to commemorate such occasions as a scholar's birthday or a memorial ceremony for one's parents led many artists to take up portrait painting.

In addition to delineating the facial features of the sitter, traditional portrait painters paid attention to the sitter's clothes and surroundings in order to show his or her social status and interests. (See, for example, Zeng Jing's *Portrait of Wang Shimin* [fig. 229] and *Portrait of Zhang Qingzi* [fig. 230].) But many scholars chose to masquerade as farmers or fishermen when they sat for their portraits, as a sign that they aspired to live a peaceful, secluded life on a farm or mountain.

After Zeng Jing, portrait painting developed along two

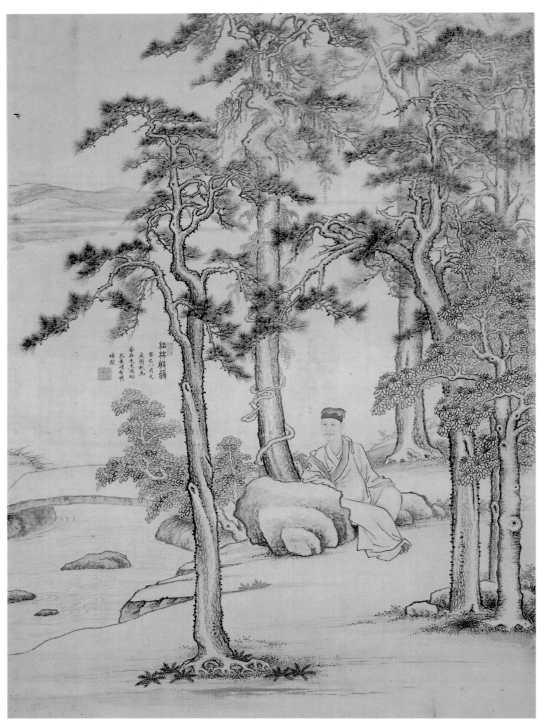

250. Xie Bin (scenery by Xiang Shengmo), *Portrait of Zhu Kuishi,* hanging scroll, ink and light color on silk, 1653. 69.2 × 49.7 cm. Palace Museum, Beijing.

lines. "One [group] emphasized ink work and applied color after the portrait had been completed in ink; the other outlined the facial features only in faint ink and relied on color to complete the portrait."[13] Among the most famous portrait painters of the early Qing are Xie Bin, Guo Gong, Xu Yi, Wang Yunjing, Liao Dashou, Zhang Qi, Gu Qi, Shen Shao, and Zhang Yuan. The sitter in Xie Bin's *Portrait of Zhu Kuishi* (fig. 250) is a member of a noble family; he looks serene and dignified. The trees and rocks in the background were painted by Xiang Shengmo (1597–1658); they are in complete harmony with the mood of the sitter.

Zhang Qi, another follower of Zeng Jing's, painted the abbot of Wanfu Monastery in Fuqing, Fujian Province. The painting, known as *Portrait of Fei Yintong,* now hangs in Japan's Mampuku Monastery in Kyoto, an indication that the Bochen School of portrait painting extended its influence overseas. Zeng Jing's disciples Xie Bin (1601–

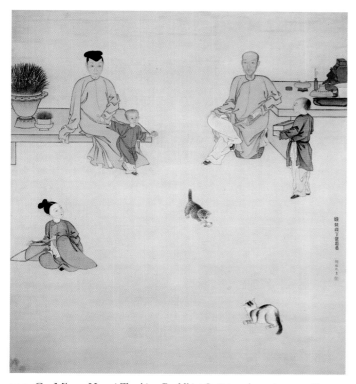

251. Gu Ming, *Yunxi Teaching Buddhist Scripture,* hanging scroll, ink and color on silk, Qing dynasty. 71.8 × 63 cm. Palace Museum, Beijing.

1681) and Shen Shao (late seventeenth century) passed on their art to Gu Ming (late seventeenth century), who in turn passed it on to another generation. Gu's only extant work, the portrait of Yunxi and his family known as *Yunxi Teaching Buddhist Scripture* (fig. 251), depicts the twenty-first son of the Kangxi emperor with his family. They are portrayed realistically, with lifelike, three-dimensional detail.

Another follower of the Bochen School was Yu Zhiding (1647–1716), a painter from Yangzhou who was active during the reign of the Kangxi emperor. After achieving fame, he went to Beijing, where he stayed for many years as a guest in the house of an official. There, he painted portraits of foreign envoys stationed in Beijing. Later he was appointed an official himself, in the Department of Rites, where he was commissioned to paint portraits for almost every notable in the capital.

His *Wang Yuanqi Cultivating Chrysanthemums* (fig. 252) is a superb portrait, executed in color on silk. Wang was not only a famous painter at the time (he was one of the Four Wangs; see above) but also a trusted senior official, close to the Kangxi emperor. Here Wang appears dignified and proud of his success. Yu Zhiding conveys Wang's status and taste as both scholar and painter by arranging books and potted chrysanthemums around him, symbols of

learning and elegance. By including a wine pot along with the chrysanthemums, Yu makes a visual allusion to the fourth-century poet-recluse Tao Yuanming.

Xu Zhang (1694–1749) was another portraitist of note, who flourished when the influence of the Bochen School was nearing its end. A native of Louxian (now Songjiang, near Shanghai), he learned to paint from Shen Shao. Shen was a student of Zeng Jing's, so Xu may be considered an indirect follower of Zeng. Several early histories of painting note that Xu had served as a court official, but although he was active in the early period of the Qianlong reign, he never received an official appointment because he failed his civil service examinations.

In *Li Kai and a Solitary Tree* (fig. 253), Xu Zhang uses both dry and wet brushstrokes; this gives texture to the face, creating a three-dimensional effect. Xu also painted portraits for public figures in his hometown. These portraits, many of which depict Ming loyalists, were collected in Xu's album *Men of Distinction in Songjiang* (Nanjing Museum). Unlike *Li Kai and a Solitary Tree,* most of these portraits were painted in black outline before applying color.

Unaffiliated Painters of the Early Qing

Quite a few artists of the early Qing did not belong to a particular school of painting. Wang Wu (1632–1690) specialized in bird-and-flower paintings. A native of Suzhou, Wang was an artist of the same caliber as Yun Shouping. Such works as *Flowers, Bamboo, and Resting Birds* (fig. 254) are known for their fresh and elegant style and their liveliness.

Xiao Yuncong and Mei Qing were important landscape painters with distinctive personal styles. Xiao Yuncong (1596–1673) was born in Wuhu, Anhui Province. He remained loyal to the Ming dynasty all his life. His landscape paintings, executed in a crisp, sober style, were influenced by Ni Zan of the Yuan dynasty. He frequently featured Mount Huang in his paintings, as in *Reading in the Snowy Mountains* (fig. 255). Here, a solitary scholar sits working in a small hut in his mountain hermitage. Only in the areas of human refuge are there hints of bright color in this otherwise somber setting. The well-filled-out composition was painted with fine, meticulous brushstrokes, the faint ink successfully reproducing the misty air on a snowy winter's day.

Mei Qing (1623–1697) was born into a highly educated family in Xuancheng, Anhui Province. Most of his landscapes were based on actual scenery, while in technique he borrowed from the Four Great Masters of the

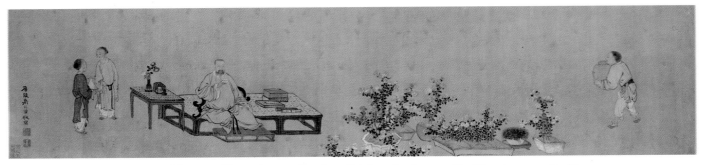

252. Yu Zhiding, *Wang Yuanqi Cultivating Chrysanthemums,* handscroll, ink and color on silk, Qing dynasty. 26.7 × 74 cm. Palace Museum, Beijing.

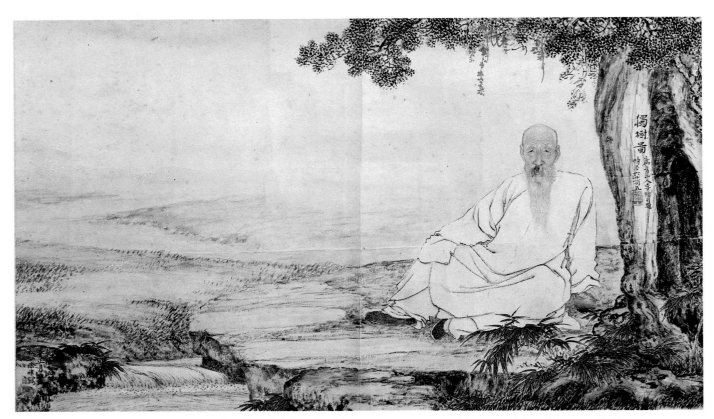

253. Xu Zhang, *Li Kai and a Solitary Tree,* handscroll, ink and color on paper, 1750. 33.7 × 57 cm. Palace Museum, Beijing.

Yuan dynasty and from the Ming painter Shen Zhou. A good friend of Shitao's, Mei often discussed art with him, exerting considerable influence on Shitao's early style. Painting in a free style similar to that of Mi Fu, Mei created landscapes that accentuated the strangely shaped peaks, rocks, trees, and clouds of Mount Huang, whose beauty inspired him to paint it many times. His hanging scroll *Tiandu Peak of Mount Huang* (fig. 256), although based on a sketch taken from life, emphasizes the unusual and strange shapes, as well as the danger of the mountain, which gives the picture both a familiar and a novel look.

Because most of the famous painters and calligraphers were southerners, when a northerner distinguished himself, he attracted a great deal of attention. One such was Fu Shan (1606–1684), a native of Taiyuan in Shanxi Province. After the fall of the Ming, Fu began wearing a red coat and adopted the name Red-Coated Daoist to show his loyalty to the fallen dynasty. He lived in obscurity, practicing medicine, painting pictures, selling calligraphic works, and carving stone seals. Nonetheless, his works attracted the attention of the Qing authorities, who tried to enlist him into government service. He steadfastly declined. His landscape paintings have an

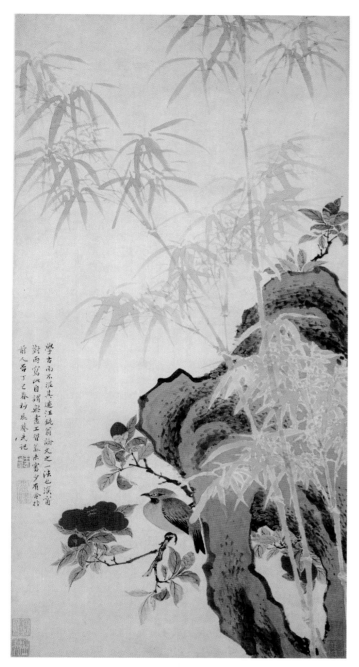

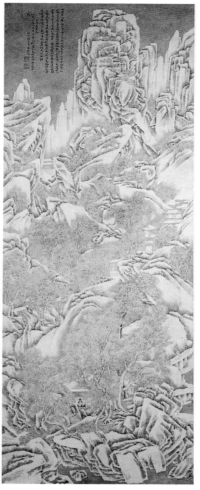

254. Wang Wu, *Flowers, Bamboo, and Resting Birds,* hanging scroll, ink and color on paper, 1657. 79.8 × 40.4 cm. Palace Museum, Beijing. *left*

255. Xiao Yuncong, *Reading in the Snowy Mountains,* hanging scroll, ink and color on paper, 1652. 124.8 × 47.7 cm. Palace Museum, Beijing. *above*

anachronistic awkwardness, as can be seen in his *Album of Landscapes* (figs. 257 and 258). He loved strange and dramatic images, odd forms, and striking colors; his paintings, like his poems and calligraphy, hint at hidden meanings. His calligraphic works, especially those done in the cursive hand, are unruly and impressive, reflecting the violent emotions of his heart. He claimed: "I would rather [my calligraphy] was awkward and not dainty, ugly and not charming. I would prefer deformities to slipperiness, the spontaneous to the premeditated."[14]

The Middle Qing

During the middle Qing, there was continued emphasis on diversity. As the Orthodox School of landscape paintings, the detailed and colorful bird-and-flower paintings, and the individualistic styles of the Eight Masters of Jinling were taking hold, another group of painters were beginning to experiment in the city of Yangzhou.

Yangzhou, a river port with good outside communications and abundant produce, is located at the junction of

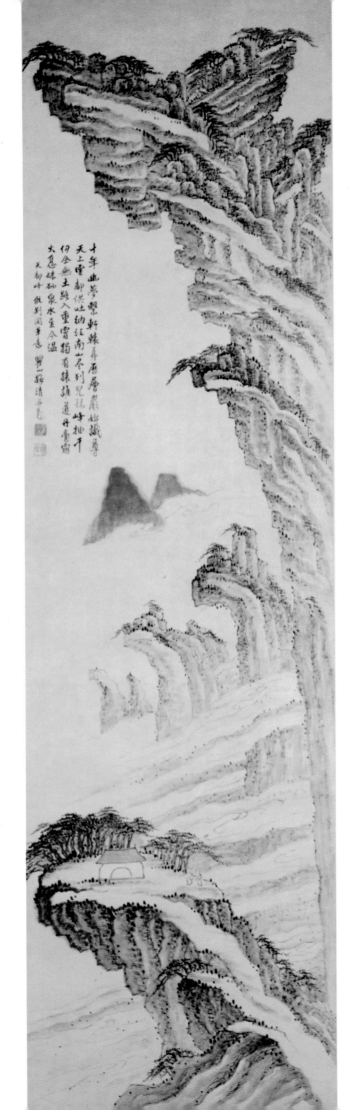

257. Fu Shan, *Landscape* from *Album of Landscapes,* album leaf, ink and color on silk, Qing dynasty. 36.5 × 37 cm. Palace Museum, Beijing.

the Yangzi River and the Grand Canal. The city suffered enormous destruction at the beginning of the Qing, but was restored to its former power during the successive reigns of the Kangxi and Yongzheng emperors. As it began to prosper economically, literati gathered there, turning the city into a cultural and artistic center. When Cao Yin (the grandfather of Cao Xueqin, author of the famous novel *Dream of the Red Chamber*) served as Superintendent of Textiles in the south, he arranged for the *Complete Tang Poems* to be printed in Yangzhou. When Lu Jian was Superintendent of the Salt Trade in Yangzhou, he supervised the compilation of a widely noted collection of poems and essays known as the *Rainbow Bridge Collection.* Wang Shizhen, a literary giant, also served as an official in Yangzhou. It was said that he handled government affairs in the daytime and met with poets in the evenings. Among the other well-known figures who lived in Yangzhou were Ma Yuequan and his brother Ma Yuelu, considered the country's greatest book collectors and the creators of a famous library in their home, Xiaolinglong Mountain Villa. An Qi, a salt merchant and well-known collector of books and art, also lived in Yangzhou.

The Eight Eccentrics of Yangzhou

According to Li Dou's *Record of the Flower Boats of Yangzhou* (*Yangzhou huafang lu,* 1795), a book that records the famous painters of Yangzhou, more than a hundred noted painters were active in Yangzhou during the reigns of the Kangxi, Yongzheng, and Qianlong emperors. Among them were the Eight Eccentrics of Yangzhou (Li

258. Fu Shan, *Landscape* from *Album of Landscapes,* album leaf, ink and color on silk, Qing dynasty. 36.5 × 37 cm. Palace Museum, Beijing.

Shan, Wang Shishen, Jin Nong, Huang Shen, Li Fang ying, Zheng Xie, Gao Xiang, and Luo Pin), who introduced new ideas and methods in bird-and-flower, bamboo, and rock paintings that allowed the artist full play in the expression of his individuality and that exerted a profound influence on painters of later generations. Each of these artists emphasized the perfection and expression of the individual personality, refusing to follow the established rules of any painter or school of painting.

Li Shan (1688–ca. 1757) was the oldest of the Eight Eccentrics. Born into a wealthy family in Xinghua in today's Jiangsu Province, he followed the typical path of scholars, sitting for the civil service examinations and receiving the degree of provincial graduate in 1711. He traveled to Gubeikou in present-day Hebei Province, where he had an audience with the Kangxi emperor. Favorably impressed, the emperor appointed him to a position in the imperial study. Li later served as a local government official in Linzi and Tengxian in Shandong Province, until he was dismissed from his post in 1740, during the reign of the Qianlong emperor. After serving a few years as a local government official and witnessing the corruption and dishonesty of officialdom, Li retired to live in Yangzhou, where he found pleasure in poetry, painting, and books and made his living by selling his pictures. In Yangzhou, he became close friends with two of the other Eight Eccentrics, Zheng Xie and Li Fangying.

Li Shan's poems and paintings indirectly expressed his dissatisfaction with reality. He was best known for his pictures of flowers, plants, bamboo, and rocks. When he first learned to paint, he followed the style of Jiang Tingxi (1669–1732), a famous flower painter in the meticulous, realistic manner. Guided as well by Gao Qipei (1660–1734), a finger painter who helped establish and define a technique for what had been practiced only sporadically, Li learned to paint in a free style. During his mature pe-

riod, his works and style, deeply influenced by Xu Wei of the Ming dynasty, became free and natural. *Pine and Wisteria* (fig. 259) depicts an old pine tree with mottled bark and dense foliage. The tree extends diagonally, while wisteria winds upward around the trunk. The picture was painted in ink with only a faint tint of color. Here, as in most of his work, Li combined painting with calligraphy and poetry, making each a part of the whole. The poem on the upper right-hand side of the painting reads:

> After all the exuberant flowers in spring have been praised,
> What in this quiet place can I find to sing about?
> In my empty yard the sun has come out after the rain, and the curtain has been rolled up,
> The wisteria is in full bloom in the glow of the setting sun.

The artist contrasts the exuberant flowers of spring with the quiet place and the wisteria glowing in the setting sun to create a mood of nostalgia and bitterness for what once was. Thus, through the poem's characterization of the flowers and trees, the poet-painter evokes his feelings about his dismissal from office.

Lotus in the Wind shows lotus flowers, leaves, and seedpods swaying in the wind, while the poem completes the meaning:

> The lotus leaves were not blackened by the mud,
> They were painted that way by dark ink.
> Last night the cloud was thick,
> I painted in my thatched house in the midst of the storm.

Suffering setbacks, the artist refuses to conform. Like the lotus, which emerges unstained from the mud, the artist retains his integrity in adverse circumstances.

Like Li, Jin Nong (1687–1764) was not a native of Yangzhou. Born by the Qiantang River outside the Tide-Waiting Gate of Hangzhou in Zhejiang Province, he was a man of profound learning, who studied poetry and essay writing as a young man and later turned to the study of Buddhism. When he was thirty-five, he moved to Yangzhou to be with some of his literary friends. Later he journeyed to the north, staying in Shanxi for three or four years before traveling extensively in Hubei, where he studied inscriptions on bronzes and stelae. In 1736, the first year of the Qianlong reign, he went to Beijing, after a local official recommended that he take an extraordinary Hanlin Academy exam reserved for those considered unusually learned. Although he refused to take the exam, he made friends with many men of letters in the capital and

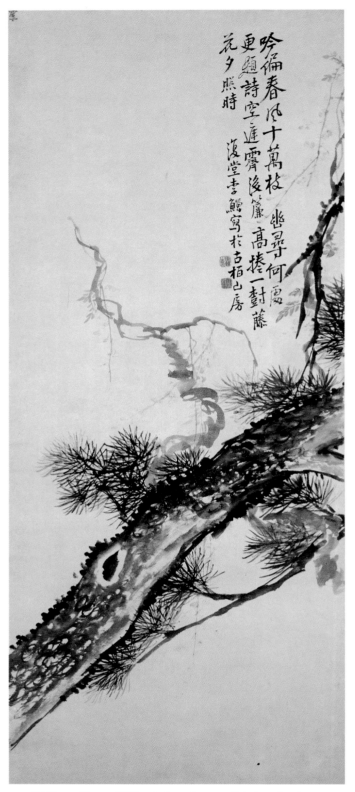

咏偏春風十萬枝
更題詩空進霽後簾高捲一對藤
花夕照時
幽尋寺何處
復堂李鱓寫於古栢山房

259. Li Shan, *Pine and Wisteria,* hanging scroll, ink and color on paper, 1730. 124 × 62.6 cm. Palace Museum, Beijing.

returned to Yangzhou later that year. In later years, he often traveled between Hangzhou and Yangzhou. He died in a Buddhist temple in Yangzhou.

Jin Nong was skilled in painting plum blossoms in the classical style, but he also specialized in figures and other subjects. In his *Self-Portrait* (fig. 260) we see a bald old man with a beard and a small pigtail who looks like an impish boy. Wearing a long robe, he is strolling along, carrying a long bamboo stick in his right hand. The portrait was drawn with simple lines, and the artist paid no attention to the proportions of the various parts of the body. Although it gives the impression of an impromptu sketch, it possesses unusual qualities.

On the right-hand side of the portrait is a neatly written inscription that lists almost a dozen artists who painted portraits for either celebrities, eunuch officials, or friends. The inscription also tells why Jin painted the self-portrait:

> I . . . used the ink-monochrome plain-outline method to myself depict the *Portrait of the Old Commoner of Three Dynasties in his Seventy-third Year* [*Self-Portrait*]. For the drapery patterns and face I used the one-stroke method; patterning myself after Lu Tanwei. When the picture was finished, I distantly entrusted it to my old friend and fellow townsman Ding Chun [Ding Jing, a renowned seal cutter and calligrapher], the Hermit Ding. The Hermit hasn't seen me for these last five years. How could I not think of him? Some day in the future when I return to Jiangshang I may walk, staff and shoes side by side, with the Hermit. We will loftily chant and grasp the scenery, and he can verify that my decayed visage still hasn't changed from the image of the spirit of mountains and groves. In the twenty-fourth year of the Qianlong era [1759], . . . Jin Nong recorded this at the Guangling [Yangzhou] Monk's dormitory's Ninth Festival Calamus Rest Hall.[15]

Gao Xiang (1688–ca. 1753) was born in Ganquan in the prefecture of Yangzhou, of a poor family. He did not make many friends, and he seems to have spent his whole life in the vicinity of Yangzhou, without ever traveling. He became good friends with the monk painter Shitao (who had settled in Yangzhou) when he was a young man, and after Shitao died Gao would offer wine at his grave on every anniversary of his death. Yet though close to Shitao, Gao does not seem to have been influenced by his paintings. More even than most of the Eight Eccentrics, Gao emphasized individuality and originality in his work.

Gao Xiang's *The Tanzhi Pavilion* (fig. 261) is based on an

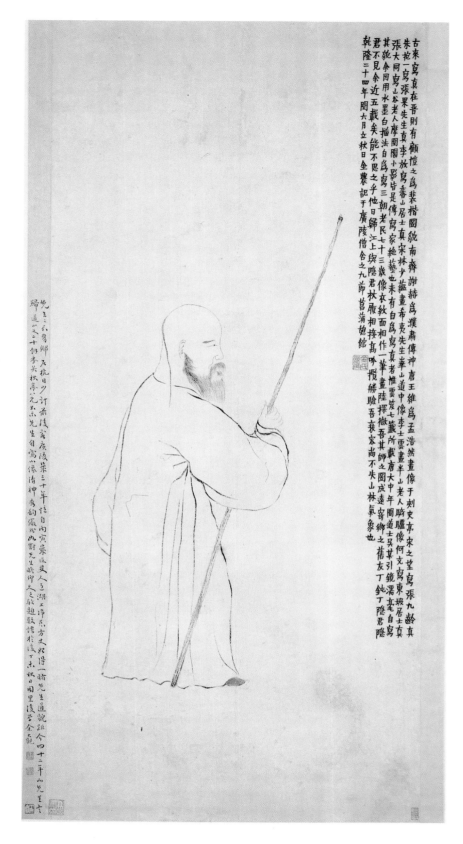

古來寫真在晉則有顧愷之為裴楷圖貌南齊謝赫為張傳神唐王維為孟浩然畫像于刺史亭宋之望寫張九齡真
朱抱一寫張果先生真李放寫春山居士真宋林少蘊畫希夷先生峯山道中像李士雲畫半山老人騎驢像何充寫東坡居士真
張大同寫山谷老人摩圍閣小影皆是傳寫家絕藝也未有自為寫真者惟雲甍七蒙所載膚大中年間道士吳某引鏡濡毫自寫
其貌余同用水墨白描法自為寫三朝老民七十三歲像衣紋面相接一筆畫成遠寄鄉之舊友丁鈍丁隱君
君不見余近五載矣能不思之乎他日歸江上與隱君秋風相接高吟攬饍聯映吾衰家尚不失山林氣象也
乾隆二十四年閏六月立秋日金農記于廣陵僧舍之九節菖蒲熊館

260. Jin Nong, *Self-Portrait,* hanging scroll,
ink on paper, 1759. 131.4 × 59 cm.
Palace Museum, Beijing.

actual place in Yangzhou. The pavilion is an elegant monks' dwelling that occupied a quiet corner near a noisy marketplace in the western part of the famous Tianning Temple. With clean, spare brushstrokes, Gao conjures up a complex that includes a dwelling, a garden, and a Bud-dhist temple. This peaceful world is enclosed by a thin fence with a crude gate. In the yard stand a few tall trees, their thick foliage providing pleasant shade. A two-storied pavilion stands among plantains and trees, its door and windows wide open. There is a long table in

each of the rooms. In an upstairs room, an incense burner rests on the table, and a picture of the Buddha hangs on the wall. Two figures are chatting in the yard. Gao Xiang delineated the trees, buildings, and figures with thin but forceful lines and filled in the tree trunks and leaves with diluted ink, thus enhancing both the texture and the depth of the images. This minute, realistic detail, combined with the emptiness of the landscape outside the fence, makes the Tanzhi Pavilion and the other Buddhist structures seem unreal; the painting has a feeling of otherworldliness.

Zheng Xie (1693–1766), the best known of the Eight Eccentrics of Yangzhou, gained fame for both his painting and his calligraphy. He was born into a scholar's family in Xinghua, Jiangsu Province, and educated in the scholar's tradition in the hope that he would have a distinguished career as a government official. He received the degree of provincial graduate in 1732, when he was thirty-nine. After passing the civil service examinations and receiving the degree of *jinshi* (successful candidate in the highest imperial examination) four years later, he began his service as a government official. He often used a personal stone seal carved with twelve characters that meant "a licentiate of the Kangxi reign, a provincial graduate of the Yongzheng reign, and a jinshi of the Qianlong reign" to record both his love of scholarship and his attainments. He served as a local government official for twelve years, losing his job after offending his superiors. After returning to Yangzhou, he sold his paintings for a living. He compiled a list of the prices of his works:

> A large hanging scroll costs six taels, medium-sized one is four, a small scroll costs two. Couplet and streamer are one tael a pair, while fan and album leaf are a half-tael each. Those who bring gifts and food are certainly not as welcome as those who come with silver, because what you give is not necessarily what I desire. If you come with cash, my heart will be filled with joy so the paintings and calligraphy will be excellent. Gifts cause nothing but trouble, not to mention deferred payment. Furthermore, in my old age, I get easily tired. Therefore, please excuse me from accompanying you gentlemen in unprofitable conversations.

He ended the list with a poem:

> One earns more from painting bamboo than planting bamboo,
> A painting six feet tall costs three thousand cash.
> However much he may talk about old friendship or connections,
> It is like the autumn wind blowing past my ears.[16]

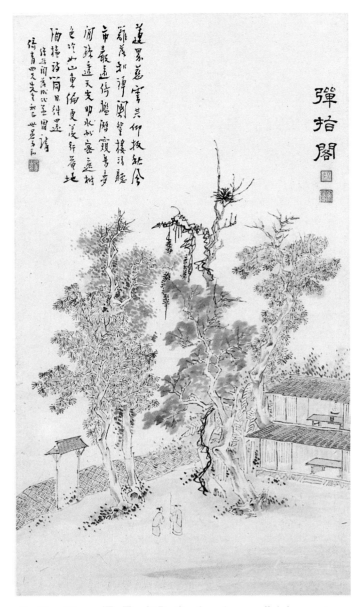

261. Gao Xiang, *The Tanzhi Pavilion*, hanging scroll, ink on paper, Qing dynasty. 68.5 × 38 cm. Yangzhou Museum.

Such comments are just like the artist himself, good-humored, frank, and straightforward.

Yangzhou was the most prosperous city ruled by the Qing, and not only did it appeal to merchants from all parts of China, but scholars, poets, officials, musicians, and dramatists were also drawn to its vibrant cultural life. Many of the men who bought Zheng Xie's paintings and calligraphic works were salt merchants doing business in Yangzhou. These were upwardly mobile men with some cultural background, who sought to emulate the scholars by decorating their homes with works of art and creating private gardens. Such merchants became patrons

of painters and calligraphers like Zheng Xie, creating a growing market for their work.

While Zheng Xie was in government service in Beijing and later in the provinces, he became a friend of Yunxi, the prince of Shen and the twenty-first son of the Kangxi emperor. Their friendship lasted for more than twenty years, during which time they corresponded and exchanged poems.

Zheng Xie was an outstanding painter of bamboo, orchids, and rocks. It was said that he painted orchids that never wither, ever-green bamboo with one hundred sections, rocks that never die, and people who never change. His pictures of orchids, bamboo, and rocks, in other words, symbolize people who are honest, faithful, and unchanging. He loved the resilience of rocks and orchids, and he painted them to comfort the hard-working people, not to please people of the leisure class.

His calligraphy combined the style of *li,* official script, and *kai,* regular script. In *Bamboo and Rock* (fig. 262), the grove of bamboo appears natural, yet the bamboo leaves, perfectly arranged, give rhythm to the picture. Painted in ink without color, the contrast of black and white and the distinct style suggest the peace to be found in nature, apart from philistines and the unpleasant reality of dealing with them. Zheng Xie used bamboo for many things: to portray his spirit, to express his friendships, to mock the injustice of society, and to voice the longings of the people. On a bamboo painting that he gave as a gift to the governor of Shandong he wrote:

Lying down at your house and listening to the rustling bamboo,
You may suspect you have heard the complaint of the people.
Small county official though I may be,
Always be concerned with matters as small as a leaf.

Zheng claimed that it took him forty years to achieve the graceful, original, and expressive charm of his bamboo and to master the three stages of painting it: "Bamboo in my eyes, bamboo in my heart, bamboo in my hand." First observe and study the bamboo, he wrote, so that you may become familiar with its disposition and characteristics before you compose the picture in your mind. Then paint that picture on paper or silk. Once the first two stages were completed, then the painting process was like what is called "lightning and thunder," and the plants looked as if they were "growing wild." Zheng usually wrote a long passage or a poem on the painting, as well; the calligraphy, poem, and painting combined were considered *sanjue,* "three perfections."

Li Fangying (1695–1755) was born in Nantong, Jiangsu Province. He studied diligently as a boy and received the licentiate degree when he was quite young. He was appointed a county magistrate in 1729. Later, while distributing relief to the victims of a natural disaster, he offended his superior and was thrown into prison on a false charge. When he was released, he had lost his job; he traveled between Jinling, Yangzhou, and Nantong, selling his pictures and living a reclusive life. Although Li did not stay in Yangzhou long, he is regarded as one of the Eight Eccentrics because his artistic interests were similar to theirs.

Li's favorite subjects were bamboo (which he painted in ink), orchids, plum blossoms, pines, and rocks. His paintings are notable for their elegant, simple style. In his *Ancient Pine Trees* (fig. 263), painted a year before his death, two pines stand one in front of the other, their branches interlocked, seemingly lost in thought; they may be seen as a portrayal of the painter himself.

The youngest of the Eight Eccentrics was Luo Pin (1733–1799), a native of Yangzhou. His parents died when he was young, and he studied painting under arduous circumstances in his early years. He later became a trusted disciple of Jin Nong, through whom he met many of the well-known painters and literati in Yangzhou.

Luo Pin's works are more varied in subject matter than those of his teacher, and many of his fine paintings of figures, landscapes, bamboo, rocks, and flowers survive. His *Orchids in a Deep Valley* (fig. 264) shows a small stream flowing down through the crevices of huge boulders, where orchids (which suggest a refined taste) grow in abundance. With seemingly careless brushstrokes, Luo gives the boulders, painted in faint ink, and the orchids, done in dark ink, an ethereal quality: they evoke a feeling of spiritual otherworldliness. Luo was probably influenced by the Buddhist philosophy of his teacher Jin.

Luo also excelled in painting ghosts. His *Ghosts* depicts strange and bizarre figures in a ghostly world; through them Luo mocked corrupt officials and societal injustices toward the end of the long Qianlong reign. The cultural elite appreciated Luo's ghosts, which they understood as satirical comments on the corruptions and excesses of contemporary officials and other powerful members of society. The works of Luo's wife, Fang Wanyi (1732–after 1779), and those of their two children, who were all good at painting plum blossoms, were known as "Luo's plums."

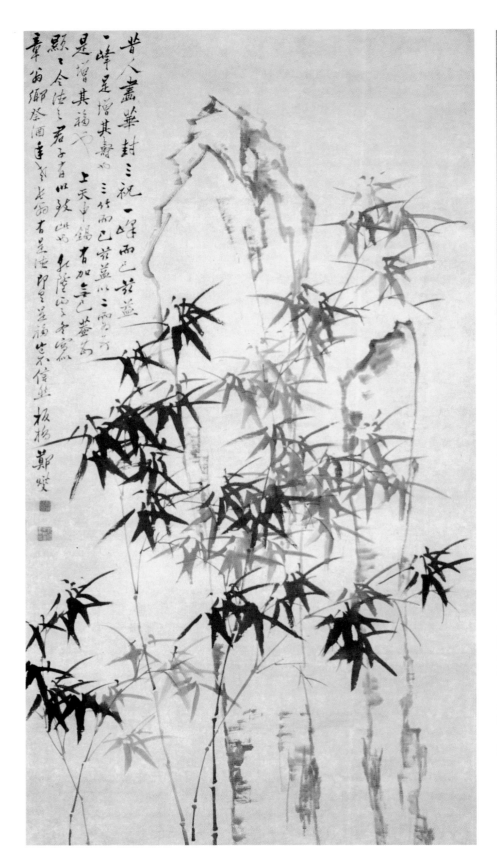

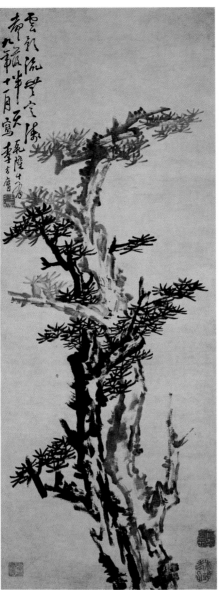

262. Zheng Xie, *Bamboo and Rock*, hanging scroll, ink on paper, Qing dynasty. 170 × 90 cm. Tianjin Art Museum. *left*

263. Li Fangying, *Ancient Pine Trees*, hanging scroll, ink on paper, 1754. 123 × 43.6 cm. Palace Museum, Beijing. *above*

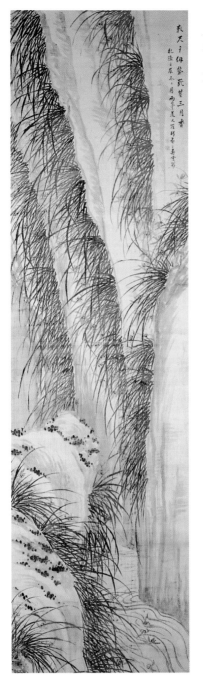

264. Luo Pin, *Orchids in a Deep Valley,* hanging scroll, ink on paper, Qing dynasty. 110 × 33.1 cm. Palace Museum, Beijing.

Hua Yan — A Scholarly Professional Painter

Hua Yan (1682–1756), a native of Shanghang, Fujian Province, grew up among local artists and painting specialists. Born to a poor family, he painted murals for family shrines as a child. He left home when he was still young, traveling first to Hangzhou and then to Beijing. In his middle years, Hangzhou and Yangzhou became his homes.

Hua Yan's art appealed to both the literati and the ordinary city dwellers and merchants. *Snow on Mount Tian* (fig. 265), painted the year before his death, depicts an itinerant merchant trudging through ice and snow in the northern wilderness on a long, arduous journey. Wearing a fur hat and an overcoat, a sword hanging at his waist, he leads a camel. The heads of both the traveler and the camel are raised to the sky as a wild goose flies overhead. The solitary traveler, the camel, and the wild goose give poignancy to the desolation of the scene. But the bleakness of gray sky, brown camel, and white snow are relieved by the overcoat of bright red. Like many poems of the Tang dynasty that describe scenes outside the Great Wall, the picture creates a lonely yet solemn and stirring mood.

The Meticulous Style in the Mid-Qing

Li Yin, Xiao Chen, Yuan Jiang, and Yuan Yao were famed for their paintings of buildings and landscapes rendered in the meticulous style that featured fine brushwork and close attention to detail. Unlike the Eight Eccentrics of Yangzhou, who were favored by Anhui merchants, painters who used this style were patronized by merchants from the north, particularly Shanxi.

Li Yin (ca. 1616–1685), a native of Yangzhou, appears never to have left the region. Only a small number of Li Yin's works survive. *Loading the Carts* (fig. 266) depicts the everyday life of ordinary people. In both subject matter and technique it follows Song academic traditions of fine, realistic detail. It portrays a winter scene after a snowfall. A small inn deep in the mountains bustles with activity: after a night's rest, merchants on a long journey are preparing to go on their way. We get only a distant view of the scene as we look down from an elevated viewpoint. Most of the picture is filled with landscape: a big river in the background, mountains in the middle. The inn and travelers are off to one side in the foreground.

We know very little about Xiao Chen (active ca. 1680–1710), a contemporary of Li Yin's, except that he was a native of Yangzhou. His *Herd Boy Returning Home Along a Willow Embankment* (fig. 267) depicts life on a farm. After a day of hard work, an exhausted herd boy is trudging homeward in the evening, driving a water buffalo. A crude bridge spans a narrow stream, and willows put forth tender green leaves, which lend the picture a poetic touch. On the picture is an inscription by Liang Qingbiao, an art connoisseur from the north and an admirer of Xiao Chen's. The artist had painted *A Scholar's House Among Banana Trees* (Palace Museum, Beijing) especially for Liang.

Two painters who specialized in pictures of palaces set in landscapes were Yuan Jiang (active ca. 1680–1730) and Yuan Yao (active ca. 1739–1788). They flourished in Yangzhou during the reigns of the Kangxi and Qianlong emperors. Because they were professional painters rather

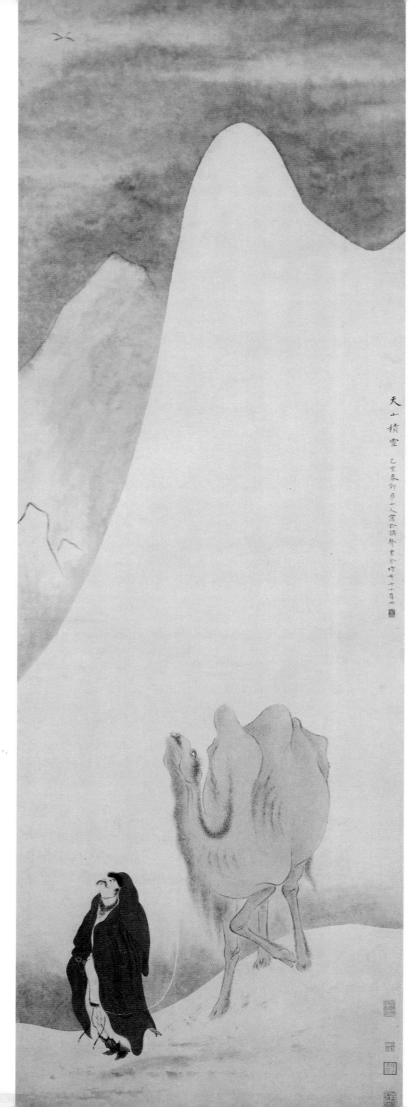

than scholar-artists, they left behind no collections of poems or essays, and no scholars wrote about them. As a result, little is known of their lives.

Yuan Jiang's early artistic activities were confined to the area around his hometown of Yangzhou. When he reached middle age, he was invited to live in Shanxi by a salt merchant who had business in Yangzhou. There he became famous for his exquisite paintings of buildings and landscapes in the Song-dynasty style. *Pavilion of Deep Fragrance* (fig. 268), one of Yuan's early works, offers a panoramic view of Zhanyuan in Nanjing, featuring the residence of Xu Da (a famous general of the early Ming dynasty), which became the seat of the Provincial Treasury during the Qing dynasty. There are many-storied houses, pavilions, covered walks, and a garden. Yuan Jiang's picture gives a faithful and detailed portrayal of the residence. Even the couplets decorating either side of the doors are clearly legible. The lines of the painting are straight and forceful, and the rockery in the garden is meticulously rendered. His *The Eastern Garden* (1710; Shanghai Museum) is a similar work.

Yuan Yao's artistic career began roughly in 1739, the fourth year of the Qianlong reign, and ended in 1788. Yuan Yao reportedly spent many years painting in the home of a Shanxi merchant. His paintings are similar to those of Yuan Jiang. In fact, without looking at the signatures, it is hard to tell the difference. Generally speaking, Yuan Yao's works have tighter compositions than Yuan Jiang's. *A Famous View of Hanjiang* (fig. 269), an enormous handscroll dating from 1747, accurately depicts a spot on the northwestern outskirts of Yangzhou: the city moat, Zhenhuai Gate, Plum Blossom Hill, Lord Shi's Shrine, and Shugang Hill can be seen in the distance. The picture was sketched from life, and its realistic effect is achieved by the use of *jiehua* (traditional architectural drawing) as well as by its detailed clarity: the foreground, middle ground, and background are clearly defined.

Court Painting

Court painting flourished during the reigns of the Kangxi, Yongzheng, and Qianlong emperors, when the dynasty reached its zenith. Initially, court painters continued the traditions established by the Ming court painters. But following the arrival of the Italian missionary painter Giuseppe Castiglione (1688–1768), who served at court in the early years of the Kangxi reign, Qing court paintings began to show a clear Western influence. Casti-

265. Hua Yan, *Snow on Mount Tian,* hanging scroll, ink and light color on paper, 1755. 159.1 × 52.8 cm. Palace Museum, Beijing.

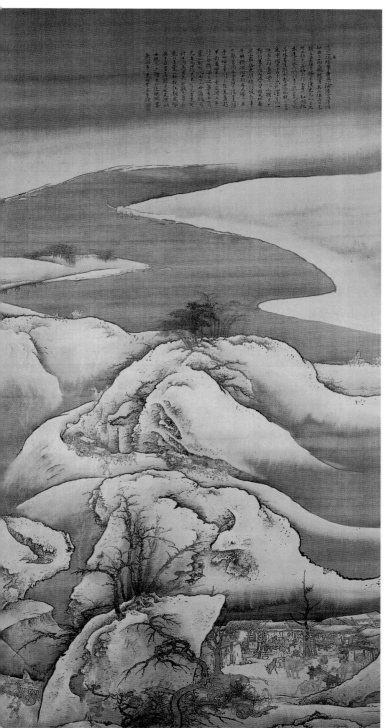

266. Li Yin, *Loading the Carts,* hanging scroll, ink and light color on silk, Qing dynasty. 133.5 × 73.5 cm. Palace Museum, Beijing.

267. Xiao Chen, *Herd Boy Returning Home Along a Willow Embankment,* hanging scroll, ink and color on silk, Qing dynasty. 44 × 25.9 cm. Palace Museum, Beijing.

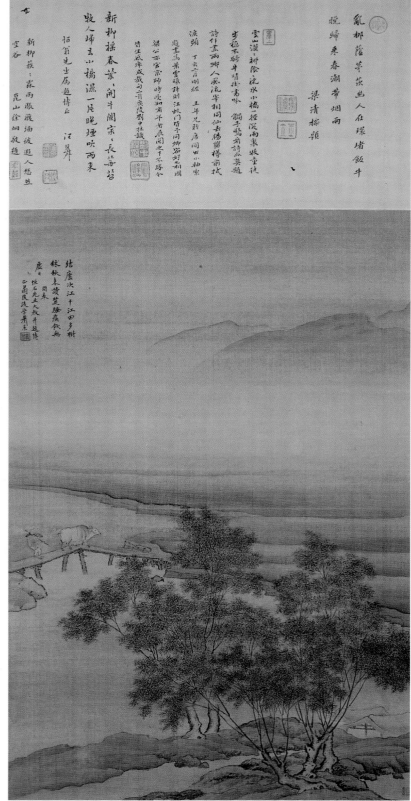

glione was followed by other Europeans. These artists significantly promoted the interchange between Chinese and Western art and culture. Together, the Chinese and European painters created a new school of painting that combined Chinese and Western methods. The influence of Western art on the Qing court paintings is particularly evident in the emphasis on light, shade, and perspective,

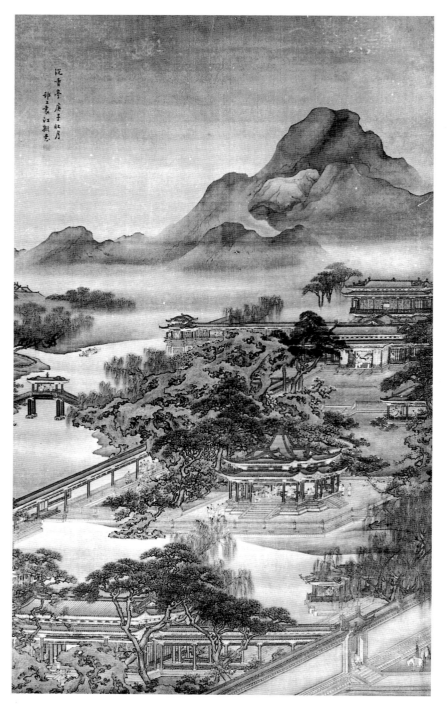

況書巢庚子臘月
邗上袁江擬意。

268. Yuan Jiang, *Pavilion of Deep Fragrance,*
hanging scroll, ink and color on silk,
Qing dynasty. 197.5 × 121.2 cm.
Tianjin Art Museum.

as well as in the priority given to recording contemporary events. In addition, the missionary painters brought the techniques of oil painting and copperplate etching to China, two genres of art that first appeared in the Qing court.

These European missionary painters represented a new and unusual development in the history of Chinese art. Following what the Europeans saw as their discovery of the world, countries like Spain, Portugal, the Netherlands, Italy, England, and France, which had considerable marine power, were among the first to extend their reach to the mysterious, rich East. In this process of exploration, religion served as a useful tool, and for many years cultural and artistic exchange between East and West was performed by the Jesuits.

The European painters not only produced many works of their own, they also introduced the various techniques and genres of Western painting to Chinese court painters, who began to combine Chinese and Western methods. The new Chinese works, however, were

criticized by the guardians of traditional Chinese art as being stiff, strained, and inharmonious. Zou Yigui (1686–1772), in writing about the three-dimensional effects produced by Western techniques, noted that "Westerners are skilled in geometry. They make precise measurements of light and shade, foreground and background. . . . The images in the pictures are measured with a set square so that they are reduced in size according to distance. People almost want to walk into the houses and walls they have painted." But, he complained, there is no method in the brushstrokes. "Though meticulously executed, their works are those of craftsmen and cannot be considered as paintings."[17] The emergence of paintings that combined Chinese and Western methods, however, was a highly significant phenomenon. It was both an onslaught against and a complement to traditional Chinese painting.

European painters in China were, in turn, influenced by the Chinese. They drew on traditional Chinese painting to enrich their own methods of expression. This can be seen most clearly in portraiture. European portrait painters often lit the sitter from one side to achieve an illusion of three-dimensionality. Chinese painters, on the other hand, almost invariably lit the sitter from the front, to depict the facial features clearly. The half-lit face was unacceptable to the Chinese. (The Qianlong emperor thought that the shadows looked like dirt, and he didn't want to be portrayed with a dirty face.) When such European painters as Castiglione painted the emperor and his consorts, they followed the Chinese method; in addition, they reduced the intensity of the light so that there was no shadow on the face, and the features were distinct.

The most popular, and most valuable, purpose of court paintings in the Qing dynasty was to record events, surpassing in this respect court paintings of the Song and Ming. These works offer some of the best data on the history of that period. Some of the more important historical paintings are *The Kangxi Emperor on His Southern Inspection Tour* (see fig. 240), consisting of twelve handscrolls painted by Wang Hui and others; *Yongzheng at Yong; The Qianlong Emperor's Southern Inspection Tour: An Equestrian Performance* (a handscroll); *Imperial Banquet in the Garden of Ten Thousand Trees* (a handscroll); *Kazaks Presenting Horses in Tribute; Mulan;* and *A Great Parade.* The *Yongzheng Emperor Offering Sacrifices at the Altar of Agriculture* (fig. 270), a long handscroll, shows the Yongzheng emperor fulfilling his sacred duties as the Son of Heaven. As mediator between heaven and earth, he performed the cosmologically significant sacrifice at the Altar of Agriculture in the springtime, symbolically holding a plow to cut the first furrow in a special plot of land. After the highest-ranking ministers had plowed a few rows, the growing season would begin. The grandeur and importance of this ritual is captured in the crowds of officials, ministers, and attendants who gather in formation in front of the altar.

With the Europeans working as court artists, many of the court paintings showed clear European influence in style. Castiglione's *Auspicious Objects* (fig. 271), for example, was painted to celebrate the Yongzheng emperor's birthday. The pine, eagle, and mushroomlike plant (*lingzhi*) are symbols of blessing; they are traditional subjects of Chinese paintings. But the technique is Western. The painter emphasized the direction of the light, the effect of shade, and the illusion of three-dimensionality. Zhang Weibang's hanging scroll *The Glory of the New Year* (fig. 272) is not a masterpiece, but it reflects the effort made by Chinese court painters to incorporate European techniques into their work. The picture has a traditional Chinese subject, but it gives the impression of a European still-life.

European influence is further evident in the work of Chinese painters who tried to add perspective to their pictures. In Xu Yang's *Spring in the Capital* (fig. 273), the orientation of some of the buildings along varying receding diagonals shows an attempt to add perspective, but the lack of a single vanishing point and the more traditional rendering of the landscape background are less successful. They conflict with what is being attempted with the buildings.

Shen Quan's Bird-and-Flower Paintings

While painting flourished at the court and in the Yangzhou area in the mid-Qing period, a successful painter of birds and flowers appeared in the south. Shen Quan (1682–1765), a native of Wuxing in Zhejiang Province, was a professional painter who followed Lü Ji of the Ming dynasty in the use of the meticulous style and bright colors. All his works are filled with sumptuous color, symbolic of auspiciousness, good fortune, and longevity. In 1731 Shen traveled to Japan with two of his disciples, Zheng Pei and Gao Jun. He stayed for two years in Nagasaki, where he taught painting to the Japanese. His painting style became highly influential in Japan, and he was extolled as the first of the visiting painters. *Pine, Plum, and Cranes* (fig. 274) shows the influence of Lü Ji, but Shen deviated from the style of Lü and the Imperial Painting Academy in his depiction of the rocks; he used a dry brush to bring out the texture in a few forceful strokes, a style closer to that of the Wu School of painting.

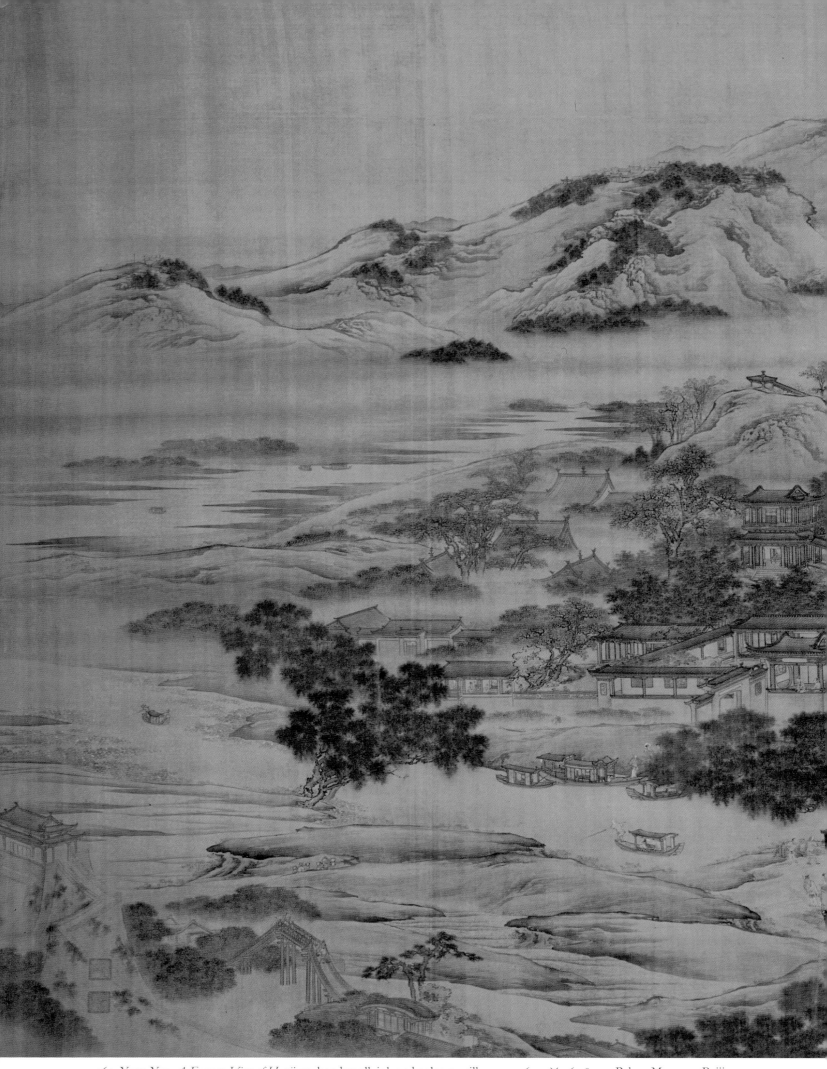

269. Yuan Yao, *A Famous View of Hanjiang*, handscroll, ink and color on silk, 1747. 165.2 × 262.8 cm. Palace Museum, Beijing.

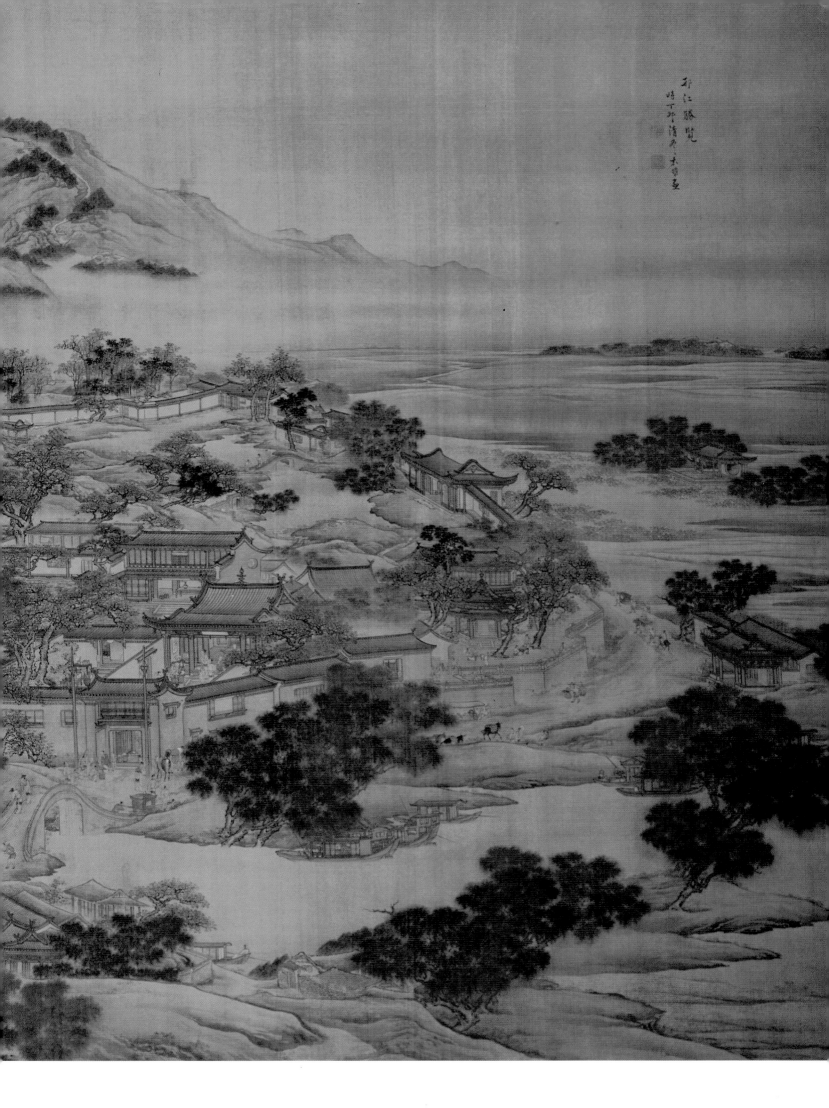

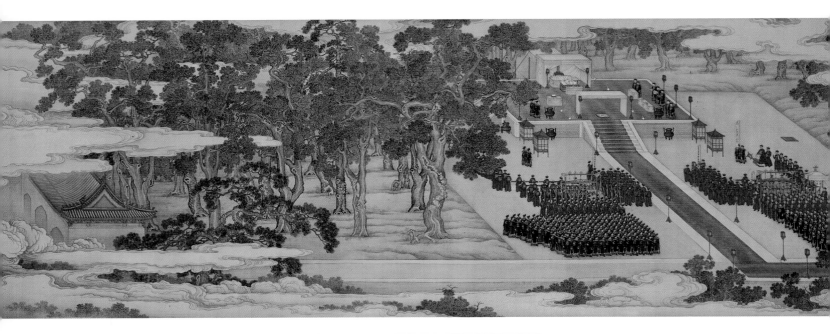

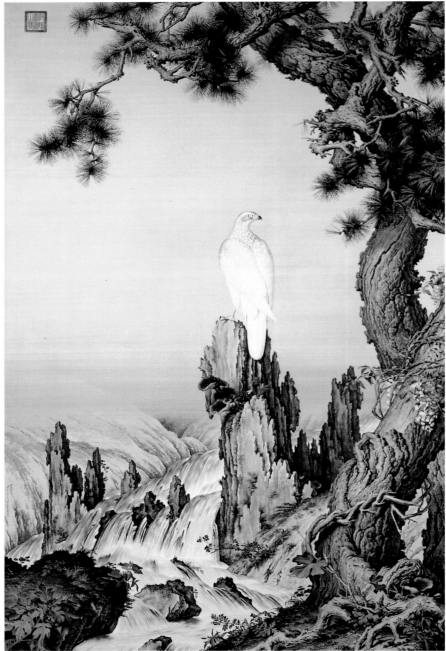

270. Anonymous, *The Yongzheng Emperor Offering Sacrifices at the Altar of Agriculture*, section of a handscroll, ink and color on silk, Qing dynasty. 61.8 × 467.8 cm. Palace Museum, Beijing.

271. Giuseppe Castiglione, *Auspicious Objects*, hanging scroll, ink and color on silk, 1724. 242.3 × 157.1 cm. Palace Museum, Beijing.

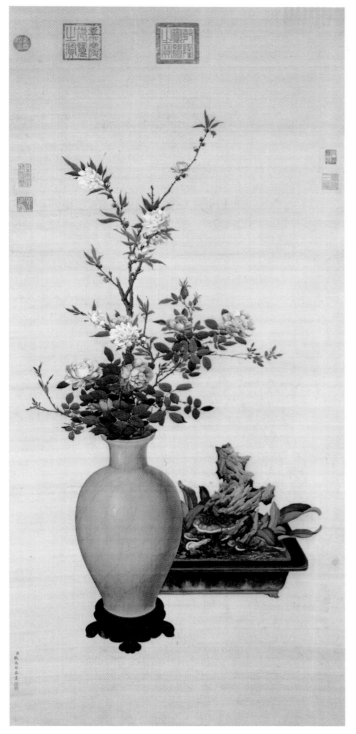

272. Zhang Weibang, *The Glory of the New Year,* hanging scroll, ink and color on silk, Qing dynasty. 137.3 × 62.1 cm. Palace Museum, Beijing.

Shen often painted pines, cranes, bees, and monkeys, for their names are homonyms of the words for good luck and blessing. This suggests his close contact with the art of the craftsmen. Because he used neat and meticulous brushstrokes and rich color, people often mistook him for a court painter. But he was an itinerant professional painter, and he never worked in the imperial court. There was, however, no impassable chasm separating the professional painters or artisans from the scholar-painters. They influenced one another, although sometimes they also discriminated against one another. When the artistic style of the scholar-painters became popular, it exerted its influence not only on the court painters but also on many of the artisans. On the other hand, some of the scholar-painters, as well as the more refined artisans, consciously introduced the aesthetic interests, themes, and methods of folk painting into their works. Chen Hongshou, a painter of the late Ming and early Qing period, for example, created many folk pictures for woodblock prints, as did the Anhui Province painter Xiao Yuncong (1596–1673). Hua Yan, as we have seen, was a craftsman who later became a famous painter.

The Late Qing

Late Qing painters continually found inspiration in the tradition of landscape, bird-and-flower, and figure painting. Increasing influence from the West, as well as from regional artisans and local craftsmen, further encouraged painters to develop personal styles, creative techniques, and innovative and imaginative compositions. Portrait painting drew upon the skills of artisans and craftsmen painters. The techniques of the Bochen School of portrait painters had been handed down among artisans, not scholar-painters, and had become the means of livelihood of regional artisans. In the late Qing, these techniques reappeared in the Shanghai School.

The Jingjiang School

In the later Qianlong and Jiaqing periods, a group of artists, represented by Zhang Yin and Gu Heqing, gathered in Zhenjiang, an important city that lies at the junction of the Yangzi River and the Grand Canal. Since Zhenjiang was also called Jingjiang, these artists became known as the Jingjiang School. It consisted of a relatively small, regional group of painters who continued the tradition initiated by the Eight Masters of Jinling of depicting actual scenes, painted from life. Zhang Yin and Gu Heqing were noted, respectively, for their pictures of

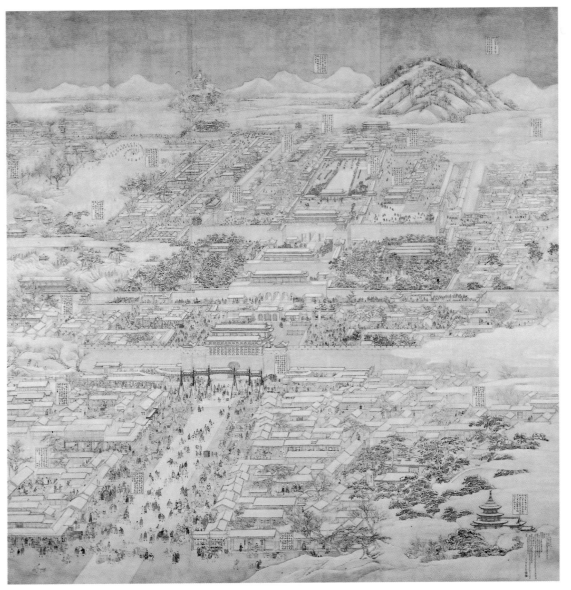

pines and their pictures of willows. People called them Zhang of the Pines and Gu of the Willows.

Zhang Yin (1761–1829) was born in Zhenjiang to a rich and cultured family. His father was a cloth merchant, who claimed as friends Pan Gongshou (1741–1794), a noted landscape painter and poet, and Wang Wenzhi (1730–1802), a well-known calligrapher and poet. In his youth, Zhang Yin made friends with Deng Shiru (1739–1805), a famous calligrapher and seal carver. In middle age, his family fortunes declined, and he was forced to sell his pictures for a living instead of painting for amusement. He died in poverty.

Until the age of fifty, Zhang had concentrated on making copies of famous paintings. When he finally began to create original works, he specialized not only in pines

but in flowers and landscape. His *Three Hills of Jingjiang* (fig. 275) depicts the scenery of his hometown. The distinctive regional characteristics make it clear that the painting was at least based on a sketch drawn at the spot.

Gu Heqing (1766–after 1830) was a close friend of Zhang Yin's. The brushwork of his landscapes was less restrained than Zhang's. The idling willows he painted are clearly done from life; they conjure up the local scenery of the rivers and lakes of parts of the south.

Pictures of Beautiful Women

The late Qing was also a time in which a number of painters appeared who specialized in paintings of beautiful women. Economic prosperity, the development of commerce, a growing diversification in daily life, and

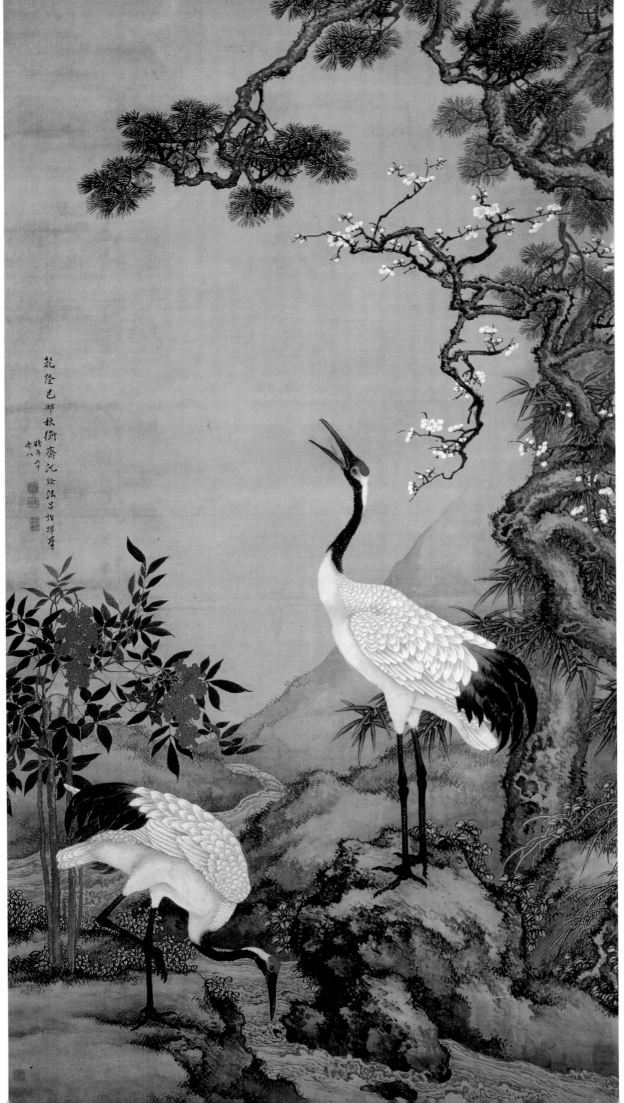

274.
Shen Quan,
*Pine, Plum,
and Cranes,*
hanging
scroll, ink
and color
on silk, 1759.
191 × 98.3 cm.
Palace
Museum,
Beijing.

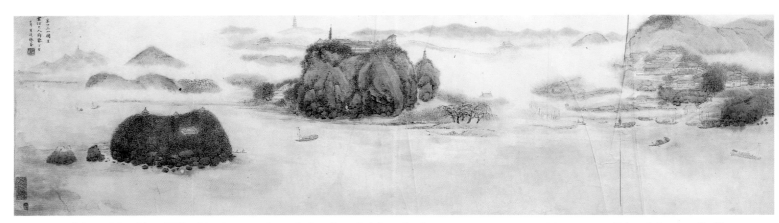

275. Zhang Yin, *Three Hills of Jingjiang,* section of a handscroll, ink and color on paper, 1827. 29.5 × 194.2 cm. Palace Museum, Beijing.

visits to brothels by the literati all contributed to this vogue. The women in these paintings all had a delicate physique, oval face, shapely eyebrows, almond eyes, sloping shoulders, and a slender waist — the embodiment of languid beauty. Two painters who made their reputation with this genre of painting were Gai Qi and Fei Danxu.

Gai Qi (1773–1828), whose remote ancestors came from the Western Regions, grew up in Songjiang, Shanghai, an area of flourishing art and culture during the Ming and Qing dynasties, where his grandfather served as a local government official. The cultured atmosphere in which he lived strongly influenced the young Gai. When he grew up, he befriended the local literati and painters, gradually gaining fame as a painter. His pictures were much sought after and favored by the nobles and high officials in Beijing. In addition to beautiful women, he also painted human figures in general, as well as flowers and bamboo. His *Beauties Under Bamboo* (fig. 276) exemplifies the style of his paintings.

Fei Danxu (1802–1850) was a native of Wuxing in Zhejiang Province. Born into a family of art lovers, Fei learned to paint when he was a boy. When he grew up, he became an itinerant painter, drifting to Hangzhou, Haining, Shanghai, Suzhou, and Shaoxing, selling his pictures. His paintings of beautiful women were stylistically similar to Gai Qi's. Both emphasized a delicate, morbid, and wistful beauty that embodied the vogue of the time. *Yao Xie and His Wives* (fig. 277) portrays a contemporary of Fei's sitting on a cushion surrounded by his wives like the moon encircled by stars.

The Shanghai School

When the closed gates of the Qing dynasty were forcibly opened by the Western powers after the Opium War in the nineteenth century, Shanghai was designated an open commercial port. As the city's economy grew, merchants, bankrupt landowners, and peasants poured in, drastically increasing its population. Torn between old traditions and these new forces, the new art patrons helped influence the emerging style of painting.

The Shanghai School created works that catered to the taste of the city dwellers. Although their backgrounds differed, these artists all faced the changed art market. The leisurely and refined taste of the literati was vanishing, replaced by a demand for novelty and innovation. Subject matter might remain the same, but how it was treated was quite different. Most of the figure paintings of the Shanghai School, for example, told stories of immortals and historical personalities familiar to the ordinary people, rather than being based on allusions known largely to the literati. The school's bird-and-flower paintings were executed in a style that combined the free sketch and the meticulous style. The colors were always bright, the images lively. Among the better-known artists of the Shanghai School were Xugu, the Four Rens, Qian Hui'an, and Wu Jiayou.

Xugu (1824–1896) came from a most unusual background. Born in Shexian, Anhui Province, he served as a colonel in the Qing army and fought against the peasant army of the Taiping Heavenly Kingdom until, sick of the brutal slaughter, he forsook the world and became a Buddhist monk.

Xugu was skilled in portraits and paintings of birds, flowers, vegetables, and fruit, as well as landscapes, and he supported himself by his painting, traveling between Yangzhou, Suzhou, and Shanghai. In time, his pictures became much sought after. In later years, he spent most of his time in Shanghai; he died in the Guandi Temple, in the western part of the city.

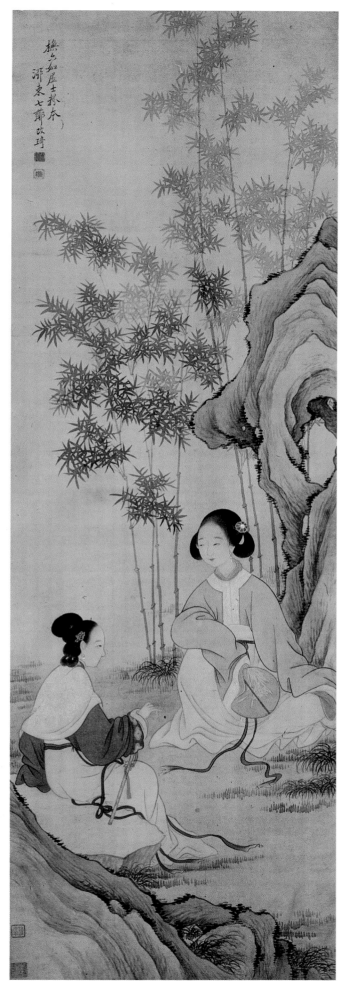

Xugu's works show several distinct ways of using the brush. He favored the dry-brush method, but he also tried broken brushstrokes, using the side of the brush, and moving the brush against the direction of the bristles (to create elegant pines and sheer cliffs). His *Long-Living Pine and Crane* (fig. 278), an occasional painting made to wish someone a long life, features a crane, a pine, and chrysanthemums, all symbols of longevity. The bird, tree, and flowers are outlined with broken and dry brushstrokes. These lines give the picture an unusual rhythm. The shapes are simple, elegant, and slightly exaggerated. The color is muted but never monotonous. This picture, painted in the later years of his life, is one of Xugu's best.

Also active in Shanghai were the Four Rens (Ren Xiong, Ren Xun, Ren Yu, and Ren Bonian [Ren Yi]). The first to become famous was Ren Xiong (1820–1857), who was born to a poor peasant family in Xiaoshan, Zhejiang Province. His father died when he was young, and his widowed mother raised the children under difficult circumstances. To support himself, Ren Xiong studied portraiture from a village schoolteacher, but he chose not to follow the man's rigid and outmoded methods. Among the rules his teacher laid down were: officials should be painted wearing a hat; they should sit straight and look serious; they should be treated with respect. Ren Xiong painted his officials hatless, sprawled in various positions (sometimes with one leg resting on the other), and with blemishes on their faces (quite exaggerated ones at times). Stung by his teacher's criticism, he left his hometown and roamed from place to place.

In 1846 he traveled to Hangzhou, the provincial capital, where he became acquainted with the collector of paintings Zhou Xian (1820–1875), living for three years in his home, the Thatched Cottage of Fanhu. During that time he practiced making copies of the paintings in Zhou's collection to develop his skills. He also became a friend of the noted poet Yao Xie and devoted more than two months to painting more than a hundred pictures that illustrated lines of Yao's poetry.

Ren Xiong's works are diverse in subject matter, including figure paintings, landscapes, and bird-and-flower paintings. In the late-Qing tradition of woodblock printmaking, he created outline drawings of characters in the novel *Tales of Chivalrous Swordsmen* for woodblock prints.

276. Gai Qi, *Beauties Under Bamboo,* hanging scroll, ink and color on paper, Qing dynasty. Guangzhou Museum.

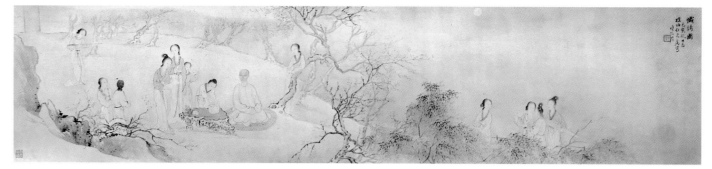

277. Fei Danxu, *Yao Xie and His Wives,* handscroll, ink and color on paper, Qing dynasty. 31 × 128.9 cm. Palace Museum, Beijing.

Among his many works, one of the most interesting is his *Self-Portrait* (fig. 279). The picture shows a towering figure, eyes focused directly in front of him, face serious. He wears a long loose robe that falls open to leave his shoulders and chest bare. It is the picture of an unbending and discontented man ready to fight like a chivalrous knight against injustice. The folds of the robe are painted in harsh and rugged lines that press closely on his body, giving the figure a tragic air. Deep disillusionment underlies the inscription:

> With the world in turmoil, what lies ahead of me? I smile and bow and go around flattering people in hope of making connections; but what do I know of affairs? In the great confusion, what is there to hold on to and rely on? How easy it is merely to chat about this! . . . When I calculate back to my youth, I didn't start out thinking this way; with a sense of purpose I portrayed the ancients for display [as paragons]. But who are the ignorant ones, who are the sages? In the end, I have no idea. In the flash of a glance, all I can see is the boundless void. Composed by Ren Xiong, called Weichang, to the tune of "The Twelve Daily Records."[18]

Born in Xiaoshan, Zhejiang Province, Ren Xun (1835–1893), who was Ren Xiong's younger brother, did flower paintings and figure paintings; in the latter, he followed the style of the Ming-dynasty painter Chen Hongshou. Ren Yu (1854–1901) was the son of Ren Xiong.

Ren Bonian (1840–1895), also known as Ren Yi, was born in Shanyin, today's Shaoxing, in Zhejiang Province. His father was a portrait painter of some note. From an early age Ren Bonian was distinguished by an exceptional ability to remember faces. One day when he was ten, a friend came to visit his father, who was not home. When his father returned, he asked the young Ren the visitor's name. The child had forgotten to ask for it, so he drew a picture, which his father recognized immediately.

As a young man, Ren Bonian served as a standard bearer in the peasant army of the Taiping Heavenly King-

dom. He later traveled to Shanghai and Suzhou and learned to paint from Ren Xun. He eventually settled in Shanghai and supported himself by selling his pictures.

Ren Bonian was a highly accomplished painter of figures and portraits as well as of bird-and-flower paintings. His figure paintings tend to be narrative in manner, based on historical and folk anecdotes. The vivid figures in these paintings are executed with fluent lines. His paintings of birds and flowers are noted for their beautiful colors and exquisite shapes. His works generally feature popular, accessible subject matter, lively and interesting form, and beautiful coloring. A favorite with city dwellers, Ren Bonian became the best-selling artist of the Shanghai School and left behind thousands of works.

Portrait of a Down-and-Out Man (fig. 280) is a likeness of Ren Bonian's contemporary, the famous flower painter Wu Changshuo (1844–1927). Wu had been a low-ranking government official with a meager salary before he took up painting, and the portrait shows the artist's sympathy toward his friend's plight. Fine lines bring out the facial features while splashes of color are used for the clothes, forming a contrast that makes the portrait a remarkable likeness both in appearance and in spirit.

Pheasants and Dahlia (fig. 281) is representative of Ren Bonian's bird-and-flower paintings. Employing a technique in which color and ink are applied separately, Ren was able to make the bird's feathers and tail appear soft and thick. His use of the brush is natural and unrestrained.

Zhao Zhiqian (1829–1884), another outstanding painter of flowers, was a native of Kuaiji, today's Shaoxing in Zhejiang Province. A bright boy and a hard worker, Zhao mastered calligraphy and seal carving, and by the time he was twenty-one, he had received the licentiate degree after passing the civil service examinations at the county level. While continuing his studies, he traveled to Hangzhou and Shanghai to sell his calligraphic works and paintings. After he passed the civil service examina-

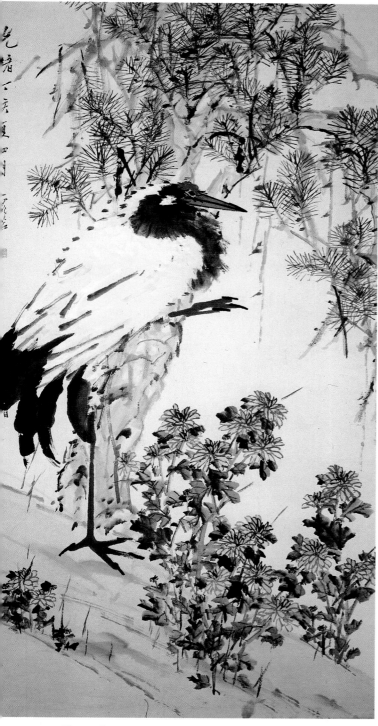

278. Xugu, *Long-Living Pine and Crane,* hanging scroll, ink and color on paper, Qing dynasty. 185.5 × 98 cm. Suzhou Museum.

279. Ren Xiong, *Self-Portrait,* hanging scroll, ink and color on paper, Qing dynasty. 177.5 × 78.8 cm. Palace Museum, Beijing.

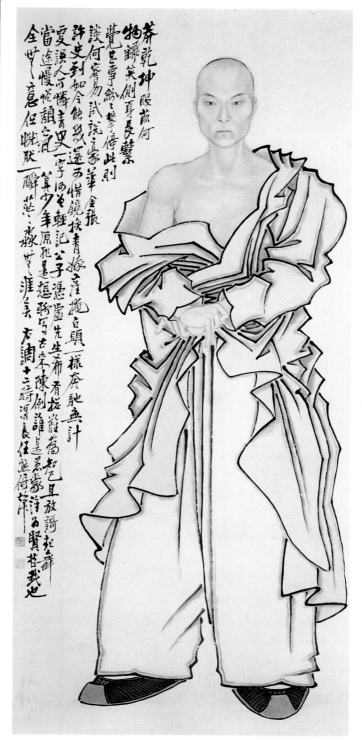

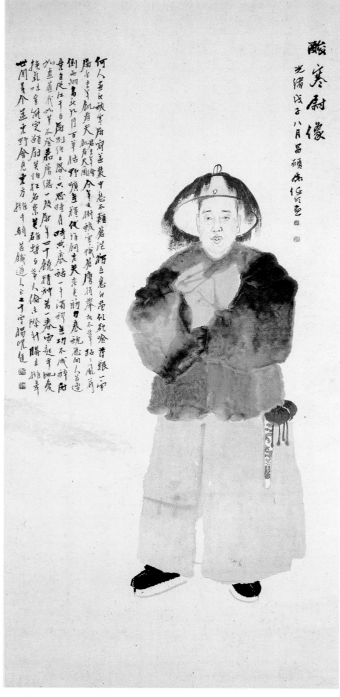

280. Ren Bonian, *Portrait of a Down-and-Out Man,* hanging scroll, ink and color on paper, Qing dynasty. 164.2 × 77.6 cm. Zhejiang Provincial Museum.

own. Since the mid-Qing, a number of scholars and calligraphers had promoted the vigorous calligraphic style of the inscriptions carved on stone tablets from the early Northern Wei dynasty against the fragile and coquettish style of calligraphy favored at the time. Influenced by this tendency, Zhao Zhiqian imparted a forcefulness not only to his calligraphic works but also to his paintings. His flowers were painted with strong brushstrokes and are full of vigor and grandeur. His *Peonies* (fig. 282) was painted in rich ink, using a wide spectrum of colors; like his other works, it shows a simple, unaffected style that came to exert a strong influence on later painters.

The history of nineteenth-century Chinese painting is much like the history of China itself in this period. The time marked the end of effective Manchu rule and the opening of China to the world, and it set the stage for the revolution, the end of the old empire, and China's entry into the modern age. Painting, too, manifested tensions between tradition and innovation, native and foreign styles, that were likewise shaping a modern China. Many of the painters who influenced art in the twentieth century — Qi Baishi and Huang Binhong, for example — were born in these years, and they embody in their lives and art the profound social, economic, and cultural changes that began in the nineteenth century.

tions at the provincial level and obtained the degree of provincial graduate, he was appointed a local government official in Boyang, Fengxin, and then Nancheng (all in today's Jiangxi Province), a job he held until his death.

In his flower paintings, Zhao Zhiqian drew on the styles of Chen Chun and Xu Wei of the Ming dynasty, Bada Shanren of the early Qing, and the Eight Eccentrics of Yangzhou of the middle Qing to create a style of his

281. Ren Bonian, *Pheasants and Dahlia,* hanging scroll, ink and color on paper, Qing dynasty. 103.8 × 44.5 cm. Palace Museum, Beijing. *opposite, left*

282. Zhao Zhiqian, *Peonies,* hanging scroll, ink and color on paper, Qing dynasty. 175.6 × 90.8 cm. Palace Museum, Beijing. *opposite, right*

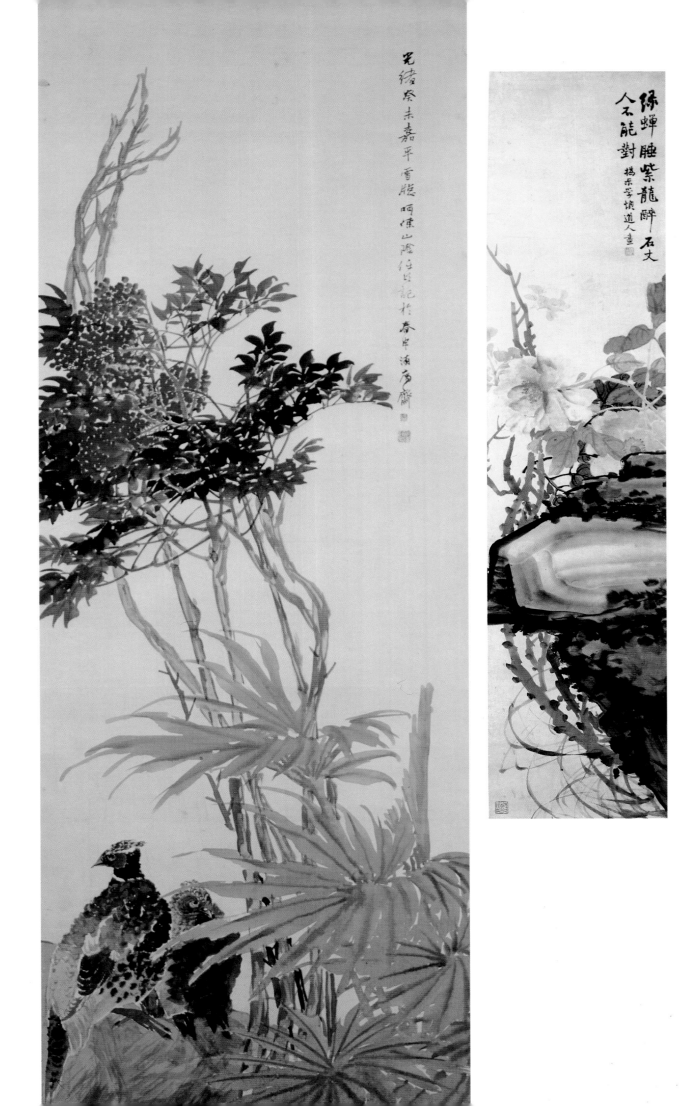

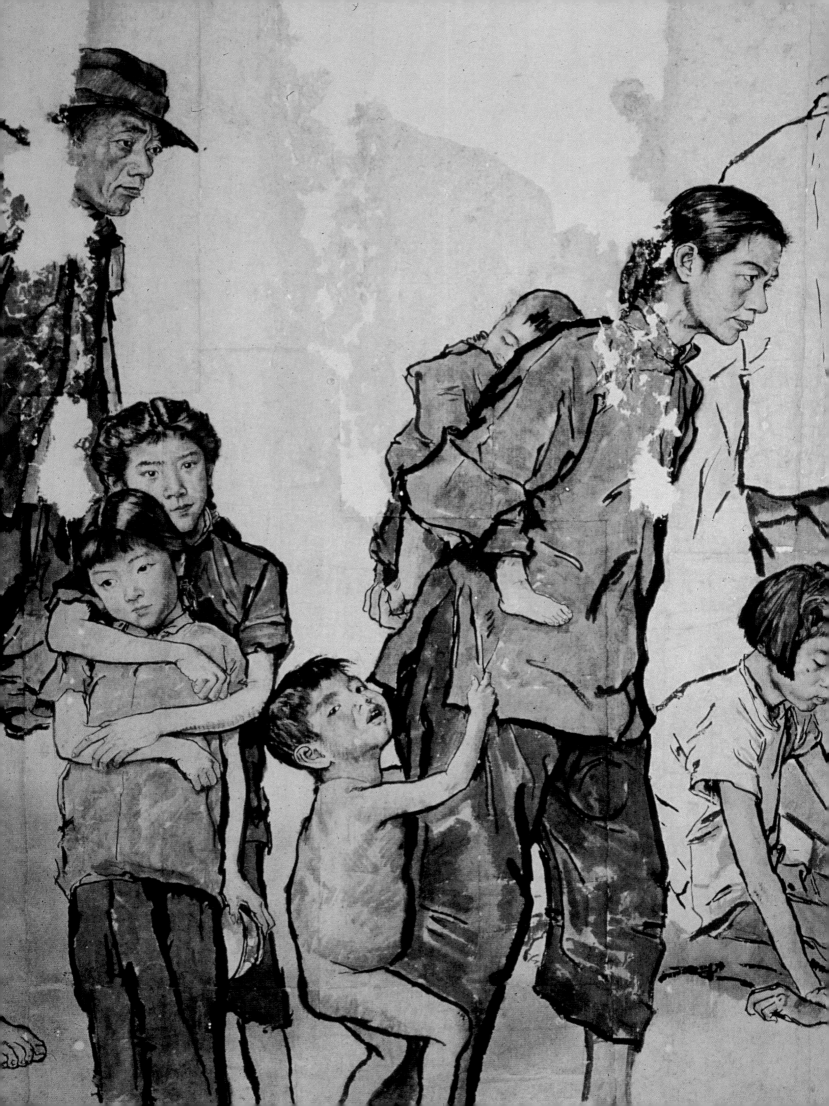

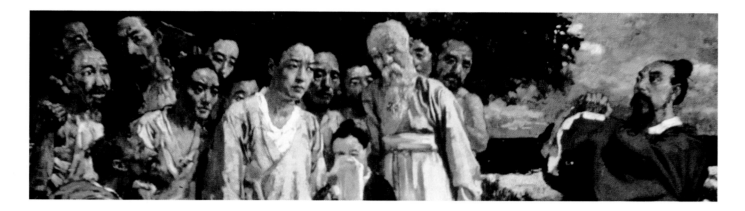

Traditional Chinese Painting
in the Twentieth Century

As the twentieth century began, China was an empire in turmoil. In 1911, the Qing dynasty, which had ruled China since 1644, was overthrown, ending two thousand years of monarchy. The May Fourth Movement of 1919 fiercely attacked the old feudal system and its culture and held high the banners of democracy and science. The Chinese people endured years of hardship and struggle through the War of Resistance Against Japanese Aggression (1937–1945) and the War of Liberation that followed. The founding of the People's Republic of China in 1949 at last brought long-desired peace. Yet the succession of campaigns launched by Mao Zedong to industrialize and modernize the new nation resulted, in some cases, in social, economic, and political turbulence. Political and cultural initiatives, such as the Hundred Flowers Movement of 1957, were aimed at transforming Chinese culture; the greatest of these, the Cultural Revolution, broke out in 1966 and continued until 1976. These social and political campaigns greatly affected the traditional culture of China.

The introduction of Western culture on a large scale was a central development in twentieth-century China. From the beginning of the century, Chinese painters posed and debated a number of questions: Should Western art be accepted? If so, then how should it be incorporated? How should China's national tradition be changed?

Details, figure 302 (*opposite*) and figure 298 (*above*)

Western influence meant an increase in the categories of painting. In addition to traditional paintings, there were oils, engravings, and paintings using different materials and serving varied purposes. People began to call traditional Chinese painting simply "Chinese painting" to distinguish it from new trends that were emerging. The "Chinese paintings" discussed in this chapter are largely traditional paintings done in monochrome inkwash, meticulously detailed and heavily colored, and other paintings using water and ink as the main media.

Painting During the Late Qing and Early Republic, 1900–1927

At the end of the Qing dynasty and the dawn of the Republic, the Chinese art world was a bleak scene. Such noted painters as Xugu, Hu Yuan, and Ren Bonian (Ren Yi) of the Shanghai School were gone by the end of the nineteenth century. Pu Hua and Qian Hui'an lived to the year of the 1911 Revolution. The only outstanding painter still active was Wu Changshuo, and he was in his golden age of creation. Most painters in Beijing either followed in the footsteps of the Four Wangs of the Qing (Wang Hui, Wang Shimin, Wang Jian, and Wang Yuanqi) or discreetly observed the old rules. Yet artists in various other cities, influenced by the revolution and the West, began to experiment artistically. Launching a "revolution in art," they reassessed ancient painting and initiated a long-lasting debate between the innovators and the conservatives.

Wu Changshuo and His School of Art

Wu Changshuo (1844–1927), sometimes called Wu Changshi, was born into a scholarly family in Anji County, Zhejiang Province. As a boy of ten he began to write poems and carve seals. When he was sixteen, his family fled to the mountains to avoid war between the peasant army of the Taiping Heavenly Kingdom and the Qing imperial troops. Somehow, Wu was separated from his family, and he began to roam the countryside. He returned home five years later and immersed himself in studying poetry, literature, calligraphy, and seal carving. At age thirty, he again left home to seek out masters of learning and friends who might share his interest in art. He became acquainted with Wu Dazheng, the renowned art collector and connoisseur, and the painter Pu Hua. In 1880, he moved to Suzhou and later to Shanghai, where he made his living by selling his calligraphic works and

seals. In 1896, he was recommended to the post of county magistrate of Andong, Jiangsu Province, but he resigned a month later and continued to make his living by selling his paintings in Shanghai. In 1904, he became the first director of the Xiling Seal Society, an organization in Hangzhou dedicated to studying seal carving.

Wu Changshuo devoted much of his life to studying calligraphy and seal carving. He began practicing calligraphy in the *kai* (regular) script of the Tang dynasty, then the *li* (official) script of the Han. Later, he mastered the seal scripts known as *zhuan* and *zhou* and was able to write the *shiguwen* (script carved on drum-shaped stones about 200 B.C.). Through years of practice, he learned to apply the li and zhuan scripts to *cao* (cursive) writing, giving it a bold but flowing character. Wu learned seal engraving from the Zhe, Later Zhe, and Anhui Schools and was influenced by the stone carving of the Qin and Han periods some two thousand years earlier. Over time, he developed a unique style, later known as the "Wu style"; his seals were either extremely elegant or intrepidly bold.

Wu Changshuo did not learn to paint until after he was thirty. Ren Bonian greatly admired the newcomer's heavy and forceful brushstrokes and advised him to apply his calligraphic skill to painting. The two gradually became good friends. From Zhao Zhiqian, a celebrated seal engraver of the nineteenth century, Wu learned to apply the style of epigraphy (antique inscriptions in metal and stone) to painting. Wu also studied the techniques of such earlier painters as Jin Nong and Wu Wei, and he became an accomplished artist in his later years. Wu maintained that one should "paint the *qi* [the emotion and idea of the object], not the *xing* [form]." A line from one of his poems reads, "Use the force of carving in the script style of the stone drum inscriptions / And paint delicate orchids in a secluded valley." His paintings of flowers, landscapes, and human figures were favorites among scholars, who appreciated the subtle emotion and profound meaning that lay beneath the robust surface.

Wu Changshuo had a preference for pure colors and sharp contrasts. He led in the use of *yang hong* (foreign red, a transparent color introduced from the West) in painting fruits and blossoms. His powerful brushwork successfully combined heavy and variable ink monochrome with brilliant and attractive colors, creating an impression of both simplicity and radiance. Although his paintings catered to scholar-officials, they also have local artistic flavor. Because of this broad appeal, Wu Changshuo was able to make his living by selling his paintings. Although he esteemed classical and refined artistic traditions and deeply revered those literati artists in history

who ignored fame and material gains, he had to cater to the interests of those who purchased and collected his work — former scholars and officials and cultured and uneducated merchants. Because he had to make his living in a commercial metropolis, Shanghai, at the turn of the century, Wu Changshuo often chose bright colors and subjects that symbolized good luck and happiness.

Wu Changshuo was especially good at painting plum blossoms, which usually bloom in the bitterly cold weather before spring arrives. For generations, scholars have cherished the quality of this beautiful flower that bravely defies the cold. Poets and painters have lauded the beauty of the plum blossom as a way of expressing admiration for the independent spirit and character of their subject. Wu Changshuo's paintings of this flower, however, differed from those of his predecessors. By following the zhuan and zhou seal scripts in handling his brushstrokes, his branches, whether in heavy ink or light, could be called "iron bones" — strong enough to cut metal or stone. Yet the strokes were reserved, honest, and simple, revealing the moral qualities Wu admired. Under his brush, the broadly or finely executed blossoms exhibited strength behind gentle, elegant lines. In bud or in full bloom, Wu's plum blossoms were delightful, sturdy, and filled with vitality. Yang hong, "foreign red," applied to the blossoms, looked intensely brilliant and "exceptionally charming," according to the veteran painter Pan Tianshou.

Plum Blossoms (fig. 283) is a good example of Wu Changshuo's skill in manipulating brush and ink. The trunk of the plum tree shoots upward, while the branches curve downward and to the right. Both trunk and branches are painted with force; none of the brushstrokes are weak, bloated, or exaggerated. To create the flowers he drew the outline of the petals and then tinted the insides of the shapes with a transparent Chinese red, *yanzhi*. The vibrant flowers supported by dark branches against the pure white background are unusually beautiful and delightful. The inscription reads, "This is done in splashed ink and is somehow similar to work by Huazhisi Seng." Wu is referring to "The Monk of the Flower Temple," another name of the Qing painter Luo Pin, who was admired for his plum blossoms. As a rule, traditional Chinese painters highly esteemed the ancients; they liked to compare their own or other artists' paintings with paintings by an important predecessor, even when there may have been little similarity to the previous master's work.

Sampling Tea (fig. 284) depicts a coarse porcelain teapot next to a branch of plum blossoms. The light yet imposing brushwork imparts a mood of relaxation and leisure.

The Chinese consider light-flavored teas to be a mark of refinement; drinking light tea is not only enjoyable but implies a disdain for grander worldly pleasures. This ethos matches Wu Changshuo's philosophy of life: he chose to be a calligrapher and an artist rather than a magistrate. Wu preferred a simple, uncluttered life. As he said, "In being a utensil, clean and of good quality, a clay jar exceeds one of gold and jade, and simple food and light tea surpass dainties." He therefore called himself Lao Fo, "Old Clay Jar."

Among Wu Changshuo's many students and followers were Wang Zhen (Yiting), Chen Shizeng, Zhao Yunhe, and Wang Geyi. His influence is also evident in the work of such celebrated painters as Qi Baishi and Pan Tianshou.

Wang Zhen (1867–1938), a native of Wuxing County, Zhejiang Province, was born in Shanghai. As a teenage apprentice at a mounting shop in Shanghai, he learned to mount and frame pictures on scrolls. In 1882, he became a student of Xu Xiaolun, who in turn was a student of Ren Bonian. Through Xu Xiaolun, Ren Bonian met Wang and advised him on painting techniques. Wang Zhen eventually became a successful businessman. As the general agent of the Riqing Shipping Company, he was regarded as one of Shanghai's top three agents for foreign business before the fall of the Qing dynasty. By 1906, Wang Zhen had returned to his native county of Wuxing and made his home in Bailongshan, the "White Dragon Mountains." He then began to use the assumed name Bailong Shanren, "Man of the White Dragon Mountains." In 1911, he became a student of Wu Changshuo and helped Wu sell his paintings in Shanghai. Gradually his style of painting began to take on Wu Changshuo's broad and simple character. As a philanthropic Buddhist, Wang Zhen was elected president of the Chinese Buddhists' Association in 1922.

Wang Zhen was a skilled free sketch–style painter of human figures, the Buddha and bodhisattvas, landscapes, birds, and flowers. He also drew portraits of Wu Changshuo and the famous reformer Kang Youwei. After age sixty, he painted in a style that merged Ren Bonian's gracefulness with Wu Changshuo's bold style. Wang favored such subjects as historical figures, folk legends, and images of nature featuring pines, plum, chrysanthemums, and lotus flowers, and chickens, cranes, sparrows, and other birds. He also created serial paintings (*lianhua*) on folk customs and the lives of the poor. In poetry that he wrote to accompany these images, Wang Zhen spread the Buddhist ideals of doing good and avoiding evil. These serial paintings have a distinctive style all their own.

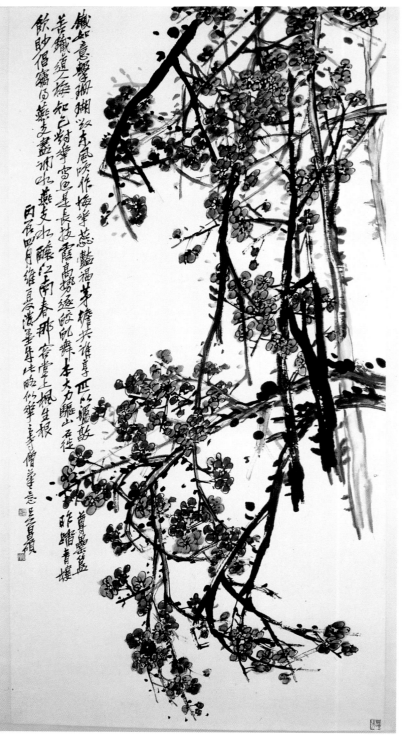

283. Wu Changshuo, *Plum Blossoms,* hanging scroll, ink and color on paper, 1916. Shanghai Museum.

Chen Shizeng (1876–1923), sometimes called Cheng Hengke, hailed from Xiushui County, Jiangxi Province. His grandfather Chen Baozhen (1831–1900) was a Qing court official in Hunan Province and a strong supporter of the reform movement. Chen Shizeng's father, Chen Sanli, was a famous poet during the transitional period between the Qing dynasty and the Republic. His brother, Chen Yinke, was a well-known historian. Chen Shizeng learned to paint and write poetry in his early years. In the early 1900s, he left China to study in Japan. After his re-turn some seven years later, he taught in normal schools in Nantong and Hunan. In later years he worked as a compiler-editor in the Ministry of Education, as an instructor at the Painting Research Institute of Beijing University, and as a professor of the Beijing National Art College. While working in Nantong, Chen Shizeng sought Wu Changshuo's advice on painting and seal carving. He also took as his teachers such painters as Shen Zhou, Shitao, Kuncan, and Gong Xian and broke away from the popular style of rigid adherence to the

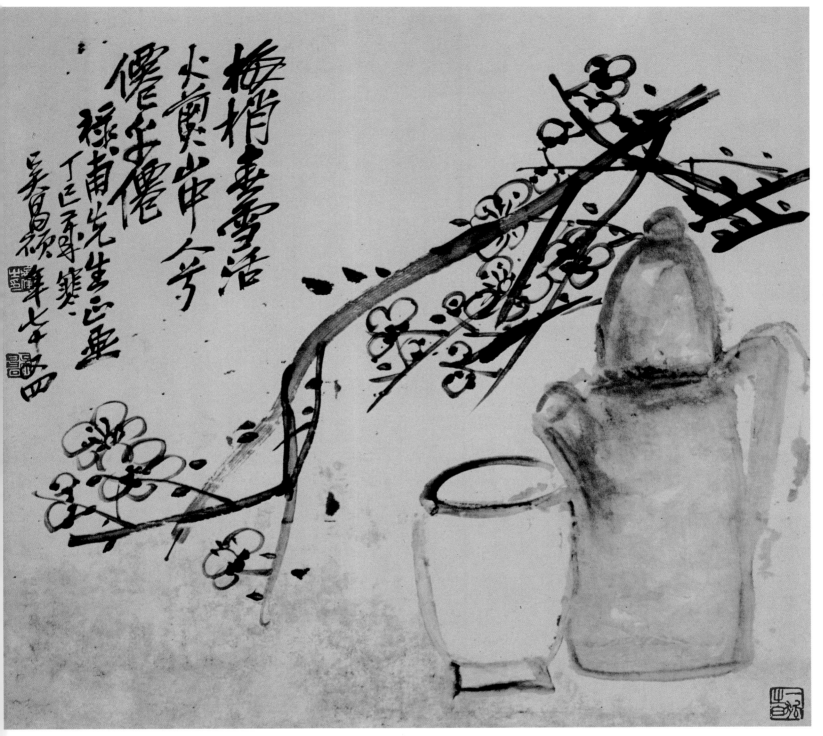

284. Wu Changshuo, *Sampling Tea,* hanging scroll, ink and color on paper, 1916. Shanghai Duoyunxuan Painting Store.

Four Wangs tradition. Chen Shizeng painted landscapes (such as *Landscape,* fig. 285), flowers, and ancient and modern people, and he had a fine free sketch style with bold strokes. Although he adopted the Western way of coloring, his paintings bear no other obvious marks of Western influence. Chen Shizeng also excelled in poetry, calligraphy, and seal carving.

Around the time of the May Fourth Movement, a number of artists and thinkers called for a revolution in art. They criticized the tradition of literati painting as "oversimplified and brusque" and "unable to portray the nature of things in the universe," and argued that it had brought on a "decline" in Chinese painting. In 1921, Chen Shizeng published his article "The Values of

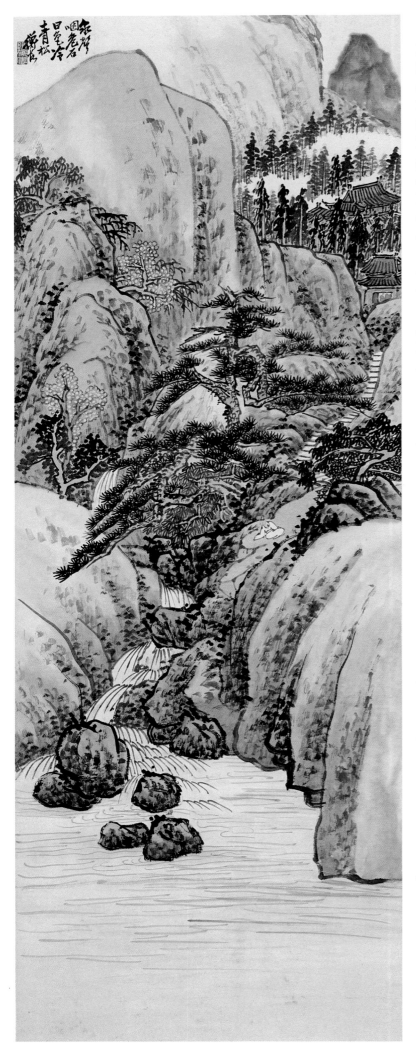

Literati Painting," speaking out in favor of traditional literati free sketch–style painting. Chen reviewed the course of development of literati painting from the Six Dynasties period to the Song and Yuan dynasties, pointing out the relation between literati painting and the philosophy of Laozi and Zhuangzi. He contended that the goal of the literati artist was to "break away from the shackles of the material world and give free expression to his emotions and feelings," as well as "to convey his personality and thoughts." Literati artists, contended Chen, combined painting, poetry, and calligraphy into one art form to create the distinctive character of their painting. Chen Shizeng also remarked that "literati painting was very influential through the Song, Ming, and Qing dynasties." This was natural, he wrote, since this kind of painting required a mixture of various cultural qualities and knowledge. The literati painters "do not focus on creating the likeness of a form because they are after something else when they paint. They are trying to express their character and ideas. The unlikeness in form actually reflects a kind of progress in painting." Although painting is nothing of great significance, Chen humbly concluded, "it requires, first of all, good moral quality; second, knowledge; third, talent and emotion; and fourth, skill in art."[1] In this article, Chen Shizeng, instead of opposing the ideas for reform, spoke knowledgeably about the essential qualities and merits of literati painting.

The Lingnan School and the Movement to Reform Chinese Painting

At the time of the revolution led by Sun Yat-sen aimed at ending the Qing dynasty, in Guangdong there emerged the Lingnan School, which advocated the reform of traditional painting. The leaders of this reform movement were Gao Jianfu, Gao Qifeng, and Chen Shuren.

Gao Jianfu (1879–1951), was born in the town of Panyu, Guangdong Province. Gao Qifeng (1889–1933) was Gao Jianfu's fifth brother. Gao Jianfu was orphaned as a young boy and began work as an apprentice in a drugstore. At age fourteen, he studied how to paint birds and flowers under Ju Lian, a noted local bird-and-flower painter. At seventeen, he entered the Ge Zhi Institute (now Lingnan University) in Macao, where he studied charcoal drawing under a French missionary. He left for Japan in 1905 to continue his studies and, while there, was deeply influenced by such Japanese painters as Takeuchi

285. Chen Shizeng, *Landscape,* hanging scroll, ink and color on paper, 1915. 135.1 × 48.5 cm. China Fine Art Gallery, Beijing.

Seihō (1864–1942). He joined the White Horse Society and Pacific Painters' Society, organizations of Japanese artists. On his return to China in 1906, Gao Jianfu took part in revolutionary activities to overthrow the Qing dynasty and was made chairman of the Guangdong branch of the Tongmenghui, United League of China, headed by Sun Yat-sen. During this period, he disseminated ideas for the reform of art with his brother Gao Qifeng and his schoolmate and friend Chen Shuren (1884–1948). The three young artists published the reformist journals *Shi shi hua bao* (Pictorial of current affairs) and *Zhenxiang huabao* (Pictorial of naked truth) in Guangdong and then in Shanghai. They also started the Aesthetics Studio to spread new ideas about art and create propaganda for a revolution in traditional painting. After the death of Sun Yat-sen in 1925, Gao Jianfu devoted all his time to art. He founded the Chun Shui (Spring Sleep) Art Institute to encourage and explore new ways of Chinese painting. During the 1930s, he traveled abroad extensively — to South Asia, islands in the South Pacific, Europe, and North America — studying the art of these cultures and organizing exhibitions of Chinese paintings. Gao Jianfu also founded Nan Zhong Art College and Guangzhou City College of Art and taught art at Zhongshan University and the Central University. Among the many students he trained are such outstanding figures as Li Xiongcai, Fang Rending, Guan Shanyue, Yang Shanshen, and Huang Dufeng.

Like his brother, Gao Qifeng left China in 1907 to study in Japan and, also like Gao Jianfu, was active in the movement to overthrow the Qing dynasty. Gao Qifeng was a talented artist who liked to paint depictions of fierce birds and other animals, which imbued his work with a heroic spirit. Sun Yat-sen praised Gao Qifeng's work as "carrying the beauty of the new age and representative of the revolution." Among his many students were such artists as Huang Shaoqiang and Zhao Shao'ang.

From their teacher Ju Lian the Gao brothers learned the technique known as boneless wash. To add color and intensity while preserving a natural effect, they liked to use the methods known as water-spatter and powder-spatter. In the first method, water is added to a painting that is already colored; conversely, in powder-spattering, powder (color) is added to a painting that is already soaked with water. In addition, both brothers used quick brushstrokes to convey the impression of swift movement. Yet Western painting as they understood it was actually new Japanese painting. The Gao brothers' monkeys, for example, were similar to those done by the Japanese painter Hashimoto Kansetsu (1883–1945).

Although they called for realism, the Gao brothers failed to master realistic painting. And although their paintings were imbued with a sense of mission and concern for the fate of the country, they underestimated the complexity of the challenge of reforming artistic tradition. Even as Gao Jianfu recommended the new, he remained fascinated by the old. In his later years, he described himself as "having retired to the woods," which meant that he had withdrawn from worldly concerns. Proud of his painting, Gao Jianfu called it "work of the new literati painter." In a piece of his writing found after his death, he wrote, "I love both the pen and the sword, both the old and the new, both traditional and Western painting. I often tell myself that life is full of contradictions." This contradictory psychology and philosophy of life was common to many intellectuals and artists of the era.

Bamboo and Moon (fig. 286), painted by Gao Jianfu in the mid-1940s, is a long, narrow composition of a thin but sturdy bamboo shooting up against the sky. It is dusk. A full moon rises through the haze, and the withered leaves of the bamboo rustle in the cold wind. The broken brushwork betrays the painter's melancholy. The background is tinted with very light ink in a traditional technique known as "painting by making tints." Although some painters preferred to tint clouds in their paintings with ink to feature the moon, in *Bamboo and Moon,* Gao Jianfu wished to show the sky in the background. His method reflects the influence of both Japanese and Western painting.

The Gao brothers were skilled painters of horses, lions, monkeys, eagles, flowers, and landscape. They also painted human figures. Most of their paintings were bold, powerful, and somewhat realistic. Their friend and colleague Chen Shuren also developed an individual style; his paintings are imbued with a fresh, pleasant, and tranquil atmosphere.

The art of the two Gaos and Chen was highly influential. In 1929, the painter Huang Binhong remarked that they were "brilliant and capable . . . able to speak their minds and paint whatever they saw." However, Huang also noted that what the three had learned from Japan was merely "to apply water and ink to paper or silk. They did what they were not familiar with, hence their work, though not weak, tends to be too dull and obscure. Despite layer after layer of tints, the brushwork looks dry, heavy, and uninteresting."[2] In another assessment, the painter Pan Tianshou wrote in *A Study of the Paintings Introduced to China from Abroad* (1936) that

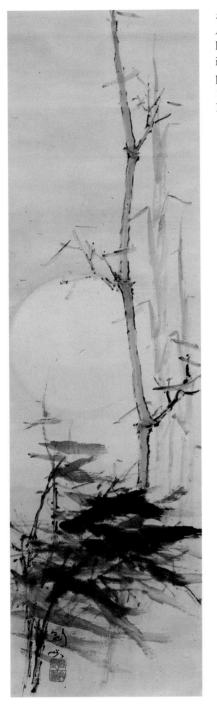

286. Gao Jianfu, *Bamboo and Moon*, hanging scroll, ink and color on paper, ca. 1940. 118 × 32 cm. Private collection.

thus fail to give full play to the outstanding characteristics of traditional painting in their brushwork and composition.

Huang Binhong and Pan Tianshou held similar views on the Lingnan School; they gave credit to the Gaos' talent and ability — their creativity — but criticized their uninteresting brushwork and unimaginative composition. With these comments they highlighted the essential difference between Chinese and Japanese aesthetic views and methods of painting.

Meanwhile, other outstanding painters such as Xu Beihong, Fu Baoshi, and Ni Yide gave full credit to the Lingnan School. Ni Yide, for instance, described Gao Jianfu's painting as "making use of his talent and breaking away from all that was inherited from the past." Fu Baoshi said, "Gao Jianfu's painting style, fostered in Lingnan, has developed along the Pearl River to the banks of the Yangzi River. The movement is neither casual nor insignificant. It has bearing on the times." And Xu Beihong concurred, saying, "Painter Gao Jianfu is broad-minded and a truly admirable person."

Traditionalists fiercely attacked the slogans of the Lingnan School. In Guangzhou in 1923, fourteen painters formed an organization called the Kui Hai Cooperative (*kui hai* is the name of the year of the pig in the Chinese lunar calendar), which in 1925 became the Society for the Study of Chinese Painting. The society published several issues of a publication named *Guohua tekan* (Special issues on Chinese painting), sponsored exhibitions, and, in the name of safeguarding the national character of art and differentiating the concepts and methods of Chinese and Western arts, criticized the works of the Lingnan School. In an article called "Chinese Painting Has Its National Character," the author, pen-named Nian Zhu, wrote that "the Chinese, Western, and Eastern [Japanese] paintings are different national arts and are beautiful each in their own way. . . . Our country has its own land and nature, people, national character, and popular customs. The deep meaning underneath all these cannot be perceived by any superficial literary man." Nian Zhu condemned those who "subordinated our Chinese to Western culture. They made our national character bow to the national character of the West. They were spellbound by Western idols, and as a consequence, they tried to learn from others but forgot what they themselves already knew."[3] Another article, by Huang Banruo, stated, "The new Chinese painting is but a plagiarizing of Japanese painting. It's not something created by one or two persons. . . . A careful examination would prove that it is

Gao [Jianfu] had a basic training in Chinese painting; . . . he learned from the Japanese, made studies of Western paintings, and formed a new style, to which he added what is traditional, thus making his work meaningful. With his talent and skill, he achieved a unique style. His style of painting was quite different from that of the Italian missionary artist Giuseppe Castiglione. In recent years, painters like Chen Shuren, He Xiangning, and Gao's brother Gao Qifeng have belonged to this school. They like to paint on a kind of processed paper or silk, often painting over the background, leaving almost no blank space. It seems they

merely a branch of Japanese painting."[4] When Zhao Gonghai reviewed the work of the Society for the Study of Chinese Painting in 1947, he stated emphatically that "Chinese painting is a kind of traditional art. It is different from the hybrid 'new Chinese painting,' which is copied from Japan and is therefore neither Chinese nor Western. The aim of the Society is to justify the identity of Chinese painting, carry forward its tradition, distinguish right from wrong, and differentiate between good and bad . . . and thereby establish an authentic style of Chinese painting."[5]

The Gao brothers and their students responded to the criticism. "Day after day," wrote the artist Feng Rending, "you gentlemen curse the new painting. You are as stubborn as the conservatives and the Northern warlords who keep cursing the Guomindang. . . . Your doctrine is the doctrine of the Yan Luo, the ruler of Hell [hence torturer of the dead]. The artistic heritage of our ancestors, whether good or bad, you regard as perfectly justified and unalterable."[6]

Neither side seemed ready to yield to the other. However, in a powerful article, Gao Qifeng, one of the founders of the Lingnan School, argued:

I started by learning purely from ancient Chinese paintings and worked painstakingly to imitate the works of the great masters of the Tang and Song dynasties. Later, I found out that despite their merits, the paintings looked vague or ambiguous if the philosophy of our ancestors was followed. The more I studied, the more I realized that studying is like sailing against the current; if you don't move ahead, you find yourself pushed backward. If we don't assimilate everything that is good, we'll lack the strength to develop. . . . Therefore, I began to learn to paint from life as the Western painters did, and I also studied their theories on geometry, the use of light and shadow, perspective, and close-ups. Meanwhile, making use of my experience, I tried to preserve everything that is artistically good in traditional painting — the brushwork, the spirit, the ways of using water and ink, the coloring, the use of metaphors, the emotion expressed, the philosophy, and the poetic meaning. With an open mind I took in all the accessible theories and painting methods of the world, absorbed the merits of both Chinese and Western paintings and carefully integrated them. Basing myself on this experience while studying the beauty of nature, the spirit of the universe, and my own feelings, I produce my work of art.[7]

The debate in Guangdong was only part of the overall contention between the old and new schools of painting. In Beijing and Shanghai, important members of the cultural elite took part in an equally sharp and heated dialogue. Some painters shifted sides in the debate. After the Revolution of 1911, for example, the leading reformer Kang Youwei became a loyalist and began to apply to painting his principle of "reviving the old in order to evolve the new." He decried the free sketch–style literati painting of the Yuan, Ming, and Qing dynasties but approved of the meticulously detailed academic style that traces back to the Song dynasty. Kang Youwei admired the Italian painter Giuseppe Castiglione, praised Raphael, and propounded the slogan "Integrate Chinese and Western to Develop a New Era of Painting." His ideas influenced Xu Beihong and Liu Haisu; both artists regarded Kang as their philosophical mentor.

On the reformist side, Chen Duxiu, later a Communist leader, published an article entitled "On the Revolution of Art" in 1917. In it, he severely criticized the free sketch–style painting of the Yuan, Ming, and Qing dynasties, particularly the painting of Wang Hui and his admirers in Beijing. "The literati painters looked down on academic painting," wrote Chen Duxiu. "They favored free sketch style but neglected the likeness between a painting and the object being painted." This perspective was initiated by Ni Zan and Huang Gongwang in the Yuan dynasty. "It was then encouraged by Wen Zhengming and Shen Zhou of the Ming and was carried further by the end of the Qing." Chen Duxiu stressed that "painters must follow the tenets of realism." In order to achieve this aim, he stated, painters needed to topple such "authentic personages of painting" as Ni Zan, Huang Gongwang, Wen Zhengming, and Shen Zhou.[8] Other influential cultural figures who were calling for the introduction of Western realism as a means of rejuvenating Chinese painting at this time were Cai Yuanpei, Lu Xun, and Xu Beihong.

Painters of the old tradition, sensing the coming "threat," reacted promptly. In 1918, such renowned Beijing painters as Jin Cheng (1878–1926), Zhou Zhaoxiang, and Chen Shizeng, with the backing of the warlord politician who went by the title General President Xu Shichang, set up the Research Society of Chinese Painting, which proclaimed "the preservation of national tradition" as its central aim. Jin Cheng regularly lectured young students on Chinese painting. "In painting there is no difference between the old and the new," he argued. "Without the old, there isn't the new. The new evolves from the old. The old, when evolved, becomes new. In

sticking to the new, the new becomes old. If you bear in mind that there exist both the old and the new, you will find it difficult to follow any rules when you paint." He admonished the young painters, "Don't be reckless and forgetful; abide by the established rules."[9]

Noted writer and painter Lin Shu expressed the same view. During the May Fourth Movement, Lin Shu persisted in using classical Chinese, opposing the use of the vernacular and "the revolution of literature." Slightly more broad-minded was Chen Shizeng. In his "Values of Literati Painting," Chen wrote positively of the nature and merits of literati painting. Although he was not opposed to using Western painting as a reference, he observed that "the main emphasis should be on the painting of one's own country." After Jin Cheng's death in 1926, his son Jin Qianan and a number of his former students organized the Hu She (Lake Society), declaring that they would persevere according to Jin Cheng's line of "strictly guarding the path of the ancients and promoting the ideas of the ancients." And so the Lake Society carried on the study and preservation of traditional painting.

The debate continued intermittently for several decades. In addition to art theorists, other painters of the Western school and people outside art circles took part in the wide-ranging and often intense dialogue. More than the mere question of painting was involved: at stake was nothing less than the character and direction of Chinese culture in the twentieth century.

The Middle and Later Periods of the Republic, 1927–1949

By 1927, the war between the Republic, founded by Sun Yat-sen, and the feudal warlords was nearing its end and the first united front of the Guomindang and the Communists had been broken. A national government was established in Nanjing. In the same year, Wu Changshuo died in Shanghai and Qi Baishi completed what he called his "transformation at an advanced age." Chinese painting was entering a new stage of development.

Qi Baishi and the Beijing Painters

Qi Baishi (1864–1957), originally named Qi Huang, was also known as Baishi Shanren (White Stone Mountain Man) or Baishi (White Stone). Qi Baishi had many assumed names: when he called himself the "Woodman," he was referring to the job he once had as a carpenter; when calling himself "Reposing in Duckweed," he was describing himself as being far away from home

and loafing around like the duckweed floating in the water and driven by the wind. The sobriquet Sanbai Shiyin Fuweng meant that he was the owner of three hundred stone seals and was considered a wealthy person both spiritually and morally. With the name Xingziwu Laomin, he described himself as an old farmer living in his native village, Xingziwu (Sunken Apricot Flowerbed). In middle age, Qi Baishi was still living in a rented house in the mountains, so he gave himself the surname Jieshanweng (Old Man Borrowing the Mountains). In addition to these names, he had a number of other sobriquets that represented certain episodes in his life, his feelings, or his outlook on life.

Unlike many of China's renowned artists, born into scholarly or wealthy families, Qi Baishi was the son of a poor farmer who lived in a small mountain village in Xiangtan County, Hunan Province. His family was so poor that after less than a year of education at the village school where his maternal grandfather taught, Qi Baishi had to leave to become a cowherd. He later became a carpenter and traveled from village to village, making furniture. He did not learn to paint until he was twenty-seven. His first paintings were folk pictures of gods, and then he began to paint portraits. Later he learned to paint landscapes, birds, flowers, and human figures. Although he did not leave the Xiangtan area until he was forty, after that he toured the country six times and studied the works of Xu Wei, Bada Shanren, Jin Nong, and other Ming and Qing artists of the Yangzhou area. After the collapse of the Qing dynasty, soldier-bandits were becoming an increasing problem in the countryside, and so in 1918, Qi Baishi took refuge from the bandits in Beijing and made his permanent home there. In the city he was often ridiculed by "cultured" people for his rustic ways. His unaffected and graceful style of painting, learned in part from Bada Shanren, was not favored by Beijing art connoisseurs. Nevertheless, the painter Chen Shizeng appreciated Qi Baishi's talent and advised him to develop his own style of painting rather than imitate the ancients. Thus encouraged, Qi Baishi began his program of "transformation" and withdrew from society. In 1927, after ten years of concentrated effort, he achieved a unique style. He called his program "carrying out reform at an advanced age."

Qi Baishi was an intelligent, hard-working man. As a boy, he enjoyed observing nature and drawing everyday subjects. He had exceptionally sharp eyes and a good memory for people and rural life. His talents were enhanced by his decades of experience as a carpenter-craftsman specializing in woodcarving and painting

portraits. He created thousands upon thousands of paintings from life, paintings in imitation of the ancients, and copies of paintings from memory. During his forty years in Beijing, he showed no interest in political or social changes and cultural trends. Day after day he sat in his Chinese-style courtyard house bent over his long drawing table, reciting poems, carving seals, and painting. "In my three-room abode fenced in by iron spikes," said Qi Baishi, "I use my brush as busily as someone working with his farm tools."

Qi Baishi's bird-and-flower paintings became quite popular. He could draw insects with extremely fine and meticulous brushwork, yet he was also accomplished at simple, free sketch–style compositions. He successfully assimilated the meticulous and the freehand styles and created stunningly beautiful paintings of insects and flowers. Most of his landscapes were based on scenes in his home village and the tourist sights of Guilin in Guangxi Zhuang Autonomous Region. Using heavy ink and vigorous strokes, he painted remote mountains dotted with flowing rivers, riverbanks flanked with willow trees, sailboats, country houses, bamboo groves, and swimming ducks. These images of life in the countryside were much admired. His most common human subjects were such historical or legendary persons as Zhong Kui and Li Tieguai. And his frequent depiction of the simple and innocent activities of children and rural folk lent many of his works an air of rustic humor.

Although he settled in Beijing, Qi Baishi maintained peasant ways of thinking and living. He loathed the sophisticated manners of citydwellers and yearned for the peaceful and leisurely life of the countryside. In a painting created in his early years in Beijing, he expressed his feelings of sadness and loss by drawing an oil lamp next to an inkstand and inscribing these words: "Leading a vagrant life in the northern land, I sit before an inkstand under a lonely light." A line from his poem "The Kitchen Garden" reads, "Fed up with the experience of worldly affairs, I love more than ever the savor of fresh vegetables." Qi Baishi also often transcribed his feelings of nostalgia into his paintings. Bamboo, palm trees, ponds, lotus blossoms, fish, shrimp (such as the delightful painting *Shrimp,* fig. 287), insects, birds, buffalo, pigs, dogs, chickens, ducks, cats, mice, boys collecting firewood, old houses in the mountains — these became his favorite subjects.

Fish, shrimp, crabs, and frogs were Qi Baishi's most common subjects. As a child, Qi Baishi loved to catch fish and shrimp in the local ponds, and painting these creatures brought back many happy memories. By experimenting with different shades of ink and adding water to the painted surface, Qi Baishi was able to portray the transparency of water-dwelling animals in a fresh and lively manner.

Lotus and Frogs (fig. 288), painted when Qi Baishi was ninety-four, is an autumn scene. The green lotus leaves of summer have turned a brownish red, and some of the seedpods have ripened and seem to be releasing a sweet aroma. Some lotus blossoms remain, pink and in full bloom. Beneath the flowers, three frogs, two dark and one gray, seem to be having a discussion. The little gray frog wears a mischievous look and extends its leg backward. The autumn sky is clear and splendid, and the frogs are lively and happy.

In *After the Rain* (fig. 289), baby sparrows perch on a palm frond. The foliage, created with ample water and heavy ink, almost camouflages the sky. Although the painting is done in monochrome ink, it expresses a colorful emotional world. The inscribed poem reads,

> To choose a peaceful dwelling the flowers and grasses
> need to be consulted,
> If they agree to move their roots to my low walls.
> Everything seems peaceful when observed with a
> calm mind.
> The lush greenery of palms makes you feel cool and
> cozy after a good rain.

As the artist indicates in the first two lines, when he wished to remove a plant, he asked its permission. In this, he personified the palm tree. The last two lines are more philosophical: because his mind is at peace, he has formed a deeper perception of the world. Qi Baishi grew palm trees around his village house, and for this reason palms frequently appear in both his paintings and his poems. In "Palms in the Rain," for example, Qi wrote,

> Flowers wither as spring departs.
> I am still delighted at the green palms above the stairs.
> Being bald, the old man has no hair to turn gray.
> This doesn't worry him as he listens to the night
> rainfall.

And he wrote in "Inscription on Painting Palms":

> The broken leaves linger outside the window.
> The time is already late autumn.
> Cool rains kept falling last night.
> How many people's hair has turned white?

The sounds of wind and rain, the scenes of spring and autumn, the constant changes of nature and the recollections of life they bring — all these reveal the emotions and thoughts of the artist.

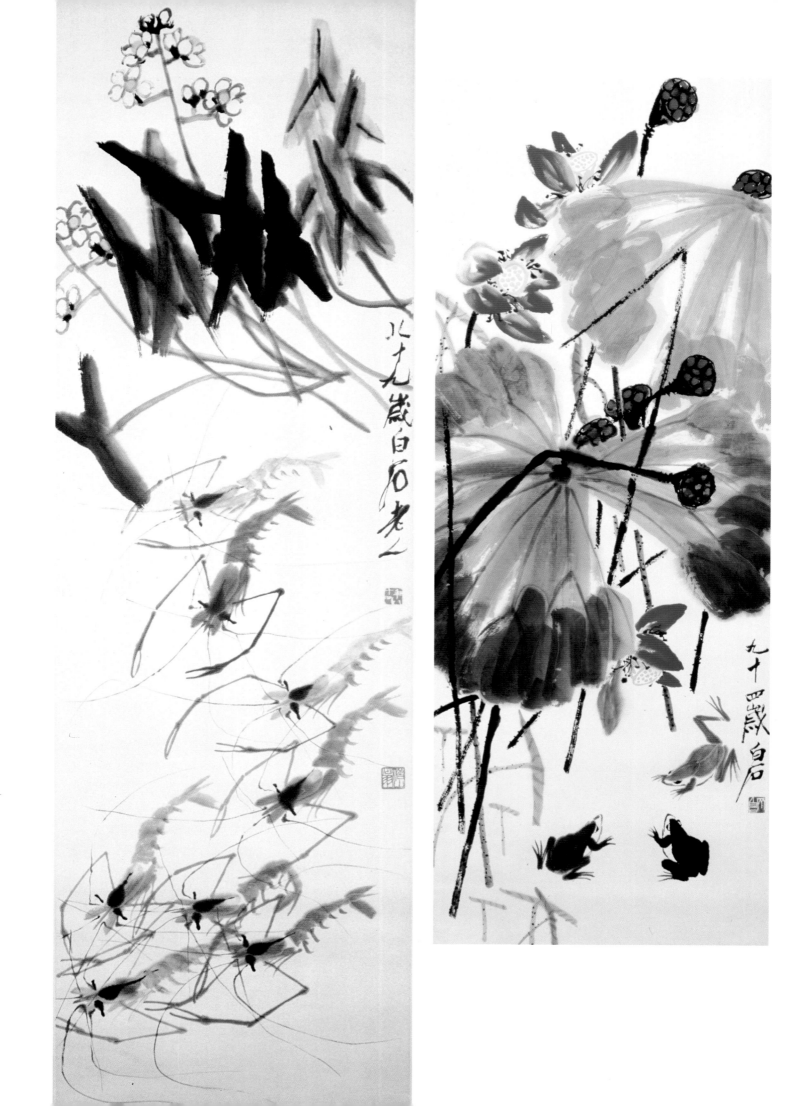

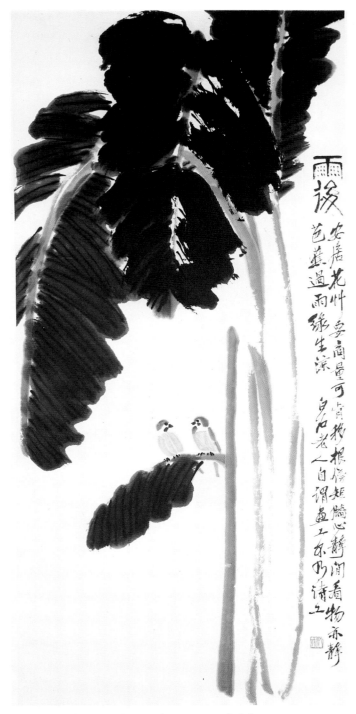

In *Bodhi Leaves and Insects* (fig. 290), Qi Baishi combined free sketch and meticulous styles of painting. The bodhi tree (*Ficus religiosa*), called *puti* in Chinese, was the tree under which the historical Buddha Shakyamuni was believed to have achieved enlightenment. In this painting, the setting is autumn, and the bodhi leaves have turned from green to reddish brown and are beginning to fall away. The leaves, having lost their moisture, bare their network of veins — as fine and delicate as carefully woven silk. Here above the sunny ground, a butterfly and dragonfly flit by, while a cicada suns itself on a branch and a grasshopper emerges from below. In an instant, in a single image, the artist grasps the serenity and intensity of the autumn season. Although the bodhi leaves

290. Qi Baishi, *Bodhi Leaves and Insects,* hanging scroll, ink and color on paper, ca. 1940. 90 × 41.2 cm. Rongbaozhai Studio, Beijing.

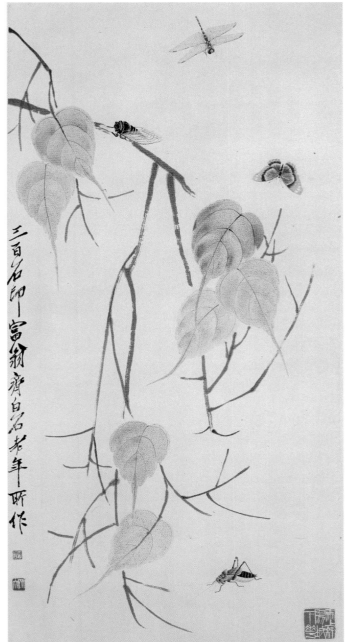

289. Qi Baishi, *After the Rain,* hanging scroll, ink on paper, 1940. 137 × 61.5 cm. Tianjin Art Museum.

287. Qi Baishi, *Shrimp,* hanging scroll, ink on paper, 1949. 138 × 41.5 cm. China Fine Art Gallery, Beijing. *opposite, left*

288. Qi Baishi, *Lotus and Frogs,* hanging scroll, ink and color on paper, 1954. Rongbaozhai Studio, Beijing. *opposite, right*

and the insects are highly detailed, the tree branches are freely sketched in light ink. This pioneering work exemplifies Qi Baishi's harmonious integration of two opposite styles of painting.

A roly-poly tumbler is a hollow clay toy painted to resemble a plump child. Inside it is weighted at the bottom, so that it wobbles when pushed but never tips over. Many Chinese folk artists shape their tumblers in the image of clownish mandarins as they appear on stage; in this way they mock the inefficiency and ineptitude of the bureaucrats. Making use of this folk tradition, Qi Baishi painted his *Roly-Poly* (fig. 291) at age ninety-two. The clownish magistrate wears his hat askew and holds a fan in his hand. Dots of white (symbolic of stage clowns in traditional operas) are painted on his eyelids. The painting is inscribed:

> He could be a child's toy, this endearing old man;
> When he topples, relax!— he quickly springs back.
> The black gauze hat on his head tips over his brow;
> Though hollow, he does have rank.

In this context, "hollow" also means heartless or lacking in human kindness. So here is a creature who lacks human feelings but holds a high official post — isn't that something to be despised and mocked? In tandem, the painting and poem form a humorous and stingingly satirical composition.

Qi Baishi devoted his life to praising nature, life, and peace and to awakening the human conscience. In 1955, he was honored with the International Peace Award, and in 1962 he was named one of the Ten Cultural Giants of the World.

A number of other artists also worked in Beijing in the 1930s and 1940s, including Chen Banding (1876–1970), Hu Peiheng (1891–1962), Pu Xinyu (1896–1963), Qin Zhongwen (1896–1974), Xiao Sun (1883–1944), Xu Yansun (1899–1961), and Yu Fei'an (1889–1959). Of this group, Pu Xinyu, also known as Pu Ru, is recognized today as the most accomplished artist. He was born in Beijing into the family of a Manchu prince of the Qing dynasty. As a young man he studied law, politics, and the history of Western literature. Later he lived a secluded life in the Jietai Temple in the hills west of Beijing, where he studied calligraphy, painting, ancient classics, and history. During the 1930s and 1940s, his fame was on a par with that of Zhang Daqian. When people spoke of accomplished painters, they often referred to "Zhang in the south and Pu in the north." After 1949, Pu Xinyu moved to Taiwan, where he taught in the art department of the Taibei Teachers University and devoted much of his time

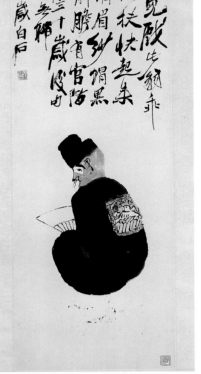

291. Qi Baishi, *Roly-Poly,* hanging scroll, ink and color on paper, 1953. 116 × 41.5 cm. China Fine Art Gallery, Beijing.

to studying the famous paintings collected in the National Palace Museum in Taibei. His landscapes, such as *Panorama of Lakes and Mountains* (fig. 292), have the refined and elaborate qualities characteristic of Dong Qichang's Southern School. But they also show the broad, sweeping power usually found in the works of the Northern School. Pu Xinyu incorporated painting with calligraphy and poetry in the fashion of many Southern painters, which added a scholarly flavor to his art. He was equally skilled in composition and draftsmanship, brush technique and coloring, as Northern painters usually were. In his later years, Pu Xinyu exercised a strong influence over painters in Taiwan.

A Shandong native, Yu Fei'an became a well-known reporter in north China during the Republican period. After 1949, he became a leader in the Chinese Painting Academy and Chinese Painting Research Society. *Peonies* (fig. 293) reveals his characteristic treatment of bird-and-flower subjects in the highly refined, meticulously detailed Song-dynasty style. The luminous red and yellow blossoms, silvery gray and green leaves, and carefully depicted stalks are represented in fluid and refined outlines with brilliant, colorful inkwashes. Yu Fei'an occasionally painted landscapes and was also remembered for his fresh, simple depictions of orchids, bamboo, and narcissus.

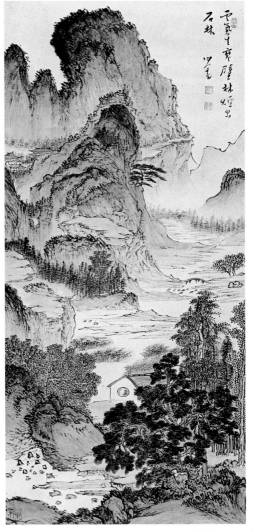

石林 云气生虚壁林峦暗雪中
（Pu Xinyu signature and seals）

292. Pu Xinyu, *Panorama of Lakes and Mountains,* hanging scroll, ink and color on paper. 107 × 47 cm. Gongwangfu, Beijing.

Huang Binhong and the Painters
South of the Yangzi River

Shanghai was the center of the Jiangnan painting movements, including artists in Jiangsu, Zhejiang, and Anhui. It was not until the 1930s and 1940s that the Jiangnan area unshackled itself from the Four Wangs, Wu Li, and Yun Shouping. Jiangnan painters studied outstanding artists of the Song and Yuan dynasties and began to explore a new way of painting from nature. A number of artists began to examine the Four Great Monk Painters of the later Ming and early Qing dynasties, the Yangzhou school of art during the reign of the Qianlong emperor, the seal makers and painters famous during the reigns of the Jiaqing and Daoguang emperors of the Qing, and the Shanghai painters active in the years between the fall of the Qing dynasty and the founding of the Republic.

The Jiangnan area artists formed painting societies, published journals, organized exhibitions, and were active in many other ways. Gathered in Shanghai were painters of every kind—Western-style artists, painters who advocated the merging of Western and Chinese styles of painting, and artists who excelled in the traditional style. Groups of painters of different styles were also active in Nanjing and Hangzhou, cities long noted for their culture and sites of renowned schools of higher learning—the National Central University in Nanjing and the College of Art in Hangzhou. It was in this flourishing art scene that such celebrated painters as Huang Binhong, Pan Tianshou, and Fu Baoshi made their debut.

Huang Binhong (1865–1955) named himself Binhong in memory of Binhong Pavilion in his birthplace, the village of Tandu (formerly Huizhou) in Shexian County, Anhui Province, which was once a scenic and thriving town. The area produced many famous painters during the Ming and Qing dynasties, and Huang Binhong himself was born into a family of scholars and painters. His father, however, was a businessman who hoped his son would pass the rigorous civil service entrance examinations and become a successful official. Accordingly, he arranged for Huang Binhong to study the Classics, poetry, and literature and found ways for him to learn to paint and carve seals. In spite of this preparation, Huang Binhong failed the county-level examinations, so he began to concentrate on epigraphy, calligraphy, and painting. In 1895, he wrote to the reform leaders Kang Youwei and Liang Qichao expressing support for their ideas. He also befriended Tan Sitong, another leading reformer.

In 1907, Huang Binhong was accused of being a revolutionary for participating in anti-Qing activities aimed at reviving the Ming dynasty. Forced to leave Tandu for Shanghai, he joined the Nanshe Society, an anti-Qing literary organization, and the Society for the Preservation of National Culture. During the next three decades, he became an editor of *Guocui xuebao* (Journal of the quintessence of national culture), directed the art department of the Commercial Press, taught as an art professor at Jinan University, Xinhua Art School, and the Beijing National Art College, and in 1937 worked as a member of the Appraisal Committee of Cultural Relics in the Imperial Palace. Among his friends were Zhang Taiyan, Huang Xing, Liu Shipei, Chen Duxiu, and other scholar-revolutionaries.

During the War of Resistance Against Japanese Aggression, Huang lived in Beijing and devoted himself to writing and painting. He moved to Hangzhou in 1948 and became a professor of art at Hangzhou National

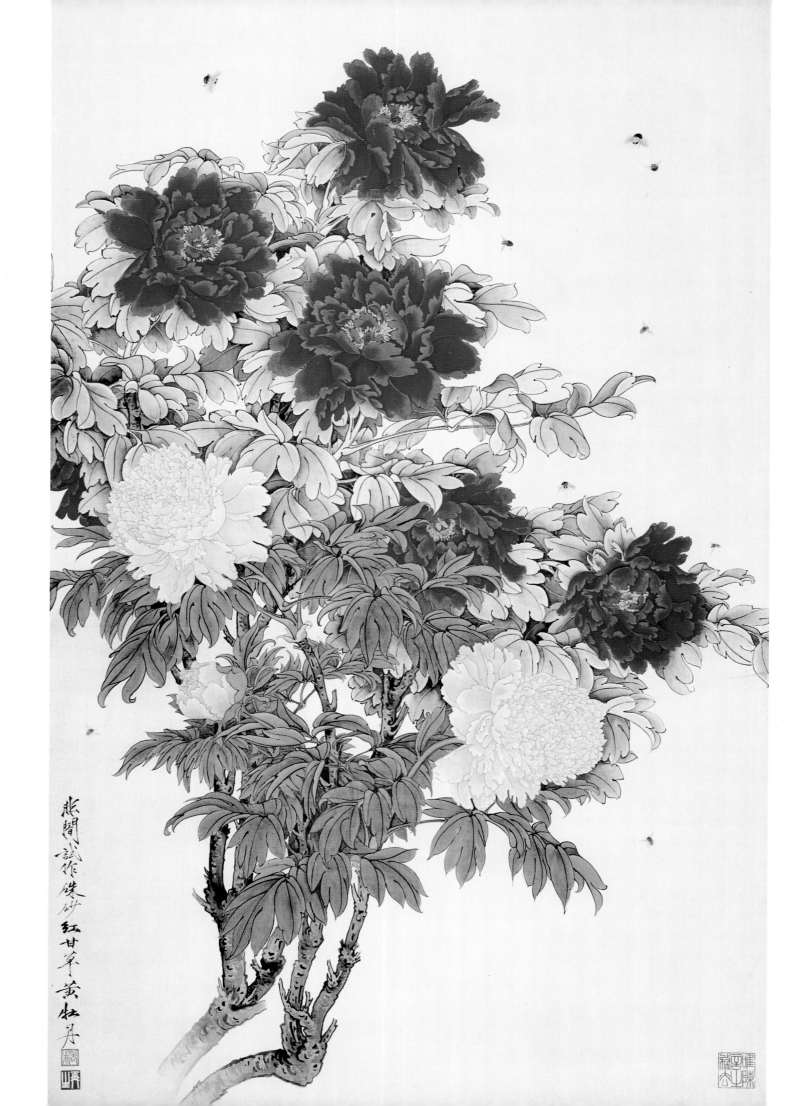

Art College and the Art Institute of Zhejiang. He also worked as the director of the Chinese Painting Research Institute and the National Academy of Art. As he was dying in 1955, he recited a line from his poetry: "Who is pressing me so hard? It's still midnight before the cock crows." During his lifetime, Huang Binhong wrote profusely. *A Study of Ancient Painting* is one of dozens of his published works.

Huang Binhong was a dedicated landscape painter. Through his fifties, he sought to learn from the works of ancient artists. In his sixties, he traveled extensively throughout the country to see the great mountains and rivers of the Chinese landscape. Only after he was seventy did his unique style take shape. Instead of following the simple and bland manner of painting based on such earlier artists as Hongren, Zha Shibiao, and Yun Daosheng (Yun Xiang, 1586–1655), Huang Binhong modeled his art on landscapes done during the Northern Song dynasty. Later, in his eighties, he changed to painting with dark ink and heavy brushstrokes. Works painted in this period became known as "dark Binhongs," whereas his earlier works were called "white Binhongs."

Of all twentieth-century artists, Huang Binhong outshone others in his remarkable skill and strategic use of brush and ink. He had a profound understanding of the inner relation of these constantly changing factors and the effects brush and ink produced, and he devoted his life to studying their manipulation. To achieve the effects he sought, he recommended the use of calligraphic skill in brushwork, making flowing and steady strokes that appeared both reserved and vigorous, delicate and steady. The use of ink, he said, should be "vivid and not cumbersome."

In his eighties, Huang Binhong painted by applying layer upon layer of ink, sometimes a dozen or even several dozen layers, attempting to create images of "magnificent mountains and rivers and luxuriant woods and plants." His strokes were free and bold but never imprudent or rugged, elaborate but never feeble or weak. He had successfully overcome the two major drawbacks of contemporary landscape paintings, which were either too tender or too coarse. In *Landscape in the Spirit of He Shaoji* (fig. 294), painted when he was eighty-nine and almost blind with cataracts, Huang Binhong relied on his skill, rich experience, and "internal sight." The scenery is a blur; the trees, rocks, and background are barely discernible. The image is worked in heavy black ink with rhythmic, unrestrained strokes. Huang Binhong first sketched in dots with light ink and then joined these dots with very heavy ink to create mountains, rivers, and trees in forceful, undulating lines. His brushwork is so powerful and sweeping that it suggests the strength of the autumn wind blowing away fallen leaves. Although the painting was inspired by the poet and calligrapher He Shaoji, it is an entirely original piece.

A Scene in Xiling (fig. 295), also painted when Huang was eighty-nine, is inscribed: "People in ancient days resorted to cao [cursive] and li [official] script calligraphy in painting. The trees under their brush were like bent iron, while mountains were like lofty cones of smooth sand." In this painting, Huang Binhong used heavy ink but a dry brush to paint the trees so that they look aged and sturdy. He manipulated strokes to paint the mountains so they appear veiled and hazy. The "Xiling" of the title refers to the Xiling Seal Society on Gushan (Solitary Hill),

294. Huang Binhong, *Landscape in the Spirit of He Shaoji,* hanging scroll, ink on paper, 1952. 93 × 45 cm. Zhejiang Provincial Museum.

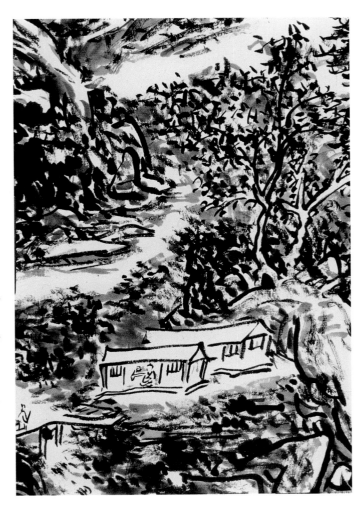

293. Yu Fei'an, *Peonies,* hanging scroll, ink and color on paper. 128.5 × 79 cm. China Fine Art Museum, Beijing. *opposite*

a small island connected to the shore of West Lake in Hangzhou by a small bridge. Anyone who knows Gushan would not identify the scene as Xiling. What Huang painted was actually a majestic view he saw with his mind's eye. Behind the brushstrokes was hidden Huang's understanding of nature and the cosmos. He once remarked that "absolute likeness plus absolute unlikeness make a really good painting." By "absolute likeness" he meant something internal, the conformity of mind and objective world. "Absolute unlikeness" is a kind of outward and physical likeness entirely different from the likeness advocated by realistic painters. This theory is similar in certain aspects to that of Wassily Kandinsky, who maintained that the essence of art lies not in its physical form but in its rhythmic composition. Kandinsky stressed abstract composition as the condensation of spirit, whereas Huang Binhong stressed the abstract nature of the brushwork and the "internal beauty" it created. To many Chinese, Huang Binhong's paintings seemed rather too aloof and high-brow, and he was not appreciated in his time. In a letter to a friend he once wrote, "Treading along all by myself, I have felt lonely for so long."[10]

Huang Binhong held unorthodox opinions on Ming and Qing paintings. He admired the literati paintings of the Northern Song and Yuan dynasties. Painters like Wu Wei were "heretical," and the "corrections" made by the "four painters of the Wu School" on the weakness of the Zhe School were "insufficient." Works by such artists as Dong Qichang, Huang Gongwang, Ni Zan, Zou Zhilin, Yun Daosheng, Cheng Jiasui, and the artists from Xin'an of the Anhui School of the late Ming were outstanding, but the painters of the early Qing, such as Wang Shimin, Wang Jian, and Wang Hui, were too "soft and fragile," and the Eight Masters of Jinling and Eight Eccentrics of Yangzhou tended to be too "coarse." "It was not until the reigns of the Daoguang and Xianfeng emperors," wrote Huang Binhong, "that epigraphy flourished and the study of paintings revived."[11] Thus Huang avoided both the orthodox praise of the Four Wangs and the new practice of criticizing the Four Wangs and praising Shitao, Bada Shanren, and the Eight Eccentrics of Yangzhou.

Huang Binhong was the first Chinese artist to make an overall study of brushwork — in theory as well as in practice. He placed into five categories the various ways of using both the brush —"flat, reserved, round, heavy, and varied"— and ink —"heavy, light, splash, deposit, and roasted." He had no desire to counter the "aggression" of foreign art as Jin Cheng and other traditionalist painters understood it. Nor was he like the painters of the new school, who called for a merger of Chinese and Western art but avoided the important role of brushwork. It was precisely Huang Binhong's conservative but penetrating study that accelerated the modernization of traditional painting.

Other painters active in Shanghai and the southern provinces at this time included Feng Chaoran (1882–1954), Feng Zikai (1898–1975), He Tianjian (1890–1977), Liu Haisu (1896–1994), Lü Fengzi (1886–1959), Pan Tianshou (1898–1971), Wu Hufan (1894–1967), and

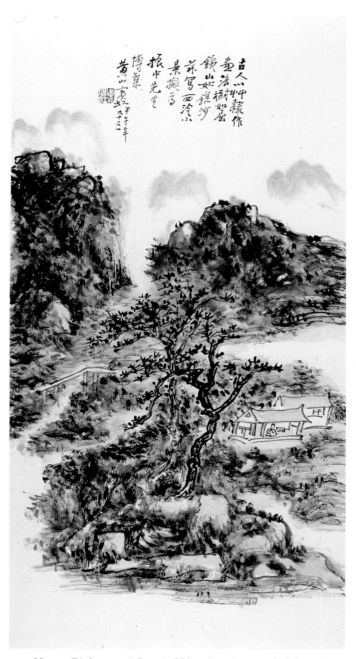

295. Huang Binhong, *A Scene in Xiling*, hanging scroll, ink and color on paper, 1954. 67 × 34 cm. Zhejiang Provincial Museum.

Zhang Daqian (1899–1983). Of these painters Liu Haisu and Wu Hufan are particularly noteworthy. Wu Hufan was a skilled calligrapher, poet, and seal carver in addition to being a respected painter who followed Dong Qichong's theories in following Song and Yuan masters. *Five Old Mountains in the Southeast* (fig. 296) represents the blue-and-green style of landscape he was particularly known for. The heavy jewel-like mineral blues and greens on the sheer cliffs and hills in the middle ground form a strong contrast with the misty gray mountain peaks in the background. They further highlight the plunging waterfall and cascading river while evoking the exuberance of nature on a spring day.

Liu Haisu, from Changzhou, Jiangsu Province, learned Western painting in Shanghai at age fourteen and two years later, with several friends, founded and became principal of the privately run Shanghai Art School. He enrolled a number of young talents and taught them both Chinese and Western painting. During the 1920s, he was on the wanted list of the warlord Sun Chuanfang for the crime of offering a class on the human body. Though conservatives cursed him as "a traitor of art," he persisted and won support from Cai Yuanpei, Chen Duxiu, and other influential cultural leaders. During the 1920s, Liu Haisu made two trips to Japan and Europe to investigate their artistic traditions. He also organized overseas exhibitions of Chinese art. The raw colors and unrestrained strokes of his oil painting show the influence of the Fauves. His Chinese painting, while absorbing the merits of Shitao, Shen Zhou, Pu Hua, and Wu Changshuo, boldly introduced sharp colors in broad strokes to monochrome works of art. As he later wrote, "In broad strokes, loud red and tragic green, these striking colors soon were being used in all parts of the country following the growth of the art school. This greatly frightened those who tried to restore the old order."[12]

In his later years, Liu Haisu created many paintings of Mount Huang (fig. 297). He executed these works in dots, hooks, chops, and splashes of color. His lines — mineral blue and green, brilliant red — are strong and terse. The sharply contrasting colors highlight the powerful and sturdy character of his work. However, Liu Haisu's painting is often criticized for its lack of creativity in spiritual expression.

Xu Beihong and His School of Art

Influenced by the thinkers active at the turn of the century and those of the May Fourth Movement, many Chinese students of art who traveled to Europe chose to paint in a realistic manner. On their return to China, many of these artists became educators, teaching sketching, perspective, and watercolor. Xu Beihong was the most influential of this group.

Xu Beihong (1895–1953) was born into a painter's family in Yixing, Jiangsu Province. His father did sketches locally. At nine, Xu began to copy human figures painted by Wu Jiayou, an artist of the late Qing dynasty. He also copied realistic Western-style animals that were printed on cigarette packs produced at foreign-run factories in Shanghai, laying the foundation for his love of realistic art. In 1915, at age twenty, Xu Beihong left his home for Shanghai to look for a job and to learn painting. Kang Youwei became his mentor. Xu admired Kang's recommendation of Song-dynasty paintings as models and his ideas for "an integration of Chinese and Western art to create a new era of painting."[13]

In May 1917, with financial help from a friend, Xu left for Japan to study Western painting. On his return, he became an instructor at the Society for the Study of Painting Technique in Beijing University on Kang Youwei's recommendation. At the same time, he came to the attention of the minister of education, Fu Zengxiang. In 1919, the government sponsored his travel to France to study art. He enrolled in the Fleming Studio of Art in Paris and a year later became a student of Pascal Dagnan-Bouveret, a French academic painter. Although his lack of funds was a constant hardship, Xu Beihong studied diligently, drawing almost a thousand sketches. He focused especially on the classic realist tradition of the West; on a study tour to Germany, for example, he did some paintings after Rembrandt.

In 1927, Xu Beihong returned to China, where he taught at the Nan Guo Art College, acted as director of the art department of the Central University, and continued to develop his interest in realistic painting. After the outbreak of the War of Resistance Against Japanese Aggression, he traveled throughout Southeast Asia, organizing fund-raising exhibitions and donating the proceeds to the resistance movement. In 1946, he became president of the Beijing National Art College, and in 1949, he was named president of the Central Institute of Fine Arts and chairman of the Association of Chinese Art Workers.

Xu believed that Ming and Qing painting declined because artists neglected realism, just as modern Western art deteriorated when it rejected the classical tradition. Xu admired masters of realistic art in both the East and the West and criticized those who strayed from realism, such as Dong Qichang and the Four Wangs, Paul Cézanne and Henri Matisse. He called the Four Wangs

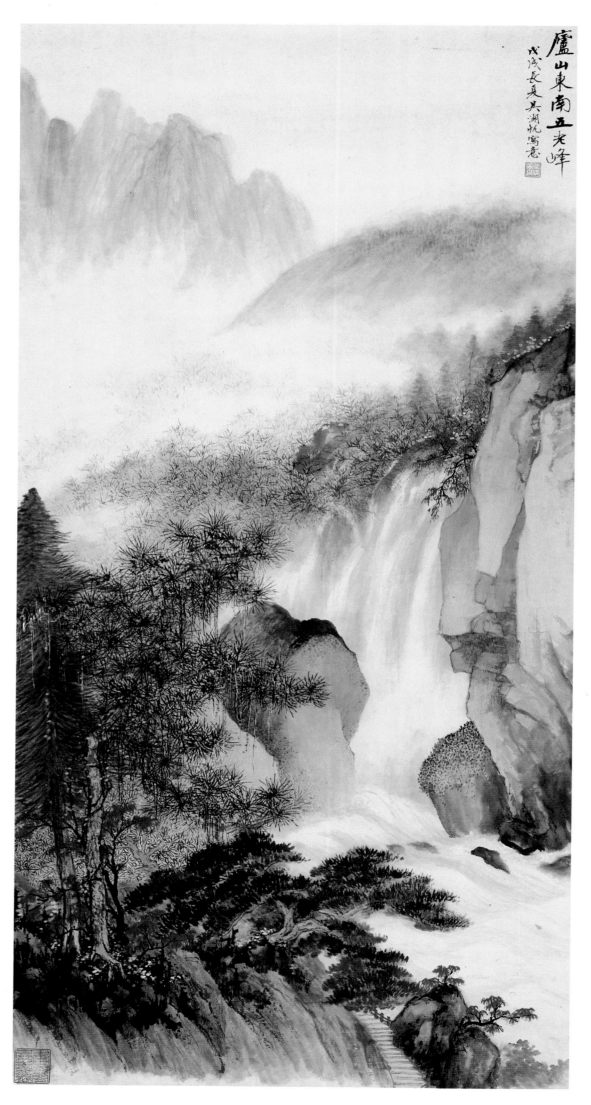

廬山東南五老峰
戊戌長夏吳湖帆寫意

296. Wu Hufan, *Five Old Mountains in the Southeast,* hanging scroll, ink and color on paper, 1958. 125.8 × 64.1 cm. China Fine Art Museum, Beijing.

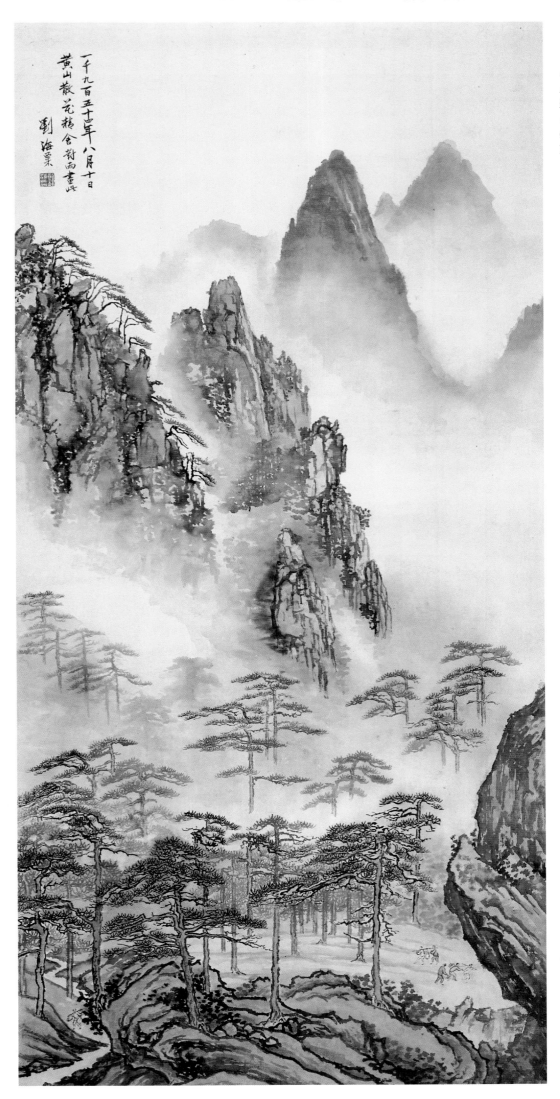

一千九百五十七年八月十日
黄山散花精舍對雨畫此
劉海粟

297. Liu Haisu, *Mount Huang,* hanging scroll, ink and color on paper, 1954. 135 × 65.6 cm. China Fine Art Museum, Beijing.

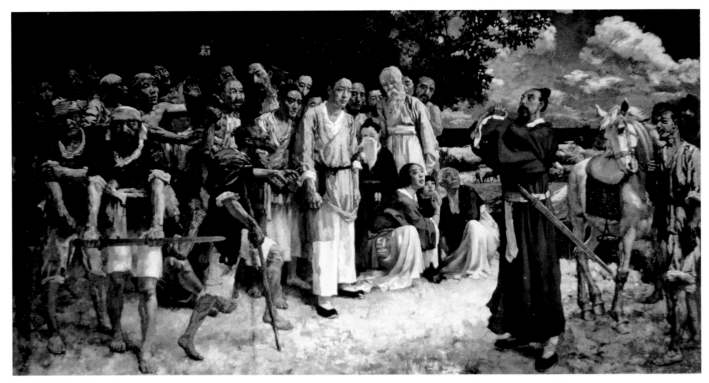

298. Xu Beihong, *Tian Heng and His Five Hundred Followers,* oil, 1930. 197 × 349 cm. Xu Beihong Memorial Museum.

"copyists" and regarded their paintings and those of Dong Qichang as clichés.[14]

In his own painting, Xu Beihong successfully integrated line drawing and the use of light and shadow to portray human bodies precisely and simply. He developed a method for painting human figures, animals, birds and flowers, and landscapes using traditional brush and ink while simultaneously exploring ways for realistic painting in colors and ink. His integration of Chinese and Western styles greatly influenced the Chinese art world of the 1940s. Major works by Xu Beihong during this period include such oil paintings as *Tian Heng and His Five Hundred Followers* (see fig. 298) and *Xi Wo Hou,* along with such traditional paintings as *The Foolish Old Man Who Removed the Mountains* (see fig. 299), *Jiufang Gao, Sichuan Folks Drawing Water from the River,* and *Galloping Horse* (see fig. 300).

Tian Heng and His Five Hundred Followers (fig. 298), painted in 1930, is based on a tale from the *Shiji* (Historical records), a classic work of the Han dynasty. The story tells of a prince of the state of Qi named Tian Heng who fled to an island during the war between the Han and the Qin. Emperor Gaozu of Han (Liu Bang) won the war and called on Tian Heng to surrender, promising him a fiefdom if he did so and threatening to send troops to conquer the island if he refused. Tian Heng answered the

emperor's call but committed suicide on his way to the capital. On hearing the sad news, his five hundred warriors killed themselves. In the picture, Tian Heng stands at the right and bids farewell to his followers. He wears a red robe and carries a long sword; he appears bold and determined to face death. In the crowd, some sigh and grieve, while others hold their swords resolutely and roll up their sleeves to fight. Still others stretch out their arms, begging their leader not to go. Two women and a child crouch on the ground to the right. Clearly they are Tian Heng's family.

At a bright spot in the picture stands a fair-skinned, serene-looking young man — the artist himself, dressed in ancient costume. Why did Xu Beihong place himself in the picture? The act brings to mind the French artist Eugène Delacroix, who placed himself in his *July 28, 1830: Liberty Leading the People.* But Delacroix painted an incident in which he took part, whereas Xu Beihong portrays an incident that took place two thousand years before he was born. By placing himself in the scene, Xu was probably expressing his admiration of the heroism of old. More than once Xu remarked that he respected the Confucian saying "One must not be corrupted by wealth, must not yield integrity when poor, must not be subdued by force and might." He called this "the spirit of a real man," and *Tian Heng and His Five Hundred Followers* is an indirect but

forceful expression of that spirit.[15] Few artists in China at this time could present such a grand view with so many characters in an oil painting.

The Foolish Old Man Who Removed the Mountains (fig. 299), of 1940, tells a story from the classic work *Liezi* about Beishan Yugong, the Foolish Old Man of the Northern Mountains, who decided to remove the two mountains in front of his house. His determination was ridiculed as folly by another old man. But Beishan Yugong said, "If my sons and grandsons continue to dig at the mountains, they will certainly be removed." When God learned of Beishan Yugong's determination, he was so touched that he ordered the mountains moved. Xu Beihong used this story as a metaphor to laud the courage of the Chinese in resisting Japanese aggression. In the painting, Beishan Yugong is depicted as a thin old man with snow-white hair and beard, leaning on a hoe and talking to his daughter-in-law. His sons and grandsons occupy the most prominent section of this long, horizontal composition. Gigantic and naked, they raise high their iron rakes and dig hard to move the mountains. By using naked bodies to depict characters in an ancient Chinese legend, Xu Beihong boldly attempts to draw on the Western artistic tradition. He painted this picture in India during the war, and many of his Indian art students acted as his models, which explains the non-Chinese features of some of the characters in the painting. Xu did create the painting in the traditional manner, however, first drawing the outlines and then filling them in with ink and color. He highlights the diggers' stature through his skillful use of light and shadow. With his convincing integration of Chinese monochrome ink technique with freehand sketching, Xu Beihong was a leader in reforming traditional Chinese painting.

Xu Beihong's monochrome ink portraits, his fine horses and gallant lions, and his cats and sparrows were highly regarded in his lifetime. The inscription to *Galloping Horse* (fig. 300), painted in 1941 in Singapore, reads: "The second battle was fought in Changsha on August 10 of the year Xinsi; my heart was burning with anxiety. Probably the outcome of this battle would be the same as the previous one. I am hopeful. — Beihong, during a visit to Singapore." In Singapore, he organized art exhibitions and collected funds for his country, and his pictures make his deep patriotic feelings plain. In *Galloping Horse,* he compares the heroic spirit of China's soldiers with qualities of the horse. His precise depiction of the animal's physique, its hooves soaring high, is very true to life and is representative of Xu Beihong's horses. He painted this picture in one step, using ink splashed with ample water.

In teaching his students, Xu Beihong emphasized sketching technique. He also insisted that his pupils learn to use Chinese materials and follow traditional Chinese styles but that they produce "precise" images. Among his many students and followers were those who are now called the School of Xu Beihong: Ai Zhongxin, Li Hu, Liu Boshu, Lü Sibai, Jiang Zhaohe, Sun Duoci, and Wu Zuoren. These painters have faithfully carried out Xu Beihong's ideas on education and painting and have developed his ideas in various ways. Wu Zuoren (b. 1908) is known for his images of desert creatures, goldfish, and pandas, and spent years wandering from Tibet to the Gobi Desert of northwest China. *Camel Herding* (fig. 301) reveals the originality of the desert subjects inspired by Wu's journeys. Close observation of nature and skillful blotting of ink on absorbent paper here imbue traditional painting techniques with new life.

Jiang Zhaohe (1904–1986), who is regarded as the most remarkable painter of this school, hailed from Luzhou, Sichuan Province. At sixteen, he went to Shanghai, where he made a living by painting portraits and creating art for commercial advertising. In his free time he sketched and sculpted. He met Xu Beihong in 1927 and became greatly influenced by his painting style and views on art. After 1930, he traveled to Nanjing, Beijing, and Chongqing to teach art and create ink-and-wash paintings. In 1940, Xu Beihong asked him to teach at the Beijing National Art College, and later he became a professor at the Central Institute of Fine Arts, a position he held until his death.

Jiang specialized in painting human figures; his modeling shows the strong influence of Xu Beihong. He was also remarkable for his integration of line drawing and strong composition with the light-and-shadow technique commonly used in sketching, but he never worked under the constraint of the stylized rules strictly observed in literati painting. Jiang Zhaohe's monochrome ink figures seem even bolder, freer, and more straightforward than Xu Beihong's. And unlike Xu Beihong, who favored depictions of historic and legendary heroes, Jiang Zhaohe preferred to paint contemporary people of society's lowest strata — the homeless, the ricksha-pullers, peddlers, and blind beggars, the laborers and farmers forced to sell their children in order to survive. He once remarked, "It's only through realistic art that we can expose the miserable fate and aching hearts of the laboring poor." Jiang knew the life of poverty firsthand: as a boy he had lost his own parents and had experienced years of hardship and deprivation.

Representative of Jiang Zhaohe's painting is the long

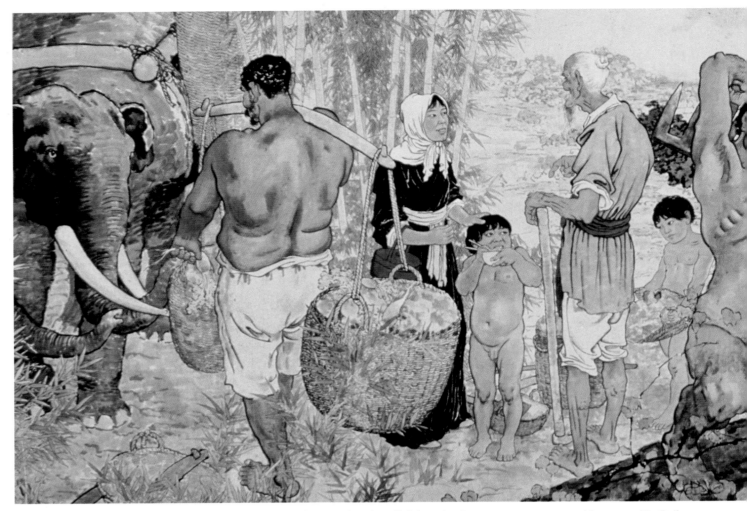

299. Xu Beihong, *The Foolish Old Man Who Removed the Mountains,* handscroll, ink and color on paper, 1940. 144 × 421 cm. Xu Beihong Memorial Museum.

scroll *Refugees* (fig. 302), painted in 1943. The subject is the life of Chinese refugees during the War of Resistance Against Japanese Aggression. To create this tableau, Jiang made trips to Shanghai and Nanjing and hired refugees and wanderers of various types and ages to pose for him. Not all of these wanderers were originally from the laboring classes; some had belonged to the middle classes and some were once scholars. Friends and students also acted as his models. More than a hundred characters — peasants, workers, the educated — appear in this scroll: old men lie dying in the street, sick and starving children are everywhere, and panicked women seek shelter from the bombing; the aged cover their ears to avoid the noise of airplanes, a university professor prepares to hang himself, and bodies of the dead are all around. *Refugees,* so true to life and lacking any trace of idealism or stylization, stands today as a rare accomplishment in the history of Chinese painting.

Jiang Zhaohe's human forms were more substantial and unconstrained than those of Xu Beihong, who paid greater attention to the elegance of his brushwork and line drawing. But to Jiang Zhaohe, elegant brushwork and lines were less important than how true to life and expressive a picture was. If Xu Beihong's realistic art was tinted with the color of idealism, Jiang Zhaohe's realism was deeply rooted in the reality of his time.

The Early Years of the People's Republic of China, 1950s–1970s

A new era in China's history began in 1949 with the formation of the People's Republic of China under the Communist leadership of Mao Zedong. Because the West imposed a blockade on the new republic, however, Chinese culture and art remained in relative isolation, its only window open to the Soviet Union and Eastern Europe. In the realm of art, Yan'an's revolutionary traditions (the political and organizational leadership of the Chinese Communist Party and the promotion of popular art

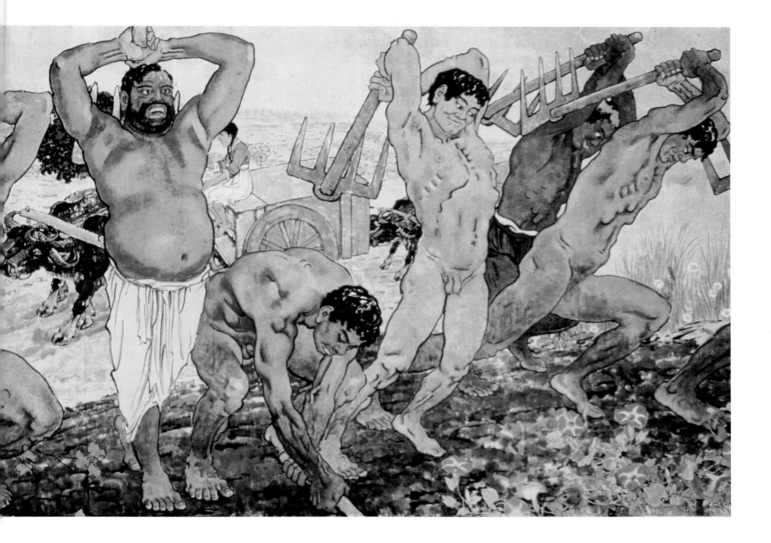

forms), socialist realism from the Soviet Union, and the realism of the School of Xu Beihong blended to become the new mainstream. Free trade in art markets disappeared rapidly, private art schools and nongovernmental journals were closed, and artists were placed under government sponsorship as civil servants. Following the government's stated principles of "serving the workers, peasants, and soldiers," "serving politics," and "making the past serve the present and foreign things serve China," painters traveled regularly to rural areas, factories, and army camps to witness and share in the lives of workers, peasants, and soldiers and to undergo ideological remolding. At the same time, there was a dramatic increase in the number of art schools and colleges as well as art courses in teachers' universities. Established painters were reaching their artistic maturity and a number of young painters were emerging. Art forms, techniques, and subject matter that enjoyed popular approval and were suitable for positive propaganda and education gained authoritative recognition. Yet works that expressed personal psychological experiences, explored

new art forms, or criticized irrational practices encountered repression and restriction. And in the late 1960s into the 1970s, as nihilism swept across the country like a plague during the Cultural Revolution, all artistic endeavors, except those of a political propagandistic nature, suffered. Large numbers of veteran painters were persecuted. Chinese culture generally and painting in particular suffered an unparalleled blow.

The Color-and-Ink Painting of Lin Fengmian

Lin Fengmian (1900–1991), a native of Meixian, Guangdong Province, is one of twentieth-century China's most important artists. His grandfather was a stonecarver, his father a local painter. Lin learned both trades during his childhood and in 1919 traveled to France for six years to study and work at Dijon Art College and the Ecole Nationale Supérieure des Beaux-Arts in Paris. In France, Lin studied European painting, especially works by Matisse, Picasso, Georges Rouault, and Amedeo Modigliani. In 1923, he traveled widely in Germany.

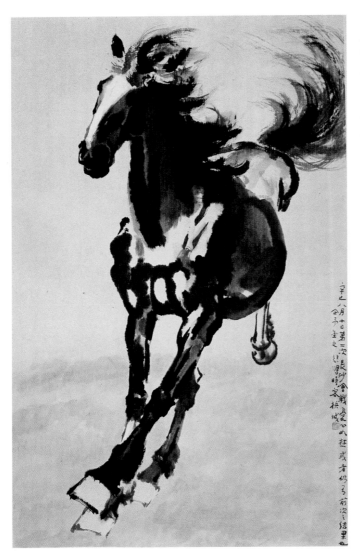

300. Xu Beihong, *Galloping Horse*, hanging scroll, ink on paper, 1941. 130 × 76 cm. Xu Beihong Memorial Museum.

Lin Fengmian began to experiment with ink-and-color painting in the 1930s. He painted landscapes, still-lifes, birds and flowers, female figures, and characters from traditional operas. His work never focused on issues of social reality or politics. In his painting Lin sought to depict a serene yet forceful beauty with a specific form and charm. He enjoyed working with still-lifes on canvas, and he painted many compositions of potted flowers, cut flowers in vases, fruits, and glassware in his studio, experimenting with the shapes and colors in different lighting. He tried to integrate the Impressionists' technique of working with outdoor lighting with ink-and-wash and to blend Western principles of composition with figure sketches using Chinese color-and-ink. In style and color, his paintings look more like Western still-lifes and thus somewhat different from Chinese bird-and-flower paintings. As a result of his ink colors and rhythmic and graceful use of the Chinese brush, however, his paintings look more like traditional Chinese works.

Other favorite subjects of Lin Fengmian were little birds, either perched on tree branches or flying over water in autumn, mandarin ducks and cranes (see fig. 304) among the reeds, and even owls, still regarded by many Chinese as ill omens, in the morning, at sunset, or in hazy moonlight.

Many of Lin's paintings were closely associated with his feelings of loneliness and isolation. In *Still-Life* (fig. 303), Lin reflects his familiarity with Impressionist painting techniques. Seeking to synthesize the spirit and expression of both Western and traditional Chinese painting, he uses heavy ink and colored washes on Chinese paper while representing a Western subject. He often favored the use of gouache and watercolors in his highly distinctive, personal visions. From the outset of his career, he alienated himself from art circles "to cultivate the land alone," as the painter Wu Guanzhong said. During the War of Resistance Against Japanese Aggression, Lin Fengmian lived in a farmhouse in Chongqing. After a brief stint as a teacher at the Hangzhou National Art College, he retired from teaching and moved to Shanghai. He was isolated, pressured, and officially criticized. In 1955, his French wife and his daughter left China. Fearing persecution, Lin destroyed many of his experimental works, yet even so, he was imprisoned for more than four years during the Cultural Revolution. In 1977, after the fall of the Gang of Four, Lin was permitted to visit his family abroad, and in 1979, he settled in Hong Kong, where he lived out his life.

The long years of hardship and the feelings they engendered found aesthetic expression in Lin's landscape paintings. His style of "poetic loneliness" is unique in twentieth-century Chinese painting. Unlike Western painters, he did not paint landscapes directly from nature; rather, he created his landscapes in the traditional Chinese manner, according to memory and imagination. Yet Lin's perspective and composition, as well as his methods of applying ink and using the brush, differ from traditional Chinese landscape styles and more closely resemble those of Western painters. He discarded the long, horizontal handscroll form for various types of composition and took color as his basic language for depicting light and shadow and dealing with focus and perspective.

Lin painted lakes, farms, and narrow paths in the woods. A favorite subject was the area of West Lake in Hangzhou, where he lived and worked at two points in his career. Yet only after being away from West Lake for fifty years was he prompted to paint the area. The lemon-colored weeping willows, clear, bright lake, empty small boats, and tile-roofed houses peeping from behind patches of verdant green, the blue mountains in the dis-

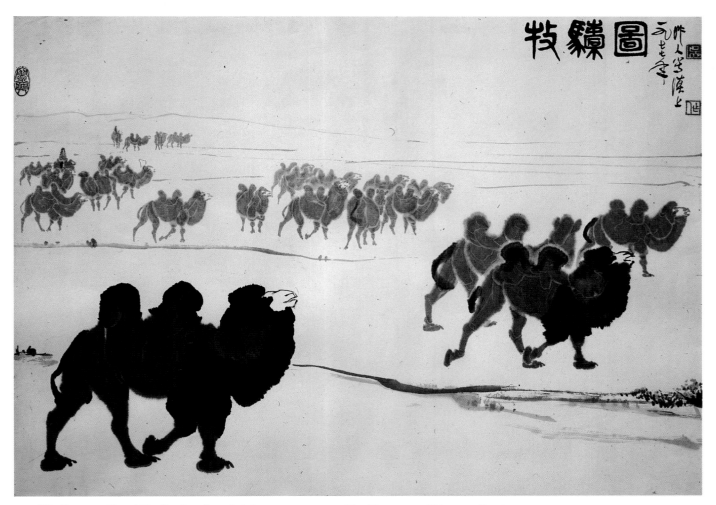

301. Wu Zuoren, *Camel Herding,* handscroll, ink on paper, 1977. 68.5 × 92.5 cm. Private collection.

tance vying with the tender flowers and beautiful round leaves of the lotus — these charming images of West Lake came from the painter's reminiscences. Lin Fengmian painted women in ancient costume, in modern fashion, or in the nude, depicting them in soft, flowing curves and pure colors. His women are distinctive and have a visionary beauty that combines the loveliness of East and West, of reality and idealism, of discreet charm and sensuality.

What was outstanding in Lin's art was the way he created a new kind of structure and style, one that differed from both traditional Chinese art and the Western tradition. Absorbing traditional Chinese art, he nevertheless circumvented the basic patterns of the Yuan, Ming, and Qing dynasties. While going back to the bird-and-rock paintings of the Han dynasty as well as to the porcelain drawings of the Song and Yuan, he integrated Matisse, Picasso, and Rouault and the distortion and simplification of Chinese papercuts and shadow puppetry into a new technique marked with rich colors and bold, rapid

brushstrokes. Against a background of monochrome ink-wash and line drawing, he deftly blended outdoor light with strong emotion, furnishing his painting with gorgeous colors set in forceful motion. The resulting rhythm of clear yet changeable light and intense sentiment became known as the "Lin Fengmian style."

Egrets (fig. 304) was painted in 1974. Lin Fengmian took a special liking to the egret and created a set of techniques to paint the bird. This painting depicts two egrets: one looks for food, while the other prepares to take flight into the cloudy sky above. A backdrop of vast stretches of reeds forms a striking contrast to the radiant snow-white birds with their black-tipped wings and black legs. With a few graceful yet forceful strokes of gray, Lin accurately renders the outlines of the egrets while expressing their vitality. Such brushstrokes, without modulation or pause, reflect the smooth quality and style of the painting and porcelain drawing of the Han dynasty. This style differs greatly from the methods of Ming and Qing literati; they stressed an inner restraint, and "one pressing-down

302. Jiang Zhaohe, *Refugees,* handscroll, ink on paper, 1943. 200 × 2700 cm. Private collection. *overleaf*

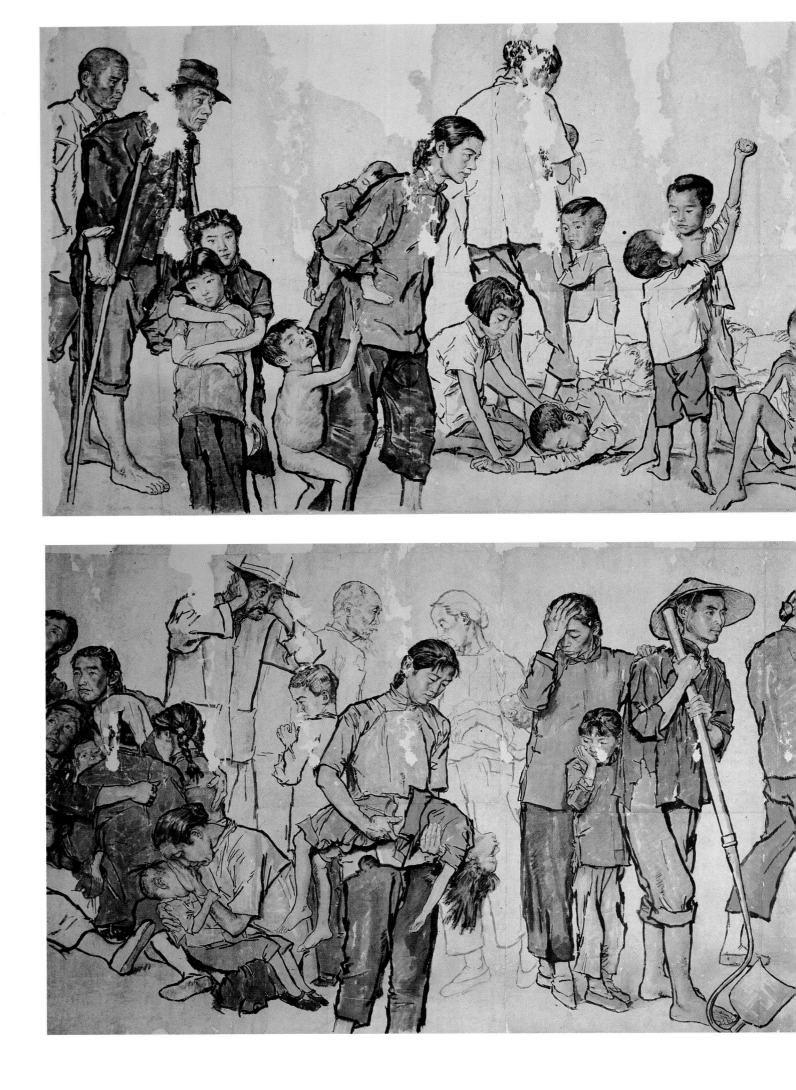

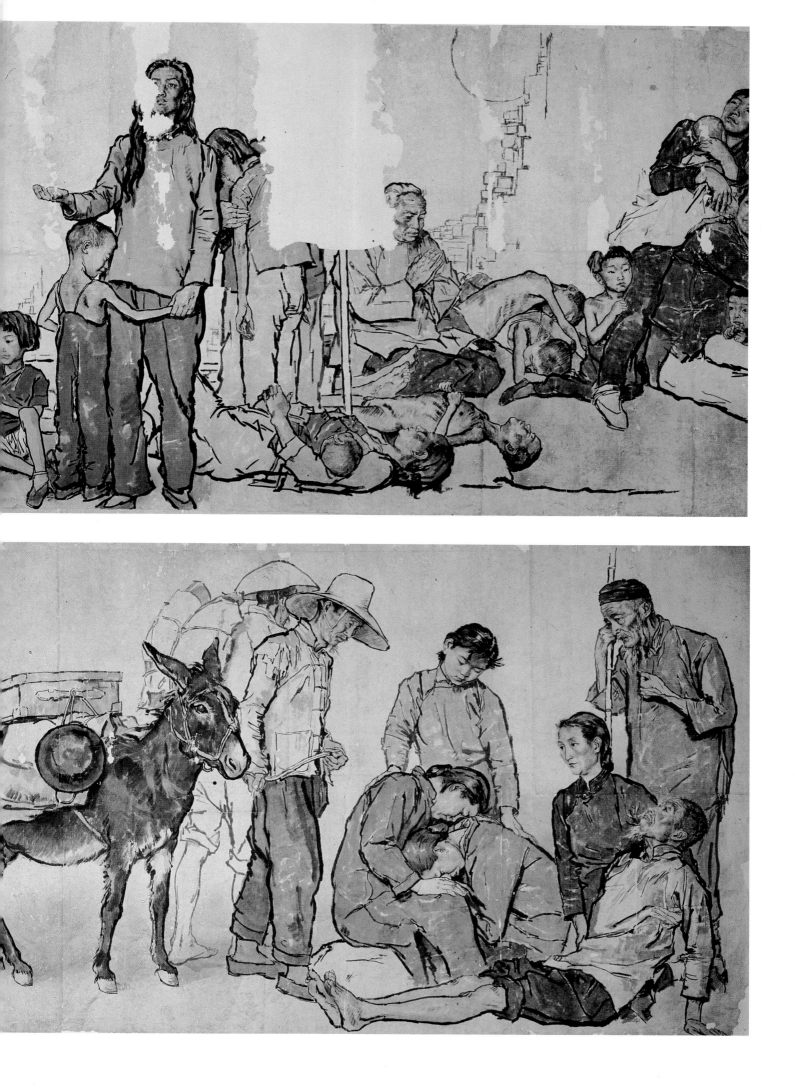

303. Lin Fengmian, *Still-Life,*
handscroll, ink and color on
paper. Shanghai Art Institute.

and three changes of the direction of the brush" (effecting delicacy and gracefulness) in drawing lines. Lin's way of painting endowed his works with lucidity, vividness, and vigor. In *Egrets,* the special quality of monochrome ink was also given full play in depicting the cloudy sky, grasses, and reeds. The result is a watery effect in which dry and wet intermingle, and light and heavy touches of the brush in light blue and reddish brown display the soaked quality of the inkwash.

Spring (fig. 305) was painted as a gift for the poet Ai Qing in 1977. Ai Qing had been a student of Lin's at the Hangzhou National Art College and had maintained good relations with Lin over the decades. Both men had been persecuted during the Cultural Revolution and were grateful to have survived. This painting depicts a bird, perhaps a mynah, perching on a slanting branch with soft and delicate greenish blossoms. The leaves have not yet emerged. Here is a plum tree blooming in the cold spring, sparkling with joy and hope by means of the master painter's brush. In these works he emphasized the expression of ideas over the skill with brush and ink demanded by conventional bird-and-flower painting. And he paid more attention to structure and individuality in modeling. This technique was new to bird-and-flower paintings.

In a late work, *Wu Song, the Opera Figure* (fig. 306), Lin Fengmian portrayed a heroic character from the famous old Chinese novel *Outlaws of the Marsh.* Wu Song had many daring exploits, including punching a fierce man-eating tiger to death. In this scene, Wu Song kills his adulterous sister-in-law and her lover. They have murdered her husband, and Wu Song must avenge his older brother's death. To represent dramatic characters of eternal value, Lin here experiments with the Cubist technique of dissecting a form into many planes, and he integrates these geometric shapes with models based on Chinese papercuts and shadow puppets. This style of character painting, however, lacks a mature painting vocabulary, nor are the abstract geometric forms in harmony with Chinese folk art models.

304. Lin Fengmian, *Egrets,* ink and color on paper, 1974. Shanghai Art Institute.

305. Lin Fengmian, *Spring,* ink and color on paper, 1977. Private collection.

Pan Tianshou and the New Zhe School

The most creative traditional painter after Wu Changshuo, Qi Baishi, and Huang Binhong is Pan Tianshou (1898–1971). Born to a peasant family in Ninghai County, Zhejiang Province, Pan Tianshou learned to paint as a child from *The Mustard Seed Garden Manual of Painting,* a manual of famous styles, motifs, and earlier compositions. At nineteen, he entered Zhejiang No. 1 Normal School, studying under such famous artists and men of letters as Jing Hengyi and Li Shutong. After graduation, he returned to Ninghai to teach. In 1923, he moved to Shanghai, teaching Chinese painting and its history in the Minguo Girls' Technical School and then at Shanghai Art College. In Shanghai, Pan visited the eighty-year-old painter Wu Changshuo, showed him some of his paintings, and asked for his advice. Much impressed by Pan's talents, Wu wrote him a couplet in seal characters, "Surprise to heaven and earth wherever the brush falls / Any talk of his own can find expression in poems," as a gift. Wu also wrote a long poem, "Reading Pan Tianshou's Landscape Screen," in which, besides offering words of encouragement, the master reminded Pan of the need to avoid the pursuit of sensationalism in order to avoid falling into "deep gorges."

306. Lin Fengmian,
Wu Song, the Opera Figure,
ink and color on paper,
ca. 1980. 34 × 34 cm.
Private collection.

Pan became a regular visitor to Wu's studio, yet he sought to blaze his own trail. He studied calligraphy, seal carving, and the history of painting and poetry. After 1928, he taught at Hangzhou National Art College and shuttled between Shanghai and Hangzhou. During the War of Resistance Against Japanese Aggression, he passed through Hunan, Guizhou, and Sichuan with the Hangzhou National Art College in retreat from the Japanese. From 1944 to 1947, he served as president of the college. After the People's Republic of China was founded, Pan Tianshou responded to Mao Zedong's call to plunge into the thick of life by traveling through the countryside and to great mountains and rivers to paint from nature, and he strove to endow bird-and-flower painting with political significance. In 1959, he became president of the Zhejiang Academy of Fine Arts, and in 1960, he was elected vice chairman of the Chinese Artists' Association. In 1966, when he was sixty-eight, Pan wrote a poem for himself:

Bustling everyday with brush and inkstone
Wandering destitute year after year

What have I got after seventy years
Only now can I sing the praise of peace.

In this poem, he expressed his deep confidence in his artistic pursuits and his loyal support of the political regime. Yet during the Cultural Revolution he was singled out for attack by Mao's wife, Jiang Qing. In spite of his strong, upright, and unyielding resistance on just grounds, he was ruthlessly persecuted both spiritually and physically. He died in September 1971 uncleared of false charges.

Pan's style of painting took shape in the 1940s and gained maturity in the mid-1950s. His artistic influences were wide and varied. In addition to Wu Changshuo, he admired Bada Shanren, whose cool, leisurely, and unrestrained style was a strong influence. Pan's style could be traced back further to Shen Zhou and Dai Jin of the Ming dynasty and Ma Yuan and Xia Gui of the Song. Since the mid-Qing dynasty, the art of painting had been gradually influenced by seal carving and calligraphy. Then, in the late Qing and the early years of the Republic, there appeared such master painters as Zhao Zhiqian, Wu Changshuo, and Qi Baishi who studied seal carving

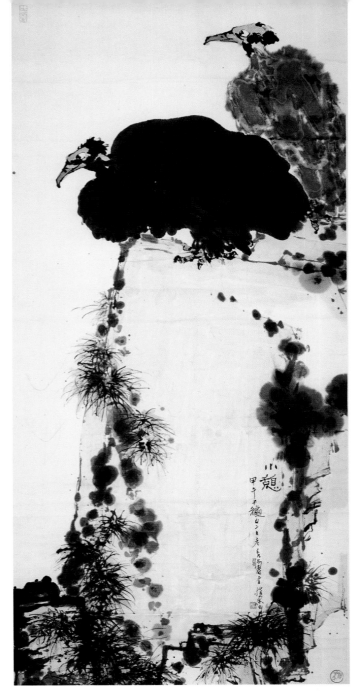

307. Pan Tianshou, *A Short Rest,* finger painting on paper, 1954. 224 × 105 cm.

gested what appealed to him while discarding what he disliked. In general, traditional Chinese literati painting demanded the balance and harmony of hard and soft, clumsy and clever, like and unlike, real and unreal, rational and irrational, plain and surprising. But Pan was just the opposite. His goal was to delineate forms that could evoke feelings of being in danger, of going to extremes, of being surprised, of having power, and of thrilling at the sight of something marvelous or even grotesque.

Pan Tianshou's calligraphy and painting were very similar in style and brushwork, especially the running script he used to dedicate paintings and write his signature. The usually squarish characters were arranged irregularly but looked surprisingly beautiful. He excelled in bird-and-flower compositions, landscapes, and especially paintings of birds of prey. Through long, powerful strokes he created the underlying structure of his compositions. His slow and steady brushwork emphasized the inner strength of the "bones"; his square seal, with the characters "strengthening its bones," signified his search for an appreciation of this unusual beauty.

A Short Rest (fig. 307), painted in 1954, depicts two vultures resting on a rock. One is black, the other gray; one looks down as the other looks straight ahead. Pan painted the black vulture by emptying a big bowl of ink onto the paper and finishing the figure off with rapid dashes and strokes. He drew the birds' eyes — sharp, cold, and threatening — with his fingernails. The vultures are oval in shape, whereas the rock under their claws is square. Their heads, too, are somewhat squarish, whereas the moss that grows on the rock is executed in round dots. The composition thus creates a sharp contrast and harmonious rhythm of squares and circles, large and small. The vultures, painted in deep colors, stand out against the background of lightly shaded rocks and peaks. It is a scene of stillness, yet there is hidden movement inside the large, powerful birds that rest quietly. The painting conveys a feeling of immensity and loftiness. Vultures are birds of prey, big and grotesque, aggressive and powerful; Pan preferred them to pretty little birds. *A Short Rest* reveals why Pan's finger paintings are the best of this genre since the Qing painter Gao Qipei. Using his fingers to render great momentum and power, he produced a painting of impressive length, fully demonstrating his skill in employing the unique quality of the Chinese ink to display the beauty and grandeur of nature.

An oblong, horizontal finger painting, *The Stare* (fig. 308), depicts a cat staring from a huge rock. Most people like to paint their pet cats as lively and lovable creatures, showing off their lustrous hair, bright eyes, and nimble

and applied its aesthetics to their work but neither followed the Four Wangs nor adopted the heaviness and forcefulness of the Zhe School. Although Pan learned the seal-carving brushwork represented by Wu Changshuo and studied seal carving and copied inscriptions from stone steles, he proclaimed that he would emulate and develop the forceful style of the Zhe School. Two factors influenced his decision. One was a rational choice — modern theoreticians advocated "the beauty of strength"; the other was rooted in his personality — Pan had a strong, stubborn, reserved, and singular character that found natural expression in his poems, paintings, and calligraphy. In following ancient traditions, he di-

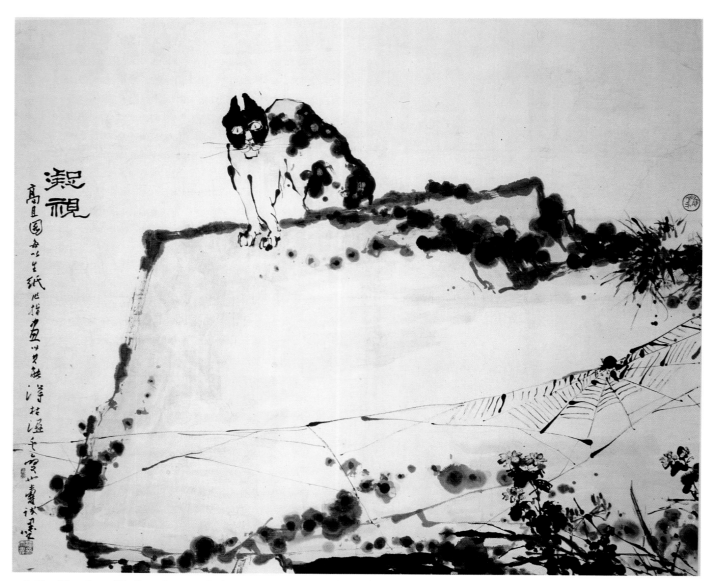

308. Pan Tianshou, *The Stare,* finger painting on paper. 141 × 167.5 cm.

poses and almost inviting viewers to caress and play with them. But Pan's cats are ugly, lazy, queer, and altogether repulsive. Through his cats and other unconventional-looking animals Pan sought to transmit his experience of life, which was seldom easy and often wretched. However, even though he suffered during the Cultural Revolution, the progress of his life was fairly smooth and stable.

In *Pine and Rock* (fig. 309), painted in 1960, a rock occupies the lower middle ground as an inverted pyramid slanting to the right, signifying its independence in the universe. The crooked trunk of the pine stretches right and left; a withered branch curls backward. Thickly inked pine needles protrude from the top of the tree, and old vines cling to the trunk. Although Pan Tianshou painted this picture from an elevated perspective, the viewer's line of sight is directed to the lower half of the painting.

The completely empty background indicates the limitless sky. The painting showcases Pan's unexpected style of structural composition, strong and dynamic brushwork, and lofty but simple artistic conception. He longed to study ancient Chinese painting further and felt the need of genuine friendship to soothe the loneliness of his artistic pursuit.

Pan felt strongly that because Chinese and Western arts had different values, it was better that they continue to go their separate ways. They should not be combined, nor should one replace the other. Each artistic tradition should maintain its own uniqueness and originality. Throughout his career, he worked against the Westernization of Chinese painting. As head of the Chinese painting department of the Zhejiang Academy of Fine Arts, he saw that more attention was paid to Chinese tra-

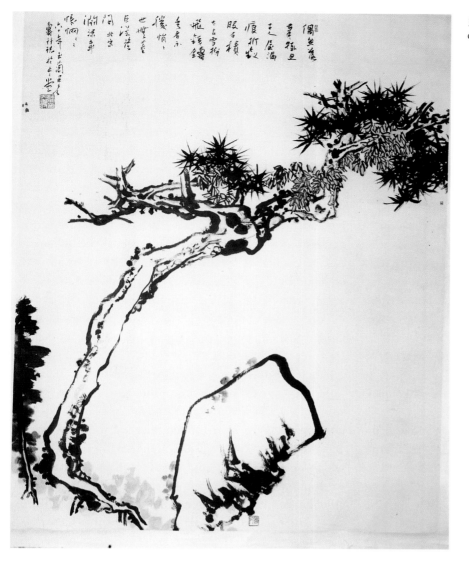

309. Pan Tianshou, *Pine and Rock,* light color on paper, 1960. 179.5 × 140.5 cm.

ditions there than at any other institution. In 1960, he implemented a system of teaching figure painting, landscape composition, and bird-and-flower painting in separate courses and made calligraphy a required course for students of traditional painting. He invited such master painters and calligraphers as Wu Fuzhi, Gu Kunbo, Lu Yanshao, Lu Weizhao, and Sha Menghai to join the faculty. The academy also emphasized the study and copying of ancient paintings and earlier brushwork. As a result of these initiatives, many distinguished traditional Chinese painters emerged from the Zhejiang Academy of Fine Arts. Because their style differed from that of the School of Xu Beihong at the Central Academy of Fine Arts, they became known as the New Zhe School.

The Nanjing Painters

In the 1960s, a group of traditional Chinese painters gathered in Nanjing. Among them were Lü Fengzi, Chen Zhifo, Fu Baoshi, Qian Songyan, and such other artists as Song Wenzhi, Wei Zixi, and Ya Ming.

Chen Zhifo (1896–1962), a native of Yuyao County, Zhejiang Province, graduated from the Zhejiang Industrial School in 1916. In 1918, he traveled to Japan to study industrial arts, becoming the first Chinese student at the Tokyo Imperial Art School. After returning to China, he taught at the Shanghai Art College, the Shanghai Oriental Art College, and then the Guangzhou Art College and the Central University. In the 1920s, he studied industrial art, taught design and art history, and published a number of books, including *Designing ABC, Designing Teaching Plans,* and *The Basics of Western Art.* He also created cover

designs for a number of magazines and began to be known as "Master Designer Chen Zhifo." As a teacher at the Central University in Nanjing in the early 1930s, he enjoyed access to some of the greatest art of the past and became interested in meticulously detailed bird-and-flower paintings. Eventually he devoted his career to studying Song-dynasty academic paintings. To be able to observe his subjects and practice sketching from life, he raised birds and cultivated flowers at home. In 1934, Chen exhibited his bird-and-flower paintings in a group show.

Chen Zhifo moved to Chongqing during the War of Resistance Against Japanese Aggression and served as president of the National Art College there from 1942 to 1944, all the while continuing to create meticulously detailed bird-and-flower paintings. After the war, he returned to Nanjing and his post at the Central University. In later years, he was elected a council member of the Chinese Artists' Association, made a member of the Chinese Committee of UNESCO, and appointed vice president of Nanjing Art College and Jiangsu Provincial Painting College.

After the Song dynasty, painters did not expand the artistic boundaries of the meticulously detailed genre. Literati painters generally favored freehand monochrome ink compositions. Most painted for their own pleasure and in a playful manner. They lacked solid training in this exacting style. In addition, they followed various academic and "professional" traditions, which, if not managed properly, could result in paintings that appeared dead or "craftsmanlike." This did not accord with the freedom, artistic conceptions, and interest in brushwork that the literati valued in their pursuit of art. Those artists who made a career of creating finely detailed bird-and-flower paintings were rarely from the literati class. Although these painters were generally well trained and skilled, they lacked the learning and refinement needed to create art that could be considered "literary" or thought-provoking.

Cognizant of this history, Chen Zhifo set a four-character norm for himself: "look," "write," "copy," and "read." "Look" meant to observe the subjects — birds and flowers and paintings of this genre. In particular, Chen demanded the observation of the differences and variations in the styles and tones of ancient paintings. "Write" meant to sketch from life so as to deepen and enhance one's observation of nature. Chen demanded that sketching from life should harmonize with brushwork; as he said, "Sketching from life is valued for creating a likeness, and yet to seek a superficial likeness without under-

standing brushwork is not painting." "Copy" meant to study the works of the ancients with an emphasis not only on creating a likeness but on learning the spirit and brushwork of the ancient paintings so as to raise one's cultural and artistic awareness. "Read" meant study of important books aside from paintings, which would heighten cultural and artistic achievements. In fact, Chen's four-character norm sought to incorporate the qualities of literati painting into meticulously detailed painting in order to raise the standards of the genre in taste, style, rhythm, and brushwork. With his excellent knowledge of art and culture, Chen Zhifo gave this style of painting greater emotional depth, a fresh sense of the delineation of form, a higher level of taste, and a more pronounced character. He was a master of design and color, had an intimate knowledge of Eastern and Western arts, and understood how to appreciate traditional painting. In short, Chen pushed modern Chinese meticulously detailed painting to a new level.

Chen Zhifo's finely lined bird-and-flower paintings impart an air of serenity and refinement. He was fond of using thin contour lines and single applications of light color washes. Another favorite method was the boneless wash technique (also called water-soaking technique), in which he applied light and black ink running with water without having drawn contour lines beforehand and then added light green dots that were allowed to ooze on the paper. As these broad washes of color spread, they gave a misty and mottled effect. Chen Zhifo often used this technique in painting tree trunks, leaves, the ground, and feathers. Overall, Chen's works express profound sentiments of peace and inner beauty; rhythm and not force is the key to their success.

Purple Roses and a Pair of Pigeons (fig. 310), of 1954, was painted on light, warm-tinted paper. With thick blue and green inks, Chen Zhifo depicted a green stone entwined by roses with graceful purple blossoms and greenish leaves. On the stone, a pair of pigeons perch quietly. The bird on the right cocks its head as if looking for something. The pigeons are painted in tones subtly lighter than the background. The fine gradations of pale colors demonstrate the reserve and elegance of Chen's technique; the results are rhythmic, clear, and pleasing.

Fu Baoshi (1904–1965) was born into a poor peasant family in Xinyu, Jiangxi Province. Fu's father was so poor that he could not make ends meet, and so the family moved to Nanchang, where he earned a living by repairing umbrellas. Fu was his parents' seventh child but the only one who survived to maturity. Fu was eleven when his father died, and he was apprenticed to a chinaware

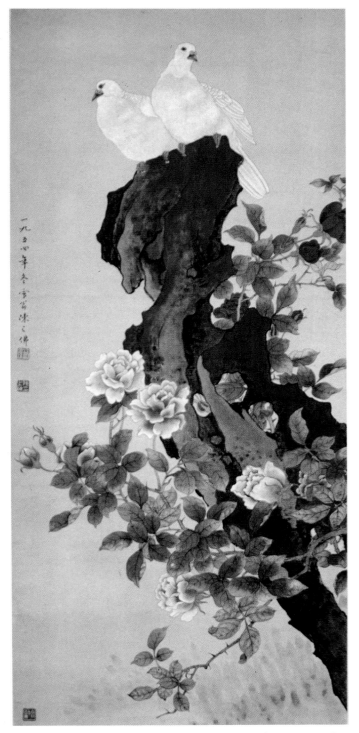

310. Chen Zhifo, *Purple Roses and a Pair of Pigeons,* hanging scroll, ink and color on paper, 1954. Nanjing Museum.

shop. This job gave him the opportunity to see Chinese painting and seal engraving in nearby shops, and he began to teach himself calligraphy, painting, and seal carving. Soon he was carving seals to earn money to help his family. Eventually he was able to attend school to learn calligraphy and painting, and after graduation, he taught in primary and middle schools. His book, *The Study of Copying Seal-Engraving,* was published in 1930.

In 1933, with help from the artist Xu Beihong, he traveled to Japan, where he studied the history of Asian art as well as crafts and carving at the Tokyo Imperial Art School. He also collected Japanese-language reference materials on Chinese art history. When he returned to China two years later, he was appointed professor at the Central University and at the Nanjing Teachers' College. During the War of Resistance Against Japanese Aggression, Fu Baoshi lived in Sichuan Province. Beginning in 1957, he served as president of the Jiangsu Provincial Painting College, vice chairman of the Chinese Artists' Association, and director of the Xiling Seal Society.

As a young man, Fu Baoshi copied ancient landscape paintings, especially the works of such Southern Song and Yuan-dynasty painters as Mi Fu and Ni Zan. He focused especially on the art of the Yuan-dynasty painter Wang Meng. Among the masters of later periods, Fu copied Cheng Sui, but Shitao and Kuncan of the early Qing dynasty were his favorites; he considered their works to be "full of life." Fu entered his most prolific period during his years in Sichuan. The majestic mountains and great rivers of Sichuan aroused in him emotions and sentiments that the gentler beauty of the southeastern provinces could never inspire. In his eyes, a tree, a hill, a gully, even a blade of grass could become the subject of a painting. He summed up the unique features of Sichuan landscapes in the following words: "Caged in by smoke, locked up by fog, misty and surprising." Fittingly, these words also describe his style of painting in this period.

Among his representative works of these years are *Myriad Bamboo in the Misty Rain, Whistling Wind in the Evening Rain, Listening to the Waterfall,* and *Cleansing the Thatched Hut,* all painted in 1945. *Listening to the Waterfall* was also called *Listening to the Spring,* a subject he painted several times in succeeding decades. In the version reproduced here, painted later in a similar style (fig. 311), spring water cascades down a mountain into rapids. At the base of the falls, in a small pavilion, a man in white stands by the rail, enjoying the gurgling sounds of the leaping water. Though the image is painted with lively brushstrokes, the mood is leisurely, forming a striking contrast to the imposing landscape. Fu Baoshi paid special attention to the depiction of great distance: the closer to the foreground the boulders in the stream are, the bigger they appear, while the mountains change in color from black to pale gray as they recede into the distance. Fu once said,

Chinese landscapes, whether horizontal or vertical, are usually sized according to a ratio of one to three. The

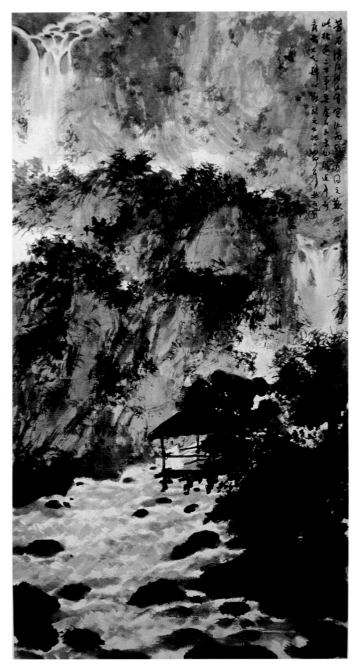

311. Fu Baoshi, *Listening to the Spring*, hanging scroll, ink and color on paper, 1963. 110.5 × 52.8 cm. Nanjing Fu Baoshi Memorial Museum.

must draw the ridges; for trees, it is better to show brushy areas than a lot of branches, and then the application of thick, watery ink will give the outstanding effect of a close-up view.

Fu used these techniques in painting *Listening to the Spring.*

Fu Baoshi was skilled in the use of the stiff-haired brush. He pushed this hard brush, its bristles sticking out on all sides, in every direction. He often used "adverse strokes," in which he pressed the stiff bristles full-length against the paper and then swept the brush across the picture in bold and forceful strokes. He developed this technique, which became known as "Baoshi's texture-shading brushstroke," on the basis of ancient textural shading brushstrokes coupled with his inspiration from nature.

In *Listening to the Spring,* Fu Baoshi exploited the rough-grained quality of tough Sichuan (or Guizhou) paper made from the bast fiber of the mulberry tree, and he used the stiff-haired brush to shade, rub, dot, and paint the rocky mountain peaks and luxuriant trees, unifying all the elements into a rhythmic, harmonious whole. His method of depicting water was unique, too — rather than simply leaving blank spaces in the picture and sketching the contours or colors, he used a technique known as "water shading," in which he alternated parallel, horizontal brushstrokes with blank space. The lightly shaded strokes that result look like a shaded current rushing by, while the blank spaces appear to be sparkling water flowing under sunlight.

In comparison with traditional methods of drawing lines to show water ripples, Fu Baoshi's technique imparted a sense of liveliness and realism. He cleverly combined methods from watercolor and Japanese painting without obvious reference to either source. Art theorists often attribute Fu Baoshi's changing method to the influence of such Japanese painters as Hashimoto Kansetsu, Takeuchi Seihō, and Yokoyama Taikan (1868–1958). Under their influence, Fu gradually abandoned hook strokes in favor of inksplash to create texture and shading and to make other objects stand out.

Fu Baoshi's landscape style continued to change in the 1950s and 1960s, especially after he visited Romania and Czechoslovakia in 1957. In 1960 and 1963, he wandered along the Yellow River and climbed the Taihua Mountains, making sketches from life. But Fu's painting declined after his return from Eastern Europe, losing some of its past grandeur and imposing spirit. His brushwork acquired a heaviness and profundity that was less appealing. Representative paintings of this period are *Wild Geese*

perspective must be unified throughout the picture space. Generally, the lower part of the picture represents objects that are close by, whereas the upper part depicts scenery that is farther away. The heart of the painting lies at the center; that space, if relatively full, will create a magnificent effect. In a vertical scroll, a scene that is nearby should be rendered by an overlooking viewpoint to show its relation to objects farther away. To depict a mountain, for instance, one

Descending to a Sandbar (1955), *Land Like This Is So Charming* (with Guan Shanyue, 1959), *Xiling Gorge* (1960), and *Let's Paint the Mountains and Rivers in Detail* (1961).

In figure painting, which he began in Tokyo, Fu Baoshi also developed a unique style. In this, he was guided by two central motives: to study the "lines" of traditional Chinese painting and to satisfy his need to create figures in landscape. A further impulse toward figure painting grew out of his admiration for ancient costume and his respect for Chinese culture and literati giants. He painted many historical figures, including Qu Yuan, the Seven Scholars of the Wei and Jin dynasties, Xie An, Wang Xizhi, Hui Yuan, Tao Yuanming, Huan Xuan, Lu Jingxiu, Li Bai, Du Fu, Bai Juyi, Su Shi, Huang Tingjian, Gong Xian, and Shitao — poets, Wei and Jin literati, later scholars who upheld the Wei-Jin demeanor, and late Ming and Qing artists. Himself a gifted scholar, bold and unconstrained, holding lofty sentiments, Fu Baoshi was an artist in the mold of Li Bai, loyally advocating the Wei-Jin demeanor. He maintained that a painter should devote time to studying historical figures so that he would come to understand them and learn their images by heart. Once he had accomplished this, their images would flow through the brush onto the painted surface. Fu's prime motivation, then, was genuine respect for these ancient artists and scholars; a second desire was to use figure painting to impart political and social advice.

In his portrait of the hero *Qu Yuan* (1942), for example, Fu Baoshi sought to portray the pent-up fury and melancholy of Qu Yuan as he stood by the side of a turbulent river and lamented the fate of his homeland. Fu's painting was prompted by an incident in Chongqing during the War of Resistance Against Japanese Aggression. The renowned poet Guo Moruo had written a five-act play entitled *Qu Yuan,* in which he expressed his firm support for the war and his opposition to capitulation by praising the ancient patriot and exposing the crimes of the traitors. When *Qu Yuan* was performed, it set off so much controversy that the Chongqing authorities banned the play. Guo and the performers protested strongly, and Fu Baoshi painted *Qu Yuan.*

Playing the Ruan (fig. 312), painted in 1945, shows Fu's skills in painting beautiful women. In traditional painting since the Ming and Qing dynasties, beautiful women were conventionally depicted with drooping shoulders and eyebrows shaped like willow leaves; they appeared delicate and graceful, yet fragile and weak. Modern paintings of beautiful women were beginning to incorporate Western techniques of realism to express women's alluring qualities. Fu's women, however, differed from both types. He took as his reference the women painted by the late fourth-century painter Gu Kaizhi, as shown in Gu's *Admonitions of the Court Instructress to Palace Ladies* (see figs. 39–41); women represented in Tang-dynasty paintings and pottery; and the women painted by the Ming artist Chen Hongshou. Gu Kaizhi presented his women with chubby cheeks and slender figures in long, sweeping skirts. To portray the head, he often used a three-quarter or rear view — he seldom depicted faces from the front. His most distinctive characteristic was his way of drawing women's eyes: painting the upper eyelids and eyeballs first with light ink and then gradually layering the eyes with darker ink. Sometimes he repeated this process more than ten times. He occasionally painted the pupils with a small, brittle, spreading brush, creating an effect of depth and interiority. Gu Kaizhi's women were noble, serene, and free of worldly cares. In making lines, he alternated dark with light, yet without breaks or abrupt turns, in harmony with the women's quiet expressions, like the continuous flow of silk from a silkworm. In Fu Baoshi's *Playing the Ruan,* one woman plays the *ruan,* an ancient stringed instrument, as two others watch in silence. The woman whose back is to the viewer but who glances backward resembles the woman sitting before her dressing table in Gu's *Admonitions of the Court Instructress to Palace Ladies.*

Fu loved his wine and in later years could not paint without drinking. As he wrote to a friend just two months before he died in 1965: "During the War of Resistance Against Japanese Aggression, because of all sorts of unhappiness, I began to seek consolation in drinking. . . . I had to drink whenever I was busy, excited, or nervous, and especially when I held a brush in my hand. Only when I had a glass in my left hand could my right hand direct the brush to the paper." In spite of his fame, he was plagued by a series of heart-rending events, among them the persecution of his son, Xiao Shi, who was labeled a Rightist, and a serious illness that struck his daughter. In addition, Fu had to be constantly alert for possible political assaults. Increasingly frustrated, he turned to drink, and although his painting was stimulated, his mind gradually became insensible to the world. In the end, the alcohol took its toll; Fu Baoshi was just sixty when he died.

Li Keran, Shi Lu, and the School of Painting from Life

To promote painting from life and to overcome the tendency to copy ancient paintings have been goals for some twentieth-century Chinese artists. Few of these artists, however, have been able to practice this style of

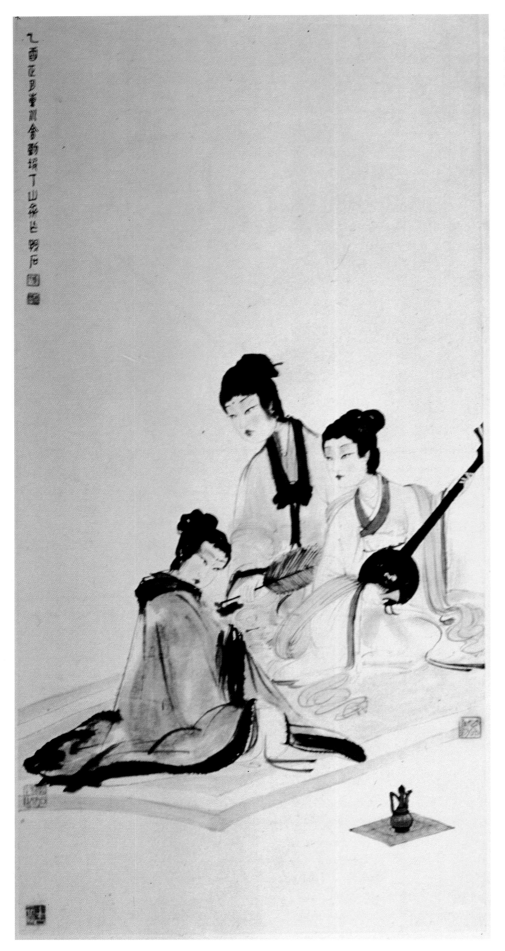

312. Fu Baoshi, *Playing the Ruan,* hanging scroll, ink and color on paper, 1945. 98.2 × 47.8 cm. Nanjing Fu Baoshi Memorial Museum.

painting with success. After the founding of the People's Republic of China, the Ministry of Culture adopted the "reform of traditional Chinese painting" as a cultural policy. Yet nobody knew how to achieve this objective. In the early 1950s, the Central Academy of Fine Arts had no department of traditional Chinese painting and offered only one course on drawing the human form; it offered basic training in line drawing for the creation of New Year's pictures and picture books. Li Kuchan, a professor renowned for his freehand bird-and-flower painting, was assigned to the reference library because there was nothing else for him to do. When a traditional Chinese painting department finally was established in 1954, there were only a few students, and they came not of their own free will but on assignment.

What the cultural administration demanded of artists was "revolutionary realism," "expressions of the new times," and "answering the call to go into the thick of life," "to depict heroic images of workers, peasants, and soldiers," and "to paint the grandeur and beauty of the motherland." Painters who had been trained in earlier times were used to painting landscapes, birds and flowers, and human figures in ancient costume, and they found it hard to adapt to these new tasks. Young painters, by contrast, generally selected oil painting, gouache, or watercolor for their major studies, because those who studied traditional Chinese painting had no prospects. As a result, the older painters were restrained by years of following the set patterns of their predecessors, whereas the young artists lacked training in the fundamentals of traditional painting. Not until the late 1950s and the early 1960s did influential painters emerge as practitioners of revolutionary realism. Of these artists, Li Keran and Shi Lu were the most successful.

Li Keran (1907–1989) was a native of Xuzhou, Jiangsu Province. His father was a cook and part-owner of a restaurant, and his mother was a housewife. Both were illiterate. As a child, Li Keran became interested in traditional opera and regional music. He began to learn landscape painting when he was thirteen from a local painter named Qian Shizhi (1880–1922), who in turn had patterned his painting style after the early Qing-dynasty artist Wang Shimin, the oldest of six Orthodox landscape masters. At sixteen, Li entered the Shanghai Art College, studying crafts and painting. By graduation, he had become the best student in imitating the refined landscape of the Wang Hui tradition. He returned to Xuzhou to teach in a local art school. By 1929, he was studying sketching and oil painting in the postgraduate class of the Hangzhou National Art College under the French teacher André Claoudit (1892–1982). He joined a leftist art organization, the Yiba Art Society, and was forced to leave school and return to Xuzhou. After the outbreak of the War of Resistance Against Japanese Aggression, he joined the art section of the political department of the Military Commission of the National Government, painting propagandistic works while traveling through such provinces as Hubei, Hunan, Guangxi, and Sichuan. In 1943, as a lecturer at the Beijing National Art College, he devoted himself to teaching and studying traditional Chinese painting. His figure paintings in freehand brushwork were highly regarded by Guo Moruo, Xu Beihong, Shu Qingchun (Lao She), and Chen Zhifo, among others. At the request of Xu Beihong, he joined the faculty of the Beijing National Art College in 1946, where Qi Baishi and Huang Binhong became his mentors. After the founding of the People's Republic of China, the Beijing National Art College merged with the Central Academy of Fine Arts, and Li continued as the professor in charge of teaching landscape painting. In 1979, he was elected vice chairman of the Chinese Artists' Association, and two years later he became president of the Research Institute of Traditional Chinese Painting.

Before he was forty, Li Keran studied both traditional Chinese and Western painting, acquiring solid training in sketching and modeling. In learning Chinese painting, he began with the Four Wangs and before the 1940s mainly followed Shitao and Bada Shanren, specializing in freehand human figures, inksplash landscapes, and images of water buffalo. He painted his freehand figures — beautiful women, literati, and fishermen — in the traditional methods of delineation by line drawing and the changing of forms by exaggeration, clumsy and humorous but not ugly. He often used mellow, steady, rapidly executed strokes to depict the folds and creases of clothes and employed watery ink-and-splash to render the backdrop for the human figures.

Noon Nap (fig. 313) was painted in 1948. In the painting, an old man with a bald head naps under a grape-covered trellis. His leisurely and relaxed bearing was probably a reflection of the relaxed and leisurely way of life that Li Keran associated with his rural background. Shu Qingchun once wrote that all Li Keran's characters come alive. No matter what expression their eyes had, their innermost feelings were shown on their faces. In his human figures, Li was expressing his own warmhearted, straightforward, and humorous nature.

Water buffalo have played an important role in China for thousands of years and have been a favorite subject in traditional painting since at least the Eastern Han dy-

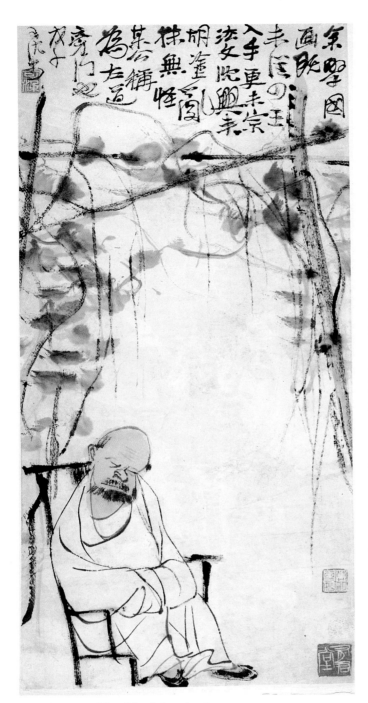

313. Li Keran, *Noon Nap,* ink and color on paper, 1948.
71 × 35 cm. Private collection.

ing the chirping of a cricket, one is reminded of the whispering autumn wind." It is fall, a time when one sighs for days gone by. The picture shows a clear, bright autumn sky. The two boys are executed in fine brushstrokes with a light tinted wash, whereas the old water buffalo is painted with splashed ink. The simplicity and light delineation of the young cowherds make a strong contrast with the thick splashed ink, while the rope shows the intimate link between the animal and its keepers. Qi Baishi's inscription and Li's painting form a flawless whole — a harmony of lines and planes in black and white. And the conjoining of poem and painting produces an interesting artistic combination. Through Xu Beihong's introduction, Li Keran took Qi Baishi as his teacher in 1947. Although *Herding Buffalo* is undated, it was definitely created after Qi accepted Li as his student. Li cherished and revered his teacher, while for his part, Qi was fond of his student and his paintings. The two had similar temperaments, and both loved the simple, honest life of the rural peasant. Qi's *Willow and Buffalo,* for instance, can be compared with Li's *Herding Buffalo.* Soon after Li took Qi as his teacher, he took Huang Binhong as his tutor for landscape painting and art theory. Under these two masters, Li greatly improved his understanding and mastery of the significance and brushwork of traditional Chinese painting.

After the founding of the People's Republic of China, Li Keran answered the government's call to carry out the "reform of traditional Chinese painting" and "to find a way to sketch from life." From 1954 to the late 1960s, he sketched landscapes from life. His footsteps took him to a number of provinces in the southeast and southwest. He even traveled to Eastern Europe, where he painted many landscapes. He strove to create new techniques by grasping the special features of his subjects, and he filled his landscapes with his own distinctive layers of shading and thickness of black ink.

Meissen Cathedral (fig. 315) was painted on the spot, without prior sketches, during Li's trip to East Germany in 1957. The use of blank space and the structural composition are skillfully done. Watching the artist at work, a German observed that it was almost unimaginable that Li could render the Gothic cathedral in so lively a manner with only one small, soft brush. With his solid sketching abilities and adept brushwork, Li Keran mastered the precise delineation of buildings through various uses of straight lines and differing intensities of ink. In this way he expressed the tallness, straightness, and mysterious qualities of the cathedral. The vividness of the composition results from the tremendous difference in size be-

nasty. In his depiction of this popular subject, however, Li Keran both used an innovative technique and gave the water buffalo new significance. *Herding Buffalo* (fig. 314) dates from the late 1940s. It features two young cowherds absorbed in watching crickets fight; they have tethered an old water buffalo to a small stake. On the painting, master painter Qi Baishi inscribed the lines "Suddenly hear-

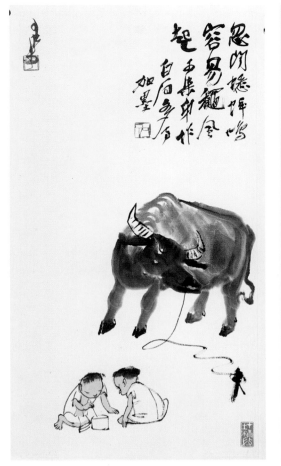

314. Li Keran, *Herding Buffalo,* hanging scroll, ink and light color on paper, 1947. 67 × 34 cm. Private collection.

315. Li Keran, *Meissen Cathedral,* ink and color on paper, 1957. 49 × 36 cm. Private collection.

tween the massive building and the small human figures, as well as the blending of abstract and concrete formed by the juxtaposition of clear line drawing with blurred inksplash. When painting landscapes, Li insisted on facing his subject directly. His goals in sketching from life were first "to get richness, richness, and richness" and then to achieve "simplicity, simplicity, and simplicity." "To get richness" meant to avoid the simple emptiness of traditional Chinese landscape painting; by "simplicity," he meant the attainment of unity and wholeness in a composition.

Li Keran had a special love for the mountains and rivers of the south. The beautiful scenery of Sichuan,

Guilin, and Mount Huang forged the distinctive features of his landscapes: the luxuriant grass, lush foliage, and smoky, moist atmosphere. Landscapes of Guilin, a region whose scenery was commonly described as "the best under heaven," became Li Keran's favorite subject in later years. *Light Rain over the Li River* (fig. 316) is typical of these late compositions. A rainy day on the Li River is rendered in light ink and pale tints: over the mirrorlike water, the clouds drizzle mist and smoke; distant mountains fade away in pale green, and dark trees clump together in the foreground. Silence reigns over the scene save for the bustle of small fishing boats in the mist. The white houses amid the trees are painted with multiple

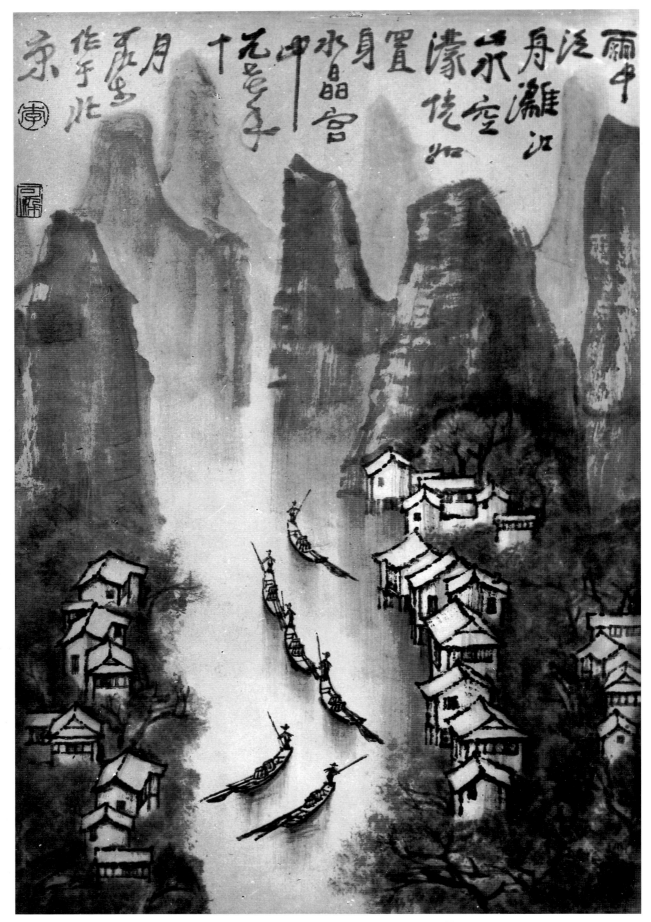

316. Li Keran, *Light Rain over the Li River,* ink on paper, 1977. 71 × 48 cm. Private collection.

layers of ink. This technique requires great skill; too many layers of ink can deaden the results. Li adopted Huang Binhong's layered-ink technique, but with a difference. Huang used very little water; his largely gray paintings impart a sensation of dryness and merely hint at moisture. Because Li used more water, his paintings appear much more moist, although even in Li's art, a faint sense of dryness is present. Each artist had his own emphasis and style.

During this same period, some painters in Xi'an were also advocating the reform of traditional landscape painting by sketching from life and exploring new styles. Because they lived in Xi'an, they were known as the Chang'an School. The most eminent artists of this group were Zhao Wangyun and Shi Lu. Zhao Wangyun (1906–1977), a native of Shulu, Hebei Province, was born into a peasant family that was also in the leather business. Zhao attended Beijing National Art College and from 1932 to 1936 traveled to rural areas in southern Hebei and north of the Great Wall to paint as a reporter for the daily paper *Da gong bao* (Impartial daily). His depictions of the miseries of the peasants were well received both in cultural circles and by the government. During the War of Resistance Against Japanese Aggression, aside from editing the *Anti-Japanese War Pictorial,* Zhao traveled to rural Shaanxi, Gansu, and Xinjiang to paint from life. He gained a reputation as the first pioneer in painting life in the countryside and border regions. After the People's Republic of China was founded in 1949, he became the first leader of the Shaanxi Artists' Association. Yet in 1957, he was persecuted as a Rightist, and he suffered even more during the Cultural Revolution.

Zhao Wangyun's early works were mainly sketches done with a writing brush. Because he lacked formal training in either Western or traditional Chinese painting, these early sketches are not successful from a technical standpoint. Yet these sketches of peasants and rural life have a harmony and a simple and sincere style that many highly skilled artists could not attain. Zhao's later works tend to be more strict in composition and more forceful in expression through brushwork, but they maintain the same sincere style. In the 1960s, Zhao led other artists in taking northwest scenery as the basis for sketches from life, thus creating the Chang'an School.

Zhao Wangyun painted *Penetrating the Qilian Mountains* (fig. 317) in 1972. The Qilian Mountains are a great mountain chain in northwest China. Here the mountains span the composition, majestic and precipitous, with ancient pines and powerful waterfalls high on the slopes and streams, a small bridge, and winding paths down below.

On the slopes, people in modern dress ride on horseback; they seem to be searching for something. Zhao used largely traditional techniques in this painting: rocks in the foreground are delineated mostly through textural shading and ax-cut brushstrokes with minimal color. The light coloring highlights the hardness of the rocks and the intensity of the sunshine. The composition displays the power that can be achieved through the special descriptive quality of sketching from life.

The best known of Zhao Wangyun's students is Huang Zhou (b. 1925), originally named Liang Huangzhou. Huang is a native of Lixian County, Hebei Province. Continuing Zhao Wangyun's emphasis on sketching and painting from life, he has created a number of works depicting the life of the Uygur and other minority nationalities in the Xinjiang region. Other favorite subjects have been human figures, animals, particularly donkeys, and birds and flowers. Huang Zhou introduced the sketching technique used in line drawing into the art of figure painting, and his modern figures became influential in the 1950s and 1960s.

Shi Lu (1919–1982), formerly named Feng Yayan, came from Renshou County, Sichuan Province. Although he studied traditional monochrome ink painting, during the War of Resistance Against Japanese Aggression he traveled to Yan'an to create propaganda for the war and the revolution that followed. In these years, he also made many woodcuts and New Year's pictures. He resumed traditional Chinese painting in the 1960s.

Shi Lu was skilled at depicting figures, landscapes, and birds and flowers. He was the first artist to use the monochrome ink-and-wash technique to paint scenes of the vast and imposing plateau of the Yellow River, in one devotedly portraying Mao Zedong as a commander at war. Favorite subjects were the fault planes and caves of the Yellow River plateau, soldiers, and peasants. His painting *On the Way to Nanniwan* (fig. 318) is a landscape of historical significance. During the War of Resistance Against Japanese Aggression, the base areas of northern Shaanxi were blockaded by enemies, cutting the troops off from needed supplies. The 115th Division of the Eighth Route Army was therefore ordered to reclaim wasteland for planting crops in order to tide the troops over during this time of economic hardship. This painting shows soldiers marching to the wilderness in Nanniwan. Unlike a traditional Chinese landscape, there are no pine woods, waterfalls, small bridges, thatched pavilions, or hermits with long staffs. Likewise, there are no mists, smoky clouds, or stone steps — no evocations of serenity or depictions of

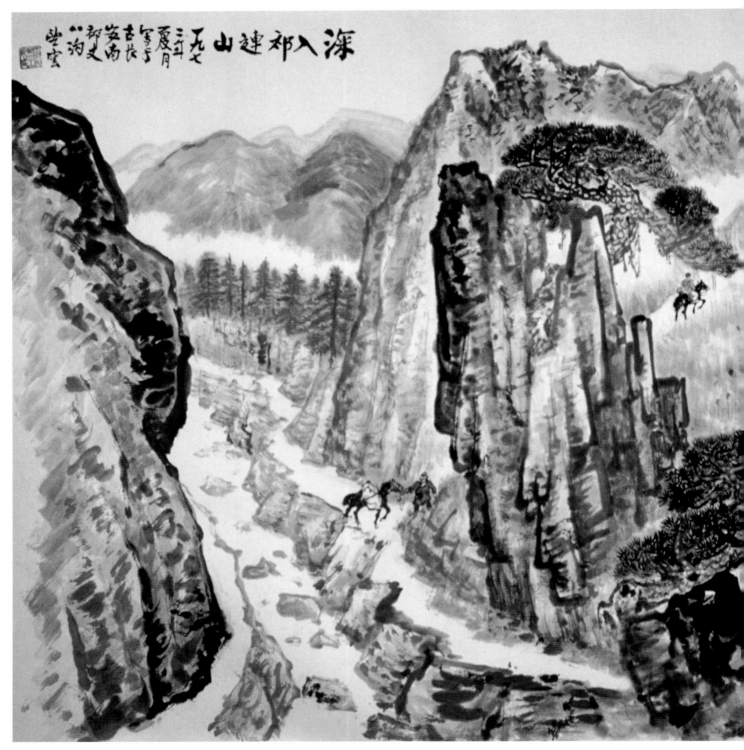

317. Zhao Wangyun, *Penetrating the Qilian Mountains,* handscroll, ink and color on paper, 1972. 83 × 150 cm. Private collection.

beauty. Instead, the painting realistically depicts rough, desolate mountains and many kinds of trees.

If Zhao Wangyun was the founder of the Chang'an School, then Shi Lu was its leader. After 1957, he was elected chairman of the Shaanxi Artists' Association, the nucleus of the Xi'an painters. In the early 1960s, Shi Lu and the Xi'an painters won wide acclaim in art circles and were recognized as "'blazing' the trail for landscape painting." During the Cultural Revolution, however, Shi Lu was cruelly persecuted because of his opposition to the Gang of Four. His works were not only labeled as "black paintings that abuse the revolutionary leader" but were condemned as "actively counterrevolutionary." He was sentenced to death. This artist, who had consistently

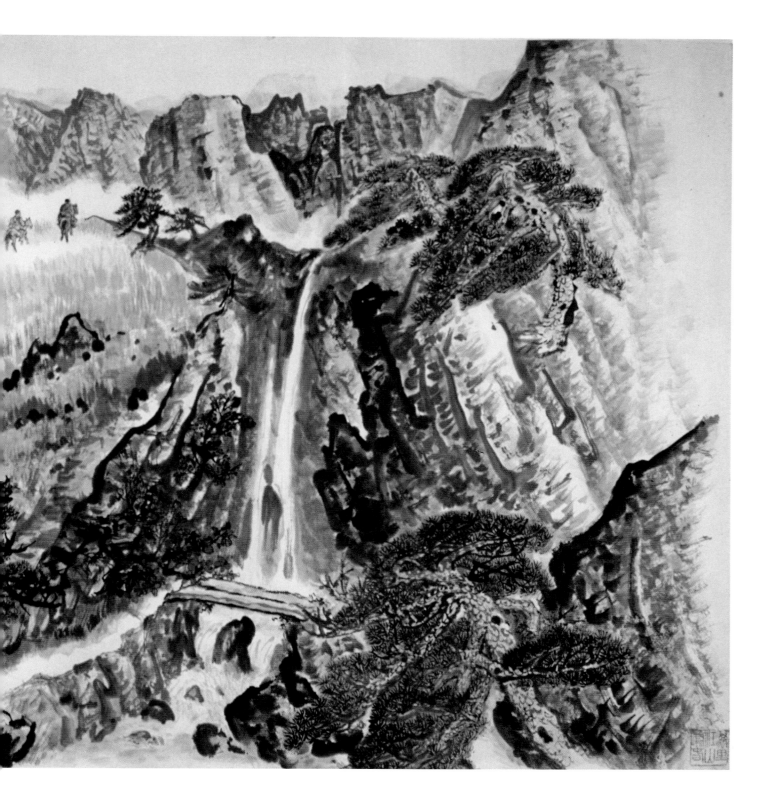

sung the praises of Mao Zedong and the Chinese revolution, was transformed overnight into "an enemy of the revolution." Criticized and denounced in mass meetings, ruthlessly tortured, for a time Shi Lu was driven mad. He managed to escape from custody, and he wandered the Qinling Mountains, tattered and dirty, keeping himself alive with wild fruits and raw vegetables. Yet even under these dire conditions, he continued to sketch on a small pad he had brought with him. After he was allowed to return to Xi'an, frail though he was, for a long time he sustained himself on wine and chilis, using his painting to express his feelings and emotions. Whenever paper and

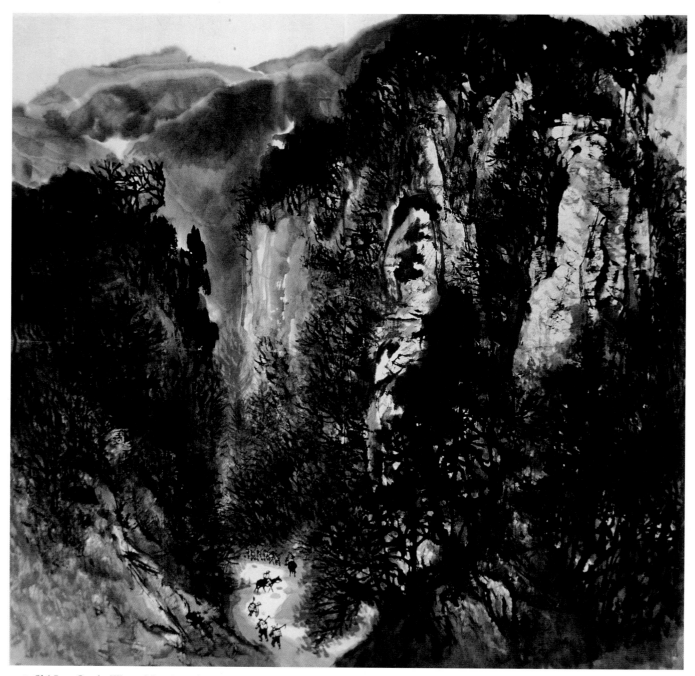

318. Shi Lu, *On the Way to Nanniwan,* hanging scroll, ink and color on paper, 1960. China Fine Art Gallery, Beijing.

brush were available, he painted and did calligraphy. Yet in the works created in this period, there is no more devoted praise and there is no imposing loess plateau. Instead Shi Lu painted the Hua Mountains, plum blossoms, orchids, bamboo, chrysanthemums, lotus blossoms, and rocks. All the mountains shoot upward to the sky; the brushstrokes are pointed, sharp, and chaotic, the inks thick and dull. These paintings often carry such inscriptions as "high sky with cold moonlight" and "great wind

sweeping the cosmos," suggesting an unyielding attitude and character.

This pioneering artist, who had long advocated the reform of traditional Chinese painting, now took up literati painting as a tool to express his feelings and opinions. He executed these works largely in sharp, chaotic, cold, and discontinued brushstrokes that are either as sharp as knife cuts or as entangling as wires. They evoke a strange, surprising, and even crazed sense of excitement and dis-

quiet. In painting the Four Gentlemen (plum, orchid, bamboo, and chrysanthemum, symbols of moral integrity), Shi Lu metaphorically expressed his state of mind. He inscribed a lotus painting with the lines "Though blooming in spring and summer / They would be given away any time." With these words Shi Lu directed his sarcasm to those who would sell their souls for profit. *Plum Blossoms* (fig. 319) depicts a branch of plum blooming in the snow with the inscription "Jade dragon, white snow under the bright blue sky." In traditional art theory, the branch, crooked like a dragon, is called a dancing dragon. Because this plum branch is dressed white with snow, Shi Lu called it the "jade dragon." The hidden meaning of this line is actually Shi Lu's belief that he had a clean personal record. The whole picture — the plum branch, the blossoms, the bright sky — form a sheet of snow-white purity. Suffering from persecution during the Cultural Revolution, Shi Lu had no other way to plead his innocence.

The New Period

With the end of the Cultural Revolution in 1976, China began to carry out a policy of reform and opening to the outside world. In this period, some veteran painters who had matured over the years came to the fore, while some young artists and painters in their middle years began to change old ways of thinking and to ponder again such questions as tradition and modernism, East and West. By the mid-1980s, a group of young artists had initiated a modern art campaign of considerable magnitude.

Some painters distinguished themselves rather late in their career and were often referred to as "great vessels that took years to produce." Wu Changshuo, Qi Baishi, and Huang Binhong were not famous until they were seventy years old, and this was largely true of Zhu Qizhan, Li Kuchan, and Lu Yanshao (b. 1909), a master of traditional landscape painting modes. In *Zhushachong Sentry Post* (fig. 320), Lu Yanshao portrays an area along the Guangdong-Guangxi border in a monumental manner, with tiny figures at the sentry post in the middle of the composition nearly eclipsed by the steep, rocky mountains and mist-filled atmosphere of inkwashes.

Zhu Qizhan (1892–1995) was a native of Taicang, Jiangsu Province. After a brief stay in Japan in 1917, he returned to China to teach in the Shanghai Art College, Shanghai Xinhua Art College, and Shanghai Studio of Painting. His early interests lay chiefly in Western oil

painting, and he patterned his style after such French masters as Cézanne and Matisse. When he was about fifty, Zhu added ink painting to his repertoire, but he really concentrated on Chinese painting only in his later years. Among his favorite Chinese master painters were Shitao, Wu Changshuo, and Qi Baishi, and he was especially interested in Qi's seal carving. By 1944, he had collected more than sixty seals carved by Qi; he called himself "the sixty-year-old millionaire in collecting seals engraved by Qi Baishi" and later published *The Plum Blossom Thatched Hall's Collection of Baishi's Seals*. Zhu's spirit and character are well summarized in the words of Qi Baishi in seals that Qi gave Zhu as presents: "Remained unperturbed," "Take bamboo as teacher and plum as friend," "The house is a small boat," and "The heart roams the wilderness." All these describe how Zhu, though living amid the bustle of the marketplace, in spirit was following the clouds and cranes to roam among great mountains and along turbulent rivers, how he had little care for fame and money, and how he became a great artist after long years of hard work.

Zhu Qizhan was a skilled artist in both Chinese and Western styles of painting. In his lengthy art career, he painted oils as well as inks, and although he never consciously merged the two media, they do merge in the paintings themselves. The oils have the flavor of ink painting, whereas an oil style is visible in his ink compositions. His later works, whether in oil or in ink, whether landscape, flower, or figure painting, are done in a bold and flowing style, mature and yet childishly clumsy, reflecting the presence of his strong personality. *Orchid in the Fragrant Wind* (fig. 321) reflects these qualities of boldness and tenacity. The orchid, rendered in fluid brushstrokes with only a hint of color in the tawny blossoms, clings to the monumental overhanging boulder. A large gray rock slab below likewise reflects a virtuoso performance of ink design from a deeply spirited, gifted artist.

Zhu generally preferred blunt, thick brushes to smooth, sharp-tipped ones. His hard brushstrokes were often drawn with a blunt, dry-inked brush so that they contain white streaks; they seldom have overt beginnings and ends, pauses and accentuations. In delineating forms, Zhu preferred clumsiness to ingenuity and heaviness to lightness. His paintings have a rough and unsophisticated appearance. Gorgeous reds, yellows, blues, and greens impart a formidable strength to his work.

Li Kuchan (1898–1983) was descended from a long line of farmers in Gaotang County, Shandong Province. In the early 1920s, he moved to Beijing to learn Chinese and Western painting, studying first at the Painting

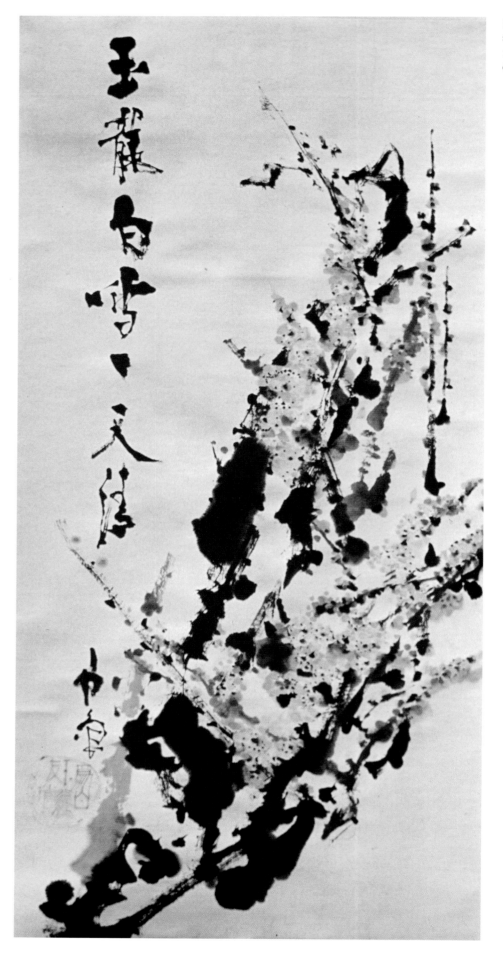

319. Shi Lu, *Plum Blossoms,* hanging scroll, ink and color on paper. 105 × 40.7 cm. China Fine Art Gallery, Beijing.

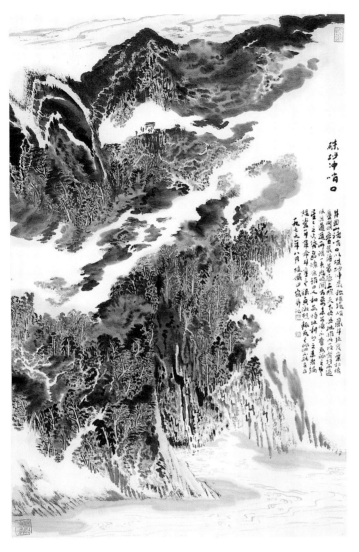

Technique Society affiliated with Beijing University and then at Beijing National Art College. He was poor and had to support himself by pulling a ricksha to pay his tuition. Though he sometimes could afford only one meal a day, his zeal for painting remained strong. In later years, he studied under Qi Baishi, concentrating on freehand bird-and-flower painting. His favorite subjects—birds of prey, lotus flowers, pines, and rocks—were characterized by magnificent, powerful, and steady brushstrokes. Li gained great fame in his old age.

Eagle (fig. 322), painted in the autumn of 1979, depicts a male eagle perched on a rock and ready to soar into the sky. The feathers are executed with ink-and-wash coupled with a few drawn lines, while the beak, claws, and eyes are drawn with double lines. The delineation of forms and direction of brushstrokes take a squarish shape, showing the ferocity and strength of this bird of prey. When painting eagles, Li's teacher Qi Baishi stressed brushwork, rendering both likeness and spirit, whereas Li emphasized ink technique, demanding a mood instead of a likeness. As the artist Wang Senran said, "On viewing Li's paintings, one feels as if one is savoring an olive, rinsing one's mouth with cold spring water, climbing a snowy mountain with sword in hand, or galloping on a horse over a vast plain."

320. Lu Yanshao, *Zhushachong Sentry Post,* hanging scroll, ink and color on paper, 1979. 109 × 68 cm.

321. Zhu Qizhan, *Orchid in the Fragrant Wind,* handscroll, ink and color on paper, 1982. 96 × 178 cm. China Fine Art Gallery, Beijing.

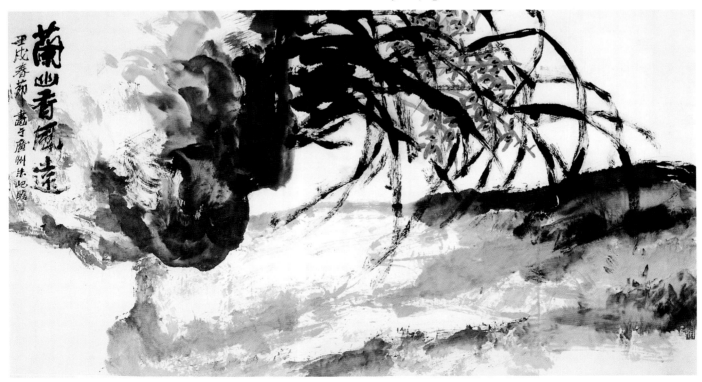

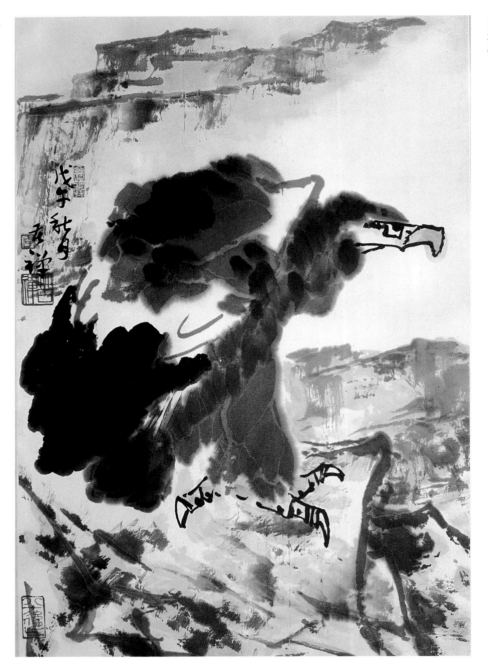

Zhang Daqian (1899–1983) was a native of Neijiang County, Sichuan Province. As a young man, he traveled with his older brother to Japan to learn dyeing and weaving. After he returned to China, he began to study traditional painting from the famous calligraphers Li Ruiqing and Zeng Xi. As he gained experience, Zhang began to copy many renowned works of earlier masters, and he distinguished himself in this style in the 1930s. In the 1940s, he took his students to the Dunhuang caves to copy the murals and study their origins. When the People's Republic of China was founded in 1949, he left for Argentina, Brazil, and the United States, finally settling outside Taibei.

Zhang became recognized as the best and most prolific imitator of ancient art. According to the artist Xie Zhiliu, "He can imitate any school of painting except the Four Wangs to such a degree that you would take the spurious for the genuine." Zhang was distinguished in many artistic fields. He wrote poetry and was skilled at painting human figures, landscapes, and bird-and-flower paintings in both meticulous and freehand styles. At about age seventy, however, he originated a large-spaced, splashed-ink, and splashed-color technique on the basis of traditional ink painting and Abstract Expressionism. Zhang's works of splashed ink and color consisted of large areas without concrete form — only sheets

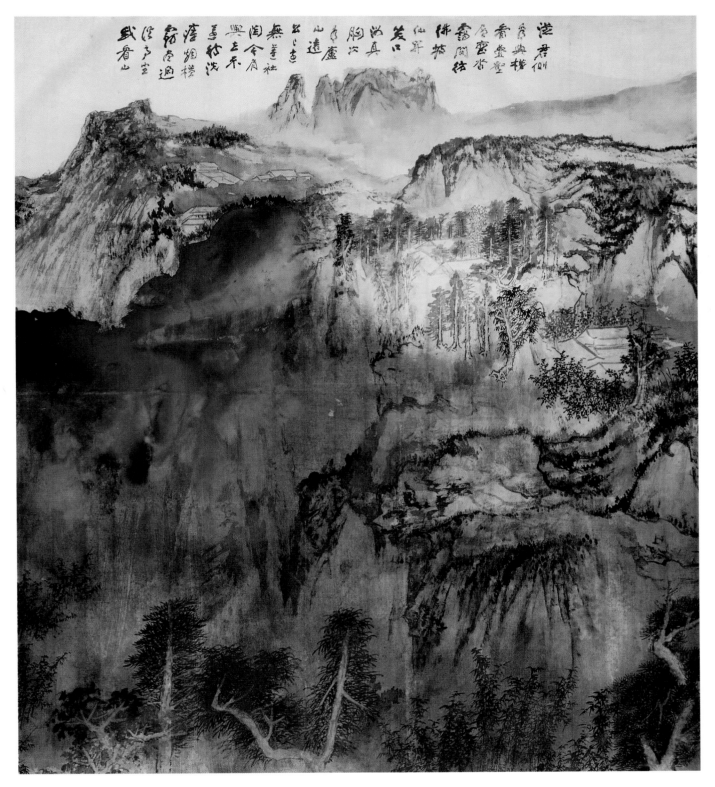

323. Zhang Daqian, *Panorama of Mount Lu*. National Palace Museum, Taibei.

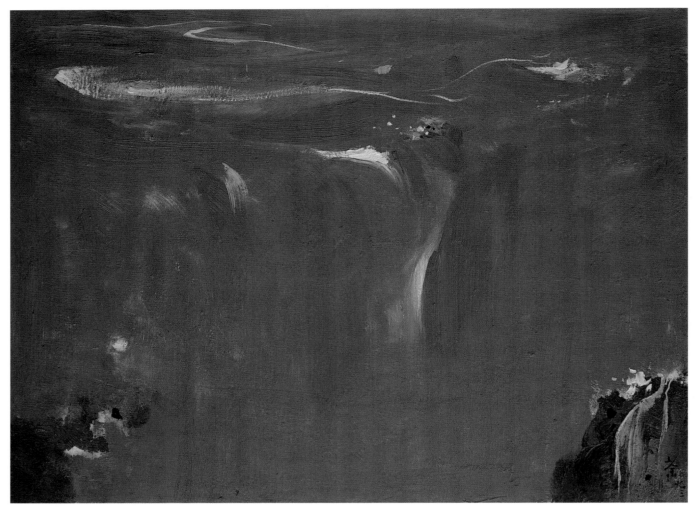

324. Wu Guanzhong, *The Yellow River,* 1993. 61 × 80 cm.

of color. Because some line-drawn objects did remain, however, the abstractness was transformed into concreteness. In the viewer's eye, the splashed color could take the shape of green woods, rocks, or clouds. This was a breakthrough in traditional Chinese painting. It also changed Zhang Daqian's image: the skilled imitator of ancient paintings was now seen as someone who created a modern style of Chinese painting.

Panorama of Mount Lu (fig. 323) was Zhang Daqian's final masterpiece. He had traveled to many places and had seen many famous mountains and great rivers, but he had never seen Mount Lu. Having left mainland China for Taibei after the revolution, Zhang could not return to the homeland he sorely missed. This painting was a crystallization of his nostalgia for his majestic and beautiful native land. But it was not a concrete description of Mount Lu: in this vast composition, he used a variety of brush techniques, various shadings and textures, dotting and dyeing, and splashed ink and splashed color. This

produced a unique effect that embodied the best of his many styles.

Wu Guanzhong (b. 1919), a native of Yixing County, Zhejiang Province, graduated from the Beijing National Art College in 1942. After World War II ended, he went to France, where he studied modern art from 1946 to 1950, and when he returned to China, he began to teach at the Central Academy of Fine Arts, Qinghua University, Beijing National Art College, and the Central Academy of Arts and Crafts. But from the 1950s through the 1970s, because of the prevailing cultural climate, he had no opportunity to express his modern views and ideas about art. Since the end of the Cultural Revolution, Wu has taken the lead in advocating such potentially controversial concepts as "form decides content" and "abstract beauty," which have shocked the Chinese art establishment. Before the 1970s, Wu painted only in oils, but in recent decades he has done ink painting, landscapes, and occasional compositions of flowers and animals. As a

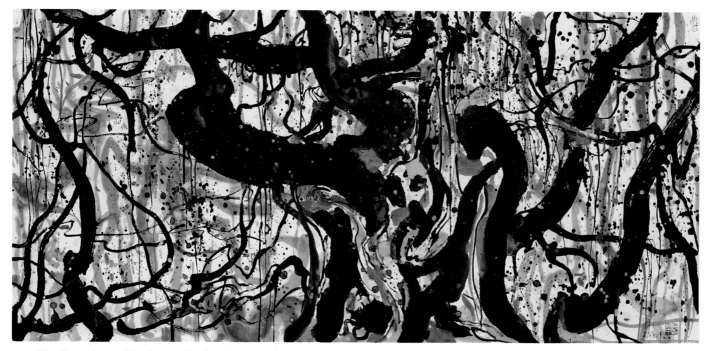

325. Wu Guanzhong, *The Banyan Tree,* handscroll, ink and color on paper, 1992. 68.5 × 138 cm.

student of Lin Fengmian, he has followed Lin in trying to integrate modern Western art into Chinese art. His oils are unique, refined in brushstroke, pure and unified in color, and rich in their expression of emotion.

The Yellow River (fig. 324), painted in 1993, is a depiction of the waterfalls of the Yellow River. In this picture, Wu Guanzhong has not followed convention in depicting the roaring waves and billows of the falls but has stressed and exaggerated the river's yellow color. The yellow looks like earth and yet resembles brocade. Were it not for the glittering spray executed with a few dashing strokes and the two rocks that face each other at the lower corner, one would hardly imagine that this was the river described by the artist-poet as the surging and roaring Yellow River with "its water descending from heaven." Through his water-and-ink techniques, as evidenced in *The Yellow River,* Wu sought profundity in serenity and purity in subtlety.

Most of Wu Guanzhong's landscape paintings are of intimate views south of the Yangzi River. White walls with black tiles, green willows, red flowers — these scenes evoke images familiar from lines of poetry, such as "during autumn harvests, the air was heavy with the aroma of osmanthus, while lotus flowers bloomed over a stretch of five kilometers," or "fish market in a village by the waterside." In *The Banyan Tree* (fig. 325), painted in 1992, Wu depicts a large tropical tree common to the landscape of south China. In addition to its great size, the

banyan is known for its twisted roots and gnarled branches luxuriant with foliage; it is a favorite subject for painting. Yet under Wu Guanzhong's brush, the branches of the banyan become an almost abstract structure. Though the general shape of the tree is recognizable, one cannot tell from the image alone what kind of tree this is. The dancing crisscross of thick and thin lines, the abstract and concrete reflections painted in light and heavy inks, and the sprinkling of bright red, green, yellow, and purple dots of color create a rhythm and rhyme scheme flavored by poetry. This is what Wu has called "abstract beauty" — the beauty of form. Although he has used traditional Chinese materials and tools, his concept, technique, and composition are thoroughly modern.

Wu has also cast off the tradition of introducing calligraphy into painting. He has maintained that painting is done by painting, not by writing. He has emphasized the association between the finished work of art and tastes of the contemporary audience, explaining that "a kite should not be cut off from the string." With such thoughts in mind, Wu has striven to make his works of art appeal to and be understood by not only other Chinese but foreigners, who often find Chinese brush-and-ink paintings difficult to understand. For these reasons, Wu Guanzhong's art has received both praise and criticism in contemporary art circles in China.

The fusion of traditional Chinese and modern Western ideas has indeed become one of the central features

of contemporary Chinese painting. Western art continues to influence and inspire Chinese painters, who respond by culling from Western art that which is deemed "best" in terms of themes, styles, and techniques without completely surrendering to its impact. In works that dramatically convey feelings, memories, and current and past events, modern Chinese painters seek to resolve the tensions between East and West, native and foreign, in expressive works of great creativity, originality, and freedom, thereby contributing to a new chapter in the history of Chinese painting.

At the heart of this movement, however, is the ancient, rich, and varied Chinese artistic tradition. Modern Chinese painters are strongly reasserting their traditional cultural and artistic values, reinvigorating and reinventing the past in dramatic and individualistic ways. Bringing new life to ancient practices, they paint distilled, reinterpreted, and freely expressive landscapes that distantly echo the regional, specialized, and literati manners; bird-and-flower compositions that recall professional artisans and local craftsmen; and figure paintings and portraits that are promising visions for a new Chinese style.

Essential to this new, exuberant painting tradition are the familiar, longstanding reliance on past painting traditions, the repertoire of time-honored styles and techniques, and familiarity with old masterpieces. Major contributions still come from popular regional traditions and local professional specialists. In addition, many Chinese painters outside China have begun to express themselves artistically, adding to a new vocabulary of Chinese painting styles and motifs. Now, in an international context, China reemerges as one of the world's greatest cultures by virtue of a new, promising tradition of modern painting that is contemporary in feeling and global in appeal, but still deeply, distinctly, and traditionally Chinese.

Approaches to Chinese Painting, Part I

1 Zhang Yanyuan, *Lidai minghua ji* (Record of famous paintings of successive dynasties) (Shanghai: Shanghai renmin chubanshe, 1963), entry on Zhang Zao.
2 Xie He, preface to *Guhua pinlu* (The ranking of ancient paintings), in *Wangshi shuhua juan* (Collection of calligraphy and paintings by Wang Shizhen).
3 Zhang, *Lidai minghua ji*.
4 Shen Kuo, *Mengxi bitan* (Mengxi jottings), vol. 17 (Beijing: Zhonghua shuju, 1963).
5 Xie, preface.
6 Sikong Tu, *Ershisi shipin* (The twenty-four aspects of poetry), in *Lidai shihua* (Essays on poetry written in successive dynasties) (Beijing: Zhonghua shuju, 1981).
7 Quoted in Ouyang Xiu, *Liuyi shihua* (An essay on poetry written at the age of sixty-one), in *Lidai shihua* (Beijing: Zhonghua shuju, 1981).
8 Xie, preface.

The Origins of Chinese Painting

1 Zhang Yanyuan, *Lidai minghua ji* (Record of famous paintings of successive dynasties) (Beijing: Renmin meishu chubanshe, 1963), 4–5. See William R. B. Acker, *Some T'ang and Pre-T'ang Texts on Chinese Painting,* 2 vols. (Leiden: E. J. Brill, 1954, 1974), vol. 1, p. 111 (hereafter cited as Acker).
2 For a detailed report on this site, see Gai Shanlin, *Yinshan yanhua* (Petroglyphs in the Yin Mountains) (Beijing: Wenwu, 1986).
3 For a general introduction to Cangyuan paintings, see Wang Ningsheng, *Yunnan Cangyuan yanhua de faxian he yanjiu* (The rock paintings of Cangyuan County, Yunnan Province: Their discovery and research) (Beijing: Wenwu, 1985).
4 Meyer Schapiro, "On Some Problems in the Semiotics of Visual Art: Field and Vehicle in Image-Signs," *Semiotica* 3 (1969): 224. The earliest mural, dating from Neolithic times, was found in Dadiwan, Gansu Province, in 1982. For an illustration, see *Zhongguo meishu quanji* (A comprehensive collection of Chinese art) (Beijing: Wenwu, 1985–), Painting, vol. 1, pl. 39 (hereafter cited as *ZMQ*).
5 Guo Baojun and Lin Shoujin, "1952 nian qiuji Luoyang fajue baogao" (A report of the excavation in Luoyang in fall 1952), *Kaogu xuebao* 9 (1955): 94, 97.
6 *Wenwu* 2 (1976); *Kaogu xuebao* 4 (1981); *Wenwu* 8 (1974); Hebei Provincial Institute of Cultural Relics, *Gaocheng Taixi Shang dai yizhi* (The Shang site at Taixi in Gaocheng) (Beijing: Wenwu, 1985).
7 *ZMQ*, Painting, vol. 1, pl. 39; Yang Jianfang, "Han yiqian de bihua zhi faxian" (The discovery of pre-Han murals), *Meishujia* 29 (1982): 43–47.
8 A surviving piece of a wall painting twenty-two centimeters long and thirteen centimeters wide was found in Anyang in 1975. The Zhou example, found in a tomb in Yangjiabao in Fufeng, Shaanxi Province, in 1979, consists of continuous diamond patterns on the four walls of the grave chamber. See Yang, "Han yiqian de bihua zhi faxian," 43.
9 The excavation report is published in *Wenwu* 9 (1988): 1–14. Published research on the painted box includes papers by Hu Yali, Chen Zhenyu, and Cui Renyi in ibid., 30–32, and in *Jianghan kaogu* 2 (1988): 72–79; 4 (1989): 54–63.
10 "Kaogong ji," in *Zhou li* (Rites of Zhou).
11 Wu Hung, "From Temple to Tomb," *Early China* 13 (1988): 78–115.
12 I reject the popular interpretation of the painting as an instrument to "summon the soul," because according to ancient ritual texts, the rite of summoning the soul takes place before funerary ceremonies, and no equipment used in this rite is buried with the deceased. See Wu Hung, "Art in Its Ritual Context: Rethinking Mawangdui," *Early China* 17 (1992): 111–144.
13 Ibid.
14 For textual evidence of Han murals, see Xing Yitian, "Han dai bihua de fazhan he bihuamu" (The development of Han-dynasty murals and painted tombs), *Zhongyang yanjiu yuan lishi yuyan yanjiusuo jikan* (Bulletin of the Institute of History and Philology, Academia Sinica), 57, no. 2 (1986): 139–160, especially 142–154.
15 Sima Qian, *Shi ji* (Historical records) (Beijing: Zhonghua shuju, 1959), 1388. See Burton Watson, *Records of the Grand Historian of China,* 2 vols. (New York: Columbia University Press, 1961), vol. 2, p. 42.
16 Paintings have been found on the walls of a second-century B.C. tomb in the city of Guangzhou that belonged to a king of Southern Yue during the Western Han. But these paintings are just decorative patterns and differ from the pictorial compositions in tombs of the first century B.C. near Luoyang. The excavation of the Bo Qianqiu tomb is reported in *Wenwu* (1977): 1–12. Discussions of the tomb murals include Chen Shaofeng and Gong Dazhong, "Luoyang Xi Han Bo Qianqiu mu bihua yishu" (The murals in the Western Han tomb of Bo Qianqiu in Luoyang), *Wenwu* 6 (1977): 13–16; Sun Zuoyun, "Luoyang Qian Han Bo Qianqiu mu bihua kaoshi" (An interpretation of the murals in Bo Qianqiu's Western Han tomb in Luoyang), *Wenwu* 6 (1977): 17–22.
17 The excavation of Tomb 61 is reported in *Kaogu xuebao* 2 (1964): 107–125. General introductions to the tomb include Jonathan Chaves, "A Han Painted Tomb at Loyang," *Artibus Asiae* 30 (1968): 5–27; Jan Fontein and Wu Tung, *Han and T'ang Murals Discovered in Tombs in the People's Republic of China and Copied by Contemporary Chinese Painters* (Boston: Museum of Fine Arts, 1976), 22.
18 Discussions of this mural include Guo Muoruo, "Luoyang Han mu bihua shitan" (A tentative interpretation of the murals in a Han tomb in Luoyang), *Kaogu xuebao* 2 (1964): 1–6; Chaves, "Han Painted Tomb at Loyang"; Li Yu, *Zhongguo meishu shigang* (An outline of Chinese art history) (Shenyang: Liaoning meishu chubanshe, 1984), vol. 1, p. 246.

19 A tomb mural from Luoyang now in the Cleveland Art Museum depicts the same subject.

20 *Xi'an Jiaotong Daxue Xi Han bihua mu* (A painted Western Han tomb in the Xi'an Transportation University) (Xi'an: Xi'an Jiaotong Daxue chubanshe, 1991).

21 Nine painted tombs belonging to this period have been found. Only a tomb in Wuwei, Gansu Province, was not located in the metropolitan center. See *ZMQ*, Painting, vol. 8, pp. 2–4. For a report on the Wuwei tomb, see *Renmin ribao* (People's daily), February 3, 1987.

22 For a detailed report on this tomb, see "Luoyang Xin Mang shiqi de bihua mu" (A painted tomb of the Xin-dynasty period in Luoyang," *Wenwu cankao ziliao* 9 (1985): 163–173.

23 Five painted tombs have been tentatively dated to the first half of the Eastern Han. Besides the Pinglu tomb, there are a tomb found in Yingchengzi, Liaoning Province, in 1931, a tomb discovered at Liangshan, Shandong Province, in 1953, and two tombs excavated in Luoyang in 1981 and 1987. See *ZMQ*, Painting, vol. 8, p. 5. But this dating is not supported by convincing evidence; some of the tombs may have been constructed in the early second century, not the first.

24 Wilma Fairbank first proposed this theory in "A Structural Key to Han Mural Art," *Harvard Journal of Asiatic Studies* 7, no. 1 (1942): 52–88.

25 Zhu Wei was a Han general who died around the middle of the first century A.D. From the style and technique of the engravings on the shrine, however, the shrine was most likely constructed during the second half of the second century. See Martin Powers, *Art and Political Expression in Early China* (New Haven: Yale University Press, 1991), 352–361.

26 More than twenty late Eastern Han painted tombs have been reported. They are located in different places in five provinces. Except for two that have one chamber, they are all large multichambered tombs. See *ZMQ*, Painting, vol. 8, p. 6. The excavation of Tomb 2 at Mixian is reported in *Wenwu* 4 (1960): 51–52; 10 (1972): 49–55. These tombs are briefly introduced in *ZMQ*, Painting, vol. 8, pp. 6–8.

27 For a detailed report on this tomb, see Hebei Provincial Institute of Cultural Relics, *Anping Dong Han bihua mu* (A Eastern Han painted tomb in Anping) (Beijing: Wenwu, 1990). On the inscription see p. 35.

28 For a detailed report on this tomb, see Museum of History, *Wangdu Han mu bihua* (Murals in a Han tomb in Wangdu) (Beijing: Zhongguo gudian yishu, 1955).

29 For a discussion of the cataloguing style in Han pictorial art, see Wu Hung, *The Wu Liang Shrine: The Ideology of Early Chinese Pictorial Art* (Stanford: Stanford University Press, 1989), 79–85.

30 For a detailed report on this tomb, see *Helingol Han mu bihua* (Wall paintings in the Helingol tomb of the Han dynasty) (Beijing: Wenwu, 1978).

31 See Wu Hung, "Beyond the Great Boundary," in John Hay, ed., *Boundaries in China* (London: Reaktion Books, 1994), 81–104.

32 See Wu Hung, "Buddhist Elements in Early Chinese Art," *Artibus Asiae* 47 (1986): 263–376.

33 The exception is a multichambered tomb discovered in Lingbao, Henan Province, in 1955; see Yu Jianhua, *Zhongguo huihua shi* (History of Chinese painting) (Beijing: Zhongguo gudian yishu, 1958), 77.

34 Eastern Han painted tombs have been found in various sites near Liaoyang. For excavation reports, see *Wenwu* 6 (1985); *Kaogu* 1 (1960); 1 (1980); *Wenwu cankao ziliao* 5 (1955); Wilma Fairbank, "Han Mural Paintings in the Pei-yuan Tomb at Liao-yang, South Manchuria," *Artibus Asiae* 17, nos. 3–4 (1954): 238–264. Reports of the stone tombs are in *Wenwu cankao ziliao* 5, 12 (1955); *Wenwu* 7 (1959); 3 (1973); 6 (1984); *Kaogu* 10 (1985).

35 Li Dianfu has discussed Koguryo tombs found in China in Ji'an, Jilin Province. "Ji'an Gaogouli mu yanjiu" (A study of Koguryo tombs in Ji'an), *Kaogu xuebao* 2 (1980): 163–186. Tomb murals found in Anak are reproduced in a beautifully printed book, *Koguryŏ kobun pyŏkhwa* (Murals of the Koguryo tumulus) (Tokyo: Chōsen gahōsha, 1985).

36 Different theories have been proposed to explain the role of Dong Shou. See Su Bai, "Chaoxian Anyue suo faxian de Dong Shou mu" (Dong Shou's tomb found in Anak in North Korea), *Wenwu* 1 (1952): 101–104; Hong Qingyu, "Guanyu Dong Shou mu de faxian he yanjiu" (The discovery and investigation of Dong Shou's tomb), *Kaogu* 1 (1959): 27–35; K. H. J. Gardiner, *The Early History of Korea* (Honolulu: University of Hawaii Press, 1969), 40–43; Audrey Spiro, *Contemplating the Ancients: Aesthetic and Social Issues in Early Chinese Portraiture* (Berkeley: University of California Press, 1990), 38–44. The official North Korean view on the dating of the tomb and the identity of its occupants is represented in discussions in *Koguryŏ kobun pyŏkhwa*.

37 Ten tombs, nine at Xincheng and one at Jiuquan, belong to this group. For excavation reports, see Cultural Relics Team of Gansu Province, *Jiayu Guan bihuamu fajue baogao* (An excavation report on painted tombs at Jiayu Pass) (Beijing: Wenwu, 1985); *Wenwu* 10 (1959); 6 (1979); 8 (1982).

38 The fourth-century examples include the Zhai Zongying tomb at Dunhuang and a group of tombs at Turpan. Reports are in *Kaogu tongxun* 1 (1955); *Wenwu* 6 (1978). For a detailed excavation report on the largest tomb, see Gansu Institute of Archaeology and Cultural Relics, *Jiuquan Siliu Guo mu bihua* (Murals in a Sixteen Kingdoms tomb in Jiuquan) (Beijing: Wenwu, 1989).

39 Just outlining the development of Dunhuang art would take too much space here. For a comprehensive introduction, see Ning Qiang, *Dunhuang fojiao yishu* (Dunhuang Buddhist art) (Gaoxiong: Fuwen tushu chubanshe, 1992).

40 See ibid., 70.

41 For a report on the tomb of Yuan Wei, see *Wenwu* 12 (1974); the Ruru Princess, see *Wenwu* 4 (1984); Li Xian, see *Wenwu* 11 (1985); Lou Rui, see *Wenwu* 10 (1983); Dao Gui, see *Wenwu* 10 (1985); Gao Run, see *Kaogu* 3 (1979).

42 See Su Bai, "Taiyuan Bei Qi Lou Rui mu canguan ji" (Notes on Lou Rui's tomb of the Northern Qi in Taiyuan), *Wenwu* 10 (1983): 26.

43 See Jin Weinuo, "*Gu diwangtu* yu *Bei Qi jiaoshu tu*" (Portraits of Ancient Emperors and Scholars of the Northern Qi Collating Texts), *Meishu yanjiu* 1 (1982).

44 Perhaps the only exception is a tomb found in Dengxian, Henan Province. But this tomb is decorated with tiles which are painted on the surface and have pictures in relief. See Cultural Relics Team of the Henan Provincial Culture Bureau, *Dengxian caise huaxiang zhuan mu* (A tomb in Dengxian decorated with painted picture tiles) (Beijing: Wenwu, 1958).

45 Etienne Balazs, *Chinese Civilization and Bureaucracy: Variations on a Theme,* trans. H. M. Wright (New Haven: Yale University Press, 1964), 226–254.

46 Ibid., 25–33.

47 See Susan Bush and Hsio-yen Shih, comps. and eds., *Early Chinese Texts on Painting* (Cambridge: Harvard University Press, 1985), 29.

48 Gu Kaizhi's essays are "Essay on Painting the Cloud Terrace Mountain" ("Hua Yuntai shan ji"), "A Discussion of the Surviving Paintings from the Wei and Jin Dynasties" ("Wei Jin shengliu huazan"), and "On Painting" ("Lun hua"), all collected in Zhang Yanyuan, *Lidai minghua ji* (Record of famous paintings of successive dynasties), in Yan Jialuo, ed., *Yishu congshu* (Collectanea of writings on arts) (Taibei: Shijie shuju, 1962), series 1, vol. 8 (hereafter cited as *LDMHJ*). For English translations, see Bush and Shih, *Early Chinese Texts on Painting,* 24–39. Zong Bing's two texts, entitled "Preface on Landscape Painting" ("Hua shanshui xu") and "Preface on Painting" ("Xu hua"), have been discussed by many scholars. For English translations, see Bush and Shih, *Early Chinese Texts on Painting,* 36–39.

49 Bush and Shih, *Early Chinese Texts on Painting,* 39 (quotation from Wang Wei). Many interpretations and translations of the Six Principles exist; for a concise review of different approaches, see ibid., 10–17. For an English translation of Yao's text, see Acker, vol. 1, pp. 33–58.

50 Acker, vol. 1, pp. 115–125.

51 The excavation of the tomb is reported in *Wenwu* 3 (1986).

52 Spiro, *Contemplating the Ancients,* 91–121.

53 Copies of other paintings likely to be of ancient origin, including *The Five Planets and Twenty-Eight Constellations,* attributed to Zhang Sengyou (active 500–550), and *Tribute Bearers,* attributed to Xiao Yi, Emperor Yuan of the Liang, follow a traditional cataloguing style and will be omitted from this discussion.

54 *A New Account of Tales of the World by Liu I-ch'ing,* trans. Richard D. Mather (Minneapolis: University of Minnesota Press, 1976), xv.

55 Han depictions of chaste women, such as those on the famous Wu Liang shrine, are also organized in a row with explanatory and framing inscriptions. These pictorial stories are based on *Biographies of Exemplary Women,* compiled by the Han imperial librarian Liu Xiang, who also had some famous historical ladies illustrated on a screen. Such a screen has been found in the tomb of Sima Jinlong, a relative of the Northern Wei royalty, attesting to the continuation of the Han tradition at least as late as the fifth century.

56 For a more detailed discussion of the tradition of illustrating exemplary women, see Wu, *Wu Liang Shrine,* 175–176.

57 For a discussion of this convention and its influence on Han pictorial art, see ibid., 213–217.

58 Hsio-yen Shih, "Poetry Illustration and the Works of Ku K'ai-chih," in J. Watson, ed., *The Translation of Art: Essays on Chinese Painting and Poetry* (Hong Kong: Chinese University of Hong Kong, 1976), 6–29.

59 Here I am indebted to Ning Qiang, who made this observation in a seminar at Harvard University in 1992.

60 See Wang Zhongying, *Wei Jin Nanbeichao shi* (History of the Wei, Jin, and Northern and Southern Dynasties) (Shanghai: Shanghai renmin chubanshe, 1980), vol. 2, pp. 541–551.

61 *ZMQ,* Painting, vol. 19, interpretation of fig. 5.

62 *LDMHJ,* 1.17; Acker, vol. 1, pp. 124–125.

63 *LDMHJ,* 8.261; Acker, vol. 1, pp. 173–174.

64 For an inventory of these temple murals, see Yu Jianhua, *Zhongguo huihua shi* (History of Chinese painting), 2 vols. (Shanghai: Shangwu yinshuguan, 1959), vol. 1, p. 82.

65 *Sui shu* (Sui history) (Beijing: Zhonghua shuju, 1973), vol. 68, pp. 1594–1595; *LDMHJ,* 8.254–255.

66 *Xuanhe huapu* (The Xuanhe painting catalogue), in Yan Jialuo, ed., *Yishu congshu* (Taibei: Shijie shuju, 1962), series 1, vol. 9, 1.54–55; *Jiu Tang shu* (The old Tang history) (Beijing: Zhonghua shuju, 1975), 77.2679–2680.

67 *Jiu Tang shu,* 77.2680; *LDMHJ,* 9.269–273.

68 Jin Weinuo, "*Bunian tu* yu *Lingyan Ge gongchen tu*" (The Imperial Sedan Chair and Twenty-Four Meritorious Officials in the Lingyan Palace), *Wenwu* 10 (1962): 16.

69 We know, for example, that parts of the painting were beyond repair as early as 1188, that a portion is probably missing, indicated by a conspicuous chronological gap separating the first six and last seven emperors, and that the two groups, painted on two pieces of silk and in different styles, were perhaps by different hands. See Tomita Kōjirō, "Portraits of the Emperors: A Chinese Scroll-Painting Attributed to Yen Li-pen," *Bulletin of the Museum of Fine Arts, Boston* 59 (February 1932): 1–8. Jin Weinuo argues that the Boston version is a Song copy of a painting created not by Yan Liben but by another early Tang artist, Lang Yuling. Jin, "*Gu diwang tu* de shidai yu zuozhe" (The date and painter of *Portraits of Past Emperors*), in Jin, *Zhongguo meishushi lunji* (Papers on Chinese art history) (Beijing: Renmin meishu chubanshe, 1981), 141–148.

70 A series of emperors' portraits engraved on the Wu Liang shrine date to 151 A.D. For a discussion of these images and their political significance, see Wu, *Wu Liang Shrine,* 156–167. The tradition of portraying past rulers continued during post-Han times and is mentioned in a text, "On Painting" ("Lun hua"), attributed to Gu Kaizhi; see Bush and Shih, *Early Chinese Texts on Painting,* 28–29.

71 *Xuanhe huapu,* 1.59. Ning Qiang made the *Vimalakirti* connection in the seminar at Harvard University.

72 Sima Guang, *Zizhi tongjian* (A mirror for the reflection of the government) (Taibei: Yiwen yinshuguan, 1962), 204.29a. See Chuan-ying Yen, "The Sculpture from the Tower of Seven Jewels: The Style, Patronage and Iconography of the Monument" (Ph.D. diss., Harvard University, 1986). The three main audience halls of the Daming Palace, called Hanyuan, Xuanzheng, and Zichen, each consisted of a main building and flanking pavilions, much like an architectural complex depicted in a paradise scene. Linde Hall, the site of imperial Buddhist rites and royal performances, showed even closer similarities to a paradise structure in both architectural plan and the uses to which the buildings were put.

73 Shi Weixiang, "Dunhuang Mogaoku de *Baoyu jing bian* (An illustration of the *Sutra of Precious Rain* in the Mogao Caves in Dunhuang), in *1983 nian quanguo Dunhuang xueshu taolunhui wenji* (Papers presented in the national conference on Dunhuang studies in 1983), 2 vols. (Lanzhou: Gansu renmin chubanshe, 1985), vol. 1, pp. 61–83.

74 Fu Xinian believes that the painting is based on a late Tang original. Fu, "Guanyu Zhan Ziqian *Youchun tu* niandai de

tantao" (On the date of Zhan Ziqian's *Spring Outing*), *Wenwu* (1978). Kei Suzuki dates the original to the early Tang, in Suzuki, *Chūgoku kaiga shi* (The history of Chinese painting), 2 vols. (Tokyo: Yoshikawa Kōbunkan, 1981). Here I follow Kei Suzuki's opinion.

75 *Jiu Tang shu,* 60.2346; *LDMHJ,* 1.56; Acker, vol. 1, p. 156. Officials like Wang Xiong, governor general of Tangzhou in the early eighth century, followed Li Sixun's style. *LDMHJ,* 10.309; Acker, vol. 2, part 1, pp. 269–270.

76 *LDMHJ,* 9.290–292; Acker, vol. 2, part 1, pp. 242–244. In addition to the short introduction to Li Linfu's landscape painting in *LDMHJ* (9.291), there is a poem by Sun Di entitled "An Answering Poem, Respectfully Offered, on a Landscape Painting by Li, Junior Premier and Director of the Grand Imperial Secretariat [titles that Li Linfu held from 736 on]." It begins with these sentences: "Since his palace duties leave many days of leisure / Landscapes have become his ruling passion. / Wishing to convey a sense of depth and height / He has turned to the making of richly embellished paintings." *Quan Tang shi* (A complete compilation of Tang poems) (Beijing: Zhonghua shuju, 1960), 1195. See Alexander Soper, "A Ninth-Century Landscape Painting in the Japanese Imperial Palace and Some Chinese Parallels," *Artibus Asiae* 29, no. 4 (1967): 335–350.

77 Fu, "Guanyu Zhan Ziqian *Youchun tu.*"

78 Wang Renbo, "Tang Yide Taizi mu bihua ticai de fenxi" (An analysis of the content of the murals in the tomb of Crown Prince Yide of the Tang dynasty), *Kaogu* 6 (1973): 381; see also Fontein and Wu, *Han and T'ang Painted Murals,* 104–105. It is possible that Li Sixun made a political painting called *Picking Melons* (*Zhaigua tu*) when he was in hiding. Illustrating Prince Li Xian's poem of the same title, this work, in Max Loehr's words, "was done as a solemn warning, in pictorial forms, to the Imperial clan, a political manifestation tied to an historical moment, presumably between 675 and 680." Loehr, *The Great Painters of China* (New York: Harper and Row, 1980), 66–67.

79 Fontein and Wu, *Han and T'ang Painted Murals,* 104; *LDMHJ,* 9.294; Acker, vol. 2, part 1, p. 248.

80 See Michael Sullivan, *Chinese Landscape Painting in the Sui and T'ang Dynasties* (Berkeley: University of California Press, 1980), 119–120.

81 Li Lincan believes that the scroll was a fabrication by a Song painter based on the painter's understanding of the Tang blue-and-green landscape style. Li, "*Minghuang xing Shu tu* de yanjiu" (A study of *Emperor Minghuang's Journey into Shu*), in Li, *Zhongguo minghua yanjiu* (A study of some famous Chinese paintings), vol. 1 (Taibei: Yiwen yinshuguan, 1973). Although the painting was traditionally associated with Li Zhaodao, this attribution can be ruled out because Li Zhaodao died before the emperor's journey. Max Loehr has suggested that the original work was created several decades after Minghuang's journey, probably inspired by Bai Juyi's famous song "Everlasting Remorse" ("Changhen ge"), which was written around 800, at a time when it became "possible to use the theme without giving offense to the Imperial family." Loehr, *Great Painters of China,* 69; see also Arthur Waley, *The Life and Times of Po Chü-i* (London: Allen and Unwin, 1948), 45.

82 The painted tombs include fourteen early Tang tombs — those of Li Shou (located in Sanyuan, dated 631), Princess Changle (Liquan, 643), Zhishi Fengjie (Chang'an, 658), Zheng Rentai (Liquan, 664), Su Dingfang (Xianyang, 667), Li Shuang (Xi'an, 668), Mr. Su (Xianyang, 668–741), Li Feng (Fuping, 675), Ashi Nazhong (Liquan, 675), Li Chongrun (Qianxian, 706), Li Xianhui (Qianxian, 706), Li Xian (Qianxian, 706–711), Wei Jiong (Chang'an, 708), Master (Xianzhu) of Wanquan (Xianyang, 710); eight High Tang tombs — those of Xue Mo (Xi'an, 728), Feng Fanzhou (Xi'an, 729), Su Simao (Xi'an, 745), Mrs. Song (Xi'an, 745), Zhang Qushe (Xianyang, 747), Zhang Quyi (Xianyang, 748), Gao Yuangui (Xi'an, 756), Mr. Han (Xi'an, 765); and five middle and late Tang tombs — those of Princess Dachang (Xianyang, 787), Yao Cungu (Xi'an, 835), Liang Yuanhan (Xi'an, 844), Gao Kecong (Xi'an, 847), Yang Xuanlue (Xi'an, 864). For sources of excavation reports, see Wang Renbo et al., "Shaanxi Tang mu bihua zhi yanjiu" (A study of the Tang tomb murals from Shaanxi Province), *Wenbo* 1 (1984): 39–52; 2 (1984): 44–55. For analyses of these tombs, see ibid.; Su Bai, "Xi'an diqu Tang mu bihua de buju he neirong" (The composition and content of the Tang tomb murals in the Xi'an area), *Kaogu xuebao* 2 (1982): 137–154.

Two excavated Sui tombs belonged to Xu Minxing (Jiaxiang, Shandong Province, 584) and Shi Wuzhao (Guyuan, Ningxia Hui Autonomous Region, 610). Excavated painted Tang tombs in provincial areas include the tombs of Li Xin (Yunxian, Hubei Province, 725) and Zhang Jiuling (Shaoguan, Guangdong Province, 740), as well as those located in Jinshengcun (684–705) and Dongruzhuang (696) in Taiyuan, Shanxi Province, and Astana in Turpan, Xinjiang Uygur Autonomous Region (Tomb 216, High Tang; Tomb 217, middle Tang; Tomb 38, High Tang–middle Tang).

Two other excavated painted tombs, belonging to Wei Jiong (d. 708) and a daughter of Princess Taiping (d. 710), were built around the same time as the three imperial tombs.

83 The excavation of the two tombs is reported in *Wenwu* 1 (1963) and 7 (1972). For brief English overviews, see R. C. Rudolph, "Newly Discovered Chinese Painted Tombs," *Archaeology* 18, no. 3 (autumn 1965): 1–8; Mary H. Fong, "Four Chinese Royal Tombs of the Early Eighth Century," *Artibus Asiae* 35, no. 4 (1973): 307–334; Fontein and Wu, *Han and T'ang Painted Murals,* 90–103, 121–123. The murals in Princess Yongtai's tomb are severely damaged. The surviving sections in the antechamber resemble those painted in the same positions in Prince Yide's tomb. According to the excavators, all the walls in Prince Zhanghuai's tomb beyond the fourth air shaft were repainted in 711, when Prince Zhanghuai was posthumously promoted to crown prince and when his consort, Lady Fang, was interred with him. The paintings along the sloping passageway, therefore, should still be dated to 706.

84 *LDMHJ,* 2.63; Acker, vol. 1, pp. 166–167.

85 For such cases recorded in Tang texts, see Wu Hung, "Reborn in Paradise: A Case Study of Dunhuang Sutra Painting and Its Religious, Ritual and Artistic Context," *Orientations* (May 1992): 59–60.

86 For a more detailed discussion of these two murals, see ibid.

87 Zhu Jingxuan, *Tang chao minghua lu* (Records of famous painters during the Tang dynasty), in Yang Jialuo, ed., *Yishu congbian* (Taibei: Shijie shuju, 1962), series 1, vol. 8, pp. 14–15 (hereafter cited as *TCMHL*); Alexander Soper, "T'ang ch'ao ming hua lu," *Artibus Asiae* 21, nos. 3–4 (1958): 204–230, especially 209. See also Osvald Sirén, *Chinese Painting: Leading Masters and Principles,* vol. 1 (New York: Ronald Press, 1956), 110.

88 Zhang on styles: *LDMHJ,* 2.71; Acker, vol. 1, p. 184. Zhang on Li Zhaodao: *LDMHJ,* 2.71; Acker, vol. 2, part 1, p. 243. Zhu Jingxuan voiced a similar criticism when he described Li Zhaodao's paintings as "crowded and delicate." *TCMHL,* 20. Zhang on Wu Daozi: *LDMHJ,* 2.71; Acker, vol. 1, p. 184. Zhu on Wu Daozi: *TCMHL,* 15–16; Soper, "T'ang ch'ao ming hua lu," 210, translation slightly modified.

89 Loehr, *Great Painters of China,* 44.

90 See Huang Miaozi, *Wu Daozi shiji* (Events in the life of Wu Daozi) (Beijing: Zhonghua shuju, 1991), 23–30.

91 *LDMHJ,* 9.285; Acker, vol. 2, part 1, p. 232. These duties are suggested by two of Wu's titles, Professor of Interior Instruction (Neijiao boshi) and Companion of Prince Ning (Ningwang you). See Arthur Waley, *Introduction to the Study of Chinese Painting* (London, 1923), 112. In Zhu Jingxuan's words, it was Wu's "Heaven-endowed talent that enabled him to comprehend the secret of painting while still young." *TCMHL,* 14; Soper, "T'ang ch'ao ming hua lu," 208. When Zhang Yanyuan states that Wu "studied" under Zhang Sengyou, Zhang Xiaoshi (seventh to eighth century), Zhang Xu (active 714–742), and He Zhizhang (659–744) (*LDMHJ,* 2.63; Acker, vol. 1, p. 166, and vol. 2, part 1, p. 232), he was emphasizing the stylistic heritage of Wu's art, not necessarily his actual teachers. It is possible that Wu took part in creating a political painting called *The Gold Bridge* (*Jinqiao tu*), which depicted Minghuang's journey from Mount Tai to the capital, Chang'an. But the reliability of this record is questionable, for neither Zhang Yanyuan nor Zhu Jingxuan mentions this event, and all references have post-Tang dates.

92 *LDMHJ,* 9.286; Acker, vol. 2, part 1, p. 237. A number of such painters cited in *LDMHJ* (9.286–289; Acker, vol. 2, part 1, pp. 232–240) were Wu Daozi's contemporaries or students. Zhang also identifies some other Tang painters as "famous artisans" (*mingshou huagong*). *LDMHJ,* 9.297.

93 See Li Yu, *Zhongguo meishu shigang* (A concise history of Chinese art), 2 vols. (Shenyang: Liaoning meishu chubanshe, 1988), vol. 2, pp. 118–119. Except for one painting, all ninety-three works by Wu Daozi listed in the *Xuanhe huapu* depicted religious images. It is possible that some of them were designs for larger murals. Existing versions of the *Chao yuan xianzhang tu* — a depiction of Daoist celestial rulers and their attendants in a long procession — are generally linked with Wu Daozi's tradition.

94 The anecdotes are carefully recorded in *TCMHL,* 16; Soper, "T'ang ch'ao ming hua lu," 208–210. The quotations are from *TCMHL,* 15. It is significant that Zhang Yanyuan compares Wu Daozi with two legendary figures in Zhuangzi's writings — a carver who never had to change his knife and a carpenter who could slice a thin layer of white lime off someone's nose with a heavy ax. *LDMHJ* 2.70; Acker, vol. 1, pp. 181–182.

95 Some of these anecdotes follow the common structures of folktales and Buddhist stories. The contest between Wu Daozi and Li Sixun, for example, can be compared with many competitions described in Buddhist literature and art, such as the contest between Raudraksa and Sariputra — an extremely popular subject in Tang painting. See Wu Hung, "What Is Bianxiang? — On the Relationship Between Dunhuang Art and Dunhuang Literature," *Harvard Journal of Asiatic Studies* 52, no. 1 (June 1992), 111–192.

96 For a related discussion, see Denis Twitchett and Arthur Wright, eds., *Perspectives on the T'ang* (New Haven: Yale University Press, 1973), 1.

97 *TCMHL,* 13; Soper, "T'ang ch'ao ming hua lu," 207–208; *LDMHJ,* 9.289, 292–293, 295, 298, 302; Acker, vol. 2, part 1, pp. 241–242, 245–246, 250–251, 260.

98 Zhang on Li Cou: *LDMHJ,* 9.292; Acker, vol. 2, part 1, p. 244. The following discussion of tomb murals is based on Wang Renbo et. al., "Shaanxi Tang mu bihua zhi yanjiu."

99 Zhang on Zhang Xuan: *LDMHJ,* 9.295–296; Acker, vol. 2, part 1, p. 248. Zhu on Zhang Xuan: *TCMHL,* 29; Soper, "T'ang ch'ao ming hua lu," 222–223.

100 There is another version of the painting besides Huizong's copy, this one in the National Palace Museum in Taibei. It bears the title *The Beauties* (*Liren xing*), adopted from one of Du Fu's famous poems, which indicates that not only Lady Guoguo but also the other Yang sisters are portrayed. No evidence supports the traditional opinion that this scroll was copied by Li Gonglin from Zhang Xuan's original. Because it shows a close stylistic resemblance to *Ladies Preparing Newly Woven Silk* in figural types, drawing technique, and color scheme, it is probably also a product of Huizong's Academy of Painting in the early twelfth century.

101 Rudolf Arnheim, *Art and Visual Perception* (Berkeley: University of California Press, 1974), 129–130.

102 *LDMHJ,* 10.322–323; Acker, vol. 2, part 1, p. 290, translation modified.

103 *TCMHL,* 210–212.

104 The argument that this painting is not a later copy seems to be clinched by the fact that the painting is formed by piecing together three smaller compositions into a scroll form. These three compositions, each bearing two female images, may have been originally mounted on a screen. See Xu Shucheng, "Cong *Wanshan shinü tu, Zanhua shinü tu* luetan Tang ren shinü hua" (A discussion of Tang-dynasty female portraits based on *Ladies with Silk Fans* and *Court Ladies Wearing Flowered Headdresses*), *Wenwu* 7 (1980): 71–75. The original format may also explain the rather awkward ground level in the present scroll. Regarding the date, both Xie Zhiliu and Ellen J. Laing have noted that the hairstyle of the painted ladies is shared by female figurines discovered in the Southern Tang royal tombs. Laing further argues that the painting depicts a traditional spring festival called Flower Morning. See Xie Zhiliu, "Dui Tang Zhou Fang *Zanhua shinü tu* de shangque" (Some different opinions about *Court Ladies Wearing Flowered Headdresses* attributed to Zhou Fang of the Tang dynasty), *Wenwu cankao ziliao* 6 (1958): 25–26; E. J. Laing, "Notes on *Ladies Wearing Flowers in Their Hair,*" *Orientations* 21, no. 2 (1990): 32–39.

105 Although some famous bird-and-flower painters, such as Xue Ji (649–713), appeared in the early Tang, birds and flowers did not become popular in tomb murals until the High Tang and mid-Tang. See Wang Renbo et al., "Shaanxi Tang mu bihua zhi yanjiu."

106 Du Fu: *Du shi xiangzhu* (Du Fu's poems with detailed annotations) (Beijing: Zhonghua shuju, 1979), 1147. Zhang: *LDMHJ*, 9.303; Acker, vol. 2, part 1, pp. 260–263.

107 Zhang Yanyuan wrote that Wang painted a panorama of Wangchuan on the walls of Chingyuan Si, a part of his villa that he had converted into a Buddhist temple after his mother's death. *LDMHJ*, 10.307. According to Zhu Jingxuan, a screen with a painting of Wangchuan stood in the West Pagoda Precinct of Qianfu Si in Chang'an. *TCMHL*, 25; Soper, "T'ang ch'ao ming hua lu," 218.

108 *TCMHL*, 24–25; Soper, "T'ang ch'ao ming hua lu," 218.

109 *Jiu Tang shu*, vol. 192, pp. 5119–5121. Zhang on Lu: *LDMHJ*, 9.300; Acker, vol. 2, part 1, pp. 257–258. According to Dai Biaoyuan's *Zaiyuan wenji*, "The original painting was a single composition, now changed into [a work in] ten sections." Cited in Chen Gaohua, *Sui Tang huajia shiliao* (Historical data about painters of the Sui and Tang dynasties) (Beijing: Wenwu, 1987), 127.

110 Zhuang Shen, "Tang Lu Hong *Caotang shizhi tujuan* kao" (A study of *Ten Views from a Thatched Lodge* by Lu Hong of the Tang dynasty), in *Zhongguo huashi yanjiu xuji* (Studies of the history of Chinese painting, second series) (Taibei: Zhengzhong shuju, 1972), 111–211; Sullivan, *Chinese Landscape Painting in the Sui and T'ang Dynasties*, 52–53.

111 *LDMHJ*, 9.301; Acker, vol. 2, part 1, p. 259.

112 *Notes on Brushwork* (*Pifa ji*), an extant treatise traditionally ascribed to Jing Hao, places a heavy emphasis on the value of brush and ink in artistic expression. For a list of works attributed to Li Cheng, see James Cahill, *An Index of Early Chinese Painters and Paintings: T'ang, Sung, and Yüan* (Berkeley: University of California Press, 1980), 42–44.

113 *TCMHL*, 228; Sullivan, *Chinese Landscape Painting in the Sui and T'ang Dynasties*, 73.

114 Zhang on Zheng Qian: *LDMHJ*, 9.301. Zhu on Zhang Zao: *TCMHL*, 216. Fu Zai on Zhang Zao: Yu Anlan, ed., *Zhongguo hualun leibian* (Classified anthology of Chinese writings on painting) (Beijing, 1956), vol. 1, pp. 20–21; Sullivan, *Chinese Landscape Painting in the Sui and T'ang Dynasties*, translation slightly modified. For a discussion of Zhang Zao, see Sullivan, pp. 65–69.

The Five Dynasties and the Song Period

1 For Guanxiu see Kobayashi Taishiro, *Zengetsu daishi no shogai to geijutsu* (The life and art of Chanyue daishi) (Tokyo: Sogensha, 1947); see also Wen C. Fong, "Archaism as a 'Primitive' Style," in *Artists and Traditions*, ed. Christian F. Murck (Princeton: Princeton University Press, 1976), 89–109.

2 Max Loehr, *The Great Painters of China* (Cambridge and London: Harper and Row, 1980), 54–59.

3 C. T. Loo, *Chinese Frescoes of Northern Sung* (New York: C. T. Loo, 1949).

4 However, a marvelous painting of bamboo in snow, in the Shanghai Museum, is attributed to Xu Xi. See James Cahill, *Three Alternative Histories of Chinese Painting*, Franklin D. Murphy Lectures IX (Lawrence, Kan.: Spencer Museum of Art, 1988), p. 81, fig. 57.

5 The print is reproduced and discussed in G. Henderson and L. Hurwitz, "The Buddha of Seiryoji," *Artibus Asiae* 19 (1956): 5–55.

6 Kiyohiko Munakata, *Ching Hao's Pi-fa-chi: A Note on the Art of Brush* (Ascona, Switzerland: Artibus Asiae, 1974).

7 *Eight Dynasties of Chinese Painting* (Cleveland: Cleveland Museum of Art, 1980), 12–13.

8 Three important landscapes in the National Palace Museum are the major monuments of Guan Tong's style. They are reproduced in *Gugong shuhua tulu* (Illustrated catalogue of painting and calligraphy in the National Palace Museum) (Taibei: National Palace Museum, 1989), 55–60.

9 James Cahill, "Some Aspects of Tenth-Century Painting as Seen in Three Recently Published Works," *Proceedings of the International Conference on Sinology: Section on History of Art* (Taibei: Academia Sinica, 1992).

10 Richard Barnhart, Marriage of the Lord of the River: *A Lost Landscape by Tung Yuan* (Ascona, Switzerland: Artibus Asiae, 1970).

11 In addition to the two reproduced here, a third landscape, titled *Xiao Yi's Theft of the Lanting Preface*, is also regarded as the work of Juran. Reproduced in *Gugong shuhua tulu*, vol. 1, p. 102.

12 The four major histories of the period are the *Wudai minghua buyi* (Additions to famous painters of the Five Dynasties) of Liu Daochun, Liu's *Shengchao minghua ping* (Critique of famous painters of our great dynasty), both written around 1060, Guo Ruoxu's *Tuhua jianwen zhi* (Record of my experiences in painting), ca. 1080, and Deng Chun's *Huaji* (Records of painting) of 1167. The imperial catalogue of painting, of 1121, *Xuanhe huapu*, also counts as a major contribution to the history of painting. See following note.

13 Three separate catalogues of the imperial collections were published in the early twelfth century: a catalogue of painting, *Xuanhe huapu*; a catalogue of calligraphy, *Xuanhe shupu*; and a catalogue of antiquities, *Xuanhe bogu tulu*.

14 Li Cheng's biography is the subject of a study by Wai-kam Ho, "Li Ch'eng and the Mainstream of Northern Sung Landscape Painting," in *Proceedings of the International Symposium on Chinese Painting* (Taibei: National Palace Museum, 1972), 251–283. See also Ho's notes on Li Cheng and Juran in *Eight Dynasties of Chinese Painting*.

15 Guo Ruoxu is quoted in Susan Bush and Hsio-yen Shih, *Early Chinese Texts on Painting* (Cambridge: Harvard University Press, 1985), 111. The translation here is slightly modified.

16 *Eight Dynasties of Chinese Painting*, no. 77.

17 Bush and Shih, *Early Chinese Texts*, 113.

18 Valerie Hansen, trans., from her new study of the scroll: *The Beijing Qingming Scroll and Its Significance for the Study of Chinese History* (Albany: Journal of Sung-Yuan Studies, 1996), 3.

19 As Valerie Hansen points out in the work cited in note 18, the subject of this scroll is certainly not the Qingming festival, since none of the activities of that holiday are depicted. Hansen suggests a date closer to the time of Zhang Zhu's colophon of 1186, through comparison with the murals at the Yanshansi in Shanxi Province, dated 1167. This therefore brackets the date of the scroll between 1060 or so and 1160.

20 The connections between art and economic development in the Song period are the subject of a doctoral dissertation being written at Yale University by Heping Liu. For a general statement of the Song economy, see Laurence J. C. Ma, *Commercial Development and Urban Change in Sung China (960–1279)* (Ann Arbor: Department of Geography, University of Michigan, 1971), 1–10.

21 Quotation adapted from Bush and Shih, *Early Chinese Texts*, 103.

22 For Zhao Yan, see Alexander Coburn Soper, trans., *Kuo Jo-hsü's Experiences in Painting* (Washington, D.C.: American Council of Learned Societies, 1951), 27, 28, 86–87.

23 For later portraiture in China, see Richard Vinograd, *Boundaries of the Self: Chinese Portraits, 1600–1900* (Cambridge: Cambridge University Press, 1992).

24 Soper, *Kuo Jo-hsü's Experiences in Painting*, 47, 49, 51, 55–56, for example.

25 Wen C. Fong and James C. Y. Watt et al., *Possessing the Past: Treasures from the National Palace Museum, Taipei* (New York: Metropolitan Museum of Art; Taibei: National Palace Museum, 1996).

26 Translation from Bush and Shih, *Early Chinese Texts*, 113.

27 See Richard M. Barnhart, with essays by Robert Harrist, Jr., and Hui-liang J. Chu, *Li Kung-lin's Classic of Filial Piety* (New York: Metropolitan Museum of Art, 1993).

28 On rebuses in Chinese art generally, see Terese Tse Bartholomew, *Myths and Rebuses in Chinese Art* (San Francisco: Asian Art Museum, 1988).

29 Chen Rong (ca. 1200–1266), a Daoist scholar, is the most important early master of the genre whose work is known today. His great *Nine Dragons* handscroll in the Museum of Fine Arts, Boston, was painted in 1244; see Kojiro Tomita, ed., *Portfolio of Chinese Paintings in the Museum*, vol. 1, *Han to Sung Periods* (Boston: Museum of Fine Arts, 1961), 127–129. See also *Eight Dynasties*, no. 62, for another work by Chen.

30 Hou-mei Sung, "Chinese Fish Painting and Its Symbolic Meanings: Sung and Yuan Fish Paintings," *National Palace Museum Bulletin* 30, nos. 1, 2 (March–April, May–June 1995), is the most complete study of the tradition of fish painting.

31 Guo Xi's important essay on landscape painting, the *Linquan gaozhi ji* (Lofty message of forests and streams) is translated in S. Sakanishi, *An Essay on Landscape Painting* (London: John Murray, 1935).

32 A broad selection of Huizong's paintings is reproduced in *Sung Painting, Part 2* ("Five Thousand Years of Chinese Art" Series) (Taibei: Five Thousand Years of Chinese Art Editorial Committee, 1985), vol. 2, pp. 2–22.

33 For Huizong's *Auspicious Cranes*, see Peter C. Sturman, "Cranes Above Kaifeng: The Auspicious Image at the Court of Huizong," *Ars Orientalis* 20 (1990): 33–68.

34 Reproduced in *Sung Painting, Part 2*, vol. 2, pp. 8–15.

35 See Barnhart, *Li Kung-lin's Classic of Filial Piety*.

36 For Gaozong's propaganda campaign and his use of art, see Wen C. Fong, *Beyond Representation* (New Haven: Yale University Press, 1992), 173–245; and Julia K. Murray, "The Role of Art in the Southern Sung Dynastic Revival," *Bulletin of Sung-Yuan Studies*, no. 18 (1986): 41–58.

37 Suzuki Kei, "Rito no nanto fukuin to sono yoshiki hensen ni tsuite no ichi-shiron" (A tentative theory concerning Li Tang's move to the south and the change in his style after the reestablishment of the Academy of Painting), part 1, *Kokka*, no. 1047 (December 1981): 5–20; part 2, *Kokka*, no. 1053 (July 1982): 13–23.

38 Robert A. Rorex and Wen C. Fong, *Eighteen Songs of a Nomad Flute* (New York: Metropolitan Museum of Art, 1974).

39 Fong, *Beyond Representation*, 195–209.

40 Julia K. Murray, "Ts'ao Hsün and Two Southern Sung History Scrolls," *Ars Orientalis* 15:1–29.

41 For a variety of examples of such paintings and the poems often accompanying them, see Fong, *Beyond Representation*, 246–323.

42 Liang Kai's paintings are reproduced in Osvald Sirén, *Chinese Painting: Leading Masters and Principles* (New York: Ronald Press, 1956), vol. 3, plates 325–333. Two important recent studies of the Southern Song period are Hui-shu Lee, "The Domain of Empress Yang (1162–1223): Art, Gender and Politics at the Late Southern Song Court" (Ph.D. diss., Yale University, 1994); and James Cahill, *The Lyric Journey: Poetic Painting in China and Japan* (Cambridge: Harvard University Press, 1996).

The Yuan Dynasty

1 For the best-known surviving example, painted in 1306, see James Cahill, *Hills Beyond a River: Chinese Painting of the Yüan Dynasty, 1279–1368* (New York and Tokyo: John Weatherhill, 1976), pl. 1.

2 For a discussion of this theme in Yuan painting, see Wai-kam Ho's essay in Sherman E. Lee and Wai-kam Ho, eds., *Chinese Art Under the Mongols: The Yüan Dynasty (1279–1368)* (Cleveland: Cleveland Museum of Art, 1968), 97–101.

3 Cahill, *Hills*, pl. 2; Lee and Ho, *Chinese Art*, fig. 18.

4 See Shih Shou-chien's study of this scroll in Wen C. Fong et al., *Images of the Mind: Selections from the Edward L. Elliott Family and John B. Elliott Collections of Chinese Calligraphy and Painting at the Art Museum, Princeton University* (Princeton: The Princeton University Art Museum, 1984), 237–254.

5 For a comprehensive study of the painting and its context and sources, see Chu-tsing Li, The Autumn Colors on the Ch'iao and Hua Mountains: *A Landscape by Chao Meng-fu*, Artibus Asiae Supplementum 21 (Ascona, Switzerland: Artibus Asiae, 1965).

6 For the last, a famous painting in the Freer Gallery of Art, see Cahill, *Hills*, pl. 9, and Chu-tsing Li, "The Freer *Sheep and Goat* and Chao Meng-fu's Horse Paintings," *Artibus Asiae* 30, no. 4 (1962): 279–326.

7 See Chu-tsing Li, "*Grooms and Horses* by Three Members of the Chao Family," in Alfreda Murck and Wen C. Fong, eds., *Words and Images: Chinese Poetry, Calligraphy, and Painting* (New York: Metropolitan Museum of Art, 1991), 199–220. Li quotes a number of inscriptions from Zhao's extant or recorded paintings that confirm the political readings of horse paintings. See also Jerome Silbergeld, "In Praise of Government: Chao Yung's Painting *Noble Steeds* and Late Yüan Politics," *Artibus Asiae* 46, no. 3 (1985): 159–198.

8 Quoted from the *Xuanhe huapu* entry on a Tang horse-painter prince named Li Xu, in Li, "Freer *Sheep and Goat*," 299.

9 Adapted from Li's translation in "*Grooms and Horses,*" 211–212. Li notes that since the short inscription in which Zhao mentions having seen three works by Han Gan is written on separate silk, it could have been transferred from a different horse painting.

10 Painting in the Yuan court has received a good deal of scholarly attention in recent years; for a good short account, see Marsha Smith Weidner, "Aspects of Painting and Patronage at the Mongol Court, 1260–1368," in Chu-tsing Li et al., eds., *Artists and Patrons: Some Social and Economic Aspects of Chinese Painting* (Seattle: University of Washington Press, 1989), 37–59.

11 Elizabeth Brotherton, in her study of this work, cites the inscriptions on a similar scroll from the same period in describing the process by which such a composite work was created. This is in her unpublished doctoral dissertation "Li Kung-lin and Long Handscroll Illustrations of T'ao Ch'ien's 'Returning Home'" (Princeton University, 1992), p. 221.

12 See Lee and Ho, *Chinese Art,* no. 201.

13 Cahill, *Hills,* pl. 72. The painting is in the Palace Museum, Beijing.

14 See Deborah Del Gais Muller, "Chang Wu: Study of a Fourteenth-Century Figure Painter," *Artibus Asiae* 47, no. 1 (1986): 5–50. Two of the surviving scrolls were painted in 1346, the Jilin scroll in the sixth month and the Shanghai Museum scroll in the tenth. The well-known scroll in the Cleveland Museum was painted in 1361; see Lee and Ho, *Chinese Art,* no. 187, and Cahill, *Hills,* pl. 70.

15 For these poems, see David Hawkes, *Ch'u Tz'u: The Songs of the South* (Oxford: Oxford University Press, 1959), 35–44; this poem is on pp. 38–39.

16 See David Sensabaugh, "Guests at Jade Mountain: Aspects of Patronage in Fourteenth-Century K'un-shan," in Li et al., *Artists and Patrons,* 93–100.

17 The paintings are in the Chionin, Kyoto, and represent the immortals Li Tieguai and Xiama; see Tokyo National Museum, *Sōgen no kaiga* (Song and Yuan painting) (Kyoto, 1962), 46, and Cahill, *Hills,* pl. 66 (Li Tieguai only).

18 See Nancy Shatzman Steinhardt, "Zhu Haogu Reconsidered: A New Date for the ROM Painting and the Southern Shanxi Buddhist-Daoist Style," *Artibus Asiae* 48, nos. 1–2 (1987): 5–38.

19 For one of these, see Cahill, *Hills,* pl. 65.

20 For a discussion of these, see Weidner, "Aspects," 39–41.

21 For the anonymous portrait of Ni Zan, painted in the 1330s or early 1340s, see Cahill, *Hills,* pls. 45 and 46.

22 Herbert Franke, "Two Yüan Treatises on the Technique of Portrait Painting," *Oriental Art* 3, no. 1 (1950): 27–32.

23 For a discussion of Zhao's works in this style, and of their stylistic sources, see Richard Vinograd, "*River Village — The Pleasures of Fishing* and Chao Meng-fu's Li-Kuo Style Landscapes," *Artibus Asiae* 40, nos. 2–3 (1978): 124–142.

24 National Palace Museum, Taibei; see Cahill, *Hills,* pl. 19.

25 *Eight Dynasties of Chinese Painting: The Collections of the Nelson Gallery–Atkins Museum, Kansas City, and the Cleveland Museum of Art* (Cleveland, 1980), no. 24.

26 In the Nelson-Atkins Museum of Art, Kansas City; see Cahill, *Hills,* colorplate 3.

27 See Osvald Sirén, *Chinese Painting: Leading Masters and Principles* (London and New York: Lund Humphries and Ronald

Press, 1956–58), vol. 6, pls. 86, 87. Wu's inscription, written in 1352, states that the painting was done "more than ten years ago."

28 Richard Barnhart, *Wintry Forests, Old Trees: Some Landscape Themes in Chinese Painting* (New York: China House Gallery, 1973), 143.

29 Undated; for a reproduction, see *Zhongguo meishu quanji* (Beijing, 1989), Painting, vol. 5 (Yuan-dynasty painting), pl. 87.

30 A large album leaf in the Palace Museum, Beijing, dated 1325 (see *Zhongguo meishu quanji,* pl. 51); *Two Pine Trees,* dated 1329, in the National Palace Museum, Taibei (see Cahill, *Hills,* pl. 34); and a fan-shaped album leaf in the Princeton Art Museum, undated but probably from this same period (see Lee and Ho, *Chinese Art,* no. 227).

31 *Clearing After Snow on Mountain Peaks,* National Palace Museum, Taibei; see Cahill, *Hills,* pl. 37.

32 It is included in the miscellany *Zhogeng lu* by Tao Zongyi, published in 1366. A partial translation is in Cahill, *Hills,* 86–88; a full translation is in Susan Bush and Hsio-yen Shih, eds., *Early Chinese Texts on Painting* (Cambridge: Harvard University Press, 1985), 262–266.

33 A long study of this scroll by Xu Bangda is in his *Gu shuhua fei'e kaobian* (Nanjing, 1984), vol. 3, pp. 76–79, and vol. 4, pls. 19–21.

34 See, for instance, the article by Du Zhesen, "Ni Yunlin 'yiqi' shuo shixi" (A reconsideration of Ni Zan's "untrammeled spirit"), *Duoyun* 4 (November 1982): 151–160.

35 *Rustic Thoughts in an Autumn Grove,* Metropolitan Museum of Art; see Cahill, *Hills,* pl. 47. A 1355 painting, in the National Palace Museum, Taibei, follows more or less the same plan; see *The Four Great Masters of the Yüan* (Taibei, 1975), no. 301.

36 Richard Vinograd, "Family Properties: Personal Context and Cultural Pattern in Wang Meng's Pien Mountains of 1366," *Ars Orientalis* 8 (1982): 1–29.

37 The painting is in the Palace Museum, Taibei; see Cahill, *Hills,* pl. 58.

38 For an excellent work by one of the Hangzhou-region masters, Meng Yujian, see Cahill, *Hills,* colorplate 8.

39 Translation by Richard Barnhart, from *Along the Border of Heaven: Sung and Yüan Paintings from the C. C. Wang Family Collection* (New York: Metropolitan Museum of Art, 1983).

40 From Wen Fong et al., *Images of the Mind* (Princeton, 1984), 104.

41 See Bush and Shih, *Early Chinese Texts on Painting,* 261. The word *xie* is there rendered as "sketching"; I have used "writing" to bring out the affinity with calligraphy.

42 Richard C. Rudolph, "Kuo Pi: A Yüan Artist and His Diary," *Ars Orientalis* 3 (1959): 175–188.

43 James Cahill, *Chinese Painting* (Geneva: Skira, 1960), 94. The painting is in the Fujii Yūrinkan, Kyoto.

44 For a thorough study of the blossoming plum as a subject in painting and the literature associated with it, see Maggie Bickford et al., *Bones of Jade, Soul of Ice: The Flowering Plum in Chinese Art* (New Haven, 1985); and Bickford, *Ink Plum: The Making of a Chinese Scholar-Painting Genre* (New York: Cambridge University Press, 1996). One version of the *Songzhai meipu* was included as no. 52b in the exhibition of which *Bones of Jade* was the catalogue, and is discussed there. The passage about Wang Mian from the writings of Song Lian, quoted below, is on p. 79.

The Ming Dynasty

1 *Huashi congshu* (Series on the history of painting), ed. Yu An-lan (Shanghai: Shanghai People's Fine Art Publishing House, 1963), p. 6.

2 Ibid., p. 20.

3 *Jinyiwei* literally means "embroidered uniform guard" and names a division of the Imperial Guards to which artists were often assigned.

4 *Ming shi: Liu Jian zhuan* (Biography of Liu Jian in the history of the Ming dynasty), ed. Zhang Tingyu (Beijing: Zhonghua shuju, 1974), p. 4805.

5 Quoted in *Huashi congshu*, ed. Yu Anlan, p. 221. *Xuanhe huapu* (The Xuanhe painting catalogue) was originally published during the Song dynasty in 1120.

6 *Mingdai yuanti zhepai shiliao* (Historical materials on the Zhe School in the Ming dynasty), ed. Mu Yiqin (Shanghai: Shanghai People's Fine Art Publishing House, 1985), pp. 24–25.

7 Ibid., quoting from the *Duhua lu* (Record of examining paintings), p. 23.

8 *Liuru* means "six likes"; that is to say, all things are like a dream, an illusion, a bubble, a shadow, dew, and lightning.

9 In the Wen family line, there were Wen Zhengming's sons, Wen Peng (1498–1573) and Wen Jia (1501–1583), his nephew Wen Boren (1502–1575), grandsons Wen Yuanshan (1554–1589) and Wen Congjian, great-grandsons Wen Zhenmeng (1574–1636) and Wen Zhenheng (1584–1645), great-great-grandsons Wen Nan (1596–1667) and Wen Dian (1633–1704), and great-great-granddaughter Wen Shu. Wen Zhengming's students and their students include Chen Chun, Lu Zhi (1496–1576), Wang Guxiang (1501–1568), Qian Gu (1508–after 1574), Peng Nian (1505–1566), Zhou Tianqiu (1514–1595), Xie Shichen (1487–after 1567), Ju Jie (d. 1585), Sun Zhi (fl. ca. 1550–1580), and Chen Huan (early seventeenth century).

10 Dong Qichang, *Huazhi* (The principles of painting), in *Hualun congkan,* ed. Yu Anlan (Beijing: Beijing People's Fine Art Publishing House, 1989), vol. 1, pp. 70–105.

11 Within the Huating School there are slight differences. For instance, Zhao Zuo (active ca. 1610–1630) also claimed to belong to the Suzhou-Songjiang School, and Shen Shichong (fl. ca. 1611–1640) to the Yunjian School, while Gu Zhengyi stuck to the Huating School. In fact, Zhao Zuo and Shen Shichong both ghost-painted in the name of Dong Qichang. It is very difficult for a layperson to distinguish their paintings from those of Dong.

12 *Kangxi Qiantang xian zhi* (Records of Qiantang County during Kangxi's reign), vol. 26.

13 Qin Zuyong, *Tongyin lunhua* (Discussing painting in the shade of *wutong* trees), in *Yishu congbian,* ed. Yang Jialuo (Taibei: Shijie shuju, 1962).

14 Quoted in *Zhongguo huihua shi* (History of Chinese painting), ed. Yu Jianhua (Shanghai: Shanghai shuju, 1984), vol. 2, p. 265. The *Yutai huashi* (The jade platform history of painting) was compiled in the Qing to record female painters. It divided female artists into four types: emperors' concubines, famous ladies, officers' concubines or servants, and prostitutes. There are three female artists in the first category, all concubines of princes. "Lady" refers to an officer's or a common person's first wife or daughter; fifty-seven female artists belonged to this category. Others painted only the portraits of bodhisattvas or took up painting only as a pastime when young. The few who became famous artists were all influenced by their families, having either a father or a husband who was an artist. They include Dai Jin's daughter, Qiu Ying's daughter Qiu Zhu (fl. ca. 1550), and Wen Congjian's daughter Wen Shu.

15 "Because Ma Shouzhen was a famous prostitute, her paintings were not only treasured by romantics, they were also famous overseas. Even the envoy from Siam bought her painted fan to add to his collection." From *Shigutang shuhua huikao* (Collected textology of calligraphy and paintings), ed. Bian Yongyu, privately printed by the Wang family in Jiangdu in 1921.

16 Instead of expressing sympathy for Xue Susu, Li Rihua's account is tinged with mockery. Scholars in the late Ming dynasty often lauded chaste women and wrote biographies for them, yet they also admired and flattered prostitutes in their poems. This was not considered contradictory behavior at that time.

The Qing Dynasty

1 Zutang was the Zutang Temple in the suburbs of Nanjing, where the artist lived in his last years. The landscape in the painting might be of this area.

2 Opinions differ as to whether Bada Shanren's courtesy name was Zhu Tonglin or Zhu Yichong. The majority of art historians agree that he belonged to the generation of the Zhu family that shared the character Tong in their given names.

3 Wang Fangyu and Richard M. Barnhart, *Master of the Lotus Garden: The Life and Art of Bada Shanren (1626–1705),* ed. Judith G. Smith (New Haven: Yale University Art Gallery and Yale University Press, 1990), 42.

4 Ibid., 140.

5 Ibid., 141.

6 Shitao, quoted in *Zhongguo lidai huajia zhuanlue* (Biographies of Chinese painters of various dynasties), ed. Yan Shaoxian and Ran Xiangzheng (Beijing: China Zhanwang Publishing House, 1986), 184.

7 Shitao, "Inscription on *Most Spectacular Peaks,*" *Zhongguo huihua shi tu lu* (List of illustrations of the history of Chinese painting) (Shanghai: Shanghai People's Fine Art Publishing House, 1984), 774.

8 Shitao, quoted in Sun Meilan, *Suo yao zhe hun — Li Keran de yishu shijie* (Soul is what is needed — The world of art for Li Keran) (Taibei: Taiwan Hongguan Cultural Undertakings, 1993), 80.

9 Wang Yuanqi, quoted in *Zhongguo lidai huajia zhuanlue,* 188.

10 Wang Shujin, quoted in *Zhongguo lidai huajia zhuanlue,* 191.

11 Wang Hui, *Qing Hui hua ba* (Notes by Qing Hui on painting), cited in *Zhongguo lidai huajia zhuanlue,* 200.

12 Wu Li, *Mo Jing hua ba* (Mo Jing's notes on painting), cited in *Zhongguo lidai huajia zhuanlue,* 202.

13 Zhang Geng, *Guochao huazheng lu* (Notes on paintings preserved in the palace), cited in *Huashi congshu* (Series on the history of painting), ed. Yu Anlan (Shanghai: Shanghai People's Fine Art Publishing House, 1963).

14 Fu Shan, *Shuanghongkan ji* (Collected works of the Shuang-hong Pagoda), 2 vols. (rpt.; Taiyuan: Shanxi People's Publishing House, 1985). Trans. Qian-shen Bai, in *The Jade Studio* (New Haven: Yale University Art Gallery, 1994).

15 Jin Nong, translated in Richard Vinograd, *Boundaries of the Self: Chinese Portraits, 1600–1900* (Cambridge: Cambridge University Press, 1992), 116–117.

16 Zheng Xie, translated in Ginger Cheng-chi Hsu, "Zeng Xie's Price List: Painting as a Source of Income in Yangzhou," *Chinese Painting Under the Qianlong Emperor: The Symposium Papers in Two Volumes,* ed. Ju-Hsi Chou and Claudia Brown, in *Phoebus* 6, 2 (1991): 261. See also Zhang Geng, *Guochao huazheng lu.*

17 Zou Yigui, *Shanshui huapu* (Catalogue of landscape paintings), cited in Wang Bomin, *Zhongguo huihua shi* (History of Chinese painting) (Shanghai: Shanghai People's Fine Art Publishing House, 1982), 552.

18 Ren Xiong, translated in James Cahill, "Ren Xiong and His Self-Portrait," *Ars Orientalis* 25 (1995): 126, brackets in original.

Traditional Chinese Painting in the Twentieth Century

1 Chen Shizeng, "The Values of Literati Painting," *Huixue zazhi* (Journal of painting) (Beijing: Painting Research Institute, Beijing University, 1920).

2 Huang Binhong, "On Chinese Painting at the Art Exhibition," in Huang Xiaogeng and Wu Jin, eds., *Guangdong huatan shi lu* (Notes on painting circles in Guangdong) (Guangdong: Lingnan Fine Art Publishing House, 1990).

3 Nian Zhu, "Chinese Painting Has Its National Character," in *Guohua tekan* (Special issues on Chinese painting) (Guangdong: Guangdong Society for the Study of Chinese Painting, 1926).

4 Huang Banruo, "The Distinction Between the New School of Plagiarism and Creative Art," in Huang and Wu, eds., *Guangdong huatan shi lu,* p. 16.

5 Zhao Gonghai, "The Development of the Society for the Study of Chinese Painting," *Zhongshan ribao* (Zhongshan daily), Sept. 13, 1947.

6 Feng Rending, quoted in *Guomin xinwen* (National news), June 26, 1927, in Huang and Wu, eds., *Guangdong huatan shi lu,* p. 48.

7 Gao Qifeng, quoted in "Painting Is Not a Dead Thing" and "Glories and Laments of Mr. Gao Qifeng," in Huang and Wu, eds., *Guangdong huatan shi lu,* p. 111.

8 Chen Duxiu, "On the Revolution of Art," *Xin qingnian* (New youth) 6, no. 1.

9 Jin Shaocheng, *Huaxue jiangyi* (Lectures on painting), quoted in *Hushe yuekan* (Hushe monthly) (Tianjin Municipal Ancient Classics Bookstore) 1 (1992): 378.

10 Huang Binhong, *Binhong shujian* (Correspondence of Huang Binhong), ed. Wang Jiwen (Shanghai: Shanghai People's Publishing House, 1988), p. 35.

11 Huang Binhong, "A Study of Painting" and "Interpretation of the Study of Painting," in *Huang Binhong de huihua sixiang* (Huang Binhong's ideas on painting) (Taibei: Tianhua Publishing, 1979), pp. 170, 172.

12 Chen Xiaodie, "The Modern Chinese Painting as Observed in an Art Exhibition," in *Meizhan huikan* (Collected writings of the art exhibition) (April 1929).

13 Xu Beihong, "Beihong's Autobiography," in *Xu Beihong yishu wenji* (Collected writings on art by Xu Beihong) (Taibei: Taiwan Artists Press, 1987), p. 1.

14 Xu Beihong, "Steps for the Development of the New Chinese Painting," in ibid., p. 529.

15 Xu Boyang and Jin Shan, eds., *Xu Beihong nianpu* (Chronicle of Xu Beihong) (Taibei: Taiwan Artists Press, 1991), p. 214.

academic style. Painting in the style of the Imperial Painting Academy of the Song (960–1279) and Ming (1368–1644) dynasties featuring realistic, meticulously detailed bird-and-flower paintings, precise renderings of architecture, evocative illustrations of poems, and realistic and detailed figural and landscape paintings with fine outlines and often colorful washes.

Academy of Painting. *See* Imperial Painting Academy.

accumulating-ink method. A technique associated with Dong Qichang (1555–1636) and Gong Xian (1618–1689) in which various tones of inkwash, from light to dark, are applied successively to the same area, creating a richly moist effect.

album leaf. Page from an album of painting or calligraphy. Albums, or books of painting and calligraphy, were sometimes created programmatically by an artist or artists and were sometimes compiled by later collectors. Small paintings and both folding and flat fans were usually preserved by mounting them as album leaves.

Amitayus Buddha. The Buddha of Boundless Splendor, who presides over the Western Paradise.

Anhui School. A group of early Qing-dynasty artists centered in Anhui Province — the Huizhou or Xin'an District in particular — including Xiao Yuncong, Hongren, Zha Shibiao, and Mei Qing, whose works reflect highly individualized styles of painting. Their favored subject matter was Mount Huang. Also called the Xin'an School.

apsara. Heavenly being or goddess. The term is usually applied to celestial musicians and dancers surrounding Buddhas and bodhisattvas.

architectural drawing or painting (*jiehua*). Meticulous representation of architecture drawn with fine lines and made using a square and a ruler.

arhats. Disciples of the historical Buddha, Shakyamuni, who lived ascetic lives in their single-minded devotion to the spirit of the Buddha's teachings. These enlightened worthies, also called lohans, are arranged in groups of sixteen, eighteen, or five hundred.

artisan. A local professional craftworker or regional specialist. *See also* literati painting; *minjian huajia*.

ax-cut brushstroke, ax-cut texture stroke. Uncalligraphic downward-sweeping stroke made with the side of the brush. The stroke exhibits a strong, sharp edge and entry, with the effect of an ax chopping into wood, and is used to provide a rocky texture to landscape motifs. Originated by Li Tang (ca. 1050– after 1130).

baimiao. Line drawing in plain black ink in the absence of color.

blue-and-green landscape style. A style of landscape painting believed to have been invented by Li Sixun and his son Li Zhaodao in the Tang dynasty (618–907) that relies on heavy mineral blues and greens and sometimes gold and silver.

Bochen School. Beginning in the Ming dynasty (1368–1644) with Zeng Jing and his followers — Xie Bin among them — the artists in this school were lauded for their realistic, illusionistic portraits. Zeng Jing's style was highly influential on portrait painters of the Qing dynasty and later.

bodhisattva. Enlightened being; a potential Buddha who has denounced final rebirth into nirvana in order to bring salvation to all suffering humankind.

"boneless" (*meigu*) method, "bone-immersing" (*mogu*) method. Painting in color and washes without black ink outlines or structure ("bones").

broken ink (*pomo*). Plentiful application of ink or color in a bold and uninhibited manner to create layers and tones of washes, together with the use of contours for rocks and other landscape forms to produce the illusion of modeling and depth.

Buddha. *See* Amitayus Buddha; Maitreya; Shakyamuni.

ca. Rubbing with a brush squeezed dry after being loaded with dark or light ink.

cao, caoshu. Grass or draft script. This running calligraphic style is cursive and informal.

Chan Buddhism. In Japanese, Zen Buddhism. This popular mystic sect of Buddhism promotes the concept of salvation through meditation to discover the Buddha nature within. First introduced into China by the Indian monk Bodhidharma in the sixth century, Chan profoundly influenced culture and art — especially painting in ink, which is done in fleeting moments of Chan inspiration.

Chang'an School. Modern painters centered in Xi'an, among them Zhao Wangyun, Shi Lu, and Huang Zhou, who have advocated reform of traditional landscape painting by sketching from life and exploring new styles.

civil service examinations. By passing a series of examinations consisting of essays on the Confucian Classics a man of merit and education could advance in government service. The first-degree examinations were held annually at the provincial level. Success there enabled a candidate to take part in the second-degree examinations conducted by the Grand Examiner once every three years. A third, national examination was conducted at the capital once every three years. A scholar who succeeded at this level gained government posts, ranks, salary, and honor.

Classics, Confucian Classics. In different periods of history different books have been treated as Confucian Classics. As many as thirteen have been included on the list. Not until the Song dynasty did most people accept that there were the standard Four Books — *The Great Learning, Doctrine of the Mean, Analects of Confucius,* and *Works of Mencius* — plus the Five Classics (*jing*), which are the *Book of Changes, Book of History, Book of Rites, Book of Songs,* and the *Spring and Autumn Annals.* In the Tang dynasty the sixth Classic was the *Book of Music.*

cloudy mountain style. *See* Mi family manner of landscape painting.

colophon. Poetry or prose annotation written by a friend of the artist, a viewer, or a later collector that is attached to a painting or piece of calligraphy. A colophon is physically separate from the work — typically at the end of a handscroll or on the mounting of a hanging scroll. Poetic colophons are usually in praise of or inspired by the painting.

Confucian Classics. *See* Classics.

continuous pictorial narrative. Painting, generally in the form of a

handscroll or frieze, in which the narrative unfolds from one section to another without break. Often the same personage reappears several times.

crab-claw branch (*xiezhao*). Clusters of short, curving brushstrokes that have a clutching appearance and resemble a crab's claw. Typical of trees in the Li-Guo manner.

craftworker, craftsman. Practitioner of a craft. The term is generally used to describe local and regional artists. *See also* literati painting; *minjian huajia*.

cun. Texture stroke. See also *cunfa*.

cunfa. A method of shading and modeling with brushstrokes to reveal the texture of tree trunks, rocks, and mountains.

curling cloud texture stroke. Brushstroke resembling rolling clouds, made with a long, curving sweep of the brush.

dian. Dotting in black ink or color for emphasis or for definition of planes and contours. Dots are used along rocks and trees to suggest moss.

directional symbols and animals. The Dark Warrior (a tortoise with a snake coiled around its body) represents north and winter; the Green Dragon represents east and spring; the Scarlet Bird represents south and summer; and the White Tiger represents west and autumn.

documentation. The signature, seals, title inscription, attribution, and mounting material of a painting. Other forms of documentation are contemporary and later writings and catalogue records.

Dong-Ju landscape tradition. Named for Dong Yuan and his follower Juran of the Five Dynasties period (907–960), landscapes painted in this style resemble the scenery of south China. They typically have a misty atmosphere; long, soft, "hemp-fiber" texture strokes; rounded "alum-head" boulders; and gently rounded hills.

dotting. See *dian*.

double-outline technique. See *goule* or *shuanggou* manner.

dry-brush method. The application of fairly dry ink, giving an effect often similar to drawing in charcoal. *See also* wet-brush method.

Dunhuang style. A brilliantly colored, dynamic painting style characteristic of the Mogao Caves, or the Caves of the Thousand Buddhas, located in northwest Gansu Province and created from about 366 to 1300. The style reflects the influence of central Asian and Indian Buddhist painting traditions.

Eight Eccentrics of Yangzhou. Group of eight famous artists active in the eighteenth century and centered in Yangzhou, Jiangsu Province, who developed highly individualistic, idiosyncratic painting styles. They include Huang Shen, Jin Nong, Gao Xiang, Li Shan, Zheng Xie, Li Fangying, Wang Shishen, and Luo Pin.

Eight Immortals. Historical and legendary Daoist figures believed to have achieved immortality: Li Tieguai, who carries a crutch and a gourd; Zhongli Quan, who holds a fan; Lan Caihe, a singer portrayed as a young boy; Zhang Guolao (seventh–eighth centuries), who appears with a mule and carries a bamboo drum with iron sticks; He Xiangu (the only woman), who appears with a lotus blossom or flower basket; Lü Dongbin (ca. 755–805), dressed as a scholar and shown with a fly whisk or a magic sword; Han Xiangzi, shown with a flute; and Cao Guojiu, who holds wooden clappers or a jade tablet.

Eight Masters of Jinling. Qing-dynasty artists based in the former Ming capital of Jinling (present-day Nanjing): Fan Qi, Gong Xian, Zou Zhe, Ye Xin, Hu Zao, Wu Hong, Xie Sun, and Gao Cen. They were chiefly landscape painters, and most were loyal to the Ming.

Esoteric Buddhism. Buddhism that is secret and spiritual — secret in the sense that the Buddhist teachings are not revealed to the uninitiated and also in that it suggests mysterious doctrines and magic spells and formulas, and spiritual in the sense that the inner or spiritual meaning underlying all surface meanings must be grasped by intuition and cannot be explained except to those whose character allows them to grasp the truth.

fan. Nonfolding and folding types existed. The most common motifs painted on fans are landscapes and flowers, but calligraphy can also appear by itself. Fans are often painted to be given as presents on particular occasions.

fenben. Preparatory draft or sketch.

five elements. Wood, fire, earth, metal, and water.

Five Sacred Mountains (*wu yue*). Mount Tai in the east (Shandong Province), Mount Hua in the west (Shaanxi Province), Mount Heng in the north (Shanxi Province), a different Mount Heng in the south (Hunan Province), and Mount Song in the middle (Henan Province).

Four Gentlemen. Plum, orchid, bamboo, and chrysanthemum — symbols of moral integrity.

Four Great Artists of Wu. Artists residing in Suzhou (formerly called Wu) in the Ming dynasty: Shen Zhou, Wen Zhengming, Tang Yin, and Qiu Ying.

Four Great Masters of Yuan painting. The scholar-artists Huang Gongwang, Wu Zhen, Ni Zan, and Wang Meng of the Yuan dynasty (1271–1368).

Four Great Monk Painters. Monks of the late Ming and early Qing dynasties who were also painters: Hongren, Kuncan, Bada Shanren, and Shitao.

Four Great Rivers. The Yangzi, Yellow, Huai, and Ji Rivers.

Four Masters of Xin'an. *See* Anhui School.

Four Rens. Ren Xiong, Ren Bonian (Ren Yi), Ren Xun, and Ren Yu — members of the Shanghai School of the late Qing dynasty. *See also* Shanghai School.

Four Wangs. The Qing-dynasty painters Wang Shimin, Wang Jian, Wang Hui, and Wang Yuanqi. *See also* Six Masters of the Early Qing.

Four Wangs, Wu, and Yun. The Qing-dynasty painters Wang Shimin, Wang Jian, Wang Hui, Wang Yuanqi, Wu Li, and Yun Shouping. *See also* Six Masters of the Early Qing.

freehand sketch. See *xieyi*.

Fu She. Revival or Restoration Society of the late Ming dynasty; a group of intellectuals who wanted to restore the glory of the early Ming.

Fuxi. One of the three legendary rulers of ancient China, usually represented with a human head and upper body and a snake-like lower body. He is often associated with the goddess Nüwa.

gongbi. Meticulous, finely detailed style of painting, usually confined to painting in color on silk.

goule or *shuanggou* manner. Double-outline technique; the use of thin contour lines around an element in a painting. In bamboo paintings, stalks and leaves are drawn in ink outline and then filled in with color.

Guanyin. Avalokitesvara, bodhisattva of loving-kindness and mercy, believed to have no gender specificity. In later Chinese

art Guanyin is often pictured as a woman with an ambrosia bottle or lotus flower in her hand and the small figure of the Buddha in her crown or headdress.

Han Chinese. Native or ethnic Chinese, as opposed to Chinese in border regions, in tribal groups, or of foreign origin.

handscroll. Horizontal picture intended to be seen at arm's length while being unrolled to reveal sections about half a meter long at a time.

hanging scroll. A painting that can be unrolled and hung on a wall. The picture, generally higher than it is wide, is meant to be viewed from a distance and at length.

Hanlin Academy. Founded by the Tang-dynasty emperor Ming-huang in the eighth century, this imperial academy had scholars and artists as members. It sponsored compilations and other scholarly endeavors patronized by the emperor and functioned to maintain standards of scholarship, education, and artistry.

hao. Pen name or sobriquet of an artist that is usually connected with a special place, event, interest, or function.

hemp-fiber texture stroke. Long and slightly wavy brushstroke like a split or spread-out hemp fiber. It is used to create the effect of eroded slopes. *See also* Dong-Ju landscape tradition.

Hinayana. The "Small Vehicle" doctrine of Buddhism, which is closer to the original teachings of Shakyamuni, the historical Buddha, than is Mahayana Buddhism. The emphasis is on doctrine rather than worship of the Buddha.

Huating School. *See* Songjiang School.

Imperial Painting Academy, Academy of Painting. Court artists were associated with various forms of organization corresponding to academies beginning in the Tang dynasty. During the Five Dynasties (907–960) the courts of Southern Tang and Shu, among others, brought distinguished artists together at court in loosely organized association. An official Song-dynasty academy was established in Bianliang (present-day Kaifeng) in 984, and Emperor Huizong (r. 1101–1125) later directed important reforms during his reign. The Southern Song Academy in Hangzhou was vigorously reestablished by Emperor Gaozong (r. 1127–1162). In the early Ming dynasty, especially in the period 1403–1435, a new academy was established, first in Nanjing and then in Beijing. The final Imperial Painting Academy was the one organized by the Manchu emperors in Beijing during the Qing dynasty, and was strongly influenced by European art. *See also* academic style.

ink monochrome manner. Method of painting only in ink and without color. In painting bamboo, for example, brushstrokes are done in varying ink tones to render the back and front of the leaves and to distinguish nearer and farther planes of depth.

ink-play. An informal type of painting by literati artists exploring spontaneous brushwork and unusual ink effects.

inscription. Poem, comment, and other writing on the surface of a painting or piece of calligraphy.

Jataka Tales. Stories of previous lives of the Buddha when he was in either human or animal form.

Jiangnan-style painting. Misty landscape of the Yangzi delta region (Jiangnan) painted with pale ink and washes.

Jiangxia School. Artists in Nanjing and, more broadly, Hunan Province who followed the style of the Ming artist Wu Wei by using swift, even brash brushwork and emphasizing emotional expression and bold effects.

Jing-Guan style of landscape. Named after Jing Hao (ca. 855–915) and Guan Tong (early tenth century), landscapes painted in this style have hard, high, sheer mountain peaks, narrow paths, and difficult ascents.

Jingjiang School. Qing-dynasty artists of the later Qianlong and Jiaqing periods, including Gu Heqing and Zhang Yin, who gathered in Zhenjiang, a city on the lower reaches of the Yangzi River.

kai. Regular or model script. In this most formal of the modern scripts of Chinese calligraphy, every stroke is written clearly and separately, and each character is organized within a square. Kai is the script usually used in printed books.

King Father of the East (Dongwang fu). A deity who presides over the eastern realm of Heaven and who is the consort of the Queen Mother of the West.

Kui Hai Cooperative. Group of fourteen modern painters in Guangdong. The cooperative later became the Society for the Study of Chinese Painting.

Later Zhe School. The professional artist Lan Ying and his students — Liu Du among them — who painted in the late Ming period and were based in the city of Hangzhou, formerly called Wulin. Also called the Wulin School.

li. Official or clerical script from which evolved the script used today.

Li-Guo School, Li-Guo manner, Li-Guo tradition. These terms generally refer to paintings in the style of Li Cheng and Guo Xi, two skillful and influential landscape painters of the Five Dynasties (907–960) and the Northern Song period (960–1127). They are known for their expansive depictions of the sparsely vegetated river valleys of the north, with hills eroded into strange shapes and clumps of bare or coniferous trees. Paintings in the Li-Guo manner convey a bleak grandeur and a sense of the struggle of living things for survival under harsh conditions.

Lingnan School. Led by Gao Jianfu and including Chen Shuren, Gao Qifeng, and He Xiangning, this group of modern artists centered in Guangdong advocated reform in painting. They followed the tenets of the New Japanese Style and introduced contemporary subjects into traditional Chinese painting, combining perspective, shading, and atmosphere with traditional brushwork.

lingzhi. Sacred mushroom-shaped fungus, a symbol of longevity.

literati painting (*wenrenhua*). A term used to describe and distinguish paintings by scholars and scholar-officials from those by professional painters. Literati painters aimed for free expression of ideas, feelings, and emotions rather than accurate depiction of external phenomena. These scholar-amateurs, who thought paintings should reveal the artist's personality, character, or mood, often lacked rigorous training. They favored monochrome ink over color and used the same materials for painting and calligraphy. They painted spontaneously, at whim, mostly for themselves and their friends, although some literati painters discreetly sold or traded their works to support themselves.

Longshan culture. Culture centered in Shandong Province and dating back to around 3000–1700 B.C. It is known for fine monochromic pottery vessels with impressed or relief patterns.

lotus leaf texture stroke. Brushstroke that resembles the vein of a dried lotus leaf.

Ma family. Five generations of the famous Ma family, including Ma Yuan and Ma Lin, all associated with the Imperial Academy of Painting at the Southern Song (1127–1279) court.

Ma style. The style of Ma Yuan (active before 1189–after 1225), whose paintings are noted for their intimate landscape views, hazy or misty atmosphere, and carefully constructed composition. The focus is often one corner of the painting where a scholar and his attendant contemplate the landscape. Other features are sharp, angular plum trees, tall, dramatic pine trees, and distant mountaintops in pale silhouette.

Ma-Xia style. The term combines the names of academy painters Ma Yuan and Xia Gui, and the style represents the typical achievement of the Imperial Painting Academy of the Southern Song. Characteristic are carefully constructed compositions, intimate views of nature, suggestive inkwashes, and dramatic, angular pine and plum trees.

Mahayana. The "Great Vehicle" doctrine of Buddhism, which asserts the existence of many Buddhas at the same time. Believers may gain salvation by praying to the Buddhas or bodhisattvas and can accumulate merit to counter any evildoing in their prior lives by dedicating paintings or sculpture to the Buddhas or bodhisattvas.

Maitreya. In traditional China, Mile fo, or Maitreya Buddha — the Buddha of the Future. Strictly speaking, Maitreya is a bodhisattva, not a Buddha.

meticulously detailed painting style. See *gongbi*.

Mi family manner of landscape painting, Mi style. This style of painting, named for the Northern Song artist Mi Fu and his son, Mi Youren, is also called the cloudy mountain style because the landscapes include mountains in fog or hills before rain. The artists characteristically employ large wet dots to depict vegetation and softly modeled hills.

minjian huajia. Local artist or regional painter. Often translated as "craftsman" or "artisan."

monochrome ink. Ink without added color. *See also* ink monochrome manner.

Nanjing painters, Nanjing School. Painters centered in the city of Nanjing. In the early Qing dynasty: Fan Qi, Gong Xian, and others; also known as the Jinling School — *see also* Eight Masters of Jinling. In the twentieth century: Chen Zhifo, Fu Baoshi, and others.

New Zhe School. Modern painters associated with the Zhejiang Academy of Fine Arts, including Pan Tianshou, Sha Menghai, Wu Fuzhi, Lu Weizhao, Lu Yanshao, and Gu Kunbo.

Northern and Southern Schools. In the Ming dynasty, Dong Qichang and Mo Shilong traced the development of Chinese painting back to the Tang dynasty and divided painters into two schools that mirrored the split in Chan Buddhism around the same time. The Southern School, promoted by Dong Qichang, favored the expression of emotion in painting in opposition to the meticulously detailed, colorful representation of real scenery, as in works produced by the Northern School. The Southern School generally included literati painters, like Wang Wei, Zhang Zao, Jing Hao, Guan Tong, Dong Yuan, Juran, Guo Zhongshu, Mi Fu, Mi Youren, Huang Gongwang, Wu Zhen, Ni Zan, and Wang Meng. The Northern School generally included professional and court painters, such as Li Sixun, Li Zhaodao, Zhao Gan, Zhao Boju, Zhao Bosu, Ma Yuan, and Xia Gui.

Northern Song monumental landscape painting. Paintings of this type are mountain compositions whose deep space, distant vistas, rhythmic structure, tiny human figures, and occasional architectural features invite the viewer to participate visually in a vast, ordered universe.

Orthodox School. Landscape painters of the Qing dynasty. The style of this school developed from painting in the late Ming dynasty, when Dong Qichang's writings consolidated the literati-amateur styles of the Southern School into an orthodox tradition. Practitioners used styles of the Four Great Masters of the Yuan period and produced variations in their own manner following Dong's theories. Principal artists were Wang Shimin, Wang Jian, Wang Hui, Wang Yuanqi, and Wu Li.

Piling School. A regional school named for the city southeast of Nanjing where they painted, Piling (present-day Changshu, Jiangsu Province). The artists — Yun Shouping among them — specialized in decorative, colorful paintings of flowers, plants, birds, and insects.

powder-spatter. The addition of colored powder to a painting that is already sprinkled with water, so that the water and powder merge on the paper for enhanced color and intensity.

professional painter. Person who paints pictures to earn a living, as opposed to a scholar-amateur. *See also* literati painting.

Queen Mother of the West (Xiwang mu). A goddess in Han popular religion, usually shown as a beautiful woman accompanied by Jade Maidens carrying flowers and peaches, the Queen Mother of the West was believed to guard the peaches of immortality. In Daoism she is the deity who presides over the western realm of Heaven and is the consort of the King Father of the East.

round brushwork. The brushtip is centered within the brushstroke, and pressure is applied evenly.

scholar-artist, scholar-official, scholar-painter, scholar-amateur, literatus artist. *See* literati painting.

seal script (*zhuan*). Elaborate form of writing used from around 800 B.C. to A.D. 200 including the "greater seal" script and the "lesser seal" script, which developed from the former. Examples of both can be found in inscriptions on bronze vessels. The lesser and greater seal scripts are now used on public and private seals.

seals. Small scarlet marks, generally square but occasionally round, oval, or gourd-shaped, stamped on paintings and works of calligraphy. A seal contains the name of an artist, a friend, or a collector; the characters can also be an identifying phrase.

Seven Worthies of the Bamboo Grove. Educated men of the third century A.D. who rejected society and all its rules and conventions, finding personal freedom in self-expression, wine, and unspoiled nature. It was believed that the seven men — Ji Kang, Liu Ling, Ruan Qi, Ruan Xiao, Shan Tao, Wang Rong, and Xiang Xiu — regularly met in a bamboo grove to drink wine and discuss literature.

Shakyamuni. The historical Buddha, Siddhartha Gautama, who is perfectly enlightened and has entered nirvana. Mahayana Buddhism allows for many Buddhas to exist at one time; Hinayana Buddhism, only one Buddha at a time.

Shanghai School. A group of artists of the late Qing dynasty whose works are characterized by free and spirited brushwork, exaggeration and distortion of shapes and images, patternization, and archaism. These artists — including Hu Gongshou, Ren Xiong, Xugu, Zhao Zhiqian, Qian Hui'an, Ren Xun, Ren Bonian (Ren Yi), Ren Yu, Wu Youru, and Wu Jiayou — catered to the tastes of city dwellers.

shiguwen. Script carved into drum-shaped stones about 200 B.C.

shuanggou manner. See *goule* or *shuanggou* manner.

Six Masters of the Early Qing. Principal figures in the Orthodox School of landscape painting, including Wang Shimin, Wang Jian, Wang Hui, Wang Yuanqi, Wu Li, and Yun Shouping. *See also* Four Wangs, Wu, and Yun; Orthodox School.

Six Principles of Xie He. The principles of painting set forth by the art critic Xie He (active ca. 500?) concerning the "spirit consonance" of painted forms, brushwork, shape, color, composition, and copying as a means of training.

Songjiang School. School of Dong Qichang (1555–1636) centered in Huating (a part of Shanghai), now Songjiang. Sometimes called the Huating School. Included are such artists as Mo Shilong, Chen Jiru, Gu Zhengyi, Zhao Zuo, and Shen Shichong.

splashed ink and splashed color. Painting technique originating in the Ming dynasty that features large areas of color without concrete forms. Zhang Daqian (1899–1983) also used the term to refer to his painting technique based on Abstract Expressionism and traditional Chinese ink painting.

split-hemp texture stroke. *See* hemp-fiber texture stroke.

sutra. Buddhist holy text usually attributed to the Buddha.

Three Friends of the Cold Season. Pine, bamboo, and blossoming plum — all symbols of longevity, winter, and the qualities of a gentleman.

three-tier ranking system. According to the *Lidai minghua ji* (Record of famous paintings of successive dynasties) by the Tang-dynasty art critic Zhang Yanyuan, all artists could be classified into three major categories: inspired (*shen*), excellent (*miao*), or capable (*neng*). Later a category called *yipin,* or "untrammeled," was added.

Two Yuans. Artists of the Qing dynasty: Yuan Jiang and Yuan Yao.

"untrammeled" (*yipin*) style. Spontaneous and completely unrestrained painting, a style employed by many artists who were considered wild and eccentric. *See also* three-tier ranking system.

Vimalakirti. A lay disciple of Shakyamuni and a man of great learning with supernatural powers. When Vimalakirti was sick, Manjusri, the Bodhisattva of Wisdom, and other disciples of the Buddha visited him. The event is known for a famous debate between Vimalakirti and Manjusri. Later considered almost a lay saint, Vimalakirti became the archetype of the Chinese scholar-official engaged with Buddhism at an intellectual level.

water-spatter. Sprinkling water on a painting that is already colored, so that the water merges with the pigment on the paper for enhanced color and intensity.

wet-brush method. The application of ink with a loaded brush so that individual strokes can be obliterated.

White Tiger. *See* directional symbols and animals.

Wu School. Suzhou-based literati-painters of the Ming dynasty beginning with Shen Zhou and including Wen Zhengming, Tang Yin, Qiu Ying, Wen Jia, Wen Boren, Wang Guxiang, Xie Shichen, and others. Wu is the former name of Suzhou.

Wulin School. *See* Later Zhe School.

xieyi. Literally, "sketching the idea." A spontaneous freehand sketch style of painting usually done by scholars in monochrome ink but occasionally done in colors.

Xiling Seal Society. Academic society devoted to the study of seal carving. It was founded in 1904 on Gushan, a small hill on an island of the same name off the north shore of scenic West Lake in Hangzhou.

Xin'an School. *See* Anhui School.

xing. "Running" or "strolling" script; a semicursive calligraphic style.

Yangshao culture. Major Neolithic tradition, also called the Painted Pottery culture. The Yangshao culture developed in the Yellow River valley between the fifth and the third millennia B.C. Sites include Banpo, Shaanxi Province; Miaodigou, Henan Province, and Majiayao, Machang, and Banshan, all in Gansu Province.

yimin. "Leftover subjects," loyalists to a fallen dynasty.

Yunjian School. *See* Songjiang School.

Zhe School. Named after Zhejiang Province, where it flourished, the Zhe School of Ming-dynasty professional and court painters, including Dai Jin, continued the academic traditions of figure and landscape painting originating in the Southern Song Imperial Painting Academy.

Zhong Kui. Legendary demon-queller, usually portrayed as a large, ugly man wearing a scholar's cap, robe, and large boots with which he stomps on offensive demons.

zhuan. *See* seal script.

Prepared by Elizabeth M. Owen

ARTISTS BY PERIOD

Artists are generally listed by their formal name and in the period in which they were born. Alternative pronunciations of names are given in parentheses. In the Zi and Hao columns, Wade-Giles transliterations are given in brackets.

Pinyin	Wade-Giles	Dates	Characters	Zi (style name)	Hao (sobriquet) and Other Names
THREE KINGDOMS					
Cao Buxing	Ts'ao Pu-hsing	3d c.	曹不兴		
JIN DYNASTY					
Gu Kaizhi	Ku K'ai-chih	ca. 345–ca. 406	顾恺之	Changkang [Ch'ang-k'ang] 长康	Hutou [Hu-t'ou] 虎头
Wang Xizhi	Wang Hsi-chih	307–ca. 365	王羲之	Yishao [I-shao] 逸少	
Wei Xie	Wei Hsieh	W. Jin, mid-3d–mid-4th c.	卫协		
SOUTHERN DYNASTIES					
Lu Tanwei	Lu T'an-wei	active 460s–early 6th c.	陆探微		
Wang Wei	Wang Wei	415–443	王微	Jingxuan [Ching-hsüan] 景玄	
Xiao Yi [Emperor Yuan of the Liang]	Hsiao I	508–554	萧绎	Shicheng [Shih-ch'eng] 世诚	
Zhang Sengyou	Chang Seng-yu	active 500–550	张僧繇		
NORTHERN DYNASTIES					
Yang Zihua	Yang Tzu-hua	No. Qi, active mid–late 6th c.	杨子华		
SUI DYNASTY					
Dong Boren	Tung Po-jen	active mid–late 6th c.	董伯仁		
Sun Shangzi	Sun Shang-tzu	late 6th–early 7th c.	孙尚子		
Tian Sengliang	T'ien Seng-liang	No. Zhou, late 6th c.	田僧亮		
Weichi (Yuchi) Bazhina	Wei-ch'ih (Yü-ch'ih) Pa-chih-na	6th–7th c.	尉迟跋质那		
Yan Bi	Yen Pi	563–613	阎毗		
Yang Qidan	Yang Ch'i-tan	active last half of 6th c.	杨契丹		
Zhan Ziqian	Chan Tzu-ch'ien	mid–late 6th c.	展子虔		
Zheng Falun	Cheng Fa-lun	6th–7th c.	郑法轮		
Zheng Fashi	Cheng Fa-shih	6th–early 7th c.	郑法士		
TANG DYNASTY					
Cao Ba	Ts'ao Pa	8th c.	曹霸		
Chen Hong	Ch'en Hung	8th c.	陈闳		
Dai Song	Tai Sung	8th c.	戴嵩		
Han Gan	Han Kan	ca. 720–780	韩干		
Han Huang	Han Huang	723–787	韩滉	Taichong [T'ai-ch'ung] 太冲	
He Zhizhang	Ho Chih-chang	659–744	贺知章	Jizhen [Chi-chen] 季真	
Huaisu	Huai-su	725–785	怀素	Cangzhen [Ts'ang-chen] 藏真	
Lang Yuling	Lang Yü-ling	early Tang	郎余令		
Li Cou	Li Ts'ou	mid-8th c.	李凑		
Li Linfu	Li Lin-fu	d. 752	李林甫	Genu [Ke-no] 哥奴	
Li Sixun	Li Ssu-hsün	651–716	李思训	Jianjian [Chien-chien] 建见	
Li Zhaodao	Li Chao-tao	ca. 675–741	李昭道		
Lu Hong	Lu Hung	active early 8th c.	卢鸿	Haoran [Hao-jan] 颢然 or 浩然	

Pinyin	Wade-Giles	Dates	Characters	Zi (style name)	Hao (sobriquet) and Other Names
Wang Mo [Ink Wang]	Wang Mo	d. ca. 805	王默		
Wang Wei	Wang Wei	699–759	王维	Moji [Mo-chi] 摩诘	
Wang Xiong	Wang Hsiung	active early 8th c.	王熊		
Wei Yan	Wei Yen	late 7th–early 8th c.	韦偃		
Weichi (Yuchi) Yiseng	Wei-ch'ih (Yü-ch'ih) I-seng	7th–8th c.	尉迟乙僧		
Wu Daozi	Wu Tao-tzu	active ca. 710–760	吴道子		
Xue Ji	Hsüeh Chi	649–713	薛稷	Sitong [Ssu-t'ung] 嗣通	
Yan Liben	Yen Li-pen	ca. 600–673	阎立本		
Yan Lide	Yen Li-te	d. 656	阎立德		
Yan Zhenqing	Yen Chen-ch'ing	709–785	颜真卿	Qingchen [Ch'ing-ch'en] 清臣	
Yang Bian	Yang Pien	Tang	杨辨		
Zhang Xiaoshi	Chang Hsiao-shih	7th–8th c.	张孝师		
Zhang Xu	Chang Hsü	active 714–742	张旭	Bogao [Po-kao] 伯高	
Zhang Xuan	Chang Hsüan	active 714–742	张萱		
Zhang Zao	Chang Tsao	mid–late 8th c.	张璪	Wentong [Wen-t'ung] 文通	
Zheng Qian	Cheng Ch'ien	ca. 690–764	郑虔	Ruoqi [Jo-ch'i] 弱齐	
Zhou Fang	Chou Fang	ca. 730–ca. 800	周昉	Zhonglang [Chung-lang] 仲朗, Jingxuan [Ching-hsüan] 景玄	

FIVE DYNASTIES AND TEN KINGDOMS

Pinyin	Wade-Giles	Dates	Characters	Zi (style name)	Hao (sobriquet) and Other Names
Dong Yuan	Tung Yüan	d. 962	董源 or 董元	Shuda [Shu-ta] 叔达	Beiyuan [Pei-yüan] 北苑
Gao Congyu	Kao Ts'ung-yü	ca. 10th c.	高从遇		
Gao Daoxing	Kao Tao-hsing	9th c.	高道兴		
Gu Hongzhong	Ku Hung-chung	10th c.	顾闳中		
Guan Tong	Kuan T'ung	early 10th c.	关仝 or 关同		
Guanxiu	Kuan-hsiu	832–912	贯休	Deyin [Te-yin] 德隐, Deyuan [Te-yüan] 德远	Chanyue [Ch'an-yüeh] 禅月
Guo Zhongshu	Kuo Chung-shu	ca. 910–977	郭忠恕	Shuxian [Shu-hsien] 恕先	
Huang Jubao	Huang Chü-pao	d. ca. 960	黄居宝	Ciyu [Tz'u-yü] 辞玉	
Huang Jucai	Huang Chü-ts'ai	933–after 993	黄居寀	Boluan [Po-luan] 伯鸾	
Huang Quan	Huang Ch'üan	903–965	黄筌	Yaoshu [Yao-shu] 要叔	
Jing Hao	Ching Hao	ca. 855–915	荆浩	Haoran [Hao-jan] 浩然	Hongguzi [Hung-ku-tzu] 洪谷子
Juran	Chü-jan	active ca. 960–985	巨然		
Li Cheng	Li Ch'eng	919–967	李成	Xianxi [Hsien-hsi] 咸熙	
Wei Xian	Wei Hsien	10th c.	卫贤		
Xu Xi	Hsü Hsi	d. before 975	徐熙		
Zhang Xuan	Chang Hsüan	active ca. 890–930	张玄		
Zhao Gan	Chao Kan	mid-10th c.	赵干		
Zhao Yan	Chao Yen	d. 922	赵岩	Luzhan [Lu-chan] 鲁瞻, Qiuyan [Ch'iu-yen] 秋巘	Original name Zhao Lin [Chao Lin] 赵霖

SONG DYNASTY

Pinyin	Wade-Giles	Dates	Characters	Zi (style name)	Hao (sobriquet) and Other Names
Chen Rong	Ch'en Jung	ca. 1200–1266	陈容	Gongchu [Kung-ch'u] 公储, Sike [Ssu-k'o] 思可	Suoweng [So-weng] 所翁
Cui Bai	Ts'ui Pai	active ca. 1050–1080	崔白	Zixi [Tzu-hsi] 子西	
Dong Yu	Tung Yü	active late 10th c.	董羽	Zhongxiang [Chung-hsiang] 仲翔	
Fan Kuan	Fan K'uan	active ca. 1023–1031	范宽	Zhongli [Chung-li] 仲立	Original name Fan Zhongzheng [Fan Chung-cheng] 范中正
Gao Keming	Kao K'o-ming	active ca. 1008–1053	高克明		
Gao Wenjin	Kao Wen-chin	11th c.	高文进		
Guo Xi	Kuo Hsi	ca. 1001–ca. 1090	郭熙	Chunfu [Ch'un-fu] 淳夫	
Huang Tingjian	Huang T'ing-chien	1045–1105	黄庭坚	Luzhi [Lu-chih] 鲁直	Shangu [Shan-ku] 山谷, Fuweng [Fu-weng] 涪翁
Huizong	Hui-tsung	1082–1135; r. 1101–1125	徽宗		Original name Zhao Ji [Chao Chi] 赵佶

Pinyin	Wade-Giles	Dates	Characters	Zi (style name)	Hao (sobriquet) and Other Names
Li Congxun	Li Ts'ung-hsün	active 12th c.	李从训		
Li Demao	Li Te-mao	active ca. 1241–1252	李德茂		
Li Di	Li Ti	ca. 1100–after 1197	李迪		
Li Gonglin	Li Kung-lin	ca. 1041–1106	李公麟	Boshi [Po-shih] 伯时	Longmian Jushi [Lung-mien chü-shih] 龙眠居士
Li Gongnian	Li Kung-nien	late 11th–early 12th c.	李公年		
Li Song	Li Sung	active 1190–1230	李嵩		
Li Tang	Li T'ang	ca. 1050–after 1130	李唐	Xigu [Hsi-ku] 晞古	
Li Wei	Li Wei	active ca. 1050–ca. 1090	李玮	Gongzhao [Kung-chao] 公昭	
Li Yongnian	Li Yung-nien	active ca. 1265–1274	李永年		
Liang Kai	Liang K'ai	active 13th c.	梁楷	Fengzi [Feng-tzu] 风子	
Liu Cai	Liu Ts'ai	d. after 1123	刘寀	Daoyuan [Tao-yüan] 道源, Hongdao [Hung-tao] 宏道	
Liu Songnian	Liu Sung-nien	ca. 1150–after 1225	刘松年		
Ma Ben (Fen)	Ma Pen (Fen)	early 12th c.	马贲		
Ma Gongxian	Ma Kung-hsien	12th c.	马公显		
Ma Lin	Ma Lin	active early–mid-13th c.	马麟		
Ma Yuan	Ma Yüan	active before 1189–after 1225	马远		Qinshan [Ch'in-shan] 钦山
Mi Fu	Mi Fu	1051–1107	米芾	Yuanzhang [Yüan-chang] 元章	Nangong [Nan-kung] 南宫, Lu-men Jushi [Lu-men chü-shih] 鹿门居士, Xiangyang Manshi [Hsiang-yang man-shih] 襄阳漫士, Haiyue Waishi [Hai-yüeh wai-shih] 海岳外史
Mi Youren	Mi Yu-jen	1075–1151	米友仁	Yuanhui [Yüan-hui] 元晖	
Muqi (Muxi)	Mu-ch'i (Mu-hsi)	13th c.	牧溪		Fachang [Fa-ch'ang] 法常
Qi Xu	Ch'i Hsü	10th c.	祁序		
Qiao Zhongchang	Ch'iao Chung-ch'ang	active early 12th c.	乔仲常		
Su Shi	Su Shih	1036–1101	苏轼	Zizhan [Tzu-chan] 子瞻	Dongpo Jushi [Tung-p'o chü-shih] 东坡居士
Sun Zhiwei	Sun Chih-wei	d. ca. 1020	孙知微	Taigu [T'ai-ku] 太古	
Wang Shen	Wang Shen	ca. 1048–ca. 1103	王诜	Jinqing [Chin-ch'ing] 晋卿	
Wang Tingyun	Wang T'ing-yün	1151–1202	王庭筠	Ziduan [Tzu-tuan] 子端	Huanghua Shanren [Huang-hua shan-jen] 黄华山人
Wang Ximeng	Wang Hsi-meng	1096–1119	王希孟		
Wen Tong	Wen T'ung	1019–1079	文同	Yuke [Yü-k'o] 与可	Jinjiang Daoren [Chin-chiang tao-jen] 锦江道人, Xiaoxiao Jushi [Hsiao-hsiao chü-shih] 笑笑居士, Shishi Xiansheng [Shih-shih hsien-sheng] 石室先生
Xia Gui	Hsia Kuei	active early 13th c.	夏圭	Yuyu [Yü-yü] 禹玉	
Xiao Zhao	Hsiao Chao	active ca. 1130–1160	萧照		
Xu Chongsi	Hsü Ch'ung-ssu	11th c.	徐崇嗣		
Xu Daoning	Hsü Tao-ning	ca. 970–1051/1052	许道宁		
Yan Wengui	Yen Wen-kuei	active 980–1010	燕文贵		
Yang Wujiu	Yang Wu-chiu	1097–1171	扬无咎	Buzhi [Pu-chih] 补之	Taochan Laoren [Tao-ch'an lao-jen] 逃禅老人
Yi Yuanji	I Yüan-chi	11th c.	易元吉	Qingzhi [Ch'ing-chih] 庆之	
Yujian Ruofen	Yü-chien Jo-fen	13th c.	玉涧若芬	Zhongshi [Chung-shih] 仲石	Furong Shanzhu [Fu-jung shan-chu] 芙蓉山主, Yujian [Yü-chien] 玉涧
Zhang Zeduan	Chang Tse-tuan	active early 12th c.	张择端	Zhengdao [Cheng-tao] 正道, Wenyou [Wen-yu] 文友	
Zhao Boju	Chao Po-chü	d. ca. 1162	赵伯驹	Qianli [Ch'ien-li] 千里	

Pinyin	Wade-Giles	Dates	Characters	Zi (style name)	Hao (sobriquet) and Other Names
Zhao Bosu	Chao Po-su	1124–1182	赵伯骕	Xiyuan [Hsi-yüan] 希远	
Zhao Chang	Chao Ch'ang	ca. 960–after 1016	赵昌	Changzhi [Ch'ang-chih] 昌之	
Zhao Lingrang	Chao Ling-jang	active c. 1070–1100	赵令穰	Danian [Ta-nien] 大年	
Zhao Mengjian	Chao Meng-chien	1199–before 1267	赵孟坚	Zigu [Tzu-ku] 子固	Yizhai Jushi [I-chai chü-shih] 彝斋居士
Zhao Shilei	Chao Shih-lei	Song	赵士雷	Gongzhen [Kung-chen] 公震	

YUAN DYNASTY

Cao Zhibai	Ts'ao Chih-pai	1271–1355	曹知白	Youxuan [Yu-hsüan] 又玄, Zhensu [Chen-su] 真素	Yunxi [Yün-hsi] 云西
Chen Lin	Ch'en Lin	ca. 1260–1320	陈琳	Zhongmei [Chung-mei] 仲美	
Chen Ruyan	Ch'en Ju-yen	ca. 1331–before 1371	陈汝言	Weiyun [Wei-yün] 惟允	Qiushui [Ch'iu-shui] 秋水
Fang Congyi	Fang Ts'ung-i	ca. 1301–after 1380	方从义	Wuyu [Wu-yü] 无隅	Fanghu [Fang-hu] 方壶
Gao Kegong	Kao K'o-kung	1248–1310	高克恭	Yanjing [Yen-ching] 彦敬	Original name Shi'an [Shih-an] 士安, Fangshan Laoren [Fangshan lao-jen] 房山老人
Gong Kai	Kung K'ai	1222–1307	龚开	Shengyu [Sheng-yü] 圣予	Cuiyan [Ts'ui-yen] 翠岩
Guan Daosheng	Kuan Tao-sheng	1262–1319	管道升	Zhongji [Chung-chi] 仲姬	
Guo Bi	Kuo Pi	1280–d. ca. 1335	郭畀	Tianxi [T'ien-hsi] 天锡	Tuisi [T'ui-ssu] 退思
He Cheng	Ho Ch'eng	1224–after 1315	何澄		
Huang Gongwang	Huang Kung-wang	1269–1354	黄公望	Zijiu [Tzu-chiu] 子久	Yifeng [I-feng] 一峰, Dachi Daoren [Ta-ch'ih tao-jen] 大痴道人, Jingxi Laoren [Ching-hsi lao-jen] 井西老人
Ke Jiusi	K'o Chiu-ssu	1290–1343	柯九思	Jingzhong [Ching-chung] 敬仲	Danqiusheng [Tan-ch'iu sheng] 丹丘生
Li Kan	Li K'an	1245–1320	李衎	Zhongbin [Chung-pin] 仲宾	Xizhai Laoren [Hsi-chai lao-jen] 息斋老人
Li Sheng	Li Sheng	14th c.	李升	Ziyun [Tzu-yün] 子云	Ziyunsheng [Tzu-yün-sheng] 紫筼生
Luo Zhichuan	Lo Chih-ch'uan	active ca. 1300–1330	罗稚川		
Meng Yujian	Meng Yü-chien	active 14th c.	孟玉涧	Jisheng [Chi-sheng] 季生	Meng Zhen [Meng Chen] 孟珍, Tianze [T'ien-tse] 天泽
Ni Zan	Ni Tsan	1301–1374	倪瓒	Yuanzhen [Yüan-chen] 元镇	Yunlin [Yün-lin] 云林, Jingming Jushi [Ching-ming chü-shih] 净名居士
Qian Xuan	Ch'ien Hsüan	ca. 1235–before 1307	钱选	Shunju [Shun-chü] 舜举	Yutan [Yü-t'an] 玉潭
Ren Renfa	Jen Jen-fa	1255–1328	任仁发	Ziming [Tzu-ming] 子明	Yueshan Daoren [Yüe-shan tao-jen] 月山道人
Sheng Mao	Sheng Mao	active 1320–1360	盛懋	Zizhao [Tzu-chao] 子昭	
Tan Zhirui	T'an Chih-jui	active early Yuan	檀芝瑞		
Tang Di	T'ang Ti	1296–1364	唐棣	Zihua [Tzu-hua] 子华	
Wang Meng	Wang Meng	ca. 1308–1385	王蒙	Shuming [Shu-ming] 叔明	Huanghe Shanqiao [Huang-ho shan-ch'iao] 黄鹤山樵, Huanghe Shanren [Huang-ho shan-jen] 黄鹤山人, Xiangguang Jushi [Hsiang-kuang chü-shih] 香光居士
Wang Mian	Wang Mien	1287–1359	王冕	Yuanzhang [Yüan-chang] 元章	Laocun [Lao-ts'un] 老村, Zhushi Shannong [Chu-shih shan-nung] 煮石山农
Wang Yi	Wang I	1333–d. after 1362	王绎	Sishan [Ssu-shan] 思善	Chijue Sheng [Ch'ih-chüeh sheng] 痴绝生
Wang Yuan	Wang Yüan	ca. 1280–d. after 1349	王渊	Roshui [Jo-shui] 若水	Danxuan [Tan-hsüan] 澹轩
Wang Zhenpeng	Wang Chen-p'eng	fl. ca. 1280–ca. 1329	王振鹏	Pengmei [P'eng-mei] 朋梅	Guyun Chushi [Ku-yün ch'u-shih] 孤云处士
Wu Guan	Wu Kuan	active ca. 1368	吴瓘	Yingzhi [Ying-chih] 莹之	
Wu Taisu	Wu T'ai-su	active mid-14th c.	吴太素	Xiuzhang [Hsiu-chang] 秀章	Songzhai [Sung-chai] 松斋

Pinyin	Wade-Giles	Dates	Characters	Zi (style name)	Hao (sobriquet) and Other Names
Wu Zhen	Wu Chen	1280–1354	吴镇	Zhonggui [Chung-kuei] 仲圭	Meihua Daoren [Mei-hua tao-jen] 梅花道人
Xianyu Shu	Hsien-yü Shu	ca. 1257–1302	鲜于枢	Boji [Po-chi] 伯机	Kunxuemin [K'un-hsüeh-min] 困学民, Zhiji Laoren [Chih-chi lao-jen] 直寄老人
Yan Hui	Yen Hui	active late 13th–early 14th c.	颜辉	Qiuyue [Ch'iu-yüeh] 秋月	
Yang Weizhen	Yang Wei-chen	1296–1370	杨维桢	Lianfu [Lien-fu] 廉夫	Tieya [T'ich-ya] 铁崖
Zhang Wu	Chang Wu	fl. ca. 1340–1365	张渥	Shuhou [Shu-hou] 叔厚	Zhenxiansheng [Chen-hsien-sheng] 贞闲生, Zhenqisheng [Chen-ch'i-sheng] 贞期生
Zhang Yu	Chang Yü	1238–1350	张雨	Boyu [Po-yü] 伯雨	Juqu Waishi [Chü-ch'ü wai-shih] 句曲外史, Tianyu [T'ien-yü] 天雨
Zhao Mengfu	Chao Meng-fu	1254–1322	赵孟頫	Zi'ang [Tzu-ang] 子昂	Songxue [Sung-hsüeh] 松雪, Oubo [Ou-po] 鸥波
Zhao Yong	Chao Yung	ca. 1289–ca. 1362	赵雍	Zhongmu [Chung-mu] 仲穆	
Zhao Yuan	Chao Yüan	d. after 1373	赵原 or 赵元	Shanchang [Shan-ch'ang] 善长	Danlin [Tan-lin] 丹林
Zheng Sixiao	Cheng Ssu-hsiao	1241–1318	郑思肖	Yiweng [I-weng] 忆翁, Suonan [So-nan] 所南	
Zhou Mi	Chou Mi	1232–1298	周密	Gongjin [Kung-chin] 公谨	Caochuang [Ts'ao-ch'uang] 草窗
Zhu Derun	Chu Te-jun	1294–1365	朱德润	Zemin [Tse-min] 泽民	Suiyang Shanren [Sui-yang shan-jen] 睢阳山人
Zhu Haogu	Chu Hao-ku	active mid-14th c.	朱好古		
Zou Fulei	Tsou Fu-lei	active mid-14th c.	邹复雷		

MING DYNASTY

Pinyin	Wade-Giles	Dates	Characters	Zi (style name)	Hao (sobriquet) and Other Names
Bian Jingzhao	Pian Ching-chao	active ca. 1426–1435	边景昭	Wenjin [Wen-chin] 文进	
Chen Chun	Ch'en Ch'un	1483–1544	陈淳	Daofu [Tao-fu] 道复, Fufu [Fu-fu] 复甫	Boyang Shanren [Po-yang shan-jen] 白阳山人
Chen Hongshou	Ch'en Hung-shou	1598–1652	陈洪绶	Zhanghou [Chang-hou] 章侯	Laolian [Lao-lien] 老莲, Fuchi [Fu-ch'ih] 弗迟, Yunmenseng [Yün-meng-seng] 云门僧, Huichi [Hui-chih] 悔迟, Chiheshang [Chih-he-shang] 迟和尚, Huiseng [Hui-seng] 悔僧
Chen Huan	Ch'en Huan	early 17th c.	陈焕	Ziwen [Tzu-wen] 子文	Yaofeng [Yao-feng] 尧峰
Chen Hui	Ch'en Hui	early 15th c.	陈㧑	Zhongqian [Chung-ch'ien] 仲谦	
Chen Jiru	Ch'en Chi-ju	1558–1639	陈继儒	Zhongshun [Chung-shun] 仲醇	Migong [Mi-kung] 糜公, Meigong [Mei-kung] 眉公, Xuetang [Hsüeh-t'ang] 雪堂, Baishiqiao [Pai-shih-ch'iao] 白石樵
Chen Kuan	Ch'en K'uan	Ming	陈宽	Mengxian [Meng-hsien] 孟贤	Xing'an [Hsing-an] 醒庵
Chen Yuan	Ch'en Yüan	Ming	陈远	Zhongfu [Chung-fu] 中复	
Cheng Jiasui	Ch'eng Chia-sui	1565–1643	程嘉燧	Mengyang [Meng-yang] 孟阳	Songyuan [Sung-yüan] 松圆
Cui Zizhong	Ts'ui Tzu-chung	d. 1644	崔子忠	Daomu [Tao-mu] 道母	Beihai [Pei-hai] 北海, Qingyin [Ch'ing-yin] 青蚓
Dai Jin	Tai Chin	1388–1462	戴进	Wenjin [Wen-chin] 文进	Jing'an [Ching-an] 静庵
Ding Yunpeng	Ting Yün-p'eng	1547–1621	丁云鹏	Nanyu [Nan-yü] 南羽	Shenghua Jushi [Sheng-hua chü-shih] 圣华居士
Dong Qichang	Tung Ch'i-ch'ang	1555–1636	董其昌	Xuanzai [Hsüan-tsai] 玄宰	Sibo [Ssu-po] 思白
Du Mu	Tu Mu	1459–1525	都穆	Xuanjing [Hsüan-ching] 玄敬	
Du Qiong	Tu Ch'iung	1396–1474	杜琼	Yongjia [Yung-chia] 用嘉	Luguan Daoren [Lu-kuan tao-jen] 鹿冠道人, Dongyuan Xiansheng [Tung-yüan hsien-sheng] 东原先生

Pinyin	Wade-Giles	Dates	Characters	Zi (style name)	Hao (sobriquet) and Other Names
Gao Qi	Kao Ch'i	1336–1374	高启	Jidi [Chi-ti] 季迪	
Gu Mei	Ku Mei	1619–1664	顾眉	Meisheng [Mei-sheng] 眉生	Also called Xu Mei [Hsü Mei] 徐眉, Meizhuang [Mei-chuang] 眉庄, Hengbo [Heng-po] 横波, Zhizhu [Chih-chu] 智珠, Meisheng [Mei-sheng] 梅生
Gu Zhengyi	Ku Cheng-i	fl. ca. 1580	顾正谊	Zhongfang [Chung-fang] 仲方	Tinglin [T'ing-lin] 亭林
Guo Chun	Kuo Ch'un	1370–1444	郭纯	Wentong [Wen-t'ung] 文通	Pu'an [P'u-an] 朴庵
Huang Daozhou	Huang Tao-chou	1585–1646	黄道周	Youxuan [Yu-hsüan] 幼玄, Chiruo [Ch'ih-jo] 螭若	Shizhai [Shih-chai] 石斋
Jiang Song	Chiang Sung	fl. ca. 1500	蒋嵩	Sansong [San-sung] 三松	
Ju Jie	Chu Chieh	d. 1585	居节	Shizhen [Shih-chen] 士贞	Shanggu [Shang-ku] 商谷
Kou Mei	K'ou Mei	Ming	寇湄	Baimen [Pai-men] 白门	
Lan Ying	Lan Ying	1585–1664	蓝瑛	Tianshu [T'ien-shu] 田叔	Diesou [Tieh-sou] 蝶叟, Shitou-tuo [Shih-t'ou-t'o] 石头陀
Li Rihua	Li Jih-hua	1565–1635	李日华	Junshi [Chün-shih] 君实	Jiuyi [Chiu-i] 九疑, Zhulan [Chu-lan] 竹懒
Li Yin	Li Yin	ca. 1616–1685	李因	Jinsheng [Chin-sheng] 今生	Shi'an [Shih-an] 是庵, Kanshan Yi-shi [K'an-shan i-shih] 兔山逸史
Li Zai	Li Tsai	active mid-15th c.	李在	Yizheng [I-cheng] 以政	
Lin Liang	Lin Liang	active ca. 1488–1505	林良	Yishan [I-shan] 以善	
Liu Jue	Liu Chüeh	1410–1472	刘珏	Tingmei [T'ing-mei] 廷美	Wanan [Wan-an] 完庵
Liu Jun	Liu Chün	active ca. 1500	刘俊	Tingwei [T'ing-wei] 廷伟	
Lou Jian	Lou Chien	1567–1631	娄坚	Zirou [Tzu-jou] 子柔	
Lü Ji	Lü Chi	active ca. 1500	吕纪	Tingzhen [T'ing-chen] 廷振	Leyu [Lo-yü] 乐愚 or 乐渔
Lu Shidao	Lu Shih-tao	b. 1517	陆师道	Zichuan [Tzu-ch'uan] 子传	Yuanzhou [Yüan-chou] 元洲
Lu Zhi	Lu Chih	1496–1576	陆治	Shuping [Shu-p'ing] 叔平	Baoshan [Pao-shan] 包山
Ma Shouzhen	Ma Shou-chen	1548–1604	马守贞	Xianglan [Hsiang-lan] 湘兰	Yuejiao [Yüe-chiao] 月娇
Mo Shilong	Mo Shih-lung	active ca. 1567–1600	莫是龙	Yunqing [Yün-ch'ing] 云卿, Tinghan [T'ing-han] 廷韩	Qiushui [Ch'iu-shui] 秋水, Zhen-yi Daoren [Chen-i tao-jen] 真一道人
Ni Duan	Ni Tuan	active early 15th c.	倪端	Zhongzheng [Chung-cheng] 仲正	
Peng Nian	P'eng Nien	1505–1566	彭年	Kongjia [K'ung-chia] 孔嘉	Longchi Shanqiao [Lung-ch'ih shan-ch'iao] 隆池山樵
Qian Gu	Ch'ien Ku	1508–after 1574	钱谷	Shubao [Shu-pao] 叔宝	Qingshizi [Ch'ing-shih tzu] 磬室子
Qiu Ying	Ch'iu Ying	early 16th c.	仇英	Shifu [Shih-fu] 实父	Shizhou [Shih-chou] 十洲
Qiu Zhu	Ch'iu Chu	fl. ca. 1550	仇珠		Duling Neishi [Tu-ling nei-shih] 杜陵内史
Shang Xi	Shang Hsi	active ca. 1430–1440	商喜	Weiji [Wei-chi] 惟吉	
Shangguan Boda	Shang-kuan Po-ta	active ca. early 15th c.	上官伯达		
Shen Can	Shen Ts'an	1379–1453	沈粲	Minwang [Min-wang] 民望	Jian'an [Chien-an] 简庵
Shen Cheng	Shen Ch'eng	1376–1463	沈澄	Mengyuan [Meng-yüan] 孟渊	
Shen Du	Shen Tu	1357–1434	沈度	Minze [Min-tse] 民则	Zile [Tzu-le] 自乐
Shen Heng	Shen Heng	1407–1477	沈恆	Tongzhai [T'ung-chai] 同斋	
Shen Shichong	Shen Shih-ch'ung	fl. ca. 1611–1640	沈士充	Ziju [Tzu-chü] 子居	
Shen Xiyuan	Shen Hsi-yüan	14th c.	沈希远		
Shen Zhen	Shen Chen	b. 1400	沈贞	Zhenji [Chen-chi] 贞吉	Nanzhai [Nan-chai] 南斋, Tao-ran Daoren [T'ao-jan tao-jen] 陶然道人
Shen Zhou	Shen Chou	1427–1509	沈周	Qinan [Ch'i-nan] 启南	Shitian [Shih-t'ien] 石田, Baishi-weng [Pai-shih-weng] 白石翁, Yutianweng [Yü-t'ien weng] 玉田翁
Sheng Zhu	Sheng Chu	active 2d half of 14th c.	盛著	Shuzhang [Shu-chang] 叔彰	
Shi Rui	Shih Jui	active early 15th c.	石锐	Yiming [I-ming] 以明	

Pinyin	Wade-Giles	Dates	Characters	Zi (style name)	Hao (sobriquet) and Other Names
Sun Kehong	Sun K'o-hung	1532–1610	孙克弘 or 孙克宏	Yunzhi [Yün-chih] 允执	Xueju [Hsüeh-chü] 雪居
Sun Long	Sun Lung	15th c.	孙隆	Congji [Ts'ung-chi] 从吉	Duchi [Tu-ch'ih] 都痴
Sun Wenzong	Sun Wen-tsung	active ca. 1360–1370	孙文宗	Zhongwen [Chung-wen] 仲文	
Sun Zhi	Sun Chih	fl. ca. 1550–1580	孙枝	Shuda [Shu-ta] 叔达	Hualin Jushi [Hua-lin chü-shih] 华林居士
Tang Yin	T'ang Yin	1470–1523	唐寅	Bohu [Po-hu] 伯虎, Ziwei [Tzu-wei] 子畏	Liuru Jushi [Liu-ju chü-shih] 六如居士, Taohua Anzhu [T'ao-hua an-chu] 桃花庵主
Wang Chong	Wang Ch'ung	1494–1533	王宠	Lüren [Lü-jen] 履仁	Yayi Shanren [Ya-i shan-jen] 雅宜山人
Wang E	Wang E	active ca. 1488–1501	王谔	Tingzhi [T'ing-chih] 廷直	
Wang Fu	Wang Fu	1362–1416	王绂	Mengduan [Meng-tuan] 孟端	Youshisheng [Yu-shih sheng] 友石生, Jiulong Shanren [Chiu-lung shan-jen] 九龙山人, Qingcheng Shanren [Ch'ing-ch'eng shan-jen] 青城山人
Wang Guxiang	Wang Ku-hsiang	1501–1568	王谷祥	Luzhi [Lu-chih] 禄之	Youshi [Yu-shih] 酉室
Wang Lü	Wang Lü	14th c.	王履	Andao [An-tao] 安道	Qiweng [Ch'i-weng] 奇翁, Jisou [Chi-sou] 畸叟
Wang Yunjing	Wang Yün-ching	late Ming–early Qing	王允京	Hongqing [Hung-ch'ing] 宏卿	
Wang Zhao	Wang Chao	fl. ca. 1500	汪肇	Dechu [Te-ch'u] 德初	Haiyun [Hai-yün] 海云
Wen Boren	Wen Po-jen	1502–1575	文伯仁	Decheng [Te-ch'eng] 德承	Wufeng [Wu-feng] 五峰, Baosheng [Pao-sheng] 葆生, Sheshan Laonong [She-shan lao-nung] 摄山老农
Wen Congjian	Wen Ts'ung-chien	1574–1648	文从简	Yanke [Yen-k'o] 彦可	Zhenyan Laoren [Chen-yen lao-jen] 枕烟老人
Wen Dian	Wen Tien	1633–1704	文点	Yuye [Yü-yeh] 与也	Nanyun Shanqiao [Nan-yün shan-ch'iao] 南云山樵
Wen Jia	Wen Chia	1501–1583	文嘉	Xiucheng [Hsiu-ch'eng] 休承	Wenshui [Wen-shui] 文水
Wen Nan	Wen Nan	1596–1667	文楠	Quyuan [Ch'ü-yüan] 曲辕	Kai'an [K'ai-an] 慨庵
Wen Peng	Wen P'eng	1498–1573	文彭	Shoucheng [Shou-ch'eng] 寿承	Sanqiao [San-ch'iao] 三桥
Wen Shu	Wen Shu	1595–1634	文俶	Duanrong [Tuan-jung] 端容	
Wen Yuanshan	Wen Yüan-shan	1554–1589	文元善	Zichang [Tzu-ch'ang] 子长	Huqiu [Hu-ch'iu] 虎丘
Wen Zhenheng	Wen Chen-heng	1585–1645	文震亨	Qimei [Ch'i-mei] 启美	
Wen Zhengming	Wen Cheng-ming	1470–1559	文征明	Zhengzhong [Cheng-chung] 征仲	Hengshan Jushi [Heng-shan chü-shih] 衡山居士
Wen Zhenmeng	Wen Chen-meng	1574–1636	文震孟	Wenqi [Wen-ch'i] 文起	Zhanchi [Chan-chih] 湛持
Wu Bin	Wu Pin	active ca. 1573–1620	吴彬	Wenzhong [Wen-chung] 文中	Zhi'an Faseng [Chih-an fa-seng] 枝庵发僧
Wu Wei	Wu Wei	1459–1509	吴伟	Shiying [Shih-ying] 士英, Ciweng [Tz'u-weng] 次翁	Lufu [Lu-fu] 鲁夫, Xiaoxian [Hsiao-hsien] 小仙
Xia Chang	Hsia Ch'ang	1388–1470	夏昶	Zhongzhao [Chung-chao] 仲昭	Zizai Jushi [Tzu-ts'ai chü-shih] 自在居士, Yufeng [Yü-feng] 玉峰
Xia Zhi	Hsia Chih	15th c.	夏芷	Tingfang [T'ing-fang] 廷芳	
Xiang Shengmo	Hsiang Sheng-mo	1597–1658	项圣谟	Kongzhang [K'ung-chang] 孔彰	Yi'an [I-an] 易庵, Xushanqiao [Hsü-shan-ch'iao] 胥山樵
Xie Bin	Hsieh Pin	1601–1681	谢彬	Wenhou [Wen-hou] 文侯	Xianqu [Hsian-ch'u] 仙臞
Xie Huan	Hsieh Huan	active 1426–1452	谢环	Tingxun [T'ing-hsün] 庭循	
Xie Jin	Hsieh Chin	fl. ca. 1560	谢缙		Kuiqiu [K'uei-ch'iu] 葵丘
Xie Shichen	Hsieh Shih-ch'en	1487–after 1567	谢时臣	Sizhong [Ssu-chung] 思忠	Chuxian [Ch'u-hsien] 樗仙
Xu Ben	Hsü Pen	1335–1380	徐贲	Youwen [Yu-wen] 幼文	Beiguosheng [Pei-kuo-sheng] 北郭生
Xu Wei	Hsü Wei	1521–1593	徐渭	Wenqing [Wen-ch'ing] 文清, Wenchang [Wen-ch'ang] 文长	Tianchi [T'ien-ch'ih] 天池, Qingteng [Ch'ing-t'eng] 青藤
Xue Susu	Hsüeh Su-su	ca. 1564–ca. 1637	薛素素	Runqing [Jun-ch'ing] 润卿, Suqing [Su-ch'ing] 素卿	Runniang [Jun-niang] 润娘
Yang Wencong	Yang Wen-ts'ung	1597–1645	杨文聪	Longyou [Lung-yu] 龙友	

Pinyin	Wade-Giles	Dates	Characters	Zi (style name)	Hao (sobriquet) and Other Names
Yao Shou	Yao Shou	1423–1495	姚绶	Gong Shou [Kung shou] 公绶	Gu'an [Ku-an] 谷庵, Yundong Yishi [Yün-tung i-shih] 云东逸史
Yun Daosheng	Yün Tao-sheng	1586–1655	恽道生	Yun Xiang [Yün Hsiang] 恽向	Xiangshanweng [Hsiang-shan weng] 香山翁
Zeng Jing	Tseng Ching	1564–1647	曾鲸	Bochen [Po-ch'en] 波臣	
Zhang Bi	Chang Pi	1425–1487	张弼	Ru Bi [Ju Pi] 汝弼	Donghai Weng [Tung-hai weng] 东海翁
Zhang Lu	Chang Lu	ca. 1464–ca. 1538	张路	Tianchi [T'ien-ch'ih] 天驰	Pingshan Jingju [P'ing-shan ching-chü] 平山静居
Zhang Yu	Chang Yü	1323–1385	张羽	Laiyi [Lai-i] 来仪	
Zhao Tonglu	Chao T'ung-lu	1423–1503	赵同鲁	Yüzhe [Yü-che] 与哲	
Zhao Zuo	Chao Tso	active ca. 1610–1630	赵左	Wendu [Wen-tu] 文度	
Zhou Chen	Chou Ch'en	active ca. 1472–1535	周臣	Shunqing [Shun-ch'ing] 舜卿	Dongcun [Tung-ts'un] 东村
Zhou Quan	Chou Ch'üan	Ming dynasty	周全		
Zhou Tianqiu	Chou T'ien-ch'iu	1514–1595	周天球	Gongxia [Kung-hsia] 公瑕	Huanhai [Huan-hai] 幻海, Liu-zhisheng [Liu-chih-sheng] 六止生
Zhou Wei	Chou Wei	active ca. 1368–1390	周位	Xuansu [Hsüan-su] 玄素	
Zhou Zhimian	Chou Chih-mien	fl. ca. 1580–1610	周之冕	Fuqing [Fu-ch'ing] 服卿	Shaogu [Shao-ku] 少谷
Zhu Duan	Chu Tuan	active ca. 1506–1521	朱端	Kezheng [K'o-cheng] 克正	Yiqiao [I-ch'iao] 一樵
Zhu Yunming	Chu Yün-ming	1461–1527	祝允明	Xizhe [Hsi-che] 希哲	Zhishan [Chih-shan] 枝山
Zhu Zhanji	Chu Chan-chi	1399–1435	朱瞻基		Ming Xuanzong [Ming Hsüan-tsung] 明宣宗
Zhuo Di	Chuo Ti	active early 15th c.	卓迪	Minyi [Min-i] 民逸	Qingyue [Ch'ing-yueh] 清约

QING DYNASTY

Pinyin	Wade-Giles	Dates	Characters	Zi (style name)	Hao (sobriquet) and Other Names
Bada Shanren	Pa-ta shan-jen	1626–1705	八大山人	Ren'an [Jen-an] 刃庵	Zhu Tonglin [Chu T'ung-lin] 朱统鐜, Zhu Da [Chu Ta] 朱耷, Zhu Yichong [Chu I-ch'ong] 朱议冲, Xuege [Hsüeh-ko] 雪个, Shunian [Shu-nien] 书年, Ge-shan [Ko-shan] 个山, Geshanlü [Ko-shan-lü] 个山驴, Chuan-qing [Ch'uan ch'ing] 传綮, Ren-wu [Jen-wu] 人屋, Lüwulüshu [Lü-wu-lü-shu] 驴屋驴书
Castiglione, Giuseppe [Lang Shining]	Lang Shih-ning	1688–1768	郎世宁		
Cheng Sui	Ch'eng Sui	active ca. 1605–1691	程邃	Muqian [Mu-ch'ien] 穆倩	Jiangdong Buyi [Chiang-tung pu-i] 江东布衣, Goudaoren [Kou-tao-jen] 垢道人
Cheng Zhengkui	Ch'eng Cheng-k'uei	mid-17th c.	程正揆	Duanbo [Tuan-po] 端伯	Juling [Chu-ling] 鞫陵
Deng Shiru	Teng Shih-ju	1739–1805	邓石如	Wanbai [Wan-pai] 顽白	Wanbai Shanren [Wan-pai shan-jen] 完白山人, Jiyou Daoren [Chi-yu tao-jen] 笈游道人
Ding Jing	Ting Ching	1695–1765	丁敬	Jingshen [Ching-shen] 敬身	Longhong Shanren [Lung-hung shan-jen] 龙泓山人
Fan Qi	Fan Ch'i	1616–after 1694	樊圻	Huigong [Hui-kung] 会公, Qiagong [Ch'ia-kung] 洽公	
Fang Wanyi	Fang Wan-i	1732–after 1779	方畹仪	Yizi [I-tzu] 议子	Bailian Jushi [Pai-lien chü-shih] 白莲居士
Fei Danxu	Fei Tan-hsü	1802–1850	费丹旭	Zitiao [Tzu-t'iao] 子苕	Xiaolou [Hsiao-lou] 晓楼, Huan-xisheng [Huan-hsi sheng] 环溪生
Fu Shan	Fu Shan	1606–1684	傅山	Qingzhu [Ch'ing-chu] 青主	Zhenshan [Chen-shan] 真山, Selu [Se-lu] 啬庐, Gongzhita [Kung-chih-t'a] 公之它, Renzhong

Pinyin	Wade-Giles	Dates	Characters	Zi (style name)	Hao (sobriquet) and Other Names
Gai Qi	Kai Ch'i	1773–1828	改琦	Boyun [Po-yün] 伯韫	[Jen-chung] 仁仲, Liuchi [Liu-ch'ih] 六持, Suili [Sui-li] 随厉 Xiangbai [Hsiang-pai] 香白, Qixiang [Ch'i-hsiang] 七芗, Yuhu Waishi [Yü-hu wai-shih] 玉壶外史, Yuhu Shanren [Yü-hu shan-jen] 玉壶山人
Gao Cen	Kao Ts'en	active ca. 1679	高岑	Weisheng [Wei-sheng] 蔚生	Shanchang [Shan-ch'ang] 善长
Gao Jun	Kao Chun	late 17th–early 18th c.	高钧	Jiting [Chi-t'ing] 霁亭	
Gao Qipei	Kao Ch'i-p'ei	1660–1734	高其佩	Weizhi [Wei-chih] 韦之	Qieyuan [Ch'ieh-yüan] 且园, Nancun [Nan-ts'un] 南村, Changbai Shanren [Chang-pai shan-jen] 长白山人
Gao Xiang	Kao Hsiang	1688– ca. 1753	高翔	Fenggang [Feng-kang] 凤冈	Xitang [Hsi-t'ang] 西唐, Shanlin Waichen [Shan-lin wai-ch'en] 山林外臣
Gong Xian	Kung Hsien	1618–1689	龚贤	Qixian [Ch'i-hsien] 岂贤	Banmu [Pan-mu] 半亩, Banqian [Pan-ch'ien] 半千, Chaizhang-ren [Ch'ai-chang-jen] 柴丈人, Yeyi [Yeh-i] 野遗
Gu Heqing	Ku Ho-ch'ing	1766–after 1830	顾鹤庆	Ziyu [Tzu-yü] 子余	Tao'an [T'ao-an] 弢庵, Gu Yiliu [Ku I-liu] 顾驿柳
Gu Ming	Ku Ming	late 17th c.	顾铭	Zhongshu [Chung-shu] 仲书	
Gu Qi	Ku Ch'i	early Qing	顾企	Zonghan [Tsung-han] 宗汉	
Gu Yanwu	Ku Yan-wu	1613–1682	顾炎武	Ningren [Ning-jen] 宁人	Original name Jiang [Chiang] 绛, Tinglin [T'ing-lin] 亭林
Guo Gong	Kuo Kung	Qing	郭巩	Wujiang [Wu-chiang] 无疆	
He Shaoji	Ho Shao-chi	1799–1873	何绍基	Zizhen [Tzu-chen] 子贞	Dongzhou [Tung-chou] 东洲, Yuansou [Yüan-sou] 蝯叟
Hongren	Hung-jen	1610–1664	弘仁	Jianjiang [Chien-chiang] 渐江	Original name Jiang Tao [Chiang T'ao] 江韬, Meihua Laona [Mei-hua lao-na] 梅花老衲
Hu Yuan	Hu Yüan	1823–1886	胡远	Gongshou [Kung-shou] 公寿	Shouhe [Shou-ho] 瘦鹤, Hengyun Shanmin [Heng-yün shan-min] 横云山民
Hu Zao	Hu Ts'ao	active ca. 1670–1720	胡慥	Shigong [Shih-kung] 石公	
Hua Yan	Hua Yen	1682–1756	华嵒	Qiuyue [Ch'iu-yüeh] 秋岳	Xinluo Shanren [Hsin-lo shan-jen] 新罗山人
Huang Shen	Huang Shen	1687–after 1768	黄慎	Gongmao [Kung-mao] 恭懋	Yingpiaozi [Ying-p'iao-tzu] 瘿瓢子
Jiang Tingxi	Chiang T'ing-hsi	1669–1732	蒋廷锡	Yangsun [Yang-sun] 扬孙, Youjun [Yu-chün] 酉君	Xigu [Hsi-ku] 西谷, Nansha [Nan-sha] 南沙
Jin Nong	Chin Nung	1687–1764	金农	Shoumen [Shou-men] 寿门	Dongxin [Tung-hsin] 冬心, Guquan [Ku-ch'üan] 古泉, Laoding [Lao-ting] 老丁, Sinong [Ssu-nung] 司农
Kuncan	K'un-ts'an	1612–1673	髡残	Shixi [Shih-hsi] 石豀, Jieqiu [Chieh-ch'iu] 介邱	Original name Liu [Liu] 刘, Baitu [Pai-t'u] 白秃, Candaoren [Ts'an-tao-jen] 残道人
Li Fangying	Li Fang-ying	1695–1755	李方膺	Qiuzhong [Ch'iu-chung] 虬仲	Qingjiang [Ch'ing-chiang] 晴江, Qiuchi [Ch'iu-ch'ih] 秋池
Li Shan	Li Shan	1688– ca. 1757	李鲜	Zongyang [Tsung-yang] 宗扬	Futang [Fu-t'ang] 复堂
Li Xian	Li Hsien	1652–1687	李俌	Yiwu [I-wu] 毅武	
Li Yin	Li Yin	active ca. 1700	李寅	Baiye [Pai-yeh] 白也	
Liao Dashou	Liao Ta-shou	early Qing	廖大受	Junke [Chün-k'o] 君可	
Lu Erlong	Lu Erh-lung	Qing	陆二龙	Boxiang [Po-hsiang] 伯骧	Qian'an [Ch'ien-an] 潜庵
Luo Pin (Ping)	Lo P'in (P'ing)	1733–1799	罗聘	Dunfu [Tun-fu] 遁夫	Liangfeng [Liang-feng] 两峰, Huazhisi Seng [Hua-chih-ssu seng] 花之寺僧

Pinyin	Wade-Giles	Dates	Characters	Zi (style name)	Hao (sobriquet) and Other Names
Mei Qing	Mei Ch'ing	1623–1697	梅清	Yuangong [Yüan-kung] 渊公 or 远公	Qushan [Ch'ü-shan] 瞿山, Xuelu [Hsüeh-lu] 雪庐, Laoqu Fanfu [Lao-ch'ü-fan-fu] 老瞿凡父
Pan Gongshou	P'an Kung-shou	1741–1794	潘恭寿	Shenfu [Shen-fu] 慎夫	Lianchao [Lien-ch'ao] 莲巢
Pu Hua	P'u Hua	1830–1911	蒲华	Zuoying [Tso-ying] 作英	
Qian Hui'an	Ch'ien Hui-an	1833–1911	钱慧安	Jisheng [Chi-sheng] 吉生	Original name Guichang [Kuei-ch'ang] 贵昌, Shuangguanlou [Shuang-kuan-lou] 双管楼, Qingxi Qiaozi [Ch'ing-hsi ch'iao-tzu] 清谿樵子
Qian Qianyi	Ch'ien Ch'ien-i	1582–1664	钱谦益	Shouzhi [Shou-chih] 受之	Muzhai [Mu-chai] 牧斋, Muweng [Mu-weng] 牧翁
Ren Bonian [Ren Yi]	Jen Po-nien	1840–1895	任伯年	Xiaolou [Hsiao-lou] 小楼	Earlier name Ren Yi [Jen I] 任颐
Ren Xiong	Jen Hsiung	1820–1857	任熊	Weichang [Wei-ch'ang] 渭长	
Ren Xun	Jen Hsün	1835–1893	任熏	Fuchang [Fu-ch'ang] 阜长	
Ren Yu	Jen Yü	1854–1901	任预	Lifan [Li-fan] 立凡	Xiaoxiao'an Zhuren [Hsiao-hsiao-an chu-jen] 潇潇庵主人
Shen Quan	Shen Ch'üan	1682–1765	沈铨	Hengzhai [Heng-chai] 衡斋	Nanpin [Nan-p'in] 南苹
Shen Shao	Shen Shao	late 17th c.	沈韶	Erdiao [Erh-tiao] 尔调	
Shitao [Yuanji]	Shih-t'ao [Yüan-chi]	1642–1718	石涛	Shitao [Shih-t'ao] 石涛	Original name Zhu Ruoji [Chu Juo-chi] 朱若极, Buddhist name Yuanji [Yüan-chi] 原济, Daoji [Tao-chi] 道济, Dadizi [Ta-ti-tzu] 大涤子, Qingxiang Laoren [Ch'ing-hsiang lao-jen] 清湘老人, Qingxiang Yiren [Ch'ing-hsiang i-jen] 清湘遗人, Xiazunzhe [Hsia-tsun-che] 瞎尊者, Kugua Heshang [K'u-kua ho-shang] 苦瓜和尚
Wang Hui	Wang Hui	1632–1717	王翚	Shigu [Shih-ku] 石谷	Gengyan Sanren [Keng-yen san-jen] 耕烟散人, Qinghui Zhuren [Ch'ing-hui chu-jen] 清晖主人, Jianmen Qiaoke [Chien-men ch'iao-k'o] 剑门樵客, Niaomu Shanren [Niao-mu shan-jen] 鸟目山人, Ququiao [Ch'ü-ch'iao] 臞樵
Wang Jian	Wang Chien	1598–1677	王鉴	Yuanzhao [Yüan-chao] 元照 or 圆照	Xiangbi [Hsiang-pi] 湘碧, Lianzhou [Lien-chou] 廉州, Ranxiang Anzhu [Jan-hsiang an-chu] 染香庵主
Wang Shimin	Wang Shih-min	1592–1680	王时敏	Xunzhi [Hsün-chih] 逊之	Yanke [Yen-k'o] 烟客, Xilu Laoren [Hsi-lu lao-jen] 西庐老人, Xitian Zhuren [Hsi-t'ien chu-jen] 西田主人, Guicun Laonong [Kuei-ts'un lao-nung] 归村老农
Wang Shishen	Wang Shih-shen	active ca. 1730–1750	汪士慎	Jinren [Chin-jen] 近人	Chaolin [Ch'ao-lin] 巢林, Xidong Waishi [Hsi-tung wai-shih] 溪东外史
Wang Wenzhi	Wang Wen-chih	1730–1802	王文治	Yuqing [Yü-ch'ing] 禹卿	Menglou [Meng-lou] 梦楼
Wang Wu	Wang Wu	1632–1690	王武	Qinzhong [Ch'in-chung] 勤中	Wang'an [Wang-an] 忘庵
Wang Yuanqi	Wang Yüan-ch'i	1642–1715	王原祁	Maojing [Mao-ching] 茂京	Lutai [Lu-t'ai] 麓台, Xilu Houren [Hsi-lu hou-jen] 西庐后人, Shishi Daoren [Shih-shih tao-jen] 石师道人

| --- | --- | --- | --- | --- | --- |
| Wu Hong | Wu Hung | active ca. 1670–1680 | 吴宏 | Yuandu [Yüan-tu] 远度 | Zhushi [Chu-shih] 竹史 |
| Wu Jiayou | Wu Chia-yu | d. 1893 | 吴嘉猷 | Youru [Yu-ju] 友如 | |
| Wu Li | Wu Li | 1632–1718 | 吴历 | Yushan [Yü-shan] 渔山 | Mojing [Mo-ching] 墨井, Mojing Daoren [Mo-ching tao-jen] 墨井道人, Taoxi Juren [T'ao-hsi chü-jen] 桃溪居人 |
| Wu Weiye | Wu Wei-yeh | 1609–1671 | 吴伟业 | Jungong [Chün-kung] 骏公 | Meicun [Mei-ts'un] 梅村 |
| Xiao Chen | Hsiao Ch'en | active ca. 1680–1710 | 萧晨 | Lingxi [Ling-hsi] 灵曦 | Zhongsu [Chung-su] 中素 |
| Xiao Yuncong | Hsiao Yün-ts'ung | 1596–1673 | 萧云从 | Chimu [Ch'ih-mu] 尺木 | Wumen Daoren [Wu-men tao-jen] 无闷道人, Zhongshan Laoren [Chung-shan lao-jen] 钟山老人 |
| Xie Sun | Hsieh Sun | late 17th c. | 谢荪 | Xiangyou [Hsiang-yu] 緗酉 | |
| Xu Yang | Hsü Yang | active ca. 1760 | 徐扬 | Yunting [Yün-t'ing] 云亭 | |
| Xu Yi | Hsü I | early Qing | 徐易 | Xiangjiu [Hsiang-chiu] 象九, Xiangxian [Hsiang-hsien] 象先 | |
| Xu Zhang | Hsü Chang | 1694–1749 | 徐璋 | Yaopu [Yao-p'u] 瑶圃 | |
| Xugu | Hsü-ku | 1824–1896 | 虚谷 | Xubai [Hsü-pai] 虚白 | Original name Zhu Huairen [Chu Huai-jen] 朱怀仁, Ziyang Shanmin [Tzu-yang shan-min] 紫阳山民 |
| Ye Xin | Yeh Hsin | fl. 1647–1679 | 叶欣 | Rongmu [Jung-mu] 荣木 | |
| Yu Zhiding | Yü Chih-ting | 1647–1716 | 禹之鼎 | Shangji [Shang-chi] 上吉 or 尚吉 | Shenchai [Shen-ch'ai] 慎斋 |
| Yuan Jiang | Yüan Chiang | active ca. 1680–1730 | 袁江 | Wentao [Wen-t'ao] 文涛 | |
| Yuan Yao | Yüan Yao | active ca. 1739–1788 | 袁耀 | Zhao Dao [Chao Tao] 昭道 | |
| Yun Shouping | Yün Shou-p'ing | 1633–1690 | 恽寿平 | Zhengshu [Cheng-shu] 正叔 | Original name Ge [Ke] 格, Nantian [Nan-t'ien] 南田, Yunxi Waishi [Yün-hsi wai-shih] 云溪外史, Baiyun Waishi [Pai-yün wai-shih] 白云外史, Dongyuan Caoyi [Tung-yüan ts'ao-i] 东园草衣, Ouxiang Sanren [Ou-hsiang san-jen] 瓯香散人 |
| Zha Shibiao | Cha Shih-piao | 1615–1698 | 查士标 | Erzhan [Erh-chan] 二瞻 | Meihe [Mei-ho] 梅壑 |
| Zhang Ke | Chang K'o | b. 1635 | 张珂 | Yuke [Yü-k'o] 玉可 | Meixue [Mei-hsüeh] 嵋雪 or 梅雪, Bishan Xiaochi [Pi-shan hsiao-chih] 碧山小痴 |
| Zhang Qi | Chang Ch'i | early Qing | 张琦 | Yuqi [Yü-ch'i] 玉奇 | |
| Zhang Weibang | Chang Wei-pang | mid-18th c. | 张为邦 [张维邦] | | |
| Zhang Yin | Chang Yin | 1761–1829 | 张崟 | Baoya [Pao-ya] 宝崖 | Xi'an [Hsi-an] 夕庵, Xidaoren [Hsi-tao-jen] 夕道人, Qieweng [Ch'ieh-weng] 且翁 |
| Zhang Yuan | Chang Yüan | Qing | 张远 | Ziyou [Tzu-yu] 子游 | |
| Zhao Zhiqian | Chao Chih-ch'ien | 1829–1884 | 赵之谦 | Yifu [I-fu] 益甫 | Huishu [Hui-shu] 㧑叔 |
| Zheng Pei | Cheng P'ei | Qing | 郑培 | Shanru [Shan-ju] 山如 | Guting [Ku-t'ing] 古亭 |
| Zheng Xie | Cheng Hsieh | 1693–1766 | 郑燮 | Kerou [K'o-jou] 克柔 | Banqiao [Pan-ch'iao] 板桥 |
| Zhou Lianggong | Chou Liang-kung | 1612–1672 | 周亮工 | Yuanliang [Yüan-liang] 元亮 | Liyuan [Li-yüan] 栎园 |
| Zhou Xian | Chou Hsien | 1820–1875 | 周闲 | Cunbo [Ts'un-po] 存伯 | Fanhu Jushi [Fan-hu chü-shih] 范湖居士 |
| Zou Yigui | Tsou I-kuei | 1686–1772 | 邹一桂 | Yuanbao [Yüan-pao] 原褒 | Xiaoshan [Hsiao-shan] 小山 |
| Zou Zhe | Tsou Che | 1636–ca. 1708 | 邹喆 | Fanglu [Fang-lu] 方鲁 | |
| Zou Zhilin | Tsou Chi-lin | early 17th c. | 邹之鳞 | Chenhu [Ch'en-hu] 臣虎 | Yibai [I-pai] 衣白 |

Pinyin	Wade-Giles	Dates	Characters	Zi (style name)	Hao (sobriquet) and Other Names

REPUBLIC AND PEOPLE'S REPUBLIC

Pinyin	Wade-Giles	Dates	Characters	Zi (style name)	Hao (sobriquet) and Other Names
Ai Zhongxin	Ai Chung-hsin	1915–	艾中信		
Chen Banding	Ch'en Pan-t'ing	1876–1970	陈半丁	Jingshan [Ching-shan] 静山	Chen Nian [Ch'en Nien] 陈年, Banding [Pan-ting] 半丁, Banchi [Pan-ch'ih] 半痴
Chen Shizeng [Chen Hengke]	Ch'en Shih-tseng	1876–1923	陈师曾	Shizeng [Shih-ts'eng] 师曾	Xiudaoren [Hsiu-tao-jen] 朽道人, Chen Hengke [Ch'en Heng-k'o] 陈衡恪, Huaitang [Huai-t'ang] 槐堂, Rancangshi [Jan-ts'ang-shih] 染仓室
Chen Shuren	Ch'en Shu-jen	1884–1948	陈树人		Chen Shao [Ch'en Shao] 陈韶, Jiawai Yuzi [Chia-wai yü-tzu] 葭外渔子
Chen Zhifo	Ch'en Chih-fo	1896–1962	陈之佛	Xueweng [Hsüeh-weng] 雪翁	
Fang Rending	Fang Jen-ting	1901–1975	方人定		
Feng Chaoran	Feng Ch'ao-jan	1882–1954	冯超然	Chaoran [Ch'ao-jan] 超然	Feng Jiong [Feng Chiong] 冯炯, Dike [Ti-k'o] 涤舸, Songshan Jushi [Sung-shan chü-shih] 嵩山居士, Shende [Shen-te] 慎得
Feng Zikai	Feng Tzu-k'ai	1898–1975	丰子恺		Ren [Jen] 仁, Yingxing [Ying-hsing] 婴行
Fu Baoshi	Fu Pao-shih	1904–1965	傅抱石	Baoshi [Pao-shih] 抱石	Changsheng [Ch'ang-sheng] 长生, Ruilin [Jui-lin] 瑞麟
Gao Jianfu	Kao Chien-fu	1879–1951	高剑父	Jueting [Chüeh-t'ing] 爵庭, Queting [Ch'üeh-t'ing] 鹊庭	Gao Lun [Kao Lun] 高仑, Jianfu [Chien-fu] 剑父
Gao Qifeng	Kao Ch'i-feng	1889–1933	高奇峰	Shanweng [Shan-weng] 山翁	Gao Weng [Kao Weng] 高嵱, Qifeng [Ch'i-feng] 奇峰
Gu Kunbo	Ku K'un-po	1905–1970	顾坤伯	Jingfeng [Ching-feng] 景峰	Yi [I] 乙, Erquan Jushi [Erh-ch'üan chü-shi] 二泉居士
Guan Shanyue	Kuan Shan-yüeh	b. 1912	关山月		Guan Zepei [Kuan Tse-p'ei] 关泽霈, Ziyun [Tzu-yün] 子云
He Tianjian	Ho T'ien-chien	1890–1977	贺天健	Qianqian [Ch'ien-ch'ien] 乾乾	Renxiang Jushi [Jen-hsiang chü-shih] 纫香居士, Jian Sou [Chien Sou] 健叟
He Xiangning	Ho Hsiang-ning	ca. 1878–1972	何香凝		
Hu Peiheng	Hu P'ei-heng	1891–1962	胡佩衡	Peiheng [P'ei-heng] 佩衡	Xiquan [Hsi-ch'üan] 锡全, Hu Heng [Hu Heng] 胡衡, Lengan [Leng-an] 冷盦
Huang Binhong	Huang Pin-hung	1865–1955	黄宾虹	Pucun [P'u-ts'un] 朴存	Huang Zhi [Huang Chih] 黄质, Binhong [Pin-hung] 宾虹, Yuxiang [Yü-hsiang 予向
Huang Dufeng	Huang Tu-feng	b. 1913	黄独峰	Rongyuan [Jung-yüan] 榕园	Huang Shan 黄山, Dufeng [Tu-feng] 独峰
Huang Shaoqiang	Huang Shao-ch'iang	1901–1942	黄少强	Shaoqiang [Shao-ch'iang] 少强	Huang Yishi [Huang I-shih] 黄宜仕, Xin'an [Hsin-an] 心庵
Huang Zhou	Huang Chou	b. 1925	黄胄		Liang Huangzhou [Liang Huang-chou] 梁黄胄
Jiang Zhaohe	Chiang Chao-ho	1904–1986	蒋兆和		
Jin Cheng	Chin Ch'eng	1878–1926	金城	Gongbo [Kung-po] 巩伯, Gongbei [Kung-pei] 拱北	Jin Shaocheng [Chin Shao-ch'eng] 金绍城, Beilou [Pei-lou] 北楼, Ouchao [Ou-ch'ao] 藕潮
Jing Hengyi	Ching Heng-i	1875–1938	经亨颐	Ziyuan [Tzu-yüan] 子渊	Yiyuan [I-yüan] 颐渊, Shichan [Shih-ch'an] 石禅
Ju Lian	Chü Lien	1828–1904	居廉	Guquan [Ku-ch'üan] 古泉	Geshan Laoren [Ke-shan lao-jen] 隔山老人
Kang Youwei	K'ang Yu-wei	1858–1927	康有为	Gengsheng [Keng-sheng] 更生	Zuyi [Tzu-i] 祖诒, Changsu [Ch'ang-su] 长素, Xiqiao Shanren [Hsi-ch'iao shan-jen] 西樵山人

Pinyin	Wade-Giles	Dates	Characters	Zi (style name)	Hao (sobriquet) and Other Names
Li Hu	Li Hu	1919–1975	李斛		
Li Jingfu	Li Ching-fu	Modern	李景福	Xinyu [Hsin-yü] 心畬	
Li Keran	Li K'o-jan	1907–1989	李可染		
Li Kuchan	Li K'u-ch'an	1898–1983	李苦禅	Kuchan [K'u-ch'an] 苦禅	Li Ying 李英, Ligong [Li-kung] 厉公
Li Ruiqing	Li Jui-ch'ing	1867–1920	李瑞清	Zhonglin [Chung-lin] 仲麟	Qingdaoren [Ch'ing-tao-jen] 清道人
Li Shutong	Li Shu-t'ung	1880–1942	李叔同		Hong Yi [Hung Yi] 弘一, Xishuang [Hsi-shuang] 息霜
Li Xiongcai	Li Hsiung-ts'ai	b. 1910	黎雄才		
Lin Fengmian	Lin Feng-mien	1900–1991	林风眠		
Lin Shu	Lin Shu	ca. 1852–1924	林纾	Hui [Hui] 徽, Qinnan [Ch'in-nan] 琴南	Qun Yu [Ch'ün Yü] 群玉, Weilu [Wei-lu] 畏庐, Lenghongsheng [Leng-hung-sheng] 冷红生
Liu Boshu	Liu Boshu	b. 1935	刘勃舒		
Liu Haisu	Liu Hai-su	1896–1994	刘海粟		Haiweng [Hai-weng] 海翁
Lü Fengzi	Lü Feng-tzu	1886–1959	吕凤子		Rong [Jung] 溶, Fengchi [Feng-ch'ih] 凤痴
Lu Jingxiu	Lu Ching-hsiu	Modern	陆静修		
Lü Sibai	Lü Ssu-pai	1905–1973	吕斯百		
Lu Weizhao	Lu Wei-chao	Modern	陆维钊		
Lu Yanshao	Lu Yen-shao	b. 1909	陆俨少		Wanruo [Wan-jo] 宛若
Ni Yide	Ni I-te	1901–1970	倪贻德		
Pan Tianshou	P'an T'ien-shou	1898–1971	潘天寿	Tianshou [T'ien-shou] 天授, Dayi [Ta-i] 大颐	Ashou [A-shou] 阿寿
Pu Xinyu	P'u Hsin-yü	1896–1963	溥心畬	Xinyu [Hsin-yü] 心畬	Pu Ru [P'u Ju] 溥儒, Xishan Yishi [Hsi-shan i-shih] 西山逸士, Xichuan Yishi [Hsi-ch'uan i-shih] 西川逸士, Hanyutang Zhuren [Han-yü-t'ang chu-jen] 寒玉堂主人
Qi Baishi	Ch'i Pai-shih	1864–1957	齐白石	Weiqing [Wei-ch'ing] 渭青	Qi Huang [Ch'i Huang] 齐璜, Chunzhi [Ch'un-chih] 纯芝, Baishi [Pai-shih] 白石, Baishi Shanren [Pai-shih shan-jen] 白石山人, Binsheng [Pin-sheng] 濒生, Kemu Laoren [K'o-mu lao-jen] 刻木老人, Muren [Mu-jen] 木人, Ji Ping [Chi P'ing] 寄萍, Sanbai Shiyin Fu-weng [San-pai shih-yin fu-weng] 三百石印富翁, Xingziwu Lao-min [Hsing-tzu-wu lao-min] 杏子坞老民, Jieshanweng weng [Chieh-shan-weng] 借山翁
Qian Shizhi	Ch'ien Shih-chih	1880–1922	钱食芝		
Qian Songyan	Ch'ien Sung-yen	1899–1986	钱松嵒	Song Yan [Sung Yen] 松岩	Jilu Zhuren [Chi-lu chu-jen] 芑庐主人
Qin Zhongwen	Ch'in Chung-wen	1896–1974	秦仲文	Zhongwen [Chung-wen] 仲文	Qin Yu [Ch'in Yü] 秦裕, Yurong [Yü-jung] 裕荣, Zhongfu [Chung-fu] 仲父, Liuhu [Liu-hu] 柳湖
Sha Menghai	Sha Meng-hai	1900–1992	沙孟海	Wen Ruo [Wen Juo] 文若	
Shi Lu	Shih Lu	1919–1982	石鲁		Feng Shilu [Feng Shih-lu] 冯石鲁, Feng Yaheng [Feng Ya-heng] 冯亚珩
Shu Qingchun	Shu Ch'ing-ch'un	Modern	舒庆春	Lao She [Lao She] 老舍	Shu Sheyu [Shu She-yu] 舒舍予
Song Wenzhi	Sung Wen-chih	b. ca. 1918	宋文治		

Prepared by Elizabeth M. Owen

FURTHER READINGS

China

Ershisi shi 二十四史 (History of twenty-four dynasties). Beijing: Zhonghua shuju, 1974.

Gernet, Jacques. *A History of Chinese Civilization.* Cambridge: Cambridge University Press, 1983.

Hucker, Charles O. *China's Imperial Past: An Introduction to Chinese History and Culture.* Stanford: Stanford University Press, 1975.

Needham, Joseph. *Science and Civilization in China.* 5 vols. Cambridge: Cambridge University Press, 1954–.

Spence, Jonathan. *The Search for Modern China.* New York: W. W. Norton, 1990.

Twitchett, Denis, and John K. Fairbank, eds. *The Cambridge History of China.* New York: Cambridge University Press, 1978–.

Chinese Painting—General

Barnhart, Richard M., Wen C. Fong, and Maxwell K. Hearn. *Mandate of Heaven: Emperors and Artists in China.* Zurich: Museum Rietberg Zurich, 1996.

Bo Songnian 薄松年. *Zhongguo nianhua shi* 中国年画史 (History of Chinese New Year's painting). Shenyang: Liaoning Fine Art Publishing House, 1986.

Bush, Susan. *The Chinese Literati on Painting: Su Shih (1037–1101) to Tung Ch'i-ch'ang (1555–1636).* Cambridge: Harvard University Press, 1971.

Bush, Susan, and Hsio-yen Shih, comps. and eds. *Early Chinese Texts on Painting.* Cambridge: Harvard University Press, 1985.

Cahill, James. *Chinese Painting.* Geneva: Skira, 1960.

———. *The Painter's Practice: How Artists Lived and Worked in Traditional China.* New York: Columbia University Press, 1994.

Chen Chuanxi 陈传席. *Zhongguo shanshuihua shi* 中国山水画史 (History of Chinese landscape painting). Nanjing: Jiangsu Fine Art Publishing House, 1988.

Cleveland Museum of Art. *Eight Dynasties of Chinese Painting: The Collections of the Nelson Gallery—Atkins Museum, Kansas City, and the Cleveland Museum of Art.* With essays by Wai-kam Ho et al. Cleveland, Ohio: Cleveland Museum of Art in cooperation with Indiana University Press, 1980.

Fong, Wen C., and James C. Y. Watt et al. *Possessing the Past: Treasures from the National Palace Museum, Taipei.* New York: Metropolitan Museum of Art; Taibei: National Palace Museum, 1996; distributed by Harry N. Abrams, New York.

Hong Zaixin 洪再辛. *Haiwai zhongguo hua yanjiu wenxuan* 海外中国画研究文选 (Selection of essays on research on Chinese painting by scholars overseas). Shanghai: Shanghai People's Fine Art Publishing House, 1992.

Lee, Sherman E. *Chinese Landscape Painting.* Cleveland, Ohio: Cleveland Museum of Art, 1962.

Li, Chu-tsing, James Cahill, and Wai-kam Ho, eds. *Artists and Patrons: Some Social and Economic Aspects of Chinese Painting.* Seattle: University of Washington Press, 1991.

Lidai minghua pingzhuan 历代名画评传 (Comments on famous paintings of various dynasties). 2 vols. Hong Kong: Zhonghua shuju, 1979.

Loehr, Max. *The Great Painters of China.* London: Harper and Row, 1980.

Lu Fusheng 卢辅圣 et al., comps. and eds. *Zhongguo shuhua quanshu* 中国书画全书 (Complete collection on Chinese calligraphy and painting). 8 vols. Shanghai: Shuhua chubanshe, 1992–1995.

Nie Chongzheng 聂崇正. *Gongting yishu de guanghui* 宫廷艺术的光辉 (The brilliance of palace art). Taibei: Dongda Book Co., 1996.

Ran Xiang zheng 冉祥正 and Yan Shaoxian 阎少显. *Zhongguo lidai huajia zhuanlue* 中国历代画家传略 (Brief biographies of artists in various dynasties). Beijing: China Zhanwang Publishing House, 1986.

Silbergeld, Jerome. *Chinese Painting Style: Media, Methods, and Principles of Form.* Seattle: University of Washington Press, 1982.

Sirén, Osvald, *Chinese Painting: Leading Masters and Principles.* 6 vols. New York: Ronald Press, 1956–1958.

Sullivan, Michael. *The Three Perfections: Chinese Painting, Poetry, and Calligraphy.* London: Thames and Hudson, 1974.

Wang Bomin 王伯敏. *Zhongguo huihua shi* 中国绘画史 (History of Chinese painting). Shanghai: Shanghai People's Fine Art Publishing House, 1982.

———. *Zhongguo meishu tongshi* 中国美术通史 (A comprehensive history of the fine art of China). 8 vols. Jinan: Shandong jiayu chubanshe, 1987.

Wang Kewen 王克文. *Shanshuihua tan* 山水画谈 (Discussion of landscape painting). Shanghai: Shanghai People's Fine Art Publishing House, 1993.

Wu Hung. *The Double Screen: Medium and Representation in Chinese Painting.* Chicago: University of Chicago Press, 1996.

Xu Bangda 徐邦达. *Illustrated Catalogue of the History of Chinese Painting.* Shanghai: Shanghai People's Fine Art Publishing House, 1984.

———. *Lidai shuhuajia zhuanji kaobian* 历代书画家传记考辨 (Chronological studies of calligraphers and painters in various dynasties). Shanghai: Shanghai People's Fine Art Publishing House, 1983.

Yang Renkai 杨仁恺 et al. *Zhongguo shuhua* 中国书画 (Chinese calligraphy and painting). Shanghai: Guji chubanshe, 1990.

Yang Xin 杨新. *Guobao huicui* 国宝荟萃 (A galaxy of stately treasures). Hong Kong: Commercial Press, 1992.

———. *Yang Xin meishu lunwen ji* 杨新美术论文集 (A collection of essays on the fine arts by Yang Xin). Beijing: Zijincheng (Forbidden City) Publishing House, 1994.

Ye Qianyu 叶浅予. *Xilun cangsang ji liunian* 细论沧桑记流年 (Detailed records of years past). Beijing: Qunyan Publishing House, 1992.

Yu Anlan 于安澜, ed. *Hualun congkan* 画论丛刊 (Series of treatises on painting). Beijing: Beijing People's Fine Art Publishing House, 1989.

———. *Huashi congshu* 画史丛书 (Series on the history of painting). Shanghai: Shanghai People's Fine Art Publishing House, 1963.

Yu Jianhua 俞剑华. *Zhongguo huihua shi* 中国绘画史 (History of Chinese painting). Shanghai: Shanghai shuju, 1984.

———. *Zhongguo meishujia renming cidian* 中国美术家人名辞典 (Biographical dictionary of Chinese artists). Shanghai: Shanghai People's Fine Art Publishing House, 1981.

Zhang Anzhi 张安治. *Zhongguo hua yu hualun* 中国画与画论 (Chinese painting and painting criticism). Shanghai: Shanghai People's Fine Art Publishing House, 1986.

Zhongguo meishu quanji: Huihua 中国美术全集: 绘画 (A comprehensive collection of Chinese art: Painting). 21 vols. Shanghai and Beijing, 1984–.

Zhou Jiyin 周积寅. *Yu Jianhua meishu lunwen ji* 俞剑华美术论文集 (Collection of essays by Yu Jianhua on fine art). Jinan: Shandong Fine Art Publishing House, 1986.

The Origins of Chinese Painting (Paleolithic Period to Tang Dynasty)

Acker, William R. B. *Some T'ang and Pre-T'ang Texts on Chinese Painting*. 2 vols. Leiden: E. J. Brill, 1954, 1974.

Chen Gaohua 陈高华. *Liu chao huajia shiliao* 六朝画家史料 (Historical materials on Six Dynasties painters). Beijing: Wenwu chubanshe, 1990.

———. *Sui Tang huajia shiliao* 隋唐画家史料 (Historical materials on painters of the Sui and Tang dynasties). Beijing: Wenwu chubanshe, 1987.

Fontein, Jan, and Wu Tung. *Han and T'ang Painted Murals Discovered in Tombs in the People's Republic of China and Copied by Contemporary Chinese Painters*. Boston: Museum of Fine Arts, 1976.

Powers, Martin. *Art and Political Expression in Early China*. New Haven: Yale University Press, 1991.

Spiro, Audrey. *Contemplating the Ancients: Aesthetic and Social Issues in Early Chinese Portraiture*. Berkeley: University of California Press, 1990.

Sullivan, Michael. *The Birth of Landscape Painting in China*. Berkeley: University of California Press, 1961.

———. *Chinese Landscape Painting in the Sui and T'ang Dynasties*. Berkeley: University of California Press, 1980.

Whitfield, Roderick, and Anne Farrer, *Caves of the Thousand Buddhas: Chinese Art from the Silk Route*. New York: George Braziller, 1990.

Wu Hung. *Monumentality in Early Chinese Art and Architecture*. Stanford: Stanford University Press, 1995.

———. *The Wu Liang Shrine: The Ideology of Early Chinese Pictorial Art*. Stanford: Stanford University Press, 1989.

The Five Dynasties and the Song Period (907–1279)

Barnhart, Richard M. Marriage of the Lord of the River: *A Lost Landscape by Tung Yuan*. Ascona, Switzerland: Artibus Asiae, 1970.

Cahill, James. *The Lyric Journey: Poetic Painting in China and Japan*. The Reischauer Lectures. Cambridge: Harvard University Press, 1996.

Chen Gaohua 陈高华. *Song Liao Jin huajia shiliao* 宋辽金画家史料 (Historical materials on painters of the Song, Liao, and Jin dynasties). Beijing: Wenwu chubanshe, 1984.

Fong, Wen C. *Beyond Representation*. New Haven: Yale University Press, 1992.

Fong, Wen C., and Marilyn Fu. *Sung and Yüan Paintings*. New York: Metropolitan Museum of Art, 1980.

Murray, Julia K. *Ma Hezhi and the Illustration of the* Book of Odes. Cambridge: Cambridge University Press, 1993.

The Yuan Dynasty (1271–1368)

Bickford, Maggie, et al. *Bones of Jade, Soul of Ice: The Flowering Plum in Chinese Art*. New Haven: Yale University Art Gallery, 1985.

———. *Ink Plum: The Making of a Chinese Scholar-Painting Genre*. New York: Cambridge University Press, 1996.

Cahill, James. *Hills Beyond a River: Chinese Painting of the Yüan Dynasty, 1279–1368*. New York: John Weatherhill, 1976.

Chen Gaohua 陈高华. *Yuandai huajia shiliao* 元代画家史料 (Historical materials on Yuan-dynasty painters). Beijing: Wenwu chubanshe, 1980.

Fong, Wen C., et al. *Images of the Mind: Selections from the Edward L. Elliott Family and John B. Elliott Collections of Chinese Calligraphy and Painting at the Art Museum, Princeton University*. Princeton: Princeton University Art Museum, 1984.

Lee, Sherman E., and Wai-kam Ho. *Chinese Art Under the Mongols: The Yüan Dynasty (1279–1368)*. Cleveland, Ohio: Cleveland Museum of Art, 1968.

Li, Chu-tsing. Autumn Colors on the Ch'iao and Hua Mountains: *A Landscape by Chao Meng-fu*. Artibus Asiae Supplementum 21. Ascona, Switzerland: Artibus Asiae, 1965.

The Ming Dynasty (1368–1644)

Barnhart, Richard M., with contributions by Mary Ann Rogers and Richard Stanley-Baker. *Painters of the Great Ming: The Imperial Court and the Zhe School*. Dallas: Dallas Museum of Art, 1993.

Cahill, James. *The Distant Mountains: Chinese Painting of the Late Ming Dynasty, 1570–1644*. New York: John Weatherhill, 1982.

———. *Parting at the Shore: Chinese Painting of the Early and Middle Ming Dynasty, 1368–1580*. New York: John Weatherhill, 1978.

———. *The Restless Landscape: Chinese Painting of the Late Ming Period*. Berkeley: University of California Art Museum, 1971.

Clapp, Anne de Courcey. *The Paintings of T'ang Yin*. Chicago: University of Chicago Press, 1991.

———. *Wen Cheng-ming: The Ming Artist and Antiquity*. Ascona, Switzerland: Artibus Asiae, 1975.

Edwards, Richard. *The Art of Wen Cheng-ming (1470–1559)*. Ann Arbor: University of Michigan, 1976.

———. *The Field of Stones: A Study of the Art of Shen Chou*. Washington, D.C.: Smithsonian Institution, 1962.

Ho, Wai-kam, ed. *The Century of Tung Ch'i-ch'ang, 1555–1636*. 2 vols. Kansas City: Nelson-Atkins Museum of Art, 1992.

Liscomb, Kathlyn M. *Learning from Mt. Hua: A Chinese Physician's Illustrated Travel Record and Painting Theory*. Cambridge: Cambridge University Press, 1993.

Mu Yiqin 穆益勤, ed. *Mingdai yuanti zhepai shiliao* 明代院体浙派史料 (Historical materials on the Zhe School in the Ming dynasty). Shanghai: Shanghai People's Fine Art Publishing House, 1985.

Weidner, Marsha, et al. *Views from Jade Terrace: Chinese Women Artists, 1300–1912*. Indianapolis: Indianapolis Museum of Art; New York: Rizzoli International Publications, 1988.

The Qing Dynasty (1644–1911)

Anhui Provincial Cultural and Art Research Institute 安徽省文化艺术研究所. *Lun Huangshan zhu huapai wenji* 论黄山诸画派文集 (Collection of essays on various painting schools of Mount Huang). Shanghai: Shanghai People's Fine Art Publishing House, 1987.

Beurdeley, Cecile, and Michel Beurdeley. *Giuseppe Castiglione: A Jesuit Painter at the Court of the Chinese Emperors.* Rutland, Vt.: Charles Tuttle, 1972.

Brown, Claudia, and Chou Ju-Hsi. *The Elegant Brush: Chinese Painting Under the Qianlong Emperor, 1735–1795.* Phoenix, Ariz.: Phoenix Art Museum, 1992.

———. *Transcending Turmoil: Painting at the Close of China's Empire, 1796–1911.* Phoenix, Ariz.: Phoenix Art Museum, 1992.

Cahill, James. *The Compelling Image: Nature and Style in Seventeenth-Century Chinese Painting.* Cambridge: Harvard University Press, 1982.

Ding Xiyuan 丁羲元. *Xugu yanjiu* 虚谷研究 (Studies of Xugu). Tianjin: Tianjin People's Fine Art Publishing House, 1987.

Fong, Wen C. *Returning Home: Tao-chi's Album of Landscapes and Flowers.* New York: George Braziller, 1976.

Giacalone, Vito. *The Eccentric Painters of Yangzhou.* New York: China House Gallery, China Institute of America, 1992.

Liu Gangji 刘纲纪. *Gong Xian* 龚贤 (Gong Xian). Shanghai: Shanghai People's Fine Art Publishing House, 1962.

Nie Chongzheng 聂崇正. *Qingdai gongting huihua* 清代宫廷绘画 (Palace paintings in the Qing dynasty). Beijing: Wenwu chubanshe, 1992.

———. *Yuan Jiang he Yuan Yao* 袁江和袁耀 (Yuan Jiang and Yuan Yao). Shanghai: Shanghai People's Fine Art Publishing House, 1982.

Pan Mao 潘茂. *Zheng Banqiao* 郑板桥 (Zheng Banqiao). Shanghai: Shanghai People's Fine Art Publishing House, 1980.

Rogers, Howard, and Sherman E. Lee. *Masterpieces of Ming and Qing Painting from the Forbidden City.* Lansdale, Pa.: International Arts Council, 1988.

Vinograd, Richard. *Boundaries of the Self: Chinese Portraits, 1600–1900.* Cambridge: Cambridge University Press, 1992.

Wang Fangyu and Richard M. Barnhart. *Master of the Lotus Garden: The Life and Art of Bada Shanren (1626–1705).* Ed. Judith G. Smith. New Haven: Yale University Art Gallery and Yale University Press, 1990.

Xie Zhiliu 谢稚流. *Zhu Da* 朱耷 (Zhu Da [Bada Shanren]). Shanghai: Shanghai People's Fine Art Publishing House, 1958.

Xue Yongnian 薛永年 and Xue Feng 薛锋. *Yangzhou baguai yu Yangzhou shangye* 杨州八怪与杨州商业 (The Eight Eccentrics of Yangzhou and commerce in Yangzhou). Beijing: People's Fine Art Publishing House, 1991.

Yang Boda 杨伯达. *Qingdai yuan hua* 清代院画 (Academic painting in the Qing dynasty). Beijing: Zijincheng (Forbidden City) Publishing House, 1993.

Yang Xin 杨新. *Yangzhou baguai* 杨州八怪 (The Eight Eccentrics of Yangzhou). Beijing: Wenwu chubanshe, 1981.

Zheng Zhuolu 郑拙庐. *Shi Tao yanjiu* 石涛研究 (Studies on Shi Tao). Beijing: People's Fine Art Publishing House, 1963.

Prepared by Elizabeth M. Owen

Traditional Chinese Painting in the Twentieth Century

Andrews, Julia F. *Painters and Politics in the People's Republic of China, 1949–1979.* Berkeley: University of California Press, 1994.

Bao Limin 包立民. *Zhang Daqian de yishu* 张大千的艺术 (The art of Zhang Daqian). Beijing: Sanlian shudian, 1986.

Chang, Arnold. *Painting in the People's Republic of China: The Politics of Style.* Boulder, Colo.: Westview Press, 1980.

Fu, Shen. *Challenging the Past: The Paintings of Chang Dai-chien.* Trans. Jan Stuart. Washington, D.C.: Arthur M. Sackler Gallery, Smithsonian Institution; Seattle: University of Washington Press, 1991.

Kandinsky, Wassily. *Concerning the Spiritual in Art.* New York: George Wittenhern, 1955. Chinese edition, Beijing: Chinese Academy of Social Sciences Publishing House, 1987.

Kao, Mayching, ed. *Twentieth-Century Chinese Painting.* Oxford: Oxford University Press, 1988.

Lang Shaojun 郎绍君. *Lin Fengmian* 林风眠 (Lin Fengmian). Taibei: Taiwan Jinxiu Cultural Publishing Co.; Beijing: Wenwu chubanshe, 1991.

———. *Lun xiandai Zhongguo meishu* 论现代中国美术 (On the fine arts of modern China). Nanjing: Jiangsu Fine Art Publishing House, 1988.

———. *Qi Baishi yanjiu* 齐白石研究 (Studies on Qi Baishi). Tianjin: Tianjin Yangliuqing Painting Bookstore, 1996.

———. *Xiandai Zhongguohua lunji* 现代中国画论集 (Essays on modern Chinese painting). Nanning: Guangxi Fine Art Publishing House, 1995.

Li, Chu-tsing. *Trends in Modern Chinese Painting.* Ascona, Switzerland: Artibus Asiae, 1979.

Li Youguang 李有光 and Chen Xiufan 陈修范. *Chen Zhifo yanjiu* 陈之佛研究 (Study of Chen Zhifo). Nanjing: Jiangsu Fine Art Publishing House, 1990.

Shui Tianzhong 水天中. *Dangdai huihua pingshu* 当代绘画评述 (Comments on modern painting). Taiyuan: Shanxi People's Publishing House, 1991.

Sullivan, Michael. *Art and Artists of Twentieth-Century China.* Berkeley: University of California Press, 1996.

———. *Chinese Art in the Twentieth Century.* Berkeley: University of California Press, 1959.

———. *The Meeting of Eastern and Western Art.* Berkeley: University of California Press, 1989.

Wang Jiquan 王继权 and Tong Weigang 童炜钢. *Guo Moruo nianpu* 郭沫若年谱 (Chronology of Guo Moruo). Nanjing: Jiangsu Fine Art Publishing House, 1983.

Wu Linsheng 伍霖生. *Fu Baoshi lun hua* 傅抱石论画 (Fu Baoshi on painting). Taibei: Taiwan Artists Press, 1991.

Xu Boyang 徐伯阳 and Jin Shan 金山. *Xu Beihong nianpu* 徐悲鸿年谱 (Chronology of Xu Beihong). Taibei: Taiwan Artists Press, 1991.

CONTRIBUTORS

Richard M. Barnhart is John M. Schiff Professor of History of Art at Yale University. His works include *Master of the Lotus Garden: The Life and Art of Bada Shanren (1626–1705)* (1990; with Wang Fangyu), *Painters of the Great Ming: The Imperial Court and the Zhe School* (1993), and *Mandate of Heaven: Emperors and Artists in China* (1996; with Wen C. Fong and Maxwell K. Hearn). He lives in New Haven.

James Cahill is professor emeritus of the history of art at the University of California, Berkeley. His many publications include *The Compelling Image: Nature and Style in Seventeenth-Century Chinese Painting* (1982), *The Painter's Practice: How Artists Lived and Worked in Traditional China* (1994), and *The Lyric Journey: Poetic Painting in China and Japan* (1996). He lives in Berkeley and Beijing.

Lang Shaojun is director of the Fine Arts Research Laboratory at the Institute of Fine Arts, Chinese Academy of Arts. His works include *Lun xiandai Zhongguo meishu* (On the fine arts of modern China, 1988), *Xiandai Zhongguohua lunji* (Essays on modern Chinese painting, 1995), and *Qi Baishi yanjiu* (Studies on Qi Baishi, 1996). He lives in Beijing.

Nie Chongzheng is a research fellow at the Palace Museum. His writings include *Yuan Jiang he Yuan Yao* (Yuan Jiang and Yuan Yao, 1982), *Qingdai gongting huihua* (Palace paintings in the Qing dynasty, 1992), and *Gongting yishu de guanghui* (The brilliance of palace art, 1996). He lives in Beijing.

Wu Hung is Harrie A. Vanderstappen Distinguished Service Professor in Chinese Art History at the University of Chicago. His works include *The Wu Liang Shrine: The Ideology of Early Chinese Pictorial Art* (1989), *Monumentality in Early Chinese Art and Architecture* (1995), and *The Double Screen: Medium and Representation in Chinese Painting* (1996). He lives in Chicago.

Yang Xin is deputy director and research fellow at the Palace Museum. His writings include *Yangzhou baguai* (The Eight Eccentrics of Yangzhou, 1981), *Guobao huicui* (A galaxy of stately treasures, 1992), and *Yang Xin meishu lunwen ji* (A collection of essays on the fine arts by Yang Xin, 1994). He lives in Beijing.

ACKNOWLEDGMENTS

A great many individuals and institutions participated in the making of this book. In China, the Cultural Relics Administration, particularly former Director Zhang Deqin and former Deputy Director Yan Zhentang, provided much-appreciated assistance. We are also indebted to the museums in the People's Republic of China that supplied high-quality glossies and transparencies of paintings. The staff at the Palace Museum in Beijing provided the single greatest number of pictures and worked hard to meet our many requests. To them and to the staff at the following museums we offer our thanks: the Shanghai Museum, the Museum of Chinese History, the Chinese Fine Art Gallery, the Cultural Relics Publishing House in Beijing, the Nanjing Museum, the Zhejiang Provincial Museum, the Shaanxi Provincial Museum, the Jilin Provincial Museum, the Guangdong Provincial Museum, the Hunan Provincial Museum, the Tianjin Municipal Museum, the Tianjin Municipal Art Gallery, the Yangzhou Museum, the Suzhou Museum, the Guangzhou Museum, the Shanghai Academy of Chinese Painting, the Fine Art Research Institute at the Chinese Academy of Arts, the Rong Bao Zhai Painting Studio in Beijing, Xi'an Jiaotong University, the Beijing Xu Beihong Memorial Museum, and the Nanjing Fu Baoshi Memorial Museum. In addition, we gratefully acknowledge the permission given by Zou Peizhu, Li Keran's widow, and Xiao Qiong, Jiang Zhaohe's widow, for the use of some of their husbands' works. We are also indebted to a number of collectors and museums outside China that provided us with needed illustrations.

A large team of translators worked on the many versions of the text. As manuscripts were rewritten by the authors, so were the translations from English to Chinese and Chinese to English, so that a complete manuscript in both languages was always available to scholars and editors alike. Those who translated the Chinese texts into English and, in some cases, offered advice on how to deal with the complex and thorny translation issues are Lin Wusun, former president of the China International Publishing Group; Zhang Qingnan, former translator at Radio Beijing; Lin Debin, former deputy editor in chief of *China Today;* Chen Xiuzheng, former editor in chief at New World Press; and Tang Bowen, former senior translator at Foreign Languages Press. Those who translated the English into Chinese are Wang Dianming, research fellow at the Palace Museum; Zhang Shenyi, former professor at Beijing College of Education; Yang Yihua, associate research fellow at the Palace Museum; and Qian Zhijian, editor at *Fine Arts* magazine. We thank them all for their painstaking work, often performed under a tight deadline.

Over the course of five years three editors at Foreign Languages Press successfully coped with the plethora of details associated with editing the manuscript. Xiao Shiling, former deputy editor in chief, ably handled the initial arrangements for the book and guided the discussions among the authors. Yan Qiubai, art book editor, helped shape and direct the work until her untimely death. Liao Ping, senior editor, worked with skill, dedication, and good spirits to edit the Chinese manuscript, sort through innumerable questions dealing with the artwork, and coordinate the complicated task of shaping the text into a final manuscript.

At Yale University Press another team was involved in making the book. Judy Metro, acquisitions editor for art, was responsible for coordinating work on the book from beginning to end—a task she handled with resourcefulness and expertise. Several fine manuscript editors improved the readability of the text and added polish: Laura Jones Dooley, Harry Haskell, Lawrence Kenney, Susan Laity, and Noreen O'Connor-Abel. A sixth manuscript editor, Mary Pasti, also conscientiously and cheerfully coordinated the work among her colleagues and the authors. The editors all sought to preserve the voice of each author while weaving the contributions into a coherent book. Mary Mayer, the production controller, skillfully oversaw the complicated production and printing process. Rich Hendel created the elegant jacket and the overall design of the book.

Elizabeth M. Owen, consultant and researcher in Chinese art history at Yale University, prepared the Glossary, List of Artists by Period, Further Readings, and captions. She also provided invaluable assistance with both Chinese and art-historical questions. For her availability and expertise, we wish to express a particular thanks.

The Editorial Advisory Board for The Culture & Civilization of China series has been an important and continuing source of support and good advice. Stanley Katz, president of the American Council of Learned Societies, has offered wise counsel and assistance throughout.

Finally, let us thank Yang Zhengquan, president of the China International Publishing Group, his able assistant Vice President Huang Youyi, and John G. Ryden, director of Yale University Press, whose unstinting support and unswerving belief in the cooperative spirit of this project made all the difference.

Li Zhenguo
Deputy Editor in Chief
Foreign Languages Press

James Peck
Executive Editor
The Culture & Civilization of China
Yale University Press

INDEX

Geographies of Development

Now in its fourth edition, *Geographies of Development: An Introduction to Development Studies* remains a core, balanced and comprehensive introductory textbook for students of development studies, development geography and related fields. This clear and concise text encourages critical engagement by integrating theory alongside practice and related key topics throughout. It demonstrates informatively that ideas concerning development have been many and varied and highly contested – varying from time to time and from place to place.

Clearly written and accessible for students who have no prior knowledge of development, the book provides the basics in terms of a geographical approach to development: what the situation is, where, when and why. Over 200 maps, charts, tables, textboxes and pictures break up the text and offer alternative ways of showing the information. The text is further enhanced by a range of pedagogical features: chapter outlines, case studies, key thinkers, critical reflections, key points and summaries, discussion topics and further reading.

Geographies of Development continues to be an invaluable introductory text not only for geography students, but also anyone in area studies, international studies and development studies.

Robert Potter was Professor of Human Geography at the University of Reading, UK.

Tony Binns is Professor of Geography at the University of Otago, New Zealand.

Jennifer A. Elliott is Visiting Researcher in Geography at the University of Brighton, UK.

Etienne Nel is a Professor of Geography at the University of Otago, New Zealand.

David W. Smith was Professor of Economic Geography at the University of Liverpool, UK.